1	2	3	4	5	6	7	8
9	10	11	12	13	14	15	16
17	18	19	20	21	22	23	24
25	26	27	28	29	30	31	32
33	34	35	36	37	38	39	40
41	42	43	44	45	46	47	48
49	50	51	52	53	54	55	56
57	58	59	60	61	62	63	64

1 Robert Anderson, North American Rockwell

2 Roy L. Ash, Litton Industries

3 Larry Bell (photo Malcolm Lubliner)

4 John Brooks, Lear Siegler, Inc.

5 James Byars (photo Malcolm Lubliner)

6 Jerrold Canter, Universal Television Company (photo Bill Brothers)

7 John Chamberlain (photo William Crutchfield)

8 Otis Chandler, Times Mirror Foundation (photo John Engstead)

9 William Crutchfield (photo Barbara Crutchfield)

10 Justin Dart, Dart Industries

11 Dr. Richard D. DeLauer, TRW Systems

12 Jean Dubuffet (photo Luc Joubert, courtesy Pace Gallery)

13 Jean Dupuy

14 W. D. Eberle, American Standard

15 Frederick Eversley

16 Oyvind Fahlstrom (photo Malcolm Lubliner)

17 Alfred Fenaughty, Information International

18 Sam Francis

19 Stanley Grinstein, Mifran-Bowman

20 Najeeb Halaby, Pan American World Airways

21 Robert M. Hall, Hall Inc. Surgical Systems (photo Roger M. Short)

22 Newton Harrison (photo Malcolm Lubliner)

23 Wayne Heath, Heath and Company

24 William R. Hewlett, Hewlett-Packard

25 Robert Irwin (photo Malcolm Lubliner)

26 Herman Kahn, Hudson Institute

27 Edgar F. Kaiser, Kaiser Steel Corporation

28 R. B. Kitaj

29 Burt Kleiner, Kleiner, Bell Foundation (photo Gene Daniels)

30 A. C. Kotchian, Lockheed Aircraft Corporation

31 Rockne Krebs (photo Malcolm Lubliner)

32 John B. Lawson, Philco-Ford Corporation

33 Wesley Duke Lee (photo Malcolm Lubliner)

34 Roy Lichtenstein (photo Malcolm Lubliner)

35 Louis B. Lundborg, Bank of America

36 Jackson MacLow (photo Malcolm Lubliner)

37 C. E. McKittrick, Jr., IBM (photo Leigh Weiner)

38 Boyd Mefferd (photo William Crutchfield)

39 J. Irwin Miller, Cummins Engine Company

40 K. T. Norris, Jr., Norris Industries

41 Claes Oldenburg (photo Malcolm Lubliner)

42 Jules Olitski (photo Eric Pollitzer)

43 Milan Panic, International Chemical and Nuclear Corporation

44 Eduardo Paolozzi (photo William Crutchfield)

45 William Pascoe, III, American Cement

46 Dr. W. H. Pickering, Jet Propulsion Laboratory

47 Jeff Raskin

48 Robert Rauschenberg (photo courtesy Gemini G.E.L.)

49 Jesse Reichek (photo Malcolm Lubliner)

50 Dr. George A. Roberts, Teledyne, Inc.

51 William E. Roberts, Ampex Corporation

52 Henry S. Rowen, The Rand Corporation (photo Leigh Weiner)

53 Robert Sarnoff, RCA

54 Richard Serra (photo & courtesy Pasadena Art Museum)

55 Tony Smith (photo Malcolm Lubliner)

56 James Turrell (photo Malcolm Lubliner)

57 Kenneth Tyler, Gemini G.E.L.

58 H. J. Van der Eb, Container Corporation of America (photo Fabian Bachrach)

59 Andy Warhol (photo William Crutchfield)

60 Lew R. Wasserman, Universal Film Studios

61 Harry Wetzel, The Garrett Corporation

62 Marvin C. Whatmore, Cowles Communications, Inc. (photo Arnold Newman)

63 Robert Whitman (photo Malcolm Lubliner)

64 Richard Zanuck, Twentieth Century Fox Film Corporation

Art & Technology

Maurice Tuchman

A Report on the
Art & Technology Program of the
Los Angeles County Museum of Art
1967-1971

Los Angeles County Museum of Art

Distributed by The Viking Press New York

Published in hard cover 1971 by The Viking Press, Inc.
625 Madison Avenue, New York, N.Y., 10022

Published in Canada by
The Macmillan Company of Canada Limited

SBN: 670-13372-8

Library of Congress Catalog Card Number: 74-146884

Contents: A&T

The Museum's Contemporary Art Council has sponsored and supported *Art and Technology* from its inception in late 1966 to the present time. I am grateful to this devoted group, and particularly to its Chairmen during the five-year development of the program—Harry Sherwood, Dr. Judd Marmor and Mrs. Joann Phillips.

Mrs. Otis Chandler was the primary figure responsible for corporation involvement. She worked indefatigably with me to obtain company support for almost three years.

David Antin, Director of the Art Gallery, University of California, San Diego, was commissioned by Viking Press in January, 1968 to write a book about the A & T program. He was an important source of information about technical matters as well as artistic concerns.

Dr. Richard Feynman, Tolman Professor of Theoretical Physics, California Institute of Technology, served as Consultant to A & T. Dr. Feynman met most of the artists involved in the more esoteric areas of corporation technology and acted as translator and guide. He was available to artists who needed him.

Nina Kaiden Wright, Director of Fine Arts at Ruder and Finn, Inc., also served as Consultant to A & T, and, among other suggestions, helped enlist the Hudson Institute as a Sponsor Corporation.

In the course of developing this program many individuals made helpful suggestions. I want particularly to thank Clinton Adams, Michael Blankfort, Paul Brach, Sidney F. Brody, Eugenia Butler, James Butler, Leo Castelli, Elizabeth Coffelt, Dorothe Curtis, Louis Danziger, L. Claridge Davis, Henry Dreyfuss, Monte Factor, Edward Fry, Ken Glen, Henry Hopkins, Malcolm Levinthal, Dr. Franklin Murphy, Jerald Ordover, Talmadge Reed, Jasia Reichardt, Pierre Restany, George Rickey, Barbara Rose, Dr. Daniel Rosenthal, Richard Sherwood, Fred Usher, Jan van der Marck, and Robert Weinstein.

Malcolm Lubliner was commissioned to record photographically the encounters between artists and corporations.

William Crutchfield was commissioned to interpret graphically the more significant interactions—his drawings appear throughout the introduction to this Report.

James Lowery wrote the descriptions of participating corporations in the final section of this book. Manny Silverman and Jerry Solomon of Art Services, Inc., rendered many gratuities to visiting artists in the course of the program.

In organizing the preview exhibition of eight artists' work from the A & T program for the United States Pavilion at Expo 70, I worked closely with Jack Masey, Deputy Commissioner General, Patricia Ezell, Exhibits Project Officer, and Designer Ray Komai. In Los Angeles, New York and Osaka, Japan there were continual meetings with the designers of the Expo Exhibition Design Team, Davis, Brody, Chermayeff, Geismar, de Harak, Associates. Designers David Sutton, Yasuo Uesaka, Gary Jacquemin and Tom Kuboda were also at the site and involved in the installation of that exhibition.

Eric Saarinen & Associates were commissioned by us and Container Corporation of America to make a film on the exhibition at Expo 70. The film will be presented during the period of the Museum exhibition. In the sections in this book on the eight Expo artists—Newton Harrison, Rockne Krebs, Roy Lichtenstein, Boyd Mefferd, Claes Oldenburg, Tony Smith, Andy Warhol, Robert Whitman—all quotations, unless otherwise noted, are from tapes made by Howard Chesley of Eric Saarinen & Associates throughout 1970.

James Kenion, Art Transportation Coordinator, was at the Osaka site with me for the three month installation of the "New Arts" exhibition in the U.S. Pavilion. Cecil Fergerson, Museum Assistant II, assisted him in Japan in dismantling the show when Expo closed. Kenion, Fergerson and Head of Technical Services James Allen will be in charge of the Museum installation, along with Elliott Hutchinson, Head of Construction and Maintenance, and his Assistant Roy Ingalls. The staffs in these sections will be called on in unprecedented ways. Ben Johnson, Conservator, will supervise the operational aspects of the works.

My secretary Florence Hairston worked on A & T from its inception in 1966. In typing manuscripts throughout this time she was assisted by Barbara McQuaide and Diane Turner. In preparing this Report, the manuscript was read by William Osmun, Senior Curator, Jeanne Doyle, Coordinator of Exhibitions and Publications, and Joanne Jaffe, Publications Associate. The writer Frederic Tuten also read the manuscript and made helpful comments.

In planning the exhibition for the Museum, I benefited from the expertise of Lawrence Morton, Curator of Music, and Robert Raitch, Audio-Visual Coordinator, Educational Services. Vincent Robbins, Head Graphic Artist, rendered diagrams of artists Rockne Krebs and Newton Harrison. A volunteer worker, Mrs. Grace Spencer, helped in research and in maintaining the voluminous records on the project.

At our request, hospitality was generously offered to

visiting artists in Los Angeles by Dr. and Mrs. Leonard Asher, Mr. and Mrs. James Butler, Mr. and Mrs. Monte Factor, Mr. and Mrs. Stanley Grinstein, Mr. and Mrs. Melville Kolliner and Mr. and Mrs. Kenneth Tyler. In New York, London and Paris several individuals graciously allowed us the use of their homes for receptions and meetings with artists: Mme. Celine Chalem, Mr. and Mrs. Ivan Chermayeff, Mr. and Mrs. William Copley, Henry Hecht, Mr. and Mrs. Frank Lloyd and Nina Kaiden Wright. In Paris, Jean-François Jaeger, Director of the Galerie Jeanne Bucher, and Denise René were also helpful in arranging meetings.

James Monte and Hal Glicksman, both former Assistant Curators of Modern Art, each worked on A & T for approximately a year. Irena Shapira served as Coordinator of A & T in its early stages and until January, 1969. The planning and execution of A & T, and the extensive documentation of the program in this book, is the result of close and continual interaction over the past three years between myself and Associate Curator Jane Livingston, Assistant Curator Gail Scott and Special Assistant Betty Asher. It has been a pleasure for me to work with them. Each of us is responsible for the accounts of artists' involvement in part 3 of this book, which was finished in November, 1970, but the primary drafting of narratives on James Byars, John Chamberlain, Jean Dupuy, Oyvind Fahlstrom, Irwin-Turrell, Rockne Krebs, Jackson MacLow, Tony Smith, Andy Warhol and Jesse Reichek is by Jane Livingston; the accounts of Newton Harrison, R. B. Kitaj, Roy Lichtenstein, Boyd Mefferd, Robert Morris, Robert Rauschenberg, Richard Serra and Robert Whitman are by Gail Scott; and Betty Asher selected and collated most of the photographs and other materials on artists.

Maurice Tuchman
Senior Curator, Modern Art
Director, Art & Technology

Introduction

Maurice Tuchman

In 1966, when Art and Technology was first conceived, I had been living in Southern California for two years. A newcomer to this region is particularly sensitive to the futuristic character of Los Angeles, especially as it is manifested in advanced technology. I thought of the typical Coastal industries as chiefly aerospace oriented (Jet Propulsion Laboratory, Lockheed Aircraft); or geared toward scientific research (The Rand Corporation, TRW Systems); or connected with the vast cinema and TV industry in Southern California (Universal Film Studios). At a certain point—it is difficult to reconstruct the precise way in which this notion finally emerged consciously—I became intrigued by the thought of having artists brought into these industries to make works of art, moving about in them as they might in their own studios. In the beginning, as I was considering this idea as just an abstract concept, I had few concrete visions of what might actually result from such exchanges. Indeed I was not certain whether artists of calibre would desire such involvement with industry. And if they did, and an organized program could be instituted to give them such opportunities, I had no idea how to go about persuading corporations to receive artists into their facilities—nor for that matter, why they should want to.

In reviewing modern art history, one is easily convinced of the gathering esthetic urge to realize such an enterprise as I was envisioning. A collective will to gain access to modern industry underlies the programs of the Italian Futurists, Russian Constructivists, and many of the German Bauhaus artists. Within these movements, no intensive effort was made directly to approach industrial firms in order to harness corporate machinery or technology, or systematically to expose artists to their research capabilities. Still, the impulse to do this is well documented. A need to reform commercial industrial products, to create public monuments for a new society, to express fresh artistic ideas with the materials that only industry could provide—such were the concerns of these schools of artists, and they were announced in words and in works.

During late '66 and early '67, I began studying the nature and location of corporate resources in California. In November, 1967, I went to the Museum's Board of Trustees, members of which were significantly involved with over two dozen West Coast companies, to outline my proposal and to elicit advice and support. As individual entrepreneurs, the Board members were rather indifferent to the experiment, and as Trustees they resisted having the Museum commit itself, and me, to such an undertaking. The proposal appeared to them too vague and open-ended, and the budget almost impossible to predict. I argued that I would raise personally the great majority of funds to get the project underway, and that if I failed to do this, we would then simply drop the

scheme before it was made public, avoiding any embarrassment or significant financial loss to the institution. Other than on a practical level, I maintained that this project was a proper undertaking for a Museum, and represented an opportunity to play an innovative role. It would draw attention to the acknowledged need in the U. S. for institutions responsive to the interests of society—in this case, the interests of artists, and perhaps even businessmen. The Board gave me tacit consent to go ahead and study the possibilities, with the program still subject to their approval.

I prepared a case with which to solicit corporation involvement, centered on three main lines of approach which I calculated to be of interest to the business community. I argued that corporate donations to the arts, which were infinitesimal compared to support of medical and educational facilities, should be enlarged. This would benefit them, as much as the recipient museums, operas, theatres, etc., since businesses benefit from proximity to thriving cultural resources in attracting talented personnel. I also pointed out that the companies' collaborations with artists might well result in major works of art, and I decided that one work of art made with any significantly cooperative corporation should be offered to that corporation. (It became clear very early that a high proportion of the companies would view this possibility as a salient motive for collaboration.) Most importantly, I argued that companies might benefit immeasurably, in both direct and subtle ways, merely from exposure to creative personalities.

These arguments may have been substantive, but there remained the problem of presenting them to the right people. I had drawn up lists of corporations I felt should be solicited, but it was difficult to obtain appointments with their presidents. (I realized then that it would be fruitless to see public relations people, or anyone other than the man at the top who could sign the check and delegate authority.) In spite of the aegis of the Los Angeles County Museum of Art, it would typically take six phone calls and two letters, over a period of six months, to effect a meeting, and even with such protracted efforts few interviews were arranged. When I did get past the front door, the response from corporation executives was usually encouraging, but the overall rate of progress was much too slow.

In June, 1967, an article in the *Los Angeles Times* mentioned my plan to "bring together the incredible resources and advanced technology of industry with the equally incredible imagination and talent of the best artists at work today." Mrs. Otis Chandler, wife of the *Times'* publisher, was intrigued with the story and telephoned me about it. I asked Missy Chandler for her assistance in arranging appointments with corporation executives. She asked whether the Museum's Board was

not the appropriate vehicle for this operation. Informed that no Trustee had shown much interest in participation when I had presented the Board with my idea, she agreed to help. Mrs. Chandler's intervention proved immediately effective. She became primarily responsible for the involvement of over a dozen corporations in the now accelerated program.

In late 1967, we began the process of contacting over 250 companies, of which eventually thirty-seven joined the program in various ways. As encounters with corporation executives took place, the logistical guidelines and the scope of the program were gradually clarified. I soon realized that, for practical reasons, the program would have to be limited to companies located in the state of California. (Much later, we were able financially to extend outside the state, and companies located in Indiana, Illinois, Ohio, and New York State joined Art and Technology.) We could not, in the beginning, know how much money a company might donate to the Museum's general fund on Art and Technology, before an artist took up residence. We discussed various figures from three to fifteen thousand, before settling on $7,000 as the amount we would request as each corporation's initial financial obligation. This somehow emerged as the optimal sum, beyond which very few companies would commit. Later, we learned that many corporations calculated their pledge in a ratio of two to one: the $7,000 donation to the Museum suggested to them an expenditure of $14,000 to the artist. There was also the question of how long the companies would agree to have artists in their facilities. We realized that most companies, before signing a contract, would want an escape clause in writing to which they could refer should they desire early termination of the project. It would have been preferable to keep this open, allowing the artist and company to themselves decide when to end the relationship. Unfortunately we were forced to see that no company would initially agree to have an artist in residence for longer than three months. Many executives, however, indicated that if the collaboration developed interestingly, they would allow it to continue naturally. In fact, when the artist wanted to extend his residence he was able to do so. Still there was an intrinsic sense of limitation suggested to certain artists by the expectation of a three month project. Anticipating a restricted time span, some artists undoubtedly inhibited the scope of their esthetic conceptions.

Yet another factor needed clarification before we could outline the terms of company obligations. Many executives wanted to know rather precisely how much financial support and staff time would be expected from them after an artist came to work. But it would have been impossible to estimate budgets from companies as diverse as, for example, Rand and Lockheed or JPL and Kaiser Steel. And it was imperative to have identical

contracts with each participating company, as it was to have identical contractual agreements with the artists. We naturally wanted to avoid setting any advance financial limits on collaborations. Obviously a key motive in the program was to allow the chance of one or both parties being stimulated to extend their commitment out of sheer enthusiasm.

Few corporations questioned our total right to select artists for them. It should be noted that corporations had the option to "approve" the artist before he took up residence: such approval is of course implicit, but by making it explicit a certain degree of company wariness was eliminated.

In April, 1968, I met with the Board of Trustees for the second time to deliver a progress report. I anticipated that we could enlist the financial support of at least twenty corporations, to the amount of $140,000 as a straight donation to the Museum for use as needed in operating the program—to cover artists' payments, transportation and installation costs. According to my prospectus these twenty companies additionally would each take an artist into residence. I requested $70,000 from the Museum as its share in supporting Art and Technology for the 1968-69 fiscal year. (Perhaps unconsciously, I had adopted the businessman's strategy—but in reverse ratio.) The Board sanctioned the plan, provided that I obtain written agreements from ten corporations before announcing the program officially. I drew up a contract which took into account three different kinds of corporation participation. I knew that certain companies would be eager to have an artist in residence, but for various reasons, often having to do with anticipated stockholder reaction, would elect not to write a check to the Museum. Other companies would financially support the program and might desire collaboration, but an artistic use of their facilities was technically unlikely. We established categories of corporate involvement: Patron Sponsor Corporations, who would agree to take an artist into residence, and also donate $7,000 to the Museum; Sponsor Corporations, who would take an artist into residence but who donate less than $7,000 or nothing at all; Benefactor Corporations, asked to simply donate at least $7,000 to the Museum; and Contributing Sponsor Corporations, who would donate only services, or less than $7,000. Patron Sponsors had the "option to receive one principal work of art resulting from the collaboration"; the other categories of corporations did not have this option. See Appendix I, p. 31, for the complete text of the Patron Sponsor contract, which differs from the others only in regard to the factors just noted.

A brochure was drafted and printed at this time for corporation executives:

> Art and Technology is the working title* of a major project now being planned at the Los Angeles County Museum of Art. The purpose of this enterprise is to place approximately twenty important artists "in residence" for up to a twelve week period within leading technological and industrial corporations in California. Works of art resulting from these cooperative endeavors will be exhibited at the Museum in the Spring of 1970.
>
> International developments in art have provided the impetus for this project: much of the most compelling art since 1910 has depended upon the materials and processes of technology, and has increasingly assimilated scientific and industrial advances. Nevertheless, only in isolated circumstances have artists been able to carry out their ideas or even initiate projects due to the lack of an operative relationship with corporate facilities. Our objective now is to provide the necessary meeting ground for some eminent contemporary artists with sophisticated technological personnel and resources. Naturally we hope that this endeavor will result not only in significant works of art but in an ongoing union between the two forces. It is our conviction that the need for this alliance is one of the most pressing esthetic issues of our time.
>
> During the past six months, we have made numerous preliminary contacts with corporation presidents in California. These discussions have served to corroborate our feeling that the advantages to participating corporate concerns are manifold. Since the project will be fully documented by CBS television for a network special, as well as being systematically publicized through other media, promotional benefits to industries can be considerable. It is expected that collaborating technical personnel may gain experience directly valuable to the corporation, as indeed has already occurred in the plastics industry. All expenses, including corporation staff time and materials, are tax deductible; in addition, Patron Sponsors will have the option to receive a work of art issuing from this collaboration. In many cases, the art works will exceed in value the total expense of the corporation's contribution.
>
> Corporations are asked to participate in one of five categories:
>
> 1. A Patron Sponsor Corporation takes an artist into twelve-week residence within one of its corporate facilities to work in a specific area with the corporation's personnel and materials. A Patron Sponsor Corporation also contributes $7,000 to the Los Angeles County Museum of Art to help defray the extraordinary expenses of the project. As noted above, Patron Sponsor Corporations have the option to receive a work of art issuing from the collaboration.
>
> 2. A Sponsor Corporation is a manufacturer who arranges to have an artist work within its plant, using specified personnel and materials, but makes a smaller contribution to the Museum's special fund for the project.
>
> 3. Contributing Sponsors donate materials and/or services to the Los Angeles County Museum of Art for this project but do not take an artist into residence.
>
> 4. Service Corporations provide specialized services such as transportation, housing facilities for visiting artists and technical consultation.
>
> 5. Benefactors are non-technical, non-manufacturing firms who donate $7,000 to the Museum's special fund for "Art and Technology."
>
> Industries located primarily in Southern California are now being approached for their cooperation. By May, 1968, a preliminary list of ten corporations should be made public. Beginning at this time and throughout 1968 and 1969, artists will be contacted by the Museum and asked to submit project proposals. Artists will be approached largely on the basis of the quality of their past work and expressed interest in specific technological processes. Projects to be implemented will be chosen by the Museum on the basis of both potential esthetic stature and practical feasibility. Corporations will be presented with an appropriate work proposal for their approval in principle; scheduling will then be arranged by the corporation, the artist and the Museum. The initial proposal submitted to corporations will be sufficiently clear to indicate the extent and nature of the corporation's involvement. It is understood that this preliminary plan may change considerably during the course of the collaboration between corporative personnel and artist.
>
> Participating artists will sign a contract drawn up by

*The reader will note reference to "Art and Technology" as a "working title." This nomenclature was never comfortably accepted by us. Years later, after lists of other titles were drawn up and discarded, we could not improve on Art and Technology. Terms like "synergy" and "interface" were considered, but abandoned for obvious reasons. We wanted to include reference to industry, but this word invariably summoned misleading evocations of *industrial design,* and that was a confusion we were determined to avoid.

the Museum setting forth rules and conditions. Non-local artists receive round-trip economy air fare plus $20 per diem expenses and Honorarium of $250 per week. Local artists receive the same Honorarium.

Corporations will enter into a written agreement with the Los Angeles County Museum of Art in advance of the scheduled residence periods.

In May, 1968, IBM and American Cement Corporation signed Patron Sponsor contracts and became the first contracted participants in Art and Technology. In October we officially announced the program. Press coverage in the *New York Times* and *Los Angeles Times* occasioned by this announcement were to help us in attracting most of the remaining corporations we required to make the program work. Two months later we listed the companies contracted to date in the first of eleven monthly reports:

PATRON SPONSORS

1. American Cement Corporation
2. Ampex Corporation
3. International Business Machines Corporation
4. Kaiser Steel Corporation
5. Litton Industries
6. Lockheed Aircraft Corporation
7. Teledyne, Inc.
8. The Garrett Corporation
9. Universal City Studios, Inc.
10. Wyle Laboratories

SPONSORS

1. Eldon Industries, Inc.
2. Hall Inc. Surgical Systems
3. Hewlett-Packard
4. Norris Industries Inc.
5. Philco-Ford Corporation
6. The Rand Corporation
7. TRW Systems

CONTRIBUTING SPONSOR

1. Twentieth Century Fox Film Corporation

BENEFACTORS

1. Bank of America
2. North American Rockwell Corporation

Much of our energy now shifted from negotiations with companies to the task of selecting and touring artists. Our discussions with artists were often strangely intense, and there was more opposition on their part to the goals of Art and Technology than we had expected to en-

counter. I had, for example, a particularly emotional conversation with Robert Irwin, who told me that many artists resented certain aspects of the program as they understood it: they felt that it was unfair for the Museum to take possession of the works created; that the Museum was primarily interested in producing an exhibition, rather than in arbitrating the process of interaction as an end in itself; that artists would be pressed by the Museum into making works for these reasons; and that they would not in fact be given access to experimental situations within companies which were not demonstrably related to the materials or processes of their past work. It was not difficult to disabuse Irwin and others of their misconceptions about property rights to the works of art, since the Museum, under the terms of the contracts, had no right whatever to receive works of art; this was made clear both in the corporation agreements and in the contract we were to make with artists.

The issue of our intended exhibition of the works made through Art and Technology was more complicated. My primary motive in attempting to make the resources of industry available to artists was emphatically not to simply mount an exhibition. I thought it would be fascinating to observe a potentially vital reciprocal process, and expected personal and professional gratification from my role as catalyst in establishing the vehicle for such connections. I believed that it was the process of interchange between artist and company that was most significant, rather than whatever tangible results might quickly occur. Obviously the probability that works of art would be created was not to be ignored—I knew that many artists would want nothing more than physically to realize esthetic ideas that may have remained in their minds only because of the technical difficulty of executing them. In short, one could reasonably expect that from twenty artists, each working several months in twenty corporations, some kinds of exhibitable things were likely to emerge. I did not regard the "success" or "failure" of the project as resting mainly with the quantity or even quality of the "results." But I also tried to indicate to Irwin that, given the rationale for such an experiment (which he admitted willingly), and given that we were an *art museum* of the county of Los Angeles, it was only reasonable that the institution would attempt to show something to its audience for its efforts. I did not feel that this would result in undue pressure being placed on the artists to produce certifiable art objects. Interestingly, Irwin himself was to provide perhaps the outstandingly valuable example of a purely interactive situation, issuing in no exhibitable object, although he did seriously contemplate making an environmental work based on his research at the Garrett Corporation's Life Sciences Department. I firmly believed, moreover, that to schedule an exhibition, and thus work toward consign-

ment deadlines, would not only give us an advantageous psychological goal, but would prove helpful in eliciting cooperation from industry. By gearing our efforts toward a culminative event, a quality of excitement and an increased dedication were brought to bear on our labors for this nebulous and prolonged endeavor. Art and Technology was an experiment—and it had to be made coherent and explicit in order to be validated.

The question of selecting artists for participation and deciding which artist should go where was a difficult one, and relates critically to the problem of making possible true "collaboration" as opposed to mere "art-making." We wanted viable, productive connections to come about, but it was important to us that these reciprocal endeavors be challenging and rewarding to both the artist and the scientist or engineer, by pro-voking them to reach beyond habituated patterns. However, we did not suppose that artists of character, accustomed to working with a particular vocabulary of forms, would be likely to abandon suddenly the esthetic means developed over a lifetime, merely because they were cast into an unfamiliar situation by taking up residence in a company. It was our intention simply to offer uncommon opportunities for those artists inclined to exercise them. How these opportunities might be used was exclusively the artist's concern.

Our intention from the outset of Art and Technology was to pay artists for time spent on the project, while they were in corporate residence, and later when instal-ling works at the Museum if their presence was needed. Funds raised from company donations allowed us to remunerate artists at a considerably higher rate than was conventionally allotted by non-profit institutions—inter-national symposia, print workshops, etc. We also attemp-ted to structure a situation whereby most of the works of art made collaboratively would become the property of the artist. To overcome any potential conflict be-tween the property rights of artist and company (the issue arises only with Patron Sponsor, not Sponsor Corporations), we advised artists concerned with owner-ship of works to plan their work in series, so that they would acquire most of the results. At the same time, companies were informed that they should expect artists to make multiple works if the artists so desired. The decision as to what constituted the "principal work" (the term stated in the contract for Patron Sponsor ownership) resided with us.

We drew up a contract for artists to include these points and to make clear that they were connected to the Museum, rather than the company, in terms of monies and possible obligations. See Appendix II, p. 36.

Most artists signed the contract, but Claes Oldenburg dissented and raised some interesting questions. Olden-

burg had been devoting considerable energy to the study of artists' contracts with dealers, galleries, printmakers, etc., over the previous year. He is possessed of a forensic acumen that makes attorneys—including his own—envious. He wrote to me on January 27, 1969.

These are my recommendations for a changed con-tract for the artist involved in the Art and Tech-nology project. I want to emphasize again that the contract is an integral part of the collaboration of art and technology. To ignore contract-making would be to remain with the old separation, where the artist says: I don't care as long as the thing gets done, a snobbish attitude which I don't feel fits the present and very American context of artist-industry coopera-tion. We're not engaged in creating property for the County Museum, but working out terms which are bound to influence future collaborations of this sort.

1. Travel.

I'll have to travel out to L.A. several times (see my proposed schedule letter of January 18).
I have already taken my allowed round trip (coach! which I changed to first class, paying difference myself) just to meet with Disney reps. According to Museum further trips will come out of my combined honorarium/diem (letter of January 17).

★ I demand that each round trip be paid for, first class, *not* from the hon./diem.
★ I also demand transportation be paid for materials I may bring out and their return. Don't corporations get spec. rates?
★ Also that transportation back be guaranteed for works not acquired by the Museum though made during the Museum project.
★ Also for the "principal work" in the event it is rejected by the patron sponsor and the museum.

2. In working with the unknown quantity of an industry, the artist engages in a risk esthetically, and he must have safeguards which assure him complete control over the result.

★ I demand that the artist should have the option to resign from the project at any time if he is not satis-fied with its progress.
★ Also that the artist should have the option to reject the "principal work" or any work made that does not meet his standards, and refuse the exhibition of the work by the Museum.
★ Problems in installation of the piece may arise and the installation of work by the Museum, if the Museum exhibits it should be subject to the artists approval. Also, if installation help is needed, the Museum should pay the artist's trip to LA to help plus expenses.

3. Paragraph 8 has been amended so that the artist retains ownership of work made during the project not "integral" to the "principal work." "Integral" should be defined as part of the work, or essential to it. Not for example preparatory sketches or models.

★ Also, the artist does not sign over his copyright of any work made during the project including the "principal work."

4. The artist takes a risk in exposing himself and his work to commercial exploitation promised in the prospectus to industry: ". . . promotional benefits can be considerable." Not however to the artist.

★ Therefore, publicity by the Museum or industry must be subject to the artist's approval and/or guaranteed not to violate his best interests. An example of this occurs in the Times article where a spokesman for the industry (Disney) states his expectations of what will occur: "I think show-biz is a good thing for an artist to learn. It helps him to clarify his ideas . . ." Granted, this info was obtained by the Times reporter, not from a release, but seems to me ominous.

5. A reading of the prospectus to industry will indicate how much the burden of sacrifice is on the artist, not on the other collaborators. Industry gets a tax deduction for help and materials provided, and presumably also for their donation of $7,000 to the project and their donation of the "principal work" to the Museum. That they will donate the work is tacitly supposed, though they are also promised the benefit of receiving art works (plural) which "will exceed in value the total expense of the corporation's contribution."

The other "collaborator"—the Museum, receives free a work of the artist it might otherwise have had to buy, depriving the artist and his agent of a sale. This gift comes with no strings attached and the right to resell—without any percentage to the artist—to *anyone*, after five years, the right to exhibit or not, etc., all the benefits had they bought a piece.

The artist receives no tax breaks, and is to work at a reduced rate for three months, supporting himself in a foreign place at an impossible per diem rate, and in addition, expected to pay his own transportation etc. Say he will work at approximately one fifth his normal rate. This is not a "collaboration" and is not set up to encourage the artist to do his best, rather to get it over with as quickly as possible, if he was unfortunate enough to sign the contract.

★ Therefore, I demand an increased "honorarium" of $6,000, which may be paid on an installment basis

out of which no other expenses are to be lifted, such as plane tickets.
★ A realistic per-diem expense of $40, considering hotel rooms, eating out, need of a car to get to Glendale. This to be paid any time the artist is in LA working on the project including installation time in 1970.

One should consider that the artist may be thinking about the project in his home base before, during or after his execution of it in LA—this is time not mentioned in the contract. Also that no studio facilities or housing arrangements are guaranteed or provided, and that a certain amount of time will be used up in just getting settled.

★ If it is at all possible to arrange, the artist should participate in any tax benefits of the gift to the Museum of his work. He should definitely receive a percentage in the event the work is sold by the Museum, especially if it is to a private party.

I replied to Claes on February 11, 1969,
Let me address myself to your comments point by point. The four starred points you make in "1" cannot be accommodated for any artist under the present budget of the project. Changes of this nature would have to hold, of course, for all of the artists, and if these changes were made, the complications and added—unpredictable—expenses would obviate the project entirely. Considering that all the expenditures made by the Museum, including preparations of different kinds and fund-raising, are for the purpose of a single exhibition, and not for acquisition of works of art, I think that the provisions for artists are fair.

In regard to "2": The artist has implicitly the "option to resign" in his contract, and to "reject the 'principal work' or any work made that does not meet his standards, and refuse the exhibition of the work by the Museum." If you would like these points stated more explicitly in your contract, we can do this. So far as installation is concerned, I know you understand that in *any* exhibition of a number of artists' works, every artist could not and has never had the right to place his work where he wants it regardless of other works. However, in some cases, specific works may be designed with a particular installation area in mind, and thus the artist would of course have that location reserved for his work. If you wish to select a site in advance of the completion of your project, we shall do our best to accommodate you. We would naturally solicit the advice of artists as to placement of the works in any event, and if help is needed, of course the Museum should pay the artist's trip to Los Angeles for this purpose plus expenses.

Re "3": "Integral" clearly does not refer to preparatory sketches or models; and there can similarly be no doubt that the artist "does not sign over his copyright . . ."

Re "4": Beyond the safeguards taken by the Museum on the artists' behalf, it would be impossible to guarantee that some independent journal will not negatively criticize an artist's work or in any number of ways "violate the artist's best interests." I know you realize this and I doubt that you would want it otherwise. So far as comments by corporation personnel go, which is what you have in mind, the Museum, while it cannot require that every company man clear an answer to a press question with us, has emphasized and will continue to request of corporations that every reasonable effort be made to clear public statements with the Museum.

Re "5": It's not clear to me what you mean by corporations "are also promised the benefit of receiving art works (plural) . . ." since a Patron Sponsor has only the option to receive a single work. Other works automatically belong to the artist; moreover, all works executed by Sponsor Corporations (as opposed to Patron Sponsors) go to the artist. Almost half of the corporations involved do not stand to receive any work of art. Furthermore, it is quite posssible that none of the Patron Sponsors will offer a work to us. This should indicate that we have not structured the project to gain "free" art works for the Museum. Your point about the Museum's right to resell a work should it be offered as a gift to us can be changed to suit you, since it is most definitely not our intention to sell any major works from the collection. If you like, you may stipulate that any gift of your work made to the Museum may not be sold in your lifetime.

The honorarium figure was the maximum sum the Museum could budget and it will not be possible to change it at this time for any, and therefore all, of the artists. I very much agree that a $40 per diem expense is more realistic than the present expense, but our figure is based on County of Los Angeles regulations. This has always been a serious problem for Curators and to date an insoluble one. I can only offer to alleviate your expenses by covering them as much as possible while you are here, and by arranging to pay you for a special event or two which could make up the monetary difference between your desires and what is called for in the contract. I do not think that time spent in planning the project can be estimated or budgeted. I do think that any possible tax benefits accruable to artists should be encouraged, but I cannot yet conceive of how this might be effected.

Despite a certain suspiciousness of the project on the part of some artists (exclusively American artists, incidentally, and particularly Los Angeles ones), only three artists, out of the total of sixty-four we approached, were categorically opposed to association with the Art and Technology program from the outset. They are all extraordinary artists, and I was at considerable pains to make certain that they did not misunderstand the premises of Art and Technology. Frank Stella simply couldn't abide even the idea of working in an industrial plant. Jasper Johns felt similarly; he patiently explained to me that the content of his art is about the move of a hand from one point in space to another nearby, and that to him the possibility of moving in a *social* situation to make art was unthinkable. Ed Kienholz, on the other hand, though not opposed to the idea in principle, could not imagine what industry could do for him that he couldn't do for himself.

Every other artist we approached was in theory willing to pursue the collaborative opportunity at least to the extent of touring corporations. Personalities as diverse as Jean Dubuffet and James Byars, Jules Olitski and George Brecht, Roy Lichtenstein and Jackson MacLow, were interested in exploring the notion of coming to California to work in a corporate setting. I had expected resistance from artists, aside from the reluctances discussed above, on "moral" grounds—opposition, that is, to collaborating in any way with the temples of Capitalism, or, more particularly, with militarily involved industry. This issue never became consequential in terms of our program, perhaps because the politically conscious artist saw himself, to speak metaphorically, as a Trotsky writing for the Hearst Empire. However, I suspect that if Art and Technology were beginning now instead of in 1967, in a climate of increased polarization and organized determination to protest against the policies supported by so many American business interests and so violently opposed by much of the art community, many of the same artists would not have participated.

As we set about contacting artists we had certain definite guidelines. First of all we were determined to involve artists of quality, regardless of their style of work, and we were not especially seeking artists whose approach was "technologically oriented." If anything, we may have been prejudiced against those artists who had been deliberately employing the tools of new technology for its own sake, because so many recent exhibitions centered on this notion had been of little interest artistically. We were also determined to discuss Art and Technology with as wide a range of artists as possible—Europeans and Americans, Japanese and South Americans; artists of great repute along with unrecognized figures; artists in their sixties and artists in their twenties. We felt that only by exposing diverse types of artists to corporations could the value of the premises of

Art and Technology be tested. Therefore we tried to approach not only painters and sculptors but poets and musicians (thus involving Karlheinz Stockhausen and Jackson MacLow). We tried to prepare for unanticipated requests from artists, and fortunately the structure of Art and Technology permitted us a degree of flexibility when necessary. For example, certain artists we approached wished to collaborate with a fellow artist (Irwin and James Turrell, Stockhausen and Otto Piene, Robert Morris and Craig Kauffman) at a particular company; or an artist might extend his period of residence over a year, or even two, by leaving and returning to the plant several times (as did Lichtenstein, Rauschenberg, Richard Serra and Jesse Reichek).

Over a period of more than two years, from late 1967 to 1970, while we were contacting artists, we also received seventy-eight unsolicited proposals from artists who had read or heard about Art and Technology. All of these proposals were studied carefully and many were reconsidered several times with various companies in mind. None, in the end, were accepted. These projects involved, most often, the areas of transduction; of plastics used in a variety of ways; of computers; and of lasers and holography. Many artists wanted to make total, elaborate and integrated environmental situations. Generally, the unsolicited proposals were made by relatively unknown artists. There was a rather high percentage of proposals received from pairs or groups of artists wishing to work together. There was also a high proportion of women artists. Few engineers or scientists approached us. There were one or two cases of eccentric, "primitive" or folk-traditional artists who wished to make mad machines through Art and Technology. We were usually reluctant to follow through on proposals which seemed too completely designed, or thought out in advance, so that the corporation's role would simply be a question of executing a previously conceived plan, rather than collaborating actively in both the conception and execution of an idea. The most interesting proposals are described in the artists' section, part 3.

Our method of approaching artists did not substantially vary from the outset of the program. Each artist was visited, or came to the Museum, and was shown material on one or more (usually four) corporations that we thought might be of personal interest. Each artist was invited to tour corporations before deciding on the nature of work he might wish to do.

These tours were usually conducted by a corporation public relations man, often a former engineer, who would introduce the artist to department heads in each division. Often a conference of these departmental chiefs, along with other executives, would be held to answer the artist's questions. Sometimes a film on the company's total operations was shown—this was often helpful. Cal Tech physicist Dr. Richard Feynman, who served as Consultant to Art and Technology, might attend, and one of us—Jane Livingston, Gail Scott, James Monte, Hal Glicksman or myself—was always there. It was quickly apparent that the presence of a congenial company representative was a critical factor. With an alert, sympathetic engineer, the tour was likely to be lively and stimulating. Without such a person to lead us into interesting areas of discourse, the facility itself would have to be intrinsically compelling, with an obvious potential art medium, for the tour to succeed. Generally one or the other of these conditions prevailed. If they did not, the tour could be a lugubrious and wearying exercise.

In originally considering appropriate artist-corporation matches, certain apt connections came to mind readily and with forcefulness: Dubuffet at American Cement Corporation, Vasarely at IBM, Oldenburg in Disneyland, Lichtenstein at Universal Film Studios, Andy Warhol at Hewlett-Packard (for holography). These five combinations seemed natural but not too pat. We expected other matches to come about less on the basis of our suggestion than through the process of exposing artists to various companies. Many of the observations made in regard to these few artists apply as well to other collaborations; I cite them as key examples of the kinds of issues and problems confronted throughout the program.

Each of these artist's work suggested to us a process which was then available in a contracted company. For several years Dubuffet had been working with cement, making sculptures and bas-reliefs on a limited scale. Vasarely's plotted paintings called to mind a computer company like IBM. Oldenburg's proposals for monuments and his anthropomorphising of objects and animals made the facilities at Disney seem almost necessary. Roy Lichtenstein had started making his first sculptures, and Universal's exceptional capacities for non-load bearing construction (with staff, a material made of plaster and fibre) seemed of likely interest. (In fact, the artist ignored this possibility and went directly to work with film.) Warhol's work suggested to me a latent relationship to holograms.

We approached each of these artists primarily with the companies noted in mind, and each was responsive. Most of these artists became deeply involved with Art and Technology and eventually made unusual works of art as a consequence of their connections to companies, although not always with the particular company with which they were first associated. Lichtenstein stayed with Universal, but Oldenburg and Warhol were to work with different companies and techniques than those visualized originally. The other two artists also became involved in the program but did not develop work to a point of resolution. The experiences of both Dubuffet

and Vasarely were similar. Each is European and over sixty. They responded to my presentation of Art and Technology with a carefully planned proposal for a monumental work. Their plans called for fabulous expenditures, straining even the grandiloquent capacity of American industry; but there was a distinct reluctance on these artists' part to engage with engineers and administrators in a true give-and-take manner. The concept of personal dialogue—critical to the nature of Art and Technology—was not at all intriguing to these artists.

In contrast to the Europeans, most American artists chose—often from a bewildering array of possible techniques—a relatively simply process, approaching the problems implicit in it with single-minded tenacity. This was clearly observable early in Art and Technology in the experiences of Lichtenstein, Oldenburg and Warhol. American artists tended to focus on a single technical principle or device. To do this properly, it was found, was no easy matter. Lichtenstein's project at Universal seemed "primitive" to their sophisticated technicians, at least until the real nature of his desire became apparent, for Lichtenstein wanted a pictorial *quality* many times more precise than is needed by Universal for their own purposes. Andy Warhol finally opted to *reveal* an integrally imperfect mechanical system, rather than make a virtuoso display by any conventional definition. Oldenburg was exclusively concerned with making mechanized versions of monumental sculptures: "make mechanics obviously stated," he wrote to himself at one point. Such a frank, or even ironical, attitude toward the machine has long been characteristic of many American artists (Sheeler, Schamberg, Rube Goldberg), albeit with a certain romantic or comic nuance.

Aside from these artist-company connections, which got the program underway, we generally went to artists with less specific notions than these in mind. Few artists we approached (Donald Judd may be the sole exception) expressed interest in reducing possible action with a company to *in absentia* fabrication. An artist might indicate to us his interest in a specific process, as, for example, Robert Morris who referred to heating and cooling devices, leading us to research our companies for this capacity. More often an artist would have no notion at all about what a corporation might have to offer, but almost all wanted to have a look at them. After touring several companies most artists formulated a more or less specific plan of attack, either a proposal for an art work or a request to explore a particular facility in depth. There were actually only four exceptions to this, that is, artists who toured companies but saw nothing to inspire an idea or a desire to work within them. These four artists were Philip King, who flew from London to visit Kaiser Steel, Wyle Laboratories and American Cement; James Rosenquist, who toured Container Corporation of America, Ampex and RCA; Peter Voulkos, who went to

Norris Industries and John McCracken who visited Norris Industries, Litton Industries and Philco-Ford Corporation.

Most of those artists who became acquainted with corporation facilities wanted to take up residence at a particular firm. Over fifty artists *wished* to collaborate; twenty-three of those actually did, spending varying periods of time at a company or companies. (This was roughly the percentage of successful matches we had anticipated achieving when we drew up the budget a year earlier.) We can now conclude that two factors largely determined whether or not a collaboration would result from our preliminary efforts. The first consideration had to do simply with the artist's personality, most particularly his ability to communicate with diverse kinds of people. This was of course a subtle factor, not quantitatively definable, but observable nevertheless. Les Levine's somewhat casual, free-wheeling manner, for example, did not ingratiate him to the people at Ampex; Iain Baxter's seeming frivolity was worrisome to Garrett; Len Lye's definiteness about his demands and impatience with apparent technical limitations did not inspire the Kaiser personnel. But of course each company responded differently: IBM personnel were perhaps offended by Jackson MacLow's unconventional appearance and dress, and possibly by his politics, but another computer company (Information International) found him entirely acceptable. Much depended on whom the artist might meet at the start, while touring a company: Robert Whitman met optics engineer John Forkner at Philco-Ford, and the two personalities were immediately sympathetic, despite a general doubt on the part of the company itself, while Robert Morris could never find a true line of communication with anyone at Lear Siegler, Inc.

Often contracted corporations would hesitate to take an artist into residence when, for technical reasons, they anticipated having to sub-contract a major part of the project. They wished to utilize indigenous techniques and materials. This was the second key factor determining the ease or difficulty of setting up collaborations, and was basically more important than the issue of personalities. This problem occurred frequently, but it could not have been avoided. The central premise of Art and Technology rested on a one artist-one company nexus. Early in the program, the need for a number of back-up companies to provide raw materials was anticipated, and in fact we sought commitments from firms such as Rohm and Haas, for plastics. But it was quickly apparent that companies required singular identification with an artist in order to produce and perform significantly. Companies would not give impersonally, so to speak, any more readily than patrons of museums make donations anonymously. To alleviate this problem we invented the category of Benefactor Corporation: we

solicited $7,000 donations from banks and other non-participatory firms to be allotted largely for the acquisition of materials or specialized services not made available by a sponsoring corporation. However, we persuaded only three companies to enter Art and Technology in this category.

The factor of anticipated sub-contracting implicit in an artist's proposal was primarily instrumental in the failure of Michael Asher, Hans Haacke, Max Bill, Stephan Von Huene, Takis, Otto Piene, Karlheinz Stockhausen, Eduardo Paolozzi and others to make corporation connections. Some corporations also rejected project proposals for reasons of excessive in-house expense, of course, but this happened less often: IBM studied Vasarely's plan for weeks and concluded that it might cost up to two million dollars to build, and then would only have a life of four years (due to the narrowing life expectancy of successive computer generations); Litton declined Vjenceslav Richter's plan, claiming it would cost over a million dollars; RCA similarly declined to work on Glenn McKay's project, the cost of which was anticipated at $500,000.

Most of the vital collaborative work done under Art and Technology took place during 1969 and early 1970. Within this period of time, some artists toured the company, returned home, formulated a detailed proposal, entered into residence at a corporation for about three months, executed as much work as time allowed, and left. This was basically the experience, for instance, of R. B. Kitaj, Oyvind Fahlstrom and Jean Dupuy. These were the comparatively simple exchanges to consummate, partly because the corporations with whom these artists collaborated, or specific divisions within them, are primarily industrial (Lockheed, Heath, Cummins) and partly because of the orderly and sequential manner of working characteristic of these particular artists.

Few cases were so simple. Most artists, as has been stated, extended their residence at a company over a year-long period, leaving and returning several times. This rhythm allowed for generally advantageous results. We observed a definite strengthening and maturing of concepts in the work of Robert Rauschenberg, Rockne Krebs and Tony Smith, for example. Rauschenberg first visited Teledyne in September, 1968, beginning an unusually long series of visits to the company, entailing discussions, the gathering of particular data, acquisition of materials from all over the U.S., testing, etc.: it was not until October, 1970, that a final period of residence occurred, and work accelerated; the project is to be realized in February, 1971. Krebs' and Smith's experiences with companies were also protracted and concomitantly enriching. However, there were dangerous moments in these prolonged collaborations, for the absence of the artist from a company tended to reduce

corporate availability. It was at such times that the Museum's active role was necessary to keep the connection viable.

Since Rauschenberg, Krebs and Tony Smith each worked with the company they had originally selected, there was a certain coherence in these collaborations in spite of the unusually lengthy period of time involved. With virtually all of the others, however, substantial involvement on our part was mandatory to keep the "marriage" together. Often artists had to leave one company for another. After contracting with us, John Chamberlain developed an ambitious scheme for a work involving diverse odors at a division of Dart Industries' Riker Laboratories. The president of the company rejected the plan. After other trials, Chamberlain became the Rand Corporation's artist-in-residence (following upon Larry Bell's stint there). Wesley Duke Lee came from Brazil to work at Hall Surgical Systems. After two months the company declined further participation, prompting thereby the Odyssey of Wesley Duke Lee through Southern California: the artist worked at over a dozen small sub-contracting firms to develop his project, which had been defined at Hall, racking up fourteen thousand driving miles, in a project that was to last eight months. It is still not completed.

The outstanding case of a project taxing the limits of our capacities was that of Robert Whitman at Philco-Ford. Whitman is probably the most experienced "collaborative" artist in the U.S., and, as I noted above, he had the good fortune of locating a brilliant and engaging optics engineer, John Forkner. With the implicit support of the company, a Patron Sponsor, plans for a radical work—technically innovative and esthetically compelling—were drawn up, only to have the company administration flatly refuse *any* funds for construction. The realization of this work required far-flung resources: the artist redesigned his work; the engineer came up with entirely altered plans for construction; a display-fabricating firm was hired to create certain parts; the Laguna Beach Unitarian Church Fellowship pressed one hundred citizens into voluntary service; and finally the United States Information Agency provided scores of laborers (when the work was first shown at Expo 70) for the final stages of construction. Similar nightmarish complications threatened to inhibit the construction of works Oldenburg researched and defined at Disney Productions, but in this case we induced Gemini G.E.L. to take over the production of one of Oldenburg's several models, and they did so with unusual efficiency and dispatch.

Given such obstacles as these, twenty artists nevertheless are expected to bring projects to a state of culmination. In virtually every case there was a particular corporation individual who made himself responsible, along with the artist, for the success of the collaboration. Such a man might be primarily an authoritative officer, who delegated responsibility, such as R. H. Robillard at Lockheed, or a genuine technical collaborator, such as Forkner at Philco-Ford. In many cases, when a company did give generously of its resources, we came to find hidden, if not unusual, motives for its doing so. Jet Propulsion Laboratory's involvement with Newton Harrison is probably accountable, in part, to the company's desire to move out of space exploration exclusively and identify itself with the larger area of environmental research. Some corporations apparently became involved with us in order to promote a particular product or process (Cowles' Xography) or an area that the company wished to make better known (Garrett's Life Sciences Department). General Electric was eager to modernize their image. Two major companies—involved, not coincidentally, with consumer-type products—contracted with us because of their presidents' social connections with Mrs. Chandler. Three companies—the smallest ones—joined with us solely for the publicity. Some companies were exceptionally cooperative because of a tradition of cultural support dating back for years (Container Corporation of America, IBM, Cummins), but other companies, whose presidents are art collectors, proved difficult to work with, precisely because that knowledge of art created a restrictive bias.

In April, 1969, after reading a second article on Art and Technology by Grace Glueck in the *New York Times,* Phyllis Montgomery of Davis, Brody, Chermayeff, Geismar, DeHarak, Associates—the Exhibition Design Team for the United States Pavilion at Expo 70—called me to discuss the possibility of my organizing an exhibition including works made under Art and Technology for the Pavilion. Accordingly, we entered into extensive negotiations with the USIA's Commissioner General (later Ambassador) Howard Chernoff and Deputy Commissioner General Jack Masey, and the Exhibition Design Team. In a formal contract, signed on May 30, 1969, we consented to postpone the Museum show for one year, and draw from it a smaller preview exhibition for Expo.

The commitment to deliver in time for Expo 70 was a distinct gamble. Our original deadline was tightened, since we had planned to exhibit results of the collaborations in April, 1970, at the Museum, whereas all works for Expo had to be installed—in Japan—by March 15, 1970. Also, certain inherent conditions restricted the range of potential works for Expo: only American artists could be selected; and a traffic flow of up to 10,000 persons per hour was expected throughout the seven-day

week, six-month long run at the Fair. (This astonishing estimate proved to be correct: 10,800,000 visitors poured through the Art and Technology Exhibition in the U.S. Pavilion before Expo closed in mid-September.)

I felt that the risk was worth taking. A fundamental belief in the necessity of giving artists access to industry lay at the heart of Art and Technology, and Expo 70 seemed to me a perfect occasion for demonstrating the validity of this concern, to an international as well as an American audience. We had six months' time in which to deliver eight "rooms" of art, for that was basically the way the art-exhibition space was designed in the Pavilion. Inevitably those six months were crisis-fraught. The complexity of the logistics involved may be indicated by the fact that when these eight remarkable works were shipped to Osaka, they comprised 15,000 separate components, occupying eighty crates and weighing forty tons. Installation in Japan took ten weeks and involved my continual presence, extended visits by five of the participating artists, several U.S. engineers, a team of designers and architects and hundreds of workmen.

The only "object" in the Expo exhibition was the first work encountered outside the main entrance door of the New Arts Section: Claes Oldenburg's *Giant Icebag,* which was in complex motion for nineteen minutes and forty-five seconds and rested for fifteen seconds. This was the only work that actually existed before the Expo installation: it was tested, and performed perfectly, in Los Angeles in January, 1970. Each of the other seven works arrived in Japan in the form of disconnected system components, which were never entirely combined and put into operation until their mounting at the Expo site. The fact that none of us could accurately visualize the Expo show beforehand—even the artists did not know precisely what their works would do in the unforeseen conditions—caused a certain amount of understandable anxiety, as well as excitement. Inside the exhibition space the viewer first found himself in Boyd Mefferd's room. One hundred twenty wall-mounted strobe units flashed in program, causing intense, apparently hallucinatory retinal images (provided the viewer took at least fifteen seconds to allow this to happen: very few did). One next entered Tony Smith's cave, made entirely of corrugated cardboard, and illuminated from above by shafts of light. Thousands of octahedra and tetrahedra, shipped to Japan in scored flat sheets, were individually assembled on site and mounted architecturally according to a complicated twelve foot model the artist had made. After the viewer traversed ninety feet through the Smith tunnel, he came up against Robert Whitman's optical tour de force: a twenty-three foot semi-circular space containing various illusionistic phenomena. Placed against the semi-circular wall from floor to eye-level were one thousand corner-shaped mirrors which reflected to each viewer, regardless of where he stood or

walked, *only* his own image, repeated a thousand times. Mounted above eye-level were five pairs of five by seven foot pulsating mylar mirrors, in front of which hovered ten eerily bright three-dimensional objects (a pear, drill, goldfish bowl with live fish, a knife, a clock, ferns, etc.). From Whitman's room one stepped into Newton Harrison's forest of five thirteen-foot high plexiglass columns, each filled with glowing gas plasmas, programmed to create varying color-shapes of pure light. In Harrison's room, as in Whitman's area, the viewer was in the dark, seeing mysterious *shapes* being formed out of light. So too in Krebs' laser room, entered from Harrison's, one perceived light patterns in a dark environment: the piece formed a complex web of red and blue-green pencil-thin beams, crossed, interlaced and in one place extended (through two enormous parallel mirrors) "into infinity." The sense of immateriality in Krebs' sculpture was strengthened by the fluctuation of the light patterns. Into a large alcove at the far end of Krebs' room were placed two 35mm rear projectors for Roy Lichtenstein's two movie screens. Each screen measured seven by eleven feet; the projected film image on each screen was a "moving picture." One image combined film footage of ocean and sky; the other screen depicted ocean surface and a dot pattern above; both screens were split with a horizon-like black line, and the images rocked. From this paradoxically anti-filmic evocation of "nature" one turned to Andy Warhol's work, which also dealt with man's transformation of nature into artifice: it was a giant field of three-dimensional printed flowers, seen through sparkling transparent curtains of water, falling like rain.

Even with the wide diversity of artistic styles presented in the Expo exhibition, certain singular characteristics were shared by the eight artists. In fact, many of these qualities now seem to apply to most of the other artists in the Art and Technology program, such as Robert Rauschenberg and Jesse Reichek. Primary among these is an emphasis on transient images and evanescent phenomena. At Expo, there was no object which sat in a traditional relationship to a ground. Flicker and vibration were omnipresent—but not in the pretentious manner endemic to much mechanical art. Distinct and tangible images presented themselves but they would become transformed or disappear. Much depended on one's particular vantage point—your neighbor was never seeing what you were seeing at the same time. This was true even though certain of the works, which had potential for individual participation, were forced to relinquish this aspect because of the enormous crowds at Expo. There was a notable absence of visible housing for each work, allowing a purity and directness of confrontation with technique rather than mechanics. But no works were designed to parade technique; almost every artist in the program displayed a certain reserve before the tools of technology. As the artists de-emphasized the look of

the machine, they were able to maximize a sense of penetrating psychological immediacy. One did not feel a palpable sense of virtuosity in these works, but rather a character of restraint and esthetic sureness.

After Expo opened, I reported to the Museum's Board of Trustees on our experience with Art and Technology in Japan, and we turned to the consideration of the Museum's exhibition. Our budget, estimated in 1968, had been proving close to the mark. We had raised over $40,000 more than expected from corporations and had therefore been able to place several more artists in residence than anticipated.

Based on what we learned from the Expo experience, a further, and even an unprecedented commitment is now required by the Museum to mount the new exhibition. Virtually all the works produced through Art and Technology are conglomerates of component parts, dependent for their very existence on elaborately constructed formal matrices. The works shown at Expo will, with the exception of Oldenburg's *Icebag*, be fundamentally reworked due to the much greater design flexibility of the Museum space. Moreover about twelve additional artists' projects are expected to be resolved for the Los Angeles show.

The accounts of interaction among seventy-six artists, over 225 corporation employees, and Museum staff members comprise part 3 of this Report. Both the emotional complexities and the sheer logistical difficulties implicit in this five-year engagement emerge cumulatively through these accounts.

October 30, 1970

AGREEMENT

IT IS HEREBY AGREED by and between _____

(hereinafter Patron Sponsor) and MUSEUM ASSOCIATES, INC. (hereinafter Museum),

as follows:

1. Museum operates the Los Angeles County Museum of Art. Museum is pre-

sently planning an exhibition tentatively entitled "Art and Technology" to be

held at the Los Angeles County Museum of Art in the spring of 1970.

2. Patron Sponsor desires to participate in and assist Museum in the

development of said exhibition.

3. Museum has advised Patron Sponsor that Museum will proceed with the

development of said exhibition if it obtains agreements, comparable to this

agreement, with no less than ten Patron Sponsors (or with other types of spon-

sors representing the monetary and resource equivalent thereof).

4. Museum has advised Patron Sponsor (a) that any work of art created in

the development of said exhibition may, in the sole discretion of Museum, be

deemed inappropriate for inclusion in said exhibition, and (b) that Museum may,

in its sole discretion, conclude that the totality of works created in the

development of said exhibition make it inappropriate to hold said exhibition.

Patron Sponsor is aware that in the event of either of these alternatives, or

if for any other reason except for failure to obtain ten Patron Sponsors (or

the equivalent) the exhibition is not held, or work undertaken or produced at

Patron Sponsor's facility is not completed or exhibited, Patron Sponsor is not

entitled to a refund of any money or services or other things of value which it

has expended in connection with said exhibition.

5. Patron Sponsor agrees to contribute $7,000, of which one-half will be

paid at the time of execution of this Agreement but no later than _____.

1.

The remaining one-half will be due on or before _____ . In addition,
Patron Sponsor agrees to commit sufficient materials, working space and techni-
cal assistance for a three-month period or until completion of the artistic
project (as hereinafter defined), whichever is shorter, at a time to be specified
by Museum. Said commitment of materials, working space and technical assistance,
together with the precise time, will be subject to mutual agreement between
Museum and Patron Sponsor, but each agrees to use its best efforts to reach such
agreement.

 6. Museum, in its sole discretion, will select an artist and an artistic
project for development and execution at the facility of and in cooperation with
Patron Sponsor.

 7. Museum, in its sole discretion, may select and exhibit at the Los Angeles
County Museum of Art any or all works of art created at Patron Sponsor's facility
as a result of said artistic project. Said exhibition may be scheduled at any
time during the year 1970. In addition, Museum may arrange for the exhibition of
any of said works of art at other museums or public exhibitions in the United States
or abroad at any time until December 31, 1972. Patron Sponsor will cooperate with
Museum in any such exhibition or exhibitions and will not display any of said
works of art before December 31, 1972 without the prior written consent of Museum.

 8. The principal work of art created as a consequence of any artistic pro-
ject at the facility of Patron Sponsor will, at the option of Patron Sponsor and
without further payment, become the property of Patron Sponsor at the conclusion
of the exhibition at the Los Angeles County Museum of Art (or at the time of noti-
fication to Patron Sponsor that said work will not be exhibited). In the event
Patron Sponsor does not choose so to acquire any such work, then it will become
the property of the artist creating it. If either Patron Sponsor or the artist
wishes to make a gift of said work to Museum, Museum may, in its sole discretion,
elect to accept or reject said gift.

9. In the event of a gift to Museum of any work of art, Museum will retain
the option to donate or lend said work to any other museum or public institution,
or, after a five-year interval, to sell or otherwise dispose of said work to any-
one. Museum will further retain the right to exhibit or not exhibit any such
gift.

10. If an artist creates additional works of art (beyond the "principal
work" described in paragraph 8), the artist will retain ownership of any such
additional works unless they are preparatory to or an integral part of said prin-
cipal work, in which case their ownership will be subject to the provisions of
paragraph 8.

11. Museum will carry liability insurance on artists during the period that
they are working at the facility of Patron Sponsor. During such time, they will
be regarded as "consultants" to Museum.

12. Museum will not insure any works of art produced in connection with
any artistic project, except liability insurance for injury or damage caused
by said works of art while they are in transit to or on display at the Los Angeles
County Museum of Art.

13. All arrangements and charges for the moving of objects from Patron Spon-
sor's facility to the Los Angeles County Museum of Art (or to other museums or
exhibitions) and return to point of origin shall be the responsibility of Museum.
Any moving anywhere else shall be the responsibility of the person requesting
said movement. Patron Sponsor agrees to store any works created in connection
with said artistic project at its sole expense, until Museum requests that said
works be moved to the Los Angeles County Museum of Art. In the event Museum
makes no such request on or before the opening date of the exhibition, Patron
Sponsor may make its own arrangements for disposition of said remaining works
at its own expense. If an artist becomes the owner of any works, shipment from
Patron Sponsor's facility or from the Los Angeles County Museum of Art is the

artist's obligation and must be accomplished promptly upon conclusion of said exhibition or the artist will have no further rights to any such work and neither Patron Sponsor nor Museum will have any obligation to return or account for any such work to the artist.

14. Patron Sponsor agrees that any works in the process of creation or created at its facility, together with said facility, may be photographed and reproduced in a catalog, press releases, slides or other photographic materials, and that all such photographic materials will be the property of Museum. Patron Sponsor further agrees that all matters relating to publicity for said exhibition, said artistic project, or the artist involved will be under the control of Museum, and that any publicity to be released by Patron Sponsor must be approved in advance by Museum. Museum will, in its sole discretion, give Patron Sponsor appropriate credit and recognition in any exhibition display, catalog or publicity.

15. All notices and other instruments which may be or are required to be given or made by Patron Sponsor or Museum to each other shall be in writing. All notices and other instruments by Patron Sponsor to Museum shall be sent by registered mail, postage prepaid, addressed as follows:

> Kenneth Donahue, Director
> Los Angeles County Museum of Art
> 5905 Wilshire Boulevard
> Los Angeles, California 90036

or to such other addressee and to such other place as Museum shall from time to time designate in a written notice to Patron Sponsor.

16. All notices and other instruments by Museum to Patron Sponsor shall be sent by registered mail, postage prepaid, addressed as follows:

.
.
.
.

or to such other addressee and such other place as Patron Sponsor may from time to time designate in a written notice to Museum.

17. No rights under this Agreement may be assigned by Patron Sponsor or Museum without the prior written consent of the other (except that Museum shall have full discretion, pursuant to paragraph 7, in arranging for exhibitions and, pursuant to paragraph 9, in dealing with any works of art that it accepts by way of gift). Subject to the foregoing, the covenants and agreements contained herein shall be binding upon and shall inure to the benefit of Patron Sponsor and Museum and their respective successors and assigns.

18. In the event that Museum does not obtain comparable agreements from ten Patron Sponsors (or the equivalent) on or before June 30, 1968, Museum will refund to Patron Sponsor the unexpended portion of its initial $3,500 payment, this Agreement shall be of no further force or effect, and the parties shall be released from all obligations to each other.

19. This Agreement embodies the entire understanding between the parties hereto, and no change, alteration or modification hereof may be made except in writing signed by the party to be charged thereunder.

IN WITNESS WHEREOF, the parties hereto have executed and delivered this Agreement this _____ day of _____, 1968.

Patron Sponsor

By_____

MUSEUM ASSOCIATES, INC.

By_____
 Kenneth Donahue

AGREEMENT

IT IS HEREBY AGREED by and between _____

(hereinafter Artist) and MUSEUM ASSOCIATES, INC. (hereinafter Museum) as follows:

1. Museum operates the Los Angeles County Museum of Art. Museum is presently planning an exhibition tentatively entitled "Art and Technology" to be held at the Los Angeles County Museum of Art in 1970 or 1971.

2. Artist desires to participate in and assist Museum in the development of said exhibition.

3. Museum has advised Artist (a) that any work of art created in the development of said exhibition may, in the sole discretion of Museum, be deemed inappropriate for inclusion in said exhibition, and (b) that Museum may, in its sole discretion, conclude that the totality of works created in the development of said exhibition make it inappropriate to hold said exhibition. Museum agrees not to exhibit any work the artist deems incomplete or not a work of art.

4. Museum and artist have agreed upon an artistic project, which if acceptable to a Patron Sponsor or Sponsor, will be developed and executed at the facility of said Patron Sponsor or Sponsor. Said artistic project is set forth in Exhibit A to this Agreement and is incorporated herein by reference. Artist agrees to work diligently on said artistic project during the time specified for a consecutive or non-consecutive period of up to three months if necessary for completion.

Museum will provide artist (a) one roundtrip economy class air ticket from his residence to Los Angeles; (b) for Artists who are not residents of Los Angeles, reimbursement for all other travel expenses incurred by the Artist in connection with this project, so long as any such travel arrangements have been made by the

Museum and approved in advance in writing; (c) for Artists who are not residents of Los Angeles, a per diem of $20, to be paid in installments of $140 at the beginning of each week of actual work in Los Angeles; (d) a $250 honorarium for each week's actual work on the project, to be paid in installments of $500 at the end of each two weeks of work. The total sums payable by the Museum to the Artist under items (b), (c) and (d) shall not exceed $4,800.

The foregoing is the only financial obligation of Museum to Artist. Artist acknowledges that Museum is under no other or further obligation to Artist for any debts or obligations incurred by Artist, and that Artist is an independent contractor, not an employee or agent of Museum.

5. Museum, in its sole discretion, may select and exhibit at the Los Angeles County Museum of Art any or all works of art created by Artist as a result of said artistic project. Said exhibition may be scheduled at any time during the year 1970. In addition, Museum may arrange for the exhibition of any said works of art at other museums or public exhibitions in the United States or abroad at any time until December 31, 1972. Artist will cooperate with Museum in any such exhibition or exhibitions and will not display any of said works of art before December 31, 1972 without the prior written consent of Museum, but this restriction shall not apply to any works of the Artist which are not selected for exhibition in the Museum's "Art and Technology" exhibition.

The installation of the work and supporting technological equipment at all of such exhibitions shall be the sole responsibility of the Museum. The Artist will assist in the installation of the work at the initial exhibition, but he shall not be obliged to do so at any subsequent exhibitions.

6. The principal work of art created as a consequence of the artistic project will, at the option of Patron Sponsor and without further payment, become the property of Patron Sponsor at the conclusion of the exhibition at the Los Angeles

County Museum of Art (or at the time of notification to Patron Sponsor that said work will not be exhibited). In the event Patron Sponsor does not choose so to acquire any such work, then it will become the property of Artist. If either Patron Sponsor or Artist wishes to make a gift of said work to Museum, Museum may, in its sole discretion, elect to accept or reject said gift.

7. In the event of a gift to Museum of any work of art, Museum will retain the option to donate or lend said work to any other museum or public institution, or, after a twenty-five year interval, to sell or otherwise dispose of said work to anyone. Museum will further retain the right to exhibit or not exhibit any such gift.

8. If Artist creates additional works of art (beyond the "principal work" described in paragraph 6), Artist will retain ownership of any such additional works unless they are an integral part of said principal work, in which case their ownership will be subject to the provisions of paragraph 6.

9. Museum will carry liability insurance on Artist during the period that Artist is working at the facility of Patron Sponsor or Sponsor. During such time Artist will be regarded as a "consultant" to Museum.

10. Museum will not insure any works of art produced in connection with the artistic project, except liability insurance for injury or damage caused by said works of art while they are in transit to or on display at the Los Angeles County Museum of Art. Museum will repair any damage to said works of art while on Museum premises which does not result from their normal functioning or ordinary wear and tear.

11. All arrangements and charges for the moving of objects from Patron Sponsor's or Sponsor's facility to the Los Angeles County Museum of Art (or to other museums or exhibitions) and return to point of origin shall be the responsibility of Museum. Any moving anywhere else shall be the responsibility of the person

requesting said movement. If Artist becomes the owner of any works, shipment from Patron Sponsor's or Sponsor's facility or from the Los Angeles County Museum of Art is the Artist's obligation and must be accomplished promptly upon conclusion of said exhibition (or within 30 days of the opening date of the exhibition as to any work Museum does not include in the exhibition) or Artist will have no further rights to any such work and neither Patron Sponsor or Sponsor nor Museum will have any obligation to return or account for any such work to Artist. Museum agrees to give Artist 30 days advance notice of his obligation to remove any art work to which he has received ownership.

12. Artist agrees that any works in the process of creation or created in connection with the artistic project may be photographed and reproduced in a catalog, press releases, slides or other photographic materials, and that all such photographic materials will be the property of Museum. Copies of the foregoing shall be given to the Artist. Artist further agrees that all matters relating to publicity for said exhibition, said artistic project, or Artist's involvement therewith will be under the control of Museum, and that any publicity to be released by Artist must be approved in advance by Museum. Museum will give Artist appropriate credit and recognition in any exhibition display, catalog or publicity.

13. If Artist resides outside the United States, Artist agrees to obtain, before coming to Los Angeles and at his sole expense, a temporary visa and work permit as well as legal liability insurance classifying artist as a "Consultant".

14. All notices and other instruments which may be or are required to be given or made by Artist or Museum to each other shall be in writing. All notices and other instruments by Artist to Museum shall be sent by registered mail, postage prepaid, addressed as follows:

Kenneth Donahue, Director
Los Angeles County Museum of Art
5905 Wilshire Boulevard
Los Angeles, California 90036

or to such other addressee and to such other place as Museum shall from time to time designate in a written notice to Artist.

15. All notices and other instruments by Museum to Artist shall be sent by registered mail, postage prepaid, addressed as follows:

.
.
.
.

or to such other addressee and such other place as Artist may from time to time designate in a written notice to Museum.

16. No rights under this Agreement may be assigned by Artist or Museum without the prior written consent of the other (except that Museum shall have full discretion, pursuant to paragraph 5, in arranging for exhibitions and, pursuant to paragraph 7, in dealing with any works of art that it accepts by way of gift). Subject to the foregoing, the covenants and agreements contained herein shall be binding upon and shall inure to the benefit of Artist and Museum and their respective successors and assigns.

17. This Agreement embodies the entire understanding between the parties hereto, and no change, alteration or modification hereof may be made except in writing signed by the party to be charged thereunder.

IN WITNESS WHEREOF, the parties hereto have executed and delivered this Agreement this _____ day of _____, 1969.

Artist

By_____
MUSEUM ASSOCIATES, INC.

By_____
Kenneth Donahue

Thoughts on Art and Technology

Jane Livingston

Art and Technology has had as one of its first premises the assumption that it is possible, and perhaps valuable, to effect a practical interchange between artists and members of the corporate-industrial society. The various cultural attitudes surrounding such a premise are deeply ambivalent. On virtually every level, including the popularly shared ideas and fears about the influence of "advanced technology" on the life of the masses, as well as the many subtle analyses of writers and critics evaluating the relationships between art, or the humanities, and technology, qualities of emotionalism and partisanship prevail.

Without delving extensively into recent historical antecedents to some contemporary aspects of the art/technology issue, one or two skeletal observations are called for. The attempts to embrace a socialist technology by the Russian Constructivists and by the Italian Futurists, during the early part of this century, were guided by a Utopian (if nominally iconoclastic) view of progressive technology, but did not fully succeed in transcending a romantic and somewhat anachronistic level of awareness on the part of its exponents. The Constructivist and Futurist artists seldom achieved *internal* stylistic manifestations of new technology, but instead represented the appearances of industrial/mechanical things. A serious ideological limitation holds also for the Bauhaus precept regarding the relation of art to technology, in as much as technology was equated with *craft;* one might say that the Bauhaus theorists were aiming to *reduce* art to craft, in a sense, and reversing the proposition, that the role of organized technology would be to elevate craft to art. The impulse which informed the Bauhaus rationale and its antecedents in European Constructivism toward a *socialization* of art in a public context has developed to the present time, but insofar as it survives in its original spirit has to an extent continued to remain identified with a European sensibility. Victor Vasarely's conviction that art should evolve out of its traditionally aristocratic, "unique object" framework and be mass-produced for public consumption is an extension of a classically Bauhaus idea. (A certain reaction to the "precious object syndrome" has certainly become a part of the American art scene in the 60's and early 70's, but is manifested in approaches which generally differ in kind from that of Vasarely.)

To some extent, artists currently are discouraged from engaging in "collusive" relationships with organized technological concerns by pressures from the intellectual/critical circles of which they are inescapably a part. The contemporary pressures, both internal and external, against collaborative activity between artists and industry are of two sorts: first there is antitechnological sentiment on political grounds and second, there can be argued substantial precedent militating against commonly held images of "technological art" on esthetic grounds. I shall deal here more extensively with the second than the first factor. My thought is to point selectively to a few components of what is an intricately complex subject. With reference to the overtly political question, the fact is that, despite a certain amount of reluctance by some of the artists we dealt with through Art and Technology to participate with "war-oriented" industries for reasons of moral objection, there were no final refusals to participate in the program on this ground alone.

The question of esthetics in relation to technological/industrial art works is bound up with certain attitudes about collective artistic activity. These attitudes devolve naturally upon several definable antitheses.

One of the fundamental dualisms inherent in the question of technology's uses in a humanist context has to do with the conflict between the belief that, in a word, technology *is* the metaphysics of this century, and therefore has to be accommodated from within, and the view that technology is somehow self-perpetuating, implacable and *essentially* inhuman, and that therefore humanist and artistic endeavor must function separated from it and even in opposition to it. Nearly all the positions taken by artists and by their scientific counterparts with respect to the art/technology relationship are conditioned by one or the other of these antithetical beliefs.

An increasingly prevalent concern of many artists and scientists is to overcome the traditional and presumably obsolete separation of academic and professional disciplines. Systems analysis, with its assumption that only by starting from an interdisciplinary or total-context approach can social institutions be made to operate productively, provides procedural methods and models for such reform. In principle, the espousing of a *systems esthetic*—illustrated preeminently under Art and Technology in the Irwin/Turrell/Garrett Corporation endeavor—represents a less rhetorical theory than any (including the Constructivist, Bauhaus and "socialized art" manifestations) which has preceded it. It implies the grasp of a powerfully efficacious means for revolutionizing art within the total cultural setting. (Jack Burnham gives an extended analysis of what I am terming a systems esthetic throughout his book *Beyond Modern Sculpture,* Braziller, 1969.)

Although the "systems-conscious" attitude is increasingly felt to influence artists of various persuasions, certainly including some of the artists who worked in Art and Technology, it is not by any means a shared attitude among all or most artists. One of the characterizing sentiments expressed by both those artists and scientist/engineers who are resistive to an information or systems esthetic, has to do with a suspicion harbored by virtually everyone at times that we are all victims of a techno-

cratic macrostructure over which no one or no institution has real control. In the light of this inescapably sinister possibility, the traditional privilege enjoyed by the artist to function independently, and to remain, in a sense, one of the last freelance agents in society, is not easily relinquished.

A natural outcome of an artistic/technological endeavor which employs a systems philosophy might be an art which conditions human sense perception and radically sensitizes people. Along with this might develop possibilities for esthetic forms that would in effect cultivate and enrich the "man-made" nature which has already replaced nature to such a remarkable degree. For those who firmly believe that society is undergoing a gradual but radical reshaping of patterns of consciousness, the changes predicted as issuing from a generation of drugusers and the increasing body of Western initiates into the various Eastern meditative practices appear to represent an inevitable and potentially corrective metamorphosis. Artists who wish to explore the means and consequences of perception-expansion need specialized information; and, reciprocally, scientists gain insight from artists in this enterprise. Both parties might maintain that anything less than directly "manipulating" human sensory response to advance new esthetic terms constitutes merely a superficial elaboration of existing esthetic conventions.

Again, in reaction to this kind of pursuit, with its potential for subliminal coercion, there are many artists who unequivocally eschew this kind of activity. I have heard the area of "systems" or "information" esthetics dismissed as a "Fascist game."

Seen against most recent efforts in the area of technological art, which are generally identified with electronic light and sound media, the results of Art and Technology are unlike anything we could have predicted. They far transcend the genre of work ordinarily called to mind by "tech art." Owing to the great variety of techniques and processes and materials made available by the corporations contracted with us, the program issued in not one esthetic type of work, but in several.

On reviewing the development of Art and Technology, three kinds of collaborative experience seem to me distinguishable. First there is the approach taken by those artists interested basically in industrial or industrial-mechanical fabrication. Second is that relating to the use of more esoteric technological media; and finally, that marked by a participatory, informational esthetic without primary regard for object-making.

A longer tradition attaches to the first category of activity than to any other manner of endeavor undertaken through Art and Technology. Sculptors have for centuries enlisted the assistance of heavy industrial methods and materials to make monumental works. Yet we have observed a significantly greater sense of anxiety and discernibly more recalcitrance on the part of those artists engaged in industrial execution than has been conveyed by the artists using advanced scientific media. Oldenburg, Kitaj, Fahlstrom and Tony Smith all experienced some amount of frustration, and expressed occasional skepticism, during the course of their projects. (Oldenburg's enumeration on page 269 of "comparative attributes" between the qualities required of the studio versus the technological artist distills the substance of these doubts.) The special difficulty for artists depending upon industrial execution relies on the fact that they have usually in the past worked alone and thus carefully controlled every stage and every nuance of their works' making; thus the intervention of middlemen, not only handling the components but making occasional technical decisions, is difficult to accept. The artist under these circumstances is automatically placed at a greater remove from the process of execution than would follow if his esthetic end required a process of developmental research in close communication with a technical counterpart. These artists found themselves coping rather frequently with a command chain of bureaucratic procedure. Possibly for just the reason that neither the artist nor the Museum was a paying client of the various corporations, the art projects were not given especially high priority, and thus often moved forward at an exasperatingly slow pace. In short, a definite cumbersomeness attended the several ambitious industrial collaborations. But even given these natural adversities, something remarkable happened. Smith, Oldenburg and Fahlstrom all saw the realization of artistic inventions of the grandiose type which generally never exist beyond sketches or models. Oldenburg's *Icebag* and Smith's cave sculpture especially represent critical milestones in their respective careers. Fahlstrom and Kitaj both established rapport with the specialized craftsmen who built their tableaux. One would not expect these artists necessarily to make a career of collaborative endeavor, but unquestionably they and other artists would utilize more often than has been possible the resources of industry were they more readily available.

In the context of heavy industrial fabrication it is worth considering the approach taken by Richard Serra at Kaiser. Serra regarded the availability of Kaiser's steel-producing plant as an opportunity basically to experiment in huge scale. In using the company's formidable scrap resources and men and equipment he did not attempt primarily to come away with a permanent, or a transportable art work, but instead to learn what he could in a few weeks' time about making sculpture com-

prising thousands of tons, rather than pounds, of material.

Roy Lichtenstein's film project certainly does not belong in the class of industrially fabricated art works, but neither was it conceived in a spirit of philosophical commitment to the principles of technological or industrial coaction. He expressed even more strongly than the foregoing artists an attitude of real doubt and hesitation about his very association with the Art and Technology program. Lichtenstein, like many other artists in Art and Technology, has repeatedly worked in a collaborative manner in his various printmaking and multiple sculpture series. The making of a lithograph, for example, is an operation requiring an intensive cooperation between at least two people. Lichtenstein's engagement in the cinematic project undertaken with us was not, it seems to me, very different in essence from his manner of working to produce prints and multiples. It is true that he (or indeed any other artist) has never before utilized cinematic technique in precisely the way he did in this endeavor; and certainly the technical difficulties and expense inherent in his Art and Technology film project were far greater than are ordinarily entailed by printmaking methods. Nevertheless, Lichtenstein determined early exactly what he was after in the cinematic works, and once he had established his criteria he strove mostly to refine and perfect the quality of the images much as he would in making lithographs.

A second general category of work done under Art and Technology includes those artists, like Robert Whitman, Newton Harrison, Rockne Krebs and Boyd Mefferd who sought to exploit the kinds of techniques ordinarily regarded as typifying advanced technology. The approach taken by such artists necessarily depends to a greater or lesser degree on a working relationship with engineering specialists whose expertise they themselves could not acquire without years of research and training; it often depends as well on the equipment and laboratory facilities available only in large corporations. In using media such as lasers, advanced mirror optic systems or gas plasmas, artists are venturing into areas which are without much esthetic history. However, in evaluating such art works, it seems to be the case that the more directly and the more purely the medium is handled, and the less the artist relies on extraneous housings, the better the result. It was our conscious intention to include in Art and Technology artists whose past production specifically in the domain of advanced technology conformed to this evaluative guideline and the works accomplished by them with us are commensurately remarkable.

There was an important element of simple luck involved in locating individual scientists and engineers, within the vastness of all these companies, who desired to enter into prolonged collaboration with an artist. Art and Technology was not, after all, a situation like the one structured by E.A.T, through which engineers so inclined voluntarily make themselves available to consult with artists. Once those fortunate connections were made, the several advanced technology projects set in motion were characterized by a strong sense of mutual commitment. The artists consistently demonstrated qualities of pragmatism, efficiency and singleness of purpose toward the end of realizing their projects. We sensed in these exchanges very little communicative difficulty on the practical, one-to-one level of exchange.

There are by now several American artists who can be considered fairly experienced in the field of collaboration with engineers. Robert Whitman stands out in this connection; so does Robert Rauschenberg, though he has of course continued to work "traditionally" as well. Experience in dealing closely with technical personnel in making art probably does give an artist a certain advantage in expediting the progress of a given undertaking. But interestingly enough, those artists inexperienced at collaboration with scientists, such as Harrison, Jesse Reichek and Jackson MacLow, worked equally effectively.

It should be noted that the use of technological media by artists has not by any means always implied interdependency with scientists or engineers. Both Krebs and Mefferd, for instance, have in the past accomplished much of their work unassisted, finding out on their own about their equipment and its potential by reading, experimenting and consulting only occasionally with manufacturers or engineers. One of the principal benefits of Art and Technology for an artist like Krebs was the great *speeding up* of information accession made possible by his contact with corporation personnel; he conveyed great excitement about the "luxury" of being offered instant access to data and expertise it would have taken years to acquire on his own. This sort of advantage was given similarly to Harrison, Whitman, MacLow and Reichek, but has so far been largely denied Mefferd for whom we never really found the fortuitous personal connection.

There is little doubt that a number of serious artists will continue to assimilate technical knowledge and will evolve an increasingly sophisticated and refined body of technologically-oriented works of art. It is, however, open to question whether or not this development will find sustained impetus from organized corporation support or must tend to rely perennially on the contingencies of sporadic intervention by scientists and the determined self-education of artists.

In considering a third order of artist-corporation interchange in Art and Technology no inclusive term or con-

cept suffices to define the situations being encompassed. A few artists shared an attitude which is distinguishable from the ascendant, short-term concerns of the others. These artists from the outset wished to investigate a psychological or experiential mode of activity *primarily,* instead of occupying themselves fixedly with technics. Two assumptions are, in retrospect, implicit in these artists' projects. One is that the function of gathering and exchanging information is important as an end in itself; the other is that *participation should be made self-aware and be used as a form of esthetic endeavor.* Behind these assumptions may lie another one—that there potentially exists in any collaborative situation between scientists and artists a special dynamic, and that if the particular conflicts and sympathies inherent in this dynamic can be made to surface, one can learn and state and do something with them. The artists referred to here further may be said to have regarded the people with whom they dealt as *themselves* "media," rather than viewing them as *personnel,* or as simply parts of a larger machine dedicated to the end of engineering and fabricating systems or objects.

The Robert Irwin/James Turrell/Garrett Corporation project is the preeminent example under Art and Technology of an endeavor based on a directly systems-conscious premise. Irwin, Turrell and the scientist Dr. Ed Wortz have not only made it their business to explore and assess the dynamics of their interchange, but were explicitly engaged in researching aspects of perceptual psychology. Their mutual investigations were not terminated at the end of an arbitrarily set time interval, but have continued organically to develop. John Chamberlain at Rand and James Byars at the Hudson Institute set about to establish participatory events; both in a high spirit of "unofficial playfulness" proclaimed themselves as gatherers of information. They made themselves subtly effective catalysts in a process of evoking attitudes. The compilations of actual "data" resulting from their efforts, in contradistinction to those accumulated in the course of the Irwin/Turrell/Wortz researches, are poetic and inconclusive: they do not at all reveal the dense complex of occurrences stimulated through the respective processes of obtaining them. Both Byars and Chamberlain treated their periods of residence in two of the nation's leading think-tanks as self-validating, purely participatory events. The work accomplished together by Jesse Reichek and IBM's physicist Jack Citron represents a consummate prototype for a truly informational exchange. Reichek and Citron succeeded in organizing a computer program which functions as a powerful image-producing tool. Both would confirm that the principles involved in their discoveries transcend any immediate results materializing from them.

With Andy Warhol at Cowles Communications, the element of participation came to issue in a startlingly literal way. Warhol agreed to design a work incorporating Cowles' 3-D printing process. But he ended by acting really as a kind of legitimizing aegis for the enterprise rather than its sole author and designer. Although he conceived the work's basic structure, he then proceeded to function as an agent, prompting crucial involvement in actual esthetic decision-making phases by his technical colleagues and even by ourselves. Despite the fact that his piece at Expo was a distinguished, if somewhat bizarre, work of art, the object itself was in some ways less important than what it represented of the multilateral esthetic participation behind its creation. In a sense Warhol has not done anything fundamentally unprecedented through the program: he has for years used technique unofficially, as it were; it is after all Warhol who, more than any other artist, made respectable commercial methods for art making such as inexpensive screen-printing techniques.

The concept of *unofficialness* in the artist's mode of working with corporate technology is of pivotal consequence to the overall dynamics of Art and Technology. It corresponds immanently to the notion of what may be termed a participatory esthetic.

Wylie Sypher, in his book *Literature and Technology: The Alien Vision,* (Random House, 1968; pp. 177; 216; 249) speaks of the state of "alienation" and "maladjustment" faced by technological personnel on every level in our society. He suggests that the goal priorities assumed within the corporate job structure run counter to the positive nature of technological endeavor, which is innately a form of *play* and *participation.* The artist, who has maintained his traditional "prerogative to use science and technique unofficially," might become a catalyst toward the end of humanizing technique. Though Sypher's contentions in the abstract too far overreach the practical sense of what occurred through Art and Technology to extrapolate here *in extenso,* his hypotheses offer the single point of correlation uniting every artist who worked with us. Each of them—some more overtly than others—approached their various projects with a sense of *playfulness,* or "unofficialness." It was their option to serve in multifarious ways as humanizing agents.

One thing none of us foresaw when we embarked on Art and Technology was what now amounts to a nearly unanimous disregard for permanent, officially installed art monuments. If many of the corporations initially hoped their participation would result in an icon representing their products and able to be owned and displayed by them, those hopes were unfulfilled. The signif-

icant fact is that the companies did *not* insist upon proprietary rights to the works made—and usually the proposals accepted by them for realization were known beforehand to be inappropriate for such purposes. The program did not become or even threaten to become a vehicle for commissioned works of art. If anything, the artists were more concerned than the companies to come away with a finished work—yet most of the artists made works transitory by definition.

The development of the various experimental interchanges in Art and Technology was on the whole a polymorphous, discursive and nonorganic process. Indeed it now appears simply that the relationship between artists and technological corporations is an intrinsically nonorganic one—at least on an *a priori* basis. The circumstance of corporation involvement in Art and Technology failed to embody a unified patronal ethic comparable to that kind of already "humanized," and standardized, morality inherent in past systems of Academic sponsorship. Concomitantly, the artist—in the by now established absence of either academic or avant-garde provinces—is startlingly free from imposed sanctions. Contrary to the myth of the "corporate image," there is seen to be no programmatic framework in the present condition of corporation patronage to support an official art of any description. A situation allowing room for play and participation—the latter term denoting a mode of activity in which inheres a self-sufficient esthetic statement—is established through the paradoxical *open-endedness* of the present state of corporate life. The artist retains his options.

Stephen Antonakos
Born Southern Greece, 1926
Resident New York City

Avigdor Arikha
Born Bukovina, U.S.S.R., 1929
Resident Paris and Jerusalem

On November 22, 1968, after reading the first A & T press release, Stephen Antonakos wrote us and expressed a desire to participate in the program. In March of 1969 the artist sent the following project proposal:

The basic look of this unit will be a 10' by 20' area made of 3,000 tubes, each 4' long. The entire area will be overhead, the bottom surface of the tubes ending about 7' from the floor, or 1' above your head.

A practically identical area will be beneath your feet. You will be separated from it by a plastic floor, although no such 'ceiling' will be present between you and the tubes overhead. All the tubes will be red, and they will all be vertical, so you will be engulfed with 3,000 tubes hanging down over your head and 3,000 tubes projecting up under your feet.

Neon was the first obvious choice for these tubes, but with neon, contact with electric current is needed at both ends, so the tubes would have a 'U' shaped, or double vertical shape. This is not what I wanted for this piece, but just one single vertical rod: a single aggressive thrust. Since I cannot use neon, I would hope to work with some large electrical company such as Westinghouse or G.E., to try to develop a 4' or 5' tube (something like a fluorescent tube) with an electrical contact at one end and just the round glass end at the other. Something like this has been developed in Europe, and I think this could be worked out here.

In October, 1968, Avigdor Arikha wrote to MT at our request proposing to make a labyrinthine environment, mainly of mirror and polarized glass. There was no participating company equipped to do this kind of research and construction. In August, 1970 Arikha sent us the following elaborated proposal with sketches:

Project For An Environmental Structure (Labyrinth) to be erected in a park or public garden

The idea:
A labyrinthal structure composed from without by black and white shapes and from within by a series of color-zones. *The outside* will be composed by two elements: the blackest black and the brightest white—a sort of a non-reflective mirror. *The inside* will be constituted by zones (rooms) made of pure color and following each other in a rhythmic order, from cold to warm, from warm to cold, from dark to light, from black to color, from color to white. The spaces of those zones are to be of different dimensions and will be conceived like music, each dimension corresponding to a tempo, and each tempo being contradicted or heightened by a color. Each zone (room) will be made of one color, all around, ceiling and floor.

The materials:
Outside, the shapes which will constitute the outer walls will have to be cast or cut as whole shapes and assembled. The material should be mat, the black being the blackest black and the white, a non-reflective mirror. They could be made of a composite-material which could be laminated (downwards profile for the black, upwards for the white) in order to increase its intensity. (It could be made of a resin-glass?) *The inside* color-zones could be obtained chemically and included in the building-material. In this case, it may be possible to cast the rooms one by one in a composite, sound-proof and fire-proof material.

Conclusion: The black and white outdoors will be the monumental part, a sort of a 'guardian' of the labyrinth itself (the attraction of black and white in a colorful garden being obvious). The labyrinth will permit wandering and passages through various intensities, which should allow the walker a 'color-bath' and a contrasted experience.

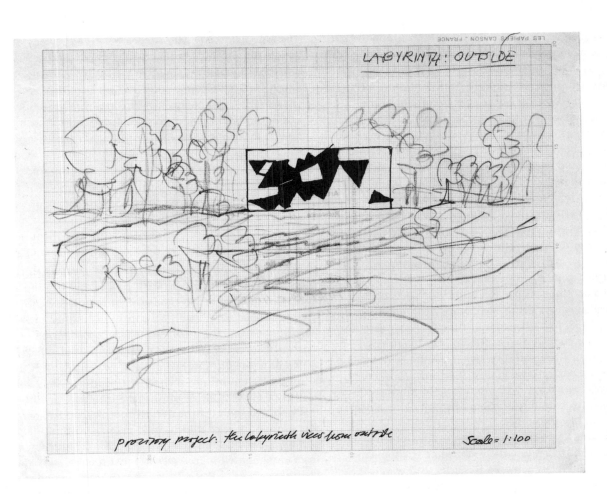

LABYRINTH: OUTSIDE

provisory project: the labyrinth view from outside Scale = 1:100

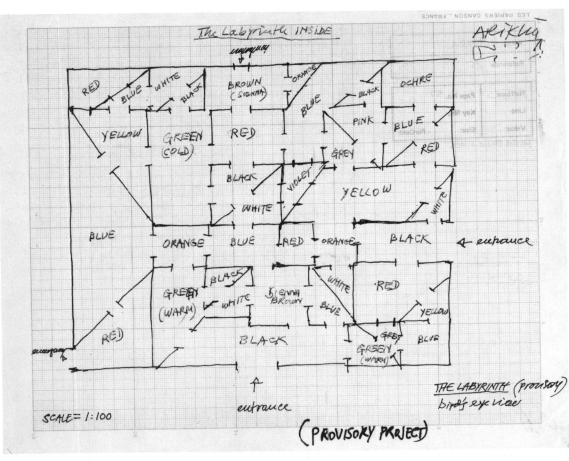

The Labyrinth INSIDE ARIKHA

SCALE = 1:100 entrance THE LABYRINTH (provisory)
bird's eye view

(PROVISORY PROJECT)

Michael Asher
Born Los Angeles, 1943
Resident Venice, California

In the early stages of our planning for A & T, during the fall of 1968, we had several discussions with young Los Angeles artist Michael Asher about doing a project with Hughes Aircraft. Asher had for several months been consulting independently with Hughes engineer Alex Jacobson, of the company's Exploration Studies Department, about making a work involving holography. Asher wanted to create a long strip of light, about three feet high and up to forty feet long, which would seem to hover freely in space; one would not see the holographic plates which produced the image, but merely the image itself. Jacobson had tried unsuccessfully to obtain a commitment from Hughes to finance the project—they needed several kinds of lasers not available at the company at that time, and outside studio space to set up the piece. We made many attempts, also unsuccessful, to obtain Hughes' contracted participation in A & T so that Asher could continue his collaboration with Jacobson. Since this channel was definitely closed, we arranged, in November, 1968, for Asher to visit Ampex. Asher described his ideas to our contact man at Ampex, Dr. Charles Spitzer, and toured their Redwood City facility. Although Ampex is engaged in research on holography, the company did not feel that they were capable of producing the kind of effect the artist wanted within reasonable financial limits. Asher wrote to us in late December,

> The proposal that I showed Ampex dealt with a phenomenon which was essentially the same phenomenon we talked about last summer. Basically, this was light floating in space and having the quality of being happened upon or elusive.

> The essential reason why Ampex believed they could not handle this project was that they could not implement unknown phenomena. In other words, if I had a project which required syrup to run up a 45° incline, Ampex would supply the pumps that would draw the syrup up but would not have the technical facilities to show me how to make my syrup run uphill. Light in space would be analogous to the syrup running uphill and the light fixtures needed to produce the phenomenon would be analogous to the pumps

> I am still most excited (about this idea) and would like to discuss at further length my project with other companies

In March, 1969, Asher visited Jet Propulsion Laboratory and spoke with physicist Dr. Richard Davies. The proposal Asher had in mind at this time was basically an extension of the idea he had developed for Ampex: rather than producing *planes* of light, he presented to Davies the notion of creating a hovering, light-filled *cube,* room-sized, which would be entirely comprised of light; he was adamant that it not be illusionistically created with solid materials, such as glass or plastic. Davies felt that the only way to achieve this would be with the use of dust-particles, smoke, or some sort of vapor or mist, which could perhaps be controlled to occupy a specific configuration in space and illuminated from within or without. Asher felt that such devices would negate the sense he was after of *pure light,* disembodied and unattached to artifically produced matter of any sort.

John Baldessari
Born National City, California, 1931
Resident Santa Monica

Iain Baxter **A&T**
Born Middlesborough, England, 1936
Resident Vancouver

John Baldessari sent us several proposals and subsequently toured Heath and Company. Three of these proposals, listed as follows, were potentially feasible, but none were realized:

1. Work with outdoor advertising companies to provide space, sign painters, and photo enlargement service. I would like to explore half-tone photo silk-screen color process to do large scale full color blowups of photos. The idea of mass art by conventional means I find intriguing. These billboards would continue the work I have already done with bus stop signs, seat posters, etc.

2. I would like to work in a botany lab. I have various ideas I would like to work out, such as coloring plants, changing growth patterns, etc. Basically, the idea is to explore living materials as opposed to inert material.

3. You are already familiar with my ideas of transmitted art, invisible art by radio waves one could receive if one wished. I have several variations currently.

 a. On commercial radio or TV, an art section of the news amidst international, local news and sports. There would be, perhaps, an ART ROUNDUP.

 b. A radio transmitter would be exhibited pre-programmed with tapes to broadcast art messages at various days and intervals. The title of the piece would be the call letters of the broadcasting band used; or a licensed station could be used, either FM or AM and anyone with such equipment could pick up the messages; or cheap receivers could be sold and a citizens band could be used. The piece would include a program guide for the month. The program notes would be part of the piece.

Iain Baxter, President of N.E. Thing Company (the name Baxter has assigned to identify his output of art in numerous areas—research, graphics, photographs, events, objects, happenings, etc.), came to Los Angeles in May, 1968 and toured The Garrett Corporation. He was primarily interested in remote-controlled inflatable sculptures. Before leaving town he presented us with the following sketchy outline for a project possibility:

Inflatable structures: take form of clouds, lightning bolts (cirrus, cumulus); large—300' to 100'; multi-colored; helium filled; remote controlled apparatus; Sky-Dog—flying car, shaped like hot dog bun.

Remote the thing, so it or they can hover over Museum—over country—large tube on desert of tough material, inflated with ½ helium, ½ air—remoted, so can roll over countryside.

Possibilities:

1. Floating cloud, remote controlled to be over Museum, Watts, parks, deserts, Pasadena—San Marino, etc.

2. Rolling, tumbling inflated shapes for desert—remote controlled movement.

3. Buried shape, inflated to raise the ground above it—may be under glass, sand, etc.,—time sequence?

Large Sculptures:

4. Discovery pieces—to be placed by helicopter in the woods—on the desert—on a remote lake—in the ocean or other remote places. Problems involved are durability of material for various weathers—also portability—should have remote controlled inflation.

5. Sky Dog—flying car—lift weight of a human, yet collapsible and portable.

6. Large shape to move down a large river—various navigation problems involved—could use ocean currents—could also be submarine with remote controlled movement.

Materials to investigate would include vinyl, coated materials such as canvas, rubber, cement (inflatable cement?)
Seeing [further] resources of the company would stimulate all other possibilities.

The Garrett staff with whom we had discussed these flying inflatables maintained that the remote control devices required to operate them could not be built by their company.

MT described various available corporations to Larry Bell in December, 1968. The artist was most intrigued with the Rand Corporation, which is located near his Venice studio. He had the impression (a "romance," he later called it) that top-secret research in the area of "mind-reading," and other "1984-type" propaganda techniques were being carried on at Rand.

As an artist whose work has become increasingly dependent upon perceptual psychology, Bell's interest in Rand was certainly related to his current esthetic thinking. But his concern about Rand's activities, whether naive or informed, was also obviously a moral one. He liked the idea of working in a non-manufacturing situation, "with a bunch of guys removed from my knowledge area."

Brownlee Haydon, Assistant to the President at Rand, agreed to take the artist into residence. He later wrote us,
> During Larry Bell's experience with Rand, we dealt with his visits on an ad hoc basis. We arranged for three seminars with groups of interested persons on three occasions, and deliberately kept attendance to about fifteen (several interested non-Rand artists who knew about the program attended a couple of these meetings). The usual consequence was of two sorts: Larry returned to visit with interested individuals or to lunch with them, or these individuals visited Larry Bell at his studio—during their lunch hour, after work, or on weekends. Several individuals established continuing personal relations with Larry—and some, I believe, still see him.

Unfortunately, nothing very interesting happened. Bell felt that Rand's attitude toward him was, "Let's all pitch in and make something for the patio." He was distressed by the lack of interest he felt expressed in him or his work, but confessed that he was "probably as much at fault" as they, because he was "not capable of maintaining an openness" himself.

In the fall of 1970, through the request of Rand's communications department, several people who had had contact with Bell at Rand talked about the collaboration. The comments of a chemical engineer and an engineer who works on the electrical activity of neural networks are given respectively as follows; although they certainly don't give a complete picture of Bell's activities at Rand, they indicate certain attitudes on the part of those with whom he consulted which are of interest:
> I met with Bell a number of times, individually and in groups and I felt there was a lot of interesting potential in Larry's continuing here. Several of us were intrigued with the idea of working with him, but nothing materialized. The biggest difficulty was that he was looking for something specific and wanting someone to describe a joint project immediately while we felt that we should take more time in exploration. Some of us who are working in visual perception and the mechanics of human color vision, for example in computer color display and image enhancement, thought there was some real potential in a joint effort Things like how you can create color sensation with white lights just by flickering them at different frequencies.

The second engineer commented,
> The things he did were a whole new bag to me. He had little cubes with semi-transparent sides and different densities of coatings on them. They would be placed in a bare, white lighted room and an observer would walk around them and receive different perceptions, especially the fact that they changed as you move around. Now these perceptions depend on very complicated signals to the visual system. Say we're exploring a project and Larry wants to make people have the sense that the object looks more shimmering depending on how fast you move around it. I could say, then, I'll build a model to try to predict how the visual system would behave with different speeds. But this would have been a psychophysical project that should have been in a psychology department. Even though there was a great deal of overlap in our interests, and a great deal of fun, when we tried to push it through to a project, it got too complicated.

> It certainly wasn't anyone's fault that Larry didn't get a project. The limitations were inherent in the context. Here you have two professions—science and art—both of which are creative, but with largely different backgrounds and goals. For a truly creative result in either profession, you need highly individualized effort. To try to blend your efforts is impossible. If I see something I want to pursue, I have to go ahead and he can't help me very much. The same is true for him. We could brush together and perhaps get stimulation from each other, but to create, we have to part paths.

The relationship between Bell and Rand terminated in July, 1969.

Max Bill
Born Winterthur, Switzerland, 1908
Resident Zurich

In October, 1968, MT met with Max Bill in Zurich to discuss possibilities for collaboration between the Swiss artist and Kaiser or another of our A & T companies. In April, 1969, we received Bill's description of a *Wind Column,* a forty-eight foot high piece he had built for the Swiss Pavilion at Montreal's Expo 67, but wished to execute a second time to make it larger and more effective. The tower is constructed of layered steel components turning at different rates and in opposite directions, and powered only by the force of wind [1, Collection Musée d'Art Contemporain, Montreal]. Bill indicated he could not come to California until August. By that time Kaiser was committed to Richard Serra.

In the fall of 1968, we asked Ronald Bladen if he was interested in submitting an A & T proposal. He was reluctant to work in a factory because of the many years he had spent in industry as a carpenter. Nevertheless, in May, 1969, he sent the following letter accompanied by plans:

I realize this may be too late. Also, it is a prohibitive project and expensive. My other ideas are pieces pure and simple, not sufficiently challenging. At any rate, this is the idea. It is a building, of course. Although I think of it as a sculpture. It has to do only with the contemplation of the inner space of a sphere. It is a meditation place. The sphere is 22' in diameter inside. Contained within a cube or building 30' long, 30' deep and 26' high. Color of sphere white. Color of building black. An opening in the wall of the sphere for people to see at 11' level.

Problems: Whether it can be done at all—in a real practical sense. Fabrication expense, etc. Can the sphere be illuminated from the inside without any interruption of the surface in any way? As I write this out it does seem impossible in terms of money and involvement and certainly shipping and assembly but it would be beautiful.

1

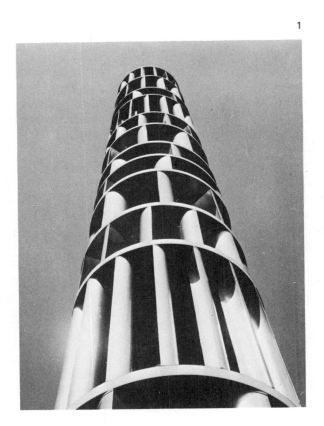

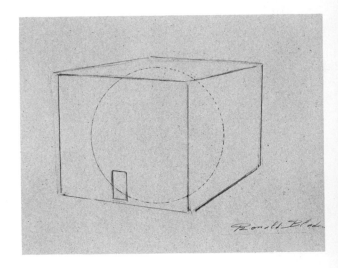

George Brecht
Born Halfway, Oregon, 1925
Resident Düsseldorf

After sending some corporation brochures to George Brecht in London, we received in April, 1969, the following two proposals:

Your 'Industrious* Art**' project sounds interesting. There are two projects I have been giving thought to recently which might fit into that context. The first is the development of stereoscopic television. Perhaps CBS is doing research on this. I have some ideas for accomplishing this with existing sets, as they have no doubt thought of. If the technique is no problem, then this is the time to think about how such a development would be used—performance aspects, and I have some ideas there, too.

More immediately, as part of my Research Fellowship at Leeds College of Art, and working with the engineering department at Bradford University, I've started some research into the aerodynamics of the alphabet; studying the behavior of letters under conditions of subsonic and supersonic airflow. I'd also like to work on the hydrodynamics, but that could be a later chapter. (Jet Propulsion Laboratories?)

In June, when both IBM and Rand had become available, MT called Brecht in England, asking for further details on his ideas to determine if either corporation was suitable. Instead Brecht proposed a third notion: to move the land mass of the British Isles into the Mediterranean Sea. He followed up this conversation with a letter stressing the seriousness of this fantastic scheme:

*Industrious—(obs.) Exhibiting or marked by intelligent work; skillful.
**Art—(all meanings, see Webster)

I'm afraid you may have gotten the impression in our phone conversation that I was not serious about the land-moving project. Actually this is a project which I have been mulling over for about three years. It was reactivated during a visit here by Walter de Maria, when we extended plans for research into its feasibility, and it remains one of my major concerns. For the 'Art by Telephone' show, for example, which begins November 1st at the Chicago Museum of Contemporary Art, I will initiate a survey of public opinion on the project.

I think you will agree that such a huge project as rearranging a country or state globally would be enormously facilitated if the capacities of a corporation like Rand, with their pool of abilities in geophysical, geopolitical, and other fields, could be made available.

For this reason, I was less than enthusiastic about IBM, since I can't see immediately how they could fit into either this plan, or the alternative two previously described to Mrs. Livingston, i.e., the aerodynamics of the alphabet, or stereo TV.

Over the next few months, Brecht conducted extensive research on the land-moving project, and in April, 1970, he had a one-man show at the Eugenia Butler Gallery in Los Angeles consisting of maps of fifteen relocation projects, one of which is reproduced here showing the relocation of England and Florida. [1]

PHYSICAL WORLD MAP

TWO TRANSLOCATION PROJECTS

1

James Lee Byars
Born Detroit, Michigan, 1932
Resident New York City

The Hudson Institute was the first out-of-state corporation to be contracted to A & T. In February, 1969, we wrote to Herman Kahn, Director and co-founder of the Institute, requesting Hudson's involvement as a Sponsor Corporation, and by mid-March, through follow-up correspondence with President Max Singer, an agreement was reached between Hudson and the Museum; it was left to our discretion to select an artist to place in residence, and a Sponsor contract was signed.

In a brochure published by Hudson, they describe themselves as,

a private, non-profit research organization studying public policy issues, especially those related to long range perspectives, to U.S. national security and world order, and to social and economic development. Its goal is to promote better communications and understanding among those working on public policy problems, and where necessary, it seeks to develop special techniques to aid both research and exposition for this purpose

The Institute strives to bring together a diversity of viewpoints as well as skills in a staff that works together in an organized manner, yet in an atmosphere of freedom and inquiry Hudson tries to provide a degree of time and detachment which is rarely possible in the studies of an official agency, and a degree of focus and integration which is rarely available in a university or center for international studies

The Institute's location, at Croton-on-Hudson, offers a quiet, pleasant place to work. Situated in open, hilly country overlooking the Hudson River, about thirty miles north of New York City, it is convenient to rural and suburban housing and is less than one hour from Manhattan by car or train.

In April, 1969, Jane Livingston met in this consciously idyllic environment with Mr. Singer and his assistant, Gail Potter. We had already discussed the possibility of working at Hudson with James Byars—he seemed a sufficiently extramundane spirit to deal in such an abstract and rarefied atmosphere as this—and Byars expressed unqualified enthusiasm over the prospect. (We had earlier, in Los Angeles, discussed with Byars the notion of working with one of the corporations contracted to A & T before Hudson entered the project. Gail Scott visited Jet Propulsion Laboratory with Byars in January, 1969. They met with JPL physicist Dr. Richard Davies, and spent most of their touring time viewing the space module displays, which fascinated the artist. Byars was not at all interested in working with specific objects or materials to make a physical art work; instead, he pressed Davies about the possibility of sending a rocket-propelled vehicle to Mars. This request seems to have struck Dr. Davies as implausible, and the Byars/JPL connection ended at that.)

Therefore, it was with Byars in mind that JL conversed with Mr. Singer and Mrs. Potter at Croton-on-Hudson. It wasn't in her power exactly to prepare the Hudson personnel for Byars' visitation, and indeed we had no preconception of what he might choose to do. Mr. Singer agreed to receive Byars, and to allow the collaboration to evolve as it might. JL was given a tour of the buildings and grounds, and took away with her a number of Hudson Reports on various weighty and unrelated international topics.

Byars began his collaboration on May 19, 1969. For the first two or three weeks, he actually lived at Hudson—"They have a dormitory for generals," he said, "where they're putting up with me." (Actually this dormitory houses students, most often, who come during the summer to "soak up the atmosphere.") After that, he commuted from New York several days a week; he continued to work until July 20, returning after a trip to Europe to work periodically through November and December. One of the first important events in the collaboration occurred early in his residence, when Byars attended a weekend briefing held for the benefit of Belgium's King Baudouin, who arrived just as Byars did, and at which Herman Kahn presided and spoke at length.

In order for us to keep some record of the course of the Hudson/Byars project, the artist and JL devised a schedule whereby they would speak by telephone once a week at an appointed time. The first of these weekly conversations took place right after the symposium, and Byars was elated. He was beginning to formulate the terms of the project he intended to carry out with, or through, Hudson, and he mentioned four points he wished to pursue. Characteristically, they are ambiguous in intent and mystifying in style, but these ideas were to be the basis of his continuing approach. The four points, as dictated by Jim, are these: 1) "The exultation of being in the proximity of extraordinary people." 2) "The one hundred most interesting questions in America at this time." 3) "The next step after $E=MC^2$." 4) "One thousand superlatives about the Hudson Institute."

Byars talked of making a trip around the country to interview certain illustrious Thinkers, and perhaps thus invoke the one hundred significant questions. This proved to be economically unfeasible, so he established a private telephone World Question Center. He found, in his words, that "there is a terrific prejudice against asking questions." It occurred to him to state, "axiomatically," as he said: "Product: ten thousand pauses caused by asking people for questions that they are asking themselves." He conceived the idea of prevailing upon the Gallup people to run a poll for him, and even went so far as to request promotional space in the major U.S. magazines. (This never worked out.) At one point, following a phone conversation with James, Betty Asher wrote in a memo to MT: "His Three Ambitions: Artist-in-residence at the Pentagon (a letter from you

HISTORY

The present Hudson site once belonged to a New York physician, Dr. Robert Lamb, who purchased the acreage in 1920 and designed the seven-building complex as a special medical care center with the purpose of providing highly individualized attention for his patients (especially those requiring mental rehabilitation). Wanting to avoid a hospital-like atmosphere, Dr. Lamb planned the hallways in the main building with windows on one side and bedrooms on the other, lending a spacious and open air to the rooms. Most of the first and second floor area was divided into suites consisting of a patient's bedroom and bath plus a nurse's room. The third floor was for the housekeeping staff.

Building Three was completed while work on the main building was still in progress. It was used primarily as a garage, with living quarters on the second floor for male employees. Buildings Four, Five and Six were built between 1926 and 1931 to provide accommodations for a small number of special patients. Dr. Lamb's residence (our Building Two) was finished in 1932, as was Building Seven, originally a workshop for the maintenance crew.

Dr. Lamb retired from active practice and closed the center in 1948, although he lived on the grounds until his death in 1952. After 1948 the property was leased to several tenants and the rental income used to finance grants to the Albany Medical School and the University of Vermont Medical College, as stipulated by Dr. Lamb.

The first tenants were the Maryknoll Sisters, who needed interim accommodations while their new convent was being built in Ossining. They left in January 1957 and the estate was taken over by the IBM Research Division, also on an interim basis, until the Thomas J. Watson Research Center was completed in June 1961.

CONSTRUCTION OF THE MAIN BUILDING 1920-1922

BUILDING ONE
contains the offices of the Director and the President as well as most of the research staff. There is a library on the third floor, a dining room and small conference rooms on the first floor and a print shop in the basement.

BUILDING SEVEN
is the main conference building for seminars and larger meetings. Our largest meeting room, furnished with audio-visual equipment, is on the ground floor, with three smaller meeting rooms above.

BUILDING TWO
houses additional offices for the research staff and a map room used primarily by the Economic Development Studies section.

BUILDING THREE
was originally a garage but is now used for storage space and a workshop for maintenance operations.

BUILDING FOUR
is the Administration Building, where the accounting, purchasing and service departments as well as the office of the Controller and Assistant Treasurer are located.

BUILDING FIVE
is now used only as a summer dormitory for graduate students employed by the Institute during their summer vacations.

BUILDING SIX
is the home of one of the maintenance crew and his family.

would be helpful). To get the Nobel Peace Prize for Herman Kahn. To run Herman Kahn for President."

Byars' contact with the Hudson Institute personnel seems to have consisted mostly of series of statements or questions mimeographed or otherwise duplicated and circulated in-house. One of the first questionnaires given to the Hudson employees requested "One hundred superlatives on Herman Kahn." Byars' own first "superlative" is, "I-fell-in-love-with-Herman Kahn-because-I-knew-in-advance-that-he-could-speak-four-hundred-words-a-minute." He made a number of items not intended to elicit response, but simply given gratuitously, such as hundreds of thin strips of paper, seventeen inches by one-quarter inch, reading "PUTTING BYARS IN THE HUDSON INSTITUTE IS THE ARTISTIC PRODUCT." [1]

JL received a letter from Byars describing his first sub-project at Hudson:

J. I hand delivered to
every staff member the
Pink Book (as an attitude note)
and the exultation slip—
next day in white suit
the white questionnaire
all as intro. J.
P.S. They loved it.

According to Gail Potter, who remained fairly close to Byars throughout his tenure at Hudson, there was in fact a general attitude of hostility on the part of the Institute personnel to Byars' presence. There were, in her words, "a lot of square people who felt that what Jim was doing was a

waste of his time and their time." Mrs. Potter felt that after the first two or three weeks, there was not much serious interaction between the artist and the Hudson staff. He continued to spend more time wandering about in the halls, chatting with people at random, than in the small office which was reserved for him.

Byars did spend considerable time with Herman Kahn,

either at public occasions or in private—he estimates that he had, overall, about twenty hours of informal conversation with Kahn, at his home or at Hudson. Gail Potter said she guessed that Byars "spent as much time with Herman as anyone ever does."

Some months after the Byars/Hudson collaboration ended, JL spoke to Herman Kahn by telephone and elicited some comments from him on James and his impact at Hudson. Kahn immediately observed that the response of Hudson staff to Byars seemed to be rather clearly divided between the younger people—under thirty—who liked, or were amused by Byars, and those over thirty, who were hostile to him. (Byars says this is a silly statement.) Asked to give his own thoughts as to why this might have been true, Kahn replied, "Most people, unless they are very young, still see *art* today in its old fashioned roles: art as religion, art as heroic, art for entertainment. Art today is none of these things. It's *happening.* That is what Byars is about, and one has to accept this to accept Jim." Kahn went on to remark in general that "God and Darwin got buried, and once Darwin is buried, the Puritan ethic goes with him. Jim understands this and is trying to move in this direction. There's the question, then, as to whether Jim is symptom or cause. Probably he's symptom."

When pressed for an opinion on the real *intellectual* value of Byars' World Question Center project itself, as opposed to the fact of the artist's presence at Hudson generally, Kahn said finally, "Well, of course it's a totally undisciplined and uninformed project." Perhaps the most interesting comments made by Kahn to JL involved a process of questioning his own motives regarding Byars' presence at Hudson. Kahn asked himself, "Why are we bothering with Jim? After all, I want the organization to run right. The presence of someone like Jim is theoretically subversive of that goal." Kahn never, even by implication, answered his own question. Byars, for his part, had some comments in answer to Kahn's observation. Significantly, he feels that "Herman tends to view things rather categorically; he generalizes as a matter of habit. He doesn't, however, see *art* in general as a category of enormous interest for himself or for the world—he tends to view it as a luxury."

Among the people Byars contacted by telephone during his first period of residence at Hudson were Alvin Weinberg, Director of the Atomic Energy Commission—his question was, according to Byars, "Axiology?"—and Marshall McLuhan, who responded, "What do you mean, questions?" Byars visited Princeton on three different occasions, where he met with Physicist Eugene Wigner (there is no record of his response that we know of) and astronomical mathematician Freeman Dyson, who allegedly said to Byars, "We're getting red light from outer space." Whether this was intended as a question or a statement is not ascertained.

1

In July, Hal Glicksman visited Hudson for a day; he happened to be there during a seminar on U.S. Policies: Domestic and Foreign. [2] Talking with JL about the conference later, Hal said, "It was one of those meetings that I guess Kahn is famous for—bringing together all types of people and presenting several different lectures on current social problems. We heard Kahn's lecture in the late morning and had lunch with him, and then attended part of an afternoon session."

JL: How did you feel Kahn was responding to Byars, or was he?

HG: He was. He was very outgoing, and somehow when a person is that rational and is asked a nonsensical question, the question and answer just don't jibe. Kahn's answers were so straight and so good to the questions that were basically ridiculous and supposed to open up the person's flow of thinking, and Kahn would answer it more or less directly. Like Byars would ask, 'What's the most important question of the twentieth century?' and Kahn says, 'Well, this question is on three levels. First of all there are cosmic questions like, How is the world created, does God exist and this sort of thing. We can dismiss those.' Then he goes on to outline the three most important questions of the current day. I forget what they were . . . Viet Nam and this and that. I mean he has *answers* for Jim—that's the important thing.

Byars felt that although he maintained a stimulating relationship with Kahn, Kahn was not particularly helpful in supplying interesting questions. (He was not, after all, seeking answers.) Indeed the artist said, "If I had limited myself to Hudson I would have failed. Only by extending myself out into the world was I able to gather questions at all."

The peculiar quality of the dialogue between Byars and Kahn when Byars was trying most persistently to invoke Questions comes out in fragments of the taped conversation between them, made on the occasion of Hal's July visit:
Byars: I'd really like to ask you for one hundred questions

Kahn: Are you going to be around tomorrow at all? . . .

Byars: It's very interesting how difficult it is to find questions. What is an interesting question in 1969?

Kahn: That's not our problem. Our problem is too many questions There are different levels. Some say the most important questions are religious. Is there a purpose to mankind? Is there any meaning to existence? Now the atheist of course says no, man is the measure of himself. But that turns out to be wrong, in some funny way

Byars: I'd be very happy to have whatever analysis you would make.

Kahn: To me an important question, for example, is, Can a computer transcend human beings? I suspect the answer to that is yes. I find it a very unpleasant prospect The computer may write better poetry than human beings, better drama, make more perceptive judgements I think before the end of the century you'll be saying yes to that It may turn out that the only way you can do this, is that the computer itself will have to learn by experience. That seems very clear.

In the selection of questions compiled by Byars at the end of his Hudson collaboration and published in book form, none was authored by Kahn. In explaining why this is, Byars cited a remark made to him by Hudson employee Frank Armbruster. Armbruster said, on the subject of posing questions, "Most of the world is concerned with problems which they think have imminent solutions." Byars' response to this was, "I'm not *interested* in solutions. No one could get this through his head, including Herman Kahn."

In the spring of 1969, Byars had been in Antwerp to participate in an exhibition there. Through his contact with the man in charge of Belgian cultural affairs, he arranged with the Belgium Radio and Television network to sponsor a live television and radio program, on which Byars would appear and hold his World Question Center, simply by telephoning certain forewarned people and engaging in dialogue with them while being televised. The following letter was sent to MT, requesting his availability during the time of the program:
On November 28th 69, the B.R.T. will broadcast a live program about and with James Lee Byars, the first artist in residence of the Hudson Institute, Croton, N.Y.

James Lee Byars (Detroit 1932) asks questions, asks himself questions. It is quite surprising that he need not refer to another world or to another reality, but simply appears as *the* reality of our world. He does so in the most simple and direct way. His significance does not lie in what he says or does, but in the attitude out of which he tackles everything, in the man who is behind it. Everything he does, even if it seems exceptional according to the usual standards, is so obvious and coherent that we easily can approve of his ideas and, with him, look at our own behaviour and our own world like a stranger.

You have been chosen by James Lee Byars to be telephoned during the program, together with a few other personalities. So, on the 28th of November, between 10 p.m. and 11:30 p.m. (GMT), Byars will ask you some questions, which he thinks important or about which he wants your opinion. All the questions and answers are to

THURSDAY, JULY 10

6:00 p.m.	Registration, Cocktails and Dinner	
8:00-10:00	Introduction: A Basic Context for Discussion of U. S. Foreign and Domestic Policies	Herman Kahn

FRIDAY, JULY 11 IMPORTANT FORCES OF THE FUTURE

7:30-8:45	Breakfast	
9:00-12:30	More on the Basic Context	Herman Kahn
	(Coffee break at 10:30)	
12:30	Lunch	
2:00-3:30	Morale and Public Works	Robert Panero
3:30	(Coffee break)	
4:00-6:00	New Elements in American Politics	William Pfaff Frank Armbruster
6:00-8:00	Cocktails and Dinner	
8:00-10:00	Discussion	

SATURDAY, JULY 12 SOME KEY MILITARY ISSUES

7:30-8:45	Breakfast	
9:00-12:30	Some Current Military Issues: Vietnam, ABM, Central War Strategies	P a n e l Johan Holst Herman Kahn Max Singer
	(Coffee break at 10:30)	
12:30	Lunch and Adjournment	

be in English. This program might be the beginning of a world question center, as Byars puts it.

We kindly request you to take part in the program and therefore we would ask you to return the enclosed letter as soon as possible (deadline: 22nd Nov.). Five hours before the program we will call you for the final checking.

We should be most grateful if you would cooperate.

Yours faithfully.

Bert JANSSENS.
Program Controller TV.—
Flemish Department (B.R.T.)

The program was not entirely successful from Byars' point of view in terms of the "profundity or seriousness" of the questions elicited, but as an event it came off excellently. Byars sat, in costume, in the midst of a group of fifty students from the University of Brussels, who acted as operators. About twenty people were telephoned, most of them Europeans, some in America. Walter Hopps, at the Corcoran Gallery in Washington, D.C., was on hand in his office with a group of other gentlemen selected by Byars. One of them, a Mr. Rosenkrantz from the National Institute of Health, asked what Byars considered the most successful question of the hour: "What is the body of the cognitive instrument?" At the end of the telephone question period, the students present with Jim in the studio were invited to ask questions, and then the viewing audience was given a phone number to call the next day if they wished to call Byars with questions. The phone was busy for hours, according to Byars, and thus the experiment ended propitiously.

On December 8, we received from Byars, on orange painted paper cut in the shape of a pronged devil's tail, a message saying in part, "M. Babe, the World Question Center on TV was sensational in both Belg. and Holland—one most extraordinary part was an Angelic Belgian voice reading at ten second intervals my 100 ?'s (like clone me?) . . . Sorry I missed you on the world phone (Telstar was crystal clear)"

And shortly thereafter he added, on a pink tissue paper tail appended to an enormous white paper circle:
. . . with the World Question Center on TV I asked for a min. of intro. without speech or sound—they said 30 sec. max.—at the end of a simple quote on the poss. of an electronic simulation which may within the decade jump all languages and earthpeople 'BEEP' 'BEEP' at U.N. Understood radios TV broke down and 4 minutes of total silence and perfectly still cameras was transmitted to all of Belgium and Holland (50 people in a pink ring sitting—looking straight ahead and 5 in a pink pants on chairs in the middle on my rt. a transparent blond and on my lt. a transparent blue girl from Ghana)

Throughout the course of Byars' project, he was thinking about possible ways of participating in the Expo 70 exhibition. We received numerous letters from him with suggestions for such a project. As early as June, 1969, James sent us a list of ideas:

I CAN
GET THE BOY SOPRANOS
AT ST. THOMAS CHOIR
SCHOOL TO SING THE
QUESTIONS (FANTASTIC HIGH
SOUNDS) USING ONLY THE
LANGUAGE AS MUSIC—
IT COULD BE MOSTLY
AUDITORY PRESENTATION?
I VIEW 'JUST THE OPPORTUNITY
TO RESPOND' AS A SHOW
TO TELEPHONE 1000 PEOPLE
IN AN AREA ASKING FOR THEIR
QUESTIONS AS A SHOW.
THIS CAN BE DONE IN WHATEVER
DEGREE OF TECHNOLOGY
THAT IS AVAILABLE (VOCALLY
IN PERSON OR PHONE OR
RADIO OR TV).
I'VE TAKEN ON ANOTHER
PART OF THIS PROJECT TO
TRY AND COLLECT
'50 SINGLE SENTENCE
AUTOBIOGRAPHIES'
GIVE ME YOURS?
MAYBE SOME WILL TAKE
ME SERIOUSLY?
ANOTHER PART THAT COULD
BE BEAUTIFUL—
A MOVIE OF FIRST SIGHT—
PEOPLE MEETING
FOR THE FIRST TIME—WHAT
DOES THE FACE TELL?—DOES
IT MATTER IF YOU'RE TIRED?
(DOES 1 FATIGUE?)—WHAT
COULD YOU SEE IN 100 FACES?
IT APPEARS TO ME AS A PERFECT
SILENT MOVIE—OR A VIDEO
SYSTEM PROJECT—THE
MOOD OF A PERSON'S FACE IS
INTERESTING 100 MOODS

At the end of 1969, BA spoke to James by telephone and drafted this memo:

J. Byars called and would like an answer today or tomorrow re his participation in EXPO.

He claims he is asking so little:
1. Opening day or night, he would be present with a Sony pocket tape recorder and the voices of Viva, a child (ascertained by the child who could whisper the highest among those who make up the St. Thomas Choir), Herman Kahn and Byars.

2. Gold sheet or hole in the wall (1 inch) for Byars lips through which he would emit one question a minute OR a 6' x 3' gold leafed panel for same purpose.

3. A superwoman (of his choosing) with whom he would exchange questions and/or dialogue for an hour. (Nothing more, I hope!)

4. Police protection if we can't include him in the exhibition in one of the above manners.

The idea that finally became most persistent in Byars' mind was that of presenting his compilation of questions in the form of an edible book. In a letter written to us, he said,

. . . The figs. on the dissolve paper are $3.70 per 100 sheets for 8½ x 11 (spec. price to me from the Chem. who invented it). Maybe I can get it for less and assume that Hud. will print it—I do want it to be exquisite however . . . the world's *first eatable public* book . . . The cover hopefully will also be eatable

At the time of Byars' request that the Museum help to produce the edible book with funds from the A & T budget, we had no funds available. Hudson was also asked to produce the book; they finally agreed to print an edition of 100, but on non-edible paper, with one question to a page in hairline type. The text is as follows:

This book is eatable?
Merry X?
Woo?
O?
I'm the self-appointed World Question Center?
Putting Byars in the Hudson Institute is the Artistic Product?
$E=MC^2$, next?
I have perfect question?
This is question theory?
Say it is yours?
The question of perfect speed and total elasticity?
A proposition is public question?
Clone me?
Which questions have disappeared?
Do you have an affection for question?

What's the difference between asking and telling?

He grabbed my nose and said what do you want a nonlinguistic question?

Put your hypothesis in general language?

Imagine the palpability of question?

Did Plato forget question?

Is all speech interrogative?

Ho! Ho! Ho! is the same in all languages?

Call all earth attention to a signal?

Arro, is repeat. info.?

I'll give you 5 min. of face?

What questions are you asking yourself?

Think yourself away?

My business is asking and access?

I'll get her question grammar?

Read Plato's nonsensical definition of the Good?

"Forget it" is a treatise?

Put your autobiography in a question?

The question is the answer?

A Pompidou?

Is self-conscious option enough?

Trancequestion?

I fell in love with Herman Kahn because I knew in advance he could speak 400 words a minute?

What's fancy for those in power (does it keep them healthy)?

A '69 question?

My only desire is to explain everything?

I listed all the Universal Questions before?

What's your general honorific sweetie?

Put question in the Encyclopedia Britannica?

I am the complete history of the world?

How to meet a General, "Imagine I have short hair and birds on my shoulders like you once had"?

This question is capable of questioning itself?

The ghost of question?

Starquake?

I'm the Unofficial Poet Laureate of the United States?

Make a soliloquy on question?

"Well?" was her favorite question?

Question is Big Art?

What's the difference between quantity and quality?

How to fall in love with a phone call?

Are all people interchangeable at some live level?

How does he question and how does he eat?

The world is so fantastic why make up?

All questions consist of establishing the notion of asking followed by a nominative?

Greg Card
Born Los Angeles, 1945
Resident Arleta, California

The Earth at least?

His head weighs 25 lbs?

Exalting question is surprising?

To present the opportunity of possible response is the
 exhibition?

I can repeat the question but am I bright enough to ask it?

Multiply a question?

Find the world question in a week?

He asks 100 times or not at all?

Mathematics HaHa?

Imagine being possessive of a question?

Questions are gifts?

I'm full of Byars?

My work is civil defense?

You're the person they pretend doesn't exist?

Herman Kahn'll be a Buber by 50?

What's the speed of an idea?

He has the heaviest question in the U.S.A.?

Questionboon?

I'll be the Artist in the Pentagon, next?

Make a question was the whole exam?

Suppose the context around this question?

I quit you?

All questions rise in intonation?

The first sentence I ever read was "I can see you"?

Israel is a philosophical mistake?

A ? Zoo?

Numbers don't count?

Ask is New English?

Limit all talk to the sound of O?

It takes 5 minutes to come down to your level?

I'm 1/16 Jewish?

Drop hello?

Empty mouth, what's the matter?

Her questions are her ornaments?

The world's smartest man got mad when asked for a
 question?

Axiology? from The Director of Atomic Energy?

I've done Anglo-Saxon?

If you ask for something that doesn't exist you deserve it
 on the intelligence of the request?

Questionbully?

Suddenly he's a collar, a necktie, and a lapel?

Credit is to identify your question?

My tongue is insured for $50,000?

James Byars has made himself into a work of art. There-
fore, in the Museum exhibition, we will present a film of
Byars. In it, he will appear life size, delivering a monologue.

 Jane Livingston

In July, 1968 Greg Card sent a project proposal, an excerpt
of which follows:

 Nine three dimensional paintings, suspended:

Color:

Variations on three colors (Red, Green, Blue) in two
forms . . . transparent and semi-opaque.

Medium:

Polyester resin (crystal clear in original form) and fiber-
glass cloth or matting. Colors will be mixed in the resin
according to the formula for each painting. Nylon or
monofilament wire will be used for the suspension
system.

Form and Dimensions:

Cylindrical with cone shaped ends These paintings
to be hollow. All paintings to have a wall thickness of no
more than ¼ inch and no less than 1/8 inch with a total
outside diameter of approximately 5 inches and a total
length of 12 feet. Paintings to be suspended in a horizon-
tal position.

Production Process:

This process is one that I have come to know as spin
forming or casting. It also has been brought to my atten-
tion that this process has been used with success by the
Mattel Corporation and experimented with by a few
other concerns.

Anthony Caro
Born London, 1924
Resident London

John Chamberlain
Born Rochester, Indiana, 1927
Resident New York City

In January, 1969, MT wrote to Anthony Caro explaining A & T, and asked to see the artist in London. Caro replied that the program interested him, but he was not planning an extended stay in the United States. Then in May he wrote to say that after discussing A & T with Jules Olitski his curiosity had been aroused. He requested information on both the Container Corporation of America and Kaiser Steel Corporation. Kaiser was no longer available, but we sent him literature on two CCA plants—the folding carton and corrugated cardboard divisions. In a letter of July 28, Caro stated that he was extremely interested in visiting CCA and wished to come to Los Angeles for that purpose. By this time, however, Tony Smith's project was underway at CCA. We requested that they take on a second artist, but CCA declined to commit their resources further.

John Chamberlain's name emerged repeatedly during our early staff selection sessions, through late 1968 and early 1969, as an artist whom we felt might do something extraordinary with—or to—a corporation. We had no special preconception of what medium he might wish to explore, and as it developed he approached the project in ways that could hardly have been predicted based on his past work.

It wasn't until April, 1969, that we finally contacted Chamberlain; Jane Livingston saw him at his New York studio. Chamberlain at that time had been working on a series of written proposals for participatory works. Most of these would simply have involved designing and building objects or environmental structures of foam, wood or steel, within which the spectator would move or manipulate props in specific ways. They did not seem especially appropriate to A & T. The notion of doing a film project, with a corporation like Ampex, RCA or CBS, was also discussed. It seemed worthwhile to have Chamberlain tour Ampex, in Redwood City, which he did with us when he came to Los Angeles in May. The idea John had chiefly in mind when he visited the Ampex facility was something suggested to him by Douglas Huebler; Chamberlain called it *42nd Parallel,* and it involved making video tapes in each of fourteen towns along the United States 42nd parallel, then showing these tapes simultaneously on fourteen screens. John saw at Ampex a demonstration of their *100* video machine. He was left with a feeling of ambivalence, if not indifference about seeing through a project there, and the idea was abandoned.

The next day, May 9, 1969, Chamberlain visited the Riker Laboratories Division of Dart Industries with JL. Riker makes and packages several drugs and inhalant medicines. He had no specific medium or project proposal in mind, but (Patron Sponsor) Dart was still available, in theory at least.

On the way from the Museum to the Riker plant in the San Fernando Valley, Chamberlain conceived the idea of making a multiple work consisting of packaged odors. These would be chemically formulated to simulate particular odors of his choosing, and manufactured in the form of inhalers or sachets, in a large edition. With this newly conceived proposal in mind, Chamberlain toured the Riker facility and asked specifically to consult with a chemist there who could gauge the feasibility of implementing such a proposal. Riker's organic chemist, Francis Petracek, discussed the problem at some length with the artist. Petracek indicated that in principle it would indeed be possible to actually gather and distill odors. He mentioned "the smell of downtown Tokyo," which prompted Chamberlain to want to extend the range of odors beyond simple products or substances to *locations.* Petracek demonstrated to Chamberlain samples of chemical odors commonly known, notably a potion which strongly evoked dirty socks. We suspected that the actual process of travelling with technicians

and equipment and distilling various scents would be beyond the capability—or degree of commitment—of Riker or any other division of Dart Industries.

Shortly afterward, Chamberlain left for New Mexico, where he was shooting his film *Thumbsuck*. During this time he wrote up a formal proposal for the *SniFFter* piece and sent it to us. Our dealings with Dart Industries on this project resulted in the suggestion that Chamberlain might collaborate with a Florida-based cosmetic branch of the corporation, and got no further. The *SniFFter* proposal was then sent to International Chemical and Nuclear Corporation with a letter mentioning that it might be used as a giveaway multiple during the time of the A & T exhibition.

SniFFter. SniFFter is an olfactory-stimulus-response environment articulated in sets and units proposed by John Chamberlain through the research and production auspices of International Chemical and Nuclear Corporation.

A list of kinds and types of odors (specific as to source, intrinsic and project quality and similar categories for unit modification) is presented. Researchers then to edit and synthesize a given number of odors. The original extraction or essence and the produced extraction or essence are both utilized in the final articulation.

SniFFter is proposed as a three-unit multiple: Unit A to consist of 100,000 inhalers of 27 different odors; Unit B to consist of 1,000 humidors, each containing 69 inhalers of various strange, pleasant, unpleasant and otherwise uncommon odors; Unit C, a small number of humidors containing 69 inhalers containing the original extractions and essences.

The numbers involved might be modified as might be the types of odors.

Unit A is proposed as a giveaway, a random occurence for the Osaka Exposition. The number is arbitrary and may be expanded or reduced.

Unit B contains a multiple programming of odor qualities, perhaps color-coded to indicate the 'tone' quality and general area of a specifically included odor. Unit B takes its source in the list of apprehended odors; Unit A may borrow from that list; and Unit C locates the original odor as essence or extract.

Unit C locates and presents the original odor essence or extract from which the others may be derived. The common and specific odors are presented here. With a the presentation becomes specific and with an uncommon odor the designated odor remains specific in itself. I surmise that there is a probability that certain odors in the specific range would contain the occasion, diet, psyche-factors, and

other conditional factors, the odor becoming unique at its source, and subtle in its difference from the general in that area. Similarly, gasoline would be of a particular variety, cow manure from a particular place—say, the Chicago stockyards in July.

Certain odors would be undistinguishable from others until a sophistication (re-education, orientation) in detection of peculiarities of particular odor origin is acquired by the sniffer of the SniFFter.

In SniFFter presentation, a booklet containing the molecular structure of each component odor on a separate page would accompany the unit presentation. More research—the sophistication in odor perception among the blind, the detection of odors by animals apparently unavailable to humans and so on—may present many possibilities in the restimulation of the adventures of the nose.

EOP=Extra-Olfactory Perception

SniFFter list of proposed odors:

1. Negro revival meeting
2. baby milk throw-up
3. Castor Oil
4. burning cellulose
5. arsenic
6. dill
7. adhesive tape
8. French roast coffee
9. Lew Alcindor's tennis shoes after a game
10. third floor of the L.A. County Art Museum
11. mother's milk
12. motorcycle race track
13. downtown Miami Beach
14. Fulton Fish Market
15. ozone
16. reptiles—cobras, etc. could be from a specific zoo
17. second grade classroom
18. Campbell's Vegetable Soup
19. Bowery flop house—NYC
20. dirty socks—specific
21. downtown Las Vegas
22. San Diego Zoo's rarest animal
23. gasoline
24. new car
25. newly lit match
26. female skin in sun
27. cocaine
28. corpse
29. amyl nitrite
30. singed hair
31. sea bass
32. billiard hall
33. sweat and copper—(pennies in hand)
34. marshland, Savannah, Ga.

35. air at 11,000 feet in New Mexico
36. rubber
37. operation room
38. electric welding rod
39. leather
40. Chinatown—San Francisco
41. musk
42. cut clover
43. German Shepherd
44. marijuana
45. Siamese cats
46. wet paper
47. paint
48. nail polish remover
49. clay
50. photographic fixer
51. New York taxi cab
52. orange soda
53. pigskin
54. scorched nylon
55. nicotine and skin
56. Courvoisier
57. Sicilian kitchen
58. cordite
59. Rembrandt painting
60. American flag at Pendleton, California Marine
 Base
61. burnt toast—specific
62. Chino Women's Prison Cottage #13
63. moonshot at Cape Kennedy
64. Pittsburgh steel mill
65. dirty sponge
66. city dump Tampa, Florida
67. bakery
68. Catholic Church—Specific
69. beehive
70. sauna bath
71. dry cleaners
72. mice
73. wrestling arena—specific
74. butane
75. OK Corral—1969
76. cough medicine
77. sheep
78. toads
79. wet fur
80. bergamot

81. vanilla
82. oil refinery
83. ashtray
84. precinct station—specific
85. snuff
86. face powder
87. bad ale
88. chalk
89. Bridgid Berlin's ink pad
90. heather
91. downtown Venice, Italy
92. money
93. menthol
94. eucalyptus
95. bamboo
96. Fillmore East—Concert Night
97. Charlie McCarthy
98. Larry Bell's studio
99. Hostess Cupcakes
100. mildew
101. Max's Kansas City disco
102. etc. . . .

International Chemical and Nuclear Corporation, whose main research facility is at Irvine, California, referred us to their strong, Cobb, Arnder pharmaceutical division in Sunland, California, as a potential facility for collaboration with Chamberlain. There were several telephone conversations with the manager of this plant, but we were unable to elicit a commitment to pursue the project beyond this. ICN had, interestingly enough, been most eager to join with A & T. Their involvement actually got no further than this unsatisfactory exchange and a tour of their facility by Mark di Suvero.

Chamberlain was planning to return to Los Angeles from Santa Fe in August, and was definitely interested in pursuing our open offer to work with a corporation. We suggested the availability of two radically different facilities: one was a division of Norris Industries which makes porcelain bathroom fixtures and enamel coated bathtubs (JL and HG had both toured this plant and were intrigued, not just with all those toilets but also with the huge kilns used to bake them); the other was the Rand Corporation, which had already taken Larry Bell in residence but were willing to

take on another artist. Chamberlain immediately opted for Rand, where he was to spend six weeks. He was persistently avoiding the idea of making sculptural objects as such, and continued to think in terms of participatory works in general. In response to a letter sent in May, 1970, from MT requesting comments about the artists' retrospective views on their experience with A & T, Chamberlain said, answering the question "Why were you initially interested in participating in ART AND TECHNOLOGY?":

I'm initially interested in anything I don't know about. I'm interested because I need something to lean on. And any material or physical contact, mental contact, whatever has possibilities for lessons. The idea being that as artists we tend to confuse and create chaos involving these facilities so as to come out on some other side.

Brownlee Haydon, Assistant to the President of the Rand Corporation, who served as our principle contact there throughout our mutual dealings, had said in a letter written to us in February, 1968,
We think Rand has something special to offer the creative artist: an intellectual atmosphere and the stimulation of being amid creative individuals working in many disciplines. In this milieu, the artist may find influences on his work apart from the other 'materials' that he may discover in the Rand environment.

It would appear that Chamberlain's reasons for working at Rand and Rand's attitude in receiving an artist would have been fundamentally compatible.

On August 7, John Chamberlain visited Rand and spent an hour or two with Robert Specht (Haydon was out of town), during which interview a great deal of mutual bafflement prevailed. John was then given an office to use as he saw fit, and left to his own devices.

In a letter of April, 1970, Haydon described in brief the extent of Rand's contact with Chamberlain from his point of view:
Rand made an office available to John Chamberlain, and provided the small amount of secretarial help needed to prepare various memoranda circulated to the staff inviting their participation, ideas, etc. Some staff members 'dropped in' on John to talk about his and their ideas—but it would be difficult to put any number on this interaction.

In a meeting early in September, 1969, Chamberlain talked about the progress of the collaboration to date (he'd been working for about three weeks). He said,
I couldn't make any headway in the beginning. I suggested that Rand should dissolve the corporation, or cut off the phones for one day, or have everyone come out in the patios and we'd take some pictures for a day. None of these things got any response

I also thought of doing a thing with a blown-up [aerial-view] photograph of Rand. I'd airbush out the existing building But it might not really be all that amusing, or mean anything. Because I'm not really against the concept of Rand, its uniqueness since 1946, through '56, even until 1960. Past '60, it's gotten, evidently, somewhat stodgy and constricting. The humor [in my approach] is supposed to pull some of that constriction out. But I don't know about this—and I'm not pretend-

ing to be some sort of psychiatrist at Rand But I'm there, and I'd like to deal with them I can't get into any of their circuits. After all, what do I know about weather modification? What do I know about cloud formations? What do I know about the war in Viet Nam? What do I know about the psychology of reflexes in New York City when faced with a police car? I don't know anything about the police car syndrome in New York City. However, it does seem that you can deal with the *people.* The people are uptight, I feel. They're very 1953 . . . you know, like the girls wear too much underwear. On the other hand, the few under-30 people tend to be much more relaxed

Chamberlain finally decided to arrange several screenings at Rand of his film, "The Secret Life of Hernando Cortez," starring Ultra Violet and Taylor Mead, because, he said, "It represents a piece of work done in defiance of a particular structure." The film was run once a day for three days, and was then discontinued. According to the artist, "Word must have gotten to Washington, D.C. that Rand was showing dirty flicks on lunch hour." A detailed version of the "banning" of *Hernando Cortez* was supplied to us some months after Chamberlain's experience at Rand by a resident Consultant in Rand's Communications office. She was interested in and sympathetic to John, and was concerned that in documenting the project, we not portray the Rand personnel as being narrow-minded and hostile in their response to the artist. (She freely said, however, "There is certainly a large contingent of very prosaic people here who are deep into the discipline they practice, and who are frightened by play. It was difficult for them to see John as a provocateur, an eccentric, a seer—people couldn't make the leap out of conventional discourse into his imaginative world.")

She described the events surrounding the presentation of Chamberlain's film. It was originally scheduled to be shown on five consecutive days, during lunch hour, for the benefit of any Rand employees who wished to view it. It was shown for three days, and, she said, "accepted by the majority of the people who saw it—on the third day there was even some applause." However, there were several complaints from staff people who felt it was "dirty, corrupt, and disgusting." A meeting was held among several supervisory personnel who have received complaints, and, with the rationale, according to our informant, that "Rand must attempt to preserve some sense of decorum"—it was decided to hold no further showings of the movie. In any event, a considerable number of Rand employees saw the film, and judging from the amount and nature of their various reactions to it, the experience influenced their view of the artist significantly. These reactions were manifested specifically in response to a questionnaire circulated by John after the film screenings.

The purpose of the questionnaire was to elicit material, in

the form of "answers," for John's final Rand project. Describing the conception and early results of this idea during the September 9 taping session, Chamberlain said,

The next thing I did was sort of muddle around, talk to people Mostly through talking to Irwin Mann [a Rand consultant], I decided to go for answers. Then it occurred to me that they might answer Jim Byars' questions [see Byars section]. So I sent out questionnaires, asking for answers. Yesterday and today I got my first office-full. I'm getting everything from 'Drop dead' to 'Why don't you leave Rand.' I'm not getting much, in short, that I can use [1, 2, 3]

TO: Everyone at Rand
FROM: John Chamberlain, Artist in Residence
SUBJECT: ANSWERS

I'm searching for ANSWERS. Not questions!

If you have any, will you please fill in below, and send them to me in Room 1138.

you're fired!

THANXS
Chamberlain

1

TO: Everyone at Rand

FROM: John Chamberlain, Artist in Residence

SUBJECT: ANSWERS

I'm searching for ANSWERS. Not questions!

If you have any, will you please fill in below, and send them to me
in Room 1138.

__THERE IS ONLY ONE ANSWER: YOU HAVE A BEAUTIFUL SENSE__

__OF COLOR AND A WARPED, TRASHY IDEA OF WHAT BEAUTY AND__

__TALENT IS.__

THANXS.

[signature: Chamberlain]

TO: Everyone at Rand 3
FROM: John Chamberlain, Artist in Residence

SUBJECT: ANSWERS

I'm searching for ANSWERS. Not questions!

If you have any, will you please fill in below, and send them to me
in Room 1138.

The answer is to
gltermi,nate
Chamberliy

THANXS
Chamberlin

. . . I would have liked maybe to use the answers to
express a viewpoint about Rand people in terms of their
intelligence. Because I'm not so sure about it—I mean, I
see people who speak Spanish and misspell simple words,
and have sort of dumb fifth grade attitudes about every-
thing.

Though John felt in the beginning that the answers might
correspond to Byars' questions, and perhaps even be used in
conjunction with them as an art work, the two artists did
not actually coordinate their efforts, and partly for this
reason the end results of their projects are essentially un-
related. Both were to some degree unsuccessful in drawing
enough interesting material from their "subjects" to consti-
tute a satisfactory artistic product, and thus often resorted
to their own inventions in working out the final
presentations.

One of the factors accounting for the depressingly hostile
tone of many of the replies to John's first questionnaire
was simply that instead of giving John disinterested (or
interested) answers, his subjects instead used the question-
naire as a vehicle for conveying their resentment, or fear, of
the film. In an attempt to reverse this trend, Brownlee
Haydon, at John's request, sent out the following memo,
with a second version of the "questionnaire" drafted by
John:

Before he left for the East, John Chamberlain gave me
the attached memo for distribution.

Because of some of the responses to his earlier memo
asking for 'answers,' I think everyone should
understand:

1. John has nothing to do with the experimental re-
 decoration of Rand's halls and offices (see Roger
 Levien).

TO: Everyone at Rand
FROM: John Chamberlain, Artist-in-Residence
SUBJECT: MORE ANSWERS

I would like to thank everyone who has participated in my quest
for answers.

Now, I would like to be more explicit. I had hoped for a more AW. 4
specific poetic imagery to induce, or suggest, an alternative to COME
thinking if or when asked to pair with it, a question or statement. ON!
The altruistic answer is nice, but less interesting...the
challenging being from without rather than from within.

While in the East, I expect to visit Rand's New York and Washington
offices seeking answers. My intention is to return to Santa Monica
in a week or so.

 John Chamberlain

2. John is a guest artist-in-residence, sponsored by and
 paid by the Los Angeles County Museum of Art.

3. His question about answers was not intended to elicit
 reviews of or comments about his film.

The response to this memo was scarcely more satisfactory
than the previous round of "answers." [4, 5]

Finally, John made up a small edition of more elaborate
"questionnaires," in which he listed a number of "answers"
formulated principally by himself, and requested that his
subjects comment on each one. Chamberlain's "answers"
are in bold type; the subject's responses are written above
each of the artist's phrases. The following are excerpts from
one of a dozen responses to this lengthy questionnaire
received by Chamberlain. [6]

Mr. Chamberlain: 5

One of the functions of the artist is to *communicate*.
I can't find one person who understood either your
first communication or your second. We would be
happy to share our spiritual experiences with you
if we knew what you are trying to express. Could
you please rephrase paragraph #2 (Ernest Hemingway
you ain't!) so we can understand what the hell you
are driving at--or do you know yourself?

 , my quest

Now, I would like to be more explicit. I had hoped for a more
specific poetic imagery to induce, or suggest, an alternative to
thinking if or when asked to pair with it, a question or statement.
The altruistic answer is nice, but less interesting...the
challenging being from without rather than from within.

While in the East, I expect to visit Rand's New York and Washington
offices seeking answers. My intention is to return to Santa Monica
in a week or so.

 John Chamberlain

Definition of Webster's Dictionary: "characterized by full clear
expression"

So is life. The correspondence between the two is a function of

self-image. Only an optimist has a heaven. "Adequate" implies fulfillment to some
degree... how can you be fulfilled and still disillusioned?

Divinity is adequate disillusionment.

Computers are impersonal fellows. The whirr and cycle and hum of contentment

comes from knowing that they are digesting a delicious data base. The data is;however,
a surrogate for truth; hence the disk represents lifelessness. Death is cold and dank.
Dirty comes from not dusting.

Dirty dank cold disk taste.

The concept of equality implies a condition of parity and balance. The essential
consideration; however, is that equality does not mean the same as identicalness. It
implies equivalence on a scale weighted with different significance vectors. We don't
know how to weigh the vectors; and that is what the argument is all about.

There is argument only in equality.

Countries are environments. They have their own sub-sets. Objects are entities and
concepts. We articulate concepts. We fight in environments. Perhaps we should try to
articulate environments and fight in concepts.

Throw the object from one country to another.

Look at the edge. Thats what really counts. It is gray.

Black on one side and white on the other.

The way through is also the way in. You always go from something to something,
capturing a bit of each place you have been through. It includes ideas, places, and
space. You cannot wait to long in any media. You will suffocate. The way through life
is also the way into life.

The way through is the way out.

Destroying mediocraty while sub-optimizing existence.

Competitive elimination.

Are we really big enough to challenge our environment? Cadillacs and expressways
say yes. Starving people and pollution say no. Are we a population of clubfoots?

The foot determines the fit.

There is no doubt that Chamberlain made significant impact on those Rand people with whom he had more than passing contact. Even now, a year after his residence at Rand, there keeps emerging commentary about the artist from various sources there.

A mathematician recently characterized the artist's approach as,

... thinking maybe there was a way of hunching your way through science instinctively or with your emotions without bothering with a bunch of mathematical theorems. Maybe you could get at things through your senses. Some people here with more dogmatic and more formalized backgrounds just didn't want to talk about it For me it was a refreshing and welcome interlude. It was refreshing to talk with him and see a man more oriented to talking with people through impressions, forms and sound rather than graphs, mathematical formulas and so forth. At the same time, his idea of communicating science through art rather than through the written word seems remote even though it was definitely worth discussing and probing. I don't say one day it couldn't be done, but that now it seems remote.

And a computer specialist said,

I think John's visit came to nothing. In general, the interaction was low. He didn't make any effort to meet many people. He installed himself in the office he was using or out on a patio with a tape recorder and let a few anointed come to him. He didn't walk around and just talk to a stranger. And not many people came to him.

People remember his film, but I don't think many dug it. We're too literal to get very far into something like that. Literalness is the nature of science as a discipline.

He'd have been a lot better off if they'd put him in a place with *materials.* We have no materials and no process and few who are willing to talk in McLuhanesque form.

My opinion is that the artist thinks he can create something by turning to technology. He wants the technician along to explain how things work, but then he wants the technician to stand aside. And he wants the scientist only in the role of technician. I guess what happens is, they don't want anybody else's help. They just want you to show them how to turn on the machine.

There wasn't much catalytic effect. It's too bad that something nicer didn't happen by way of people who like art meeting others who like art.

Most of the ideas around here are not all that abstract. We can say pretend such and such is true and let the notion carry us where it will. But wondering why a guy would crush auto bodies and call it sculpture is a different game. Abstract the way the scientist means it is perhaps a different world from the one we live in, but nonetheless a well-defined world. I don't really know what the artist is doing. Maybe pleasing himself.

Chamberlain's final Rand Piece consists of statements suggested to him from various sources (few of his "answers" are entirely original, and many can be recognized as, for example, McLuhanese in altered form), but the statements seldom came to him directly from Rand personnel in the course of his questionnairing process. John hoped that either Rand or the Museum would publish the Rand Piece in a relatively large edition, but neither institution had the means to do this. At the time of this writing, the work is still unpublished, except for its inclusion here.

The following are eight excerpts from the work, which is thirty-four pages long, divided into two sections. The first part, called "WHAT ARE THE CIRCUMSTANCES TO THESE RESPONSES," consists of answers; part two, "WHAT IS THE RESPONSE TO THESE CIRCUM- STANCES," consists of questions. It is prefaced by this statement by Chamberlain: "The Rand piece is constructed to be used by anyone or groups as far as the imagination or curiosity can carry it. All possibilities are considered to be valid at least by me." [7-14]

7

Baby dumpling

You can find out who your friends are by seeing how they take it.

Coal-black habit; empty creature.

Fairly Kosher.

His trouble could be yours or mine.

It's important that everyone cheat.

8

Once the problem is posed, it is insoluble.

Go to Atlanta and make a right turn.

For the size of his attitude, he has quite a stance.

A hot Danish process.

The hinge that holds them together is as real as the line that divides them.

Freedom to breed will ruin the egg.

9

A box of fat.

Purple, pink and oblivious.

Fifteen carpeted steps.

All legs and no backbone.

The ULTRA naked astronaut.

Cold grey honey.

10

Anguish, remorse and woe.

They're always doing something Chinese to it.

Between the sheets.

By jiggling your horoscope.

Black is the color—none is the number.

It was inserted in the wrong end.

11

Which quantity is purifiable?

When was congruency established?

Is arbitration possible under these conditions?

What are the shades of waiting?

What will keep the dancers clean?

Who is responsible for the preservation of rhetoric?

12

Where is love's mansion?

Where does the progression initiate?

Is this the time of the assassins?

How did you get past the union authorities?

When was the siege accomplished?

Have you committed to memory the paradigms of concern?

13

Which works do you seek of the ones you serve?

Is it endlessly extended?

What will the song be like?

Is eleven enough?

How many pictures are concealed in this rabbit?

Why don't you do what you're watching?

14

How is it wise to leave and enter at the same port?

What is the dialogue of conduct?

Which map describes the territory?

In what way is continuity related to direction?

Which performances are protected by their ambience?

What are the underlying sentiments of contrivance?

Jane Livingston

Christo
Born Gabrovo, Bulgaria, 1935
Resident New York City

Ron Cooper
Born New York City, 1943
Resident Venice, California

In November, 1968, Christo wrote to us:
 I am very anxious to have a 5600 cubic meter package erected in the United States and my friend Bill Copley suggested that I interest you in this project.

 I also send you two photographs of another project: 15 miles packed coast that could be realized simultaneously with the erection of the air package.

These two gigantic projects should be presented by the Los Angeles County Museum as an exhibition where the Museum's activities go beyond the usual Museum space.

Los Angeles artist Ron Cooper came to us in October, 1970 to discuss two proposals for environmental art works. Cooper, consulting with various experts on his own, had satisfied himself that the projects as he conceived them would work technically, but needed financial and technical assistance.

One work involved projecting variously colored light from several points around the perimeter of a room so that the respective shafts would converge in the center, forming a white, cube-shaped configuration [1]; the second proposal entailed projecting colored light into a reflective pan of water on the floor, so as to direct mixed light beams from the water surface onto a wall, filling a rectangular area with white light. [2]

We were intrigued with the ideas as he presented them to us, and it happened that G.E., whose previous collaboration with Dan Flavin had ended unfulfilled, was still potentially available and willing to take on another artist. We therefore sent Cooper to G.E.'s Nela Park Advanced Lighting Division, where he presented his projects and consulted chiefly with lighting engineer Terry McGowan. Later, G.E. indicated that, although they were technically able to realize one or both art works, they would or could not expend sufficient funds to bring it to completion.

1

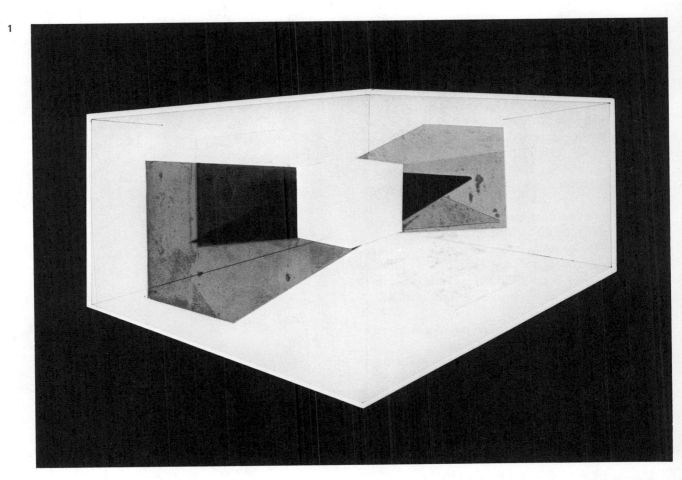

2

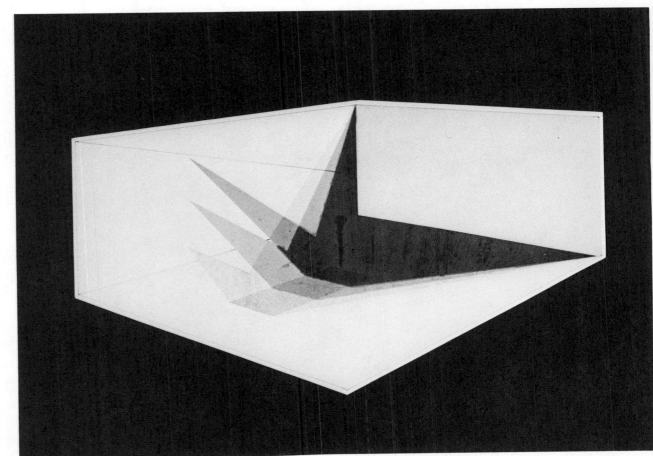

François Dallegret
Born Morocco, 1937
Resident Montreal

In January, 1969, while François Dallegret was visiting the Los Angeles area, we invited him to tour several corporations. Hal Glicksman accompanied the artist to Ampex Corporation where they met with Dr. Charles Spitzer and saw various laboratories in the Advanced Technology Department. Dallegret was anxious to work on a relatively large scale using electronic transducing devices to react to external stimuli. Ampex could not handle a project in the scale Dallegret outlined. Next he and HG saw Kaiser Steel, which Dallegret found exciting, because of the obvious potential for giant scale works.

In early February he submitted his proposal:
> The idea will consist of setting (in as many different ways as possible) in, on and out of the Museum, through the plazas and parks around, a series of hard collapsible 'skins' in tension out of fixed but mobile containers, to define directions, areas and volumes . . . and surprises.

And later in March, he elaborated on this idea in another note accompanied by a series of drawings:
> You will find enclosed three sketches—very quick visualizations of the way I may use metal 'rigid/flexible' . . . The structure being hinged and the skin rolled. The final concept should come from the result of decisions in the analysis of the fabricator and myself and yourself. To face the site and its people to come to a right 'dimension' of the 'thing.'

In July, Dallegret wrote saying that two steel manufacturers in New York were interested in his proposals; he wanted to work with one or both of them under the A & T program. This did not prove feasible.

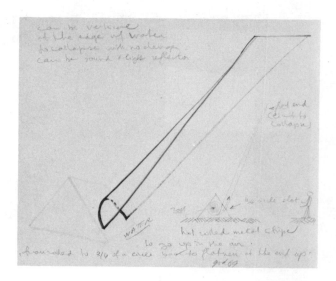

Channna Davis
Born Los Angeles, 1932
Resident Tarzana, California

Late in 1968, Channa Davis presented a proposal entitled
Suspension of Vertical Beams Moving in Space, which
would employ time and light in choreographed movements
based on a modular grid system. The piece would consist of
eight cylindrical beams made of clear plexiglass, with pro-
grammed movements in each. The beams were to be suspen-
ded by magnetism or jets of air.

Movement: In a vertical direction one foot for every
move and each foot of movement takes twelve seconds.
Beam then remains in that position for a minimum of
three seconds and a maximum of sixteen seconds.

Light: Illusion of light beam pushing the beam up from
lower position, suspending the beam in middle position
and pushing the beam down from the highest.

5 intensities of light—5 movements to beam except at
completion of cycle.

4 lights for each beam—1 sputter and 1 high intensity
above and below.

#5 brightest light—#1 weakest light.

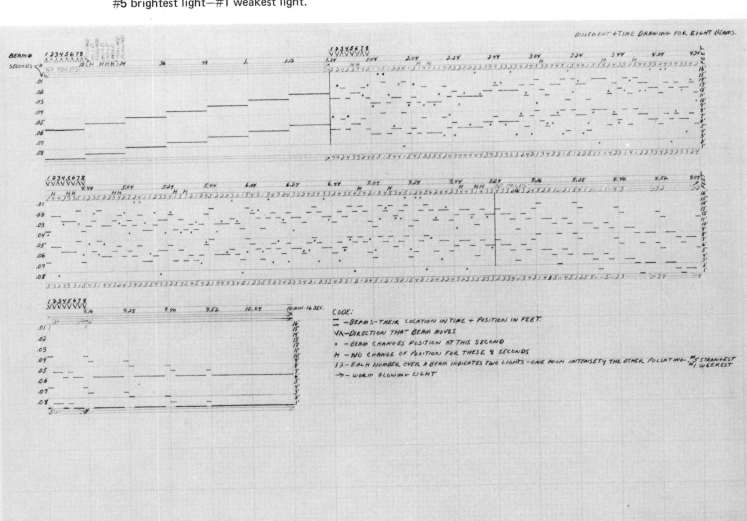

Ron Davis
Born Santa Monica, California, 1937
Resident Los Angeles

Walter De Maria
Born Albany, California, 1935
Resident New York City

Ron Davis originally spoke with Hal Glicksman in the Spring of 1969 about doing a project for A & T. Davis was intrigued with the possibility of using computers to assist him in plotting complicated geometric figures, of the kind he has used for several years in his resin paintings. Largely because of Davis' interest in this project, we spent considerable time and effort negotiating with California Computer Products, Inc., in an attempt to solicit their participation. (Cal Comp had been visited in early April by Eduardo Paolozzi.) In May, HG arranged for the corporation to make for the artist a sample computer drawing of a complex geometric shape, identical to a configuration used in one of the artist's recent works, showing it in various positions, which demonstrated the principle Davis could employ in using computers himself. We were optimistic about consummating an agreement, but the corporation was reluctant to commit the extent of computer and programming time necessary for the artist's needs. In July, Davis visited the corporation's Anaheim facility and saw several demonstrations of computer graphic output. About a month after that meeting, when Cal Comp had still not signed a contract with us, we asked Jeff Raskin to consult with Davis and the Cal Comp people about the project. Raskin visited the company with the artist, and suggested that they make available to Davis a console which he could operate from his own studio. This suggestion was apparently not regarded as feasible by the corporation, and finally they indicated to us their decision to decline any commitment.

In July, 1969, when Larry Bell's work at the Rand Corporation terminated unsuccessfully, Rand agreed to take on another artist. We invited Walter de Maria, among others, to submit some ideas for a project at this think tank, but he declined on the basis of other commitments. We saw him later in the Fall, mentioned several other A & T companies still available and asked if he had any further interest in developing a project proposal. His response was positive; specifically he wanted to see RCA. Thus far in the program three artists—Andy Warhol, James Rosenquist and Sam Francis—had toured RCA's Van Nuys electronic and computer division but no match had evolved; in addition we

1

had presented the company fully outlined proposals by Victor Vasarely, Glenn McKay, and Boyd Mefferd, none of which were acceptable to RCA management.

We arranged for de Maria to tour the Van Nuys facility. After this initial visit, de Maria embarked on an intense period of preliminary cerebral activity, attempting to formulate his idea. He reported on December 1, that before submitting the proposal to the Museum or to RCA for approval, he wished to visit the facility on several more occasions to gather additional information. Following these subsequent visits, he sent us two proposals, written with felt-tip pen on paste board. [1] Accompanying these proposals

3.

THE PROJECT.

FOR LOS ANGELES COUNTY MUSEUM OF ART 1970/71
ART AND TECHNOLOGY ... ART AND INDUSTRY

TO WORK WITH R.C.A. — Computers
TO CREATE A WORK OF ART

PROPOSAL I

SCULPTURE SITUATION —
5 PARTS —
COMPUTER
DIRT RECTANGLE 21 FT. x 12 FT. · 6 IN.
WORD CHINA — IN THE DIRT
COMPUTER TERMINAL ON STAND
SHOWING NO INFORMATION IN COMPUTER

SITUATION TO BE SEEN IN TRADITIONAL WAY.
ROPE TO BE PLACED IN FRONT OF SCULPTURE —
NO USE OR INVOLVEMENT WITH TERMINAL —

Total Visual Situation / Sculpture —

CHoice is MADE NOT to use computer, just

THE 4 elements of the Sculpture are seen.
Computer, Dirt, word, Terminal
No explicit connection between the computer, or word
or the Dirt.

A powerful formal situation which EXISTS.

5)

Proposal II (cont.)

CHINA 1,000 / Love / Death

SHOULD BE MADE SO THAT
IT WOULD HAVE A LIFE
BEYOND THE L.A. COMMUSEUM SHOW.
Institution or
MUSEUMS — WHICH COULD BUY A
BED (DPLATFORM / TERMINAL) SHOULD
BE ABLE TO TIE INTO A LINE
AND USE THE SITUATION AT ALL
TIMES.

DiVLaps — lease Arrangements,
could be desired. —

COST

PROGRAMMER — TO BE HIRED for one year
TO catalog THE poems
AND tie to their insertion

($10,000 — 15,000)

CHinese Literature advisor — Academic Specialist to
Be retained to advise
or the literature. ($5,000)

Computer — COST OR EACH platform —
avg. etc. ($2,000. ea.)
Series of 5 to be built as
prototype. — ($10,000)

TOTAL COST — ABOUT $28,000 plus computer lease time. —) ABOUT $50,000
plus cost of Terminals

Return of Cost

4 versions of this multiple —
could be leased or sold
throughout the world

with Artist — R.C.A. —
ACTING AS partners in
return. —

estimated Return — (first year)
5 platform sculptures
sold at 15,000 each $75,000
—30,000
—$100,000

4)

PROPOSAL II CHINA 1,000 : Love / DEATH

NON - MUSEUM SITUATION
private - quiet situation —

A computer is filled with 1,000 years
of Chinese poetry — on subjects LOVE AND DEATH.

A cataloging of thousands of Books —

THE viewer would be Able to choose the
category — (Love or Death) THEN a year
18) LOVE 1350
or DEATH 1735

A poem from that year would THEN
read out across THE Terminal.

Setting : THE TERMINAL is set upon
A special wooden platform —
on the platform is a rug,
several cushions + pillows —
AND a small vase with flowers —
a vase
THE viewer can THEN recline — AND
in silence — read a number of
poems. —

6)

Summary. : Results of Study NOV + DEC. 1969 —
Visits TO R.C.A. Van Nuys.

PROJECT I SEEMS best
suited TO MUSEUM SITUATION. —

NO COST TO R.C.A. — other than
use of the computer + terminal
AS Formal elements in the
environmental sculpture. —

THE CHoice NOT to use TECHNOLOGY
at certain times may be as
important as using it.

(It's presence is always implied.)

PROJECT II

A personal use of computer
And Terminal ____ but
unfortunately not suited to a
museum situation where
thousands in a day may pass through —

But A project I would very much like
TO DISCUSS/ AND determine if it is
possible to realize.

Thank you.
Walter De Maria
Dec. 1969
P.O. Box 858 N.Y. 13 N.Y. 10013

were six typewritten pages of speculation on A & T, notes on his ideas, cost estimates, etc. [2]

We sent copies of de Maria's proposal to West Coast and East Coast management and the following letter from MT, dated January 2, to Mr. Julius Haber, assistant to Dr. Sarnoff:

> Recently we brought an exceptionally gifted and provocative artist, Walter de Maria, to Los Angeles to tour the RCA facilities here. As you probably know, since our last communications regarding Boyd Mefferd, we have considered several possible candidates for RCA in the Art and Technology program. None of the artists seemed to be right for you or us. Mr. de Maria, however, has now come up with a very ambitious and far-reaching program. He was inspired to draft the enclosed project proposals after two visits to RCA here. There are two proposals—a 'private' and a 'public' one. As you will see, they are unusual approaches to the Art and Technology project, but could be of special significance.
>
> I am writing you about it, because Mr. de Maria is back in New York, and I suggest that you, and hopefully Dr. Sarnoff, could see this artist to discuss the plan.

During the next three months, in several follow-up conversations, Haber explained that the decision was being delayed because he had been unable to present the proposal to the president. He intimated, however, that despite Dr. Sarnoff's decision, there was very little interest or enthusiasm about de Maria's ideas among the RCA staff; indeed, his own attitude was one of wry skepticism. Finally, in late April, we received word that RCA would not execute the project. No further artist/RCA match was attempted.

Art and the 20th Century

Art and Technology ... Art and Industry

**

Movies, Radio, Phonograph Records, T.V., Video Tape.
The Automobile, Airplane,
The Camera Photograph, Magazine, Book.

**

There has been a marriage between the new technology and art throughout the century.

 Theater + Photo technology = Movies
 Music + Sound technology = Records

The question then seems to be where do the FINE ARTS...painting and sculpture...meet with the new technology.

 The sculptors have in the sixties been meeting this question
 head on. The use of the new materials stainless steel,
 plastic, fiberglass, lasers, and other light sources...has
 already shown that the artists are alive.

The question seems to be not whether artists can use the new technology ...for that question has long since been answered, rather the question here seems to be the relationship between the artist and INDUSTRY.

The Artist and Industry

Industry ... The Industrial Society.

 A system where energy (money = stored energy)
 money, technical knowledge and work energy are
 joined to produce in quantity the essential
 things necessary for people. Food. Shelter.
 Survival.

Statement: The products of the Industry or even the tools of
 the Industry, can be, and often are beautiful in
 themselves.

 It is not necessary for an "artist" to modify
 them in any way in order to make them into "art".

Tools, example: A laser beam. When this device is set up and
 used it is simply beautiful.
 A Motor is beautiful in itself.
 An oscilliscope.

 etc.

THE PROJECT

 TO WORK WITH THE ENTITY R.C.A. RADIO CORPORATION OF AMERICA

 TO USE THE COMPUTER AND COMPUTER TERMINAL PRODUCED BY R.C.A.

 TO USE THIS TECHNOLOGY...AND MAKE A "WORK OF ART."

THE PROPOSAL/WORK / China 200 ... 1776-1976 China Mind

 The history of China since 1776 to the present, and then for the
 next six years, shall be processed and inserted into an R.C.A.
 computer.

 At the exhibition to be held at the Los Angeles County Museum of
 Art an R.C.A. computer terminal shall be set up with a trained
 person in attendance, so that the visitors to the exhibition shall
 be able to "ask the computer" questions about the history of China.

 The question will then be put through the terminal and the visitor
 shall see the answer "read out."

Cost and Financing and Return

The China 200 project is designed to cover a six year involvement. It differs from other projects submitted to the Art and Technology program in several facets.

 I. The situation/sculpture/project shall have a long life. It is
 not done in a three month period, with just the idea that a
 work will be done for the purpose of the Los Angeles Show only.

 II. The ideas and Facts constitute the body of the work, as much as
 the physical nature of the work.

 First: The Idea of the Whole Project Itself
 Secondly: The Facts stored by the Computer.

Because the project is set up to cover a six year period the work should be in an active state during this entire six year period.

 The artist proposes that the attitude in which the industry
 R.C.A. and the artist enter into the working arrangement, is
 of prime importance.

It is hereby proposed that the Artist serve as a consultant/supervisor to the project during its entire six year term.

Secondly that the Artist and the Industry consider themselves partners of equal rank during the entire period.

Moreover, the project should be considered an economic venture. And not a charitable act on the part of the Industry.

It is hereby proposed that the Los Angeles Museum be allowed to use the computers free of charge and that the next two Museums to which the exhibition travels also be allowed to use the computers free of charge, but that subsequently to that whenever the CHINA 200 sculpture is exhibited a leasing fee shall be charged to the exhibitor.

THE CHINA 200 sculpture shall be considered a joint partnership project between the artist Walter de Maria and R.C.A.

As the Artist is often called upon to participate in group shows in various Museums, he will then, through his dealer representative be able to lease the work of art. Thus the Industrial concept of providing a service to society and retaining a just reward for that service will be added to the esthetic nature of the work/sculpture/situation which is inherently in the China 200 project, by virtue of the fact that it has been created by the Artist.

Moreover: The Artist will be able to initiate, through his dealer, the sale and lease of the China 200 to individual art collectors.

This revenue ... sale and lease will then be shared on a 50/50 basis between the Artist and R.C.A. corporation.

At the termination of the project (January 1976)

I. All rights to the China 200 project can be sold the monies then being divided on an equal basis between the company and the Artist

or

II. A decision can be made between the company and the Artist to work on an improved project:

CHINA 224

China 224 will continue the operation of China 200 but will continue the storage of information/and the sale lease arrangements through to the year 2000.

In June, 1969 Mark di Suvero arrived to tour several corporations we had previously described to him. Hal Glicksman took him to International Chemical and Nuclear, a most unlikely place for an artist working in monumental steel and wood sculptures, but di Suvero had conceived of an incredible scheme to solve "the problem of helium fusion" and a fantastic proposal for constructing a floating city on the ocean. Hal later recalled this visit: "We did this funny little dance, going across the white line from the dirty side to the clean side of the radiation laboratory, putting on paper slippers and smocks. After going through the labs there really wasn't much to see." ICN's manager who conducted the tour and chatted with HG and di Suvero, was apparently startled by the artist's untidy appearance and flamboyant notions, and the interview was short.

Di Suvero then toured Kaiser Steel Corporation in Fontana. He was enthralled with the rolling mills and fabrication plant with its enormous yards stocked with cranes and massive steel-forming machinery. His enthusiasm, as well as a description of his project proposal, are communicated in the following letter to Kaiser after his return to Chicago some weeks later:

After visiting your giant complex in Fontana, I have been filled by the extraordinary possibilities which exist in modern steel sculpture through your participation in the L.A. County Museum's Art and Technology project.

I have spent nine years (of my dozen plus years as a sculptor) working steel and I feel that I could learn vastly and could continue my structural explorations (within the concept of constructivism) by working at your plant.

In a recent piece of sculpture I deformed a WF beam 30° cold and found that it returned to its original position when the pressure was relieved. [1] I am interested in exploring the limits of 'memory' in steel (especially the corrosion resistant high tension steels).

1

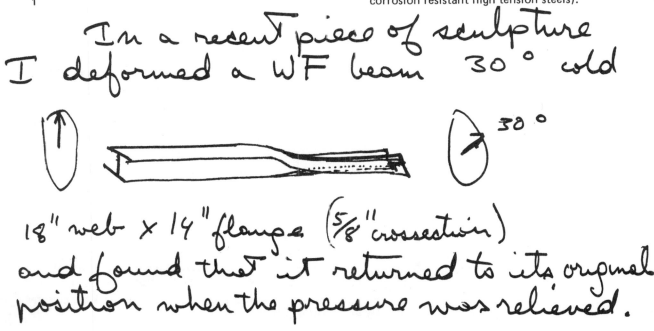

In a recent piece of sculpture I deformed a WF beam 30° cold

30°

18" web × 14" flange (5/8" crossection) and found that it returned to its original position when the pressure was relieved.

Since your opportunity for multi-sculptural experimentation is so great, I would like to share my project with two other artists: Voulkos and Serra. I would like to work six weeks on my own projects and then invite Voulkos and Serra to Fontana, so that the art would not only have a dialogue with technology but so that there should be an artist to artist intercourse in the middle of technological possibilities. For every artist, art comes from other artists: it is our work to reshape thought and form which result in (God willing) new exploration.

The extraordinary possibilities could only exist if there were an unlimited supply of steel (say up to 1,000 tons) and a working crew of four to eight men. I imagine that the major part of the work would take place in the fabricating division, but I would like to leave open the possibilities of exploring new forms in the rolling mills and casting processes.

I am very excited at the possibilities. I hope that, as a result of our mutual cooperation, I may be of service to you in suggesting new processes/new forms.

P.S. If I am accepted, I would like to have the written approval of Edgar Kaiser.

Meanwhile Richard Serra had submitted a proposal for work at Kaiser (independent of di Suvero's request) which we and the company accepted.

Our experience with Dubuffet and American Cement began with visits to the French artist in his Paris studio, first by Irena Shapira and then by M.T. Dubuffet expressed interest in the program, and eventually submitted a plan for the construction of a twenty-six foot high tower in concrete. This was related to the series of sculptures called *Tour aux Figures* which he had been developing in limited scale over the past three years, but the tower was to be a full-size architectural monument, containing complicated interior passageways. For American Cement this represented a major undertaking, but the company became eager to work with Dubuffet after two executives flew to Paris for three days of discussion with the artist. Their top research engineer in concrete construction, Dr. Samuel Aroni, saw Dubuffet, and came to regard the technical problems posed by the artist's proposals as pertinent and challenging to the company—and as a vehicle for affirming the viability and professional excellence of American Cement's research-oriented Technical Center in Riverside, California. Jay Rowen, Public Relations officer who accompanied Aroni, was similarly enthusiastic. And President James Giles, more than almost any other company president in A & T, was personally committed to the plan. Dubuffet tentatively agreed to come to California for two months and return later as necessary. The following account by Dr. Aroni explains what happened.

**Size and Culture
—an Attempt that Failed**

Sitting here, surrounded by my diaries, notes, letters, books, etc., I am attempting to describe a failure; our failure to work with Dubuffet, to build one of his unique edifices. And yet, for me, the experience was rewarding in many ways. It opened a window, an insight, into the work and life of a great artist. It also reinforced a belief that the difference between art and technology is not as great as some would have us believe.

Why did we not succeed? On the surface, the answer is very simple. We were prepared to build an edifice twenty-seven feet in height, a monument without an accessible interior. We wanted to work at our American Cement Technical Center at Riverside; the edifice had thus to be transportable. Our budget was sufficient for this job, but still finite. Dubuffet wanted to see a much larger structure built, at least twice the height and possibly with an interior. He envisaged it as a permanent edifice, not subject to transportation limitations, large and important enough to justify his coming to California. As an alternative, he desired to see the development of a "device" to work from a small model, enlarge it, say ten to twenty times, and construct a full scale structure. Our objectives did not agree, and the project did not materialize. But the story does not end here. Influencing it to an unknown degree were cultural differences.

The internal strife in the American Cement Corporation (ACC), with all its subsequent events, is now a matter of public knowledge. This was emerging at the beginning of 1969. However, as it happened, Dubuffet abandoned the project before it could have been affected by these problems. Why did ACC participate in the first place? Beyond the obvious public relations and publicity values, my knowledge on this question is incomplete. However, I witnessed and experienced great enthusiasm on the part of James P. Giles, at that time President of ACC, and on the part of our Technical Center staff. Dr. G.J.C. Frohnsdorff, at the time Manager of R. & D., Dr. K.E. Daugherty, Research Chemist, Senior R. & D. Staff, and myself, who were more intimately involved, and everyone else on the research staff, felt a sense of excitement and expectation. We had been busy in exploratory research, basic and applied, with the objective of developing a better understanding of a wide range of materials, organic and inorganic, in order to develop new and improved products. We had developed an environment where ideas could flourish, and where the interaction with a creative man of Dubuffet's stature was regarded as a most welcome stimulus. Our sincere hope was that this experience would also be stimulating and rewarding to Dubuffet.

Though the initial contacts between the Museum and ACC were probably made in February or March 1968, and the contract signed the end of May, the first I learned of Dubuffet was the beginning of October, 1968. I remember being shown the book on *Dubuffet Edifices,* * and examining the *Tour aux Figures,* an eighty foot tower with a designed interior [1]. There were strong and diverse reactions among my colleagues at ACC to Dubuffet's work. My first impressions, which were reinforced by later experiences, related to the great care for detail in the descriptions of the text, and the difficulties, from a structural point of view, of designing, analyzing, and faithfully reproducing such a complex monument.

1

*Published for the Museum of Modern Art, New York, 1968.

Six weeks passed between this first encounter and our visit to Paris. During this period, I met Maurice Tuchman and Irena Shapira. Also, we learned more of Dubuffet's thinking from his letters. He was concerned about the problem of magnification from a small model, as he noted in a letter to Frohnsdorff on October 26, 1968:

The main question for me remains the finding of a practical method for rapidly and easily enlarging any subject, to the extent, if possible, of ten times or twenty times.

Consider a *comb* in which the teeth are movable and able to slide vertically in the horizontal bar perpendicular to them. The teeth are graduated. If the comb is applied to a relief surface, the depth can be read (and written down if the teeth are immobilized while their positions are recorded).

Then consider a gadget which resembles not only a comb but a *brush* (that is to say provided with numerous rows of teeth). These teeth being similarly mobile and similarly graduated and similarly capable of being immobilized while their positions are noted.

Finally, a similar brush-like gadget but ten times as large (and the graduations on the teeth being ten times larger).

It only remains to find a means so that the teeth of the large brush can be fixed in the same positions (at the same graduation marks) as the teeth in the small brush. We ought to be able to find an electronic process for this without very great difficulty.

In the past, Dubuffet has used a pentograph to obtain magnifications of up to three times. The question of a device to "rapidly and easily enlarge any subject" appeared constantly during our negotiations. To undertake the development of such an automated device, as our main project, seemed to me to be a hazardous attempt. I foresaw no undue problems, using various techniques on an ad hoc basis, to construct an edifice from a small model, during which we could develop some ideas and experience towards the automated device. Nevertheless, we spent much time, both before and after the visit to Paris, thinking about various ways that the device could be achieved. Our wild ideas ranged from electronics to optics, and from mechanical means to holography. Dubuffet, in a letter to Maurice Tuchman on October 28, also wrote of the need for proper colors:

I would like to point out (so that you may let American Cement know) that all of my projected monuments and structures are multi-colored; this is true whether they are to be made in concrete or in epoxy resin or other materials.

Very bright clear colors are needed so as to give an appearance of glazed pottery (it is necessary to avoid techniques which give dull or chalky colors which are not clear). The particular need is for a fine bright very

startling red; also a fine snow white; and a powerful black.

Of course, it is necessary for the colors to be perfectly resistant to ultraviolet radiation, and they should not be at all altered by the sun since they must be stable for fifty years.

I expect to use polyurethane paints; I believe they will fulfill these conditions.

I have heard that American Cement makes colored cements; but I am worried that these colors mixed with cement would be a little dull and chalky.

In the meantime, I had a very useful meeting with Mr. John Hench, of the WED Enterprises. Their experience at Disneyland and elsewhere confirmed my estimates for the construction of the *Tour aux Figures,* at least eighteen months work and $2 million, well outside our constraints. However, in his letters Dubuffet exhibited flexibility. He wrote to Frohnsdorff on October 14,

I already have several models of monuments and structures which are available and ready to be produced. Some of these could be produced in concrete but others will have to be considered for possible production in epoxy resin or for certain parts to be of concrete and others of epoxy

On November 16, 1968, Jay Rowen and I flew to Paris. Our mission was to negotiate and finalize the subject of our cooperative work. When we walked from our hotel to Dubuffet's home, on Sunday morning, it was cold and it started to snow. However, the warm and friendly reception more than made up for the weather. We met Dubuffet together with Girard Singer, an artist who worked with Dubuffet in the production of some PVC colored replicas using a technique similar to the making of relief maps, and who was supposed to join Dubuffet on his California trip, and also Antoine Butor, the young architect. [1] They were prepared for business: a translated list of key words, writing pads, pencils, and lots of questions. Is ACC also a construction company? Do you deal with plastics? Who is going to pay for the execution? How much will *Tour aux Figures* cost? Our answer of over $2 million did not surprise Dubuffet, who agreed that it was obviously too much to expect. We told him about ACC, and showed him various things that we brought with us, some synthetic colored aggregates that we were developing, a piece of white limestone from the Crestmore deposit. In our excitement, the tea that Mrs. Dubuffet prepared got cold before we settled down to it. One encouraging aspect of our discussions was Dubuffet's agreement on the difficulty of having to transport the structure. He commented, "We obviously could not make it very large," but also said, "What could I do in the U.S.A. that I cannot do here?" The second question surfaced many times in later discussions and correspondence.

Before lunch we visited his studio, a large, two story house, with some six rooms and a small courtyard, one of a number of studios that Dubuffet uses in Paris. Dubuffet's studio is the essence of good organization and planning. Each model is labeled (date, name, etc.), photographed, and recorded: "Art is like planning a war," was Dubuffet's reply to my comments. Dubuffet's method of work consists of cutting the original from a polystyrene mass, using a hot wire tool. A mold is made next by applying silicone elastomer and plaster. Finally a fiberglass epoxy model is produced and painted with polyurethane paint.

At lunch, Dubuffet expressed interest in seeing Disneyland. He said that New York City exhibited "architecture built to terrify people," and it became evident that Dubuffet was not just producing sculptures, but architecture. To affect

2

the physical and visual environment, some "mass-production" was vital, he felt. To "design," by sculpturing a model, rather than drawing, was an appropriate means to do this. But, the question was how to reproduce and enlarge. And how to design and analyze structurally. I described to him the use of models for structural analysis, how we can load them and measure strains with special equipment, and reach conclusions relevant to the full-scale prototype. (Apparently some French engineers had expressed doubts about building the *Tour aux Figures.*) A discussion of the non-linearity of stresses with size followed. The technique of shotcreting was discussed, and Dubuffet told us excitedly about the structures at the Paris Zoo, "Their only mistake was having regular interiors!"

And so, we all went to the zoo. [2, left to right: Dubuffet, Aroni, Girard Singer and wife] It stopped snowing, but the

fresh fall covered everything, including the thirty-year old thin concrete structures. [3] Dubuffet had made his point: if these structures could have been built so long ago, why not his edifices today? My feet got wetter by the minute. "This is a disaster for Californian shoes," declared Dubuffet. On our return to his home, he offered me a pair of his shoes as a substitute. The fit was good, but I was too embarrassed to accept.

Returning to the hotel that evening, Jay and I felt very happy with this first day of our encounter. We had established a good relationship. We genuinely liked Dubuffet and Singer, and we felt that they liked us. So far though, we had not yet negotiated.

Next day Dubuffet took us to see his enlarged version of *Tour aux Figures,* a ten foot epoxy construction. Later that day, we saw the shop where the pentograph enlargements and the casting of the epoxy models were executed. That evening our real negotiations began. Dubuffet and Singer, Jay and I, focused on the important question of what should be built. I emphasized the advantage of building something smaller first, before a truly automated reproduction and enlargement technique would be developed. We were eager to build something reasonable in size, with the experience gained being a valuable stepping stone. I suggested first that we just build one of the walls, as a free standing thirty foot monument, but Dubuffet was not happy. We were looking through the *Dubuffet Edifices* publication and Dubuffet suggested the *Tour de Chantourne.* The description of it in the book states in part,

> The tower could also be conceived more modestly as a small hollow monument, eight meters high, whose base of four square meters could in this case be built in concrete or resinous epoxy, having only one very small

door through which one could enter, but without any interior arrangement other than the necessary reinforcing elements. [4]

We accepted this compromise of building a twenty-seven foot monument, without an interior. I could see ways of making it in parts and transportable. We were all pleased with the result. It was agreed to meet again next morning, at his studio, together with an interpreter so that many procedural and working details could be decided. We shook hands, and Dubuffet suggested that we celebrate that evening.

The detailed discussions that took place next morning are worth reporting, if only to demonstrate Dubuffet's concern for organization and details, as well as the firmness of our mutual desire to proceed with the job. An American art student in Paris did the interpreting. Though Dubuffet speaks good English, and I speak some French, he wanted to avoid any misunderstandings. The question and answer session followed. Where will if finally be located (after the Museum exhibition)? We were not sure. How much will it cost? Probably $75-100 thousand. Who would own it? ACC will probably donate it to the Museum. Could we have two models to start the detailed preparations, one painted and one only with the black lines?** Yes, he will make the necessary arrangements. The original was going to be exhibited at the Musée des Arts Decoratifs in about three weeks. He will try to make the models within this period; painting might take an additional month. When will he come to California? Probably twice, first about February 15, 1968,

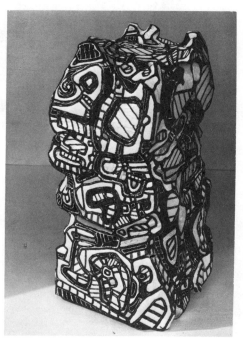

4

**At that stage, I thought of building it in panels to be assembled later. The black lines would have served as appropriate locations of joints. A different concept was developed later.

and stay as long as possible. In the meantime, we will develop the techniques of reproduction and construction; maybe experiment on arbitrary segments. We will need true polyurethane paints. We will use white cement. We promised to make and send him some samples to test the colors. How long after casting can we paint? He was worried about changes of color with moisture. Should we paint it at all or use pigments? How should we paint it? Will a gun cause overspray? Should the white parts be painted for protection purposes? Will the Museum send the exhibit to Japan? Might it rain there? It would be interesting to have it exhibited, at the Museum, on a turning platform. We examined the model of *Tour de Chantourne* carefully and took many slides. It had five vivid colors: red, black, dark blue, and light blue, in addition to white. In typical fashion the model had a small inscription: "Tour II (projet de Tour à 8 m. pour la Faculté des Sciences) No. 65, 25 Juillét 1967."

Dubuffet was flexible as far as making changes for the construction, such as straightening some slopes at the lower part of the tower, and simplifying the roof. The morning passed quickly, and it seemed that our mission in Paris was almost completed. Next day, on Wednesday, I only spoke to Dubuffet on the telephone. He wanted to know if our decision to build *Tour de Chantourne* could be mentioned in the printed material being prepared for the exhibition of Monumented Paintings at Galerie Jeanne Bucher in December.

Returning home, Jay wrote to Dubuffet on November 26 that,

> We have been in touch with Mr. Tuchman and Mrs. Shapira at the Museum, and with my company's President, Mr. Giles. They are all enthusiastic at the prospect of building the *Tour de Chantourne*. Sam and I will be making a formal presentation of the project within the next few weeks and we will have final approval shortly thereafter.

The presentation to the top management of ACC took place on December 6, 1968, with Maurice Tuchman and Irena Shapira present. We described our experience in Paris, and Maurice spoke of the overall project, and of Dubuffet as an artist. Jim Giles was very enthusiastic, and no real opposition was expressed by any of those present. I had now a budget and a job to do.

My work towards construction involved too many aspects and too many people to mention them all. It was significant, however, how catalytic the project proved in obtaining help and advice from many quarters. John Hench, of WED Enterprises, was very helpful in providing the accumulated experience of Disneyland in the construction of unusual structures. They were going to make some plaster models for us, from the original, to be sliced both horizontally and vertically and serve as additional tools in the reproduction work. Also, through their help, I found Frank White, an experienced lather, to serve as the backbone of a team of people that we prepared to be ready for the actual construction. The preparations went so far as preparing lists of required materials, and clearing the work through the union channels. I visited the Twentieth-Century Fox Film Corporation Studios, and Ivan C. Martin, their Superintendent of Construction, and others were most helpful with suggestions and ideas. Initially we were going to use shotcreting. The Koll Construction Company was building the huge log ride at Knotts Berry Farm, and we investigated their experience. J. A. Moore, of the California Gunite Company, was interested in helping and maybe doing the shotcrete work. He introduced me to the Paramount Pictures Company people, who had some proposals on a process of reproduction using precast plaster forms. Finally, I decided that for our purposes hand plastering was more suitable than shotcreting. The construction concept that emerged involved dividing the structure into four self-contained parts, each about seven feet in height, by means of suitable horizontal cuts. The interior would be made of steel frames, which would be erected on top of each other. Lath, wires, and rods would be welded around each frame and shaped to the model requirements. The procedure of shape reproduction would use a special reference frame with a number of pointers, moving both vertically and horizontally, to enable the location of any required point. A scaled version of the frame would take "readings" from the model. Finally, hand plastering the painting would finish each segment. The size of the segments was still amenable for transportation and their erection, though requiring care and planning, was not seen as a difficult task.

During our preparations, I kept Dubuffet informed of the progress. We sent him some pictures of the Disneyland Matterhorn (12/16/68), and samples of white cement with various additives (for example TiO_2 pigment) to increase its brightness (1/3/69). Ken Daugherty performed tests of various paint systems, and evaluated their performance up to two months of exposure to the environment. It is very significant to note that our work on trying to increase the brightness of white cement, led to the discovery of an additive which not only significantly increased the brightness but also the strength of the material. This is at least one tangible dividend left with ACC from the "Art and Technology" project. On December 9, 1968, I wrote to Dubuffet,

> I hope this week to try out the gunite technique on an irregular shaped surface. We will also start to design the interior steel structure and to initiate its construction. To finalize some dimensions, it would be necessary to have the unpainted model, and I would be pleased if you could send it to us as soon as possible. I will keep you fully informed of our progress.

His secretary replied on December 14:

> Immediately after your departure, Jean Dubuffet made the necessary arrangements to reproduce the model of

the *Tour de Chantourne.* We hope to send you the un-painted model on January 15, 1969.

The model never arrived. In its place, black clouds started gathering over the project. On December 22, 1968, Dubuffet wrote to me,

It was agreed during your visit to Paris that after your return to Los Angeles, you will consider the construction of the *Tour de Chantourne* to a height of fifteen meters (fifty feet) and will confirm it in writing. I wonder why I have not received any confirmation. Has your management considered this project and are they prepared to approve it?

I persist to regret that we excluded the construction of *Tour aux Figures* to a height of twenty-four meters (eighty feet) and with its interior (according to the model *Gastrovolve*). This would have been, without a doubt, much more impressive than the *Tour de Chantourne* to a height of fifteen meters and without an interior.

He proceeded to indicate that a French contractor, together with a qualified engineer, estimated the construction of the *Tour aux Figures* to be only $600 thousand and not the $2 million I mentioned. When the letter arrived, I was home, sick with the flu, and my secretary read it to me over the telephone. I made her repeat the first paragraph. Had we agreed on a height of fifty feet? Our recollection, assumption, written notes all said eight meters (twenty-seven feet). Could we have been wrong? Or had Dubuffet changed his mind? Why?

The same day, Irena Shapira received a long letter from Dubuffet, dated December 20, 1968 (two days earlier than mine). Its contents were similar to mine, also emphasizing the fifteen meter height, except the first paragraph, which read:

I have now the translation of the contract for the project. I find that the role played by the 'artist' in this contract is neglected in comparison with that of the 'patron.' It would be good if on his part the 'patron' had some responsibility, as against the gift made by the 'artist' of his creation and his work.

His pride was hurt, and, in retrospect, I realize that we did not respond adequately.

Three letters went out without much delay. One from Jim Giles, dated January 2, 1969:

I am very pleased to inform you that American Cement Corporation has made the following commitments to the Los Angeles County Museum for their project, Art & Technology.

1. To construct the *Tour de Chantourne* to a height of eight meters as shown in the publication, *Dubuffet Edifices.* The structure will be built at our Technical Center in Riverside, California, and will be transportable for purposes of exhibition at the Los Angeles Museum.

2. To undertake, as part of a continuing relationship with you, preliminary stress and engineering studies of *Le Gastrovolve.* We hope that these studies will lead to the eventual realization of the *Tour aux Figures* through the combined efforts of a half dozen or more large corporations. Mr. Tuchman is investigating that possibility.

3. To make available to you all of the varied facilities, materials, and techniques of our research and technical center for the further pursuit of your interests in design and structure.

We are all looking forward to your arrival, and to working with you.

Our undertaking to study the large structure, for its eventual realization, as well as the third commitment, were new undertakings in an effort to please Dubuffet. On the same date, I wrote to Dubuffet,

I am very sorry that you have not received yet our official confirmation. This is now being written by our President, Mr. J. Giles, and you should receive it at the same time as this letter arrives. With great enthusiasm, we have decided to proceed along the lines discussed in Paris and construct the *Tour de Chantourne* as a monument, eight meters high, as conceived in your book on edifices. It will probably be made in four parts, each of about two meters high so that it can be transported from Riverside to the Museum in Los Angeles, for their exhibition. There will be no interior arrangement other than the necessary supporting frame.

Also, as we mentioned in Paris, we are very eager, if you so desire, to proceed during your visit with our experimental stress analysis of the *Gastrovolve* model. This could serve as the basis for its structural design. In discussions with Mr. Tuchman and Mrs. Shapira, the possibility was also mentioned of investigating the collaboration of a number of firms towards the possible eventual construction of the *Tours aux Figures.* During your visit here, Mr. Tuchman will take the initiative in this direction, and I believe that the execution of the *Tour de Chantourne* will act as a significant stimulus towards this aim.

Everyone at the Technical Center is eager for the opportunity of working with you. We believe sincerely that you will find in Riverside a very stimulating and helpful environment and we are eager to enable you to execute any other small works for yourself that you may desire to do during your stay.

The arrangements for the work on the *Tour de Chantourne* have been progressing well. I am now organizing the group of people who will perform the actual construction. We are also looking into the details of the reproduction and construction techniques. We are starting to design the interior steel frames. I am very glad of your progress in making the epoxy models. We will need the unpainted model as soon as you can send it to us, hopefully by air mail. The painted models can arrive later. I hope to send you, during the next week, samples of white materials. The final decision on the material and paints can wait for later, however.

Again on January 2, 1969, Irena Shapira wrote explaining the U.S. practice of signing contracts; the fact that ACC had also signed a contract with the Museum (a copy was enclosed); that the contract was intended to protect the artist and to enable the Museum to make payments during the artist's sojourn here; that the Museum was, after all, a state organization. But, she wrote, "If you want to make changes, to eliminate or to amend, please make them and let me know." Though fair and reasonable enough, this was apparently not an adequate solution.

Dubuffet's reply to this series of letters was written January 9 to Irena Shapira:

Thank you for your letter of January 2, 1969. I have not had the necessary time to examine the contract proposal with a specialist. I intend to do it, but have been constantly very busy with my work and have not had the leisure to proceed with studies of this kind.

I should tell you that I am somewhat troubled by the nomenclature of 'patron sponsor,' given to the corporation benefiting from my collaboration, and also by the spirit in which this document was drafted, implying that in this relationship I am generously given a return, economy class, ticket to Los Angeles with a small salary for the journey, corresponding to the cost of my cigarettes, for the effective working days which I spend there, and I am in a position of being obliged to you. I don't feel this way and I don't think that it reflects the true situation.

I have received from the President of American Cement a letter proposing the construction of the *Tour de Chantourne,* not to the height of fifteen meters, which was decided with Mr. Aroni and Mr. Rowen during their visit to Paris, but to a height of only eight meters. Such a realization does not seem very interesting.

If it is necessary to make an object which is transportable, and which has dimensions not exceeding the height of eight meters, it seems that it should be made of epoxy and not of concrete. There is no sense in making it of concrete.

I do not like a clause of the proposed contract which stipulates that the objects realized could be disposed as desired. I want, if I make a present, that it should be honored as such.

The proposed contract stipulates that, in the case that other works are executed they will belong to me. But as there is no commitment stipulated concerning these eventual other realizations, this clause seems to be a pure formality and to be void of practical importance.

And to me he wrote a similar letter:

In your last letter you speak of the construction of my *Tour de Chantourne* to a height of eight meters, without referring to the height of fifteen meters which was agreed during your stay in Paris. I have also received a letter from the President of American Cement Corporation in which he also mentions the same height of eight meters

You don't mention at all the project of the device of enlargement, allowing the immediate enlargement, with ease and rapidity, of any model. Have you given up the development of such a machine? It is very important if it could be done.

At this stage, the fact that Dubuffet changed his mind about our agreement in Paris, for whatever reason, became evident. In the catalogue of *Fiston la Filoche,* published by the Galerie Jeanne Bucher, for his exhibition of Monumented Paintings in December, 1968, the following statement appears: "The American Cement Technical Center in Los Angeles is presently studying the construction of the *Tour de Chantourne* in the form of a twenty-six foot high hollow monument of painted cement, before attempting more ambitious projects." The only source for the "twenty-six foot" height, so far as I know, would have been Dubuffet. Therefore, it becomes clear that Dubuffet *had* understood the height to be twenty-six feet when we left him in Paris.

J. F. Jaeger, Director of Galerie Jeanne Bucher, Dubuffet's agent, wrote in a long letter to Irena on January 21,

The difficulties connected with Dubuffet's proposed trip to Los Angeles, and the execution of an 'Edifice,' arise essentially from a poor conception of the basis of the project. Your contract sets up on one hand the artist, and on the other the patron, creating thus a duality, a hierarchy which appears false

Dubuffet does not need for his existence, or his creations, a 'patron' of any kind In the spirit of the contract sent to Jean Dubuffet, I do not think there is much chance for agreement If you want to work with Dubuffet [you] need to abandon definitely the notion of patron.

Even before we received Jaeger's letter, I reached the conclusion that the only way the project could be salvaged would be for Irena and me to go immediately to Paris, and, with the consent of the Museum, to drop the contact completely. I hoped we could repair the damage to Dubuffet's ego, and also make an agreement on the execution of a reasonable structure. Jim Giles approved the idea, but the Museum thought that a letter should be tried first. My letter, however, could not very well address itself to the question of the contract, since this was only mentioned in his correspondence with the Museum. And so, on January 23, I wrote,

> In summary, to keep within the limitations of transportability and budget, we would like to excute for the Museum the *Tour de Chantourne* in concrete, to a height of eight meters. However, in addition to this work, we will budget a specific sum of money towards the execution of additional smaller works or studies. These would belong to you and would be done fully according to your desires. I sincerely feel that you will find it very useful to have access to the services of a strong interdisciplinary group of highly qualified and experienced people, and the facilities of our Technical Center at Riverside.
>
> There are many possibilities for the additional smaller projects. The possibilities include the execution of a small concrete sculpture using the plaster gun technique, the study and the production of complete engineering drawings for a reinforced concrete design for the *La Gastrovolve,* the study and some construction towards the enlargement device, an execution in epoxy or a combination of epoxy and concrete, or any other suggestion that you might have. Mrs. Shapira and I are prepared to come to Paris to discuss with you the details of our joint work.

Dubuffet's reply, addressed to Maurice, and dated February 6, sounded final:

> I regret that I must abandon the project of my participation in the operation, 'Art and Technology.' On one hand I am displeased with the contract you sent me; on the other, the realization of my *Tour de Chantourne,* in concrete, to a height of eight meters, without an interior, and in a form that the monument is demountable and transportable, does not hold much interest.

As a desperate move, after some meetings, Irena wrote to Dubuffet on February 11, 1969, inviting him to come to Los Angeles for face to face discussions. A return air ticket was enclosed, and the statement made that, "In your particular case, the Museum decided to omit the need for a contract." Dubuffet answered her on January 18:

> Thank you for your kind letter and for the ticket. But I hesitate to undertake a trip which might be useless. I speak very bad English. I don't express myself easily, and I don't understand it well. Besides I am not a technician. Then all my models are in Paris. There will be nothing to talk about in a concrete manner
>
> I think that an elegant situation of the project would be that the monument which will be realized should be given to the Museum as a donation and secured to remain for the future in the Museum's collection (the donors will always keep a right to the eventual further displacement of the work). The donor should be on the one hand myself and on the other the construction corporation. I want to be a donor, which in fact will be according to reality and as such just opposite to the wording of the contract you have sent me and in which the author of the monument, strangely enough, was considered as receiving a gift.

In addition, he explained to me in a letter dated January 14,

> I hope that we will have, in the near future, another occasion for collaboration.
> I don't find very sound the arrangement in which your company pays the cost of the realization. I prefer a sounder and cleaner way, in which I myself pay for the costs of studies and construction. In this way I am not a receiver of generosity, and feel much more comfortable.
>
> It is possible, I hope, that in the near future I will reestablish contact with you, with a view of working in a better way.

This represented almost the end of my relation with the project. And so ends the story of a failure. It is a question, I presume, of personal judgment as to which was the more valid reason for our failure: size or culture; an artist's pride or the cost of technology. There is a moral hidden somewhere here.

Samuel Aroni, Professor
School of Architecture and Urban Planning
University of California, Los Angeles

Later, in evaluating American Cement's efforts to realize Dubuffet's monument, James Giles commented on the reaction of ACC's management to the whole affair. According to him the research program at the Riverside Technical Center had been underway for two years, but was still on an experimental basis at the time of ACC's agreement to participate in A & T. Giles himself considered Dubuffet's proposal as an excellent opportunity for the research staff with potential advantage for the company, but this feeling was not shared by other top executives. The Dubuffet project actually became a symbolic issue raised by opponents of Giles in the corporate structure in the managerial upheaval which occurred early in 1969. A & T was cited as an example of the kind of research policy Giles was pursuing and which was to lead to his dismissal.

Jean Dupuy
Born Moulins (Alliers), France, 1925
Resident New York City

During Jane Livingston's April '69 New York trip, several people suggested that she make a point of seeing Jean Dupuy; it was finally at Tony Smith's suggestion that she visited him. We knew of Dupuy at that time only through his participation in the Museum of Modern Art's Machine Show exhibition, in which he was represented by a work called *Heart Beats Dust*. JL saw *Heart Beats Dust* during her April visit to the artist's studio in the Bowery. According to Dupuy's description, this work consists of ''a two-foot cube of glass in which a pile of dust—powdered pigment—rests on a rubber membrane. The machine includes coaxial speaker, a tape recording of heartbeats, or an electronic stethoscope so one can hear one's own heart, with various shutters and lenses. Moved by the vibrations produced by the heartbeats, the dust shapes and reshapes itself into strange formations, while a certain amount rises in suspension and is illuminated by a beam of light so that a pyramid of dust is defined.'' JL learned that Dupuy would be free and eager to work on a project for A & T if something could be arranged with a suitable corporation.

In June, Dupuy sent us a number of proposals for art works, which we forwarded to the Ampex Corporation for consideration; we requested Ampex's Dr. Charles Spitzer, with whom we had dealt for several months in trying to arrange a collaboration, to advise us regarding their interest in having Dupuy tour Ampex.

We were aware that not all of the proposals were appropriate to Ampex in terms of their technological capability, but hoped that one might interest them. The proposals are as follows:

Project: SPARKS
Words spoken into a microphone are converted into electrical impulses, then amplified to a voltage strong enough to generate sparks upon a metal plaque (bursts variable according to the phonetic properties of the words).

Technology: based upon the same principle as the color organ or the phonetic typewriter (I.B.M.) which will transcribe spoken words directly.

Project: INVERSE/REGENERATIVE
1. A labyrinth (realization simple, of lightweight, honeycomb cardboard; noise of electronic feedback within) which will lead to the chamber.

2. A room isolated from all sound, for one person at a time.

Put in this condition, totally isolated from all exterior noises, one can hear the physiological functions of the body (sound of heart, lungs, blood circulation, etc.).

Project: PROBLEM IN RE AERONAUTICS
An airplane flying at supersonic speed creates a cone of vibrations which begins from the nose of the plane and extends backwards in ever-enlarging diameter. At the moment when the cone touches the ground, it provokes the well-known boom by the intense accumulation of these vibrations.

Problem: How possibly to make this cone apparent?

Project: 'L 'INGENIEUR POMME' (THE ENGINEER APPLE)
1. A word is spoken into a microphone: Apple.

2. Apple is repeated by an echo chamber—A.P.P.P.P.P.

3. An audio-electronic system transforms the sound repeated by the echo into ultra-sonic sound.

4. Two ultra-sonic beams, projected by magneto-striction rods into a transparent sphere, diameter 4', meet at a certain point.

5. At this point, an apple is placed. It bursts.

Instrumentation:
Section 1: microphone
10 watt amplifier
loudspeaker
reverberation circuitry*

Section 2: audio to
5-kw amplifier at 30 kHz
3 magneto-striction transducers*
fixtures to mount and focus transducers*

Section 3: construction time for starred (*) items above

'APPLE' PROJECT
PURPOSE
The purpose of the technological phase of this project is:
1. Provide controlled reverberation of the spoken word,
2. Supply by transduction and gain, ultrasonic energy sufficient to shatter a spherical object, such as an apple,
3. Devise and construct the instrumentation and apparatus to carry out 1 and 2.

The subsequent description of the Project will be divided into sections corresponding to the above division.

SECTION 1: REVERBERATION
The action will be initiated by a spoken word or phrase. This will be picked up by a microphone, amplified, and supplied to a loudspeaker. By conventional controlled reverberation circuitry, a portion of this will be fed back

to the input and the spectator (participant) will hear a gradually diminishing repetition of the input sound.

SECTION 2: ULTRASONICS

Since inadequate energy is available in the audible portion of the spectrum, it will be necessary to transform the input into some other energy form to accomplish the desired effect. It has been decided to use ultrasonic devices. A portion of the audible output in 1 is heterodyned to provide an ultrasonic input. This is amplified to a level of several kilowatts and applied to two or three magnetostriction transducers. These will be aimed and focused on the apple. By adjusting the level of the input, and setting the time interval, the precise time after the word or phrase is uttered at which the apple is shattered can be determined. It is proposed that the transducers be located several inches away from the apple, but subsequent considerations may require contact.

SECTION 3: INSTRUMENTATION

The following apparatus will be required:

Section 1: microphone
10-watt amplifier
loudspeaker
reverberation cicuitry*

Section 2: audio-to-ultrasonic converter
5-kw amplifier at 30kHz
3 magnetostriction transducers*
fixtures to mount and focus transducers*

Section 3: construction time for starred (*) items above

Shortly after these proposals were sent, Dupuy sent us an elaborated version of *Sparks*. [1] We felt this proposal to be the most likely possibility for Ampex, and thus sent it on with the following letter to the company president from Hal Glicksman:

Dear Mr. Roberts,

Ampex has shown interest in our Art and Technology project from its germinal phase in late 1967, and still no artist is at work in your company. After numerous artists have toured and submitted proposals, the choice has devolved upon a project by French artist, Jean Dupuy, called *Sparks*. Dupuy was one of six winners in a competition for artists and engineers who were included in the Museum of Modern Art's exhibition, 'The Machine as Seen at the End of the Mechanical Age.' This exhibition is currently on view at San Francisco Museum of Art.

Dr. Spitzer has seen the project and is concerned that a skilled electronics technician will have to work for 2½ months to complete the project. He has asked us to make a formal request to your office for this time. A technician's time is precisely the resource that any artist would most need while working at Ampex.

If you could satisfy Dr. Spitzer's concern that his own department would not have to carry the task through unaided, we would be very grateful.

Ampex's response to HG's letter, written by Executive Vice-President Arthur H. Hausman, was negative:

Dear Mr. Glicksman:

Mr. William E. Roberts has forwarded to me your letter of 24 June 1969. I have reviewed this matter with Dr. Charles Spitzer, and discussed it with Mr. Roberts. It appears, from all the information which I have been able to gather that Mr. Dupuy has made a number of proposals which, while certainly interesting, places us in the somewhat embarrassing position of essentially constructing for him that which he, as the artist, in my judgment should be more responsible for creating. From discussion with Dr. Spitzer, some of the artists who toured Ampex appear to fit into the category reflected by Mr. Dupuy's proposals—i.e., they have an idea but they essentially want Ampex to do the bulk of the work in creating the art form, while other artists who have toured Ampex have left the impression that if they were to work in our company they would, in fact, be much more involved in the creative work itself than has been indicated by Mr. Dupuy.

Accordingly, I would suggest that since the success of this program depends upon a mutual understanding and a good rapport between the sponsors, the artist, and the company, that you seek to find another artist satisfactory to you, but with whom we believe we will find a better relationship than is indicated in he case of Mr. Dupuy.

Dupuy's proposals were not sent to other corporations—by this time most of those companies which could have implemented his works were either matched with other artists or had proved uncooperative. We relegated his file, with numerous others, to pending status.

In September, the Cummins Engine Company of Columbus, Indiana, having heard about A & T through the news media, telephoned the Museum to inquire about the program and perhaps offer their participation. We sent a packet of literature, with the brochure describing the terms of corporation participation, to Cummins' Public Relations representative Dan Graves. Graves telephoned within a few days to express Cummins' interest in becoming a Patron Sponsor; contracts were sent from the Museum. We began to think seriously about artists whom we felt might work with diesel engines. It was a problem requiring imagination. Through Dan Graves, whom JL spoke to on several occasions between mid-November, when the contract was finally signed and

1

Jean Dupuy
1969

PROJECT: ~~THE POEM~~ SPARKS

Words spoken into a microphone are converted into electrical impulses, then amplified
to a voltage strong enough to generate sparks upon a metal plaque (bursts variable
according to the phonetic properties of the words).

Technology: Based upon the same principle as the color organ or the phonetic type-
writer (I.B.M.) which will transcribe spoken words directly. Specific information
results from conversation with Mr. Cecil Coker, Bell Labs, Summit, New Jersey.

I. Speech Recognition Ideas
 A. Pitch Detector

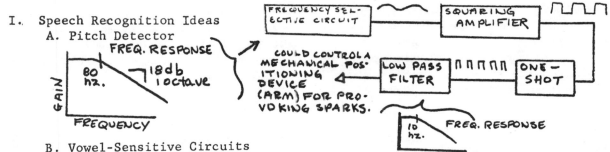

 B. Vowel-Sensitive Circuits
 (Vowels are identified by resonances of the mouth - circuits can be
 built to select usually one resonance per circuit - a frequency meter
 system like the pitch detector can determine frequency of that resonance.)

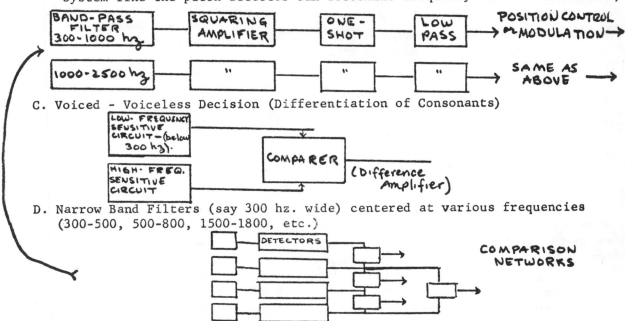

 C. Voiced - Voiceless Decision (Differentiation of Consonants)

 D. Narrow Band Filters (say 300 hz. wide) centered at various frequencies
 (300-500, 500-800, 1500-1800, etc.)

II. Spark Generation
 A. Tesla Coil -- Corona Discharge (especially corona discharge loudspeakers
 used in microphone calibration).

 B. Modulation of an Arc Welder
 1. A-C Arc Welder with silicon controlled rectifiers (doubtful).
 2. Modify the control circuits of a D-C arc welder; rapid on-off
 switching of welding machine controlled by SCR (silicon-cont. rect.).

Participation of public: 1. Properties of the spoken word (pitch, vowel- or consonant-
 structure) translated into varying bursts of sparks.
 2. Possible manipulation of stylus which will provoke sparks.

returned, and January, we were pressed to consider a number of artists favored by Cummins' President, J. Irwin Miller, himself a collector of art and energetic promoter of corporation support of the arts. (The town of Columbus is famous for its many public and private buildings designed by eminent modern architects; Miller has been chiefly, if not solely, responsible for this.) The artists mentioned repeatedly as being foremost on Cummins' list of preferences were Vasarely, Warhol and Lichtenstein. The two latter were of course already matched to corporations under Art and Technology; Vasarely had been involved early in the project with a proposal studied by several companies, but was no longer under consideration. Aside from these factors, however, it was for obvious reasons not easy for us to envision any of these artists as likely candidates for Cummins. The artist who did come to mind as a possibility was Jean Dupuy. In late October, we had received a new proposal from Dupuy, via his friend Irene Winter in New York:

Project: THE AUTO
In a large space (hall), very dimly lit, an automobile—situated in the center of the room and slightly raised (the wheels in space). At the steering wheel, a driver. This latter will start the motor and will utilize alternately or simultaneously different energies of the vehicle which will in turn make 'sculptures' appear in different parts of the hall, related to the four natural elements.

AIR
Burned gas leaving the exhaust pipe will be conducted by an air-tight tube into a closed space, transparent on three sides and having an evacuation chimney. Within this space the vapors of the gas will be made visible by a luminous process (to be specified).

FIRE
From the rim of one of the two hind wheels a transmission band is relayed to the hub of another wheel equipped with a tire and placed perpendicular to a metal plaque in such a way as to create friction between the two. The point of a nail, fixed inside, extends from the wheel. The contact of metal plaque and nail on the plaque and an explosion of sparks each time the brake is hit.

EARTH
In a closed and transparent space, some kind of powder or dust made from earth will rest on a membrane of rubber stretched over a speaker. The vibrations of the motor, amplified by the acceleration and transmitted to the speaker by a simple electronic system, of which the volume will be controlled by the rotation of the steering wheel, will set the powder in motion—visible only in the beam of the two headlights which will thus create two horizontal cones of dust.

WATER
Perhaps utilize either the water from the windshield-wiper system or the water of the radiator (to be studied).

We contacted Dupuy in New York to mention the availability of Cummins. Dupuy and Miss Winter traveled to Columbus in January, toured the plant, met with Mr. Miller, and returned to New York feeling enthusiastic about the prospect of a collaboration. Dupuy said of his first meeting with J. Irwin Miller, "I described the engine project to him, and he understood it immediately. He is a charming man—shy, after all, like me. Very quick and intelligent. I made him a little drawing, and he said, 'O.K.' Just like that. 'Beautiful.' " It was decided that Dupuy would move to Columbus on March 1 and expect to reside there for three months.

After this initial visit to Cummins, Dupuy wrote up his proposal, which he called *Fewafuel* (1970):
A Cummins diesel engine will be shown in working condition. The public participates by sitting in a driver's seat and operating certain controls, such as pedal and clutch. The four natural elements: FIRE, EARTH, WATER, AIR, which, either as sources of energy or as wastes, are part of the functioning engine, will be made visible with minimal elaboration.

 1. To respect the form of the engine.

 2. To indicate the basis in Nature of the engine's system.

 3. To sense the power of the engine by sound.

Clearly this conception derives from the *Auto* proposal which preceded it, and which Dupuy had actually presented to Renault in Paris, but which was considered too ambitious in scope for Renault to execute at that time.

Dupuy worked steadily at Cummins from March 1 through the end of May. He was received with extraordinary solicitousness by the Cummins personnel. The first person Dupuy was put in contact with was a Swiss engineer, Willy Henny, the head of one of Cummins' engine divisions. Henny was to work closely with the artist during the entire development of the project. On the first day they met, according to Dupuy,
We spent the entire day talking. This man, who is absolutely remote from the art world, understood very well what I wanted. He was interested in a specific problem I presented, which was to make a window in the engine showing the combustion chamber while the engine was working. This represented a difficult technical problem to be resolved I didn't know whether we could show the fire. I thought it might be impossible. I knew that there is no fire in an engine, except in the exhaust

part of a gasoline engine—but not in a diesel engine. So I thought the smoke would have to represent the fire, and the earth would be the carbon monoxide residue.

Henny was able to resolve this problem; in the completed engine, each element envisioned by Dupuy is displayed fully.

Cummins organized the Dupuy project to proceed like clockwork. Besides Henny, two other engineers worked daily on the development of the engine, and toward the end of the collaboration, three shop workers were involved on a full-time basis. The following memorandum, one of many, conveys some idea of the magnitude of the operation, and its logistical complexity:

Status Report—V-470 Engine
For Art Exhibit
The program is currently running slightly ahead of schedule. It is understood that a commitment has been made to representatives of the Los Angeles Art Museum who wish the 'package' early in May and the schedule of March 17, 1970, has been determined to accomplish this.

Following is the status of items on the March 17 schedule:

Item 1—Assemble and mount engine and radiator—complete

Item 2—Water flow tests—complete

Item 3—Evaluate one bank operation—complete

Item 4—Evaluate quartz crystal in cylinder head—Parts are in machine shop. This phase will be completed when unit is assembled. Expected completion date—5-15-70.

Item 5—Mount complete unit—Expected completion date—5-1-70.

Item 6—Operate on test cycle—Planned completion date—5-29-70.

Item 7—Update unit and prepare for shipment—Expected completion date—6-5-70.

Item 8—Obtain or fabricate sub-base—Complete.

Item 9—Design and obtain cylinder head insert—Expected completion date—4-27-70.

Item 10—Obtain fuel tank, batteries, and controls. Fuel tank, battery eliminator, and electrical controls are on order. The throttle control will be developed when the unit is built.

Item 11—Design and obtain exhaust viewing chamber—Chamber has been obtained. Mounting parts are designed and a price is awaited from a local shop. Expected completion date—5-1-70.

Material for the exhaust system in the component area is held up because of labor problems in the trucking industry. If material is not received this week substitute material will be used so that the system is operable by May 1, 1970.

In early May, Jane Livingston stopped in Columbus for two days en route between New York and Los Angeles, and saw the *Fewafuel's* maiden voyage. The black painted engine was not yet completed, missing still the inverted bell jar which would collect carbon debris and thus represent the "Earth" element, and the window which would provide a glimpse of the fuel in combustion, thus "Fire"; but the other two elements—water, gushing through a section of glass piping; and air—being the fan system—were in evidence. Perhaps most conspicuous was the element of sound, which was overpowering. The only device finally incorporated to allow spectator participation was a throttle with which one could speed up or slow the rate of engine turnover.

Dupuy's final statement, or description, of the work, is essentially a simplified version of his earlier proposals:

Fewafuel

A diesel engine will be shown in working condition. The four natural elements: FIRE, EARTH, WATER, AIR, which (either as sources of energy or as wastes) are part of the functioning engine, will be made visible with minimal elaboration.

The public will participate by sitting in a driver's seat and operating a throttle.

In several respects, the Dupuy/Cummins collaboration was singular in the context of A & T. Dupuy, unlike many of the other artists, lived and worked in the corporation for three months, without interruption, and he made a distinct impact, not only on the corporation but on the community of Columbus by his presence there.

During the first two weeks of Dupuy's residence in Columbus, Cummins rebuilt his *Heart Beats Dust* piece, and arranged for it to be shown publicly in a local high school auditorium. The artist also presented two other works, one involving projected slides, the other film—*Paris-Bordeaux* and *Central Park,* both made in 1969. These presentations were received with lively interest by the community. Dupuy said later,

For the first time, I was working on an art project which involved a whole town I met a great many people who asked, 'What is your project? What are you doing with an engine?' These people were waiting for the results. I showed *Heart Beats Dust* and two other works in local high schools. This town was really involved in a piece of art . . . for the first time. That was terrific—because for me art is quite dead. The art world is so small, actually, that society generally is not concerned It was for me a new relationship between art—my art—and society.

It was difficult for me sometimes. The second day I was there, I was arrested by the police, when I was walking at night. I suppose it was because of my long hair, etc. But I wanted to be visible, not invisible, precisely for the reason that I am an artist, and I want to *push* people in the direction of art. These people, you see, are so far from my own philosophy, if I have one But finally it worked. By the end, the people were receptive. Just before I left, I presented my *Paris-Bordeaux* work in a high school gymnasium, and it was a success.

The collaboration between Dupuy and Cummins resulted in what is certainly the most literal esthetic embodiment of a particular industrial product or technology produced under A & T. Rather than using a specialized process, or combination of techniques, as means to an essentially nonmimetic esthetic end, Dupuy chose simply to work with a functional machine, allowing it to remain essentially integral. He said,

My intention has been to escape an esthetic point of view—thus I show the engine as it is The engine has a certain reality. The car or the truck is probably the most usual object of our time. The engine is also probably the primary image of the capitalist economy [But] to show the engine is to show nature, not just technology It is the humanization of a technological thing. I destroyed the function of the engine, and transformed the fuel, taken from the earth, into earth again. Earth to earth—that's too Biblical—but that's what I did.

Jane Livingston

Frederick Eversley
Born Brooklyn, New York, 1941
Resident Los Angeles

In July, 1969, we invited Frederick Eversley, a Los Angeles sculptor and former electronics engineer, to visit Ampex Corporation. Eversley, accompanied by Hal Glicksman, went to the Redwood City facility where he met Dr. Charles Spitzer, and toured the optics laboratory. In addition to showing the artist their various laser research displays, Spitzer introduced Eversley to liquid crystals. Ampex uses neumatic liquid crystals, which are voltage sensitive, in their computer memory systems. Spitzer also described cholesteric crystals, which have the property of reflecting light at different wavelengths according to the temperature of the surface material. The crystals assume different hues—from pearlescent reds to deep blues—as the temperature shifts. They discussed the possibility of employing cholesteric liquid crystals as an artistic medium.

After this visit, Eversley researched the area of liquid crystals on his own, and in August presented us with a project proposal, excerpts of which follow:

> . . . The specific hue is dependent upon the temperature within the range with a red hue appearance at the lowest range temperature and, progressing through the visible spectrum with increasing temperature, to a violet hue appearance at the highest range temperature. Below and above the specified temperature range the liquid crystals appear colorless. The liquid crystals are completely reversible in their temperature-color behavior and have a thermal response of less than one second. The above described properties of cholestic liquid crystals suggest their use as a display medium on which multi-color images may be constructed by controlling the instantaneous temperature of each selected element of liquid crystal area on the display surface. This proposal defines a project which utilizes cholestic liquid crystals as a display medium and a programmed heat source to create images on the display medium.

> *Project Description:* The project will consist of performing the necessary R & D, design, construction and image programming of a large scale multi-color environment using liquid crystal compounds as the display medium and program controlled directional heat sources. The environment may take the shape of a flat panel, curved panel, circular enclosure, hemispherical dome or a section of a hemispherical dome.

> The environment will utilize a structural material (wood, metal, glass, plastic, etc.) as the supporting substrate to which the liquid crystal display medium will be applied. The substrate material may either be opaque such as wood or metal or translucent/transparent such as glass or plastic. If use of a translucent or transparent substrate proves feasible, it will provide a double color effect with the color images on one side being reflected light in nature in a manner analogous to a painting and the color images on the opposite side being transmitted light in nature in a manner analogous to a color transparency.

> The program controlled heat source may be a laser or a collimated beam of infrared incandescent light. The multi-color images will be written onto the liquid crystal display medium by sweeping the surface of the display medium with the heat beam from the program controlled heat source. Optical-mechanical methods are envisioned to accomplish the horizontal/vertical heat beam sweep in a manner analogous to the horizontal/vertical sweeping of an electron beam in CRT devices. The multi-color image will be constructed by instantaneous modulation (varying the intensity) of the heat source, under program control, during the horizontal/vertical sweep process. The optical-mechanical sweeping mechanism and the intensity of the heat source will be controlled by a tape recorded program. A thermal feedback system will be employed, if necessary, to compensate for changes in the ambient temperature surrounding the environment.

> The location of the heat source and associated sweep optics may be arranged to permit a limited degree of spectator interference with the sweeping heat beam. This interference will result in the thermal shadows, of varying hues on the programmed images on the display medium surface. These shadows will result in human forms in varying hues to be mixed with the pre-programmed images appearing on the display surface, and in greater active participation of the spectators with the environment. The hues of the various parts of the human shadow form or forms will depend upon their relative speed of movement and their size and shape will depend upon their distance from the heat source.

Ampex agreed to proceed with the project. Over the next few months Eversley continued his research, reading virtually all trade literature on liquid crystals—their properties, durability and methods of application. He conducted experiments in his studio to test various surfaces and techniques of spraying the material. He elected to work this way, independently, before spending an extended period of residence at Ampex. Throughout this time he maintained contact with Spitzer.

As this catalog is being prepared, Eversley's project is still in the research stage. He now wants a three-dimensional matrix of translucent liquid crystal imagery. The crystals would be sprayed onto thin layers of plastic or possibly sheer silk, each layer with a different temperature characteristic and creating a "thermal barrier" for the next. And he has tentatively decided that instead of programming the piece, the kinetic interaction of exhibition spectators should cause the temperature variation and subsequent shifting of hues, by triggering the heat source—a narrow focusing light, perhaps a mercury vapor or tungsten iodine lamp.

Born Sao Paulo, Brazil, 1928
Resident Stockholm, Sweden

In January, 1969, Jane Livingston telephoned Oyvind Fahlstrom to invite him to Los Angeles to tour corporations—primarily the Container Corporation of America. Fahlstrom's response to our suggestion was prompt and positive. He wrote,

> Very excited about possibility of working with industry for your show. I think Container Corporation would offer the most interesting opportunities.
>
> Off the cuff (and without having had time to consult their New York office, as I am a week from the opening of my show at Janis) I have a few very general suggestions:
>
> 1. ultralarge-and-light (laminated?) structures (flat silhouettes, to be assembled in different ways.)
>
> 2. ultralight flat shapes floating on air-cushion
>
> 3. giant coloured plastic bubbles, changing shapes depending on how much air is inflated
>
> 4. structures in self-disposing, decaying material ('wither away' automatically, gradually, different parts at different pace)
>
> 5. plastic gel 'blobs'—that can change in shape and can have hard-and-flat shapes inserted (and taken out without marks, holes)
>
> Now, my problem as you know is one of time and space. On a *very tentative* basis I could think of a time schedule
>
> 1. first confrontation with company, March 11-12, or 12-13 (Have to be in N.Y. by 15th)—(Mail detailed project descriptions during spring)
>
> 2. see models, samples etc. 1-20 September
>
> 3. follow production etc. 7-20 December
>
> 4. check finished works 1-7 February

> (*Unlikely* alternative—might possibly spend vacation, August, in L.A. and maybe stay through Sept. 10th or so; maybe skip 3 or 4.)

We brought Fahlstrom to Los Angeles on March 10. The next day, he toured the Container Corporation's Folding Carton Division and was shown examples of various die-cut, flat containers—margarine boxes, for example, printed and repeated endlessly on sheets of board—and witnessed the machine processes of cutting, folding and assembling these containers. Fahlstrom's response to what he saw at Container was somewhat apathetic. (In a note from Sweden some weeks later, he said "Haven't worked out anything for Container Corporation—feel limitations push me into minimalist bag—which isn't mine [i.e. non-experimental minimalist].''

Since it was clear that Fahlstrom was not immediately inspired by his view of this corporation, we spent several hours reviewing the list of contracted, still available corporations to determine what other companies he might visit while he was in L.A. We arranged a tour at Eldon, a toy manufacturing company, which failed to elicit much response of any sort. It seemed to us also that Heath and Company, who had joined with us in January, '69 as a Sponsor Corporation, might be of interest to Oyvind. Heath makes commercial signs. The materials and techniques required for this seemingly straightforward product are, to say the least, diverse. The fabricating of a Colonel Sanders or Fosters Freeze sign involves elaborately formed components of anodized aluminum, other sheet metals and plexiglass; if the sign revolves or is illuminated in its interior, mechanical and electrical systems are of course needed as well. [1, 2]

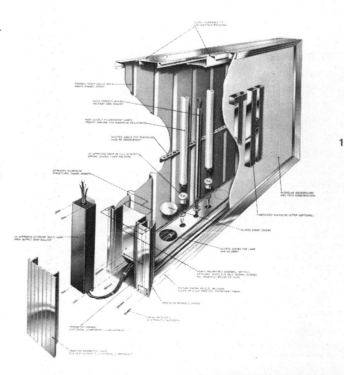

1

2

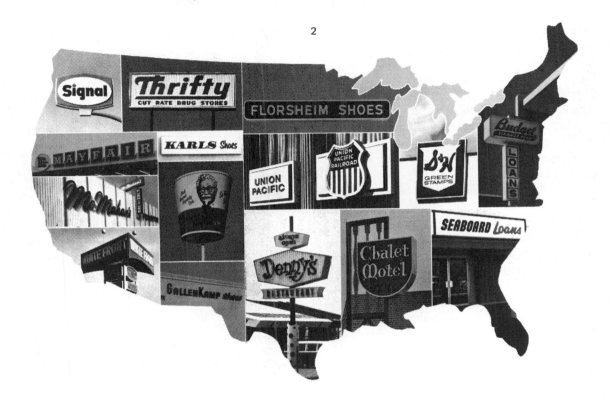

In view of Fahlstrom's past three-dimensional work, it was evident to us that Heath, more than a conventional steel or aluminum or plastics company, might at least offer him the opportunity to execute a tableau on a more extensive scale than would be remotely possible for him on his own, and with a greater variety of materials and colors and textures. Fahlstrom visited Heath on March 12 and was impressed by the craftsmanship of the skilled technicians who hand-sawed sheet metal into complicated shapes, and by the extensive plastic forming facilities. And it is impossible not to be delighted by the enormous yard surrounding the plant which is filled with a staggering array of gigantic, eccentrically shaped and fantastically colorful outdoor signs.

After touring three corporations, Fahlstrom had begun to limit his objectives somewhat. He later said,

My idea was when I originally heard about A & T, that I would get involved with huge companies with research programs or laboratories, so that I could propose something I've never done, without knowing what might come out. Like shapes that would float in the air by themselves, and expand or contract depending on the flow of air. Or another idea I had was to make a sculpture that would decay by itself by some sort of air or temperature action. Or the idea of a plastic fountain—you'd have some sort of plastic fluid that would come out like water and then coagulate and form shapes, and gradually it would become larger and larger. But then I visited two companies, a toy company and the Container Corporation, that were based on a multiplying thing, according to a module. The point would be making

molds, or models; and then having a great many objects made from them. I did think for a while of having the Container Corporation make up sort of molecular models, geometrically shaped boxes that you could combine and let grow into a structure.

It should be noted that Fahlstrom's interest, at least conceptually, in making non-sculptural or non-graphic works dates back several years. He was rather closely associated with E.A.T. in its early years. The March 18, 1968 issue of *E.A.T. News* includes several of his ideas which are related to the proposals in his first letter to us; these ideas were conceived, according to the News Letter, in 1966:

Fahlstrom and Rauschenberg want to float, suspended in air.
Control objects at a distance.
One or more floating forms following man that moves.
Activate objects at distance with vortex gun, heat, light-beam.
Balloons coming out of head. Like thought balloons.
Clouds.

Fahlstrom did in fact participate in E.A.T.'s *Nine Evenings* in October, 1966, with a performance work called *Kisses Sweeter than Wine*. The work incorporated film, video tape and sound elements, as well as " 'snow bubbles' rising from the ground, people enveloped by 'clouds'. . . .", etc. The artist said in the catalog which accompanied *Nine Evenings*, "I think of it as initiation rites for a new medium, Total Theatre."

Despite Fahlstrom's longstanding involvement with a "technological/conceptual" esthetic, the major part of his oeuvre, and that work which finally establishes him as an artist of stature, is graphic and sculptural. Fahlstrom is profoundly concerned with *iconography* in his work. Certain images appear again and again in variant forms [3]; these images all have specific, symbolic meaning for him. Only by recognizing this obsession with a highly developed personal iconography, whose images are often taken from archtypically *Kitsch* sources (popular magazines, posters, cinematic cliches) can one understand the importance for Fahlstrom, and ultimately for his A & T project, of a particular event which occurred during his brief visit to Los Angeles in March, 1969: Hal Glicksman showed him a series of ZAP comic books. The first issue of ZAP appeared in October, 1967; it was circulated as an underground publication, out of San Francisco, and featured comic strips by, among other artists, Robert Crumb. The first issue, No. 0, was to provide not only a full vocabulary of images for Fahlstrom, but the title of his work: MEATBALL CURTAIN. (Many images were derived from later issues of ZAP as well.)

What happened, basically, was that Fahlstrom was introduced to ZAP comics and the Heath sign company simultaneously; he went away, contemplated what he had seen, and decided to use these two resources, the literary inspiration and the means of transforming it into physical form, to make a work of art. A week after Oyvind returned from Los Angeles to New York, he mailed us a brief, scribbled note saying, "Hal, thanks for the guided tour! Also ZAP, most inspiring, might make Heath piece into a (or call it) MEATBALL CURTAIN . . . P.S. Will send Maurice project notes soon (on Heath idea)"

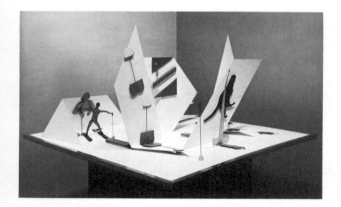

3

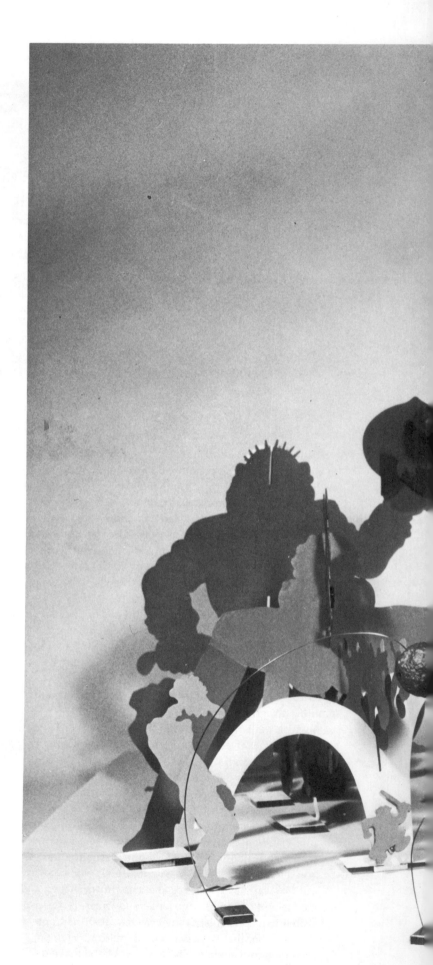

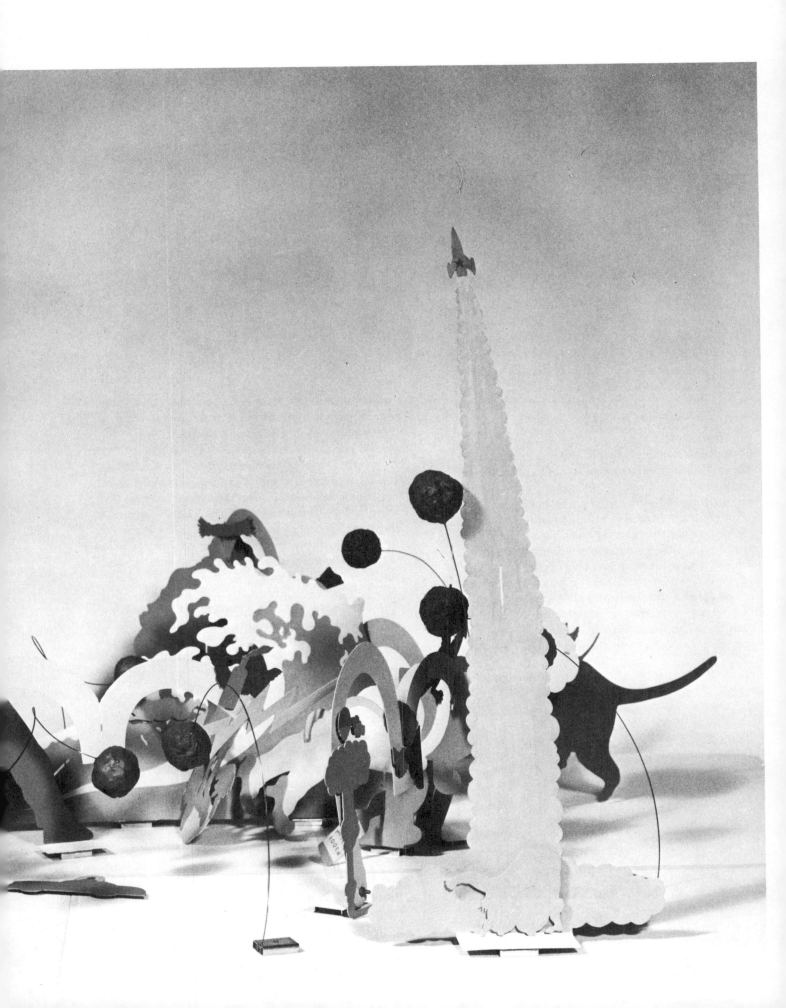

Fahlstrom sent drawings for the piece shortly thereafter.
[4] He indicated that some of the images he sketched
should be fabricated of sheet metal, sprayed on both sides
with enamel paint, and others made of plexiglass. The work
was conceived as a complex tableau of free-standing
objects.

It remained for us to reach an agreement with Heath to
have Fahlstrom work there. He had decided to come in
August, to stay for at least six weeks. Our contact there was
Assistant General Manager Jack Lloyd. We submitted
Oyvind's sketches to him for consideration by himself and
the president, Wayne Heath; they consented to work with
Fahlstrom, and we confirmed the arrangement.

Fahlstrom arrived early in August to begin work at Heath.
Despite a number of difficulties—having to do with finding
convenient living quarters, working out transportation to
and from the plant, and communicating effectively with re-
sponsible people once his work was underway—he worked
efficiently and accomplished his work within six weeks
time with little direct intervention on our part. In discuss-
ing the experience later, he said,

I worked with a lot of people, and I had all sorts of dif-
ferent—mostly positive—relations. In general there was a
great deal of good will [on the part of] the people I
actually worked with. But in the beginning, they felt
that I was to fool around with some of their materials in
some far away corner of the company and come up with
some funny little abstraction or whatever. Gradually
then it dawned on them that I had a plan, and I wanted
to be involved physically as little as possible; I wanted it
to be done by their craftsmen and with their machinery
even though what they do and what they have is nothing
terribly sophisticated in terms of technique. But I
couldn't have done it myself, even if I had specialized
tools.

I am not very good at talking to people and getting ac-
quainted, but it was very interesting to talk to some of
the men in what little time I had, because we had very
short breaks and a rather disciplined life. But in the end

I felt I was getting close to some of the people. The
workers that were interested in the whole thing about
being an artist and working this way do things on their
own now.

We asked Fahlstrom whether anyone approached him and
inquired about getting involved, without being assigned by
his foremen to work on the project. He replied,
No. No one did that because they do what they are told.
So it was a matter of my manipulating foremen, and a
few other people, and sort of putting pressure on them
. . . . But after a while it became a sort of very organic
thing, and ultimately very satisfying. Nothing was really
organized for [my project], and there was really no time
for it, but gradually they put in some time here, and one
worker there, and another one there, and in the end it
was done

The workers enjoyed it. In a sense they appreciated my
work as children. They didn't seem to feel conscious
that the images might be prurient, or pornographic—they
just enjoyed it. They sometimes had suggestions for
changes—like adding different colors. They started work-
ing on a sort of private artistic level.

Fahlstrom's approach to the *Meatball Curtain* is based on
"game theories" which have informed his work for several
years. In 1964, he wrote a piece called "Manipulating the
World"; the principles outlined in it apply directly to the
work done at Heath five years later:
In my variable pictures the emphasis on the 'character'
or 'type' of an element is achieved by cutting out a silho-
uette in plastic and sheet iron. The type then becomes
fixed and tangible, almost 'live' as an object, yet flat as a
painting. Equipped with magnets, these cut-outs can be
juxtaposed, superposed, inserted, suspended. They can
slide along grooves, fold laterally through joints, and
frontally through hinges. They can also be bent and
riveted to permanent three-dimensional forms.

These elements, while materially fixed, achieve their
character-identity only when they are put together; their

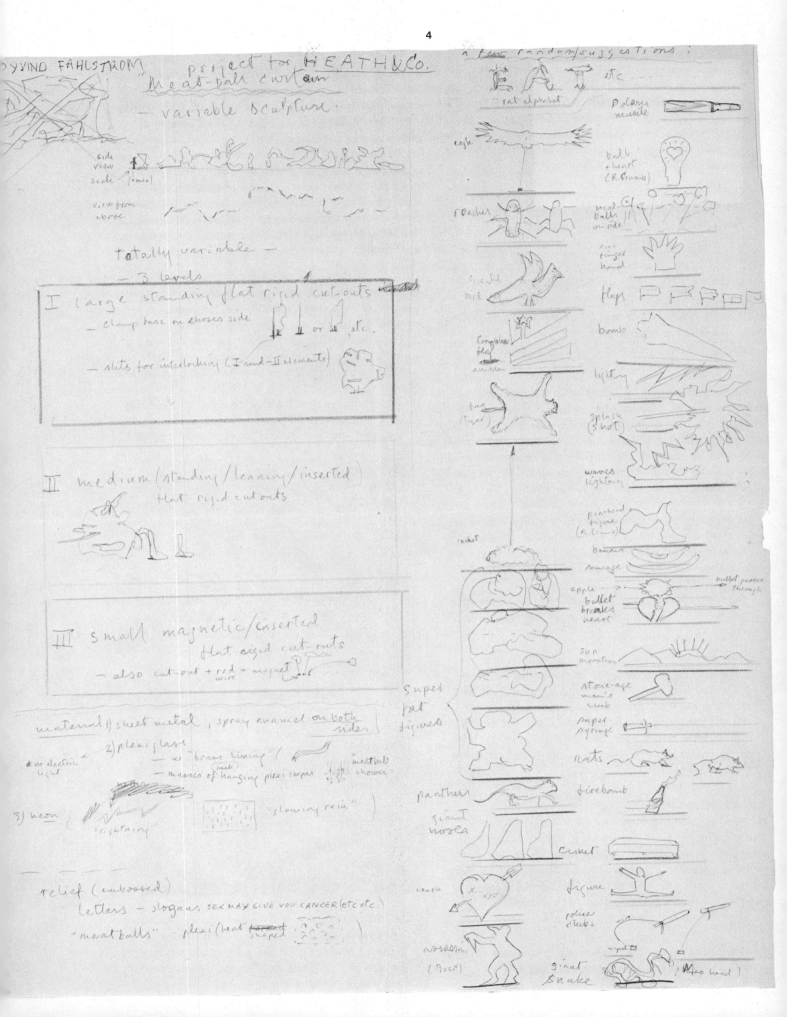

character changes with each new arrangement. The arrangement grows out of a combination of the rules (the chance factor) and my intentions, and is shown in a 'score' or 'scenario' (in the form of a drawing, photographs or small paintings). The isolated elements are thus not paintings, but machinery to make paintings. Picture —organ.

The finished picture stands somewhere in the intersection of paintings, games (type Monopoly and war games) and puppet theater.

Just as the cutout materializes the type, the factor of time in painting becomes material through the many, in principle infinite, phases in which the elements will appear. As earlier, in my 'world' pictures such as 'Ade-Ledic-Nander' and 'Sitting . . .' a form would be painted on ten different places on the canvas, now it may be arranged in ten different ways during a period of time . . .*

The American comic-strip has served as a vital source for Fahlstrom's work since the early sixties. It is the nature of comic-strip art to portray *sequences of events in time.* The underlying structure of Fahlstrom's character combinations is founded on images distributed to imply *both discontinuousness* and a kind of *alterable* sequentialness. Forms and figure-images play upon one another arbitrarily, "in the same way," he wrote in 1964,

a ball in a game by falling into a hole will give the value of 1000, whereas if it rolls past the hole it will give 0. There is nothing in the ball and the hole that necessarily relate them, nor that make a certain relation valuable.

The association of disparate elements to each other thus makes game rules and the work of art will be a game structure.

This, among other things, leads to presupposing an active, participating spectator who—whether he is confronted with a static or a variable work of art—will find relations which will make him able to 'play' the work, while the elements that he does not relate and in general his individual disposition make for the chance, the uncertainty that, when clashing with the 'rules,' create the thrill of the game.†

It is not difficult to see how Fahlstrom was drawn to comic-strips as an inspiration for his own distributions of character-images, given his interest in the repetition of elements, and in sequentially ordered narrative, as means of building "playable" tableaux. There is, however, a far more profound literary basis for his interest in popular comic-book art. Unlike Roy Lichtenstein, whose comic-strip

paintings generally depict a single incident, or episode, and are presented as highly estheticized satirical statements—parodying both the form and the sentiment of Pop imagery —Fahlstrom's use of comic-strip figures is filled with complex *mythological* content. Fahlstrom sees in comic-strip art manifestations of deep-seated social and cultural fears, urges, *myths*—and uses this imagery in his work for much more than satirical intent. Certain images—for example, the rocket thrusting upward on its own trail of smoke, or the panther—recur again and again in his work. These are for him potent symbols, embodying political, psychological and literary attitudes.

To explicate the sources and symbolic content of each component of *Meatball Curtain*, or the work as a whole, would require a lengthy study. Fahlstrom did, however, comment on these things after the project was finished:

The title, *Meatball Curtain,* comes from Volume 0 of ZAP. It has a cartoon called Meatball by Robert Crumb [5], one of his best, most interesting ones which deals with a supernatural event. Meatballs fall out of the sky. People who are struck with a meatball, in this comic strip, are transformed to a level of—what would you call it—inner happiness. Revelation. It's sort of a parable of

6

the idea of everyone—well, having an acid trip or some type of experience like that On the cover of Volume 0 there's a great character connected to an electric wire and being like electrocuted by some sort of great insight or illumination [6]

*Art and Literature, Vol. 3, Autumn-Winter 1964, Société Anonyme d'Editions Littéraires et Artistiques, Lausanne, pp. 225-226.
†Ibid., pp. 220-225.

I've been looking a lot at the underground cartoon makers. They have a sort of exuberance and precision, and that extreme expressiveness of their outlines . . . I would say sixty, seventy per cent of the images in this piece are direct outlines from Robert Crumb. I think it should be said that this work is an homage to Robert Crumb, to a great American artist 5

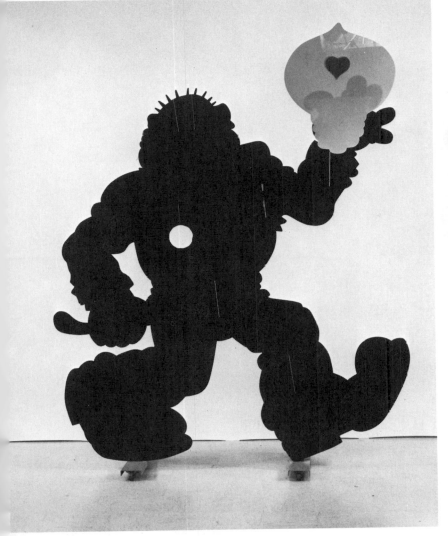

8

I wanted my figures to have a sort of quality of exuberance and the energy of American life and the fatality and rawness of it and the sort of dumbness about it too and the animal-like quality which is very well depicted in Crumb's drawings, as well as the aspect of madness, the ecstatic factor.

When pressed to explain the figures in greater detail, Fahlstrom said,

The large, dark blue figure has his hair stretched out like he was terribly scared—and in his hand there's a sort of stylized light bulb with a heart in it, which is from a Crumb figure. It denotes this moment of illumination or insight, the moment of truth, which is part of the whole Meatball series.[7, 8]

Then there are two more Robert Crumb cutouts
There's one somewhat ambiguous figure—the man with
the long nose who seems to be struggling with or holding
a little girl with a bow in her hair. [9] It might be inter-
preted as sort of an incestuous situation And
there's the lady diving down into a toilet seat, like some-
one looking for something, but being scared by some-
thing, or trying to hide. The interpretation would
depend on how I assemble the figures when I set up the
piece. I could assemble them in such a way that she
would appear to be hiding from fear One of the
most important ones is the four dancing figures, four
men that come closer and closer in perspective. [10, 11]
The furthest one has a normal, or in fact larger than
normal head. As they get closer, the head shrinks, and in
the very largest, closest figure, with enormous plexiglass
boots, you see that the head has shrunk to almost
nothing. This goes back to an imagery or idea that
appears in Robert Crumb's comics about the *acid* head
as a person with a tiny head—it's like a pin point in
many of his drawings. In this case I have modified the
drawing of his where the characters actually have nor-
mally proportioned heads in order to add this dimen-
sion

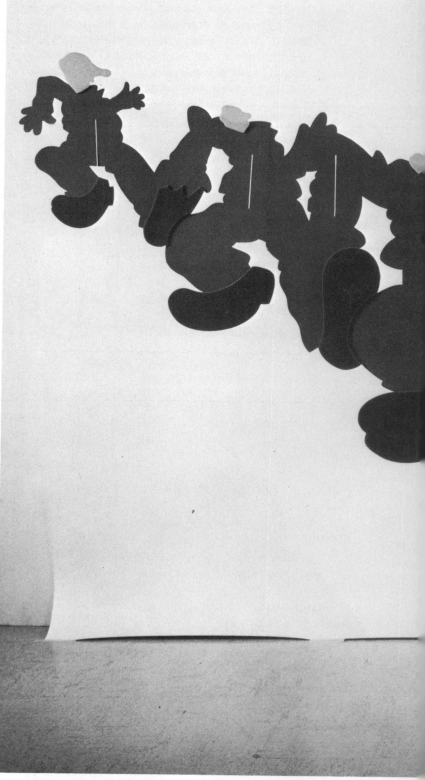

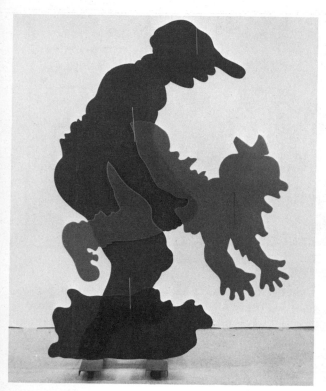

9

10

11

Then we have a pouncing, leaping panther, or actually it's a leopard shape, from a photograph in my last show at Janis. [3, 12] Then there's a green wave, with very light green foam, sort of stylized like a Japanese print [13]; it's from a detail in a Crumb drawing, but greatly aberrated. The tallest shape, the yellow one which is a cloud burst, or vertical smoke coming from a rocket, that you see on top, very small, is also based on a photograph. [3, 14]

The division of colors roughly follows the simplified scheme of dividing the forces in the world, or the power structure, according to color as I did in all the pieces in my last show. Everything that has to do with the American sphere of influence is blue and variations of blue; the 'third world' would be green or brown. You might have violet as a sort of intermediary color, and yellow, red, orange for Socialist countries, China and so forth.

JL: What about the meatballs? Are they scatological?

OF: No. They're just meatballs. A meatball is very plain and down to earth. It represents food—plain everyday sort of food. [15]

The components of *Meatball Curtain* are all made of either heavy gauge sheet metal, saw-cut by hand, or vacuum formed plexiglass (the meatballs and smaller shapes—those which are inserted into slots, or affixed by magnets to the large figures—are plastic).

14

12

One of the most significant aspects of *Meatball Curtain,* as compared to Fahlstrom's earlier work, is the relatively bold and uncluttered nature of the figures. In this work, the *silhouettes* of the large forms, apprehended instantaneously when one sees the work assembled, before the eye is drawn to investigate detail, carry the weight of the esthetic experience. The expressiveness of outline, to use Fahlstrom's term in describing Crumb's comic strip style, becomes the ascendantly important visual element. Fahlstrom said,

What I wanted to do here was to avoid working in a great deal of detail as I have usually done in the past, with complicated outlines—black outlines indicating creases, and elaborate clothing details, etc. I wanted

rather to simplify. In order to do this I had to choose pieces that were either single figures, or combinations of figures and objects that were expressive plus being understandable immediately, or if not, at least ambiguous in an interesting way.

It is tempting to attribute this change in approach, in part if not exclusively, to the environment at Heath in which Fahlstrom worked. He was constantly seeing the huge signs which lay about there, and it is the nature of sign images to rely for impact on bold overall or interior silhouettes. The image on the familiar Colonel Sanders bucket-in-the-sky, for instance, when observed at close range, cannot be read as a face; the configurations which form the eyes, the mustache, the lines in the cheeks, appear to be just oddly shaped obtrusions of brown plastic against a curved field of metal. Whether or not this visual ambience alone stimulated Fahlstrom to increase the scale and eliminate busy detail in his work, the fact that he did these things is of great importance in terms of his artistic development; *Meatball Curtain* is undoubtedly one of the most successful tableaux he has made, in great part owing to its large size and its economy of interior visual elements.

Jane Livingston

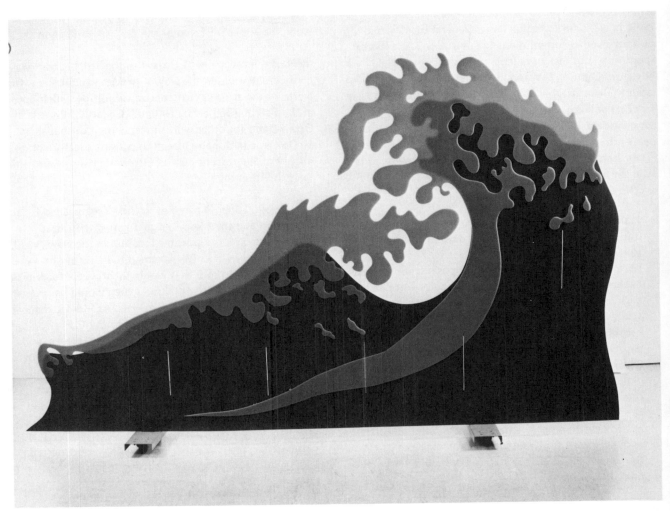

13

15

MT first spoke to Dan Flavin about A & T in January, 1969, in New York. At that time, General Electric had given us a verbal commitment to enter A & T as a Patron Sponsor, and to make available to an artist their Nela Park Advanced Lighting Division, near Cleveland, Ohio. MT indicated to the artist that if he was interested in touring Nela Park and perhaps working there, we would arrange it; we felt confident that GE would sign a contract with us, and were enthusiastic about having Flavin work with them. Flavin seemed open to MT's suggestion, and finally, in late July, the artist visited Nela Park for two days. He wrote to us after this,

It should be understood that my remarks here are of initial conjectures from just two days of beginning with various consultants of General Electric. Firstly, as reported by telephone, a backup proposal from previous experience and with in-production equipment would be a variably sized system of ultra-violet light (absolutely safely filtered tubes, etc.) with dimming cycle and stroboscopic-like moderation prompted by humanly governed capacitors, if the possible situational usage warrants. Secondly, and hopefully, preferably, the engineers and I will determine how to excite dispersed phosphors or other matter in the atmosphere in a safe and somewhat consistently visible manner. (If possible, I would prefer not to have to employ a more spatially limited carrier such as water.) But what we research may not all clarify the vague suggestion just stated. We should know much more in October

Flavin returned to Nela Park for what we supposed to be a week, and turned out to be two days, in August. He spent that time in consultation with lighting engineer Terry McGowan; they discussed numerous possibilities for projects employing advanced kinds of lamps which the artist had not used previously in his work. According to McGowan, Flavin was, however, primarily interested in fluorescent light, which he has used, almost exclusively, in his past works, and to the present time. McGowan did make a mock-up for Flavin of a circuit using one flashing ultraviolet lamp. McGowan said that G.E. encouraged Flavin to use ultraviolet, and we were under the impression that Flavin intended to execute a U-V piece for the Expo show. However, in talking later with McGowan, he said to us,

"Dan did not indicate in any way to us what his piece would be either for Expo or the L.A. (A & T) show."

Most of the assistance G.E. gave to the artist—and it was considerable—was in the way of providing equipment for works in the artist's retrospective exhibition which opened in the Fall of 1969 at the National Gallery of Canada in Ottawa, and for other works independent of that show. McGowan additionally agreed to present a lecture on the history of fluorescent light at Ottawa in connection with the exhibition there.

In October, 1969, Flavin met in New York with MT, Jane Livingston and the Expo Design Team at their headquarters, to discuss a possible location in the New Arts Pavilion for his work. (We assumed there *would* be a work, and in fact Flavin told us it would incorporate forty-inch U-V tubes, emitting bluish light, which would be programmed to dim out and flash at intervals. As indicated above, this plan was apparently not known to the G.E. people.) The space allotted in the Pavilion area for Flavin's work designed as a room into which one looked, but did not enter, was commensurate in size to that given for other works in the exhibition, and the artist indicated that he was satisfied with it. However, on October 24, we received in Los Angeles the following cable from Flavin: SINCE MYSELF LAST IN EXHIBITION CONSIDERATION BECOMING POTENTIAL VILLAIN OF OSAKA INSTALLATION ROLE UTTERLY UNACCEPTABLE WANT TO DECLINE INVITATION NOW BEFORE IT BECOMES TOO LATE.

Although we were at a loss to understand the rationale for his telegram, we accepted this declination perforce, but continued to regard the Flavin/G.E. collaboration as viable, and as potentially issuing in a work for the Museum exhibition. Flavin indicated for several weeks that he planned to return to Nela Park, and G.E. was anxious to have him do so. By January of 1970, however, when Flavin had still not made any definite commitment to spend time at G.E., the collaboration was terminated.

We have continued to the present time to attempt to effect an artistic collaboration at G.E. (see sections on Ron Cooper and Robert Morris) but have not succeeded.

Sam Francis
Born San Mateo, California, 1923
Resident Santa Monica, California

Over a nine month period, from April through December, 1970, we made extensive efforts, none successful, to include Sam Francis in A & T. He suggested diverse ideas for projects, most of which necessitated enormous technical and financial support. One of Francis' initial proposals was to execute an elaborate programmed strobe light environment—possibly taking shape as a light show in the sky. This grandiose project eventually developed into an idea requiring a salvo of rockets to be fired over the Southern California basin. We brought him together with Dr. Richard Feynman, who rather liked the scheme. Feynman made several calls to persons he knew at NASA and determined that the cost of Francis' plan would be about $1,000,000.

In addition to the light performance Francis was to a lesser degree interested in executing sculpture in cement or ceramics. In April we toured American Cement's Technical Research Center in Riverside and discussed Francis' sculpture with Dr. Kenneth Daugherty. Scientists at the Center had recently developed a method of injecting color into cement or concrete mixtures, a process which we felt would be of interest to the artist. Francis was willing to consider this possibility but first wanted to further pursue those corporations which might execute an indoor strobe environment before committing himself to the cement company.

Accordingly, in May, Gail Scott accompanied Francis (and, as it happened, James Rosenquist) to Ampex Corporation in Redwood City, where they met with several staff members in the Advanced Technical Section. The optics department dealt with theoretical research which was of no immediate use to Francis, and their electronic products did not include the kind of hardware he needed.

In September, Francis visited RCA in Van Nuys, and the outcome was much the same as at Ampex. They could have programmed the work, but not provide any light equipment. During this period, we had seriously considered sending Francis to General Electric, since the Dan Flavin project at G.E.'s Nela Park Laboratories near Cleveland, had been discontinued, but for Francis an extended period of residence in Ohio was not feasible.

In September, 1969, we took Francis to American Standard, a ceramics company which only recently had become involved in A & T. Again, as at American Cement, the artist and the plant manager, Jack Day, were agreed that the factory had the capacity to produce sculpture for the artist: the kilns were large enough; they could produce a rich color glaze; and, most importantly, Day indicated that the structural, tensile and balance problems posed by Francis' sculptural concepts would be a stimulating challenge to his engineers. Again, Francis demurred on the basis of his preferred scheme; he still was not excited about the notion of executing sculpture when the option of a strobe environment remained a remote possibility. However we were not able to find a company to accommodate his needs.

Hans Haacke
Born Cologne, 1936
Resident, New York City

In February, 1969 we contacted Hans Haacke, asking him to submit a project proposal for A & T. In early March he submitted descriptions for six projects involving aerodynamics, condensation cycles, transduction and information retrieval.

We sent all six proposals to Dr. Charles Spitzer, our contact at Ampex Corporation, for his consideration. No collaboration with Ampex had emerged from several previous attempts, and we were anxious to effect a match. Dr. Spitzer indicated his willingness to discuss one of the proposed works, called *Environment Transplant* [1] at length with the artist, indicating at the outset that the major obstacle would be the use of *real time.* Early in April Haacke flew to Los Angeles and was accompanied to Ampex, in Redwood City, by Hal Glicksman. During two days of discussion Spitzer and Haacke thrashed out the major problems: securing an FCC permit for direct, real time transmission, a difficult bureaucratic procedure to undertake; hiring a truck and driver for the four month duration of the exhibition; and procuring certain television projection equipment which Ampex did not manufacture. Ampex did not want to assume responsibility for solving any of these problems.

Even if Haacke decided to use a time delay feedback system—taping the information instead of employing direct transmission—there was still the problem of obtaining the television projection equipment. Our efforts to get a donation of this equipment from other contracted A & T companies like G.E. were unsuccessful.

We wrote Haacke explaining the impasse we had reached; undaunted, he replied by telephone with still another project proposal called *Information Retrieval.* He wanted to program a computer to ask census-type questions about spectators at the exhibition; this information would be gathered and stored during the time of the exhibition, and retrieved at will. The resulting compilation of data would constitute a sociological profile of the exhibition visitors. Although we were unable to execute this proposal—since all participating computer corporations were already involved with other artists—Haacke was able to execute a variant of this piece for the *Software* exhibition at New York's Jewish Museum held in September, 1970.

ENVIRONMENT TRANSPLANT

A large white room in the shape of a vertical cylinder.
In the center equipment for visual projection mounted on
a slowly moving turntable so that projections would sweep over
the curved walls like the beams of a light house. Loudspeakers
are situated behind the walls all around the room so that the
sound can actually follow the sweeping of the projected images
(a less desirable though cheaper version would be to mount a
single loudspeaker on the turntable).

Corresponding to this set-up in the museum sound and image
recording devices are mounted on a truck. Like the projection
equipment the recording equipment is fixed onto a slowly
spinning turntable. It continuously scans the "horizon".
During exhibition hours the truck drives through the entire
Los Angeles Metropolitan Area constantly recording the sights
and sounds of the streets it goes through.

The recorded material is immediately (without any time lag)
transmitted into the museum and projected onto the walls
or emitted through the loudspeakers of the room. Visitors
will sometimes stand between projector and "screen". Conse-
quently their shadows will appear on the wall and they them-
selves become the "screen". Whatever noises they make will
also mingle with the streetnoises piped from the truck into
the room.

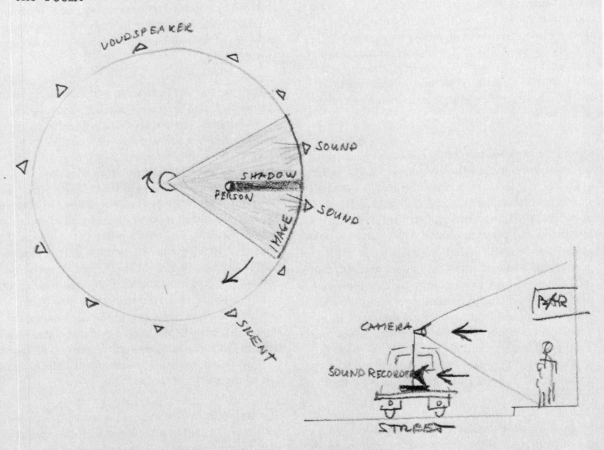

Newton Harrison
Born New York City, 1932
Resident La Jolla, California

Newton Harrison has taught since 1965 in the art department at the University of California, San Diego. In the fall of 1967 he described to his painting class a notion he had been pursuing of rendering colored light as form, in a way not possible with ordinary neon tubing or incandescent lights. One member of his class, Keith Carter, a former physics student, responded by showing Harrison a glow discharge display in a bell jar in one of the physics laboratories. A glow discharge is the ionization or breakdown of gas (helium, neon, argon, etc.) into a diffuse arc by means of a plasma or fluid which conducts electricity. A simple form of a glow discharge is neon light, but because the ionization activity takes place within the constricted, narrow area of a tube, the various types of phenomena which occur during ionization are not visible. Glow discharge is a commonly known physical phenomenon, used by scientists for years in various kinds of research and experimentation, for example as a method of converting thermal energy into electricity.

Harrison was intrigued by the possibilities of artistic expression inherent in this phenomenon. The colors that can be made to appear range from subdued pinks to bright orange to blues and greens. Under varying conditions one can observe that the light takes on numerous distinct shapes: arcs, lightning streaks, platelets, bubbles, or shafts of color. The colors and forms depend on three variables: amount of vacuum in the chamber; type and amount of gas used (primarily helium, neon, argon, carbon dioxide and nitrogen); amount and type of electricity (either AC or DC). Harrison set up a display in his studio with a primitive piece of equipment and experimented with it for some time, attempting to determine the capability of a glow discharge as a workable art medium.

At about this time we learned of Harrison's interest in A & T from his colleague David Antin at UCSD, and in April, 1969, Hal Glicksman visited his studio and saw the experimental set-up of a glow discharge in the three foot bell jar. With Antin's encouragement, Harrison submitted to us a project proposal titled "Light as color in space," which states in part,

> Our normal associations with light are that it defines or illuminates a pre-existing form by its presence or absence. This is true of conventional sculpture. It is also true of every light work I have ever seen. Even searchlight sculpture in defining giant space volumes must be considered as drawing on a grand scale. In this work that I propose light as color is the form. It defines itself. It needs no object. A plasma is light unadulterated.

After studying the proposal and checking through our roster of contracted corporations, we decided to send a copy of Newton's proposal to Dr. Robert Meghreblian, Deputy Assistant Director of Jet Propulsion Laboratory. (We had toured JPL with James Byars, Richard Serra, Mark di Suvero and Michael Asher but had been unsuccessful in placing any of them at this extraordinary research facility.) In July, we visited JPL to discuss further the feasibility of a collaboration between the company and Harrison. The artist met first with Dr. Meghreblian, who was impressed by the amount of research Newton had already accomplished and by his ability to converse intelligently about the scientific aspects of the problems involved. Meghreblian assigned Donald Bartz, Manager of Propulsion Research and Advanced Concepts Section, to work with Harrison. That same afternoon Harrison had a lengthy discussion with Bartz, Ray Goldstein and several other plasma experts. This meeting evolved into a productive problem solving situation, establishing a rapport between Newton and the JPL staff which existed throughout the collaboration. At that preliminary session they talked of revising the shape of the gas container from Newton's original concept of a six by nine foot cube to a cylindrical shape, thereby eliminating the necessity for several glued seams and strengthening the vacuum chamber. The size of the cylinder remained flexible, to be determined at a later date along with other esthetic and technical considerations. In addition they discussed the problem of removing or disguising the electrical wire running from top to bottom of the chamber. Various tentative solutions emerged but nothing definite was decided. Bartz suggested that a JPL design team be assigned to investigate these structural and technical problems and to project a cost estimate.

In the next few weeks Newton met with Bartz and the engineering team on several occasions from which eventually emerged the final design for the gas containers: they decided to make five identical columns, each of one inch thick plexiglass, eighteen inches in diameter and twelve feet high, or from floor to ceiling. This solution eiliminated the need for visible exterior wiring since the electrodes would be housed in end-plates at top and bottom and all support mechanisms would reside in floor and ceiling. The cost estimates for building the five units were so high that JPL, because of its connection with NASA as a non-profit space research organization, decided it would not completely finance their construction. JPL agreed to supply technician time to run all necessary tests on the tubes, to furnish additional engineering designs [1], and to make available on a loan basis any miscellaneous equipment they could spare, but they would not fabricate the plexiglass units or cover the cost of the electrical fixtures.

The project at this point became more than a one-to-one collaboration, and in accordance with this special situation, Newton agreed to apply some grant money he had acquired from UCSD to design and construct the power

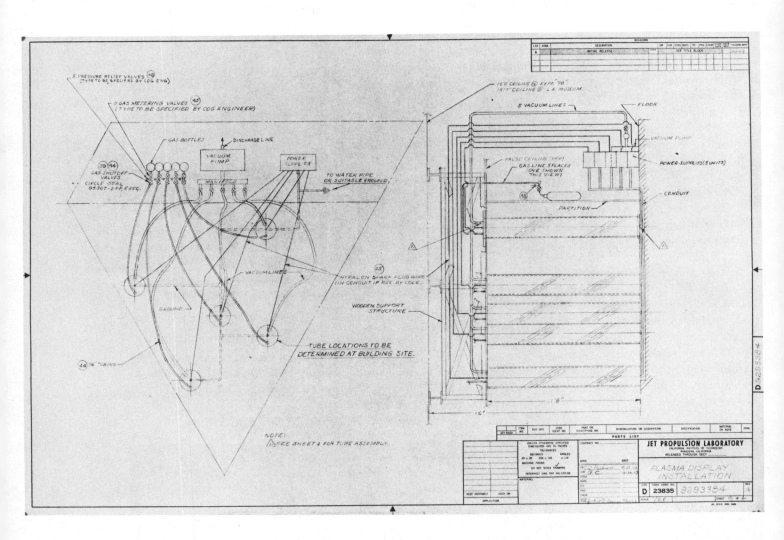

1

supplies (transformers and variacs) and gas injection
system. For this part of the project he pressed into
service Keith Carter who, from his previous experience
with the glow discharge, had the knowledge to carry it
through, using the metal and electrical shop facilities at
UCSD. Fabrication of five plexiglass tubes was done by a
local plastics firm and paid for by the Museum's A & T
"materials" budget.

By August work had begun on all three of these fronts,
and by this time we were considering Harrison's sculp-
tures as likely for the Expo show. For a time, the design
of the installation became a collaborative effort involv-
ing all of us. In several meetings with Newton we discus-
sed various possibilities, including that of a total environ-
ment using liquid crystals in some kind of configuration
with the tubes. An idea Newton had had in mind for the
São Paulo Bienale was to make a liquid crystal pathway
which would change colors under heat and pressure from
the passing crowds. He now proposed using liquid
crystals in conjunction with the tubes, perhaps as a path
leading to the cluster of five light columns. We en-
couraged him to extend this notion further, suggesting
an arrangement of liquid crystals in a stepped formation,
ending at the columns. An alternative solution was to

design a corridor with the wall surfaces covered by the crystals and heat lamps spaced along the floor with an electric-eye device triggered by the passing crowds who, by their movement, would control the color modulations in the liquid crystals.

However after considering all of these notions, Harrison decided that the tubes would have greater impact if they were displayed by themselves, dispersed in a carefully worked out configuration in a room devoid of ambient light. The spectators would pass through the grouping of columns, actually coming into contact with them and possibly altering the glow discharge by interfering with the electrical field.

In October, after delays in fabrication, testing began on the tubes at JPL. Several technicians, primarily Ray Goldstein [2], first ran tests designed to examine various kinds of stress on the structural strength of the tubes, and the results showed a safety factor of 7.0 above the expected loads. (Safety factors of 4.0 and 5.0 are typical in engineering design.) Harrison and Carter began experimenting with the phenomenon itself, manipulating its three elements—the gases, electricity (in the form of a

heavy duty neon sign transformer) and a vacuum pump. One of the first things they discovered was that the range of visible effects in a twelve foot column was, as could be expected, much greater than in a three foot bell jar. Harrison gradually became able to control a wide range of color-shapes and configurations which became his formal vocabulary.

His initial conception had included certain key prerequisites which he later outlined in an interview:

I wanted this piece to have a participatory quality. I found that by touching the tube, a human being could alter what was going on in there because inside those chambers are electro-magnetic fields and a human being is a resistor, I guess, and so his field interferes with what goes on there or affects it. So now I had at least one element that I could call participatory about it.

The next thing I wanted was a certain kind of configuration. If you have just a beautiful glowing tube, the metaphorical possibilities are limited, but the minute lightning arcs start occuring, you have a frankly frightening object.

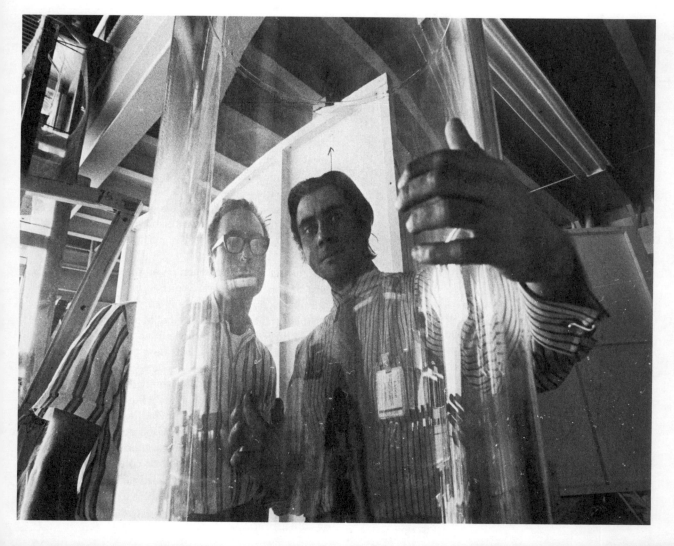

2

I wanted them to be simultaneously beautiful and scary and eerie and contemplative

After the tubes had been running constantly for about fifty hours, the plastic surfaces began to cloud over, obscuring the configurations and movement of light. Because the glow discharge is used only intermittently for scientific purposes, such chambers in the past rarely developed this defect, and the technicians were not prepared for this contingency. A spectralanalysis of the clouding indicated that the ion bombardment was cracking the surface of the plexiglass. Keith Carter discovered, quite by accident, a possible solution. Applying a silicone grease to the interior surface of the cylinder would, he found, protect against ion bombardment and the consequent obscuring effect.

In December the plexiglass columns and all miscellaneous equipment were shipped to Osaka. Before the tubes were en unpacked, the Japanese Safety Commission for the World's Fair refused to allow them to be installed, fearing that the vacuum chamber and gas injection might implode or that crowds touching the tubes might receive an electrical shock. MT made emergency calls to us at

the Museum, and we in turn contacted Bartz and Meghreblian requesting a letter explaining the extensive safety precautions taken by the JPL staff. Bartz wrote a statement describing the electrical design of the tubes, concluding with the statement that "touching the surface of these tubes is no more dangerous than touching the surface of an ordinary fluorescent lamp." The Japanese authorities were persuaded to allow the installation to proceed.

At this point another problem arose. On one of the tubes, which had undergone the most experimentation and testing at JPL, a solution had been applied which cleaned the interior surface, but it also caused small fissures and cracks in the plexiglass which did not appear until after transit to Japan, where Harrison discovered them. [3, 4] With the opening deadline rapidly approaching, this tube was sent to a local Japnaese plastics firm in a last minute attempt to polish out these imperfections.

Before coming to Japan, Newton had spent several weeks working out a placement scheme for the tubes. His intention was to avoid a geometric configuration and

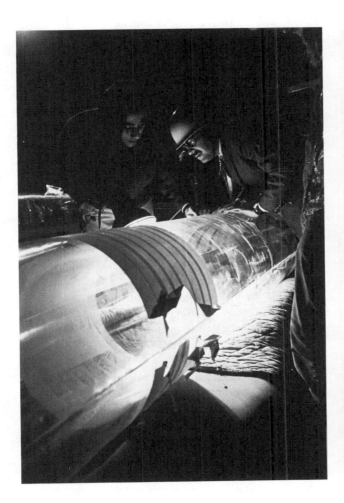

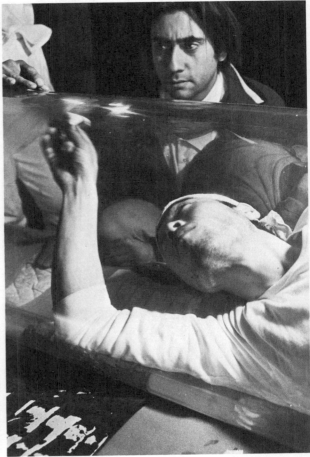

3

4

to arrive at random appearing arrangement. With the programming assistance of Jeff Raskin at the UCSD computer center, he had attempted to achieve a random disposition but abandoned this method because, in his own words, "every time I obeyed the computer and placed tubes randomly the results looked calculated." He then used full-scale cardboard models and experimented with them in the UCSD art gallery, marking off the size and shape of his area in the Pavilion. He went on to say.

I ended up choosing an array that had two columns very far apart. By having two as far apart as possible, I was able to make one column brighter and one column slightly dimmer, and so when you stood at one end, the space expanded or compressed, depending upon which end you were looking at, by virtue of light constancy. I felt it was very important that the columns, exclusive of the light, energize the space. I also put two columns very close to one another so that a sense of surround could happen, with one uncomfortably close to the wall so that a little pressure to the wall would tie the whole array to the room. [5]

Once the tubes and vacuum pumps were in place, the ceiling to support the vacuum pumps completed, and the scaffolding removed, Harrison was finally ready to determine the composition of each chamber. Months of research, design and testing were merely preparatory steps to the process of actually creating the piece. Throughout the preceding eighteen months, both with the bell jar display in his studio and with the actual tubes at JPL, Newton had familiarized himself with virtually every relationship of color, shape, and movement of which the system was capable. He had purposely avoided deciding beforehand which gases would go in

each tube, so that he could manipulate the numerous possibilities in the space itself. Newton later described how these final choices came about:

. . . in the first tube I put an arc that was a mixture of helium and argon. The helium helped the arc path; the argon guaranteed that it would be a shocking

pink-violet arc. We set it up so that the gas was injected in such a way that it started out as lightning, stayed lightning for about two minutes; became an arc; stayed the arc for about three minutes; became a glow—a total glow in the tube; . . . the glow started to break down into platelets and then I shot more gas in so it would be an arc again. This was a ten minute cycle. I found out strange things. I had originally

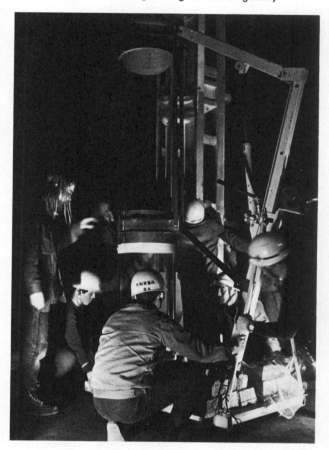

wanted to make it just lightning for five minutes. But lightning for five minutes was a bore. Lightning for four minutes was a bore. Lightning for a minute and a half to two minutes was exciting and lightning flipping into an arc every six minutes say, had a right sense to me. That flip was very important, and if I lengthened the time between the flips, it became less frightening. One of the things that is frightening is sudden and unexpected change, so I used sudden change as a time frame system.

We took the far tube and put nitrogen in it, and started to run it from arc, to mass, to space. Through the color changes that are involved in that, I started to play with timing. I found out that if two tubes arced at once, they gave each other away. But if they would arc at different times, we quadrupled the sudden change that was going on as well as strengthened the dialogue. So I programmed the nitrogen at the far end to go into an arc state only when the first piece was in lightning form or in mass form. If you

5

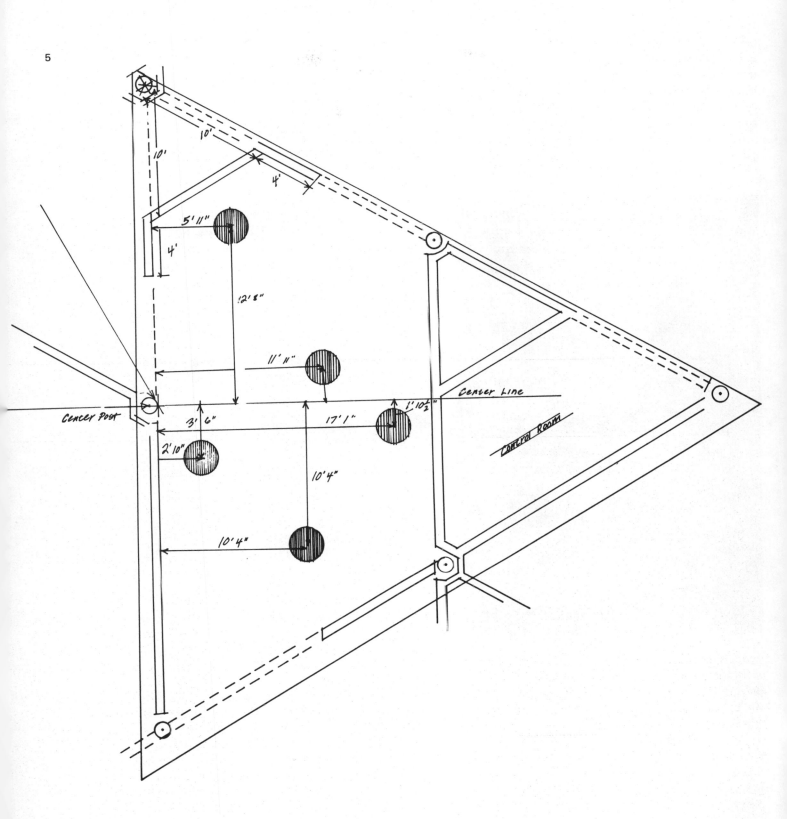

make a painting out of day-glow colors exclusively, they cancel each other out. They have an acidity in common that makes you tire of them quickly. I found out that all the gas colors also have a certain acidity, a low-key brilliance in common. The difficulty was to cancel that sense of commonality in the gas. Keith, with great delicacy, resolved the critical timing problem. I chose in one tube to use neon

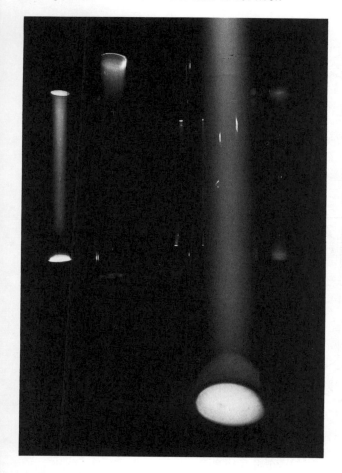

which is orange-red and in another helium which is green and white. Then I had one tube left and after playing with it, introduced CO_2 to it. It was bluish-white, and as a color it talked a bit to the lightning, and argued a bit with the rest of them, but it made strange platelets that were very narrow and then turned into bubbles. I found out that when you touched those bubbles, they were responsive to you too; you could actually raise or lower a bubble of light

I was involved in creating a friction. The cylinders look very organized; they are very contained; they are very sedate. I wanted to create a friction between the neatness and the elegance of the cylinders and the sensation of the sudden release of more power than you had ever seen before in one place. When that floppy arc happens, you cope with that. The eye tells you everything is contained and safe; your experience says I doubt it. It's the friction between those two

responses that I was interested in, rather than either response. The whole piece has that kind of an attitude in it.

When Newton had finished programming the cycle, the group of sculptures suddenly came together as an esthetic entity. It was an exciting moment. The element of timing is the critical factor, as Harrison said:

> The cycles run from ten minutes to forty-five minutes, and to really see how the thing works, you have to spend about ten hours with it, but nonetheless, you could know it in a non-rational way, feel it, in about two or three minutes, and that was a very tough problem which conditioned how fast I made the spaces grow. For instance, if the spaces grow too fast, then they look tricky, but if they grow slowly, it's too slow to see but it's suddenly there anyway. I like the idea of playing with slow and fast changes and transformations. There is a much slower than heartbeat change, and then there are abrupt changes; the work becomes a study of small differences and changes.

He also described some of the specific intentions he had. An interesting example was a color configuration, in one of the tubes—a rose-white hue—which hovers on the top and bottom with an empty space in the middle. Newton explained this as,

> . . . just what Rothko was dreaming about. I knew what he was doing He was trying to make paint do what paint could never do, although he got his work to cast a light. The far tube to the right I really made a sort of private homage to Rothko. I made a very specific reference to him. If you looked at the shape on the top, it was a Rothko type shape, a Rothko color shape, a Rothko intensity shape and it was surrounded by a dark field. This was my way of acknowledging a man whom I thought was involved in a kind of magnificent and very lonely vision.

Newton also described a further fantasy about the work:

> . . . The variables in it were sufficiently simple so that we could use one of the brainwave converters and once a person had played it with a control panel, he could undergo further transformation and work the thing by alpha waves alone. At that point, you could call in storms by your own mental activity. I would like the work to be such that a person could be so familiar with the keyboard that he could then put the cap on and experience a whole other kind of control and activity. This kind of experience might be interesting scientifically. Until now we've been working with state-of-the-art technology, and one shouldn't see these works as 'science.' It's really engineering.

In retrospect it was the opinion both of Newton and of the JPL staff that although the project was perfectly suited to the laboratory's capability, the collaboration

itself—interaction between the artist and the scientists—was not as extensive as it might have been. Dr. Meghreblian commented that one of JPL's reasons for participating in A & T was to establish a staff interaction with an artist, but that this objective was only partially realized because executing the project involved so few personnel. Those individuals, however, did make a significant contribution, specifically in the design and

in a studio was to do painting and sculpture. As I abandoned the concept of myself as an artist, I began to think of myself as a problem solver instead. This was very much enhanced by my experiences at JPL

What I've reached is something else; I'm now almost uninterested in offering single pieces of art. What I do

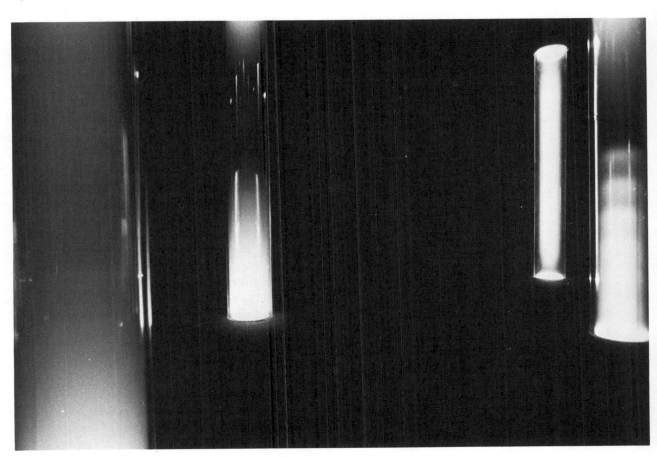

testing of the chambers. But because of JPL's financial limitations, Newton had to rely on sources outside the host company and consequently the real collaboration took place between him and Keith Carter. Carter made a major innovative contribution in the design of the gas injection system and in working out the final timing sequence of the tubes.

Nevertheless, Newton's A & T experience was valuable in provoking changes in his attitude toward his work:
> My whole sense of priority has changed. Normally, artists have a fierce, one-pointed preoccupation with making a form of art, and end up censoring and cancelling anything that appears irrelevant. I find that attitude personally destructive. My own growth came as I tended to give up the designation of artist, giving permission to myself to be as diffuse as I choose or as focused as I choose. As a result I abandoned my studio about a year ago and have only been in it to assemble things. I no longer think in my studio. To be

comes out of interaction of all kinds. It might be interaction with something I have seen, but I find it's more productive to interact with human beings: they can talk back I have ceased making art by myself. As an activity I find it uninteresting, and I am appalled by the isolation that surrounds the artist's approach to his work. So many people find it natural and inevitable. I surely don't.

The real learning experience in this multiplex collaboration was my own development of a way to admit people into my process immediately past intuition rather than at the much later point when formalization takes place. I am now experimenting with executing works with people during the intuitive state or even in advance of it and in search of it.

A tangible extension of this conclusion has been developing in the months since the Expo show. While watching Newton operate the chambers in Japan, John Fork-

ner (the engineer on Whitman's environment) commented that the glow discharge phenomenon works in much the same way as the aurora borealis. Intrigued by this way of looking at the glow discharge piece, Newton conceived of making an artificial aurora borealis and has since been pursuing the problem, trying to resolve the logistics of its execution. It would involve projecting a rocket into the ionosphere which, when fired, would activate the ions in much the same way that a plasma functions in a glow discharge, creating a similar effect on a grandoise scale. Newton met with Dr. Feynman, who agreed to attempt to procure small rockets and permission to use a launching site through his contacts at NASA. It remains to be seen if these efforts will be realized.

Gail R. Scott

The photographer Erich Hartmann saw MT in New York in December, 1968, and wrote to us later that month:
Since I saw you I have speculated and daydreamed pleasantly and repeatedly on which corporation would interest me and what sort of work within it I would propose. But although this is fun, it is finally self-defeating. It cannot help but sound like a sales talk for myself and even worse, it attempts to make predictable what should not be predictable if it is truly to fulfill the purposes of the project. Ergo, no concrete proposals from me.

Instead, I want to give you the state of mind, the attitude, with which I would approach this project regardless of the industry, the products, the people, the underlying ideas involved. I would first of all attempt to *sense* who and what they are, what they make and how they make it, their underlying principles of concept and design and manufacture. I would want to do this with all my senses, without preconception of knowledge or experience, but using instinct and intuition. I would want to soak up the place and the people and the environment until I were full like a sponge, hearing conversations reverberate in the mind's ear and seeing previously seen sights in the mind's eye long afterwards. Only then would I begin to ask of myself and of others the questions which signal the entry of intellect and of the desire and the need to organize experience into something meaningful and expressible and understandable.

Most important of all, during all of such a project, I would intend to address myself on every level of perception possible to the meaning of the project itself, Art and Technology, to the attempt and the effort to fuse the two entities into an expression of their relatedness. My belief is best expressed in a sonnet by Francis Thompson: 'All things, Near or Far, Hiddenly, to each other linked are . . . '

What this frame of mind together with experience and skills, plus the stimulation of the host environment, would yield for the 1970 exhibition I don't know and cannot possibly foretell. Perhaps it would be photographic or in some ways related to photography, perhaps not. From my core as a photographer I have ventured into other fields, not always related to photography, such as graphic and conceptual design, a personal blending of words and images, into the design of three-dimensional structures and objects to convey the feeling and sometimes even the meaning of complex technological ideas like programming for computers.

Robert Irwin
Born Long Beach, California, 1928
Resident Venice, California

James Turrell
Born Los Angeles, 1943
Resident Venice, California

One of the first artists with whom MT seriously discussed joining A & T was Robert Irwin. Irwin's initial reaction to the idea of working within a corporation was to express skepticism—not about his own ability or desire to collaborate intensively with engineers or scientists, but about the structuring of the program [see introduction, p. 12]. Once the artist was persuaded to visit corporations and sign a contract with us, his involvement developed into a virtual life commitment. Indeed the ramifications of the "Irwin/Turrell/Garrett project" so far transcend the immediate parameters of A & T that it is not possible for us fully to know, much less to document, every phase or outcome of the ongoing work set in motion by the original A & T connection.

In August of 1968, Irwin toured two Patron Sponsor Corporations recently signed with us—Lockheed Aircraft Corporation and IBM. With him and our staff on the Lockheed tour was R.B. Kitaj [see Kitaj section]; they visited Lockheed's Rye Canyon research center, as well as the Burbank aircraft production complex. It was evident even during this preliminary view of a corporation that Irwin, unlike Kitaj, was not interested so much in industrial fabricating techniques as in the more abstract areas of theoretical experiments in perceptual psychology. At Rye Canyon, there was an anechoic chamber (a room heavily insulated against outside noise stimuli and thus non-reverberant), and a chamber into which sound and visual stimuli could be introduced for the purpose of testing human responses to various sensory phenomena. These were precisely the kinds of research facilities to which Bob wished to gain access. According to notes made by Gail Scott following this tour, he asked to locate a Lockheed specialist with whom he could discuss "acoustic coatings—what he wants is architectural acoustics. Wants to do an environment using optics, acoustics, lasers, etc. without any mechanism exposed."

On the IBM tour Bob was accompanied by Cal Tech physicist Dr. Richard Feynman; they spent two days at IBM's enormous San Jose complex. Again, Bob was most drawn to investigate the laboratories researching human responses to special environmental situations. The IBM San Jose facility is equipped to deal in areas seemingly far afield from the production of computers—there are elaborate physics and chemistry labs, for example—and, although nothing came to develop between Irwin and IBM, the tour, especially through his close contact with Dr. Feynman, was an extremely rich experience for the artist.

A match between Lockheed and Kitaj was effected in September but Irwin arranged to consult with Lockheed's Don Christiansen, of their Public Affairs office. Bob drew up for Christiansen a rough listing of techniques and experimental phenomena he wished to study:
Space craft cabin/support environment:
investigations necessary to determine what perceptual awarenesses are necessary for basic orientation and stability.
sound—what kind, how much, interrupted? natural environment noises for attention, sleep, etc.

visual stimulus for attention, orientation, space, sitting

tactile—touch orientation to instruments, space of capsule

how much can be corrected through training or assumed/what kind of training?

what kind of equipment was used to gather this information? Ganzfield sphere, anechoic chamber, etc.

How was this information applied to the design of the capsule? visual information of instruments, sound information, how much sense of control was built in and not entrusted to the astronauts.

all information where man's sensual awarenesses were tested with conclusions of degrees of awareness/ human prowess (sighting of specific objects on the earth) basic necessities for maintaining sanity.

Materials:
Morano
light properties of paint, ceramics, materials with abilities to diffract, diffuse, curve light—high absorption or reflectivity. Materials with special sound properties—deadening high reflectance, etc. how do they protect the men from the sound during liftoff? ability to change any perceptions of sound.

Optics:
any materials with optical properties. diffraction gratings screening materials—diamond or triangular shaped thread. rear screen projection screens, glass or plastic.

gases for flames/optical projection screening lights— xenon, quartz-iodine point sources (as close as poss.)

lenticular screening materials. polarizing any particular surface, wavelength, etc.

Light, color, weight and density in the open air:
Vandenberg vapor trails
chemiluminescence or electroluminescence
coronas and halos and 'glorys'
ice crystals, iron filings

lightning balls—plasma
visual observation and photos of sound waves
Schlieren images and shadows images
electrical fields around the earth—glowing Van Allen belts

When he gave us a copy of this outline, he spoke to us about his general intentions, here recorded in memo form:

Bob knows exactly what he is interested in technically (see his own report of his fields of interest), and was very persistent in asking the various experts at Lockheed for specific information. He will carry on himself with Don Christiansen, although he will not be working at Lockheed. He wants to collaborate on a project with Jim Turrell, perhaps at JPL.

Generally Bob is involved with perceptual psychology:
Processes of receiving and reacting to information. He wants to find out more about the application of studies and equipment used in recording people's reactions to light, sound, color, weight, density, etc., before he even starts to work out a project.

We learned at this time that Irwin had been in close touch with James Turrell over the Summer of '68, and that the idea of collaborating with the younger artist on a project for A & T had apparently been in his mind for some time. There can be no doubt that Turrell had suggested to Bob many of the concepts he was exploring with Christiansen at Lockheed and with Dr. Feynman. Significantly, he attached to his outline for Christiansen a bibliography compiled by Turrell of books and articles on perceptual psychology. Turrell, having had considerable academic training in psychology at Pomona College, had more direct access to literature in the field, and had a greater understanding of experimental methodology than Irwin. Bob, however, had for years been intuitively dealing with certain subtle aspects of the psychology of perception through his work. When the two artists met and entered into a period of intense dialogue, they both felt a sense of extraordinary potential—it was as if each had found in the other an ideally complementary source of information. Irwin brought to the relationship his long experience as an artist and his highly evolved esthetic sensibility; Turrell had an intellectual background, and thus a verbal knowledge of theory and technique, which could open wide new possibilities for application by Bob or both artists together. [1, Turrell at left, Irwin right]

When it was proposed to us that the two artists enter into corporation residence collaboratively, we agreed without hesitation. We weren't certain whether Jet Propulsion Laboratory, where they were eager to work, could provide a satisfactory degree of commitment,

since they were not a Patron Sponsor Corporation and had placed definite limits on the extent of time and money they could afford to put into the project.

There was, however, another aerospace-oriented corporation contracted with the Museum as of May, 1968—The Garrett Corporation—which we had not yet matched with an artist. (The young Canadian artist Iain Baxter, and kinetic sculptor Len Lye had both toured Garrett, but nothing came of these encounters.) In November, 1968, it was arranged for Irwin and Turrell to meet with

1

Tom Vanides, our contact man at Garrett, and Dr. Ed Wortz, Head of the corporation's Life Sciences Department in Torrance, California. This preliminary meeting—attended by us and Dr. Feynman, as well as the artists—was one of the most exciting and spontaneously productive occasions of its kind we attended during the entire course of A & T. It was immediately evident that Dr. Wortz's interests and field of research were precisely parallel to those of the two artists. Wortz has a Ph.D. in Experimental Psychology from the University of Texas. He has been with Garrett since 1962. The nature of his work at Garrett is directly concerned with human perceptual responses in special conditions: the Garrett Life Sciences Department has been importantly involved in developing life support systems for manned lunar flights. Wortz has done considerable research on the problem of actually walking on the moon—this implies such considerations as the astronaut's perceptions of space and perspective when he is near or on the lunar surface, what his physical and psychological tolerances are during various phases of his exertions, etc.

On the basis of several preliminary meetings between the two artists and Wortz, it was agreed to proceed with an artist-corporation match. Artist contracts were signed, and the collaboration proceeded. Irwin and Turrell met

frequently with Dr. Wortz—sometimes at Garrett, often at one of their studios, or at Wortz's home—from November through July of 1969. [2] In January, Wortz moved with his family to Manhattan Beach, primarily in order to be nearer the two artists.

The areas of investigation pursued during these months were manifold. For the first two months, the artists were definitely working toward the designing of a structure for the Museum exhibition. (This plan was later abandoned for several reasons.)

The following statement was formulated in January, 1969, as a tentative proposal for a course of action:
Project Art and Technology's time schedule is seen in three parts, first six months devoted to development of overall perceptual thesis between the principals, Dr. Ed Wortz, and artists R. Irwin and J. Turrell, the basic perceptual research to begin in January 1969, with the cooperation of Jay Dowling, UCLA Psychology Department, with students of that department and forms of stimulus complexity/uncertainty considered for the project.

Begin planning physically, forms and means considered, development of a number of possible working spaces, and various ways of implementing the physical needs of the thesis.

Research in depth, tools, materials and people necessary to implement or expand project.

The second six months, having arrived at the basic format and physical plan, a space will be leased to build and then refine the actual working space, methods of entrance, exit, control of elements, input of stimulus, etc.

Research will continue with a variety of subjects in actual working space, to determine and refine time spans, positioning and final working of the project.

Physical structure will then be dismantled and reassembled in the Los Angeles County Museum, in keeping with the time schedule for the 'exhibition.'

The project is seen now, by the principals, to involve four periods of perceptual change, plus and minus, each working with the states of consciousness.

PART 1 A queuing area, to be seen as a part of the museum, but isolated, sound dampened, 2 or 3 persons at one time. This area to develop a time span and positioning for Part 2.

2

PART 2 Sensory Deprivation

 a. one person for a period of from 6 to 15 minutes using an anechoic type space.

 1. This space to be fully sound dampened and in total darkness.

 2. Time span to be experimented with using subjects to determine optimum lengths.

 b. Person to enter with as little orientation to size, shape and his position in space, as is possible.

 1. Entrance should obscure outside scale, and position of room within museum space.

 c. Within first minute or two, stimulus to be introduced/visual, audio/to define a space on his senses and to focus and heighten attention on his sense awareness. This is to be done near his area of expectancy.

 d. Events not to be repeated. This will leave him with a lingering anticipation and a form of participation; in his sense isolation his focus should fall back on his own sense phenomena.

 1. The sounds of his own system, retinal color fields, etc.

 2. He could back into a subtle form of meditation.

 e. Sensory deprivation seems to alter the orders of our established sensory dependence.

PART 3 Sensory participation/controlled input, person to enter directly from deprivation space, to spend 6 to 15 minutes.

 a. Content of this space to be seen as a singular sense experience, to see space as surrounding and positive.

 b. Stimulus information to avoid any imagery identification/non object/a major objective is to make all stimulus harmonious.

 1. Development of sensory crossovers/ the support of any awareness or positioning by the use of more than one sense.

Over a one-month period, from mid-January to mid-February, James Turrell periodically wrote up formalized notes on the Garrett project, outlining the possibilities for the Museum "sensory chamber" and stating general observations about his own—and, by implication, the team's—overall intentions and philosophy.

PROJECT WITH GARRETT 1-15-69
Possible setup with three spaces:

1. queuing area—preparatory area
sound dampened, less complex than the outside world, time: 5-10 minutes

2. anechoic chamber
entrance from chamber 1 is obscured by either a blind wall or curve.
visitor is seated in chair in reclining position with head mounted in center of space
size of room: a cube, approx. 12 x 12 x 12
sound dampening elements flocked back
The chair the visitor is seated in is constructed of moveable parts which will slowly flatten as it is hydraulically lifted up to the third, upper chamber so that the visitor will end up prone on the floor of the upper chamber.
there will be no light or sound stimuli at first in the chamber, and any that will be presented will be determined by forthcoming experiments; expected stimuli will be something on the order of sub-threshhold light flashes and sound flashes 'reorienting stimuli'; these stimuli will increase gradually to the point which seems to be between hallucination and reality.
time spent in chamber will be between 5-10 minutes.
This chamber is a sensitizing situation for the following chamber as well as a unique experience in itself.

3. upper chamber
domed, cylindrical, semi-translucent for back projection, constructed of seamless plexiglass.
visitor's first sensation of this chamber will be that of experiencing a Ganz field.
The space will have a sound quality and a light quality which will be manipulated; we do not plan to use any images per se, but are more interested in changes in light quality, color temperature of light, intensity of light, pulsating effects. We are interested in having changes take place behind the person, or on his periphery, therefore there is a need for a tracking device to determine the position of the viewer.

4. Leaving the upper chamber:
 The platform reforms itself into a chair.
 The visitor sits on it and descends back into the
 anechoic chamber which is lit, a door opposite
 from the entrance opens, and the visitor exits
 through it via a tunnel to outside of the museum;
 the tunnel becomes gradually less sound absorbing
 as it approaches the outdoors.

We are working with states of consciousness and
awareness.

Find out about the sound device that makes a wall
act as a speaker. Bob Eriser deals this product for a
company called Rollen Star.

To decide the best use of the anechoic chamber we
will do some experiments with the chamber at UCLA
studying the effects of:
 length of time in the chamber
 visual stimulation
 auditory stimulation
 kinesthetic stimulation
 and combinations of these variables

We will seek results dealing with the S's thresholds,
JND limens, likes-dislikes, and their impressions of
any hallucinations or changes in psychic state while in
the chamber.

We'll also try to find how to produce the proper set
for the next space, the next experience.

Subliminal word 'spacing', tatistascopic exposures

PROJECT WITH GARRETT 1-21-69
Technology is merely a means—not an end. Techno-
logical instruments are extensions of ideas, i.e.: they
measure what you already think is there, what you
have decided to measure.—Symptoms—not necessarily
what is significant.

Allowing people to perceive their perceptions—mak-
ing them aware of their perceptions—We've decided
to investigate this and to make people conscious of
their consciousness. We're concerned with manipula-
ting the conscious state.

Sense of sensing: awareness of perceptions, a reflexive
act. Working with the sense of the senses—a change in
value.

working with non-verbal experience

This project, we believe, is an extension of our work,
just as our work is an extension of some mainstream
of modern art. A problem may arise with this project
in the minds of the art community who may regard it
as 'non-art'—as theatrical, or more scientific than
artistic, or as being just outside the arena of art.
Although it is a strong alteration as far as methods,
means, and intent, we believe in it as art, and yet
recognize the possibility of a redefinition needed to
incorporate it into the 'arena.'

The necessity for this statement stems from the fact
that this project will ultimately be dealt with by the
art world, not so much the scientific world, though
this might not be unwarranted, and therefore we are
held to the dialogue of the art community and are
subject to its reviews and criticisms. Thus we feel we
must make our position clear, that we feel our project
is not inconsistent with what has come before. (How
can it be?)

If we define art as part of the realm of experience, we
can assume that after a viewer looks at a piece he
'leaves' with the art, because the 'art' had been
experienced.

We are dealing with the limits of an experience—not
for instance with the limits of painting. We have
chosen that experience out of the realm of experience
to be defined as 'art,' because having this label it is
given special attention. Perhaps this is all 'art' means—
this Frame of Mind.

The artist singles out that which he feels needs to be
experienced. Possibly because it hasn't been experi-
enced enough—is rare—When it has been experienced
(on a cultural level) this isn't necessary and may no
longer be within the bounds of 'art.' Hence, everyday,
common objects, acts, forms of another culture (i.e.,
Japan) may seem close to art for us but to those of
that culture they are just part of their everyday
experience. The object of art may be to seek an
elimination of the necessity for it.

Much art today appears unprofessional, some artists
as revolutionaries, attacking existing structure, others
are involved in construction of new structures, all
artists pass through many stages in their development.
Need for some perspective to tell where trends are
going and where artists are in relation to each other.

Plans for continuing to work together after complet-
ing this project include retaining the space that will
be rented for this project. There we can build en-
vironments and so experiment ourselves, and/or
interest universities to carry on with some of the
facets of our work. The project may open new areas
of work to be involved with.

Discussion of an experiment: S's isolated up to 72

hours with auditory, visual and tactile deprivation. Results: ½ S's had progressions of alpha, beta, and delta rhythms, others experienced digressions of these rhythms—effects of deprivation ran both ways—maybe effects are dependent on the attitude of the S (whether he got into or withdrew from the experience).

We can consider this study to be done on poor experimental design, and we don't accept the results that sensory thresholds were not changed after deprivation. This is because the deprivation consisted of being blindfolded, earmuffed, and hand tied.

One finding relevant to our work was that the changes in the brain rhythms depended in part on the time of the day, for example, circadian rhythms exist only in late afternoon and early evening.

Sensory experience is heightened when sense modalities act in phase. Consciously trying to bring them into phase destroys the effect: *not necessarily true.*

The work we have selected to deal with is interesting to art by the fact that it is what artists have previously been envolved in, yet have never approached exhaustively. The works of previous artists have come from their own experiences or insights but haven't given the experience itself. They had set themselves up as a sort of interpreter to the layman. A change of this trend began with non-objective painting, the abstract expressionists, who were involved with the idea of 'it is the thing itself.' Today, Pop artists are into extensions of this thinking. Our interest is in a form where you realize that the media are just perception.

Dealing with states of consciousness is like a drug experience: most people hold back from going through—experiencing—the new until they have correlated it to something already known, whereas the artist may be unique in that he seeks the new experience, and lets himself go accepting it as a unique experience.

In the project we have designed, there is a cleansing situation where the people may relax and be able to open up—to be able to experience something unique.

PROJECT WITH GARRETT 1-25-69
Make certain viewer is aware that the experience is formed within, that *he* forms the experience, gives it substance.

While he is in the anechoic chamber, the visitor is being set up for the experience in the upper chamber, if a different space is even to be used, so aside from it

being an experience in itself, the anechoic chamber is also a preconditioning situation.

The viewers must assume the responsibility, they get into the experience, and they make the art—they are the actuality.

Concerning the statement we are writing about the project: 'what we tend to accomplish is to bring you to an awareness of perception, of perceiving yourself perceiving, pressing the information against the senses—making the sense of reality a sense of the senses.'

'. . . instead of placing our images on an object, we will define a non-object situation in setting up the boundaries of experience to be perceived . . .'

(now explain what we are trying to accomplish) The experience is the 'thing,' the experiencing is the 'object.'

Instructions to visitors? that's asking them to make enough of a change from their normal state. The quality of their involvement is dependent on the degree they play the game, but we need something where the setup of the thing makes them want to play the game. Hit them at the level of expectancy so they become engaged and then manipulate them to our level—a seductive act.

Therefore, whatever we do should begin at *their* level of expectancy, i.e., in the anechoic chamber, the presentation of the first light stimulus can act to define the space and that will excite them, yet at the same time it will do what we want, to get them looking at their retinal field after the flash, therefore getting them looking at their own eyeball (to look at their looking), and listening to their own ears.

PROJECT WITH GARRETT 2-10-69
Queuing or conditioning area:
Start with realm built with selected vocabulary, non-literal. The space will be museum-like, with 2 or 3 people keeping them there as long as we desire. We can program people there using words to produce a thought-idea continuum which would have no literate context. The words can either be presented audibly or visually or combined somehow. They can start off as subliminally presented moving toward conscious presentation. The more spatial the presentation, the more effective it will be.

Find words through dictionary and thesaurus, and form groups of words as we like them. Categorize them as to: object-words, sound-words, action-words, state-of-being-words, place-words, sensual-words, etc.

Must structure the forms we want, so they corres-
pond with experience we want them to have. Also,
must think in terms of the multi-level input we are
creating and structure it so that it is understated
rather than over-whelming.

We must choose words to correspond to the experi-
ence the people are going to have, i.e., pick words
that describe the space of the anechoic chamber.

What we are dealing with are meditative states. The
preconditioning sets up state of meditation, so when
they leave the first chamber they will be in that
encapsulated form. Then we want to take them
slowly out of that form to a specialized space where
they change from being oriented inwardly to their
own space or a space awareness that extends maxi-
mally 6 feet around themselves, to where they push
their experience outward to the space outside.

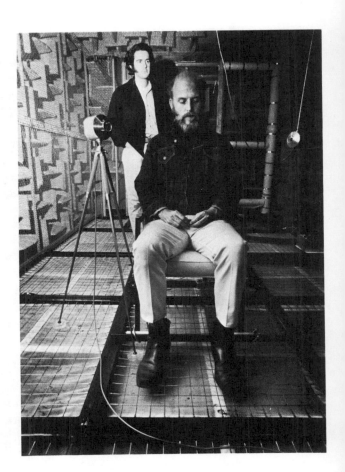

Quote from Blake: 'If the doors of perception were
cleansed, everything would appear to man as it is,
infinite.'

Try to deal with the space the words make, as if each
word had the power of a mantra. Remove it from any
literary connotations, so that the word is denoting
portions of your thought-idea continuum or portions
of your mental space, rather than connecting itself
literally to other words. Thus making the word an
image-conjuring, spatial-feeling, sentient-feeling
device.

Time is illusionary, events make the time.

There is no such thing as modern art, there was art
that was done then, and art that is done now, art is
equal.

All art is experience, yet all experience is not art. The
artist chooses from experience that which he defines
out as art, possibly because it has not yet been
experienced enough, or because it needs to be experi-
enced more.

All art-world distinctions are meaningless.

Several experiments were devised, principally by Turrell,
to test subjects' responses to special environmental
conditions which might be designed for the Museum
environment. These were written up in January:
 Investigations
 The following are a series of studies that we plan to
 undertake before deciding upon the finished structure
 and form of the experience we are to present at the
 end of our contracted association with the Garrett
 Corporation and the Los Angeles County Museum of Art.

These studies will begin with our own observations in the anechoic chamber and will later involve a number of subjects. The investigations will be amended as necessary to accommodate our findings as the study progresses.

May change order.
May alter experiments.
May eliminate experiments.
Want results not explanation.
Mainly based upon personal observations.
Will use subjects when whether we sense something (i.e., when we know what we are about to sense) or not is a question.

Experiment Schedule
Experiment I: Investigate a person's reaction to the experience of an anechoic space and length of time in the space.

Experiment II: Investigate the experiencing of anechoic space when the person is brought into the space blindfolded, i.e., without prior visual knowledge of the space. Can't see space.

Experiment III: Investigate a person's reaction to the experience of an anechoic space when the person is brought into the space blindfolded and spatially disoriented, i.e., without prior visual and directional (spatial) knowledge.

Experiment IV: Investigate how the experience is altered when the space is strobed—made visible for an instant, i.e. whether and/or how a person's self-generated space is changed when the actual room space is made known for an instant. Alternative strobe with strongly colored light (violet) so that space is not identified—but a color field is created on retina—some color field is experienced without stimulation.

Experiment V: Investigate the experience of gradually introducing very low levels of light (varying colors gradually diffused) into an anechoic space after the person has been in total darkness and soundlessness. Light to border on its questionable existence—as to its being real or retinal field induced.

Experiment VI: Investigate the experience of gradually introducing very low levels of sound tones into an anechoic space. First hear the quality and kinds of sounds the ear (s) is experiencing in soundlessness— possibly use sound to draw different kind of space. See if subject (idea) of space can be changed in this manner.

Experiment VII: Investigate visual and auditory intersensory relations. (color-tone synesthesia) Area

of separate investigation prior to (taste tone, etc. Exp. VIII).

Experiment VIII: Investigate the relations of taste and tone by duplicating the taste and pitch experiments of Holt-Hansen. This experiment should be fairly easy to duplicate and requires a sound setup very similar to that needed for experiments IX—XI. This investigation may satisfy our needs for a great beer while familiarizing us with the auditory sense.

Experiment IX: Investigate the experience of a space and tone (what sounds feel proper in a space— whether the sounds that make a space resonate are perceived as most correct or pleasant, etc.).

Experiment X: Investigate the experience of light and tone in a space.

Experiment XI: Investigate 'word spaces' and whether any programming (loading or priming) prior to the experience of an anechoic space will enhance, heighten, or hinder the experience of that space.

Experiment XII: Investigate Alpha Conditioning.

Not all of these experiments formulated by Turrell were carried out, but Experiment I—with the use of an anechoic chamber made available to Turrell and Irwin at UCLA [3, 4]—was elaborately implemented. All in all, about thirty or forty subjects underwent the experiment, and were asked to record their responses. A questionnaire with one subject's responses follows:

EXPERIMENT I
INTRODUCTION: The purpose of this investigation is to determine a person's reactions to isolation in a completely dark anechoic chamber for a short period of time.

The periods of isolation for three different groups of people will be 4 minutes, 7 minutes, and 10 minutes.

PROCEDURE: The person is told 'We want you to come and sit in this room for a period of time and see what it's like.' (This set of 'looking for something' is not unlike coming into an art experience with a 'looking sense.') 'This experience is yours alone. No one is observing you. Afterwards we will instruct you as to what to do next.'

The person is taken into the anechoic chamber and seated. The light is turned off, and the door closed for the time duration. Ten persons will experience the four minute duration, ten the seven minute, and ten the ten minute duration. After the time is up, the door is opened, the light turned on, and the person is casually asked: 'How did it feel?' to obtain an initial

3

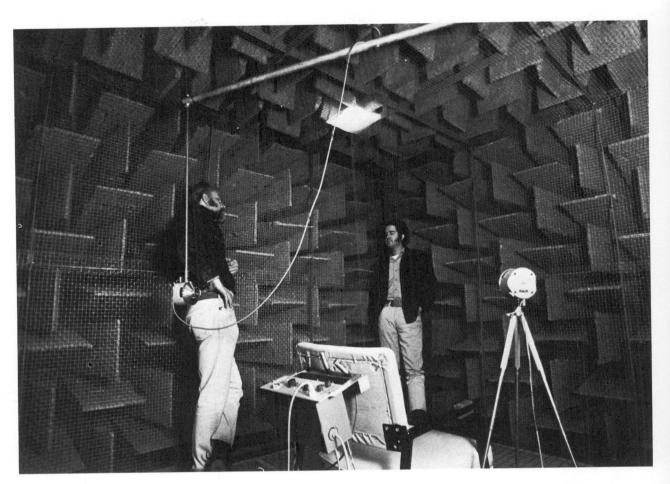

4

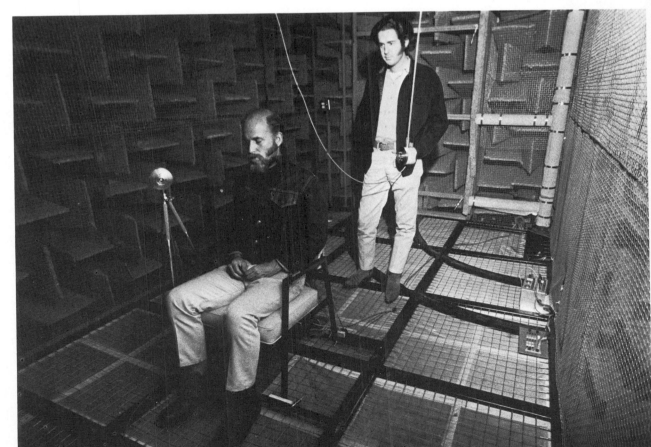

verbal reaction. The person is then asked to 'Please come out and be seated and fill out this questionnaire. Answer those questions you can.'

The questionnaire is a follows:
Answer any question that you feel is pertinent. Please add any impressions that you feel were not covered by the questions:

How did the room feel?
Subject: Hard to put a shape to it. Flat in front of me. Hallucinations had shallow depth. On looking straight ahead, I felt light converging on the sides as if from behind, but when I turned it was even darker.

What, if any, was the effect of entering the room?
S: Springy floor. Could be scary since it was dark.

What, if any, was the effect of leaving the room?
S: Waking up, bright, weird.

Describe the overall field after the light went out.
S: Shooting backwards through a tunnel. Blue-gray after-images on a darker-grey field. A shiny object to my left stayed with me then vanished.

What did you see?
S: Gray on dark gray. Rod-shaped blue things and lights swelling in from sides. Hallucinations (e.g., faces from weird angles—mainly looking up at them—focus on eyes and noses—mainly 'Christ-like' and 'blond-female' types.) and designs (e.g., fractionated planes) and colored objects (e.g., a red and green eye).

Describe the visual space you were involved in.
S: Dream-like. In fact, it was so hard not to close my eyes that much of what I did 'see' was partial dreams. Up and flat at 5 feet or so.

What did you hear?
S: Fast vibrating mechanical sound throughout, water sounds, walking sounds, stomach gurgles, bone creakings, when I clicked my tongue—it had a dull, faraway sound.

Describe the auditory space you were involved in.
S: Water sounds off right, walking behind me, vibration in my head, I was elevated from my body sounds.

What did you think while you were in the room?
S: Of falling alseep (felt guilty about this); of trying to think about these questions which I knew I would have to answer (i.e., concentrating on seeing and hearing mainly).

How long did you feel you were in the room?
S: Very long time—I don't know—timeless.

What sensations, if any, were intensified or modified while you were in or since you have come out?
S: Sounds are louder, no hallucinations now!

Did the air seem abnormal in any way?
S: Stuffy, a sneeze stuck with me for a long time.

Did you feel claustrophobic in any way?
S: Yes, when I tried to look around.

Were you relieved to get out?
S: In a sense, so that I would remember 'my dream.'

Did you want to stay in?
S: No

Do you meditate?
S: No

Age: 25 *Sex:* F

The artists also duplicated an experiment written up by Kristian Holt-Hansen, of Copenhagen University, in 1968, called "Taste and Pitch." The Holt-Hansen paper described,
> . . . a new method of quantitative determination of taste. In a special experimental situation Subject compares taste and pure tones. The latter are varied in pitch until Subject finds the pitch which characterizes the sample. The method is illustrated by results for two samples, Carlsberg Lager and Carlsberg Elephant Beer. New problems are involved within the psychology of perception.

Irwin, Turrell and Wortz were successful in confirming that there are definite "pleasure zones" of corresponding taste and tone—when drinking Carlsberg Elephant Beer, the tone (which could be manipulated by turning a dial connected to earphones) that produced a sense of harmony with the taste of the beer was 650 Hz.; when drinking Carlsberg Lager, a less sharp-tasting beer, the pleasurable tone was about 10-15 Hz. Certain tones produced no effect on the taste of the beers, but when the relationship occurred, i.e., when the tone was at the particular pitch cited, the beer tasted distinctly better.

The artists were interested in exploring the relationships between tone and color perception, as well—Wortz at some point provided them with information in this area of colortone synesthesia—though they didn't actually engage in formal experimentation. The principal aspect of their work in visual perception had to do with Ganz fields. According to Wortz's description, a Ganz field "is a visual field in which there are no objects you can take hold of with your eye. It's a complete 360° field, or at

least has to include total peripheral vision, and it's entirely homogeneous in color, white in our case. Its unique feature is that it appears to be light filled. That is, light appears to have substance in the Ganz field." The ones constructed by Wortz, Irwin and Turrell were concave hemispheres, no larger than about three feet in diameter. When one of these was illuminated, it appeared, as you looked into it, to be solid, as if there were a flat plane across the top. [5] Wortz says it is a "fairly infinite space. One of the most exciting things about it is that if you have a continually changing light level, the Ganz field will disappear and then reappear."

the "alpha chamber," having been hooked up to the EEG and instructed briefly by Wortz. [6] Although a single session of this kind of experimentation is not enough to enable one to enter at will a true meditative state, and thus sustain alpha production, all three were able to achieve relatively prolonged "alpha states." The experience in itself of *doing nothing* for a half hour—of sitting, relaxed and alone, intensely aware but of nothing in particular, is one to which most people are not habituated. Nothing was being done to the subjects—they were simply training themselves to achieve a special state of consciousness for a few minutes at a time. Several

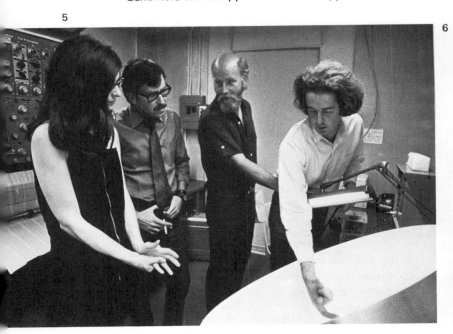

5

6

Perhaps the most important phase of the investigation pursued by Dr. Wortz and the two artists was in the area of alpha conditioning. Alpha is the designation given to certain measurable cycles of brain waves which have for some time been known to occur strongly during states of meditation. Sustained alpha rhythms of between twelve and eight cycles per second can be induced by putting oneself in a meditative state. One can test one's own ability to produce alpha with the use of an electroencephalograph machine, hooked up to some kind of audile or visual sensor which tells the subject when alpha is occurring. Dr. Wortz contrived a device which worked extremely well for himself, Irwin and Turrell. He attached a small light to a pair of glasses worn by the subject while sitting, relaxed, in a comfortable chair; the subject would close his eyes, and see through his eyelid the light, which would come on only when the EEG registered alpha rhythms of twelve cycles per second or lower.

One day in July, MT, Jane Livingston and Gail Scott visited Garrett to meet with the artists and Dr. Wortz, and specifically to undergo alpha conditioning. Each in turn spent thirty to forty-five minute periods alone in

hours after MT, JL and GS had returned from Garrett to the Museum, all three of them experienced definite, inexplicable sensations of anxiety, or a sense of mental dislocation or dissociation. Since these peculiar sieges of emotional change occurred to all three, and to all within approximately the same period of time, it seems reasonable to speculate that they were effects caused by the alpha conditioning. (This is apparently not an unusual phenomenon from one's first exposure to alpha, but it is said that such "after-effects" disappear with increased expertise in this kind of meditation.)

The experience of alpha conditioning for the two artists and Dr. Wortz was important not so much in itself, but for what each learned through it about states of consciousness, and specifically the potentially life-changing consequences of meditation. In talking to us recently, Dr. Wortz did mention one quite specific result from the alpha experimentation.

As far as the meditative experiences are concerned, both Jim and Bob were very useful to me, because they provided the perspective for the internal experiences. Their explanations and descriptions were really useful. There were things that I wouldn't bother

trying because I didn't expect any results; but they went ahead and tried them, and they worked nicely. This primarily involved visualization. Prior to these experiments, in the literature on this area, it had been assumed that you couldn't do much in the way of visualization while producing alpha. This just didn't hold up at all With the alpha, visualization tends to be enhanced in its sharpness, and in the aspect of brilliance.

During the period while they were working intensively with alpha, Wortz formulated a list of exercises for meditation and itemized a number of his own responses during a meditative state which are precisely described and indicate the essential kinds of experience he and the two artists were undergoing:

EXERCISES IN MEDITATION

General Instructions:

Sit comfortably—but erect at all times—head level—preferably full or half lotus but a straight chair will do.

Hands in lap—one cupped within the other—palms up—tips of thumbs together.

Twice a day—Eyes closed.

1. Counting breaths—1 week
 Breathe slowly and rhythmically with the gut
 Count the exhalations
 Count up to 100 and then backward to 0
 Attend to breathing and to the count
 Try to attend only to the breathing but do not particularly fight other thoughts—when they arise, however, do not pursue them.

2. Seeing breaths—1 week
 Same as above but try to see the inhalations and exhalations (The buddhists say that the breath is blue—I struck out on this one).

3. Hearing—1 week
 Same as 1 and 2 but try to hear the breath as well while breathing as quietly as possible.

4. Illumination—1 week
 When breathing rhythmically try to increase the level of illumination of the room (seen through the closed lids).

5. No thought
 Proceed through the meditation period without thought—work at no thought. (I think this is the best individual exercise.)

6. Group effort—Meditate in a group and try to help others—help them to do what? It's for you to decide.

7. Koan
 Strenuous effort to understand intellectually a purely intellectual question that has no intellectual resolution. (Who were you before you were born? What is the sound of one hand clapping? What's in the meaning of the word Mu?—pick your own.)

8. Eyes Open
 Achieve a meditative state with your eyes open—look at the floor about 1-2 meters away—eye lids lowered slightly. No other instructions are necessary.

9. Tantric
 Meditate on a mystical phrase or word such as Om. The word is repeated over and over.

Psychophysiological experiences I have had during meditation include:

1. Peripheral vasoconstriction (extremities feel cool)
2. Profuse salivation early in the period
3. Unique stimulating effect of unexpected noises—resulting in a whole body 'thrill' sensation and sometimes accompanied by a flash of light
4. Time compression—30 minutes seem like 10
5. Loss of limb localization
6. Apparent and paradoxical spinning of the room
7. 'Butterflys' in the stomach
8. Phosphenes
9. Seeing the 'moon rise'
10. Expansion of mind and body
11. Expansion of mind
12. Floating sensation
13. Full feeling in the forehead like blocked sinus
14. Irritated area on the forehead
15. Waxing and waning of a drawing sensation around the nose and eyes at approximately 47 cpm (seems to be linked with threshhold movements of jaw muscles)
16. Reduction in blink rate
17. Relaxation of lower eye lid

As they concentrated increasingly on the alpha conditioning, Irwin and Turrell became less inclined—through the Spring and into the Summer of 1969—to carry out their original plan for designing an environment combining an anechoic chamber with a Ganz field for the Museum. One of the reasons for this waning of enthusiasm about constructing an "object" had to do with their feeling that any such work, because of the necessity to have only one or at most three or four participants enter it at a time, could not possibly be exhibited at Expo 70, and would be difficult to handle even in a considerably less crowded Museum situation. But there were, perhaps, other less concrete reasons for

their gradual relinquishing of concern for "making a work." They began to become deeply involved in the highly personal experience *itself* of intimate collaboration. Then, in August, Jim Turrell suddenly abdicated from the project. He terminated his relationship with Irwin, though he has continued to the present time to see Wortz. Irwin said later that had Turrell maintained his participation in the project, they might eventually have consummated an environmental piece, but that he didn't feel inclined to pursue it on his own, or with Dr. Wortz.

In speaking individually about the three-way collaboration more than a year after it happened, Wortz, Irwin and Turrell all made some significant comments to us reflecting on the direction it took. Wortz sees himself basically as a sort of catalyst in the relationship, and tends to stress the active role played by the artists in a mutual learning process, with himself as a kind of "passive instructor." He said,

> For me the first part was to learn who these guys were, and how to deal with where their heads were. I was trying to figure out how I could contribute to what they were involved in. I felt I was essentially support personnel. But Bob and Jim didn't agree to that kind of role Eventually we decided to turn our heads to specific kinds of projects. And we got very close to carrying some of them off . . . for example the sensory experiments, particularly combining the Ganz field with the anechoic chamber The whole process was such an interactive process that it's difficult to sort out any one person's contribution.

Wortz's comments about the difference in approach between the two artists, made only after some pressing by us, are quite revealing of the dynamics of the collaboration:

> Bob approached information differently than Jim or myself. Jim and I are primarily information sops. Bob withholds information. He keeps the information at a distance, which is interesting, because he would arrive at the same observations and the same set of conclusions by holding off information. It was a very effective technique. Jim and I would sop it all up

> We tried all kinds of things. We tried [with the UCLA anechoic chamber] to find out what occurs when individuals isolate themselves from sensory input and have to look inward. From what I know of Bob's early experience with painting, sitting for years looking at lines, I'm pretty well convinced that this sensory deprivation is what he was engaged in. I'm firmly and one hundred per cent convinced that Bob understands a line. I've come to this . . . over a long time, and I've learned how he understands a line. I

don't understand a line, but I know damn well he does

Wortz indicated that, although the collaboration at a certain point became "non-goal-oriented," it might—had Turrell not opted out—have issued in something concrete. He said at first, "What we learned has mostly to do with our personal development. Whether there are any other fruits beyond ourselves remains to be seen" But he later stated, "I really am convinced that if this problem [between Irwin and Turrell] hadn't happened, it would have matured into some sort of specific, concrete product." He went on to speculate about artistic collaboration in general,

> People like myself are continually involved in cooperating in all sorts of research, design, etc. In fact we do almost nothing individually, because one person just isn't capable of handling these problems himself. Now if art moves to the level of complexity that my field has attained, I think there's a pretty good chance that artists can work together similarly. If it doesn't move to that level of complexity, I don't think there's any reason for that collaboration [among artists] to occur.

> The fundamental purpose of our research was really twofold. We were doing things that were providing us with some new insights into ourselves and perception, and also providing us with insights about how we could work with each other. The business of working with each other came along very nicely, and I still have that kind of relationship with Jim and Bob individually.

The artists both talked with us during the same period (September, 1970) as Wortz. Irwin said,

> All this kind of information has very strange social connotations. You find yourself not telling everyone about it, because a lot of people look at you like you've dropped your cookies. It's not a verbal experience Wortz and I operate out of common experience. We would do various experiments together, and then begin to talk about them afterward. But when you spend this long playing with non-verbal forms, it gets hard to talk. You don't have a *desire* to talk about it. It doesn't work, and it doesn't feel right.

In response to a question about their abandoning the idea of building an environment, Irwin said, "There was doubt about it from the very beginning. But the thing that stopped it was Turrell's abdicating."

About the collaboration in general, he said:

> Most often, I didn't know who really came up with an idea, or who did what. So when one person dropped out, we couldn't really proceed in the same

line But I feel extremely accomplished for having entered into the project. I learned a lot about how people handle information; what defines the state of consciousness

The areas of extended perceptual research we got into have to do with the ability to handle information in non-physical symbols So how does man deal with this? What are the states of consciousness that allow him to function in this more elaborate way? That's where we are.

Turrell's comments, after more than a year had passed since he had walked away from the three-way interchange, were quite different from those of Wortz and Irwin. Often his statements seem immensely distanced from the issues at hand, and reveal as much about the evolution of his thinking over the last year as about his role or approach during the time of the collaboration. Fragments of his responses to various questions about the project are as follows:

I don't know that anything really startling came out of the whole thing I sometimes feel I've found some things out, but they don't apply to anyone else unless they come to them in the same way

If either art or technology becomes a religion, maybe this stuff will start getting more exciting. There's got to be an Art and Technology Christ

I have found out [largely through the collaboration] that you can order people's experience. There's really a lot that you *could* control in making people confront something

You could make this thing [A & T] historically significant if you want to. I have the feeling that whatever is happening here is a symptom of something that's going on—but I think—I hope—it's going to be vastly overshadowed by the thrust of the things going on independently.

We're going to have to work through this time of ego, and of separating artists from all those around them We're very involved in our roles as individuals right now. The thing that happens with technology, or [something like] the Manhattan Project . . . in which people put their energies into a cause where they have to forget themselves People are afraid to dissolve themselves into any sort of human cosmic consciousness We're standing next to a swimming pool a little bit frightened about jumping in. But everyone's going to get pushed in, or jump in finally. It doesn't make any difference which. There are forces which are about to push us in.

The scientist has reserved the universe of the un-

known as his place. What the artist has to reveal seems to be a different order—but it probably isn't, in the end.

The only reply Turrell made to the question as to why he had decided not to continue working with Irwin was, [I had to get away from] all ideas of ambitions and PR and constructing yourself in the second derivative, feeding back things, so you're watching yourself in this very peculiar mirror . . . very good for the head. Trying to maintain any sense of vanity, and looking at that, was hard I decided all that didn't seem necessary.

Replying to a question about his view of the success or failure of some of his experiments, particularly with UCLA students, he said, "One of the surprises was to find that the things you're setting up aren't seen by other people in the same way. That's all." (Irwin, responding to the same question, said, "We learned that the information we were interested in was not that obscure—anyone could get it. I think it had a similar effect on them [the subjects] as it had on us.")

Turrell continued,

All of this is very Pavlovian. You're not really asking much of the person, or yourself. And all you can watch are the surface responses. People were often going through a dance with you Then [the project] began to change, and move into sensory interaction, where the senses influence one another. And then into alpha conditioning, which is sort of taking a Pavlovian approach into spirituality. It has no end

Our culture is going through a strange time—looking at Eastern thought—their work with meditation, their sense of the body and mind and soul. We're approaching it through psychology. We're very physical. When we want to go into the universe, we can't look at a rock, like the Japanese. We have to actually go to the moon. We're so literal. We totally ignore the Eastern way. There are actually meditative sciences, or sciences of the soul. We have devices, sensors, alpha conditioning machines. The machines are just manifested thought. Technology isn't anything outside us We just go about it very clumsily and very wastefully. Because we have to actually *make* all these devices, we have to *go* to the moon, we can't see the cosmos in a rock, and we can't meditate without having this thing strapped on us.

After August, 1969, at the point when Turrell resigned his commitment, an important involvement continued between Wortz and Irwin toward a specific new goal (among other involvements)—the First National Symposium on Habitability, which sprang directly from the

personal connections instigated by A & T. In the summer of 1969, Dr. Wortz was asked by NASA to consider the problem of formulating a new approach to certain areas of research having to do with "habitability." Wortz arranged a meeting at Garrett with some colleagues in various fields of scientific research, and asked both Irwin and Turrell to sit in on the meeting. According to Irwin, he and Turrell "corrupted the meeting. They started out by trying to define the word 'habitability.' NASA's projections of what this meant seemed incredibly limited to us. Our definition of habitability completely altered the premise they were assuming. We broadened the term." (After this initial session, Turrell was no longer involved.)

The details of the process of determining the format and selecting participants to attend and present papers at the Symposium, which was organized in great part by Wortz, are much too complex to recount here. It took place in Venice, California from May 11-14, 1970. The following is an excerpt from a letter sent to prospective participants by Wortz in November, 1969:

> The symposium will be concerned with 'habitability' as a general phenomenon influencing the planning and design of undersea vehicles and stations, lunar bases, space stations, spacecraft, terrestrial vehicles and structures, and urban settlements. The symposium will probe our current understanding of the concept of habitability; the factors which influence the quality of life associated with various environments; the need for and characteristics of habitability criteria; the planning and design of a 'habitable' environment; and will further seek to develop testable hypotheses relevant to this subject.

The speakers and panelists finally involved in the symposium were drawn from widely disparate professions. The list of speakers is as follows:

Dr. Willis W. Harmon, Director, Educational Policy Research, Stanford Research Center, Menlo Park, California

Dr. Kiyoshi Izumi, Architect Planner, Chairman, Human Information and Ecology Program, University of Saskatchewan, Regina, Canada

Dr. William Larson, Chairman, Division for Behavioral Sciences, California Polytechnic College at Pomona, Pomona, California

Dr. Shashi K. Pande, Department of Psychiatry, John Hopkins University, Medical School, Baltimore, Maryland

Dr. Stan Deutsch, Chief, Man Systems Integration Branch, Biotechnology and Human Research Division, National Aeronautics and Space Administration, Washington, D.C.

Dr. William Haythorn, Department of Psychology, Florida State University, Tallahassee, Florida

Dr. Loren Carlson, Chairman, Basic Medical Sciences, School of Medicine, University of California, Davis, California

Dr. Eric Gunderson, Navy Medical Neuropsychiatric Research Unit, San Diego, California

Mr. Allen Louviere, Chief, Systems Support Branch, Manned Spacecraft Center, National Aeronautics and Space Administration, Houston, Texas

Dr. David Nowlis, Consultant on Habitability, Garrett/AiResearch, Los Angeles California

Dr. Ronald O. Loveridge, Department of Political Science, University of California, Riverside, California

Dr. Seymour I. Schwartz, Department of Systems Engineering, University of Southern California, Los Angeles, California

Mr. Morton Hoppenfeld, Director of Planning & Design, Rouse Corporation, Columbia, Maryland

The panelists were Dr. Art Atkisson, University of Texas, School of Public Health; Dr. Jelliff Carr, Director of Life Sciences, FASEB; Dr. Morton Leeds, Director Plans and Programs, HUD; Robert Irwin, Artist; Dr. Ted Marton, General Electric; Dr. Thaddeus Glen, University of Toledo; Dr. Dave Martin, University of Texas, School of Public Health; Dr. Richard Haines, NASA/Ames Research Center; Dr. William Soskin, U.C. Berkeley; Dr. George Rand, Columbia University; Dr. Robert Ornstein, Langely Porter Institute; Dr. Edward Wortz, Garrett Corporation; Dr. Melvin Zeisfein, Franklin Institute.

The event was extraordinary in several respects. Its physical environment, designed by Irwin, along with artist Larry bell and architect Frank Gehry, distinguished it dramatically from other conventions of its kind. It was in great part simply owing to the psychological conditions achieved by the special surroundings that the event became the tense and complex encounter session that it did. The space in which the morning sessions took place—organized each day so that four speakers would discuss their previously submitted papers, before four panelists would then discuss them—was located in a large, studio-like room on Market Street, near the sea. The speakers and panelists sat in the middle of the room, in two rows facing each other; above them were two tinted skylights. On either side of the central platform were rows of low, bleacher-like seats, made of chunks of corrugated cardboard; this seating arrangement was designed by Frank Gehry. On

the side of the large white room which faced Market Street, Bob, on the first day of the Symposium, set up large, white cardboard cylinders, floor-to-ceiling; the participants and audience entered from a small doorway in the rear. On the second day, the white cylinders were replaced by a large plastic tarp, letting in light from outside, but not wholly transparent; and on the third day, the entire side of the room facing Market Street was opened up.

A combination of subtle psychological factors were brought to play on the dynamics of the Symposium sheerly by virtue of its environment: for example, the

low seats were rather uncomfortable—intentionally so, according to Irwin—making it impossible for the audience to relax physically. Nor was the space insulated from street noise, so it was often difficult to hear what the speakers were saying; again, Bob felt this was a positive factor, forcing concentration on the proceedings.

At the outset of the Symposium, one sensed a definite psychological tension between what Dr. Wortz characterized as the "square" and "hip" participants—this dualism gradually gave way to other factional conflicts, and eventually a whole set of unpredictable positive situations emerged in the dynamics of both the group as a whole and the discussion sub-groups, and in the nature of the information exchanged. Irwin commented later,

"I was interested in it as an event. It was a chance to exercise some things I was personally curious about, directly in relationship to the A & T project It really worked. What happened with the afternoon discussion groups was fantastic; really heady kinds of information."

It is not possible here to be more explicit about the circumstances and results of this Symposium; however, much of the proceedings were recorded and have been published by the Garrett Corporation, and a Second National Symposium on Habitability is currently being organized.

Simultaneously with their preparations for the Symposium, and since that time, Dr. Wortz and Irwin have

Donald Judd A&T
Born Excelsior Springs, Missouri, 1928
Resident New York City

continued to work together on various other projects. Wortz has consulted Irwin on several occasions in connection with his researches for Garrett. He spoke to us in September, 1970 about Bob's participation in an undertaking contracted by NASA:

> Right now we're establishing some criteria for a spacecraft. Bob has helped us on this We've looked at the problems of providing a very enriched environment. Bob is very interested in the arts involved in the construction of things . . . of hot-rodding, for example, as a very artistic endeavor Hot-rodders will massage portions of the machine that no one will ever see, just because it feels right. This is the way Bob feels about art. Everything has to feel right. He was thinking that portions of the spacecraft should be designed or painted to have an appropriate *suchness* for their function. He's designed us a little oven. So we have the first tentative art input into a spacecraft.

Wortz spoke about yet another—rather mysterious—project in the works between himself and Irwin:

> There's a thing Bob and I would like to try. Right now it's just an experience, but if it could be made into a thing it would be nice. If it works it will produce an emotional response which you might be surprised about. It has to do with the technique of producing a loving response in someone.

(Irwin later "demonstrated" the technique to JL and MT; it does indeed work, and has to do with pulling people or objects into one's immediate circle of psychological perception, in a sense as an extension of oneself.)

Dr. Wortz and Bob Irwin have recently indicated to us their interest in realizing an environmental art work of the kind originally outlined, combining an anechoic chamber with a Ganz field. Turrell's involvement in such an undertaking is unknown at this point.

Jane Livingston

MT described A & T to Don Judd in his New York studio in April, 1969. Judd indicated little interest in collaboration *per se,* but stated his desire for a facility which could cast metal sculptures for him, and asked for literature on Kaiser and other companies. The following correspondence occurred between May and August, 1969:

May 8, 1969
Maurice Tuchman: I have considered the Kaiser aluminum casting project and am interested in it.
Don Judd

May 19, 1969
Dear Don Judd,
It is interesting to me that you are interested in Kaiser aluminum casting. However, we have never had Kaiser Aluminum as a Patron Sponsor. We have had and continue to have Kaiser Steel as a Patron Sponsor and this corporation is still available.
Very truly yours,
Maurice Tuchman

May 22, 1969
Dear Mr. Tuchman:
Thank you for your letter to Don Judd of May 19. Don Judd is interested in Kaiser Steel as a Patron Sponsor. I mistakenly wrote "aluminum". Apologies.
Sincerely,
Dudley Del Balso
for Don Judd

May 27, 1969
Dear Dudley Del Balso,
Thank you for your letter of May 22 to Maurice Tuchman. We are currently considering three proposals for Kaiser Steel Corporation. We would be interested in learning the nature of Don Judd's proposal so that we can move on it in the event that Kaiser remains available.
Very truly yours,
Betty Asher

June 19, 1969
Betty Asher: Regarding your letter of May 27, I am interested in casting steel in rectangular shapes. What are the possibilities?
Don Judd

July 8, 1969
Dear Don,
Electronic Enclosures Division of Wyle Labs had recently been made available to us. We would be glad to send you a ticket to fly out and see it. Their most interesting piece of equipment is the Wiedemann ST tape controlled turret punch press.

Ampex, IBM, Norris (porcelain enamel and metal

stamping), Container Corporation and Rand Corporation are still available.
Sincerely,
Hal Glicksman

July 10, 1969
Hal: I have received your letter and enclosures. Norris sounds especially interesting, but I can't make a decision now. I will be in California the end of September and will be in touch then.
Don

July 22, 1969
Hal Glicksman: Don Judd has asked me to write you again about his interest in the Norris project. It is impossible for him to come to California before the end of September however.
Mrs. Dudley Del Balso
for Don Judd

Judd did not contact us while in California in September, 1969 and we could not locate him.

In August, 1970, Aleksandra Kasuba sent us two project proposals:

DESCRIPTION OF PROJECT #1
The Spectrum Environment

The Spectrum Environment consists of seven units, each measuring 8' x 8' x 12' long, assembled into one linear walk-through ensemble. Each unit is made of translucent color material, intensely lit on all sides from the outside. The units are interconnected by 22" wide and 7' high doorways whose openings are aligned to present a diminishing view of the Spectrum to visitors as they walk into and through the Environment. Within each of the six spectral color units one hears its specific vibration—the sound of green, yellow, orange, red, purple, or blue. In the center of each spectral color unit, through an opening in the ceiling, a mild air stream carries in a related color odor and temperature. The seventh unit, combining all that has been passed through, is lit with intense white light, filled with the combined color sounds, each one octave higher, has no odor, and has normal temperature.

Visitors passing through the Spectrum Environment would be totally engulfed by one color at a time, and experience the different effects of each with four of their senses. [1]

DESCRIPTION OF PROJECT #2

The shells housing the element presentations are 4 interconnected half-spheres, each 24 feet in diameter at the base. The interiors are lit by sunken lights moving around the perimeter of the floor clockwise at 12" per minute.

The 4 elements—earth, fire, water and air—are each placed in one of the shells and presented in their common forms of behavior.

The environment is to deepen awareness of the simple daily presences that have not changed through millennia. To emphasize their relationship to man, the natural processes are designed to intensify their activity whenever man is present. Thus, in terms of actions, space and time—the factor that brings about the interplay—is made perceptible and can be experienced as a vital force and not as an empty gap. [2]

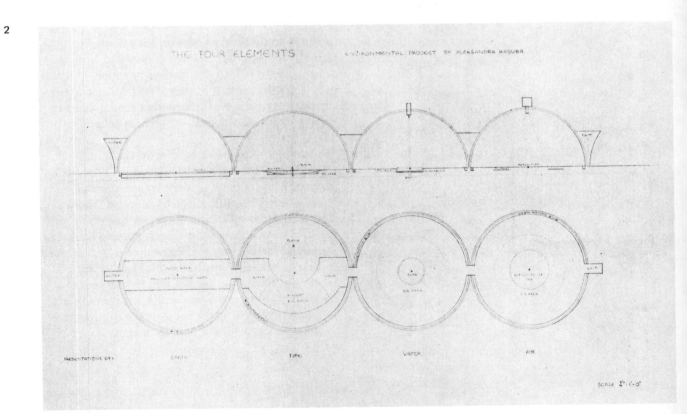

Ellsworth Kelly
Born Newburgh, New York, 1925
Resident New York City

Philip King
Born Tunis, North Africa, 1934
Resident London

MT saw Elsworth Kelly in the fall of 1968 and described various available companies, particularly manufacturing firms that could be used for sculpture projects. Kelly said that he was more interested in working with a computer corporation than in making sculptures. He described his paintings of the early 50s, made in Paris, as responses to the random play of lights on the Seine; he indicated that the systems of black and white configurations on these canvases might be analysed and permutated by use of a computer. He felt that this would be an important project to pursue but that his other commitments would prevent his serious involvement for at least two years.

Philip King flew from England to visit a number of companies in which he expressed interest after reading literature we had sent him. Hal Glicksman took him to see Wyle Laboratories, Norris Industries, Kaiser Steel Corporation and American Cement, after which he indicated that he considered American Cement to be the only feasible location for a collaborative effort. He found Norris' steel forming techniques too restrictive; hydraulic press methods have limited size capability and necessitate expensive tooling processes. Kaiser's Fontana plant is mainly a steel rolling mill with only limited fabrication facilities, and he found nothing to inspire him at Wyle.

At American Cement he wanted to execute a work on a hill behind the Riverside Technical Center. As he explained in an interview,

> I could conceive of being able to spray a particular kind of colored cement onto the hill from an airplane. I'd like to be able to introduce a kind of spray technique where you could lay down a dry powder of cement and then spray water over it in order to harden the cement to set in a consistency which would then, with the action of rain, dissolve and re-form at a different level according to time; it would eventually disintegrate. I want it to be able to be destroyed, to change; possibly it would be more beautiful while it's being destroyed. When I make a sculpture, I lay myself right out. This is sort of experimental for me, and I'd like to keep it as experimental a thing all the way through. I like the idea but I don't know if I can get into it philosophically as a work of art.

In addition to the sprayed cement, King wanted to execute a number of cast cement objects and disperse them also on the hill. Of this method he stated, "I'd also like to introduce pre-cast forming, but I'd like it to be functional, to help prevent the kind of erosion process; it's sort of a landscape exercise for me, in color."

After returning to England, King wrote us,

> After much deliberation and in the quiet of my London home, I think I cannot go ahead with American Cement. The project which I outlined briefly on tape was too much an attempt on my part to fit into a situation in a hurry and although the idea has a certain appeal for me, it is not really the kind of thing I want to be deeply involved with. The limitation of cement as a material does not give me the kind of flexibility I need at the moment in an extension of my own work. I liked the people there enormously, and the atmosphere, and I am sorry about it.

In 1967, when A & T was still in the early stages of development, MT proposed to R. B. Kitaj the possibility of working with an industry. Kitaj's immediate reaction was to suggest executing in three dimensions an idea he had been planning for painting. He had wanted to do "some old-fashioned paintings about the kind of grey, haze-like, dull daylit, Bohemian, urban atmosphere you see in photos of places like studios in the old days . . . Medardo Rosso's studio [1] Brancusi's studio that sort of thing." Kitaj had been intrigued with the reconstruction of Brancusi's studio in Paris Musée de l'Art Moderne in 1964, and the experience served as a primary impetus for the idea.

About a year later, in August, 1968, Kitaj came to Los Angeles during a teaching stint at Berkeley, to visit Lockheed Aircraft Corporation along with Los Angeles artist Robert Irwin. We accompanied the two artists in touring Lockheed's Rye Canyon Aeronautics Research facility and the Burbank Aircraft construction complex. On the way to Rye Canyon, Kitaj elaborated on his initial conception, stating that he wanted to create the physical situation of a fictional "modern sculptor"—to reproduce, in a sense, his studio atmosphere by means of a series of visual "clues." The space, he said, would evoke the artist's "complex, ethical presence" not through memorabilia and personal artifacts but through the objects—works of art in various states of completion—dispersed throughout the "studio." Because of its emphasis on advanced theoretical research, the Rye Canyon Center was obviously not suited to Kitaj in terms of the proposal he already had in mind. (Irwin, on the other hand, was extremely interested in the research being conducted with their anechoic and sound chambers, as well as other aspects of the facility.)

We next visited the Burbank production facility, where Lockheed was then developing the L-1011 commercial super-transport plane. We were introduced to a man who was later to become a key figure in the project, Robert Robillard, leader of the Lockheed team responsible for the interior design of the L-1011 Tri-Star jet, and general supervisor in charge of various mock-up operations, including plastic, sheet metal, fabric and carpentry shops. After an exhaustive tour of these model-shop facilities and a brief look at additional production-line processes, Kitaj was satisfied that the Burbank complex had appropriate materials, equipment and skilled personnel to carry out his scheme. We arranged, in agreement with the Lockheed management, that after several months in London, he would return to Burbank for a prolonged period of residence.

1

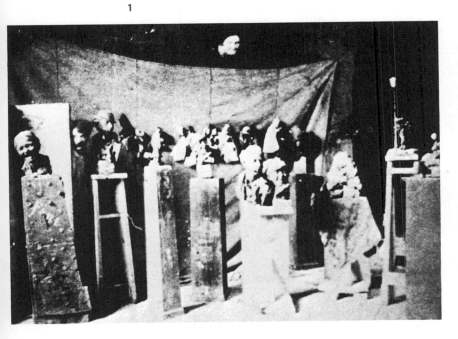

In October, he wrote to his contact in the Public Affairs office, Don Christiansen:

R. B. Kitaj in transit to London, September, 1968

Among the few themes I have wanted to return to through the years, an attraction remains with me for those occasions, those contexts (in real life) where what I would like to call a modernist presence has taken shape, is finding, pursuing form, germinating. I mean to reproduce some of those conditions by designing a fiction: a place, a working space . . . a studio, so to speak, where a convincing and/or extra-ordinary collection or conjunction of things have been made, are being made . . . what you might call art-things rather than sculpture . . . food for the mind at any rate, embraced by a human presence—(the man who works at the things has stepped out for awhile.) . . .

so—what it may amount to is a room . . . perhaps an unlikely scale—maybe ten feet square or smaller with a fifteen feet or ninteen feet high ceiling or skylight three portable walls, a ceiling, a floor—all de-tachable and all to be designed according to what (Lockheed) can make available in terms of materials, artisans, time, energy . . . and then—what the open-face room space will contain . . . not clear in my mind yet but the issues should begin to resolve at my drawing board in London. In any case—various works, some standing free, some placed for working . . . in various states of finish and development and size; maybe some twelve pieces invoking an intellectual range and time span (early works)—an uncommon stylistic ambition. From what I saw at Lockheed—Mr. Robillard's mock-up shop might carry the weight of this plan. I would want to mock-up some models in small scale at first—like small stage sets and I might like to choose from whatever we make together, the things which will, in the end, go into the space . . . that is to say permutations should be possible. Your vacuum-forming facilities are on my mind and I should like to execute a few of the works in plastic— the final room space and the works it embraces should be brought into a considerable visual em-phasis . . . coloristic demands of a high order should be made of the constituents . . . spray work and anodizing and the natural values of materials. I should like to introduce the atmosphere of a working place without going into literary detail. And in the end I want to design something that will be as complex as experience is complex and ultimately quite simple.

Early in February, 1969, Kitaj arrived in Los Angeles. In the first month of collaboration the artist was confront-ed by an overwhelming maze of bureaucratic procedures. Despite Lockheed's attempt to accommodate the artist's needs and to maintain some flexibility in their normally complicated system, Kitaj found it increasingly frustra-ting to find out *how* to expedite his needs. As he later explained in a letter,

There was an air of trying to be helpful . . . some-times genuine, sometimes false among the brass and management with an undercurrent of reluctance to go along with this highly unorthodox intrusion, but it did and still does seem mad, in my terms, to imagine that one's poetic references could thrive with any ease in the very thin air of Big Business and Big Business was what the daily regime spelled out in no uncertain terms. Latterday Chaplinesque semi-heroics

After weeks of futile attempts to actually begin working, it was Robillard who came to the rescue of the artist, cut through the organizational red tape of working proce-dures (purchase order numbers, supervisory control over the workmen assisting Kitaj, etc.) and set the operation in motion. Although Robillard had no direct participa-tion in the planning or modification of the project, his respected and important position in the company allowed him to settle the logistical problems. Robillard's feeling was, as he said to the *New York Times,* "Let's give him what he wants and get him out."

One of the most interesting aspects of Kitaj's experience at Lockheed was the evolution of the original "studio" idea—partially reflecting changes in his own thinking before he even arrived at the site, but also as a direct result of circumstances he confronted at Lockheed. In January, 1969, while still in London, he had written to Christiansen asking him to arrange for a technician to oversee the project from beginning to end. He added, "My ideas are changing every day and will be condi-tioned by what I will confront in beautiful downtown Burbank . . . as far as I can tell it will be a matter of making a number of things and bringing them together in a conjunction . . ." This statement, in the way of a casual aside, anticipated precisely the turn of events in the weeks to come. During the period before he arrived at Lockheed, Kitaj began to feel less and less inclined to follow through with his idea for a "studio," primarily because as he later wrote,

I found it too attractive to do what *I* want to do rather than to try to imagine what someone else would do. And ultimately perhaps boring to imagine what someone else would do . . . I didn't really like studios that much, or artistic situations in real life anyway and then I became bemused with the possibil-ity of having all kinds of different *things* made in those short two months—things which might be brought together in some *more* interesting way—some unique visual literary and political way . . . *after* the fact of their making.

For some time Kitaj had been "obsessed" (as he put it)

with imagery related to the Industrial Revolution. He studied and collected old photographs and engravings depicting industrial landscapes of the Victorian era, and had planned to execute paintings on this theme. He later explained his fascination with this period by comparing it with Roy Lichtenstein's interest in the *moderne* style of the 1930's. While still in London, Kitaj executed some sketches drawn in part from source material like

illustrations in Samuel Smiles' *Lives of the Engineers* and Francis Klingender's *Art and the Industrial Revolution.*

These drawings contain the basis for most of the large objects eventually constructed at Lockheed. One drawing [2] depicts a tunnel with a shaft of light penetrating to the floor, a motif which had been of special interest to Kitaj for some years. (He lives near London's Science

2

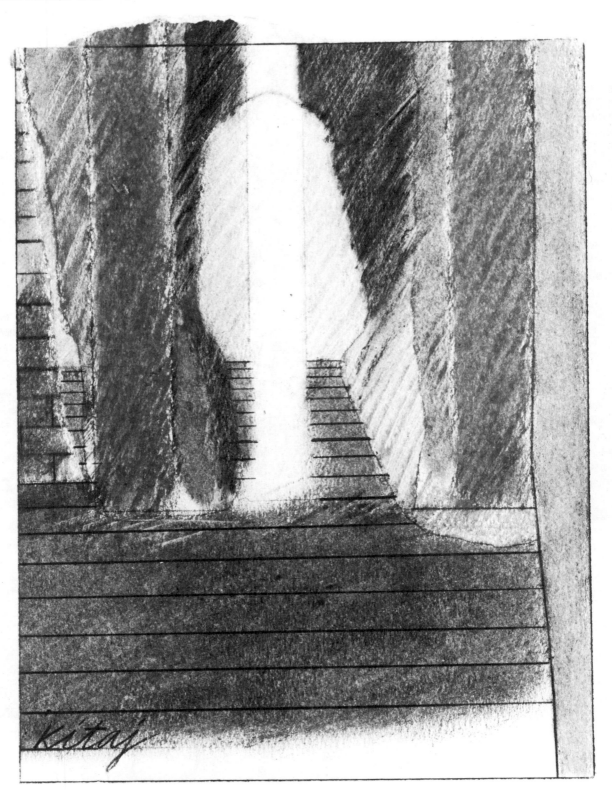

Museum which houses a full-size labyrinthine coal mine reconstruction—a favorite visiting place of his young son.) It was the quality of light—a cylindrical body of illumination—which particularly intrigued Kitaj and which he had encountered in numerous Victorian illustrations of coal mines such as J. C. Bourne's *Kilsby Tunnel,* 1837, reproduced in Klingender. [3] He constructed such a coal tunnel at Lockheed [4]; it measures about four feet high and six feet long, and is complete with tracks and box car; the shaft of light becomes an almost solid volume, rendering an eerie, spectral atmosphere. A second drawing [5] consists of a backdrop of

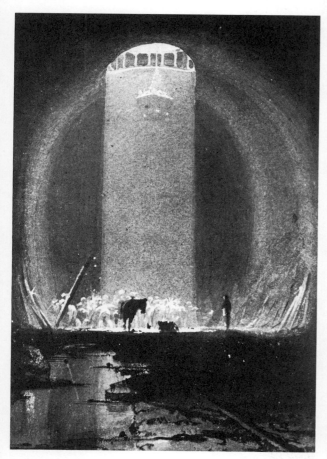

3

4

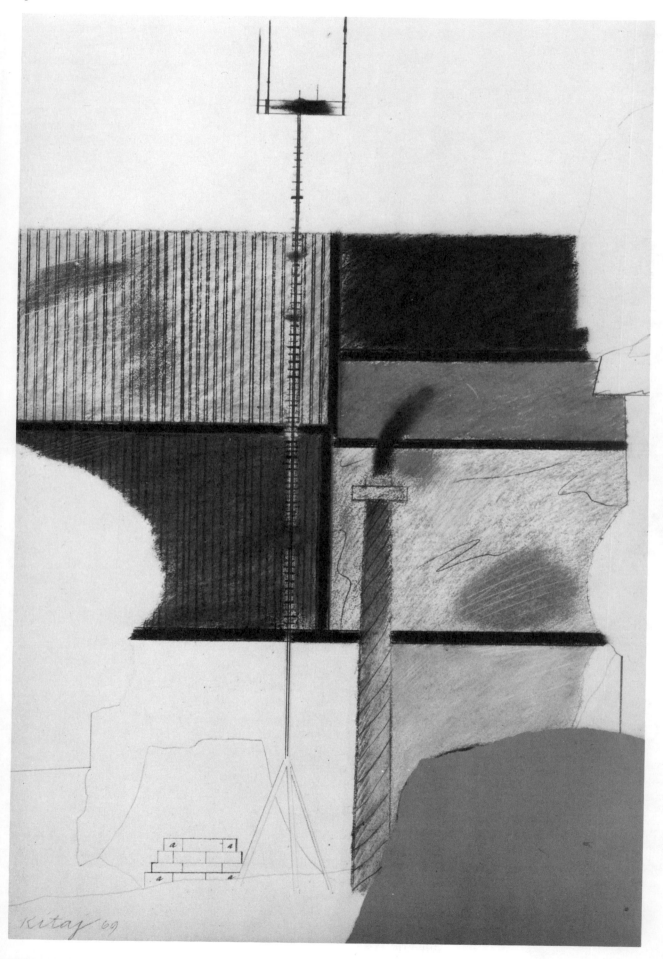

Kitaj 69

6

rectangles in a grid configuration, with varying surface textures. This motif evolved at Lockheed into a mural-like screen [6] titled *Chelsea Reach (First Version for J.A. Mc.N.W.).* Kitaj said of it,

In fact this is the first manifestation of an idea I have wanted to execute for a long while. I got interested in fabrics and textiles when I was in Berkeley [in 1968]. Maybe it had something to do with exposure to Oriental stuffs that I hadn't had before. I conceived of a large wall hanging or a large wall screen which would be completely abstract—rather decorative, and it would be a collection of fabrics which would be separated on the tatami principle—you know, that you see on Japanese floors, divided by slatting and pinned down in that way so that you see a wonderful sequential floor situation. Well, I wanted to take that principle onto the wall. I actually had begun to collect some strange fabrics, some ancient ones, old ones, and some that were really cruddy, that came out of poor situations. That's where this idea came from. I just happened here to use airplane fabrics, aircraft seating fabrics. I wanted to call that screen piece *Chelsea Reach* after Whistler's usage of that title because he was one of the original Western artists who hooked onto *chinoiserie,* and the possibility of employing that. I don't want to leave it just as a backdrop; I want it to be a piece in some light.

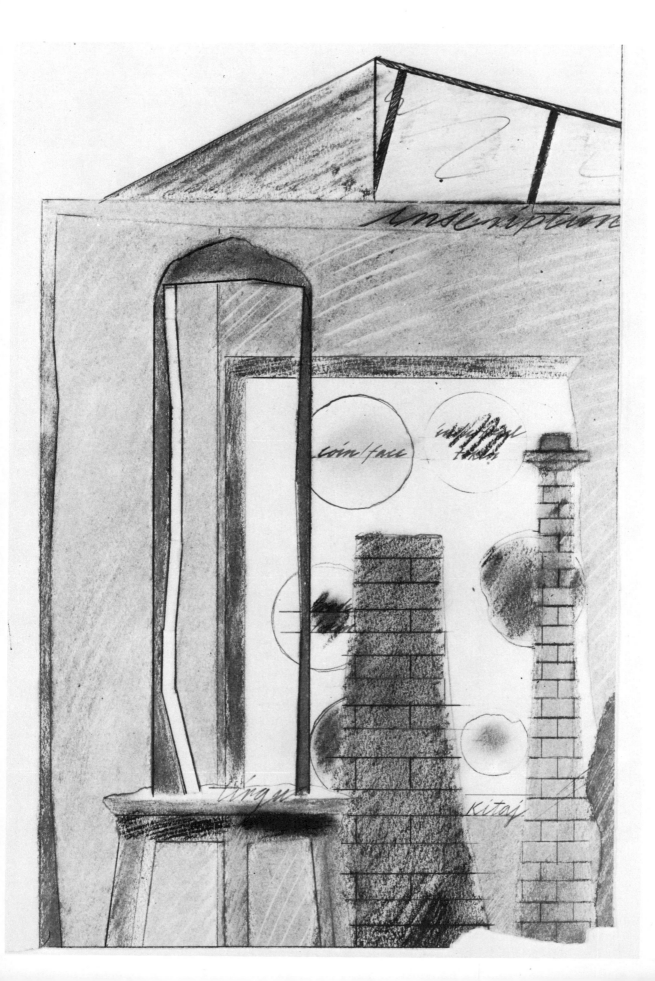

Another motif which occurs in the second preliminary drawing [5], and again in the third drawing [7], is that of an industrial smoke stack or chimney, a familiar object of the Victorian landscape. Three such towers, each twelve feet high and each with a different surface pattern and impediment, were eventually constructed at

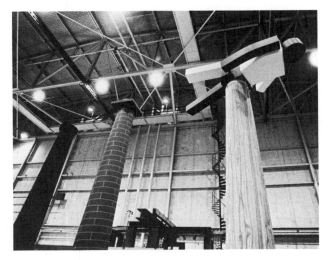

8

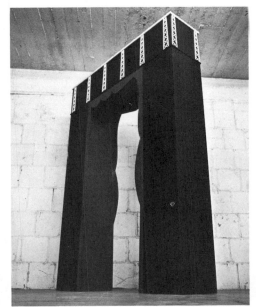

9

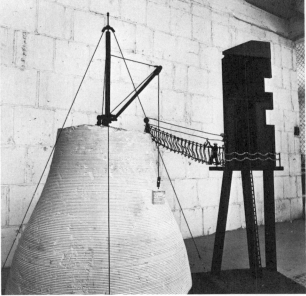

10

11

Lockheed. They were fabricated by a vacuum-forming process and were the largest forms ever attempted by the Lockheed shop using that method. [8] The third drawing [7] also formulates the basic notion for the main-entrance archway or viaduct which was designed by computer graphic process and built at the Lockheed plant. [9] The other large component [10] in the Lockheed series, which does not appear in any of the preparatory sketches, derives from an illustration in Metius Chappell's *British Engineers* [11], showing a half-completed lighthouse project under construction. Kitaj later commented that he liked the enigmatic quality of this piece—the fact that the type of building it represents is not easily identifiable as a lighthouse, but evokes the feeling of industrial activity.

In addition to these large structures, Kitaj also produced a series of vacuum-formed medallions, depicting in relief various images such as a railroad box car or an airplane panel instrument [12], and fabricated out of multi-colored, marbleized plastics used in airline interiors. The idea for these circular medallions derives from an obscure historical source; they refer to eighteenth century industrial trade tokens and coins, issued by some British factories to commemorate their founding.

From the beginning Kitaj was interested in perhaps realizing at Lockheed a number of peripheral projects which he had begun to think about before arriving at Lockheed. In December, 1968, he had written to Don Christiansen,

> . . . There are one or two things you could do for me could you dig up and send me any pictures of how Lockheed *began*. What would really help would be photos of the very earliest Lockheed workshops. (Like Henry Ford tinkering with his first car in a shed, etc.) . . . also photos of component *parts* (whatever is not secret), modern parts, etc. . . . perhaps there is a small pile of literature you could *Airmail* to me. I am also interested (as a side issue) in what would be called WASTE . . . waste which is

fabrication of such "sculptures," when they could be picked from a storage shelf, would have been pointless.

Consequently the studio piece was channelled into a secondary project, the production of the book titled *Wings (Recent Sculpture and Buildings).* It consists of color photographs of individual airplane parts which the artist had anodized, chromeplated, and spray painted in bright primary colors. The "sculptures" were then arranged against scale-deceiving or neutral backgrounds and photographed by Malcolm Lubliner. Kitaj had the photographs mounted in a handsome leatherbound book (in an edition of five) and gave each one an ironic, humorous and literary caption-title. [13, 14, 15] In his original conception of the "artist's studio" piece, which he decided not to make at Lockheed, Kitaj had intended the "studio" to have certain satirical overtones—to make a kind of implied statement concerning modernist or formalist sculpture, using a fictitious sculptor's work as the agent of the irony. But even before leaving London it had occurred to him that "that particular irony wasn't strong enough conceptually to carry the weight of this expensive and ambitious collaboration." The book *Wings,* then, developed as the most suitable means for expressing this unique complex of ideas.

12

thrown away and waste which is too *valuable* to throw away and perhaps is used or sold elsewhere Is there any possibility of sending me examples of drawings being made of planes in the far future? Dream planes as it were?

Once he began work at Burbank and had searched among the storage bins he was amazed to find literally hundreds of custom-made and prototype airplane parts which in isolation bore for Kitaj a striking resemblance to the forms of abstract minimal sculpture, such as those which he had intended to disperse in the studio environment. The quality of these objects strengthened for Kitaj his feeling that the studio idea was not an appropriate project for his Lockheed venture: to attempt a full-scale

The small group of six or seven men in the mock-up shop who became enthusiastically involved with Kitaj's project were, for the most part, a now rare breed of artisans skilled in traditional methods of hand tooling and model making. Kitaj's relationship with these workmen was greatly satisfying to him. These men—particularly Arthur Monroy, William Stullick, Clyde Gossett, James Scott and Nicholas Eckhert—provided valuable contributions to the design of the work. Although Kitaj maintained control over every aspect of esthetic decision-making, the individual components took shape largely as a result of the interchange between the artist and these men. In one specific instance, Kitaj and his co-workers had tried by several methods to achieve the effect of a volumetric shaft of light in the

13

14

15

coal tunnel by modifying the light source at the top or forming the light beams using a piece of plastic, but without success. William Stullick finally devised the solution: he attached strands of very thin fishwire to the top, surrounding the light source opening; these were then spread out and attached to the bottom, forming a volume as the light struck the transparent wire.

Looking back on this involvement with the workers, Kitaj reminisced:

> . . . the guys on the floor were *everything* I would have wished to find again . . . I felt very much at home and warmed up and on their side in no time at all . . . old Bolshevik merchant mariner sentiments welled up and a hundred daily dramas played themselves out like an anthology of Proletarian literature brought up to date . . . Viet Nam arguments, suburban life and all the newest terrors of layoff in aerospace. Many of the guys I knew best were for [Tom] Bradley [the current mayoral candidate] and against the war and it all felt good and I won't forget them in that stinking suburban valley and hope they get out into those National Parks a lot.

The artist also worked closely with David Belson, from Lockheed's computer department. Belson first instructed Kitaj in computer drawing methods. (On one such occasion Dr. Richard Feynman accompanied the artist and participated in the lesson.) Gradually Belson became fascinated by the types of images the artist wished to execute on the computer. Together they designed the man-figure which was subsequently fabricated [16]; they also computed the shape for the arch. [17] While still in the midst of this work, Kitaj described to us the nature of his relationship with Belson:

> Dave began as one of those peculiar birds out there who has a blank check—that means that every time I walk into his office he can get up off his desk without permission from anybody else and walk away with me and spend as much time as I require. For instance he seems to be able to satisfy his own curiosity about the project as if he was being paid to do that. We sat all morning in front of all the scopes, and Dave will go back there late this afternoon when the scope is not being used, just to satisfy his curiosity and to find out more about what we were learning this morning, not only to be in a position to be able to explain more to me when we meet next, but for his private reasons.

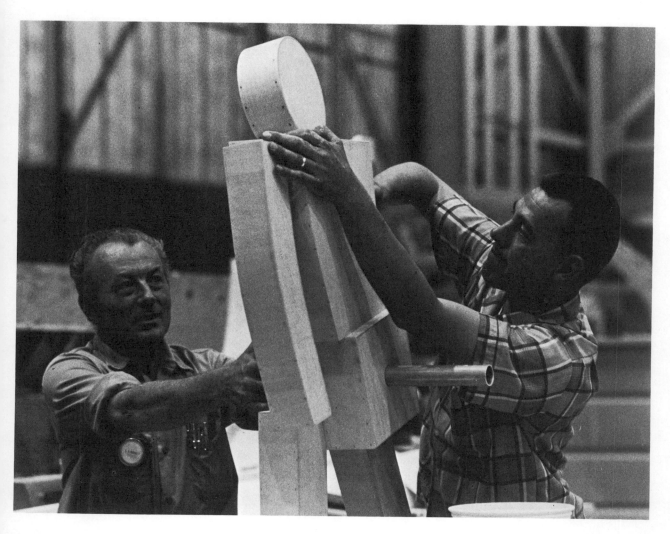

16

17

In addition to preliminary designs for the sculptural components, Kitaj executed with the computer a series of drawings which constitute another aspect of the project. He made a portrait drawing of a girl's head in several variations [18] and intended to execute other portraits after leaving Lockheed by sending material back and forth to Belson from London. But after returning to London, he found it too difficult to carry through this scheme by correspondence. However, the female portrait and several abstract drawings also made with the computer [19] were later incorporated into a series of lithographs which Kitaj produced in conjunction with the poet Robert Creeley.

18

Kitaj's retrospective evaluation of the diverse and often fragmented aspects of his total experience at Lockheed is ambivalent. He wrote,

> Thinking about it now, so much seems *so* funny, *so* ridiculous; maybe that's got to be one of the best results: walking down endless corporate corridors each day, back and forth, miles of modern hallways, wearing a badge or two badges, carrying all kinds of important plans and papers Then when the hallways reach the more executive parts, the floors become nicely carpeted and indirectly-lit old prints and photos of early primitive aircraft, seaplanes, nostalgic passenger planes like from Lost Horizon spaced along the walls. And the kind of *fake* and ultimately meaningless (for my own life) encounter over those weeks with the really enormous tidal wave of machinery and a massive technology I could never hope to approach intelligently let alone fathom. Maybe the heart of the experience lies there for me—a confirmation of the utter boredom I always feel when art and science try to meet—that is to say, the feeling of very slender accomplishment in those forms of art which pretend to operate scientifically. Over the last fifty years, these art and science people only manage light jabs and then seem to wither . . . while an immense technology remains . . . progressive, destructive, what have you Dealing with the people in the corporation and in the plant was by far the most memorable experience—far better that intercourse than the indeterminate results.

In describing the works, Kitaj elaborated on the "ironical ambition" which had been a primary impetus in the studio piece and which carried over into the present work:

> There is a certain irony in the historical thing. Some of it can be construed clearly, and other aspects of it needn't be talked about; it goes without saying. Obviously those times were the beginnings of a capitalism that we've learned to live with and mistrust in many ways. Especially in *those* times and in our own time, industry has brought all sorts of energy and misery and poverty and ambition into the world.

19

What fantastic ironies lived in those times, we're all aware of. Obviously just seeing a stack on a landscape in Cornwall isn't a heavy enough occasion for me to live and die with. It's everything that those beginnings of industry imply that interests me more, that have always conditioned my thinking—the poverty, despair, loneliness. So that these are tips of an iceberg. I don't expect that any of that will be apparent or terribly interesting from the visual fact of looking at those things in an installation. That's why I've always insisted in my whole working life on an explanation—some kind of help. Even in the case of appreciating abstract art an incredible amount of spade work is necessary to enhance your position—to enjoy the work or criticize the work or live with the work or whatever No matter what anyone says, any visual work is not going to stop at its visual nature; it will always carry philosophical implications.

Kitaj's Lockheed work will finally be realized only in the process of installation. The presentation will convey all of the diverse aspects of the artist's Lockheed experience, including an array of enlarged photographs, drawings, computer graphic material, the book *Wings,* and the major sculptural components dispersed in a room-sized space, in much the same way as he originally envisioned the studio environment. Kitaj here describes the whole complex, which he calls,

Mock-up: Lives of the Engineers

A room full of things and fragments of things mostly made or mostly relating to things made in the mock-up shops at Lockheed while the very craftsmen were also working on the model parts for their new L-1011 passenger liner . . . (working men moving back and forth as in a film) (Rene Clair etc. . . . precision/confusion) the room space shd be *introduced* by the large black arch which may yet have to be completed by addition of: white? viaduct cut-out strip design; (with tiny puffing train image? or people) various stenciled wording (*SELF-HELP; THRIFT; DUTY* etc re: *Sam Smiles*); *and* one of the variant (red?) sets of wooden inner doorway pieces creating an unorthodox entrance space

At the far side of the space, (against a wall, maybe 20'—25' away) *the large* screen (which I have called a version of *CHELSEA REACH*—a Whistlerian connotation because I want *a* version to carry Chinoiserie fabric combinations but settled here for aircraft seating fabric which gives it its van Doesberg look) . . . there still remains the fact of either having or *not* having to deal with the *2nd* set of (I believe—complete) fabric panels in, I think, a dark color range . . . but I may dispose these on the walls in a certain way I have in mind. The complex begins to take on attributes of a very crowded and allusive theatre

staging area . . . incomplete but complicated innuendo . . . historico-political-literary . . . as if specific drama could emerge as a possibility.

> *like a Meyerhold Production* from *Akimov* p. 701 (Soviet Theatre) [20, illustrated on p. 717, set design by Akimov for Verneuil's *My Crime* at the Leningrad Theatre of Comedy]

My fondest dream is to develop the expressiveness of *things* to a point where I need not be ashamed to put them on the stage beside the best of actors. As yet this waits in Utopia, but if I should ever succeed in bringing upon the stage a chair at the sight of which the audience as one would sob, I would die in peace. If Van Gogh were working in the theatre today, I am convinced that he would be able to do it.

Walls are to be heavily hung with large computerized sheets (orange); framed computer abstractions; large grey, sepia, violet detail-like panel blow-ups like film clips enlarged, highly varied; also the set or portrait engravings (retouched?); some framed pertinent book jacket prints inspired at Burbank (i.e.—the Burbank cover etc.); some unfinished work leading on

Most of what is hung above shd bear highly insinuating captioning etc.

A disposition will be found for the set of plastic emblem-tokens (printed stencils—Walker Evans, James Agee have yet to be attached).

Within the staging space places can be found for the tunnel oblong (I believe wording has yet to run around the facing frame of this piece) also a lighting fixture may be involved. The chimney pieces—one or some, standing, lying and/or fragmented, torn . . . they don't seem right or good but we'll see. The flying man—(with a nod to Schlemmer) . . . placed out of context, I think on the floor or leaning somewhere rather than mounted atop a tower as before.

The half lighthouse complex (OUR THING?)—is it on its cork covered base? . . . are the mechanical parts put together?

Some of these pieces may have things added to them or images implanted in or on them or things subtracted from them or allusive characteristics given to them to heighten effects in themselves or in the general drama of the combinations.—glass cases are to contain at *least* some open copies of *WINGS* and most likely other material . . . also enlarged details from the collection of photos for the book (some not used in the book) shd join the dramatic hanging in the place.

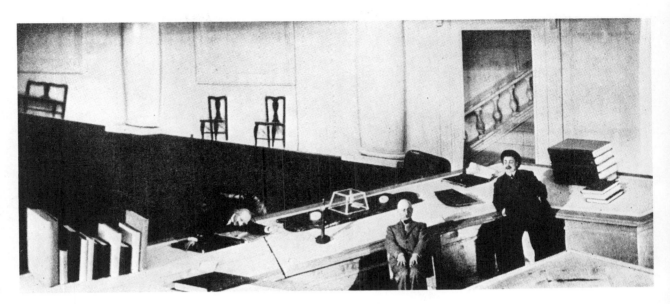

20

Kitaj's *Mock-up*—like most of the other A & T projects—will assume the distinctive mark of the artist only in a final disposition of the individual components in the installation. Judging from the above description, the environment will relate to Kitaj's style of painting and become in the end a complex of objects, the character of which will be determined by the conjunction of multi-layered, often obscure, poetic, historical, and esthetic associations. Kitaj once commented,

> What is and was important was to connect *often* over the weeks and months with those fugitive passions which occasion themselves and pattern themselves at the centers of one's interest There is no, or very little question of, *ultimate* meaning, as, I think, issues of meaning are far less clear than is often supposed, even in simple, abstract art The [project] might have been called 'The Vitality of Fresh Disorder.' That's Blackmur's phrase . . . and he goes on to say: 'Each time we look at a set of things together, but do not count them, the sum of the impressions will be different, though the received and accountable order remains the same.'*

Gail R. Scott

*Letters from 31 Artists to the Albright-Knox Gallery
Spring 1970, P. 18

Piotr Kowalski
Born Poland, 1927
Resident Paris

Primarily because of his successful participation in the
International Sculpture Symposium in 1964 at Long
Beach State College we invited Piotr Kowalski to submit
a proposal for A & T. Kowalski indicated he would, but
surprisingly, he did not.

Rockne Krebs
Born Kansas City, Missouri, 1938
Resident Washington, D.C.

The Hewlett-Packard Corporation contracted with the Museum as a Sponsor Corporation in August, 1968, after a fairly prolonged exchange of correspondence between the Museum and David Packard. Hewlett-Packard had declined to join as Patron Sponsor, and we might not have persisted so long in soliciting their cooperation except that we had toured their Palo Alto facility with Mr. Packard in July and felt strongly that their technological potential for an artist, especially in the area of lasers, was exceptionally important. By joining the program in the Sponsor capacity, Hewlett-Packard ultimately provided valuable resources and went to considerable effort and expense in assisting the artist matched with them—their commitment finally equalled that of most Patron Sponsor corporations.

After Hewlett-Packard had signed a Sponsor Corporation contract, nearly a year passed before they received an artist, though the assignment, when made, was accomplished easily.

In March, 1969, Hal Glicksman received a letter from Washington, D.C. artist Rockne Krebs:
> Walter Hopps suggested that I contact you if I was interested in participating in the L.A. County Museum's 'Art and Technology' show. I am.
>
> Perhaps Walter mentioned my light structures to you. I would be particularly interested in producing one in collaboration with a corporation which makes lasers. I have been plugging away at these things since the spring of 1967 when I panhandled a laser and set one of the structures up in my apartment. Since then there have been three one-man shows—a fourth coming up at the Corcoran in May [this was later rescheduled for November]. I have yet to scratch the surface in terms of the possibilities. The inevitable inhibiting factors for me are technical assistance and the equipment necessary to realize the work. Needless to say, your project sounds attractive to me.
>
> I now have eight lights of my own. All but one were purchased from Spectra-Physics, a firm based in Mountain View, California. Their local rep has been reasonably cooperative about lending me equipment when he has it available. I understand that Spectra-Physics is one of the few companies left whose primary product is lasers. I mention this because Spectra-Physics might be limited in how much they could afford to subsidize this kind of project as compared to a large corporation for which lasers would be a subsidiary product. I am just speculating, however. Laser applications apparently have not kept up with what was envisioned initially.
>
> If you are interested, I will prepare a detailed proposal for a piece.

We were indeed interested, and on April 11, Rockne sent us a carefully drawn up proposal. It described two works, one to be set up outdoors and shown at night, the other an indoor piece. He called them *Night Passage* and *Day Passage.* In May, we brought Krebs to California for three days to tour corporations. He visited Hewlett-Packard, and signed an artist contract. It was immediately evident that Hewlett-Packard would be well equipped to work with Krebs, and following Krebs' tour, we sent his proposal to Dan Lansdon, Administrative Head of Hewlett-Packard's laboratory, with a letter urging that a collaboration be initiated. On June 6, Lansdon phoned to say that Hewlett-Packard was prepared to work with Krebs: it was agreed that Krebs would begin residence in mid-July. A year later, Rockne wrote about his feelings at that time, just after he had first toured the corporation:
> Initially, from the point of view of realizing a laser piece, I had some misgivings about a collaboration with Hewlett-Packard. They made lasers, but I had no idea if they were the type suited for my work. The security lid was on the project they had going with lasers and they refused to discuss it with me.
>
> I did feel that there were some interesting people there but in terms of Hewlett-Packard's products, I did not immediately see any possibilities for the kind of work that was on my mind when I went to Palo Alto
>
> To be completely honest about it, at the time I wanted very much to make a piece. This is not the cool, think-tank theme that might be popular to peddle, but several years of ideation and attempts to visualize pieces that were beyond my resources to realize, both technically and financially, had preceded my initial visit.
>
> Maurice Tuchman and Hal Glicksman stressed the importance of the unknown possibilities that this sort of collaboration might point to: Quote MT: 'You may not even want to make a laser piece.'
>
> Okay. I was skeptical, but I told MT, HG, JL and BA that I would be glad to go to Hewlett-Packard and spend time in the labs and see what happened.
>
> Who knows what was on the group mind at the Hewlett-Packard labs? There was an unknown. Titillating.

Krebs was at this time more enthusiastic about doing an outdoor piece (some version of *Night Passage*), than the indoor *Day Passage* and in June sent us an RCA price schedule on laser equipment with hand-written notes on how he might use their argon laser, Model LD 2100, for such a project. He wrote,

The LD 2100 has an internal cavity prism assembly which permits the selection of a minimum of six individual frequencies—colors.

It should be possible to devise a way to run through its color range continuously which is from green-yellow to blue. Now try to imagine a huge exterior light structure of three of these on different cycles and one stable red 50 mw helium neon zapping between the buildings and finally shooting off over Wilshire into the L.A. atmosphere. [1]

Flowers would grow in the cement out front of the L.A. County Museum the three or four hours a night that it was turned on.

In fact—let this be my proposal to Hewlett-Packard. I recall that they have one argon laser some place. They would begin by making an automatic wavelength selector device that runs on a continuous cycle for their argon laser. (Although I would be interested in how it's done, it is not necessary that I know. Then if I'm allowed out there I could have that to begin experimenting with when I arrive in July. If it does what I think it will, we could then see about renting or borrowing the one or two more lasers necessary to realize the piece.) I would like to be able to control the cycle rate—slow or fast, and to be able to stop it on a specific color if I wanted

By the time Krebs arrived in Palo Alto in July, and the collaboration was underway, it had become fairly certain that some of the A & T projects would go to Expo 70, and we encouraged Krebs and Hewlett-Packard to execute a laser environment that could be displayed in the New Arts area. Thus, the idea of creating an outdoor work was relegated to secondary priority. Krebs and Hewlett-Packard's physicist Laurence Hubby did run some night tests during his stay at Hewlett-Packard involving a laser beam directed into the atmosphere and hand-manipulated mechanically to change color. This peripheral experimentation was actually of key importance to the artist in many respects. He afterward wrote,

I have a reasonably good science-fiction background. When I arrived at the Hewlett-Packard labs I could turn a laser 'on' and 'off.' I felt that the technology involved was best left to the technicians. Still do with this qualification: I want to know all the capabilities and limitations of the tool. What we were doing wasn't merely collaborating on the execution of a piece for Expo. I was able, with the assistance of Hubby and others, to research in a much broader sense, possibilities for work that had nothing to do with any particular piece. For example: Larry Hubby and I would go back to the labs in the evening (on his time off). We would set up and run the tests for outdoor pieces. With Larry's assistance I was able to

determine the power of laser required to do an outdoor piece, and the size of optical telescope necessary to refocus the laser light to get minimal divergence in relation to distance. In other words, what my scale limitations were. I learned that there was a definite relationship between the particle size, the frequency of the light (color), and how well it scattered under normal atmospheric conditions—appeared visible along the path of the beam. I learned that the blues and greens would be scattered better by the incidental matter present in the atmosphere than the longer wavelengths of red.

Throughout Krebs' initial residence at Hewlett-Packard, from July 21 through August, and in the later stages of the project, Dan Lansdon served as his principal contact. Lansdon was extraordinarily helpful in directing the artist to the right personnel for advice and assistance in the various technical aspects of the project; according to Krebs, "Lansdon had the authority, and used it: he knew what people to see and how to approach them." Krebs not only worked with a great number of technicians at Hewlett-Packard, but made several connections with laser experts outside their laboratory. The Palo Alto area is probably the world center of laser research, and on five or six occasions, Krebs was led by Hewlett-Packard people to seek information from experts at such nearby organizations as Spectra-Physics, Coherent Radiation Laboratories and Stanford Research Laboratories. He presented a slide lecture to personnel at Spectra-Physics which was received with considerable enthusiasm. Indeed the first two or three weeks of Krebs' stay in Palo Alto were devoted primarily to a process of gathering and exchanging information and simply conversing informally with various laser researchers. Krebs said later that when he arrived at Hewlett-Packard with his project in mind, he "didn't know if the piece was *possible;* I suspected it was, but it was much more complicated than I had envisioned. Technically, it's more complicated than any work I've done."

Rockne also commented that he was intensely affected intellectually by his experience in Palo Alto: "My mind was stimulated," he said, "in a way it never had been before, and probably never would be, particularly by art."

Krebs was extremely gratified to find that he could easily obtain direct and precise answers to questions he had hitherto not been able to resolve. For example, he consulted with a Stanford Research Institute physicist, Dr. Arthur Vassiliadus, on the issue of the precise threshold levels of eye damage by laser light, and got exact quantitative information from him, based on recent studies, that probably was not available at that time anywhere else in the world.

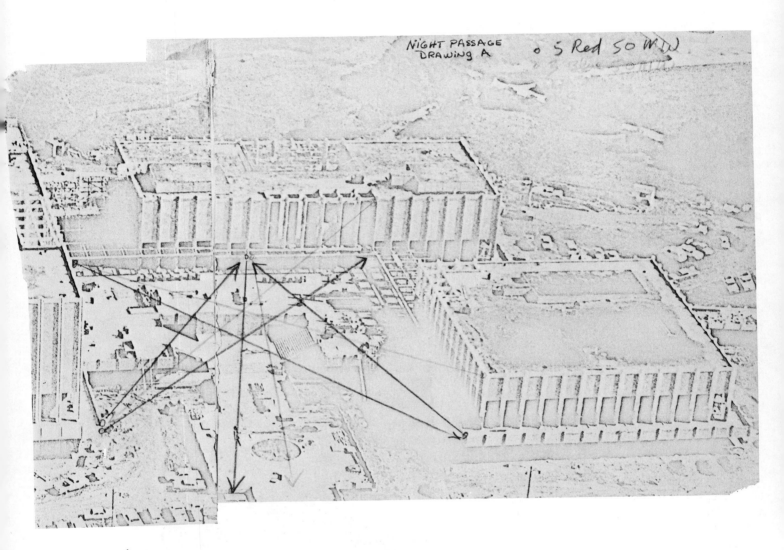

1

One incident occurred, not directly related to his work on the main project, which may have especially significant ramifications for Krebs. He was asked to present a lecture with slides to a group of Hewlett-Packard employees. The talk elicited similar interest to that expressed by the Spectra-Physics audience, and one man, a scientist named Egon Loebner, approached Krebs at the end of the presentation to invite him to lunch. Loebner is an authority on patent procedure (he was teaching a course in invention at Stanford), and he felt that something Rockne had demonstrated might in principle be a patentable technique. He saw in some of Rockne's laser light configurations a potentially utilitarian function as a device showing particular ways of architecturally delineating space, or "light as structure." Loebner and Krebs sought the advice of a patent lawyer whom Loebner knew, and as a result a patent search is presently underway for what is being termed "architectural photon structures." According to Krebs' description of the projected uses for this phenomenon, it would be employed literally as an architectural element. For example, temporary walls, false ceilings and room dividers might be created with laser light. Such structures could be constructed indoors or outdoors; one advantage, for instance, might apply in a landscape situation, in which one wished to mark out a space without physically disrupting the terrain or flora. Although this potential function for his laser environments had not occurred to Krebs, he quickly saw its rationale, as envisioned by Loebner. Krebs had used light in this way repeatedly, but was not particularly aware that it might constitute a patentable invention, or even that he may indeed have been doing it for the first time.

In executing the piece for Expo, Krebs worked perhaps most closely with Hewlett-Packard physicist Laurence Hubby [2], who designed and put together the optical apparatus, and with optics engineer Bruce Ruff. Of the system designed by Hubby, Krebs was to say later, "The apparatus that controls the argon beam is a work of art in itself. It has been absolutely beautifully designed." [3] (A technical description of the optical system developed for Krebs was written for us by John Lazier, and is included as an appendix on p. 176.) Besides the intricate optical system, which incorporated hundreds of parts, the work basically comprised a series of small mirrors to direct the light beams, two helium neon lasers, special mounts for the helium neon lasers, the large argon laser, the fog-producing machine needed to increase the visibility of the beams, and two eight and one-half by fourteen foot plate glass mirrors which were made in Japan. The Japanese company that provided the mirrors stated that they may be the largest true mirrors ever made. Rockne wrote, elaborating on the system,

These *small* mirrors were no small design problem.
First, they needed to be adjustable through three axes—x, y, and z, with as much adjustment as pos-

sible. The latter was necessary to give me flexibility when redirecting the light beam. Second, they had to be stable, so that once a position was determined the mount itself would not slip and cause misalignment. Third, the mount had to be attached to a wall of similar plane. Fourth, I wanted all this to happen in as discreet a piece of apparatus as possible: a small three inch diameter mirror mount that would protrude little from the wall. (My feeling about these pieces is that the *work of art* is not the apparatus. Rather, it is a score or arrangement [or whatever] determined in relationship to a specific enclosure. Allowing for the obvious contradiction of the necessity for some kind of apparatus [mirror mount] to redirect the light it is important to me that they be as inconspicuous as possible.)

This kind of mirror mount (or Maurice's term 'beam joint') is not stock optical equipment. Dan Lansdon and I spent an amazing number of hours discussing the requirements and attempting to find some kind of existing mount that could be altered—none existed! Although several of Hewlett-Packard's mechanical engineers worked on it at various times, it was Lansdon who resolved and perfected a mirror mount which satisfied my requirements, with the beautiful plus of being relatively inexpensive to produce—about $30 per mount. If I continue to work with lasers, as

2

seems likely at this time, try to imagine how long it would have taken, how much it would have cost, how difficult it would have been for me to locate people capable of and willing to bother designing this one little item. With the prototype which I now have I can have them made myself.

The main aspect of the project accomplished in terms of realizing the piece for Expo during Krebs' initial stay at Hewlett-Packard was the designing of the programmed optical system; this is of course in some ways the crux of what the work is about, but it still remained to actually obtain the large argon laser (a problem which caused difficulties until the last moment) and physically set up the entire structure for final experimentation and perfection. This process had to take place in the installation area at Expo. Fortunately, there was considerable flexibility in the final disposition of the components within a prescribed space.

HG wrote this memo to the staff on August 28, 1969:
Rockne Krebs has left Palo Alto for Washington, D.C. He will return mid October. [This was eventually postponed.] Hewlett has approved $10,000 worth of mirrors and other devices for the infinity reflector system and other uses which Krebs gets to keep. The Argon laser has *not* been approved. Jelco (Japan Electronics Co.) makes a suitable laser that could be rented in Japan. Lansdon is investigating this and other possibilities.

In September, Krebs met in New York with members of the Expo Exhibition Design Team and us. At that time a tentative location for the work was selected. It seemed then that the major problems were the hazard created by

3

the artificial fog (this actually posed no difficulties) and the rental or purchase of the argon laser. Krebs needed a corridor-like space or spaces with low ambient light; these requirements were easily met, and it was provisionally decided to distribute the bouncing light beams in several sections located at various points in the area, mounted high overhead. Krebs made several drawings showing alternative plans for distributing passages of laser light through the New Arts area. [4]

After this meeting, some radical revisions in the New Arts area were effected.

Krebs wrote to Dan Lansdon on October 15,
> . . . I mentioned when I called last week that the architect of the U.S. Pavilion in Osaka, Ivan Chermayeff, indicated there were going to be some changes in the New Arts Exhibit area. I have just received a revised plan for the area. The space is now divided into rooms rather than having it in one big area. My new space is roughly forty feet by twenty feet. This changes the enclosure to the extent that my piece will have to be reworked. I am concerned now that in a more confined area the intensity of the Argon's green and blue beams will wipe out the lower power He Ne red.

> The altered space should not change the apparatus we collaborated on this summer except for reducing the number of small mirror mounts required. I think I said twenty versus thirty mounts last week when we talked. Reduce that to fifteen total (or fourteen in addition to the prototype I have), and hold up making the mount for the He Ne lasers

Hewlett-Packard and the Museum attempted to procure the argon laser as a donation from its manufacturer. Finally, it was purchased by Hewlett-Packard from Coherent Radiation Laboratories, and two helium neon gas lasers, model 251, were lent by University Laboratories.

Once it was determined that the large parallel mirrors would be made in Japan, and the sources of the three lasers and the fog juice was resolved, the question of actually installing the work at Expo was at issue. There was no doubt that Krebs would have to supervise the installation himself, but before his arrival considerable preparation was expected.

Krebs wrote to David Sutton, November 28, 1969,
> Regarding your suggestion in your November 18 letter that the Japanese contractor purchase and install the mirrors—I have three enclosures which should give you the information he would need. I like the idea of having the floor to ceiling wall of mirrors as you suggested over the phone, and I think it could

be done. It would make for a better looking installation than what is called for in my enclosures. My reasons for not suggesting this possibility initially were the additional expense of the mirrors and the difficulties encountered in aligning the mirrors in a co-planar relationship. It would be necessary to install the plywood paneling in such a way that you could insure the two walls used with the mirrors be co-planar before any attempt is made to install the mirrors. Then, in installing the mirrors, I would recommend covering the entire surface of the plywood with an even coating of 'mirror mastik.' This could certainly be done before I arrive in Osaka. (Note: the mirrors to be used are simply standard one-fourth inch thick plate glass. They come in a stock size of eight feet by ten feet in the U.S.) Once I am there and install the lasers and other apparatus, it would be necessary to drill three holes in one mirror. However, I do not think this will pose a problem.

Krebs returned to Hewlett-Packard for a week in January, 1970, to finish the work begun the previous summer—the lasers had still to be tested in operation with the small mirrors, and the optical system completed. During this period he worked intensely with Laurence Hubby, and again Lansdon assisted him significantly. Because Krebs was to accomplish the installation himself, without the assistance of the Hewlett-Packard scientists who had developed the work, he had to be taught to assemble and operate the optical system. Krebs wrote,
> John Lazier, the Hewlett-Packard electronic technician who designed the electronic shuttering system and the program which could control the rate of change and configuration and color change, had worked out a number of variable program possibilities. He and I discussed these at length, he trying to visualize what the various program possibilities might look like. I decided for the most apparently random program. The limitations were: three positions, 'A,' 'B,' and 'C' which could result in three separate light configurations and two basic colors. I wanted the rates, color, and position changes independent of one another. We were told the average viewer would spend roughly three minutes in the space, so the possibility of the piece completing its cycle—running through all three positions and the final 30-second rapid stage—had to be worked out with this three-minute time factor in mind. The more we discussed it, the more I began to see how important the rate of color change and the rate of re-positioning would be to the final piece. And without actually experiencing it in the space I was reluctant to settle for a basic program which I could not alter. John Lazier was sympathetic and spent considerable extra time designing into the system a control mechanism which would allow me to alter the rate of the cycle to fit

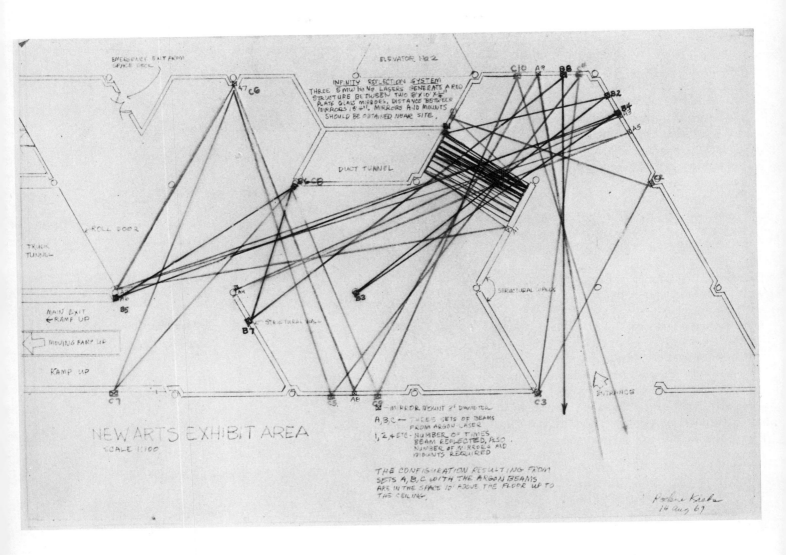

NEW ARTS EXHIBIT AREA

SCALE 1:100

4

the situation. Also, to facilitate making the piece, a switch was put in so I could leave it on at any designed point in the cycle.

The last night I was in Palo Alto, Lansdon, Hubby, and I were up into the wee hours setting the argon laser and its optical system up to test it. We actually mounted several small mirror mounts and put up a test configuration. Everything worked beautifully except the collimating telescopes. I felt that visually the beam's intensity was too weak because of the beam diameter. I asked Larry Hubby to redesign the telescope and reduce the beam diameter to one-half inch, which he did.

On January 24, Krebs arrived in Osaka to begin the six week job of installation. The space in the New Arts area allotted for the work measured twenty-three feet by forty-six feet; it was a parallelogram-shaped room. Beside it there was a separate, walled off utility room within which the laser apparatus was to be mounted; the large mirrors were placed face to face in the center of the room. [5] Krebs accomplished nearly all of the immensely complicated installation himself. He moved into a schedule whereby he would work at night, alone; it was easier for him to function undisturbed by the workmen in adjacent areas.

The work is difficult to describe, but in assessing the artist's intentions for it, and the important issue of its special nature as a collaborative project, some attempt at description is necessary.

Two kinds of laser light were used. The argon laser produced most of the light, and because its powerful light green and blue beams could be controlled by the optical system (in conjunction with the small "beam joint" mirrors, to disperse the beams) [6, 7], to flash on and off, or change color, it was used to generate the

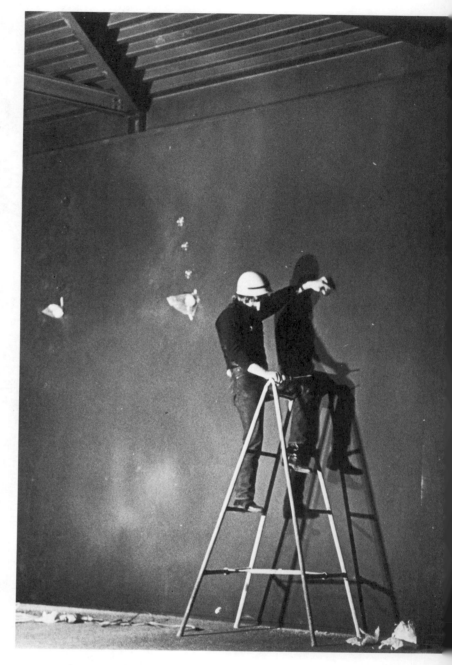

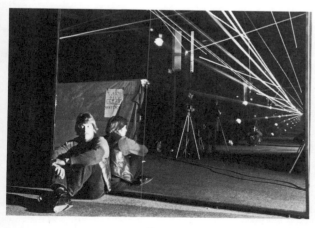

5

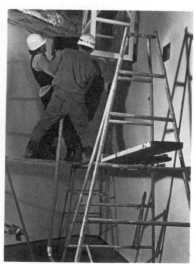

complicated configurations of continually changing light structures. The red beams emanating from the smaller helium neon lasers formed a *static* configuration seen reflected "to infinity" in the two parallel mirrors.

The argon beams were structured in three basic sections. Originating at each end of the room, and traversing it length-wise, were "fans" of light. At one end, "joints" of light originating from a single beam (sections of beams reflected between small mirrors) traversed the area in a parallelogram which hung horizontally, at a distance of seven and one-half to eight feet above the floor. At the other end, a beam was positioned vertically, up the wall, from eight to twelve feet above floor level. This beam would then fan out in a vertical line and twist into a horizontal configuration. Then this entire system would be reversed, and the same thing would occur at the opposite end of the room. The configurations of light were programmed to run through a repetitive cycle; they would pop back and forth, or seem to swing; just as the spectator began to apprehend the pattern from one point of view, it would suddenly begin to enter a "dialogue" phase, popping back and forth across the space. The cycle was determined at seven minutes, based on the anticipated rate of traffic flow through Krebs' room.

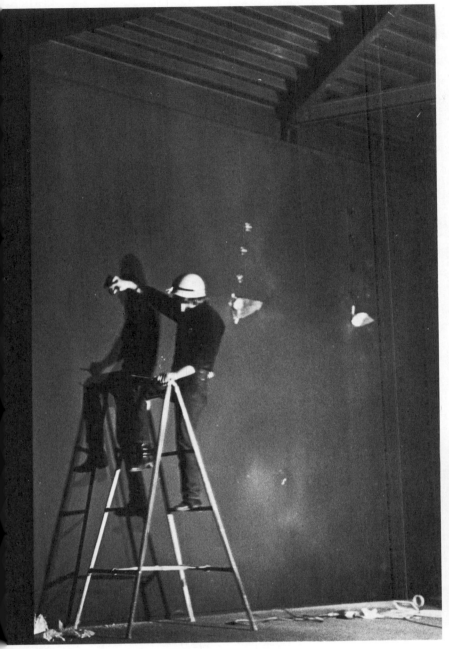

6

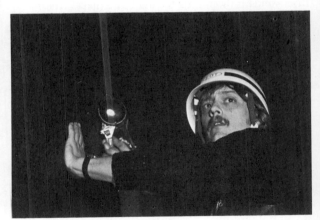

7

The third argon beam was positioned vertically in the center of the space, running down the center of the mirrors. This generated a kind of "wall," but worked into the sweep of the beam activity originating from each end of the room. The center beam worked in various combinations with the peripheral argon structures. Reflected in the infinity reflection system it moved in and out and changed shape in relation to the "armature" of the red (helium neon), static beam network.

The apparent depth perceived as one stood between the parallel mirrors was calculated by Krebs to be about ten times that of the actual distance between them (about) eighteen feet). Thus as one walked through the area, he entered a passageway between the mirrors which was

actually *narrower* than the rest of the room, but seemed to open out suddenly into a great expanse.

When this description of the work had been written, it was shown to Krebs in the hope that he could add to, or clarify it. Krebs felt that it was not totally accurate, and submitted three drawings which he hoped would make the structure more easily visualizable to us. [8]

In relation to Krebs' past work with lasers, this piece represents a significant departure chiefly by virtue of the programming system, which he could not have developed without the assistance of specialists. The artist had for some time wanted to find a way to weaken the psychological persistence with which laser beams are perceived as apparently *real matter.* He felt that by making the beams temporarily disappear, and then reappear, or by repositioning the light from one source into a series of varying configurations, he might succeed in achieving a sense of the light in its true character—as simply light. The ability of laser light to suggest spatial delineation, and to convey both the transiency and relativeness of this process, is realized, Krebs found, only when clues are given to counter the strongly illusionistic felt presence of a laser beam projected uninterruptedly. The clues were provided by the programming system. Discussing his intentions for the Expo piece, Krebs wrote,

> The light beam would fill the room with one config-
> uration and then another—versus 'to flash on and
> off' you just have the sense of something that's
> in one place and then it's in another. As you noticed,
> the beams of laser light have visually a tangible
> presence. But I am not dealing with material in the
> same manner the sculptor has in the past. Conven-
> tionally a sculpture is a configuration of mass that
> one sees because it is illuminated by some light
> source. I reversed this proposition. I put incidental
> matter into the atmosphere (or use what is already
> present) and project light through it. The path the
> light beams take as they pass through incidental
> matter in the atmosphere is the sculpture. It is a piece
> of sculpture that one could physically move through.

> But, it is light (I think Newton called it 'a unique
> form of matter') and it has unique capabilities. In the
> configuration that resulted from positions 'A' or 'C'
> there was never any sense of the structure as a kinetic
> thing—of the light moving from one point to another.
> Rather it was simply there in a space that had previ-
> ously either been empty or occupied by a different
> structure.

> So these are some things that I am able to do with my
> medium that I could not do with another. There are
> other possibilities. This piece was not an attempt to
> demonstrate all the unique properties of light in

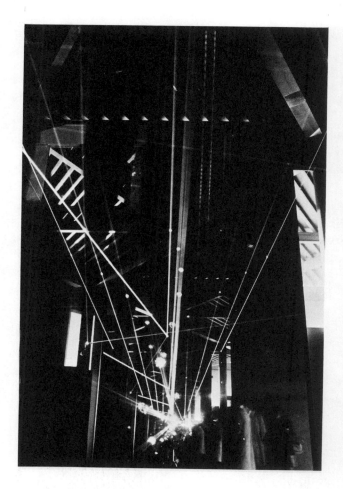

> general or laser light in particular. It was an attempt
> to realize a particular work of art which did of course
> use some of these properties.

> The visual presence of the laser light can be sufficient-
> ly convincing that one forgets with his eyes and
> ultimately with his mind the reality of what he sees.
> The idea of reconfiguration is then a self-conscious
> attempt to tickle both his mind and eyes.

Rockne plans to expand the basis for the Expo piece somewhat in doing a work for the Museum exhibition; there will probably be a greater profusion of light beams from the argon lasers, and possibly the addition of one or two helium neon lasers. We are planning as well to arrange for the artist to set up an outdoor work, using one or more powerful argon lasers, shooting beams out over the city of Los Angeles from the Museum.

Jane Livingston

The room looks in plan like this:

① Lasers mounted on wall with light entering the I.R.S. through holes in the mirror.

Utility Space

Traffic Flow

Argon

HeNe | HeNe

Infinity Reflection System

23'

46'

③

② Blow-up of Argon section of the above plan view.

a b c

Mirror with 1" diameter hole for the three separate beams of Argon laser light to enter the space. The hole is 10' above floor and centered.

A, B, C are the green and blue light beams which produce the three separate configuration - A, B, and C. Actually the beams would enter the space either one at a time or in the combinations of "A" and "B" or "B" and "C".

Structure "A"
Side View

Top View

Beam ends

End View

④
Structure "B"

In "B" the light walks down the two mirrors of the I.R.S. which run vertically from floor to ceiling.

5½'

14'

b

Beam ends

⑤ Structure "C" is similiar enough to "A" that it should suffice to think of "C" as "A" reversed.

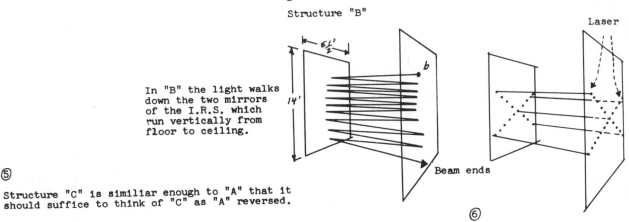

Laser

⑥ 2 HeNe red-projected through two holes in mirror 9' above floor - from the configuration shown as the light beams walk down mirrors diagonally.

8

A Simplified Explanation of the
Beam-Switching Sequence

There are three separate angles at which the beam can be directed,
and two separate colors (blue and green).

It is easiest to visualize nine shutters, one for each angle and one
for each color (at each angle), as shown below. For a blue beam at angle A,
we would open shutter "α" (blue) and shutter "A", etc.

The actual shutter-control system is more complicated but less versatile
than as outlined above, due to limitations in the practical placement of the
shutters.

-2-

There are two, separate, adjustable "clocks" or oscillators. One, designated as the basic clock, controls the rate at which the beam changes position (angle). The other is called the color-change clock and does just that; i.e., it controls the rate at which the beam changes color.

Let's consider the basic clock first. In its direct (fast mode) it sequences the beam thru the three angles: A, B, C, A, B, C, etc. The time, T, at each angle is as indicated on the dial calibration, and may be adjusted from .14 to 3.5 seconds.

After 10 cycles (30 angle changes), the basic clock output is switched to a slow mode. Now the beam will stay at each angle for a time equal to either 80 times T or 160 times T (depending on a rear-panel switch). For example, if the switch is in the 80 position and the basic clock is set for a period of 1.5 seconds, the time at each angle will be 120 seconds.

After one complete cycle (3 angle changes), in the slow mode, the clock output is switched back to the fast mode and the process repeats.

The color-change clock operates at a generally slower rate (1.6 to 80 seconds), changing the beam color alternately between blue and green. Thus, during the fast mode of the basic (angle) clock, the beam will normally go through several angle changes before changing color. In the slow mode, the color will change faster than the angle.

This color-change control is totally independent of the other timing circuits.

-3-

A third cycling circuit, called the additional-color flip-flop, provides an added (and opposite) color beam at angle B along with the normally-provided beam at angles A or C. The shutter-gating table may be helpful in visualizing this sequence.

This additional-color effect is operative half the time, being triggered on or off after each fast-slow cycle.

TIMING DIAGRAM
KREBS LASER-ART PROJECT

BASIC CLOCK

|← 100T →|

×10 TIME SCALE

BASIC CLOCK (EXPANDED)

ANGLE A (EXPANDED)

ANGLE B (EXPANDED)

ANGLE C (EXPANDED)

|← T →|

|← 30T →|

ANGLE A

ANGLE B

ANGLE C

|← 80T →|

FAST-SLOW
FLIP-FLOP

ADDITIONAL
COLOR F.F.

COLOR-CHANGE
CLOCK

THE COLOR-CHANGE CLOCK IS SHOWN SET AT 20× THE BASIC
CLOCK SETTING (TOTAL PERIOD = 40T). IT IS INDEPENDENT.

THE BASIC CLOCK PERIOD IS DESIGNATED "T" (RANGE = .14 - 3.5 SEC.).

THE SLOW-MODE TIME IS SET AT 80T. IT MAY BE
SWITCHED TO 160 T. (TOTAL F-S PERIOD = 270T OR 510T.)

SHUTTER AND BEAM LIST

KREBS LASER-ART PROJECT

COLOR & ANGLE	OPEN SHUTTERS	"ADD. COLOR" COLOR & ANGLE	OPEN SHUTTERS
α A	2, 5	α A & β B	2, 3, 5
α B	1	α B	1
α C	2, 6	α C & β B	2, 3, 6
β A	4, 5	β A & α B	1, 4, 5
β B	3	β B	3
β C	4, 6	β C & α B	1, 4, 6

SHUTTER	BEAM
1	α B
2	α AC
3	β B
4	β AC
5	A
6	C

α = 4880 Å (BLUE)

β = 5145 Å (GREEN)

A = 8.56°

B = 0°

C = 355°

SHUTTER GATING TABLE

KREBS LASER-ART PROJECT

"ADDITIONAL COLOR" F.F.	COLOR-CHANGE F.F.	÷3 COUNTER	ANGLE A	ANGLE B	ANGLE C
ϕ	ϕ	ϕ (A)	α	—	—
ϕ	ϕ	1 (B)	—	α	—
ϕ	ϕ	2 (C)	—	—	α
ϕ	1	ϕ	β	—	—
ϕ	1	1	—	β	—
ϕ	1	2	—	—	β
1	ϕ	ϕ	α	β	—
1	ϕ	1	—	α	—
1	ϕ	2	—	β	α
1	1	ϕ	β	α	—
1	1	1	—	β	—
1	1	2	—	α	β

$\alpha = 4880 \text{ Å} \ (BLUE)$

$\beta = 5145 \text{ Å} \ (GREEN)$

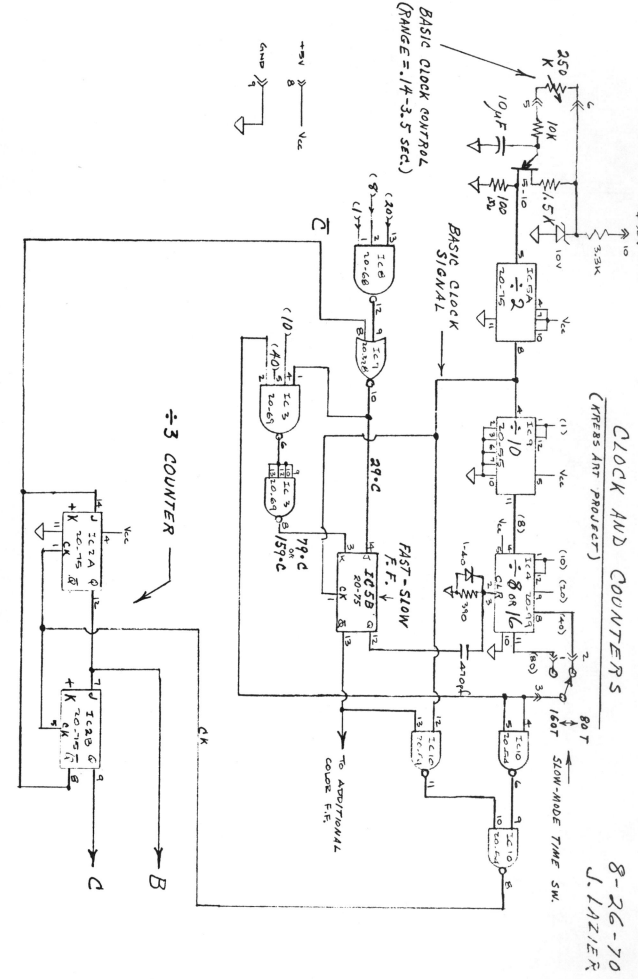

CLOCK AND COUNTERS
(KREBS ART PROJECT)

8-26-70
J. LAZIER

BASIC CLOCK CONTROL
(RANGE = .14-3.5 SEC.)

BASIC CLOCK SIGNAL

÷3 COUNTER

FAST-SLOW F.F.

SLOW-MODE TIME SW.

TO ADDITIONAL COLOR F.F.

(1), (8), (10), (20), (40), AND (80) REFER TO OUTPUTS OF THE COUNTER SECTIONS WHICH ARE HIGH AT THE INDICATED COUNT

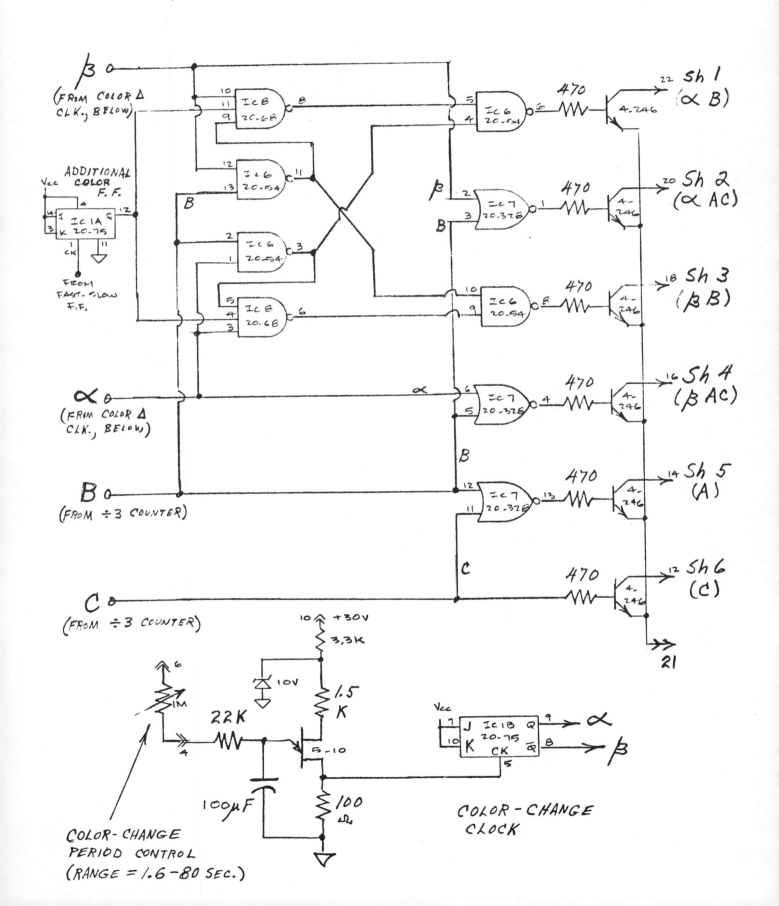

8-26-70
J. LAZIER

SHUTTER GATES AND DRIVERS

(KREBS LASER-ART PROJECT)

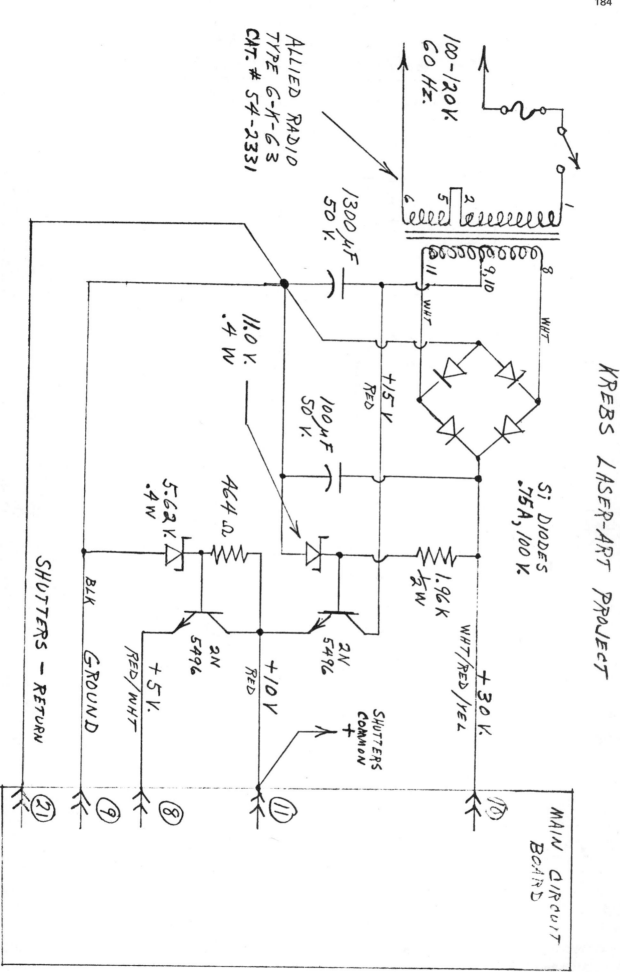

POWER SUPPLY

KREBS LASER-ART PROJECT

8-26-70
J. LAZIER

POWER TRANSFORMERS

6-K-63 6-K-64 6-K-65 6-K-66 6-K-67

All of these transformers will operate in full wave center tapped or bridge type circuits with readily available rectifiers. Each transformer has the winding arrangement and terminal numbering shown in the schematic diagram. A variety of combinations are possible using the taps on both windings, plus the "aiding" or "bucking" action of the extra winding. The secondary winding of each transformer consists of two identical windings connected to terminals 8 - 9 and to 10 - 11. Use the tables showing the various output voltages for specific terminal connections as your guide. Many combinations are possible other than those listed in the table for your experimental work.

6-K-63

Full-Wave C.T. — Output 2.0 A.D.C. *1000 MFD.

Input 117vac Term. No.	Resistive Load — Secondary Volts AC	Output Volts DC	Capacitive Load* — Output Volts DC
1-2	29.4	11.2	13.6
1-6	26.0	9.8	11.7
1-7	23.0	8.4	5.9
1-3	22.7	7.4	5.9
1-7	20.8	6.7	7.6
1-6	19.4	6.7	8.0
1-7	17.8	5.3	6.7
1-3	16.3	4.7	6.1
1-7	14.9	4.1	5.0
1-6	13.4	3.6	4.4
1-7	11.7	3.3	3.5

Full-Wave Bridge — Output 1.25 A.D.C. *500 MFD.

Resistive Load — Secondary Volts AC	Output Volts DC	Capacitive Load — Output Volts DC
28.5	23.0	27.9
25.7	20.0	26.4
22.3	17.3	22.2
20.3	15.4	19.7
18.6	13.9	15.7
17.2	12.7	13.8
15.1	11.2	13.3
14.3	10.2	11.6
12.7	8.9	10.4
11.4	7.9	9.5
11.1	7.4	8.7

6-K-64

Full-Wave C.T. — Output 1.0 A.D.C. *2000 MFD.

Input 117vac Term. No.	Connect Term. No.	Resistive Load — Secondary Volts AC	Output Volts DC	Capacitive Load* — Output Volts DC
1-2	2-6	29.3	11.7	14.7
1-6	2-5	26.2	9.8	12.6
1-7	—	24.4	8.6	11.3
1-3	3-5	21.5	7.4	9.9
1-7	3-5	19.2	6.4	8.2
1-6	—	16.4	6.1	7.5
1-7	4-6	15.5	5.5	6.6
1-7	4-5	13.5	4.4	5.3
1-6	4-5	12.9	3.9	4.8
1-7	4-5	12.0	3.7	4.0

Full-Wave Bridge — Output 2.0 A.D.C. *1000 MFD.

Resistive Load — Secondary Volts AC	Output Volts DC	Capacitive Load — Output Volts DC
29.3	24.3	29.3
26.0	21.6	26.0
24.0	19.5	23.9
21.8	17.6	21.5
20.5	15.5	20.6
18.9	14.2	17.8
17.6	14.2	17.4
16.4	11.7	14.2
14.2	10.1	13.7
13.4	11.7	12.7
12.0	8.9	12.0

6-K-65

Full-Wave C.T. — Output 8.0 A.D.C. **4000 MFD.

Input 117vac Term. No.	Connect Term. No.	Resistive Load — Secondary Volts AC	Output Volts DC	Capacitive Load* — Output Volts DC
1-2	2-6	29.2	12.0	14.5
1-6	2-5	25.7	10.5	12.5
1-7	—	22.8	9.2	10.9
1-7	—	20.5	8.3	9.6
1-3	3-6	20.6	7.7	8.7
1-7	3-5	17.6	7.0	7.8
1-7	—	16.2	6.3	7.6
1-6	3-5	15.1	5.8	6.3
1-4	4-6	14.2	5.4	5.8
4-5		13.3	5.3	5.3
1-6	4-5	12.5	4.9	4.9
1-7	4-5	11.7	4.3	4.5

Full-Wave Bridge — Output 4.0 A.D.C. **2000 MFD.

Resistive Load — Secondary Volts AC	Output Volts DC	Capacitive Load* — Output Volts DC
28.8	24.0	32.0
25.7	18.7	27.3
22.8	16.6	22.7
20.7	15.4	20.6
19.1	14.0	19.8
17.8	12.7	17.1
16.2	11.6	16.1
15.1	11.2	15.9
14.4	10.2	14.2
13.3	9.8	13.3
11.8	8.8	11.4

6-K-66

Full-Wave C.T. — Output 12.0 A.D.C. **6000 MFD.

Input 117vac Term. No.	Connect Term. No.	Resistive Load — Secondary Volts AC	Output Volts DC	Capacitive Load* — Output Volts DC
1-2	2-6	29.8	11.5	14.4
1-6	2-5	26.0	9.9	12.7
1-7	—	23.8	8.7	11.6
1-7	—	21.2	7.6	9.0
1-3	3-6	21.0	7.0	8.0
1-7	3-5	17.9	6.2	7.2
1-6	3-5	16.0	5.7	6.4
1-7	—	15.4	5.1	5.9
1-4	4-6	14.6	4.7	5.2
1-7	4-5	12.5	3.5	4.7
1-6	4-5	12.0	3.3	4.3
1-7	4-5	11.7	8.4	3.9

Full-Wave Bridge — Output 6.0 A.D.C. **3000 MFD.

Resistive Load — Secondary Volts AC	Output Volts DC	Capacitive Load* — Output Volts DC
29.6	24.6	29.2
26.3	20.6	26.4
23.8	18.6	23.6
21.7	15.2	21.3
19.7	16.6	19.4
16.8	16.6	17.6
15.6	12.5	16.1
15.4	11.4	15.4
13.5	10.3	14.2
12.9	8.4	13.3
12.0	8.4	12.0

6-K-67

Full-Wave C.T. — Output 15.0 A.D.C. **7500 MFD.

Input 117vac Term. No.	Connect Term. No.	Resistive Load — Secondary Volts AC	Output Volts DC	Capacitive Load* — Output Volts DC
1-2	2-6	29.7	11.4	14.8
1-7	2-5	25.4	9.9	12.5
1-6	2-5	24.1	9.3	11.6
1-3	—	21.5	8.2	10.0
1-7	3-6	19.3	7.1	8.7
1-6	3-5	17.6	6.4	7.7
1-7	3-5	15.6	6.0	6.5
1-7	—	15.5	5.5	5.7
1-6	4-6	14.4	5.1	5.1
1-7	4-5	13.4	4.5	4.4
1-6	4-5	12.9	4.3	4.4
1-7	4-5	12.2	3.9	4.4

Full-Wave Bridge — Output 8.0 A.D.C. **4000 MFD.

Resistive Load — Secondary Volts AC	Output Volts DC	Capacitive Load** — Output Volts DC
29.0	23.7	32.5
25.4	19.4	27.0
24.0	19.1	23.5
21.3	14.9	21.2
19.1	13.4	17.4
17.4	12.5	16.1
16.7	11.2	14.5
15.4	10.7	13.2
13.3	11.1	13.0
13.2	9.5	11.9
12.1	8.7	10.4

Wesley Duke Lee
Born São Paulo, Brazil, 1931
Resident São Paulo

Hal Glicksman became acquainted with the work of
Brazilian artist Wesley Duke Lee while in São Paulo
installing the 1965 Bienal. He recommended that we ask
Lee to submit an A & T project proposal, and in February, 1969, we wrote to the artist to this effect. In March
he replied enthusiastically, stating that in June en route
to Tokyo (where he was to install his Helicopter piece at
the Museum of Modern Art) he could stop off in Los
Angeles and discuss this possibility.

When he arrived in town, HG took him to Information
International and to Hall Surgical Systems in Santa
Barbara, a small company which produces air-driven
surgical drills. Lee was intrigued by his visit to Hall,
especially by Dr. Hall himself, and promised that while
in Tokyo, he would work out an idea for presentation to
us and the company. On June 14 he wrote to us, describing *The Birth Capsule,* or *The Suspended Pneuma of Los
Angeles*:

> I think I have already hit upon an idea; it can be
> easily constructed and would be a continuation of the
> *Helicopter,* deepening the idea that, if you could
> provoke a *full regression in time* in an adult person,
> he would be suddenly enlightened about his origin
> and his main problems, thus taking full consciousness
> of *himself, his environment, his time;* so I arrived at
> *The Birth Capsule* or *The Suspended Pneuma of Los
> Angeles.*

The piece in itself would be a plastic or glass box
3 x 3 x 3 meters (a cube) in which the observer would
go in, put on his space suit, look at himself, adjust his
'Air Helmet' from which he is going to breathe, and
receive the special smells of: blood-shit-sea-forest, and
hear the sound of a heart beating plus the blood
running through his vessels; after he presses several
buttons of his 'hand control panel' a quantity of air
would go in the capsule and press him or support him
(if he decides to lean forward!). Then the whole box
would start getting dark, to pitch dark, then slowly
turn to red, then to some kind of mirror surface (so

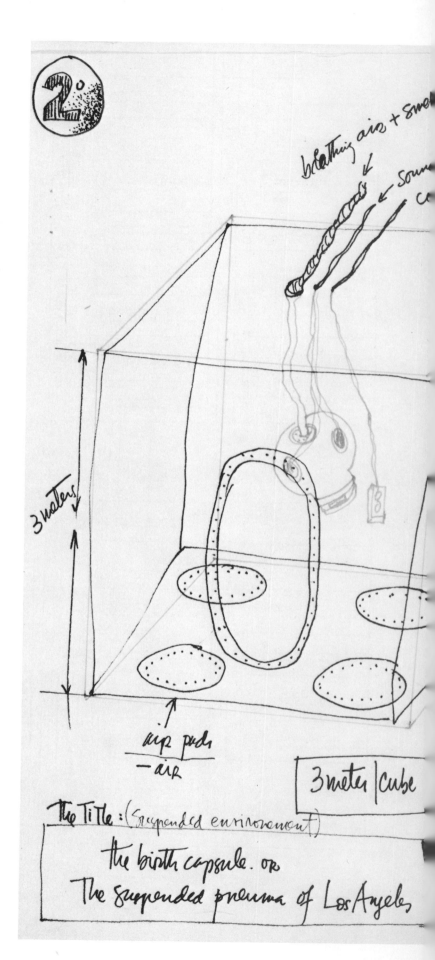

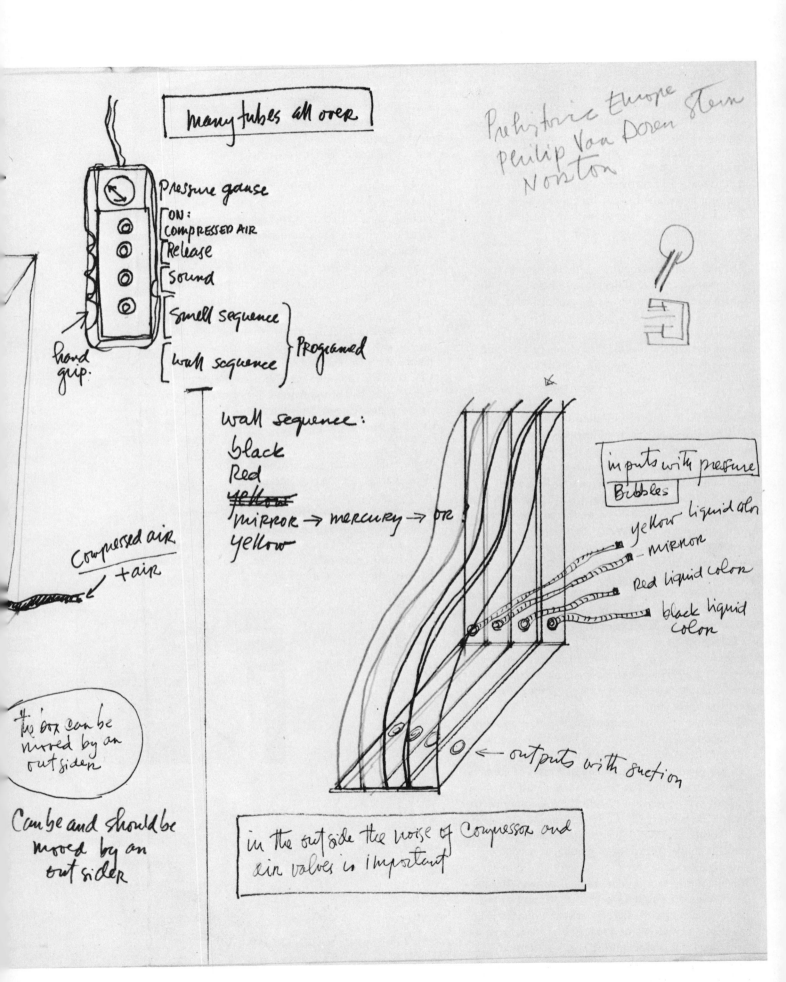

Many tubes all over

Pressure gause

ON:
COMPRESSED AIR
Release
Sound
Smell sequence
wall sequence } Programed

hand grip.

wall sequence:
black
Red
~~Yellow~~
mirror → mercury → or
yellow

Compressed air
+ air

Prehistoric Europe Stein
Philip Van Doren
Norton

inputs with pressure
Bubbles

yellow liquid color
— mirror
Red liquid color
black liquid color

← outputs with suction

the box can be moved by an outsider

Can be and should be moved by an outsider

in the outside the noise of Compressor and air valves is important

as to reflect him to himself) then to yellow, then to white or transparent and the air would go out and decompress the camera. To do this the walls would be made of five sheets of plastic so as to make a space between each other where compressed air introduces a colored liquid to tint the capsule. [1] The whole mechanism would be the two principles of air: positive air and negative air. The negative would be in the pads below the capsule that would allow a second person to move the capsule with the person around the room while 'he is getting born.'

The plans for construction would depend on some information from technicians as to how much pressure a person or 'an average person' can hold, site of materials, etc.

I read the catalogs from JPL and maybe I can use some ideas from their construction of space capsules, if it is possible.

In addition to its direct inspiration from the artist's visit to Hall Surgical Systems, the inception of the *Birth Capsule* is related to his three previous environments; it is the fourth in a group of five such rooms (the last is still in a conceptual state) which comprise a series entitled *The Five Stages of Man*. In different ways each of these environments is meant to involve the viewer at a "profound psychological level." Lee later indicated several other sources for the *Birth Capsule* idea. At one point he wrote to us on the back of a Xerox copy of a Zap comic strip, indicating that the *Birth Capsule* was inspired by this particular Victor Moscoso cartoon and by a statement of the Greek philosopher Anaximenes, "As our soul being air sustains us, so pneuma and air pervade the whole world." [2] In addition he later commented that "capsule" refers to space travel and the piece itself is a sociological comment on the state of consciousness that prevails as a result of the drive to master space. He said,

The farther away we go in space, the more frustrated we become; going to the moon has to do with power; it's a political power play. It's already boring, essentially. I'm trying to deal in fast processes of communication; something that could shorten all the fears we have of getting together. And I think we only do that by full examination of our structure, and this is what the *Capsule* is about. I have an idea which is not mine; it comes from a lot of reading in psychology and my admiration for Freud. If you could re-enact the birth process and your whole life seen with the adult eye, you would have at your disposal a life power which can be used to live with your fears. So my dream was to invent a machine so that man could be exposed for a short period and would be so shocked by the experience that he would automatically start to revise himself.

When Lee returned from Japan in July, he and HG met with Dr. Hall, to whom the artist described in detail the *Birth Capsule* idea. On the basis of Hall's encouraging comments and suggestions, Lee agreed to research certain problematic areas—such as the feasibility of extracting and projecting odors and the amount of pressure the human body might safely withstand in the space suit—and to refine the mechanism. Hall offered the assistance of one of his design engineers, but after waiting for two weeks for this man to free himself from other duties, Lee set out independently to seek advice on these problems. With the help of our corporation roster, Lee met with numerous technical experts, such as Dr. Francis J. Petracek, a medical chemist at Dart Industries' Riker Laboratories, and Carlos Diaz de Villalivilla, research chemist at Max Factor, both of whom provided helpful information not only about distilling the odors, but also about the mechanical design. With Dr. Edward Wortz of Garrett Corporation's Life Sciences Division, Lee discussed the air pressure system. Hall had also introduced the artist to a young mechanical engineer, Peter Mele, who was interested in assisting Wesley.

Early in September, Lee estimated the total cost of the project and presented his findings to Hall, who agreed to provide financial and whatever technical support he could toward realizing the project. Hall made arrangements (unique among all the budgetary procedures for A & T artists) for Lee to purchase necessary materials and pay for labor, on a special *Hall "Art and Technology"* checking account.

1

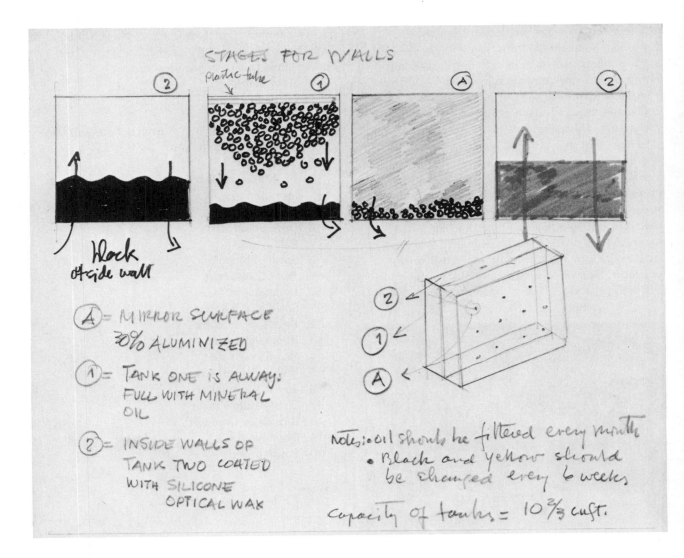

STAGES FOR WALLS

plastic tube

② ① Ⓐ ②

Block
offside wall

Ⓐ = MIRROR SURFACE
30% ALUMINIZED

① = TANK ONE IS ALWAYS
FULL WITH MINERAL
OIL

② = INSIDE WALLS OF
TANK TWO COATED
WITH SILICONE
OPTICAL WAX

② ① Ⓐ

Notes: oil should be filtered every month
• Black and yellow should
be changed every 6 weeks
capacity of tanks = 10⅔ cuft.

2

With Hall's commitment confirmed, Lee's travels throughout Southern California began in earnest. In the course of the project he dealt with over forty companies, individuals and small businesses, covering 14,300 miles from Santa Barbara to San Diego. Lee and his assistant labored indefatigably to design the capsule and its mechanisms. The walls of the tank were at first intended to be eight foot square sheets of plate glass, constructed in two layers, for the passage of various fluids. However, several consultants had expressed serious doubt that glass walls would be strong enough to withstand the pressure of the flowing liquids. Lee and Mele investigated substituting plexiglass instead and contacted numerous local plastic firms for estimates. Ray Products in Alhambra took the job and promised delivery in November. Meanwhile construction of the mechanical system began at Gold Divers, a manufacturer of portable

underwater mining equipment, located in Hawthorne. At Gold Divers Lee refined the programming cycle. He outlined "the twenty steps to birth an adult":

1. Enter Capsule
2. Close door
3. Put suit on
4. Press button ON OFF Button deflates suit—open door—system continues
5. Capsule lift
 Ventilation system in helmet—sound system in helmet
 Capsule lights on
6. Dark period starts
7. Suit inflates
8. Smell of blood
9. Red bubbles start
10. Empty black
11. Smell of shit and sex
12. Empty red bubbles
13. Room lights off
14. Ocean smells start
15. Yellow period starts
16. Forest smell starts
17. Empty yellow starts
18. Release air from suit
19. Door opens
20. Lower capsule

it took 14,300 miles to build the capsule

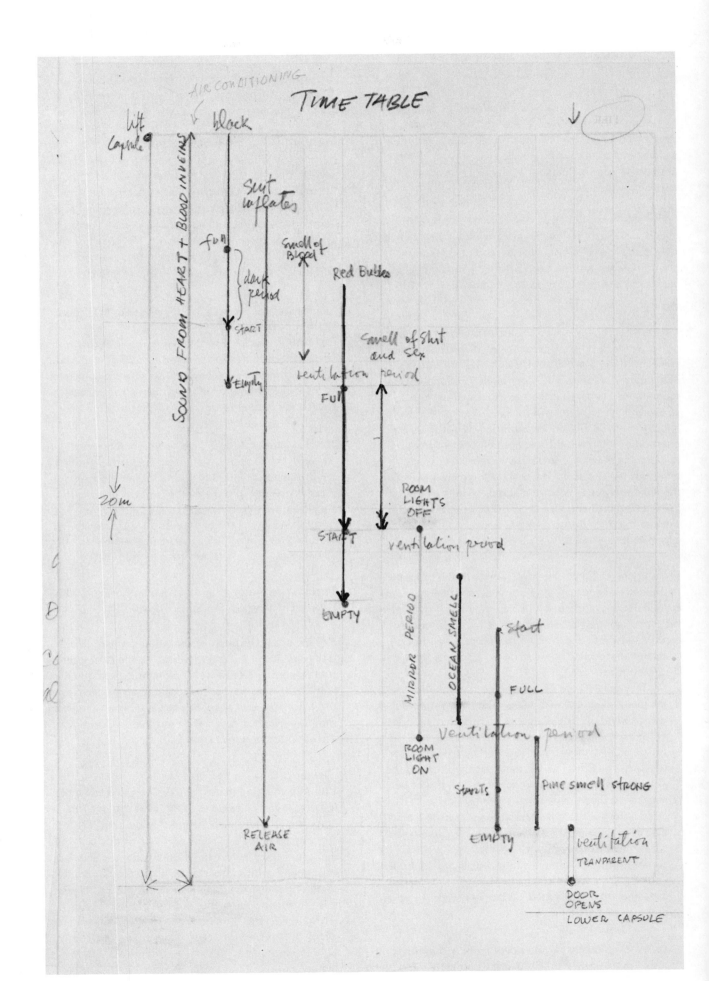

For several weeks work progressed on these separate fronts, but by early November a series of delays and schedule setbacks occurred. Then, on November 22, Hall indicated that his company could expend no further funds on the project. Wesley was startled and upset, but determined to see the project through. Since the major components of the *Birth Capsule* were nearing completion, we decided to underwrite the few remaining estimated expenses from our "materials" budget.

Construction continued at Gold Divers, and by the middle of December the plexiglass walls of the chamber were completed and the unit was ready for testing with the fluid pump system. Lee was of course extremely anxious to see the *Birth Capsule* in operation for the first time, and he and the designers of the cubicle were prepared to celebrate the long-awaited culmination of their efforts. The injection system was turned on, the liquid was forced by air pressure between the sheets of plastic forming the walls of the cell, and one entire side immediately cracked. The material used, which already represented a considerable expense, was clearly not strong enough to withstand the pressure required to inject the flowing liquid, and thus it was not simply a question of replacing the damaged component, but of re-designing the entire structure with heavier gauge plexiglass. At this point the project foundered. Without the unilateral supervision of a company prepared to make a sustained and well organized commitment to execute the *Birth Capsule,* it was destined to remain unrealized.

From the beginning of his involvement in the program, Lee had kept a journal on the project, containing sketches, calculations, and notes documenting every stage of the *Birth Capsule*'s development. He kept meticulous accounts of every expenditure and every individual or company approached along the way. Excerpts from this journal follow:

> My feeling is: There's a form of corruption in these people, they go through life without knowing what is the meaning of 'Ethics'—consequently they wish to know even less about Esthetics, which puts an end to the possibility of Art and Technology to come together, for Ethics and Esthetics is the very base of Art. So, my project is running the possibility of being considered incomplete for the exhibition The distaste for technology increases, and for the man that deals with it. I haven't met yet a 'Technologist.' What I have dealt with until now is 'employees' of corporations that exploit minor results of technology. Something should be changed. This new race carries the same 'pomp' that medical doctors have. And that bothers me quite a bit

> Da Vinci gradually slowed down more and more in his painting until it finally became completely inhibited as he turned to science—a turning away for which da Vinci apparently bitterly condemned himself as he lay dying. Technology to start with is in a very crude state in comparison with art, that has a much longer tradition. The 'crazy dream' comes when you try to melt the two together. If we want to go further technology will have to, first, pay full tribute to art—go through a process of modesty—which I think very difficult in our time—when apparently the 'wings of success' touched several projects—like going to the moon! Now we have to go to other planets, because going to the moon did not answer 'The Question' and brought no pleasure. Before technology learns about 'Pleasure'—Art is Ahead—And I will stick to it.

Before leaving Los Angeles, Wesley wrote to MT, summarizing his experience:

> Basically, it made me reconsider painting as my most important output, and that all the dealings that I had with machines, technology, and such, were connected to a very neurotic process, which I used as a substitute to my natural resources and ways of expression.

> Your exhibition exposed me to a complete situation. Through the process of 'building the birth capsule' I trapped myself (naturally with a lot of help from Acapulco Gold) into seeing the 'sin' I was committing. First to myself, through deviating from my natural and best ways of expression. Second, against Nature, you don't build a mechanical womb! as in the same way you don't take heaven by assault!!!

> I committed the sin that many have before me, who believed in a perfect imitation of nature.

> For me this is the jewel of the whole project, this discovery about me and my time. So the *Birth Capsule* will be my last endeavor along this path. I will work from now on, on 'the magic of arrest time' on a piece of linen with a few brushes and pencils, nothing should move, but your mind, and that's a secret I discovered only now.

On October 31, 1970, Lee wrote us,

> I've been thinking that the *Birth Capsule* is the most important work I've done so far; even though you haven't seen anything concrete, I know that it is almost finished The importance of this piece to me is that never before has a Brazilian artist engaged in a project of this importance, and it would remove some of the distrust that exists about our art. Maybe this is not relevant to you, but it is capital for our environment, and I am interested in the development of things here and the repercussions it would have If you come to Brazil you will understand my reasons

Les Levine was one of the few nationally known artists to contact us with an unsolicited proposal. In November, 1968, he sent us the following letter indicating his interest in Art and Technology:

Donald Droll tells me that you are doing a show which involves artists and companies and he suggests I contact you directly.

I have been working in this area for some time and have been successful in obtaining some cooperation from large companies. As a matter of fact for almost five years this kind of cooperation has been kernel to my work. In the past I have worked with both American Cyanamid Co. and Eastman Kodak. I am presently working in the area of television. Perhaps you are familiar with my large plastic environmental works.

I would consider it of enormous value to my work to be able to work with a company in the area of plastics or of video equipment.

In subsequent staff meetings we discussed the possibility of Levine's participation in connection with both Ampex and the Container Corporation of America—Ampex for audio-visual equipment, and CCA for mass produced "disposable" works of art.

In February we contacted Levine and invited him to tour these two facilities. He arrived on April 14, and Gail Scott accompanied him to Container. He was enthusiastic about their four color lithography press on which they print six foot square sheets for margarine, detergent, and other consumer product packaging. He considered their printing process more "contemporary" than the leading lithography art workshops. Although Levine was certain he could easily make a "disposable" or giveaway item, he was not enthralled by the idea, asserting that with the experience he had had with more sophisticated technology, it would be a wasted opportunity for him merely to produce an object. Levine suggested that instead of a one-artist to one-company match at CCA, we should invite each artist participating in A & T to execute a large lithographic print on their four color press—a proposal to which we subsequently gave serious consideration.

The next day GS and Levine flew to Ampex with the hope that their advanced audio-visual equipment might be of greater interest to the artist. Levine was intrigued with their small-scale television studio, housing a sophisticated array of broadcasting equipment including Ampex's RA-400 machine; a random access videotape programmer, an elaborate closed-circuit television set-up; and a multi-track tape recorder with a modular expansion of eight to twenty-four channels.

Levine was certain that, given an opportunity to experiment with these resources, he could create something—probably involving specially designed equipment rather than Ampex's standard products. He proposed spending some time at the company without outlining any definite project. He desired a completely open-ended situation without being restricted to a preconceived idea. We were in accord with this plan, but Ampex insisted on following their option to request from Levine and us detailed descriptions of the scope of the project before agreeing in principle to work with the artist.

Levine agreed to study Ampex product brochures, consider the information gleaned from his visit, and contact us with some sort of proposal. On April 22 he sent the following sketchy description of his intention:

Enclosed is a rough idea of what I want to do and it is not at all worked out at this point for obvious good reasons as I think it is important to keep the system open.

I would also probably want to use their television studio for the production of a T.V. special but this is something I could probably work out after their initial involvement.

I hope that this will be of some help and if there are any further questions we could talk about them when I get back from London.

Project for Ampex Corporation is to create audio-visual model of a human being. A piece that will allow the spectator to consider himself as though he were a working model.

The audio aspect would permit the viewer to hear whatever sounds can be detected from his own body as it moved through space, played back on several channels such as pulse, heart beat, blood flow, muscle manipulation, etc.

The visual aspect of the piece would allow any movement to be seen from all its possible views as somebody other than the subject would see it. To paraphrase this idea I suggest that a man driving in an automobile should be able to have inside his automobile the view of his automobile that a hitchhiker could obtain.

The system will probably require several small television cameras and monitors and some recording equipment for delay processes. It will also probably require some switching devices and information storage.

We informed Ampex of Levine's plans but they declined to accept his proposal, indicating that it exceeded their financial and technical commitment to A & T.

From the earliest staff meeting in the Spring of 1968,
Roy Lichtenstein was considered by us in connection
with Universal Film Studios. MT saw Lichtenstein in
June in New York, described A & T, mentioned some
available companies and suggested that the artist tour
Universal. Roy was interested, and although he was
unable to travel West until the Fall, we were so confi-
dent of his collaboration that we postponed considera-
tion of any other artist for Universal until after his visit.

Lichtenstein toured the studio on September 12, 1968.
In two days he visited most of Universal's key facilities
on their vast grounds in the San Fernando Valley.
Several department heads explained the capacities of the
film laboratories, including optics, cutting, editing and
special effects. There was a visit to the set of *Topaz,*
then being filmed; and a behind-the-scenes look at the
mechanical set-ups for the public tour of the studio.
Lichtenstein was enthusiastic about Universal's facilities
and was introduced to Alexander Golitzen, Supervising
Art Director, who was established as our primary con-
tact man. The artist also met several top executives, two
of whom had Lichtenstein lithographs hanging in their
offices. There was no problem in obtaining Universal's
agreement to work with Lichtenstein as artist-in-resi-
dence, even though he had made no indication as to the
nature of the work he might do there.

Before Roy returned home, he said he would probably
work with film. This was a surprise to us, and, we later
learned, to Universal. Comic strips, basic to Lichten-
stein's past work, possess, at least for him, a distinct
cinematic quality—he mentioned how narrative is devel-
oped in comics with abrupt compositional transitions
from close-up to aerial to interior views, etc. One pro-
posal which he outlined would be a sequence of shots of
a woman's face with contrasting lighting (for example,
green light on the left, red on the right), or tattooed
with dots, or with varieties of makeup. He rejected this
plan because it was too "zippy," or slick; also it would
have been too expensive and elaborate an enterprise to

justify the idea. He was also intrigued with making a literally "moving picture." On the basis of this pun, he proposed a series of landscape moving pictures. The films, displayed as a group, would be sequences of landscape fragments—water, clouds, sky—in combination with synthetic images such as textured aluminum for sunrays or a Ben Day dot grid for sky. He wanted it to look "fairly phoney."

Lichtenstein affirms a direct relationship between the films and his 1964-65 series of landscape collages made from heterogeneous materials—shiny, textured plastics and metals resembling rays of sunlight or expanses of undulating water. [1] Some of these collages were kinetic, incorporating motor-driven parts to simulate moving water or daylight to night-light changes. The idea for showing the films simultaneously on different screens derived from the installation of kinetic land-scapes at the Pasadena Art Museum's Lichtenstein exhibition in 1967. They were displayed side by side and their different rates of motion fascinated the artist.

Our initial impression of Roy's idea was that it was too simple; we were later disabused of this opinion. We

encouraged him to develop his idea for films and exploit Universal's technology and expertise. Lichtenstein felt his best work in the past had always evolved from a basically simple concept and that he might attempt something more complex after his primary project was accomplished.

Lichtenstein returned on February 3, 1969 and was given as a studio Jack Benny's old dressing rooms. He had decided to do the landscape, or as they turned out, seascape films. Each sequence would be divided by a heavy black "horizon" line. Above it would be a "sky" image, either clouds of a blue expanse, or a grid pattern of Ben Day dots; below would be a rippling water surface, or an underwater scene with tropical fish, or, again, the dot pattern. Some of the image combinations would rock slowly back and forth as if the camera were in a boat. Roy stressed two requirements for the film: that it be projected in such a way that the viewer would not see or interfere with the light source or mechanics of the system, so that the film would appear to exist autonomously, as a painting; and that the images be exceptionally clear and precise.

1

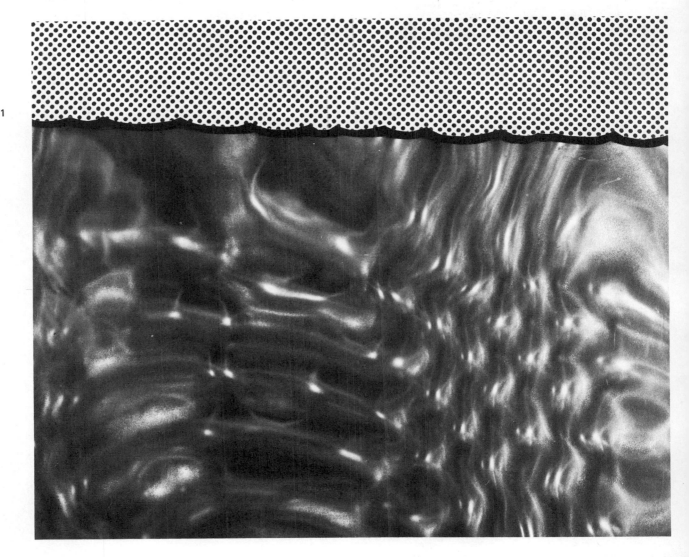

Although his ideas were intelligible, if not yet completely defined, and his demands were by no means beyond the capability of the Universal facilities and experts, it seemed difficult for them to comprehend why he wished to use film in this way or combine images of this sort. Despite their uncertainty as to the esthetic intentions of the artist, they were eager to evolve a method for projecting the films as Lichtenstein wished. The only rear screen projection system developed to date required forty feet of throw between screen and projector, which

would be an impractical use of exhibition space. Customarily, a series of mirrors is used to reduce the distance between projector and screen but this results in a loss of clarity. Universal technicians agreed to investigate ways to shorten the projection throw without sacrificing quality.

By this time the logistics of the project became a primary concern. Because of other commitments Roy could only stay in California for about two weeks, but it was necessary that he be closely involved in every stage of the operation, particularly in the initial steps of selecting certain types of images to be filmed. It was agreed that on his return to New York he would consult with his friend Joel Freedman of Cinnamon Productions and propose the idea of working with Freedman on some experimental filming.

In his New York studio, Roy made a series of sketches showing fifteen variations of combined images. [2] With these drawings and a precise idea of the imagery and effect he sought, Roy approached Freedman. After studying the problems and searching for suitable locations, Freedman, Roy and two technical assistants began filming near the artist's summer house at Southampton, Long Island. For the first attempt the assistants stood on the ocean shore and held a four by six foot wooden board, painted with blue dots on a white field, suspended over the water. The camera was rocked back and forth to simulate the motion of a boat. When this film

was processed the results were unsatisfactory for several reasons: the color could not be controlled, as the dots and ocean required different exposures; the foreground of dots and background of ocean could not be held in focus simultaneously; and by tilting the camera, they could not simulate the water's movement successfully because of the "depth of field" phenomenon. After this unsuccessful attempt, they decided to film the natural landscape fragments and the dots separately, combine the images on film, add horizon line and rocking motion, and synchronize the whole in an optical laboratory.

They filmed clouds, various bodies of water in both color and black and white, and tropical fish in a tank. Roy particularly wanted a series of sunrise, daylight, sunset and starlight sequences in which the sun would rise and set in a vertical course directly in the center of the picture, not in an arc as is apparent in nature. To film a sunrise over the Atlantic and keep the sun in the center of the scene required an elaborate time exposure procedure. The sequence was made frame by frame in intervals of two minutes. The camera was shifted after each shot to keep the sun in the center. But this effort resulted in failure. In the print the sun wiggled back and forth. Another unsatisfactory trial was made, using a telescope calibrated to the camera.

Roy returned to Los Angeles in July with the sample footage. Golitzen arranged a screening of this film for us and several Universal technicians including William Wade, head of Camera Department, James Phillips of Projection Department, and Wes Thompson, head of Process and Projection. The moving water shots (some of which Roy had filmed himself) were especially impressive. In the next few days Lichtenstein selected footage from Universal's film library of sequences which he and Freedman had been unable to shoot—an airplane passing horizontally through the sky and going through a cloud bank, as well as certain sunlight and artificial starlight shots. He asked to have these sent to him in New York. Again, Lichtenstein opted to return to his New York studio and his summer house in Southampton, where he

and Freedman would continue filming and editing. Roy commented later,

> I think . . . that had I been in California and lived there, I could have really worked with them closely but as it turned out, most of this was done with Joel Freedman in Cinnamon Productions. He's a freelance, independent film maker who lives in New York and it was easy for me to work with him and get the film made. It was a question of proximity and of course our friendship more than anything else. Universal was perfectly willing to give me all the help I needed, but I wasn't there. And some of these things have to be filmed and looked at and color-corrected, and you can't really—although they would be willing—fly things back and forth. So most of the work took place between Joel Freedman and me, even though Universal footed the bill. I learned a lot about how to proceed from them.

> The disturbing thing I feel about any idea that people present to me (and I think there is a tendency to present artists with things to do—everybody's doing that—they have projects they want done and they want certain artists to do it. It's the same ten artists all the time, but that's something else) is that you're getting led by other people's ideas. Sometimes it's interesting and sometimes you get into things that are useful and lead you to interesting things; but other times it's like filling orders. I didn't really get that feeling in this project, I must say, but there are so

many things that people want you to do. I think you could fill orders and never go in your own direction. I prefer not to be led I like to work in my studio and let one painting lead to the other.

We were seriously considering Lichtenstein's project for the Expo show and asked Alexander Golitzen to advise us about a projection system for displaying the films. In discussing this with Lichtenstein, we described the special conditions of a World's Fair exhibition—particularly the massive crowds expected to pour through the U.S. Pavilion—and explained that there would be room to have only two screens, rather than the optimum arrangement of ten to twelve. Lichtenstein then selected two seascape sequences he felt were suitable. One was a sequence of gently moving blue-white-black water below with blue dots on a white field above; the other used footage of rippling sunset-lit water below and blue sky above, with a white seagull poised in flight but stationary. [3] The water in each rocked back and forth, but at different rates. He had eliminated the scenes with tropical fish, and those with the passing clouds-passing water combination, because those images were *too* exotic or interesting.

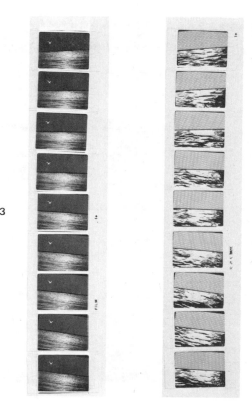

3

To satisfy Lichtenstein's standards of quality, the job of editing and composing each film loop became a complex task, involving much consultation with optics and animation experts. First it was necessary to determine the exact composition of the images. After filming many shots of seagulls—both flocks and single birds—Roy selected a bird image that he liked, but it appeared in the wrong section of frame on the original film. It was cut out from the frame, blown up and remounted on a field of blue sky in the correct location. The exact specifications for the dot pattern—how many, of what size, and in what grid configuration—were calculated through a series of graphs and charts. Lichtenstein was especially concerned about the quality of color; he attempted to control the color of the film as precisely as he would in mixing paint, and therefore demanded numerous correction prints. Roy's decisions about composition and motion were made intuitively, on the basis of each film's internal consistency, as well as its relationship to the group and the type of installation. In the two films for Expo, the motion of the internal elements was minimal and thus called for rocking motion. In the Museum exhibition, on the other hand, there will be ample time for spectators to view the film, and it will be possible for Lichtenstein to select sequences with more engaging internal activity, as well as a rocking motion. But for all sequences that rock, the key factor is that they be set out of synchronization with the others in the group. After processing the film, the final step was to match exactly the beginning and ending frames to form a continuous loop, without skips. At the completion of this tedious editing process, which took about nine

months, Joel Freedman commented in a letter to us, "It was quite a difficult project, I've now got to say—behind the quiet tranquility of a suspended seagull over sunset water there is a maze of graphs, charts, photography, animation, Neanderthal lab technicians driving me nuts and—a bit of money."

Throughout his association with A & T, Roy maintained a certain skepticism regarding the possibilities for technological collaboration which he later explained in an interview:

The thing that's advanced scientifically is the theory, and artists don't get anywhere near the theory; they're usually using the equivalent of a refrigerator or a light bulb or some by-product of the theory, it seems to me. In being avant garde, they're really using old-fashioned products. There's nothing to understand in a laser, even if you understand the principle. I'm not putting down the laser as useful in art; I'm just saying that you can immediately comprehend the laser—what it does, what it looks like and how it's done. It can be explained to you in five minutes and you get it. There's nothing mysterious about the medium. I'm not sure it should be mysterious; that's not the point, either. Very few artists are really using anything that can be considered advanced technology. It's not putting it down, it's saying that it isn't advanced, and one tends to believe it's advanced. There's something disturbing connected with both the artist using technology and the scientist wishing he were an artist, and I think that both of them get into a kind of romantic fantasy—it's a longing for

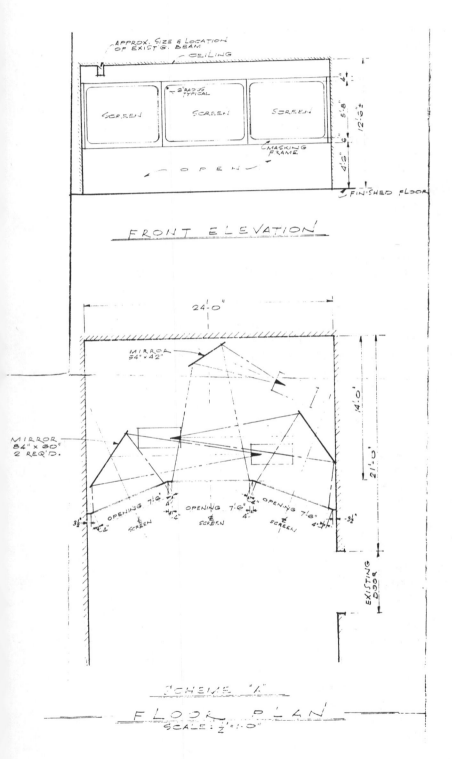

something, to be something you're not. And there's nothing wrong with that, either, esthetically; it could really work out. I don't think art has anything to do with either of those things. If you really invent something in order to conceive of it you also have to have a new conception of form. You don't conceive things without conceiving their form. To invent the theory is really being the inventor; to use the product is the same thing as using a paint brush—it isn't any more advanced.

In spite of Roy's disclaimer regarding the complexities of technological tools, it is worth noting that perhaps alone of all the artists who worked in this program, Lichtenstein completely altered the conventional nature of his medium. In fact, he used film in an utterly anti-filmic manner. This anti-filmic quality, which is common to all fifteen films, involves a basic sense of contradiction, "a play," as he said "between reality things and artificial things." In part this derives from Lichtenstein's method of structuring the two compositional elements, water and sky, as *one* image on the picture surface. They are meant to be seen as a total visual field. In a customary cinematic sequence of water, horizon line and sky, the intended effect is a vista, and the ordinary perceptual process of the viewer is to integrate foreground and background into a visual pattern which creates the illusion of three-dimensional space. In Lichtenstein's films this effect is intentionally avoided and even contradicted, and makes it impossible to feel any sense of spatial recession. All motion takes place on the picture plane; the rippling water does not move *back* into space but *up* the surface of the screen, abruptly meeting the horizon line. This line itself further underscores the flatness of the picture plane. Moreover, Lichtenstein gives no visual clues (no localized objects like a boat on the horizon) but isolates fragmented bodies of water or sky. In the case of the tropical fish which swim in random multi-planar patterns, a certain degree of three-dimensionality is defined, but the area (that of a foot deep fish tank) is strictly circumscribed and confined.

The installation planned for the Museum, using three screens [4], should discourage a focused concentration upon any single image and should induce a scanning, contemplative viewing of all the images in the visual field. This inclusive or "dedifferentiated" way of viewing is possible because nothing *happens* in any of the films. There is no action, no narrative element. Lichtenstein remarked that they are "useless" films. In this context Andy Warhol's films come to mind, particularly *Empire*. In both the effect is boredom. But there is a difference: in *Empire*, the film's action is created by the environmental changes affecting the building during an eight hour time span; whereas Lichtenstein's films are perpetual cycles of repetitive imagery with no beginning and no end.

Len Lye arrived in Los Angeles on August 20, 1968 to tour Kaiser Steel Corporation in Fontana. The artist described three pieces he wanted to execute, and drew a rough sketch of each. Gail Scott described his plans in a memo at that time:

Gateway to the Universe: is ideally conceived as an oval structure of steel resting on a large base. The dimensions of the oval would be ninety feet long, sixty feet high, twelve feet thick, but a more feasible scale for our exhibition would be thirty by twenty by six feet. The exact dimensions would depend on technical calculations, permanent and temporary exhibition sites, and transportability. The entire structure would oscillate back and forth in a rolling motion, controlled by an electro-magnetic device, attached at two points at the base of the piece. In its ultimate situation, *Gateway* would be the entrance to a whole complex of kinetic objects in a total environment, but obviously this is outside the range of possibility for A & T. He describes *Gateway* as: the nearest I can see it is a great elephant reincarnated as an ebb tide at Big River where the meeting of the tides creates a rolling whirlpool action. He has a nine foot model in his New York studio which he would advise having the engineer assigned to the project look at. There are several structural problems which need to be worked out: type of base; securing the oval to the base, finding a type of steel which would not bend at the top of such a large oval shape; programming the electro-magnetic device.

Blade: is a sheet about twelve feet high, twenty-two inches wide, made of 3/64" thick steel, standing upright with a striker device to one side, consisting of a steel ball on a pipe. The sheet steel would be programmed to oscillate in a waving motion creating double and at times triple harmonic sounds. When the movements reach a certain curvature, the striker would then hit the sheet with a bonging sound. The entire structure, striker and all, would then rotate on its axis, shimmering and reflecting light projected onto it. A composer, perhaps in percussion, would program the reciprocating device. Lighting would be coordinated into the motor stepping.

Storm King: is a sheet of steel, sixteen feet long made of 3/64" thick steel with two brass curved arms extruding from one side. The whole structure would oscillate, creating storm sounds and reflecting light projected onto it. This piece would be placed against a long sheet of brass which is also programmed to move in a waving motion. The piece would be suspended from the ceiling with a small reciprocator at the top.

Len Lye wrote MT on August 26,

Oom. Seeing you at the helm prowing the art and technology seas was wow fore and aft.

The fly in the kiss me quick of my unto consists of motion comp as the end of the fabricating trip and what that's to be I alone decide so the trick is knowing when the goal is getting off course.

Attached is what it takes for that and a few other tacks.

Along the way there's the listed kind of squalls and all of us learning to keep our seats dry but if the ancients could deliver Stonehenge, the Nile temples even unto those Aztecs and Tolmecs with a lot of heave ho why can't we and we with the plan you've got can.

As you know I'm up to my eyebrows but while passing through I'll give it a go, otherwise it's no skin off my bowsprit if the conditions listed can't be met.

Could you let me know a final reaction as soon as poss.? I don't want to back and forth at all with skidding verbiage. What happens will affect my next lot of doings including something for next all summer I'm about to sign but if we go ahead, then I'll ask for spare time to keep in touch from Japan where we'll be 1969 with Ann and a job and maybe Garrett have a private plane or space suit outfit to get the to and fro done.

Once again for your efficient smoothing and understanding of all the aspects of which I know I'm but one. Last but almost the most the perfect hospitality of your friends. It was all magnificient.

Oom . . . thanks

*Points which must be agreed to by both the Museum and the donor manufacturing corporation:

(1) Whatever work may be chosen by the manufacturing corporation, I would expect a second model be made for me not to be used for public display. This version should not be in any way inferior to the one they build for themselves. If any improvements were made which could not be repeated on my model, then, rather than accept the first, I would require a new version.

Four works, *Sky King, Universe, Blade,* and *Moon Bead,* [a sculpture he had only mentioned in passing] are now being considered for construction. I realize the right of the corporation to retain copies of the works promoted by the museum, but, should they

Jackson MacLow
Born Chicago, Illinois, 1922
Resident New York City

construct all four, it would be unfair to me, the artist, that I should be deprived of future commissions on these pieces because they already exist in a public collection. Therefore, for this and other reasons I will only allow two works of the four to be copies.

(2) Len Lye, the artist, would retain the authority to cancel and have destroyed either work in progress or work completed if he sees it becoming somebody else's thing. This means that he, or his assistant, would have to be kept in constant touch with stages of appreciable development of a piece and approve of them. If unable to visit the shop, he would want to see decipherable drawings.

(3) Whatever work chosen by the fabricator, and built, should not be exploited commercially (such as a roadsign type of role), nor subverted to a gimmick type attraction (such as being lit up in garish colors), but rather it should be set in surroundings which enhance it. To this end I would like some authoritative say in its exhibition. I would also, therefore, have approval of any ultimate disposition of the work, that is after it leaves the museum.

(4) When the exhibition is finished at the museum, my work is to be immediately crated and shipped to a given destination, possibly overseas.

(5) I retain full copyright of the start and end design and a blue print copy of all mechanisms and wiring schematics.

Lye had outlined several other definite requirements for the works: *Blade* and *Storm King* had to be fully programmed, and a type of steel must be used which was both resilient and would produce a proper tone when struck; *Gateway,* as an outdoor piece, had to be weatherized; *Storm King* and *Blade* would have to be placed in a soundproofed area in an installation; all three required secure bases to withstand constant vibrations.

The major drawback, as the Kaiser engineers pointed out, was that the company does not manufacture either spring steel or stainless steel, both of which are sufficiently ductile materials for kinetic sculptures. Kaiser produces structural steel which is strong, flexible and brittle, for architectural purposes and bridge building—I-beams, H-beams, piping, etc. The other difficulty was in programming the works; Kaiser has no electronic facilities to devise a control system.

Lye had also toured the Garrett Corporation and delivered the same proposals. Garrett had agreed to survey its various divisions to determine the capabilities for execution. Both Kaiser and Garrett eventually declined to take on the project.

Jackson MacLow's participation in A & T came about for several unusual reasons. His was from the beginning a special case, since he is not an artist but a poet, and could thus not be expected to have the same kind of relationship to a corporation as other artists contracted with us. Our rationale in approaching MacLow had in part to do with an intensely frustrating impasse reached with an important corporation: namely, there came a point in our dealings with IBM when it seemed we must either try a totally new approach or simply give it up. Since we had attempted unsuccessfully to obtain IBM's approval for interactions with several artists—Vasarely, Robert Irwin, Eduardo Paolozzi and Vjenceslav Richter—and since one reason for this failure appeared to be the difficulty for these artists of using computer technology in a way mutually satisfactory to them and IBM, we thought of bringing in a poet, who could use computers as a linguistic medium. The suggestion to include MacLow was David Antin's.

MacLow is associated with concrete poetry, an international, heterogeneous school of poetry, which came to prominence in the early fifties. However, unlike many of the younger exponents of this poetic movement who specifically seek a synthesis between traditional poetry and painting, MacLow has conformed to an older manifestation of this style. In his *Anthology of Concrete Poetry,* Emmett Williams discusses a kind of poetry which best describes MacLow's own work:

> The visual element in this poetry tended to be structural, a consequence of the poem, a 'picture' of the lines of force of the work itself, and not merely textural. It was a poetry far beyond paraphrase, a poetry that often asked to be completed or activated by the reader, a poetry of direct presentation—the *word,* not *words, words, words* or expressionistic squiggles—using the semantic, visual and phonetic elements of language as raw materials in a way seldom used by the poets of the past.

MacLow studied music from the age of four and began

composing music and poetry at fifteen. His educational background includes studies in philosophy, comparative literature, Greek language and music. In 1954 he published *Five Biblical Poems,* in which he invented a kind of verse using as the basic unit the "event" rather than the traditional foot, syllable, stress or cadence. The poems are based on actual Biblical happenings and the events are either single words or silences, each equal in duration to any word. Integers in the title indicate the verse structure which can be made verbal by musical or other non-verbal sounds produced at the ends of lines and stanzas. *Five Biblical Poems* is also the first work MacLow composed by chance operations, a method he has developed and extended in his later work. Since 1954, he has written several plays, as well as a book published in 1968 by the Black Sparrow Press, *Twenty-two Light Poems.* Besides writing poetry and plays, he has done a number of paintings, collages and constructions.

Besides admiring MacLow's work in general, Antin knew of several performance pieces he had composed involving simultaneous readings of randomly ordered fragments of poetry by several people in concert, following a rhythmic "score," and accompanied by musical sounds. The principle behind this technique, it seemed, could be applied to computer input and output, similar perhaps to methods used by John Cage.

In April, 1969, Jane Livingston met with MacLow in New York, where he lives and teaches at NYU. Jackson was immediately enthusiastic about coming to California to work with IBM: in fact he had even then a definite idea for a project. He talked in terms which seemed impressively knowledgeable: the areas he indicated were of interest had to do with artificial grammars and word-string processing, computer-generated sounds, modification of speech by computer or related methods, and the use of APL consoles and various educational machines. The theme he wished to pursue was "The Conservation of the Earth": he would draw on regional ecological information for the words and images. He wanted, he said, to combine words projected as pictures, with sound-recorded words or abstract sounds.

We contacted IBM to describe MacLow's general intention for collaboration. It was agreed that MacLow would come to Los Angeles to meet with personnel at IBM's Scientific Research Center in Century City, rather than touring the enormous San Jose facility which had until then been intended as the base for an artist's residence with the corporation. In June, 1969, MacLow arrived with his wife and young children—they came by train, as he avoids flying—and a meeting was held the day of his arrival at Century City with the poet, JL and a number of IBM physicists and mathematicians. It was a two hour session, and a memorably uncomfortable occasion, at

least for Jane Livingston. MacLow had formulated an immensely ambitious proposal, involving an egg-shaped, environmental housing for the work—he had a rough sketch for this structure, which stood on legs and was conceived to be large enough in its interior to accommodate several people—and an elaborate computer system for accepting and feeding out massive amounts of information based on the ecology of the Los Angeles metropolis. It was to be a participatory experience. The viewer should, according to his scheme, be able to request information at will and receive it in one of several forms—flashed onto a screen, orally recorded and emitted through a speaker, etc. As Jackson presented his idea (which was obviously more complex and technical than outlined here), the seven IBM computer scientists attending the meeting listened politely, but with palpable skepticism and even amusement. The contrast between MacLow's demeanor—he looked, on one hand, like a mad professor, and on the other like a gypsy itinerant—and the cool, groomed appearance of the gentlemen whom he addressed, was extraordinary. After the poet's initial description, the conference developed into a series of patient explanations as to why Jackson's ideas were totally beyond the realm of practicability, both from a financial standpoint and in view of the limitations of computer technology. Gradually, MacLow altered his requirements to conform to the realities of the situation, and by the end of the meeting it was plain that he would be willing to compromise significantly enough to work within whatever parameters IBM might set for his project. However, it became evident to us later that IBM was not interested in working with MacLow no matter what his project involved. IBM did, as a sort of consolation gesture, arrange for MacLow to attend a week-long course in computer programming at IBM's downtown Los Angeles headquarters.

Fortunately another, much smaller, computer company—Information International—had joined A & T as a Sponsor Corporation in December, 1968. We had visited the company with Eduardo Paolozzi and Vjenceslav Richter, and had discussed with them the possibility of working with Ron Davis, but no match had been effected. The computer system that I.I. wished to make available to an artist, and demonstrated for each visitor, was a graphic display console manufactured by them. It is described in a letter from their Public Relations consultant, Dawn Walker:

> A system made by this firm seems exceptionally suited to your purpose. It is a computer optical system which can be used as an artist's tool to produce graphics. It is capable of generating computer-animated film and other graphics. The machine, valued at half a million dollars, is used for a number of scientific and industrial purposes. However, it becomes a tool for the artist because of its high capability to react to what is desired of it graphically.

Because it has the capability to record directly on 35-mm or 70-mm film, it can be used to produce computer-animated movies from digital information. The creation of these movies is controlled by the operator through a number of means, including monitoring of the process via a television-like screen. In essence, film is created via a number of controls, and emerges ready for the camera from the machine.

(A widely-shown animated film made with Information International's system was created by John Whitney and his son, Michael, we had seen this, and the Whitneys were eager to participate in A & T, but we were not especially interested to have another such film done through the program, although such an undertaking by an artist would have exploited the unique capabilities of the machine in a way more advantageous to the corporation for commercial exposure than what was finally done with it by MacLow.)

On June 19, MacLow visited Information International, met with Charles Ray, Manager of Applications Development, who demonstrated the graphic display console. (Both Ray and the company's president, Alfred L. Fenaughty, were to be extremely helpful to MacLow and enduringly cooperative with us in the course of the project.) One of the programs used abstract, linear geometric configurations which appeared on the screen and moved rhythmically through a randomly ordered sequence of alterations, accompanied by music—a Bach fugue in this case. A program accompanied by abstract sounds—bips and bleeps—synchronized to image fluctuations was also shown. Programs could be called up or altered with the use of a light pen held to certain points on the screen; MacLow sat at the typewriter console for fifteen or twenty minutes experimenting with this device, which fascinated him.

It was agreed on this day by the company, the poet and us that MacLow would enter into collaboration with Information International. The poet began work immediately, commuting each day for ten weeks from his rented apartment in Hollywood to the company's facility in Santa Monica. He was at first assisted principally by the Corporation's Director of Programming, John Hanson. The use MacLow made of the company's PDP-9 Computer (manufactured by D.E.C.) was actually not technically difficult or sophisticated in terms of the programs themselves; according to Charles Ray, the basic programming for MacLow's poems was accomplished in an eight hour period early in the collaboration, and was later refined. This was done by Hanson. In later stages of the project, Senior Programmer Dean Anschultz was heavily involved in working with MacLow, refining and extending the program to enable greater sophistication in his word groupings than was initially possible. MacLow didn't learn to actually program himself (this would have been virtually impossible in the time he had)—in other words, he couldn't *instruct* the machine— but he did learn to *operate* the equipment, by manipulating the typewriter-console. He was given access to the computer system for four hours a day, from six to ten A.M., five days a week, and working on this basis he composed a significant body of poetry.

Although MacLow's demands on Information International's programming expertise were relatively modest, he did provide a novel experience for Information International's personnel in that the PFR-3 system (this is the designation for the entire graphic display unit, including the programmable film reader, magnetic tape units, etc.) had not previously been used by them to produce *word* images, but was employed chiefly for graphic patterns. By relying on the computer's ability to propagate words directly onto the screen (as a series of dots, rather than by scanning lines, as in a television screen), MacLow bypassed the PFR-3's film reading capacity, which involves photographing images.

MacLow finally composed nineteen poems. Each one was built differently, and they became progressively more complex as he, John Hanson and particularly Dean Anschultz elaborated the program. Only one program was made. It initially consisted of forty-eight characters, including spaces, which could be generated by pressing the typewriter keys on the display unit. During the first phase, individual two- or three-letter words could be permuted in various ways. They then devised a linker mechanism, enabling series of words to be always linked together in the same way; thus larger blocks of words could be permuted in various configurations. Finally a carriage return device was added to the program, so that a number of lines of poetry could be made to appear simultaneously on the screen. In the last poem, *THE*, each message was composed of a number of complete

sentences, rather than just linked words or phrases. Most of the poems were based on a family of words with related imagery. *SOUTH,* for example, uses words all referring to plants and animals in Latin America and Africa.

MacLow submitted several of the poems made with Information International to *Stony Brook,* for its no. ¾, 1969 issue. He included a letter to the Editor, George Quasha, explaining the way in which the poems were composed:

The . . . poems enclosed are xeroxes of print out realizations of poems I composed last summer (1969) on a PFR-3 programmable film reader at Information International, Inc., in West Los Angeles, for the Art & Technology exhibition of the Los Angeles County Museum of Art, organized by Maurice Tuchman. A PFR-3 programmable film reader is a device, or rather a linked group of devices including a DEC PDP/9 computer, which 'reads' film in the sense that it turns the image on the film into digital form and thence projects this image via a computer onto a special type of cathode-ray tube (CRT) in a monitor console. It can modify the image when it is in digital form or analyze it in myriad ways (e.g., it can project the x-ray image of an organ of the body, increase the contrast of its features, trace the contours and give notice of anomalies, etc.). Its applications range from medical diagnosis to oil prospecting.

In composing nineteen poems this summer (see below for what I mean in this case by 'poem') on the PFR-3, I didn't make much use of the film-reading potentiality of the device (I did wish to work with photos of handwriting, but my programmers, John Hanson and Dean Anschultz, were too deluged with other work to be able to get to that program before I had to leave L.A.). The program made for me by Hanson and Anschultz began as a simple permutation program: It allowed me to type in (on a teletype) up to one hundred forty eight-character, single-line 'messages' as one group or poem. When one was not typing messages in, the computer would pseudo-randomly range over the entire group of messages, settle on one, select one or more or all of the units in the message, and select one permutation of that group of units. This group of units would appear at a pseudo-random position (I say 'pseudo-random' because the means used were pseudo-random numbers) on the monitor CRT.

Two special features of the CRT must be noticed: the fact that it propagates its image by a series of dots rather than by line-scanning as in video., and the fact that images fade gradually rather than abruptly from the face of the two due to the use of long-persistence phosphors. As against the bluish-white first appear-

ances of images, the after-images are chartreuse and black. In addition, the particular PFR-3 monitor console I worked on was wired to an audio amplifier in such a way that every time an image (e.g., a series of words) appeared on the CRT, the same series of impulses from the computer which fired the electron gun to produce the image also went through the audio system to produce a sound. In the case of my word groups, the longer the series of characters was, the deeper in pitch the tone (a sound in the oboe-bassoon family, more or less) and the longer its duration. Thus single words would produce high pitches; several-line groups (which the later forms of the program made possible) had the sound of deep organ pipes.

In addition, if one desired printout, one could push down one of the 'program-sense' levers on the console, whereupon the teletype would type out every tenth word group that appeared on the screen. This feature of the program is the source of the present examples. Moreover, in the later forms of the program, I was able to vary the speed of propagation of the word groups by depressing various combinations of the AC levers on the computer itself. A regular feature of the console itself is a group of knobs that enables one to shift the image horizontally or vertically or change its horizontal or vertical size (or any combination of any number these four possibilities); when one shifts the setting of one or more of these knobs while an image is being propagated, one produces chartreuse tracks!

In the earlier forms of the program, the permutable units were single words and I had no period as a printable character. The program would pull out any of the permutations of any of the combinations of the words of any of the up-to-one hundred messages which constituted a single 'poem' in this sense. The two-page run beginning 'ALWAYS ARE TRANS-FORMING ENERGIES ALL PARAMETERS' is the earliest example of this stage. It is printoff from the poem 'TRAN,', which consists of the single message 'ENERGIES ARE TRANSFORMING ALL PARAM-ETERS ALWAYS' and which I improvised on the PFR-3 teletype the first day I worked on it in the middle of June, 1969. From the same stage is the poem 'DANISH' (or 'DANSK') which was the first one completed with one hundred full-line messages. (Of this I enclose the first realization drawing on all one hundred messages—the actual printoff beginning with 'GRANDFATHERS BENIGNANT' I also enclose three xeroxed runs of printoff of 'DANISH': the single-page beginning 'CRUNCHING ARE'; the three-page run beginning 'PAVEMENTS CARPET-ING ARE JACARANDA VIOLET FLOWERS'; and the single-page beginning 'TROMBONES LOUD

TONES ARE RESONANT SOUNDING LONG'.) SENTENC)ES'
'DANISH' consists of one hundred complete sentences, some composed by means of systematic chance, some just dreamed up, each of which has its verb in either the present progressive (e.g., 'is/are going') or past progressive (e.g., 'was/were going') tense and each of which consists of a maximum of forty-eight characters, including spaces. It was composed during most of the last week of June, 1969. The use of the '-ing' form of verbs as present participles, gerunds (nouns), adjectivals allows for a maximum of at least fragmentary grammaticalness when these words appear in random groups as in these examples: it is easy for the -ing form to shift from one grammatical role to another according to the permutational context. Elements of some of the sentences were drawn by chance from a dictionary and from *Black Elk Speaks* (Neihardt).

In later stages of the program, I had a 'linker' by which I could link up any number of words—even whole sentences—and use them as units rather than merely single words. 'SOUTH,' of which I send you a complete sixteen-page run, is one using this linkage feature. It began as a series of sentences improvised the first time I worked with the PFR-3. Somehow the lack of grammaticalness in the resultant printout of pseudo-random permutations of combinations of the words of the sentences I typed in didn't 'make it' for me, but by scanning through it for actual and suggested sentences, I produced the one hundred messages of the final version of 'SOUTH'—each of which consists of one or two whole sentences which are the actual units of the messages since their words always appear in the same succession because of the linkage. The imagery of 'SOUTH' is an indiscriminate mixture of flora and fauna from both Central and South America and Africa (possibly also southern Asia)

A very late feature of the program was a workable 'carriage return'—i.e., the possibility of messages having more than one line of forty-eight characters, of propagating on the CRT face multiline groups of units or whole messages, and of printing out such multiline messages and unit groups. This was a terribly complex programming problem (or rather, making these *three* types of carriage return possible and compatible and also making it possible to *edit* such messages—which is another long story)—finally solved by Dean Anschultz, the red-bearded Demon Programmer of Venice on the Pacific.

In the poem 'DAVID' (the name refers to Dave Antin, I guess, whom I saw several times in both Los Angeles and in Solana Beach, and who saw and heard the PFR-3 in action—both 'playing' some of my

poems and having new ones typed into it), all of the one hundred messages are questions or statements about questions involving 'DAVID' asking questions, etc. All of the words of each question or statement are permanently linked, and they run from two words in length to three lines. See the page beginning 'DAVID ASKED.' (By the way, I also got an operational period about the time that I did the final [sentence] version of 'SOUTH.') This page is from the middle of a long run of printout-realization of 'DAVID.'

The last poem I worked on (for two or more weeks, I believe) in August, 1969, was 'THE'—of which I enclose three short runs of printout. In 'THE,' each message consists of four to six short sentences, each typed originally on a separate line. These short sentences are the units of the messages of the poem, and their words are permanently linked within each sentence. Thus each word group propagated on the CRT face and/or printed out is a sort of strophe of one to six lines, each line of which is a complete sentence. As is obvious from the printout-realization examples enclosed, each sentence mentions a more or less 'universal' phenomenon; each strophe consists of a closely related group of such phenomena. Ex. 1 ('THE SUN SHINES.') is from an early stage of this poem, in which I had not yet accreted many messages. One may print out at any stage of the game, so that earlier printout draws from small numbers of messages; later printout is drawn from larger numbers of messages—up to one hundred, except for 'THE'— which has such long messages that it overran the memory core of the PDP/9 at about the 43rd message: it's the Saint-Saens' 4th—organ pipes and all—of my PFR-3 poems. It reached the limits of the computer's capacity and had to be trimmed back before the computer stopped, just giving up altogether (as it did every time I passed a certain limit in adding messages to the poem). There were a lot of *human* phenomena that I never got to put into the poem because I put them off to the end of the list of messages, thinking I'd be able to accrete up to one hundred of them despite the extreme lengths of the individual messages. The organ pipes came from the fact that there were so many characters and lines in most of the word groups propagated on the CRT that most of the corresponding audible tones were similar to those of very deep organ pipes—still vaguely 'double-beating-read' in timbre, some being chords or tone clusters. (This isn't the Saint-Saens' 4th but the Mahler 9th of the PFR-3 poems.)

Ex. 1 is early since it draws from only a few messages and still has the word 'animals' rather than 'mammals'—the word used in the later stages of 'THE' 's composition. Ex. 2 ('THE WIND BLOWS.') and Ex. 3

('THE PEOPLE BUILD METROPOLISES.') are from late stages of 'THE'; they are, respectively, complete two and four-page runs of printout.

We seriously considered displaying MacLow's computer-generated poetry in the New Arts Exhibition at Expo 70, and even went so far as to have some test film footage made of the PFR-3 screen with the poetry appearing on it. (It was plain that the equipment itself, in operation, could not be seen long enough or closely enough to be understood by crowds of people passing through the exhibition area.) The film as we saw it was not entirely successful, and it would have required an expenditure beyond our means, or the company's, to produce it in acceptable form.

The following are excerpts from six poems made by MacLow at Information International: *The, Danish, Diane, David, South* and *Trans.* They are reproduced from Xeroxes of direct printout. *Diane* is given in two forms: the first is a series of "messages," which are then randomly arranged to form the poem.

Jane Livingston

THE EARTH TURNS.

THE STARS SHINE.
THE EARTH TURNS. THE MOON SHINES.

THE STARS SHINE.

The

THE MOON SHINES.
THE EARTH TURNS. THE SUN SHINES.

THE STREAMS FLOW.
THE RAIN FALLS.
 THE OCEANS FALL. THE OCEANS RISE.
THE SNOW FALLS.
 THE WIND BLOWS.
THE RIVERS FLOW.

THE PLANETS SHINE.
THE EARTH TURNS.

THE EARTH TURNS. THE MOON SHINES.
 THE PLANETS SHINE.

THE PLANETS SHINE.

THE EARTH TURNS. THE STARS SHINE.
THE PLANETS SHINE.

THE OCEANS FALL. THE WIND BLOWS.
THE SNOW FALLS.
THE RAIN FALLS.
 THE RIVERS FLOW.

THE WIND BLOWS.
THE OCEANS FALL. THE RIVERS FLOW.
THE SNOW FALLS.
 THE STREAMS FLOW.
 THE RAIN FALLS.
THE OCEANS RISE.

THE SNOW FALLS.
 THE RIVERS FLOW.
THE OCEANS FALL. THE STREAMS FLOW.
THE RAIN FALLS.
 THE OCEANS RISE.

THE FLOWERS ARISE.

THE WIND BLOWS.
THE RAIN FALLS.

THE RAIN FALLS.
THE STREAMS FLOW.
THE SNOW FALLS.

THE ANIMALS ARE BORN.
THE REPTILES ARE HATCHED.
THE INSECTS ARE HATCHED.

THE SNOW FALLS.
THE STREAMS FLOW.
THE RIVERS FLOW.

THE BIRDS ARE HATCHED.
THE INSECTS ARE HATCHED.
THE PEOPLE ARE BORN. THE ANIMALS ARE BORN.
THE FISHES ARE HATCHED.

THE INSECTS ARE HATCHED.
THE PEOPLE ARE BORN.

THE PEOPLE ARE BORN. THE BIRDS ARE HATCHED.
THE FISHES ARE HATCHED.
THE ANIMALS ARE BORN.
THE INSECTS ARE HATCHED.
THE REPTILES ARE HATCHED.

THE MOON SHINES.

THE BIRDS ARE HATCHED.
THE FISHES ARE HATCHED.
THE REPTILES ARE HATCHED.
THE INSECTS ARE HATCHED.

THE REPTILES ARE HATCHED.

THE TREES GROW. THE FLOWERS GROW.

THE PLANTS GROW.
THE BUSHES GROW.
THE FUNGUSES GROW.
THE MOSSES GROW.
THE FLOWERS GROW.
THE FERNS GROW.
THE LICHENS GROW.

THE LICHENS ARISE.
THE FLOWERS ARISE.

THE FISHES ARE HATCHED.
THE ANIMALS ARE BORN.
THE BIRDS ARE HATCHED.
THE PEOPLE ARE BORN. THE INSECTS ARE HATCHED.
THE REPTILES ARE HATCHED.

THE FLOWERS GROW.
THE TREES GROW. THE PLANTS GROW.
THE FUNGUSES GROW.
THE FERNS GROW.
THE MOSSES GROW.

THE FERNS GROW.
THE BUSHES GROW.
THE TREES GROW. THE FUNGUSES GROW.
THE FLOWERS GROW.

THE STARS SHINE.
THE SUN SHINES.
THE MOON SHINES.

THE PLANETS SHINE.

THE TREES GROW. THE BUSHES GROW.
THE FLOWERS GROW.
THE FERNS GROW.
THE PLANTS GROW.
THE LICHENS GROW.

THE MOON SHINES.
THE STARS SHINE.
THE EARTH TURNS. THE SUN SHINES.

THE PLANETS SHINE.
THE SUN SHINES.

THE PEOPLE ARE BORN. THE REPTILES ARE HATCHED.
THE FISHES ARE HATCHED.
THE BIRDS ARE HATCHED.
THE ANIMALS ARE BORN.
THE INSECTS ARE HATCHED.

DECENT BICYCLISTS STAGED THINGS TRIBES WITNESSED

DILUTED MILK STARTLED MOUNTED STEVEDORES WORST

WONDERFULLY

DECENT PEOPLE PICKED REAL MOUNTEBANKS AS LEADERS

THO DRINKERS DINED ON CHAMPAGNE THINKERS DENIED

GIANTS HEARD PLENTIFUL FLAMENCOS WEARILY

WANLY

STANDING SILENT

WEARILY

YET DRAMAS MINGLED TRAGEDIES WITH FRANTIC FARCE

DAFFY PILL-TAKERS CLASHED WITH PLANTED SUFFERERS

WEIRDLY DENSE KIBITZERS GRATED CLANNISH PLAYERS

DEFENDERS LIBERATED CRASHERS

DISTANT FINLAND'S COASTS FOUNDED UNIVERSITIES

DISCOVERIES DILATED STARTLING JOINED GROTESQUES

DAMASK DOWNED WESTERNERS

WRYLY

DISTINGUISHED LIGHT COATS CHANGED VOICES WEEKLY

BADLY

THE GOBI DESERT DIFFERED

A DIRECTOR FILMED DEAD SCHNAUZERS

DAFFY PILL-TAKERS CLASHED WITH PLANTED SUFFERERS

A DRUMSTICK HIT A SCALY ANTEATER STANDING SILENT

FIGS STARTED PLUNGING INTO WASTE PIPES

DAFFY PILL-TAKERS CLASHED WITH PLANTED SUFFERERS

AND DOGGED WITNESSES FRAZZLED FLINTY PROSECUTORS

PUNGENTLY DROMEDARIES PISSED

DORIC PILLAGERS DRAGGED FRANTIC KINDERGARTNERS

A DASHING HIGHWAYMAN DEALT WITH FUNNY PROCESSES

DISCOVERIES DILATED STARTLING JOINED GROTESQUES

DISASTERS LIBERALS REALIZED STUNNED WHITEHEAD

DOCILE DIALECTICIANS PRANCED BRONZE HORSES

DAPPER WITS FRAMED FRANCISCANS REGRETTING WASTE

A DRUMSTICK HIT A SCALY ANTEATER STANDING SILENT

PAINFULLY MAIMED DINGOES RINGED PLATYPUSES

WHILE DETERMINED PIGS FEATHERED LINNAEAN LINTELS

REGRETTING WASTE DAPPER WITS FRAMED FRANCISCANS

DECENT BICYCLISTS STAGED THINGS TRIBES WITNESSED

DEFENDED KINGS PLACED MANNERS ABOVE CAREERS

WANTONLY

AND DEDICATED PILLAGERS CLAIMED HAUNTED HOUSES

BRAVELY DEACONS FINESSED CRAZED PLANTERS

A DIRECTOR FILMED DEAD SCHNAUZERS

DAFFY PILL-TAKERS CLASHED WITH PLANTED SUFFERERS

EXPRESSLY DAVID MIXED PRATTLE WITH PRINCIPLE

THAT DISCOVERED WILD SHARON'S YOUNGER AND WEAKER

DRAB KILLERS HEADED MAINLAND ARMIES WASTEFULLY

DAZZLING BIOLOGISTS DIAGRAMMED BONNY EXPRESSIONS

DECENT PEOPLE PICKED REAL MOUNTEBANKS AS LEADERS

DREAMS FILLED CRAZY EVENINGS SUMMER WARMED LATE

DIALECTIC MISTAKES DRAMATIZED ETHNIC DIFFERENCES

DAVID MIXED PRATTLE WITH PRINCIPLE EXPRESSLY

WITH USELESS WIND DUSK FILLED PRACTICAL PLANNERS

GRATINGLY WILDLY DESERTERS SHOUTED "ULAN BATOR"

DARK FIBERS COATED GRANOLITHIC PUPPETS ON WHEELS

WANLY DUNCES RISKED SMARTING GLANCES AND MOCKERY

EVIDENTLY WET

WITLESSLY WHITE DOGS KILLED FLAG-WAVING PRINTERS

AND DEFIANT TICKET AGENTS DRAFTED RAUNCHY THESES

AS PRINCES WINCED

NYMPHOMANIACS HUNGRY MERELY

 WERE TREES COVERING

 AMNESIACS GARDENS LITHE POPULATING ARE

FERROCONCRETE LIONS ARE

WET

SOLEMN INNOCENT OR ARE TRUE SELDOM

 HERE

 VECTORS INFECTING OFTEN MOSQUITOES

PHILOSOPHICAL ALSO

 VOCALIZING

 CHILDREN LAUGHING SPLATTERING DROPS ARE GLINTING

 ARE INCREASING DAILY

 ARE

 FLOWERS EUCALYPTUS HONEYMAKING BEES ARE DRAWING

 INNUMERABLE

SEPTUGENARIANS ENVIOUS ARE JAILING KIDS AWAKENED

 ARE MOURNING CLANDESTINELY

 ENLIVENING WHIPPOORWILLS TOO

REVEALING

 JAPANESE

 CHARGING

 TRAVELING WARNING WERE VOICES HEARING

VIOLS RECORDERS ARE ARPEGGIATING

 ARE FILLING AWAITING NOW

MUM WAREHOUSES HAUNTING ARE DUSTY

ARE REMINISCENCES OVERWHELMING PERCEPTIONS

MORNING THIGHS DROOPING EYELIDS ARE LIFTING

 SATISFYING ARE SELDOM PLEASURABLE RENUNCIATIONS

 HAUNTING DORMANT

WIDOWS DANISH BLACK ARE SCOUNDRELS POISONING RED

WET BODIES SHINING WARM SUNLIT MARMOREALLY

BODIES

RECORDERS VIOLS COUNTERPOINTING ARPEGGIATING

ROLLING SHY PRAISING ANGELS

ARE TRUE COINCIDENCES

ASIATIC APES GIBBONS SMALL

ARE MEANINGFUL EVENTS NEARLY

HOPES ALL ENTERING ARE MANY

DINOSAURS MOLDING STUPIDLY ONCE WERE ECOLOGIES

CHILDREN

FLOWING SMILING GIRLS NOW TRESSES ARE

LEADING ARMS CONTROLLING

KICKING WERE PLUNGING HORSES FLOUNDERING BISON

ARPEGGIATING COUNTERPOINTING

ARE SOOTHING OCARINAS OLD DULCET

GIBBONS ASIATIC TAILLESS APES ARBOREAL SMALL

ARE

OUTDOOR LIGHTING WERE

TOTEMISTIC ALWAYS WERE BOASTING NEARLY ANCESTORS

MOLDY OVERWHELMING REMINISCENCES PERCEPTIONS

NO DIFFICULTIES ENCOUNTERING ANIMALS PATIENT

IDEAS SLEEPING COLORLESS ARE GREEN

SOON FACES GRASSES SPROUTING WERE SHOWING TENDER

ARE

ABSENTMINDED PLASTIC BONES

WERE SIOUX OXEN

NOW CONTROLLING

HUNTING

SMALL ARE ARBOREAL GIBBONS APES TAILLESS

FIRES CORUSCATING JEWELS WAVERING WERE REVEALING

CHARGING PAST BUFFALOES LAKOTAS BELLOWING WERE

SELDOM SATISFYING PLEASURABLE RENUNCIATIONS ARE

DAZZLING BIOLOGISTS DIAGRAMMED BONNY EXPRESSIONS
DETERMINED PIGS FEATHERED LINNAEAN LINTELS
A←DASHING←HIGHWAYMAN DEALT←WITH FUNNY PROCESSES
A←DISTRACTED←VINTNER QUAILED PHANTASMIC PETRELS
DISGUSTING FICTIONS COAXED LOONY FISHES
DIANE←WAKOSKI SILVERED PLAYING LIONS SINCERELY
A←DIRECTOR FILMED DEAD SCHNAUZERS HYSTERICALLY
DECENT PEOPLE PICKED REAL MOUNTEBANKS AS LEADERS
A←DUCK DISTINGUISHED PEANUTS DAINTILY IN←JERSEY
DIDDLING FIJIANS THANKED CRANKY WESTERNERS
DELIGHTED FIDDLERS PRACTICED DRUNKEN SCALES
A←DRUMSTICK HIT A←SCALY←ANTEATER STANDING SILENT
DARK KITCHENS TRANQUILIZE QUINTESSENTIAL QUAKERS
A←DANDY FILCHED CLASSICAL ROUND←STEAKS PERFECTLY
A←DAUGHTER←OF←HUNTERS HID TRAPS PAINTED VIOLET
DISTINGUISHED LIGHT COATS CHANGED VOICES WEEKLY
WHO DECLINED HIS WILD GRAZING AND RUNNING RANGES
THE←GOBI←DESERT DIFFERED IN←STATES FOUND EXTREME
DIFFICULT MISTAKES ACADEMIZED TWENTY ODD SOVIETS
WHO DISCOVERED WILD SHAR-NURU YOUNGER OR WEAKER
DESERTERS WILDLY SHOUTED "ULAN←BATOR" GRATINGLY
WHAT DEVELOPED LIVING PRAGUE'S ABUNDANT STAGES
DATA ON←A←MINOR CHARACTERIZED HIS SPINE AS LARGE
DENEB RIPENED PLANETS AND PLANETOIDS IN←SPACE
DOCTORS RIPPED←OUT PRACTICAL GLANDS PERVERSELY
DUNCES RISKED SMARTING GLANCES AND MOCKERY WANLY
DRUGS DISGUSTED PLAIN-SPOKEN DIANE DIFFERENTLY
DREAMS FILLED CRAZY EVENINGS SUMMER WARMED LATE
DOGS KILLED FLAG-WAVING PRINTERS WITLESSLY WHITE
DUSK FILLED PRACTICAL PLANNERS WITH←USELESS←WIND
HIS DRAMAS MINGLED TRAGEDY WITH←FRANTIC←FARCE
DELIGHTED MINSTRELS FLATTERED PRINCELY HUNTERS
DIRTY MIXTECS CLAMBERED←UP MOUNTAINS WICKEDLY
DYING FINGERNAILS SLASHED GRADUATING STUDENTS
DOROTHY DISLIKED PLAYFUL PRANKSTERS EXTREMELY
DISCOVERIES DILATED STARTLING JOINED GROTESQUES
DAVID MIXED PRATTLE WITH←PRINCIPLE EXPRESSLY
DEFINITIONS FINISHED DIALOGUES SAINTS TRACED
DINGOES RINGED PLATYPUSES PAINFULLY MAIMED
DIALECTIC MISTAKES DRAMATIZED ETHNIC DIFFERENCES
DIGESTED MILLET FLAVORED TRANSFORMED PROTEINS
DILUTED MILK STARTLED MOUNTED STEVEDORES WORST
DAFFY PILL-TAKERS CLASHED←WITH PLANTED SUFFERERS
DISTANT RICHNESS CLAIMED PHANTOMS' CONCENTRATION
DIRECT DIALING WEAKENED PRONOUNCED MAGNETISM
DOLOROUS WITS BRAGGED MAINLY ABOUT MASTERPIECES
DEIFIED GIANTS HEARD PLENTIFUL FLAMENCOS WEARILY
DIABOLICAL FIGHTERS BLASTED SAINTLY PEACENIKS
DRAB KILLERS HEADED MAINLAND ARMIES WASTEFULLY
DOGGED WITNESSES FRAZZLED FLINTY PROSECUTORS
DROMEDARIES PISSED←ON FLASHY FLANEURS PUNGENTLY
DEACONS FINESSED CRAZED PLANTERS BRAVELY
DARK FIBERS COATED GRANOLITHIC PUPPETS ON←WHEELS
DANK RIBBONS SHADED STANDARDIZED MACKERELS
DEFIANT TICKET←AGENTS DRAFTED RAUNCHY THESES
DENSE KIBITZERS GRATED CLANNISH PLAYERS WEIRDLY
DUSKY PIANOS GRANDLY SOUNDED FULGENTLY WAILING
DROOPY FIXERS DIAPERED SPONTANEOUS BABIES WARILY
DAINTY PILLOWS GRACED DIONYSIAN ORGIES WEDNESDAY
DEWY DIAMONDS CRACKED IRON CASTE WALLS DAILY
DOCILE DIALECTICIANS PRANCED BRONZE HORSES WRYLY

DIANE &
DIANE 4
LIST.

DECENT BICYCLISTS STAGED THINGS TRIBES WITNESSED
DURABLE LITTLE LEAVES THEN WANDERED WISTFULLY
DOORS SITUATED IN←PAIRS OPENED ONTO←GARDENS
DREAMERS HIT FLATTERERS BEING PROFESSORS WINCING
DOCTORS VISITED CLASSES PAINTING TASTEFUL WOMEN
DEFENDED KINGS PLACED MANNERS ABOVE←CAREERS
DISCOVERERS BIT LEAF-BUDS SPUN OVER←DRIVERS
DIGNITARIES DINED WITH←AGASSIZ AS PRINCES WINCED
DRINKERS LIVED TRAGICALLY RUNNING STATES WRONGLY
DUKE←KARL←AUGUST LIKED HEADY DINNERS AND TABLES
DIFFIDENT DISPUTES SHADED THINKERS EVIDENTLY WET
DEMOCRATIC TIMIDITY DEADENED OPINIONS IN←DISSENT
DEVELOPERS DIFFERENTIATED CLASSES WHEN STUDENTS
DEMOCRATS DISCUSSED ERASMUS AND CHANCE TENDERLY
DEWEY DISCOURAGED TEASERS SPONTANEOUSLY AGREEING
DESTINY WILLED BEATINGS THE←STRONGEST SUFFERED
DISASTERS LIBERALS REALIZED STUNNED WHITEHEAD
DISTANT FINLAND'S COASTS FOUNDED UNIVERSITIES
DAMASK VIVIDLY SEASONABLE DOWNED WESTERNERS
DEFENDERS LIBERATED CRASHERS DRUNK IN←CATHEDRALS
DRINKERS DINED←ON CHAMPAGNE THINKERS DENIED
DELICATE DISHES REALLY THINNED LUCIEN WINTRILY
DEFENSE WITNESSES SCARED SCANDALOUS JUDGES
DEMONSTRATORS BILKED ACADEMICIANS GIANTS ABUSED
DEDICATED PILLAGERS CLAIMED HAUNTED HOUSES
DUCKS PINCHED CHAINED BRINKMEN STONED ON←WINE
DAPHNIS PINNED CHALKY FLANKS CHLOE WHIPPED BADLY
DEFIERS DISMAYED PRAGMATISTS NANNY←GOATS BUTTED
DELICIOUS PITTED PEACHES RUINED PROMETHEANS
DANGEROUS MINKS GRABBED SKINNED BEAVERS WANTONLY
DAPPER WITS FRAMED FRANCISCANS REGRETTING WASTE
DAMNATION SICKENED BRAIDED FLUNKIES SCAVENGING
DRIFTERS JILTED PIANISTS NEON NUMBED WONDERFULLY
DATURA PICKERS WEAKENED PRANCING PONIES WOEFULLY
DECEPTIVELY DINAH DEAFENED CRINGING PROLETARIANS
DEPUTIES DISINFECTED CLARINETISTS MEANLY WEANED

WHOM DID DAVID ASK WHAT HAPPENED?

"WHAT'S HAPPENED," ASKED DAVID.

WHERE WAS DAVID WHEN WHAT HAD HAPPENED HAD HAPPENED?

"WHAT HAPPENED?" ASKED DAVID.

WHOM HAD DAVID ASKED WHAT HAD HAPPENED?

"WHAT HAS BEEN HAPPENING?" ASKED DAVID.

"WHAT IS HAPPENING?" ASKED DAVID.

WHAT DID DAVID HAPPEN TO ASK?

HOW DID DAVID HAPPEN TO ASK?

WHY HAD DAVID BEEN ASKING WHAT HAD BEEN HAPPENING?

WHAT HAD BEEN HAPPENING WHEN DAVID WAS ASKING WHAT HAD BEEN HAPPENING?

HOW DID DAVID HAPPEN TO HAVE BEEN ASKING WHAT HAD BEEN HAPPENING?

WHY DID DAVID ASK WHAT WAS HAPPENING?

"WHAT'S BEEN HAPPENING?" ASKED DAVID.

DAVID ASKED WHAT WAS HAPPENING.

WHEN DID DAVID ASK WHAT WAS HAPPENING?

WHAT HAD HAPPENED WHEN DAVID WAS ASKING?

WHAT WAS HAPPENING WHEN DAVID WAS ASKING?

HOW HAD DAVID BEEN ASKING WHAT HAD BEEN HAPPENING?

WHERE WAS DAVID WHEN WHAT WAS HAPPENING WAS HAPPENING?

WHY HAD DAVID BEEN ASKING WHAT HAD HAPPENED?

HOW DID DAVID HAPPEN TO HAVE BEEN ASKING WHEN HE WAS ASKING WHAT HAD BEEN HAPPENING?

WHOM HAD DAVID ASKED WHAT HAD HAPPENED?

WHAT HAPPENED WHEN DAVID ASKED?

DID ANYTHING HAPPEN WHEN DAVID ASKED?

HOW DID DAVID ASK WHAT HAD HAPPENED?

WHERE DID DAVID HAPPEN TO ASK?

WHY DID DAVID ASK WHAT HAPPENED?

DAVID HAD BEEN ASKING WHAT HAD BEEN HAPPENING.

WHERE HAD DAVID BEEN ASKING WHAT HAD BEEN HAPPENING?

"WHAT HAPPENED?" ASKED DAVID.

WHAT HAD HAPPENED WHEN DAVID WAS ASKING?

WHOM DID DAVID ASK WHAT HAD HAPPENED?

DAVID ASKED WHAT HAPPENED.

HOW DID DAVID ASK WHAT HAD HAPPENED?

"WHAT'S BEEN HAPPENING?" ASKED DAVID.

WHAT HAD DAVID BEEN DOING WHEN WHAT HAD BEEN HAPPENING HAD BEEN HAPPENING?

WHOM HAD DAVID ASKED WHAT HAD HAPPENED?

HOW DID DAVID ASK?

HOW DID DAVID HAPPEN TO HAVE BEEN ASKING WHAT WAS HAPPENING WHEN HE WAS ASKING ABOUT IT?

WHY DID DAVID ASK WHAT WAS HAPPENING?

WHAT HAD HAPPENED WHEN DAVID WAS ASKING?

WHERE HAD DAVID BEEN ASKING WHAT HAD HAPPENED?

"WHAT HAPPENED?" ASKED DAVID.

WHERE HAD DAVID ASKED WHAT HAD HAPPENED?

WHOM DID DAVID ASK WHAT WAS HAPPENING?

WHERE DID DAVID HAPPEN TO ASK?

WHERE DID DAVID HAPPEN TO ASK?

WHERE DID DAVID ASK WHAT HAPPENED?

WHY DID DAVID ASK WHAT HAPPENED?

WAS ANYTHING HAPPENING WHEN DAVID WAS ASKING?

WHAT WAS HAPPENING WHEN DAVID WAS ASKING?

"WHAT'S HAPPENED," ASKED DAVID.

WHOM DID DAVID ASK WHAT WAS HAPPENING?

DAVID HAD ASKED WHAT HAD BEEN HAPPENING.

HOW DID DAVID HAPPEN TO HAVE BEEN ASKING WHAT WAS HAPPENING WHEN HE WAS ASKING ABOUT IT?

"WHAT HAPPENED?" ASKED DAVID.

WHERE WAS DAVID WHEN WHAT WAS HAPPENING WAS HAPPENING?

WHOM DID DAVID HAPPEN TO ASK?

WHERE HAD DAVID BEEN ASKING WHAT HAD HAPPENED?

DAVID HAD BEEN ASKING WHAT HAD BEEN HAPPENING.

WHAT HAD BEEN HAPPENING WHEN DAVID ASKED?

WHY HAD DAVID BEEN ASKING WHAT HAD BEEN HAPPENING?

WHY DID DAVID ASK WHAT HAD HAPPENED?

DAVID HAD ASKED.

WHERE DID DAVID ASK WHAT HAD HAPPENED?

WHERE HAD DAVID BEEN ASKING WHAT HAD BEEN HAPPENING?

HAD ANYTHING BEEN HAPPENING WHEN DAVID WAS ASKING WHAT HAD BEEN HAPPENING?

WHOM DID DAVID HAPPEN TO ASK?

WHOM DID DAVID ASK WHAT HAD HAPPENED?

DAVID HAD BEEN ASKING WHAT HAD BEEN HAPPENING.

WHY DID DAVID ASK WHAT HAD HAPPENED?

WHERE HAD DAVID BEEN ASKING WHAT HAD BEEN HAPPENING?

WHERE HAD DAVID BEEN ASKING WHAT HAD HAPPENED?

WHOM DID DAVID HAPPEN TO ASK?

HOW DID DAVID ASK WHAT HAPPENED?

WHERE WAS DAVID WHEN WHAT WAS HAPPENING WAS HAPPENING?

WHEN DID DAVID HAPPEN TO ASK?

DAVID HAD ASKED WHAT HAD BEEN HAPPENING.

HAD ANYTHING HAPPENED WHEN DAVID ASKED?

WHY DID DAVID ASK WHAT HAPPENED?

HOW HAD DAVID BEEN ASKING WHAT HAD BEEN HAPPENING?

WHERE WAS DAVID WHEN WHAT HAD HAPPENED HAD HAPPENED?

WHAT PEOPLE FLY? WHERE ARE THE BLACK ORCHIDS?

GREY LIANAS VIOLATE GREEN TREES. PARROTS EAT.

AN ORANGE LIZARD IS EATING BLUE EGGS.

AN ARMADILLO EATS A GREYISH SNAKE. BIRDS SCREAM.

BIRDS' EGGS ARE GREY AGAINST A BLUE-GREY SKY.

SNAKES AND COATIMUNDIS PEOPLE A BROWN TREE.

EGGS LIZARDS AND SNAKES CRUSH ARE FRAIL.

AN ANCIENT ZEBRA SCREAMS AT A JAGUAR.

ARE THERE ANY PEOPLE HERE?

A BIRD EATS A FLY. A TAPIR EATS A BIRD.

A JAGUAR JUMPS ONTO A BLACK BRANCH. PARROTS EAT.

BLACK-AND-WHITE ZEBRAS RACE ACROSS DRY SAVANNAS.

PEOPLE PEER AT IGNORANT COATIMUNDIS.

BIRDS FLY ACROSS PEERING MANDRILLS' FACES.

PARROTS RACE ACROSS VIOLET ORCHIDS.

FIERCE SNAKES EAT ANCIENT COATIMUNDIS.

ANCIENT PEOPLE EAT GREEN PARROTS' EGGS.

AN ANCIENT JAGUAR CRACKS AN ARMADILLO.

EGGS LIZARDS AND SNAKES CRUSH ARE FRAIL.

PEOPLE ARE SHEARING IGNORANT SCREAMING ZEBRAS.

BROWN ARMADILLOS SCREAM AT IGNORANT PEOPLE.

VIOLET TREE TOADS VIOLATE VIOLET ORCHIDS.

PEOPLE SCREAM AS ORANGE LIZARDS CRUSH SNAKES.

RED PEOPLE PEER THROUGH DRY PURPLE LIANAS.

AN ORANGE LIZARD IS EATING BLUE EGGS.

SLITHERING TREE SNAKES EAT BLUE BIRDS' EGGS.

SNAKES EAT.

BROWN BABOONS VIOLATE VIOLET TOADS.

BIRDS' EGGS ARE GREY AGAINST A BLUE-GREY SKY.

ANGRY RED PARROTS ARE SCREAMING OVERHEAD.

BIRDS CROSS GREY SKIES.

PARROTS EAT TOADS. ARE THERE ANY PEOPLE HERE?

A GREYISH TAPIR TAPS A SLOW ARMADILLO.

A GREYISH TAPIR TAPS A SLOW ARMADILLO.

FIERCE SNAKES EAT ANCIENT COATIMUNDIS.

BROWN ARMADILLOS SCREAM AT IGNORANT PEOPLE.

BIRDS SCREAM. AN ARMADILLO EATS A GREYISH SNAKE.

PEOPLE ARE SHEARING IGNORANT SCREAMING ZEBRAS.

WHERE ARE THE BLACK ORCHIDS?

A BIRD EATS A FLY.

LIZARDS ON BRANCHES ARE EATING FLIES.

MANDRILLS SCREAM. BLUE BIRDS FLY IN A GREY SKY.

BABOONS VIOLATE BANANAS IN VIOLET TREES.

ANGRY RED PARROTS ARE SCREAMING OVERHEAD.

A BROWN BIRD RACES PARROTS ACROSS THE SKY.

GREY LIANAS VIOLATE GREEN TREES.

BLACK-AND-WHITE ZEBRAS RACE ACROSS DRY SAVANNAS.

ANGRY PEOPLE ARE EATING TREE SNAKES AND BIRDS.

FLIES EAT.

PARROTS EAT TOADS. ARE THERE ANY PEOPLE HERE?

EGGS LIZARDS AND SNAKES CRUSH ARE FRAIL.

A BROWN MANDRILL CRACKS TANNISH EGGS. BIRDS EAT.

SNAKES AND COATIMUNDIS PEOPLE A BROWN TREE.

AN ARMADILLO TAPS A BLACK BRANCH.

PARROTS EAT TOADS.

TAPIRS JUMP. ZEBRAS RACE ACROSS DRY BRANCHES.

MANDRILLS JUMP TOADS.

WHAT ARE THE FLIES DOING?

A GREYISH TAPIR CRUSHES FRAIL EGGS.

GREY LIANAS VIOLATE GREEN TREES.

BABOONS JUMP. PEOPLE AND FLIES VIOLATE ORCHIDS.

PARROTS RACE ACROSS VIOLET ORCHIDS. ZEBRAS EAT.

FLIES IGNORE ARMADILLOS AND TOUGH COATIMUNDIS.

PEOPLE ARE SHEARING IGNORANT SCREAMING ZEBRAS.

A TOUGH RED-AND-GREEN PARROT SCREAMS AT A TOAD.

ZEBRAS RACE JAGUARS AND GREYISH MANDRILLS.

FLIES FLY.

BIRDS SCREAM. AN ARMADILLO EATS A GREYISH SNAKE.

A GREEN LIZARD PEERS AT A TOUGH MANDRILL.

WHAT PEOPLE FLY?

PEOPLE AND FLIES VIOLATE ORCHIDS.

LIZARDS JUMP BABOONS. A BIRD EATS A LIZARD.

PEOPLE SCREAM AT GREEN-AND-VIOLET TOADS.

PEOPLE ARE SHEARING IGNORANT SCREAMING ZEBRAS.

PEOPLE ARE SHEARING IGNORANT SCREAMING ZEBRAS.

PEOPLE SCREAM AT GREEN-AND-VIOLET TOADS.

YELLOW PARROTS RACE ANCIENT JAGUARS.

ARMADILLOS JUMP.

A TOUGH RED-AND-GREEN PARROT SCREAMS AT A TOAD.

PEOPLE SCREAM WHILE GREEN TOADS VIOLATE PARROTS.

ZEBRAS RACE JAGUARS AND GREYISH MANDRILLS.

MANDRILLS IGNORE ARMADILLOS AND COATIMUNDIS.

A GREEN LIZARD PEERS AT A TOUGH MANDRILL.

WHAT PEOPLE FLY?

BABOONS VIOLATE BANANAS IN VIOLET TREES.

FLIES IGNORE ARMADILLOS AND TOUGH COATIMUNDIS.

ANGRY ARMADILLOS ARE SCREAMING AT RED PARROTS.

MANDRILLS IGNORE ARMADILLOS AND COATIMUNDIS.

A GREY TOAD EATS A GREEN-AND-ORANGE FLY.

ZEBRAS JUMP. PURPLE-FACED MANDRILLS ARE FIERCE.

TTONS

JML;PAIRS1$L

JML;TRANS1$L

 ALWAYS ARE PARAMETERS ENERGIES TRANSFORMING ALL
 ENERGIES
ENERGIES ALWAYS
 ALL TRANSFORMING ALWAYS
ALWAYS PARAMETERS
 ENERGIES PARAMETERS ALL ALWAYS TRANSFORMING ARE
ARE ALWAYS TRANSFORMING ENERGIES PARAMETERS ALL
ENERGIES TRANSFORMING PARAMETERS ARE ALL
 ARE
 TRANSFORMING PARAMETERS ENERGIES ARE ALWAYS ALL
 ENERGIES PARAMETERS
 ENERGIES ALWAYS TRANSFORMING ALL ARE PARAMETERS
 ENERGIES ALWAYS PARAMETERS ARE TRANSFORMING ALL
 TRANSFORMING ARE ENERGIES ALWAYS ALL PARAMETERS
 PARAMETERS ALWAYS
 ENERGIES
 PARAMETERS ARE
 PARAMETERS ARE
TRANSFORMING ARE
ALL ARE ENERGIES PARAMETERS
 PARAMETERS ALL
 PARAMETERS
 ENERGIES ARE ALL PARAMETERS TRANSFORMING ALWAYS
 ALL ALWAYS ENERGIES TRANSFORMING PARAMETERS
 ALWAYS ENERGIES TRANSFORMING ARE PARAMETERS

ARE TRANSFORMING ALWAYS ENERGIES ALL

ALWAYS ARE ENERGIES ALL TRANSFORMING

PARAMETERS ENERGIES ALL ARE

ALL ALWAYS

ARE

TRANSFORMING ALWAYS ARE

TRANSFORMING

ALL PARAMETERS ENERGIES ALWAYS ARE

ALWAYS

TRANSFORMING PARAMETERS ENERGIES ALL

ARE ALWAYS ENERGIES PARAMETERS ALL

ALWAYS ENERGIES TRANSFORMING ALL

ENERGIES ARE ALL PARAMETERS ALWAYS

ALL PARAMETERS ALWAYS ENERGIES TRANSFORMING

ENERGIES ALL ARE TRANSFORMING

TRANSFORMING ALL ALWAYS ENERGIES

ALL

ENERGIES ALWAYS ARE TRANSFORMING

TRANSFORMING ENERGIES ALL ARE PARAMETERS ALWAYS

PARAMETERS ALWAYS ALL TRANSFORMING

ENERGIES TRANSFORMING ALL ALWAYS

ALL ALWAYS ARE PARAMETERS TRANSFORMING ENERGIES

ALL ENERGIES ARE TRANSFORMING PARAMETERS

Robert Mallary
Born Toledo, Ohio, 1917
Resident Amherst, Massachusetts

Charles Mattox
Born Bronson, Kansas, 1910
Resident Albuquerque, New Mexico

In early November, 1967, while investigating the possibility of making sculpture via the computer, Robert Mallary sent us a written description of the system he was employing at the University of Massachusetts in Amherst. Mallary's work in this area had its origins in his research in the mid-forties into various types of three-dimensional cinematographic projection. He wrote,

> What I propose, put in its simplest terms, is this: that I create a simple structural form here in Amherst which is contoured, digitalized and taped. The computer on the campus is hooked up for a few minutes (probably only a few seconds) with a computer, say at Cal Tech and the constituent contour of the form emerges out there as a print out. These are taken over by technicians at the Museum, photographed on to slides, enlarged by projection on to plywood (or possibly plastic) sheets, cut out, assembled as a laminate, surfaced (to eliminate the contour 'steps') and polished.

In August 1968, Mallary told us of a simplified method that could be used to produce a sculpture by converting the output to paper tape and guiding thereby "a numerically controlled tool which would directly carve out the sculpture."

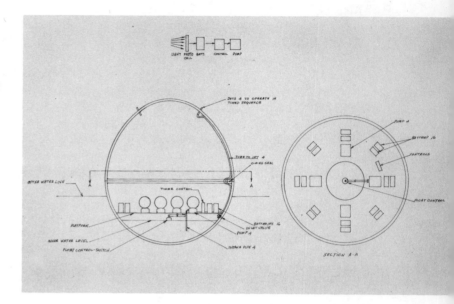

In the spring of 1969, kinetic sculptor Charles Mattox sent us plans for a proposed fountain.

> Fountain consists of a fibre glass shell, eight feet high, six and one-half feet through center. It would be a contained system, the upper section above the seal would have a pattern of photo cells over the surface up to the jets. These cells would produce electrical energy from light and store it in the sixteen batteries. The level of power storage would actuate a voltage regulator switch and when the correct level was achieved the pumps would operate. The pumps to be controlled by a timer and the jets to squirt in a rotating pattern that will be tuned to the natural cycle of the mass so that a rotating oscillation of the piece is achieved. When the energy level in the batteries drops to a predetermined point, the pumps shut off and cells again recharge the batteries. The inner water level will be controlled by a float valve and switch.

> The piece would be anchored with a swivel at the base to prevent its drifting. The weight inside will be adjusted to hold the piece in an upright position.

John McCracken
Born Berkeley, California, 1934
Resident Venice, California

Glenn McKay
Born Kansas City, Kansas, 1936
Resident San Rafael, California

Los Angeles sculptor John McCracken toured Litton Industries and Philco-Ford in March, 1969. After studying company brochures and reflecting on his two tours, he indicated to us that although both facilities interested him, he had no specific project involving electronics in mind. But he explained, in a letter to us,

> The only possibility I consequently see at this point is to go into it with pretty much that attitude—not knowing at all what might happen, and maybe even accepting the possibility that nothing might happen beyond the occurence of an educational experience for me and hopefully for the engineers as well. This would be a meeting of minds interested in doing something together, with very few preconceptions on either side, and as I think about it it seems like a pretty exciting idea.

Since he was in New York for several months, McCracken asked that we not reserve either company for him, but said that on his return he would like to visit Kaiser Steel Corporation. Kaiser, however, was already working with Richard Serra. Instead we took McCracken to Norris Industries' bathroom fixture manufacturing plant, but the facility did not inspire him to propose working there.

Glenn McKay leads a light show group called Head Lights based in San Francisco. On the recommendation of Hal Glicksman, we invited McKay to propose a work for A & T. He wanted to build a multi-media environment including an array of closed-circuit televisions, movie screens and a programmed sound system. HG took him to RCA, and McKay returned several times on his own in the process of refining his proposal.

In April, 1969, he presented to us plans outlining the environment, which was to be a U-shaped room, each wall containing a movie screen surrounded by sixteen televisions. Each of the forty-eight closed circuit television cameras would focus differently on the spectators; one would locate on a face; another would be a wide-angle view of the crowd, etc. These live images were to be superimposed over a sequence of previously taped abstract images. Simultaneously on the central screen of each wall McKay's special type of light show would be projected. Programmed into the visual display would be a sound sequence comprising music by Eric Satie, electronic noise, the Jefferson Airplane and Marshall McLuhan reading.

McKay came to Los Angeles to make a special presentation of this ambitious display at RCA. They studied the proposal, projected a cost estimate and submitted both to the New York office for consideration. Several weeks later we received word that RCA turned it down on the basis of prohibitive expense.

Boyd Mefferd
Born St. Louis, Missouri, 1941
Resident New York City

Jane Livingston went to see Ralph T. Coe's *Magic Theatre* exhibition in Kansas City in June, 1968 and reported that Boyd Mefferd's piece was in her view the most interesting work presented. She wrote in the September *Artforum*,

Boyd Mefferd's *Strobe-Lighted Floor* was . . . unquestionably the most important work in the exhibition. In it, one entered a large, carpeted room containing square lucite floor insets, spaced regularly in a simple grid pattern, each surmounting a strobe light made to fire with capacitor overflow, and thus 'randomly,' as the viewer walked about the room. The lights were placed beneath colored filters, but appeared white on actually looking at the flash—only the after-image took on color. On first entering the room, my impression was that the lights emanated from walls, ceiling and floor, and even when I had become oriented to the location of the light sources, it was impossible to look at them, or to discover by looking at any particular spot in the room precisely what was happening all around at a given moment. In short, what Mefferd presented was a way of seeing (retinal images) that does not relate to looking directly at an object or objects. Unlike most of the other environments in the exhibition, the spectator was not compelled to move in any specific way, or to 'play' the work, in order to fully apprehend it. Certainly the dream-like sensation of having one's head filled with vaguely colored images which endure, multiply and actually seem to assume different shapes, and to expand or contract, to sharpen and fade, is an extraordinary state. By limiting himself to a basically simple format and allowing only the effect that interested him to make itself discernible, Mefferd succeeded in exploiting that effect to a high degree.

On the basis of the *Magic Theatre* piece, we contacted Mefferd and asked him to consider working with a company which would allow him new technical possibilities. He responded,

. . . I should be able to get right to work on a floor unit which will have two side-by-side rows of 50 flash tubes each, arranged so that the protective glass for each unit joins the one next to it, eliminating the carpeted sections of the Magic Theatre format, and making continuous blankets of intense light possible. Also, instead of the random firing of the Magic Theatre, this work will be fully programmed. I think that this kind of work must move in the direction of increased control if many of its possibilities are to be developed and effectively presented. I have been experimenting with a ring-counter type of circuit which will fire the entire line of lamps, or part of it, with microsecond delays between each lamp, so that as an after image, one end of the line is different in color from the other, and the change between ends is completely gradual. Color in this case is completely a

product of timing, and not of color filters as was the case in the Magic Theatre. Obviously I won't know how well this will work until the 100 lamp unit is finished, hopefully late this winter. From this kind of stripe experiment, I would like to go directly into a 20' x 30' or so floor of continuous flash tubes, with about 600 separate units. This would require quite an elaborate tape programmer, and I would have to work with someone like IBM if many of the various possibilities were to be worked out. This is the kind of work that I would like to build in Los Angeles.

IBM was at this time seriously considering a major project we had proposed with Victor Vasarely. Since we could not approach them about Mefferd, as he had suggested, we went to Litton Industries, which had already had unsuccessful encounters and discussions with three artists: Robert Morris, John McCracken and Vjenceslav Richter. Litton had thus far offered for an artist's use only one of their many divisions, which dealt in the area of microcircuitry. We requested of Litton that more of their diverse facilities be made available for potential artistic use, and that serious consideration be given Mefferd's proposals.

Litton seemed to respond favorably. Fred Fajardo, in the public relations department of the head office, became our new contact man, and offered us information about other divisions. Mefferd then toured Litton in Los Angeles and wrote us from New York on June 12, 1969:

The idea of the project is still wearing well on me. If I am to work with Litton, it would be good to spend more time snooping around My last four years or so of working with lights and circuitry seem to have taken me into various areas of mildly complex equipment, to seeming dead ends, now only to put me back into an area where most everything I want to do can be accomplished fairly simply Without my experiments I would not have come so clearly on my simple works, of course, but I do seem to be in a state of mind where complex ideas seem unnecessary. Complexity being the advantage of Litton (or very new materials, used simply, which is also probably a complex process of some sort), my ideas for other work would probably have to come out of the advantages of what they could show me rather than anything I might know about now.

Based on the meetings with Litton personnel, we expected that the company would execute this project, which was already fairly well conceived, and then might prompt Boyd to explore fresh areas of invention. Two weeks went by, with no commitment forthcoming from Litton.

On June 16 Hal Glicksman called Fajardo and wrote the following memo to MT:

Call to Fajardo. Litton does not like Mefferd's project, too much expense in non-Litton material and Litton contribution would be very simple-minded, and it could be done at any computer facility.

We asked Boyd to call Fajardo himself and explain his position. HG wrote this memo to MT on June 27, 1969:

10:30 call from Mefferd. Call with Fajardo ended vaguer than he would have liked. Mefferd had to admit that there was no necessary reason that only Litton could take on the project. Mefferd said he was not there to think up technological puzzles but to bring them ART.

11:00 from Fajardo. Project is very expensive and does not seem to be especially a 'Litton type of project,' others could do it, etc. He asked what others were doing, and I gave him the bit about Universal film studio's project being simplistic but costly, etc. 'F' was impressed that we wanted the project so much. He said he would have trouble selling the project to higher ups. I said we sold them on A & T and we can sell them the project. He said, 'You may have to do that.'

Fajardo set up a meeting with us and James Lewis, Director of Public Relations and Advertising. No significant objections were raised by Lewis; indeed the tenor of the discussion was optimistic, even enthusiastic, since we were considering the Mefferd room as a definite possibility for the U.S. Pavilion at Expo 70. Nevertheless the project was refused by Litton, for reasons no more explicit than appear in HG's memos cited above. We despaired of Litton but pressed on for Mefferd. RCA officially joined A & T at about this moment, signing a Patron Sponsor contract after having for several months studied proposals by Vasarely and Glenn McKay and eventually turning them down. With these artists out of consideration, we approached RCA's Government and Commercial Systems Division in Van Nuys, California with Mefferd's project, and we simultaneously urged Mefferd to personally contact Julius Haber of RCA in New York. Mr. Haber is directly responsible to Dr. Robert Sarnoff, President of RCA, and we had been informed that Dr. Sarnoff, an art collector, would personally inspect any art project involving the company. Boyd saw Haber in early August and followed up with a letter to him on August 20:

I am enclosing a few of the things published on my *Strobe-Lighted Floor* which was originally shown in Kansas City, and later in St. Louis, Toledo, Montreal, and will be seen this year in New York. Other descriptions appeared in *Time, Newsweek,* and a number of other publications. Essentially this work is serving as my prototype for the Los Angeles project, and helps me speculate on the psychological impact of the larger, more powerful floor which will be built there.

The Los Angeles floor will differ in that the negative, non-luminous carpeted areas of the *Strobe-Lighted Floor* are not in the plan, and instead the entire floor will be glass, with a flash unit under each of 500 sections. The floor will become one positive, luminous sheet of light and electrical energy, and viewers will see each other etched as dark shapes in what I guess will be the most luminous background there has ever been. This is a direct reversal of the figure-ground relationship in traditional art. Color will be produced as a product of timing, taking advantage of a chain of retinal reactions which are triggered by bombarding the light-adapted eye with a brilliant flash of pure white light.

I am sympathetic with RCA's interest in wanting to take advantage of your most recent and impressive advances in electronics and color television. I realize that if a good work of art can possibly be made around these, it would be the best statement of the unique qualities of RCA. I realize that any one of a number of companies has the technological capability to build my work. The only solid reasons I can give you for building mine is that I think it will be good, and that it will be very electric, a really massive use of electric power, controlled for esthetic ends. To the general public RCA is an enormous, diverse company, involved in everything from making washing machines to getting men on the moon, and electricity is the only common ground which runs the gamut from Johnny Carson to integrated circuits. While RCA executives have one idea of what RCA is, and would appreciate your most recent advances shown in a new way, an artist's way, I imagine that the public sees RCA in a completely different way, doesn't know what you can already do, and will look at anything that you can do well and powerfully as something good and memorable, whether it is technically involved or not.

My entire premise for a good work of art is that it transcend materials to reach an esthetic consistency. Just as Whirlpool takes the most expedient path to making a good, convenient washer, in the same way I am dedicated to taking the most direct line to the best work of art I can make. My experience with color television led me to believe that it is a cumbersome, limited art medium. For communications and entertainment it is ideal, but art is really not about communication or entertainment. My experience with more complicated electronics has led me back to attempting very precise control of some relatively simple circuits. I think that the reason that we have seen so little quality in art and technology projects is that artists have spent too much money and energy trying to compete with industrial consumers who need advanced technology to make things more

expedient. Art, and an artist's standards, are still quite different from the motivations of industry, and it seems out of place to expect both groups to be able to utilize all the same hardware. Companies, working with industrial aims, have tended to support art works which best demonstrate their products and capabilities, but art is not really a process of demonstration.

In closing I'd like to add that I am more than a little amused when you think, on quick examination, that my project is not electronic. As a paying customer in the last four years I have purchased about ten thousand dollars worth of RCA semiconductors for various exhibitions and commissions, and if more artists were as 'non-electronic' as myself, RCA stock just might go up a few fractions.

Julius Haber replied immediately to Mefferd:
Thank you for your letter of August 20th and the accompanying material describing your *Strobe-Lighted Floor.*

These were very carefully reviewed by a group of us, and while we found your ideas very stimulating the consensus was, regretfully, that we would forego the opportunity of sponsoring this interesting project because it seemed too far afield of our own technical interests.

We do appreciate very much your courtesy, and that of Mr. Tuchman, in giving us an opportunity to look at this proposal.

Next we tried Wyle Laboratories, through Frank Wyle, President of the company. We also enlisted the services of Los Angeles artist Frederick Eversley, who had formerly worked for Wyle Labs as an engineer. Eversley was hired as a technical consultant to A & T, primarily to resolve the Mefferd situation. We felt he could explain the technical needs better than we could, and also, since he knew Frank Wyle, effectively present the case for the important esthetic potential of the work. We felt then—correctly, it would now seem—that resistance to Mefferd's proposal was based on the corporation's skepticism as to its artistic merit.

Eversley argued brilliantly for the work as a suitable and important project for Wyle Labs. Frank Wyle remained unconvinced of its potential value, wary of the costs envisioned, and felt not at all challenged by the nature of the technical problems involved in designing a control device or programmer. Eversley sought to clarify and reduce the budget, assuming, as we all did, that Wyle would at least begin to interact with Boyd if the company's monetary reluctance could be assuaged. Eversley wrote to numerous Japanese electronic firms in an effort

to find one that could fabricate five hundred strobe modules at a reduced rate, since the lower component and labor costs in Japan would be more economical and also cut shipping expense for installation at Expo.

Encouraged by our determination to find a company for him, Mefferd made a small working model of the piece in his New York studio. This was seen by James Kenion, Ivan Chermayeff and Jack Masey, with the end view of including the resolved environmental work in the U.S. Pavilion. Everyone was impressed with the mock-up, and had no difficulty imagining its impact as a room-size work containing a sophisticated light control system.

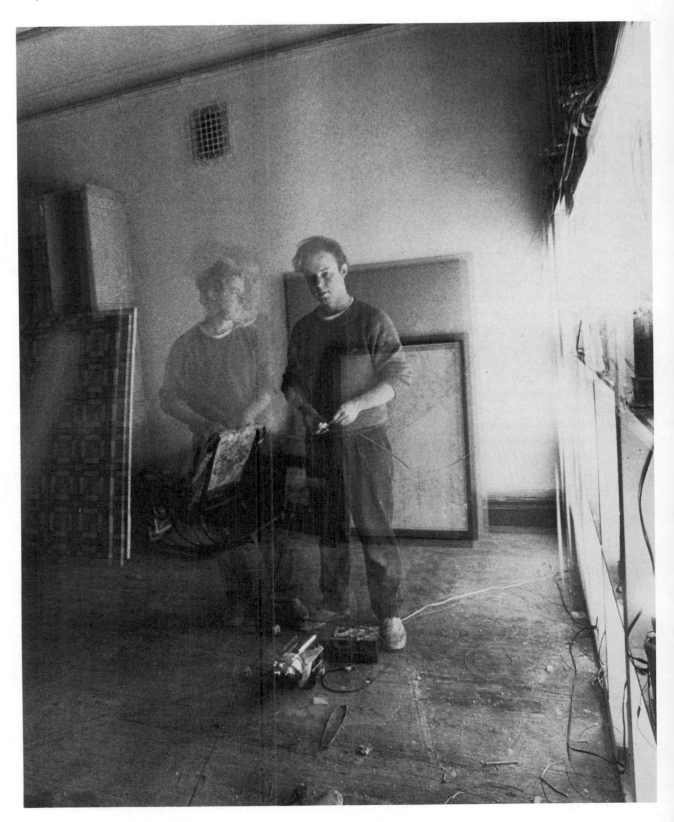

Not wishing to depend on Wyle's decision alone, we extended our search to include other companies that could do the job, or part of it. We phoned General Electric (Patron Sponsor) to ask for a donation of strobe units. G.E.'s Photo Lamp Department declined, but offered a discount on a new model. In New York, MT met with executives of the Xerox Corporation, which owns a Pasadena-based electronics firm, Electro-Optic Systems. We asked Missy Chandler to have another try at Litton. HG wrote and phoned Spiratone, Inc., Rodan, and E.G. & G. Corporations.

Boyd Mefferd suggested calling Monsanto, thinking that a plastics contribution would be helpful to provide the facing of the strobe units and thereby reduce costs. It should be noted here that the various estimates for his project were strangely inconsistent, ranging as they did from $6,000 for materials and construction, to $25,000. In another attempt to reduce the budget, Mefferd began designing a room whose walls, rather than floors, would contain the flashing lights. He wrote to us in October, 1969,

> I am pressing the idea of a plastic room, because Monsanto makes plastic buildings. If they will get into this, I think that I would get pretty enthusiastic about expanding the work up the walls more and making more use of the tall space. Dr. Gordon knows a key executive at May Company, and if Monsanto will do the plastic room, I think that he can approach May Co. to help with the electronics. Then perhaps I can keep a pretty tight control on them and hire what technical help I need with the programmer. I would be ready to start work on that immediately, and I like the idea of making the electronics as simple as possible. I suspect that once I get into it, some simple things will turn out to be significant. If I am in control of that aspect, I imagine that I can build the controls bit by bit and do my experimentation as I go along, and thus do without the versatility of a crossbar scanner or other elaborate controls which would have the options of going various different ways.

Boyd simultaneously wrote to Richard Gordon at Monsanto in St. Louis,

> From my work, the originators of the exhibition are counting on a high-impact experience which will reach a large number of people. Rather than using the floor, as I did in the Magic Theatre, in Japan I will develop an entire plastic room and place my strobe lights behind the walls. The luminous plastic interior will become the artwork. I feel that collaboration with Monsanto could result in developing such a plastic interior, and I hope that we can work together on it.

We also put Boyd in contact with Today's Displays, a fabricating company recommended to us by designers of the U.S. Expo Pavilion Exhibition Design Team, who had had experience with this firm. After meeting with Joseph Grunwald of Today's Displays, Boyd wrote to MT:

> I am not too impressed by Today's Displays, and I don't really see what they can offer. Grunwald talked about using one of the cheap Japanese photoflash units, and their building the control. I have great reservations about something like that. I feel strongly that we should try to build our own flash units with the lamp that GE will sell us for $4.50 ea. This is vastly better equipment than the little Japanese units and will give us longer life, more light, the option of changing lamps if necessary, and the advantage of being able to use top quality parts throughout instead of things selected to make the cheapest possible units. I think that a good flash can be built for about $40 each, including labor. For 250 units, this would be $10,000 Grunwald was talking about roughly $100 a unit, which based on 250 units is exorbitant. I'm sure they can do some good things, but in general they seem to be uninformed and over-priced. I will do some more thinking on how the control could be handled simply.

By the end of October every lead had failed. Wyle had phoned to decline, and the other companies we had contacted similarly expressed no interest. On October 31, with Mefferd's project hanging fire, and the USIA deadline nearly at hand, MT remembered M.A. Gribin, a collector of Cubist paintings whom he had met a year previously. Gribin was president of an electronics company in Los Angeles, Universal Television. We persuaded Gribin to visit Mefferd's studio and see the model. Gribin was interested and subsequently signed a Patron Sponsor contract. However, even with the company's support, no collaboration between Mefferd and a Universal technician could be effected; but Mefferd proceeded on his own to prepare for the Expo show.

No project was more difficult or frustrating to implement than Mefferd's, despite the fact that from the start, his intentions were clear and his ambitions were high but not unrealistic from either a technical or a financial point or view. Nor was this a reflection of the artist's temperament, for he is eminently likeable, articulate and modestly business-like in his approach. Mefferd wrote to us in retrospect evaluating his numerous corporation contacts and commenting on the A & T program in general:

> I found the brass incredibly cautious, slow moving, and stodgy, for people who had their power, and middle management, while a little more lively, were completely afraid to do anything to counter the higher-ups, so they might as well have not existed. I am convinced that Monsanto spent at least a thousand dollars just to decide *not* to do my project. Brass

would not act without first having lower people research and investigate, and then when the report was favorable, they decided that there wasn't enough time to do it anyhow. I began to think that it is quite an accomplishment just to make a profit with so much heavy baggage in a firm, and they give you the feeling that they could clean up the land a little, lower prices a little, do most everything they will have to do for the good of the country, if they could only streamline and up-grade management. This is an optimistic feeling, I suppose, but it doesn't help much if you are trying to work with a company as it exists now

One of the key problems in working with companies seems to be that they like to take things over, to demand that things be approached in their way. Because they are usually nervous over costs, insisting that an art project be a relatively small undertaking for them, and then deny the artist his own unique way of doing things, it is no wonder that the projects seem to provide so little challenge. It is important that the initial concept was a challenging one, the concept of artists in residence. Individual flair seems to have been lost somewhere in corporate thinking, and nobody in these companies seems to feel much compulsion to do anything with much style. Probably they look to artists for that sort of thing now. Maybe artists will be the last of the big time spenders. Companies seem to have forgotten about the value of independent operators. Obviously they hire people who have little interest in independence, and nobody seems to remember that the men who started our giant corporations were all small and independent, more like artists than the people who run the companies now. They don't seem to understand the value of injecting this kind of thinking back into their ranks. They go to great expense to hire strong, bright people, and then do their best to isolate them. I sincerely think that an artist would be a great encouragement to the individual aspirations of a company's employees, and of great long-range value to a company. I'm sure that in the midst of penny-pinching budget talk, A & T people were tempted into the old saying, if you have to ask the price, you can't afford it. It seems that just as money stands between the artist and his exploration of simple technology, it also stands between the companies and their sharing of a more sophisticated technology. If things are going to hang up on costs, the potential of technological sophistication is meaningless. Accordingly, Universal Television was able to work with me, and hopefully with the Los Angeles installation we can all learn from the project, even though their technical capabilities are limited, while giants like Litton, RCA, Monsanto and the like were not able to work. I get the feeling that much of the energy that giant corporations expend on development is wasted because they

don't have the human foresight that it takes to utilize it. Of course this can be expanded to include our growing global ecological problems, but I presume the purpose of the catalog is not to insult industry, and there is no point in going more into this now.

In the U.S. Pavilion, Mefferd's space comprised the introductory area to the New Arts section, occupying ninety-two feet of running wall space in two adjacent V-shaped configurations. One hundred twenty identical flash tube units, covered by two foot square plexiglass sheets, were mounted in a grid pattern on four walls to a height of six feet; the walls were then furred out. The flash tubes were designed by the artist, adapted from normal photographic flash units; they are 450 volt xenon lights operating off normal line current. Since no one working in the U.S. Pavilion was as well-equipped as the artist to assemble the piece—a delicate, time-consuming chore—he did so himself with the sole aid of his girl friend; the process took three weeks.

A critical factor determining the success of the work was the degree to which ambient light could be reduced in the surrounding space. As the Mefferd room was at the entrance of the New Arts area, we cut down the size of the passageway to the minimum set by Japanese safety codes. It was expected that dense crowds of visitors would further block out light and greatly darken the room, but this could not be precisely calculated beforehand. For a week Mefferd tested various rhythms of firing. This was the creative period for him, all that had gone before being merely a question of technical preparation. Mefferd's intention for the Expo piece (in anticipation of the massive traffic) was to produce the strongest possible impact in a short time span. He finally arrived at a carefully determined system which he felt was direct and "formal"—especially in comparison with his Magic Theatre piece. Each V-shaped group of lights had a separate trigger mechanism, controlled by a simple motorized timing device. One group fired at fifteen second intervals; the other received its impulse every thirteen seconds. The total frequency of flashes was thereby staggered within those sequences; at times both groups exploded simultaneously with subsequent lengthening of the flash.

On March 15, Expo opened and swarms of people poured through the Pavilion in a dense stream. Mefferd's room was significantly darkened by the enormous

crowds, and the piece worked—provided that the spectators delayed their rush through the room for two or three seconds. Most Japanese would not pause, however, and they experienced the work only as a minor eye irritation—like the flash from a nearby camera. For those who dallied long enough to receive the series of light discharges the experience was intense.

The first burst of white light to hit a spectator's eyes was the most startling and disorienting; with the firing of successive charges, one's vision was subjected to a series of brilliant color mutations: from white, the light shifted to turquoise and to blue; then from rose to violet, and finally to orange. In the first moment one may be fearful and instinctively shut one's eyes from the light, but it has been observed that this fear vanishes almost instantaneously, as the multitude of hues explodes in one's visual field. Whatever shapes were between the spectator and the walls of light—usually other people—interrupted this pure color field, resulting in frozen chromatic silhouettes and bifurcated forms.

Mefferd has not studied these optical phenomena from a scientific standpoint; nor is he particularly interested in the various theories which explain them. Indeed, he has said, "Essentially, I believe that an artist is still an artist and that his growth will be one of intuitive decisions, utilizing feedback from his work, with occasional flashes when confusing things become clear, and that the materials he works with are still secondary to traditional art work habits." The process which brought Mefferd into strobe lighting was not the result of research in the field of optics, but (in confirmation of the above statement) an empirical development, based on intuitive judgments of his past work. In 1967 he had executed a series of small light boxes using fluorescent lights layered between plexiglass, formica or chrome-plated metals. He began to evaluate them, in terms of other light sculptures being done at that time, and in terms of what he really wanted from light as a sculptural medium. He later explained,

> The boxes were modulations on a certain cycle; you could enjoy looking at them for some time, but you've seen the *content* in a very short time. I got more and more interested in trying to make works that are completely discontinuous; which would exist and then cease their existence. I was also interested in making works that didn't have any physical form— not even any tangible product. What you saw was completely intangible. I got into using flash units as a way of making an interval and identifying something, but I found that the strobes do that, but not very gracefully. The optical quality, which is very strong, is something I really wasn't looking for in the beginning, but being there, it is the strongest thing about them. The intangible thing was not something I expected to find but happened onto.

These two elements of the strobe pieces—discontinuousness and intangibility—constitute Mefferd's esthetic concern, rather than manipulation of an optical effect. Regarding the notion of discontinuousness, Mefferd has stated in a previous exhibition catalog:

> Because viewers are free to decide how long they will spend with a work, *time* has always played a role in the perception of art. Undoubtedly artists of the past have given thought to the duration of involvement that could be expected of their audiences. In recent years, however, some artists have taken to direct manipulation of time, making visual change the basis of their art. This development has placed new importance on the total role of time. If the visual changes

> were likened to the plot of a book, the total viewing time would correspond to its length. Just as it is unlikely that an author would approach a full-length novel in the same way he would write a short story, likewise it is unlikely that an artist who is interested in time control to design similar works for the museum viewer, who has anywhere from several minutes to several hours with a work, and the private collector who may be with it a lifetime. If he is interested in both public and private audiences it is likely that the time oriented artist will develop distinctly different public and private art forms.*

Thus Mefferd's A & T projects are predicated on the fact that spectators are expected to remain in the room for certain lengths of time (obviously it will be longer at the Museum than at Expo). Based on that expectation, Mefferd arranges the timing sequence of the flash units to establish the *pace* at which the work moves.

It is the quality of intangibleness which most distinguishes Mefferd from other artists dealing with light as a medium. In traditional art forms which utilize electric light as a sculptural component, the form of the work is defined primarily in terms of the shape of the light container—the neon tube or incandescent bulb. In Mefferd's

*Milwaukee Art Center, *White Lightning: A Public Situation,* 1969

strobe pieces, the experience generated by the light is independent of a tangible light source; one is only conscious of the immediate visual experience which takes place in the eye; the only tangible objects are the surrounding persons which comprise the fragmented image.

The piece Mefferd plans for the Museum exhibition will contain an expanded electronic system, and the installation should be more supportive of that system than was possible at Expo. The room itself will be rectangular with a light-trap entrance way painted black to fully dark-adapt the viewer before he enters it. Lights will be arranged in two L-shaped groups with entrance and exits between, allowing adequate space to linger in the environment as long as desired.

The most significant modification will be with the strobe units which will contain not one flash tube, as at Expo, but three; the two additional tubes will be color filtered and programmed to fire at intermittent intervals. There will be the deliberate, rhythmic overriding pattern of the Expo piece with its repetitive sequence of color mutations; but added to this will be bursts of colored lights, interrupting that set pattern. In the months between Expo and the Museum show, Mefferd researched these colored lights; he had units specially made using neon, argon and crypton gases, hoping that a specific gas might produce a certain dominant color. Since there was no significant result, he decided not to go to the expense of having these made but to use filters instead. Programming this new network of flash units, with its complex array of possible color combinations, will be the major task in preparation for the Museum exhibition and will, at last, involve a collaboration between the artist and Universal Television technicians. In excuting the Museum piece, Mefferd's intention was not to disregard the Expo piece, but to elaborate on it and expand the basic idea. In a letter describing the new work, Mefferd said, "I favor doing it as richly as possible as I want an organic, luxurious end product, rather than the rather stark affair we have in Osaka."

Gail R. Scott

Michael Moore
Born Los Angeles, 1942
Resident San Francisco

On May 17, 1969, after trying to contact MT in New York on behalf of Pulsa, Michael Moore sent us his own project proposal:

This project is concerned with the activity of sunlight on and within a structure in the landscape. The sketch [1] fancifully illustrates an application of this idea in the area of Point Dume, although any location along the coastal range with exposure to the sea would do as well. Programming equipment will be buried beneath the floor of a box defined by four walls, each in turn comprised of four nearly transparent, continually moving panels 10' x 10' to a side, inconspicuously contained within four 10' x 15' metal frames, with a solar battery mounted atop a clear plexiglass pylon in the center as an on-site energy source.

The realization of this project requires research in the areas of plastics, solar energy conversion, programming, and movement of the panels. Research into plastics will require experimentation with as many materials and processes as possible to determine a maximum amount of information on light transference properties under a variety of conditions before the panels can be constructed. Lamination and etching are two processes that would be good starting points, and exposure to the appropriate research department of a chemical company should immed-

iately open up manifold additional possibilities.

As to energy conversion, I favor the solar source both practically and conceptually and understand a unit 6' x 6' with a storage battery to conserve overflow for sunless periods would furnish the requisite power.

The programming package, in addition to governing the behavior of the panels, must also incorporate timing devices for initiating and stopping programs as well as a system of sensors and attendant motors to align the solar batteries with the sun. These and all other aspects must be simple, sophisticated, and impervious to the vicissitudes of humanity and nature for a period of at least several months without maintenance.

Driving the panels in accordance with the program will be achieved either by the use of 16 reversible or 32 non-reversible electric motors of the necessary quality, or, more hopefully, electromagnetically; efficiency and availability of materials are the crucial factors in this particular choice.

The end realization of this endeavor should be anonymous; its electronics refined to the point of invisibility; its origins obscure. It will rise prominently but unobtrusively, a hymn to the sun of space.

1

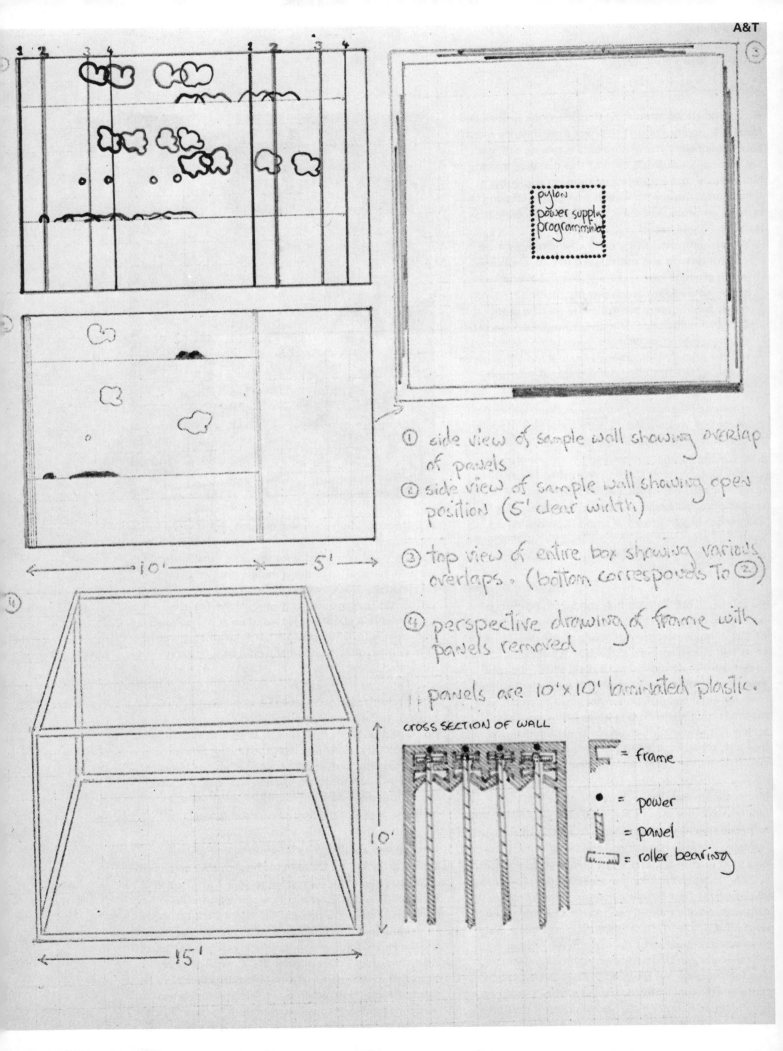

pylon
power supply
programming

① side view of sample wall showing overlap of panels

② side view of sample wall showing open position (5' clear width)

③ top view of entire box showing various overlaps. (bottom corresponds to ②)

④ perspective drawing of frame with panels removed

— panels are 10'×10' laminated plastic.

CROSS SECTION OF WALL

= frame
= power
= panel
= roller bearing

10'

5'

10'

15'

Robert Morris was one of the first artists we approached for A & T, and our efforts to effect a satisfactory match have continued to the writing of this catalog, still without success. Throughout most of this two year period, Morris had a specific project in mind: to work—hopefully in an aerospace firm—with environmental control systems. In September 1968 he sent the following proposal:

> An environmental situation involving temperature control systems and utilizing the devices themselves which generate heat and cold. What is envisioned is not an entire room which gets hot, cooler, etc., but rather specific areas controlled by specific units. Certain amplification of sound from the devices producing temperature changes is also being considered, but the primary concern is to explore local changes of temperature within an extended spatial situation.

In attempting to locate a company working with temperature control, we contacted Litton Industries. Roy Ash, President of Litton, had requested, at the time the contract was signed, that the collaboration take place at Litton's Data Systems Division. We called Ralph Oliver, our public relations contact at Data Systems. We described the artist's field of interest, and Oliver eagerly and unequivocally assured us that Litton could "do anything" along that line. Encouraged by his willingness and optimism, we arranged to visit the facility with Morris on October 29.

On this occasion, we were first conducted into a conference room for an "S.O.B." (Standard Overview Briefing) of Litton Industries, consisting of a movie and a flipcard chart talk on the corporate structure. Oliver then took us through three major areas of the facility—the command and control display center for live radar testing, environmental testing laboratories and a microcircuitry manufacturing plant. Data systems *only* works with temperature control consisting of tiny humidity and heat-cold chambers used to test the endurance of microcircuits and other small electronic parts.

Morris maintained that such machines, having very limited capability in scale and versatility, would be of no help, and that he wanted to work in a department where research was being conducted in environmental (meaning on a scale relative to people, not computer parts) control systems; in reply the Litton management explained that *all* research at Data Systems was applied to specific contracts, usually military, and that no general research went on at any level. Oliver, however, assured us that there was another area of the division we had not yet seen that was working with air conditioning systems. The following day we returned to Data Systems to investigate this section, which contained a fabrication shop for aluminum quonset huts, housing tactical computer equipment called, in Data Systems' abbreviation system,

IFF (Identification of Friend or Foe). But it was a futile trip because the air conditioning "system" turned out to be merely self-contained units acquired outside Litton. We were to discover in the coming months that in being restricted to "DSD," where the military involvement of Litton was concentrated and where there prevailed a misconception about the nature of an A & T collaboration, our efforts to find an artist to work at this giant firm with its diverse potential would be repeatedly frustrated.

In the hope that Morris would be stimulated by other types of technological resources, and perhaps revise his proposal, Gail Scott took him to Ampex Corporation in Redwood City. They met with Dr. Charles Spitzer, and since it was the first visit by anyone from our Museum staff, they had a thorough briefing and tour. Although Morris found the tour interesting, he persisted in his desire to carry out the original thermal project.

After an abortive effort to interest Philco-Ford in Morris' proposal, we toured Lear Siegler, Inc., an aircraft corporation recently contracted to A & T as a Patron Sponsor. Two particular divisions seemed capable of implementing Morris' project: the Holly Division, a fabrication plant for home and trailer air conditioners; and the Hokanson Division, producing technically exacting systems for aircraft missiles. Both divisions were interested in the artist's scheme, and both claimed to be able to handle "any requirement." That promise was becoming familiar, but we were anxious to have Morris see both facilities first hand. We mailed him brochures,

and he responded directly with a letter on March 3:

Hokanson's heaters and coolers look sweet. Can hardly wait to get my hands on one of those 'Male, female cap duct coupling—MS 33562' or some skid mounted water chillers Then there's the whole world of 'Strongback mounted electric driven (Rail Mobility Concept) air conditioner that operates normally when strongback is in horizontal or vertical position or during transition for missile erection.' Each one sounds better than the next. I just had to close the book when I got to a device that supplies 'automatic head pressure control.' Zowie bang snort lemme at em.

Pretty big, hulking devices all of these toys. Want to ask only one thing: when the show that eventuates from all the collaboration takes place does it have to be inside? Because I want to do it outside. Want to bury all this technology right in the ground and have nothing there but a little more weather than was there in the first place—what miniature golf did for the game this piece might do for the National Parks.

Due to other commitments, Morris couldn't begin work until July 1, but we felt assured that the Lear Siegler collaboration would develop fruitfully. We therefore reserved that company for several months until Morris arrived. In June he sent a more detailed description of the thermal project:

Site: Want to make the installation outside in uninhabited land, any type of landscape, about one square mile to work within.

Preliminary Studies: Want to make and record some ecological processes in the site area—changes of temperature, rainfall, animal food chains, etc. Want to start this before installation of machinery.

Technology: Installation of several air conditioners and heaters underground. Outputs above ground, interface between technology and nature disguised with fiberglass rocks, etc . . . frigid rocks, hot wind coming out of a tree perhaps . . . etc.

Additional Records: Would like to make two films shot from helicopter traversing entire area at constant height. One film in color, one in infra-red (after machine installation). Have ideas for a particular way of presenting these films in the museum . . . a continuous showing. I'm at present working on a similar film for Kepes for Brazil.

On July 3 GS took Morris to the two LSI divisions, guided by George Moak from the general administrative offices. An account of that tour was recorded in the following memo:

GS went with Bob Morris for initial tour of two divisions of Lear-Siegler. First saw the Holly Division which manufactures residential heaters and air conditioners, but the capacity of these is not really sufficient for Bob's needs. Then went to the Hokanson Division (Santa Ana) where they manufacture large air conditioners for industrial purposes. These will be much more suitable for Bob's project, and he is confident that they will have all the equipment he'll need. We met with R.W. Rowlin (manager of Industrial Relations at this plant) who will be one of the main contacts and will introduce Bob to engineers. Bob will study their catalogs in the next two days, then contact Rowlin to begin work. George Moak made it clear that it was the division's responsibility to see through the project as far as they can. If we need approval for funds we should first contact Moak who seems fairly open towards Bob and the project in general.

For consideration:
(1) Bob wants a plot of land on which to do the project. He doesn't want to use the Museum's park; wants it to be near some foothills, on land which is not being used. He needs about ½ square mile.

(2) He will need to rent a helicopter and camera equipment to make the infrared and color films of the site.

Morris rented a house in Balboa, not far from the Hokanson Division where he went several times, trying to discover some engineer or scientist who might be doing research in environmental controls or the conductivity of metals and other structural materials, or at least someone interested, at a theoretical level, in his concept. But unfortunately, research at Hokanson was geared primarily toward quality control of specific products; as at Litton, there was no general R & D department. After three weeks, Morris finally found someone, William S. McKinney, Director of Engineers, who expressed interest in the proposal.

Meanwhile, we had made inquiries and finally located a piece of land on which to install the work—one square mile of a cattle ranch in Irvine, near Balboa, owned by Mr. and Mrs. Richard O'Neill, who are art collectors.

Morris had to leave for Europe in July and couldn't return until December to devote a long period of time to the project. He promised, however, to send William McKinney drawings, plans and diagrams of the necessary equipment, as well as a map of the site on the O'Neill ranch.

Morris wrote us on September 16,
The next step that has to be taken on the part of technology is the following:
How to get five or six heat sources, as varied as pos-

sible, into a natural environment and make them function and also conceal them.

How to get five or six cooling sources, as varied as possible, into a natural environment and make them function and also conceal them.

How to power these dozen devices, how to reduce the noise to almost zero, how to switch them off and on.

These are essentially the problems I presented to the several engineers I met out there. I realized that some authority had to come from the top for them to actually put in some time and solve the above problems. That is where we still are with the project—i.e., the same question exists: Will LSI provide the equipment, will the engineers solve the problem?

We called McKinney to forward Morris' message but were told that he was "unavailable"; successive attempts found him out of town or similarly unreachable. Mystified by this response we contacted George Moak in the head office. Several days later he called back to say that LSI wished to be dropped from Patron Sponsor participation, adding that McKinney had been assigned to some high priority engineering project and would not be able to assist the artist. He frankly admitted that there was no one else with sufficient "imagination" to carry on the collaboration. Obviously the project was verging on collapse, so we asked Moak to come to the Museum. At this meeting, it became apparent that LSI's main concern was the estimated costs for the project—including rental of a helicoptor, cameras, film, installation of the equipment, etc. Further negotiations proved futile, and the collaboration ended precipitously.

In May of 1970, after Dan Flavin had ceased to work at General Electric, the company pressed us to find another artist; they were eager for concrete results from their participation in A & T. We contacted Morris to see if he was still interested in doing something in the program. He replied by suggesting that he and Craig Kauffman might tour G.E.'s Nela Park Laboratories in Ohio, and possibly collaborate on a project, but by October, 1970, when they were free to visit the company, G.E. maintained that they were no longer able to commit to an extensive collaboration.

Gail R. Scott

In March, 1968, after hearing about A & T from Ed Kienholz, Bruce Nauman wrote to us describing his interest in holograms:

> I have made photographs and film loops of myself making faces and will do a set of 3-D pictures using the plastic lens material which I imagine you have seen as soon as Leo Castelli has enough money for an edition.

> I would like also to do a similar set of holograms. I talked with TRW in Los Angeles and while they make a lot of the equipment and do a lot of the experimenting, they won't do outside work. They gave me Conductron in Michigan and they (Conductron) are supposed to make and reproduce holograms that can be viewed in white light so there is apparently not much display problem.

Basically what Nauman wanted to do at this point and when we later talked to him was to make holograms not only of his face, but also a set large enough to depict his entire body. He was able to accomplish both these goals without assistance from the Art and Technology program.

Claes Oldenburg
Born Stockholm, 1929
Resident New York City

Walt Disney Productions is a corporation whose participation we hoped from the outset of A & T to enlist, because of their enormous production capacity and their sophisticated research into problems of visual illusion. No more strenuous attempt to contract any company was made than our effort with Disney, or its partner firm, WED Enterprises. In January, 1968, Missy Chandler made the first of numerous calls to Roy O. Disney, Sr. in an attempt to arrange a meeting with MT and him. Eight months after that initial call, a meeting was finally arranged in Glendale between MT, Missy Chandler, Irena Shapira, and WED's Neal E. McClure, Secretary (Legal Counsellor) and Richard F. Irvine, Executive Vice-President. McClure and Irvine were not terribly interested in A & T, but neither were they eager to offend Mrs. Chandler, and they promised to consider the idea in further meetings with their Head of Design and Mr. Disney. On October 2, McClure wrote,

My Dear Mrs. Chandler:
After checking further both here at WED and at the Studio, we must advise you that we are not in a position to participate in your imaginative 'Art and Technology' plan.

As discussed with you last Thursday, there are several reasons persuading against our participation, the two most cogent being our extreme work pressure to complete Walt Disney World in Florida, and the highly confidential nature of much of the work performed here at WED.

Despite this letter, MT urged Missy to continue arguing our case, and she succeeded in arranging a second meeting at Disney on October 31 with the company's Head of Design, John Hench and Executive Vice-President, E. Cardon Walker. MT was in New York on A & T business at the time of this meeting, and received a phone call from the Museum, informing him that WED had committed to the program as a Patron Sponsor. Disney's legal counsellor Neal McClure later requested and obtained an interesting alteration in the contract—one of tenor, rather than substantive legal import—by "reserving the right to the Company to *disapprove* any artist or project."

MT immdiately called Claes Oldenburg and went to see him. Oldenburg had been approached by us some time previously, but had not responded favorably to our invitation, primarily because there was no contracted corporation relevant to his needs at the time, but also because of doubts he had about working with company people, engineers and administrators. He was skeptical about the advantages industry could provide in executing his work, and about the necessity for his being at a company in person: "As far as I'm concerned," he said to the *New York Times,* "the Yellow Pages provide enough technology for me." From our point of view, however, to have an artist of Oldenburg's importance and prestige working under the project was critical at this early moment in the development of A & T. Such a collaboration as that between Oldenburg and Disney would, we knew, lend concreteness to the public conception of the program, which was at that time rather vague. It would also, we felt, prompt participation by other corporations and strengthen the preliminary interest we were encountering in discussions with other artists. (We made an effort to involve Dubuffet at around this time for similar reasons.) We persuaded Oldenburg to come to Los Angeles and tour Disney's facilities. He came on November 17, 1968, and was shown various workshops and research areas in Glendale and several rides at Disneyland by John Hench.

Hench and Oldenburg were at first wary of each other, and MT was put in the position of attempting to explain one to the other and somehow alleviate the sense of mutual suspicion. By the time Oldenburg left, he was convinced that Disney *could* be of enormous benefit to him,* and even displayed a degree of excitement about certain plans he was already envisioning. He said he would draft a schedule for visits to Disney throughout the coming year. Oldenburg remained cautious, however, as he indicated in a letter to MT on December 14, 1968: "John Hench's quote in the Glueck article** certainly makes me pause. I wonder to what extent he will assume the position of spokesman for what might be done. The trouble with WED is that they are ideologically involved as well as technologically, as we know."† Nevertheless, he then sent John Hench and us a proposed schedule:

Set up housing Describe project	March 2–16	2 weeks
Main work on project	May	4½ weeks
Additional work on project	June 29–July 12	2 weeks (if necessary)
Additional work on project	Nov. or Dec. (or Feb. '70	3 weeks (if necessary)

Disney was still worried. Neal McClure called Betty Asher on January 30, and she reported this conversation in a memo to MT:

A Mr. McClure called from WED Enterprises. They would like to see a proposal of just what Claes intends doing at Disney. Also, they have not had the opportunity of approving the artist or the project as per the contract. They would like that opportunity.

He would like to have you call Mr. Hench. They are afraid they might get a Kienholz-type product and, after all they are a family directed-operation.

I assured him that "set up housing' just meant that Claes was planning on taking some time to find his own digs convenient to their facility. He was afraid that he expected them to provide housing there.

*Much later, Oldenburg told Max Kozloff that he was fascinated with the idea of working at Disney because he "wanted to know what people who have been *making animals without genitalia for thirty years* are like."

**Grace Glueck, "Los Angeles Museum Plays Matchmaker," *New York Times,* April 17, 1969.

†In another letter written by Oldenburg at this time, but not mailed, he said, "The name of my piece for Disney, Maurice, will be *Leaves of Grass.* Disneyland must have its Whitman section full of homosexual streetcar conductors."

On February 21 Claes wrote John Hench:

I will be detained on projects in NYC until about the first of May—I hope to spend the whole month of May on the coast. At that time I hope to have obtained residence facilities in the Balboa area, in order to commute to the Disneyland workshops. My preference is to have a basic studio at Disneyland and from there visit, whenever necessary, the Glendale workshop. At Disneyland, I'll need an office space to draw in and to make some small models and to write on my typewriter—a place that is relatively private and quiet. It doesn't have to be large.

After getting settled I would expect to continue exploring the facilities for a few more days and then to retire if that's the word to formulate a project on the basis of and arising out of what I've seen. I want to stress this approach—that I won't be arriving with a project ready to go under my arm. I will bring a notebook of possibilities and some preconceptions . . . but I can't say in advance what area of the many offered by WED workshops will be drawn upon.

If you bear with me, by the end of May, something definite should be in the works. If it is, I'll be returning in the summer and late fall to complete it, and in the meantime maybe can direct it from NYC. Maybe it will go by itself the times I'm not there.

On May 1, Oldenburg settled into a motel near the Disney plant in Glendale. He worked daily throughout the month. This was a productive time, and visitors to his workroom at WED found a fertile body of proposals and models being developed by Oldenburg. [1] One writer was impressed by these plans sufficiently to plan a book on "Oldenburg in Disneyland." As Claes prepared to leave at the end of May he drew up two general projects for consideration by WED, which included many separate sections and models he had been preparing. He referred to one project as a *Theatre of Objects* or *Oldenburg's Ride.* The other was the *Giant Icebag.* He explained,

The practical way to approach working with any corporation or any material or technique supplier is to see where their services fit in with your needs. And first of all I had to ask myself what is it in my work that requires technological assistance on the scale that this program will give me. Most of the time I don't use technology very much. There was a class of objects that had been contemplated and suggested in '65, and these were all of a kinetic sort—they moved or they broke or they reconstituted themselves, or they peeled themselves—they went through simple motions. And so knowing that I was going to get into a technological program, I went through all my notes and I selected those things which seemed to fit the program, and those are the notes that I brought out with me, such as the one with the jello mold [2],

2

1

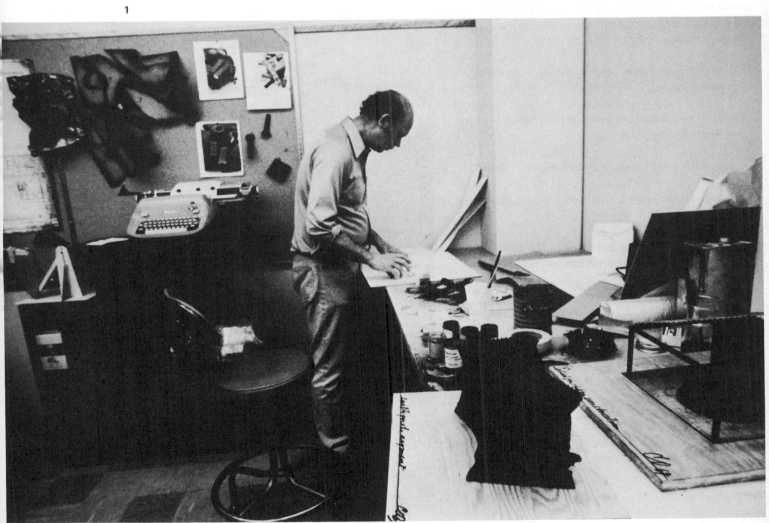

which dates from 1965. All of those ideas with breaking things and changing things are all of my notebooks from 1965. When I arrived at Disney, I looked around for the service that would fit me, and they were then engaged in preparing the haunted house which opened later. But in the haunted house they had all these effects where things were metamorphosing and they were using mirrors and stuff, so I went to the library and I got books on simple magic and also books on simple mechanics. I tried to fit my thoughts about what I needed in technology into what services they provided at that moment.

Oldenburg's Ride was to be a large series of magical, mechanical sculptures, enclosed in an amphitheatre of the artist's design. [3, on the right] By May 23, when MT made his last visit to Oldenburg's workroom at Disney, Claes was considering designs of the following component sculptures for the theatre:

a giant toothpaste tube [3, center], which rises and falls, and is raised by the paste

a colossal rising and falling screw which releases oil at its top

a large object, as a car or piano, made in soft material, mounted on a machine that would twist, compress and change its shape (the machine was suggested by Disney's materials-testing device)

a large undulating green jello mold [2], with fruits suspended inside

a bowl of cornflakes and banana slices falling from an inverted disk [4]

a cup which would break and then reconstitute itself

a plate, on which eggs are cracked, thrown, scrambled and then reconstituted

a pie case, in which pies would gradually disappear as if they were being eaten, and then be reassembled

a 'chocolate earthquake' made of giant chocolate bars, which would shift precariously, crack open, and settle back (suggested by a magazine advertisement and the then current earthquake scare in California) [1, 5, 6—a small sculpture made of broken Hershey

4

ice bag indoor size

#2 SMILLING BOWL OF CORNFLAKES, BAN-
ANA SLICES

BALLOON SCULPTURE, OSAKA

C. 69

5

ice bag in indoor site

BALLOON SCULPTURE, OSAKA

#3 CRUMBLING CHOCOLATE BAR
WITH ALMONDS

C. 69

6

bars and sealed with resin, 7—an "earthquake segment" of cardboard and fabric]

Several metamorphic pieces, in which metamorphosis would actually occur, including a banana transformed into a fan [Claes labeled it a "fanana": in this connection Oldenburg recalls Jim Dine's painting, *The Plant Becomes a Fan,* of 1961-63].

Common to all these proposals were phenomena of disintegration, transmogrification, and reconstitution. Oldenburg speaks eloquently of these projected works as having to do with "the tragedy of brokenness" and the denial of that tragedy—"As in a dream," he said, "where your teeth fall out, but on awakening you find out they didn't." These works relate strongly to both dream

states and to various superstitions ("If you encounter a situation in real life which has occurred to you before, you *do* it"). They also call to mind the curious sense of denial, or temporal negation, suggested by film footage when it is run backward. Oldenburg's illusionist proposals comment serio-comically on American inclinations toward escapism and unfounded optimism—the "happy-ending" syndrome.

These sculpture designs were to be developed, from their state as sketches and collages, into working models by Disney craftsmen and model builders. Oldenburg was encouraged by the company to make as many proposals as he liked, and he was assured that all his plans for illusionist works in the *Theatre of Objects* were well within the capabilities of Disney's technology.

7

earthquake segment

Oldenburg's other proposed work, the *Giant Icebag,* had been developed to the point where an engineered model could be constructed. [8, 9, 10] He was eager to concentrate on a single work that could be available for Expo 70. Claes drew up the following descriptions for Disney model makers before he left, expecting to return in August:

ICEBAG—skin

The 'bag' is made up of pleat sections, attached at the bottoms to a circular frame in some way that permits easy removal. It will probably be necessary to reinforce the sections or attach some sort of frame to the collar. Each pleat may be cast separately and joined to the other by very large and concealed zippers for easy transport. In the process of assembly, the pleats would be laid out around the frame and machinery supporting the 'cap' like a giant flower, to be brought up and together one by one.

The material may be represented by sewn vinyl in the working model. A pink vinyl which I have purchased is stored at Gemini and can be obtained through Tuchman or the Museum.

9

10

In the full-size piece, this material should be fairly thick, so that the pleats maintain their shape and the movement of the material communicates resistance to the turning motion, but it should be capable of developing folds. The folds may be predetermined.

The material should take color, be opaque, be glossy. Most desirable would be if the material contained the color. The color is roughly the salmon-pink indicated on the models.

The material should be as durable as possible, since this is an outdoor piece, but the part construction allows for replacements.

ICEBAG—top of 'cap'
The top of the 'cap' is a reflecting disk eight to nine feet in diameter. A night version is conceivable—the surface which reflects the sun and sky by day could be made to show illumination from the interior at night—could it? The sculpture could thus have a day and night phase. A weak illumination, moon-like.

ICEBAG—Mechanical [11]
This cross-section of the *Icebag* attempts to indicate
the type of movement desired.

The 'cap' 1) turns 2) telescopes or spirals up and
down 3) tilts. The movement may be compared to
that of a searchlight at a Hollywood opening.

As the 'cap' moves, it should stretch or create folds in
the 'bag' which is to be made of flexible material. It
will be necessary to separate the 'bag' collar from the
'cap' to permit rotation continuously in one direc-
tion, but if this is unfeasible, the movement could be
a 'winding' and 'unwinding.'

The movement should be very slow. A model should
provide the means for testing different rates of
motion.

It would be desirable for the progress of the project
to have a working model of this machine prepared in
my absence (I will return in early August). The model
should be about eighteen inches high at furthest
extension—or whatever scale serves the purpose.

When Oldenburg left Disney, he left behind him scores
of drawings and diagrams, and several models along with
instructions, in his workroom. He departed feeling
pleased with the prospects for his future collaboration,
as did we, and as we understood did Disney. Two weeks
later John Hench called MT and asked him and Museum
Director Kenneth Donahue to visit Disney and deliver an
"official" opinion of the work before the company
proceeded to construct models for Claes. After this visit
took place, MT wrote Hench on June 23,

Following our visit with you last Friday, I want to
tell you how extremely delighted we are with the
projects Claes Oldenburg has conceived to be carried
out with WED. I feel that both the *Icebag* and *Olden-
burg's Ride* (the *Theatre of Objects*) will most de-
cidedly be among the lastingly significant works to
come out of Art and Technology; certainly Olden-
burg himself assumes high priority in our estimation
of the program as a whole, and there is no doubt that
the ideas inspired by his contact with Disney are
potentially some of the most important work of his
career.

We shall definitely count on sending the *Giant Icebag*
to Expo 70 at Osaka, and I feel more and more
strongly that whatever components of the *Theatre of
Objects* can be completed in time, such as the *Choco-
late Earthquake* or the *Falling Egg,* should also be
included in the Osaka exhibition.

May I take this opportunity to congratulate and
thank you for your exceptional responsiveness to the

artist matched with your corporation. We anticipate
that this endeavor will be uniquely momentous and
gratifying for all concerned.

On July 2, the following letter from E. Cardon Walker
was delivered by messenger to the Museum:
Dear Mr. Donahue:
We have received your letter and Mr. Tuchman's
letter, both dated June 23, 1969, and directed to
John Hench, Vice-President, wherein you advise us
that you are selecting *The Icebag* and *Oldenburg's
Ride* as artistic projects for the *Art and Technology*
program.

While we understand your keen interest in the pro-
jects submitted by Mr. Oldenburg, we find there are
other substantial factors to be considered by us.
Therefore, pursuant to Paragraph 6 of the November
25, 1968, agreement between the Museum and the
Disney organization, we do hereby advise you of our
disapproval of these artistic projects.

Being aware of your expressed delight with the pro-
jects proposed by Mr. Oldenburg, we are willing,
upon our being relieved of any further responsibility
or obligation, to make available all right, title, and
interest in the preliminary works developed by Mr.
Oldenburg in order that they may be completed by
others.

We wish to extend our best wishes for your success in
this venture and to thank you for the opportunity of
working with you and with such a renowned artist as
Mr. Oldenburg.

MT immediately attempted to meet with Messrs. Walker
and Hench, who were not eager to do so, but who finally
agreed to see him. MT reviewed this meeting in a letter
to Walker on July 7:
I am replying to your letter of July 1 to Mr. Dona-
hue. The Director has been out of the country and
will not return until later this month. I want to thank
you and Mr. Hench for meeting with me on July 3 to
discuss the relationship between WED and the Mu-
seum in regard to Mr. Oldenburg's project proposals.

Let me review our discussion of July 3. In your July
1 letter, you refer to your 'disapproval of Oldenburg's
artistic projects' and state that 'there are other sub-
stantial factors to be considered' which lead you to
desire to abandon the collaboration with Mr. Olden-
burg and the Museum. You told me that these factors
primarily involved time, energy and money; that the
cost to WED to build Oldenburg's *Icebag* would be
about $125,000.00, that this was too high a sum to
expend, and that WED's personnel could not under-
take such an involvement this year. Since Mr. Oldenburg

11

(I) — up and down

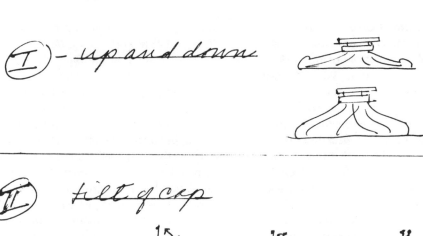

(II) tilt of cap

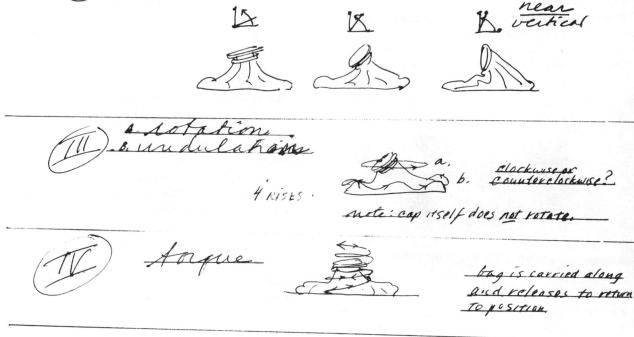

near vertical

(III) a. rotation
 b. undulation

4 RISES.

a.
b. clockwise or
 counterclockwise?

note: cap itself does not rotate.

(IV) torque

bag is carried along
and releases to return
to position.

(V) "creep", "breathing"

at edges is a
result of
mechanical
movement

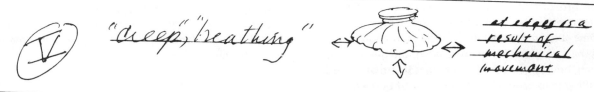

(VI) distortions in cap "mirror"

slight "fun house" effect.
wave contour line of cap.

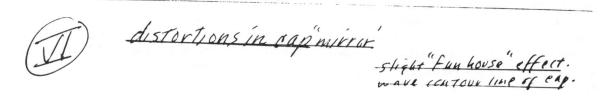

movements ice bag

rate of movement: $\frac{1}{2}$ or $\frac{3}{4}$ or 1 r.p.m. no faster
 rheostat control.

was also proposing a *Theatre of Objects* (also called *Oldenburg's Ride*), which is composed of eight or nine separate parts, all of which are uniquely dependent upon, and were prompted by, WED's imaginative engineering, I asked you to consider discussing with the artist how this project might be accomplished. You agreed to have John Hench discuss this possibility with Mr. Oldenburg next week in New York, when Mr. Hench would be there. I just contacted Mr. Oldenburg, informed him of these sudden developments, and asked him to meet with Mr. Hench along with one of my staff members (since I am leaving for Japan July 7). The artist indicated his willingness to consider the making of several separate works from the *Theatre of Objects* proposal, but he was just then leaving for London for ten days and therefore could not meet with Mr. Hench next week. He indi-

12

cated also that while he is open to and indeed interested in working on several separate components of the *Theatre,* or even a modest size model of the *Theatre,* that it would be unwise to hold discussions without some guideline set down by WED as to feasible costs. If the *Icebag* would cost too much, the question is, then, how large a sum (including staff time) is WED willing to expend. Until this matter of budget is determined by you, it would not be possible to proceed with Mr. Oldenburg. The artist was scheduled to make his third journey to WED on August 1 for two weeks, and if you can provide this financial guideline, he could come out and continue research on the project at that time.

Since you had not been intimately involved with this project over the last few months, I attempted at our July 3 meeting to fill you in more extensively on the WED-Oldenburg relationship, and on other matters pertaining to the entire Art and Technology program. I indicated that the progress between Oldenburg and WED had been extraordinary; and that 'Oldenburg in Disneyland' was already a world-famous enterprise, and had prompted excitement on the part of every leading periodical and newspaper informed of the event. Countless stories have been and are now in the

works at publications like *Fortune, Business Week, Time,* and *New York Times, the Los Angeles Times* and European television. Recently, the Museum has been invited by the United States Information Agency to prepare the New Arts exhibition for the United States Pavilion at Expo 70, Osaka, Japan. This will be officially announced by President Nixon next month, but a formal contract between the Museum and the USIA has been signed. The Museum has informed the USIA, in a report of June 1, that among our highest hopes for projects to be included in the Worlds Fair were works of art expected from the Oldenburg/WED collaboration. This would mean that WED and four or five other American corporations would be the sole representatives of the United States to a world audience of an estimated forty million persons. In this context, as I submitted to you two days ago, it seemed to me imperative that every attempt be made to arrive at a satisfying and productive relationship among you, the Museum and this most important and talented artist. With the world's eyes upon us, and with every reason to believe that the benefits to WED—if for no other reason than the truly vast promotional exposure—are so compelling and important, the Museum again asks you to continue working with us to a productive conclusion.

E. Cardon Walker replied on July 16,
Our position in regard to other projects from Claes Oldenburg, as you requested in your July 7, 1969, letter, is that we cannot properly set a limit on staff time for these projects. In fact, the original concept of the agreement was that we would pay the Museum $7,000 and commit to supply materials, working space, and technical assistance for three months or until the completion of the project, whichever period was shorter.

Mr. Oldenburg first visited us on November 18, 1968, and by letter of January 23, 1969, request was made for working space in March of 1969. As you know, we have honored our obligation of $7,000, and the three-month period is now long past. Since Mr. Oldenburg was scheduled to return to WED on August 1, we would, of course, consider a proposal developed by him during such a two-week period, but, as indicated above, his proposal would have to reflect the major labor on the project as being performed by himself, leaving our technical staff relatively free. Any costs involved should not be disproportionate to the original $7,000 contribution to the Museum.

We are sorry a mutually agreeable project was not developed, but we must now turn our corporate efforts toward fulfillment of our primary obligations.

None of the points mentioned in this letter conform to
the contract signed by Disney and the Museum; see the
Patron Sponsor Contract, p. 31.

Informed of these developments, Claes Oldenburg was
dismayed, but set about constructively to realize his
plans, or one of them, in other ways. He suggested fabri-
cation of the *Icebag* as an enormous balloon. After study
on our part, with technical advice from balloon and
rubber companies (for a time it looked as if Goodyear
Rubber would take over the project), this was deter-
mined to be unfeasible. In the process of researching
balloon companies for the *Icebag*, we had come upon a
small firm that seemed promising for Claes's other plans
for illusionist sculptures. To the end of investigating this
possibility, Oldenburg returned to Los Angeles on
August 1 and toured, with MT and Gail Scott, a firm

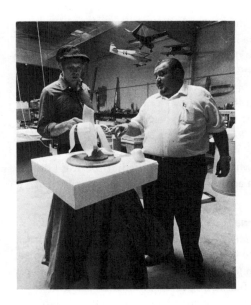

13

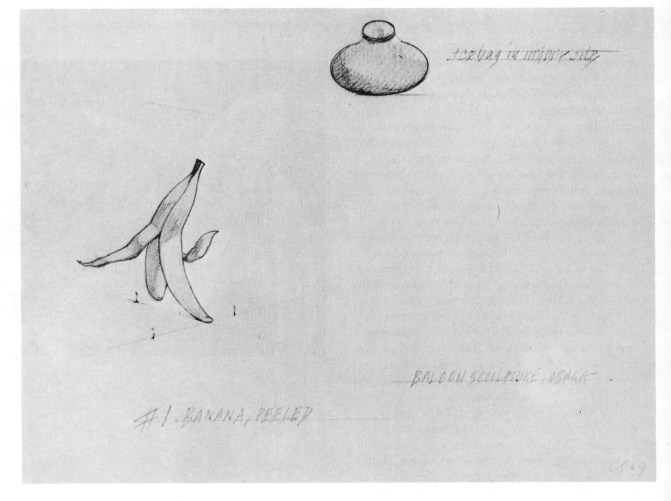

then called Vee-Line, later Allied Research and Develop-
ment Corporation, in Fountain Valley. Vee-Line made
large inflatable structures for scientific and military
purposes but mainly for advertising, with items then
called "Replic-Air Displays." Claes was amused by a
forty-foot potato chip bag balloon that had been made
for Laura Scudder. Oldenburg worked at the company
for four days with David Tanner, the chief designer-

engineer-administrator. He gave Tanner a small model of
the *Chocolate Earthquake* [6], to be made into a three-
foot working model. The model was delivered three
weeks later [12] and did not perform to the artist's sat-
isfaction. Oldenburg then turned to working on an
inflatable banana [13], related to the *Fanana* plan devel-
oped at Disney. This sculpture was to be about twelve
feet high, mechanized so that four banana peels (held

together by a magnetic winch at the base) would unpeel while the banana would slowly disappear (being deflated sectionally) as if it were being eaten. [14] Various models were made by Claes [15] and then by Tanner, the shape, color and texture were approved, and we commissioned the company to produce a half-size model in order to test the working parts and the fabric, and to determine the kinetic rhythms of the work. This time, delivery of the model was delayed over a period of months, and when it finally appeared, it too was unsatisfactory to the artist. The project was abandoned.

At this point we turned Oldenburg's designs and models for the *Giant Icebag* over to Ken Tyler at Gemini G.E.L., asking Tyler to investigate production possibilities. In an interview with MT in October, 1970, Tyler recounted his adventures in fabricating this monumental sculpture:

> The things we were concerned with in the beginning were an elephant-like quality in the fabric, the breathing quality and the swiveling movement. We also were originally talking about a thirty-foot diameter bag. And that meant that there was no place I could find —I made a lot of phone calls across the country in those days for you—there was no place I knew that could spread out a circle of fabric thirty feet in diameter and sew it. There's no seamstress outfit that large. We had all these things, and the cap was to be constructed in fiberglass, or wood, or steel. Those were no *real* problems, we knew we could solve them. But we couldn't schedule in such a short period of time because we couldn't locate houses that were capable of manufacturing these large scale items. When it came down to it, we settled for animation houses. So, we went to the same people as Disney would go to, which happened to be Krofft Enterprises, in the final analysis. We started out with General Displays. They built the first two prototypes—a six footer and an eight footer. The eight footer is what we used in the movie, *Sort Of A Commercial For An Icebag.* At that time, meeting with Claes and going back and forth with my private engineers, people that I knew who have helped us on other projects, and with General Displays, we came up with the various movements that we felt could be done hydraulically or by air. We settled for hydraulics because it was a self-contained unit with lasting ability where air had some problems: movement would be too staccato-like and also air cylinders became too complex technically given the time we had to construct the bag

Then we found out by discussing this over and over again with Claes that the tilt of the cap was an important movement to him, which none of us had ever considered. We always thought that that was a fixed position, and as it rotated the cap created the impression of a wave, of an up and down movement. And then he always talked about the serpentine action of the bag related to a roller-coaster because remember he had been working on the Disney *Oldenburg's Ride,* so all of that was kind of in his head, and it was very difficult to get it out of his head and put it down on a piece of paper and say would you settle for this, would this be a sufficient movement for this piece. And that is all we were involved with in the first four weeks. We were trying to find from Claes one movement at a time. What was our latitude in that movement? Would he settle for six inches or a foot? Did we always have to maintain a thirty foot diameter? Could we shrink it if we had to? How much could we shrink it? We talked about twenty-eight feet. We talked about twenty-two feet. We kept bringing him down in increments then finally got around to the eighteen foot one. Now how did we get around to that? By just spreading it out on the floor and suddenly he saw that an eighteen foot diameter was pretty large and this defined the scale for him

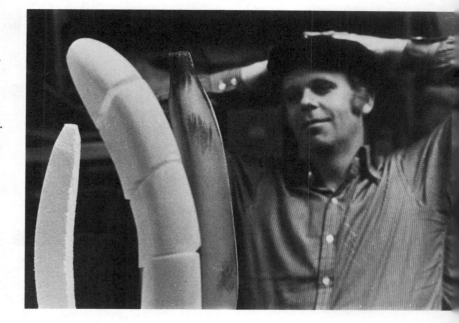

14

15

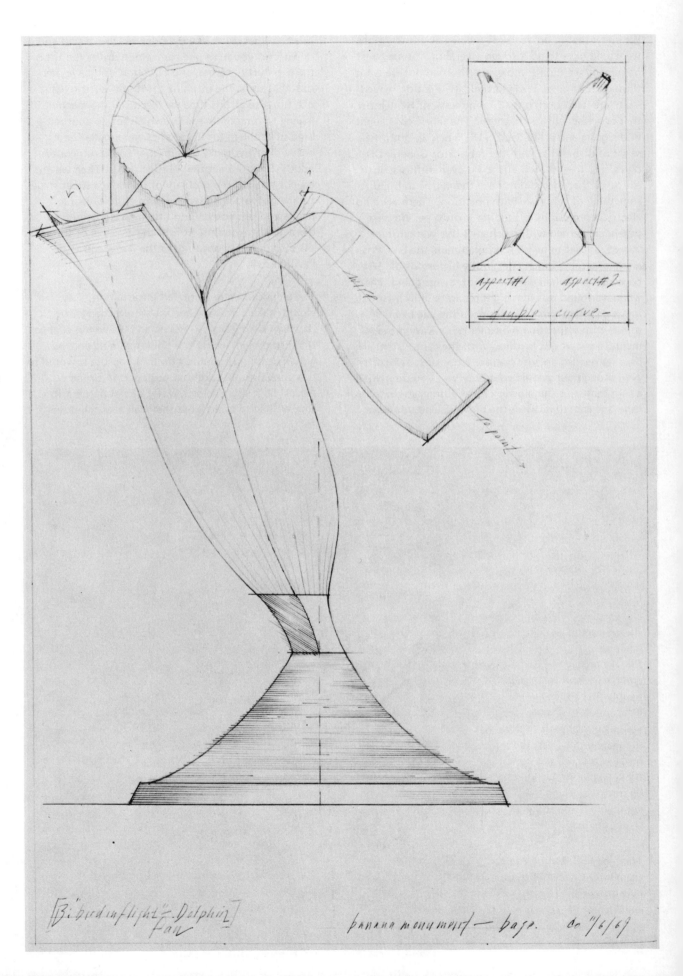

["bird in flight" Delphin]
Fan

banana monument — base. Oc 11/6/69

We knew that in order to get the bag absolutely right we would have to go through several prototype bags: how many we didn't know. As it turned out we went through four bags. Two got built, two got destroyed —one ate itself during the filming session. Remember that one when you were there? The fabric got caught in the gears and it ate itself. [16] Then we got into a series of difficulties with the fabricator General Displays, and they turned out to be over-enthusiastic in the sense that they didn't have the means to build something of this scale with precision. There were no electrical provisions in the first prototype. We were purely concerned with mechanics. We were not involved, at that time, with programming the bag. Programming came much later in the history of the bag's construction, when we got eight blowers going. That's when we found out that eight separate blowers inflating at different times would move the bag like a snake, with serpentine movements, or wave movements. Now we got involved with the cam system and here we needed an automation house such as Krofft, even though our people could say yes, you do it with a cam that trips the blower one at a time, so that you have one cam that drives the blowers, and you have

one cam that drives the cylinder which goes up and down, and you have one cam which drives the tilt of the cap thirty degrees, and of course you have one cam that shuts the machine off if you want to shut it off. But also at this time we discussed the machine having to run continuously, which set up another kind of problem for us. Studies were made for a heavy duty hydraulic system that could run continuously. This put another burden on us. Then we got caught up with the problem of building a super-structure with the bag light enough to go to Osaka in pieces because you couldn't have an eighteen foot-diameter—it wouldn't fit into the airplane or through the existing door openings in the American Pavilion

The engineers were being fed information, they would make a drawing and we would change the drawing, we'd get a cap design and we would change that cap design, we'd get a hook-up going and we would decide we couldn't do that because it would be too unrealistic to take that bag apart in so many pieces. So it was decided, really out of desperation, that we had to build what they call a knock-down

16

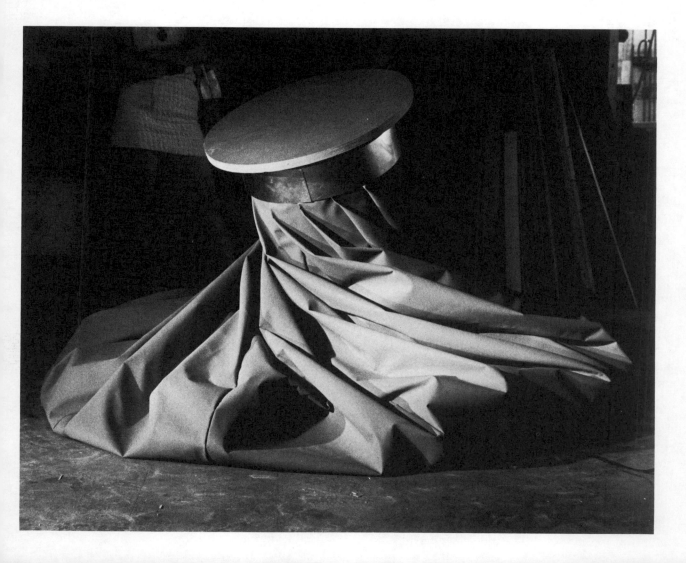

unit—a unit that anyone could put together anywhere in the world with a manual. We proceeded to make, like a refrigerator or a stove is made, a part and a bunch of other parts to go together with the guidelines of a manual. Everything locks together with bolts and nuts, and there is no one rigid kind of construction. And I think this is when the real form of the bag was established, eighteen feet in diameter, rising to a height of about twelve to sixteen feet, with an established path of travel. By this time adequate testing on vinyls and other fabrics had been made, and Claes, collaborating with Sidney Felsen, made his decision on the pink shade and the type of polyvinyl that we were to use. During this time, Sid spent many days attempting to secure sufficient material to construct the bag without having to order a special mill run which was too costly. We then got to the weight of the fabric; then dressed the weight up with foam inside so the bag would again return to the elephant-like movement

Then we couldn't find a stock cylinder to use because Vickers, which manufactures the type of hydraulic cylinders we were looking for, had to ship all they made to Viet Nam, for use in helicopters. We wasted a lot of time on this problem. Stanley Grinstein got on the phone calling all around the country trying to buy cylinders that we could adapt to drive the bag up and down and couldn't find one. Finally Krofft found Conquip, in Upland, California, and Conquip said, I understand your plight, and they had a fairly good idea of what we wanted, and by that time we had some pretty good models constructed at Krofft. So they came in and said, We think we can make you cylinders within six to nine weeks, which wasn't good enough. We had to have cylinders before that. By this time we were still working with your deadline of September which we couldn't make, and then you gave us I think another thirty days which made it October or November; I am not sure of those dates. Finally we got to December and shipped in January. So as it turns out, if there wasn't this company in the valley that was manufacturing pistons of the size we were looking for, we wouldn't have completed and shipped the bag

With most projects, the aerospace or military requirements screw up somebody's delivery. The one manu-

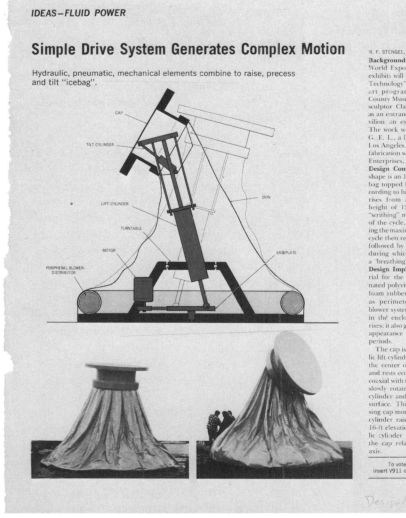

IDEAS—FLUID POWER

Simple Drive System Generates Complex Motion

Hydraulic, pneumatic, mechanical elements combine to raise, precess and tilt "icebag".

R. F. STENGEL, WEST COAST EDITOR

Background: At the 1970 Osaka World Expo, one of the U.S. group exhibits will be works from "Art and Technology", an ongoing modern art program of the Los Angeles County Museum of Art. Participating sculptor Claes Oldenburg designed as an entrance piece for the U.S. pavilion an eyecatching giant icebag. The work was sponsored by Gemini G. E. L., a lithography workshop in Los Angeles. Engineering design and fabrication were performed by Krofft Enterprises, Inc., Van Nuys, Calif.

Design Concept: Oldenburg's basic shape is an 18-ft dia salmon pink icebag topped by a silver gray cap. According to his concept, the cap slowly rises from a 7-ft rest height to a height of 12-ft while performing a "writhing" motion. Near the top end of the cycle, the cap also tilts, bringing the maximum height to 16-ft. The cycle then reverses downward, and is followed by a 12-minute rest period during which the vinyl bag exhibits a "breathing" motion.

Design Implementation: The material for the icebag is nylon-impregnated polyvinyl, backed by a layer of foam rubber. A plenum ring serves as perimeter ground anchor. A blower system maintains air pressure in the enclosed volume as the cap rises; it also generates the "breathing" appearance of the bag during rest periods.

The cap is supported on a hydraulic lift cylinder which passes through the center of a horizontal turntable and rests eccentrically on a baseplate coaxial with the turntable. As a motor slowly rotates the baseplate, the lift cylinder and cap move on a conical surface. This generates the precessing cap motion. Extension of the lift cylinder raises the cap from 7-ft to 16-ft elevation. An auxiliary hydraulic cylinder then independently tilts the cap relative to the lift cylinder axis.

To vote for this Design Idea, insert V911 on the Reader-Service card.

facturer we were dealing with to sew the bag was busy building tents and we couldn't get his time. Then we found Featherlike Products Company. This company was really the secret to the *Icebag* at the last minute. They said, 'Yes, we can sew it,' and with that we were able to pursue the course with the engineers, hydraulic people, design people, and Krofft So then the bag went ahead. We almost lost the project when it got to the point where they wanted three months to run and test the bag and we couldn't give it to them because the bag had to be shipped by boat on a certain date.

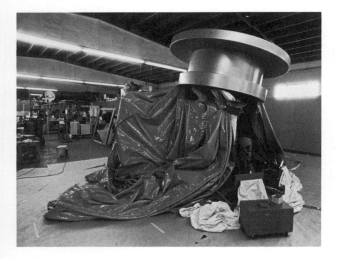

Featherlike was my buffer. I went back to Krofft and said look I have got somebody that can sew our bag and you won't have to take your costume people off the filming of *PufnStuf* to sew this fabric and they have a big room over there where they can sew a balloon thirty feet in diameter. But in fabric construction a pattern can be off by as much as fifty percent of the material, depending on how you pleat it, how you sew it, how you cut it and the whole bit. So Sid got this fabric—which took another solid week of phone calls all the way around the country calling every manufacturer of polyvinyl material. The seamstresses were almost going to kill themselves trying to sew this. They were very heroic in this effort. These women just couldn't handle that kind of weight so additional help was required. Just to drape several hundred pounds of material and sew it was quite an awesome job

When we got into the movement of the bag, once we resolved the sixteen foot height, we got the general perspective of the bag, up and down motion and so on. Then we were able to come up with some general concepts of moving the fabric up and down. One idea was a roller-coaster concept which would be a trough that ran around the outside of the bag shaped like a roller-coaster. It would have an undulated quality to it. There would be a big ball on an arm, and it would

roll around this roller-coaster and therefore move the fabric. This idea I came up with seemed very reasonable at the time, but it turned out to be so bizarre that even Jules Verne would have rejected it

In collaboration you have to be careful not to give the artist one hundred choices because then it is going to take him six months to decide which choice he is going to like best. So we were trying to keep Claes in the position of informing us rather than our informing him. [17] In other words, we would present something to Claes and then watch him closely and if he reacted very, very favorably, we would pursue it for another couple of days and then try it out. We just didn't know. No one had built anything of this size before, nor had anything been built with the durability aspects that we were trying for, because most outdoor displays don't last. Most Fairs are built only for a Fair's time. Things are not built to last five, ten, fifteen, twenty-five years so that was the obstacle course we were running. Also we were simultaneously trying to come up with a design and double-checking everyone's ideas. Will that motor last, how long; has it got hermetic seal bearings; can we install a larger motor so it will last longer; will we have enough power in the U.S. Pavilion in Osaka. We couldn't obtain enough power there, I learned, so we changed the voltage for the bag, reducing every motor down in amperage. It scared the daylights out of me because each time you would give me a phone call it would just throw everything in a state of chaos with the changes. None of us ever knew what was feasible in this collaboration

When my partners Sidney Felsen and Stanley Grinstein finally negotiated the contract with Krofft there were two things we asked for. One, we asked for total participation by all of Krofft's members. In other words, we wanted to have the ability to go from the sewing department to the animated department to the woodworking department to the electric department to executive offices if we had to. But we also asked if we could bring anybody we wanted into their shop at any time we wanted to inspect what they were doing, and if necessary even take part of their shop and have it analyzed because we were under a tremendous obligation with no time and virtually no money. They were able to see this because Hollywood operates under very strange circumstances. They are not like most manufacturing outfits. So I used the people who built my press to study the hydraulic system and tell me it was all right. I used Featherlike to tell me if the bag was sewn properly. We used our wood model makers to tell us if what they were putting on was wrong and therefore changed it. Krofft controlled most of the testing, and we had them build a machine to test the stretchabil-

17

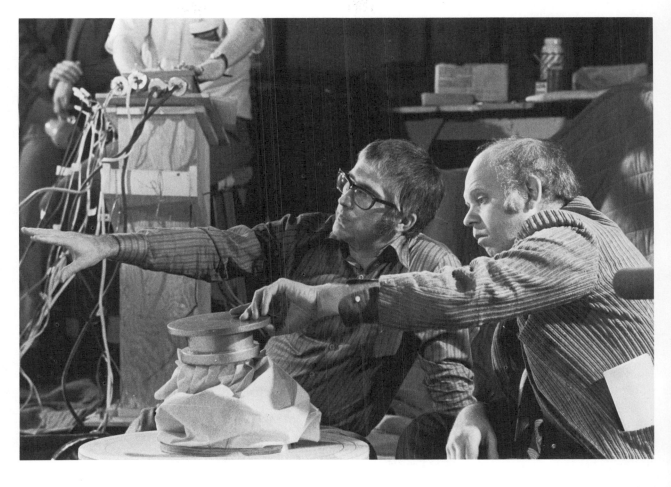

ity of a polyvinyl. Even though manufacturers gave us these test results we didn't believe them. Every step required some form of checking

We had to go to theatrical people, we couldn't go to aerospace people or to other engineering people who are used to six and seven months lead time, or engineers who are used to taking a problem home and making teeny models and looking at it for a week before they even dare make a step to produce something larger. We had to go to people like Sid and Marty Krofft, who had guts and who were able to say fantastic, we believe in you, go ahead and do the project. You don't make great movies without doing this or great puppets or great sculpture. They thought of the *Icebag* as another character in one of their movies. It was very funny to hear them talk about all the characters that they have built. They talk about these time schedules where a guy says on Friday afternoon, and the board meeting is a week away, 'I don't like the look of that dog. I surely don't want that on television next week with that stupid dog in it.' [18] That gives them seven days to change the dog, so no one goes home. They just keep working until the dog is changed. Well, we really came in with the same kind of concept. We don't like what we have as a schedule for you, we said. We don't like what we are presenting in drawings because they are not very

accurate. But you are professional people in a theatre and you are used to working all hours. So you have to write a contract with us which says I stay up twenty-four hours a day, you stay up twenty-four hours a day. Whether the artist is there or not, you work any schedule I want you to work until the bag is completed. So we exclusively would have X amount of

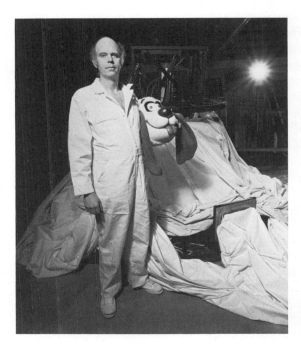

18

people from start to finish. That's it. It has to be on that schedule or we will never make it and therefore it is silly to sign a contract with you because you will only be late. If we are late, the Museum will be cheated out of their piece, and they have an agreement with the government, etc., etc. Krofft signed the contract. It was easy to drive that bargain with them because they were theatrical people. You can't do this with other kinds of businesses. They work under regular union shop hours. The union says you don't work unless you get double time, triple time. And you can't even work around the clock, it is against the law. But with these kind of people, who are all skilled artists, they work as long as they have to work to get something done. So they were really very much like artists. An artist doesn't stop painting when he wants to continue, he just keeps going until he falls down. Maurice, we had a very sick looking group at the end of the project. In fact, four of them didn't go to bed for three days. That's what it took to get the *Icebag* to the opening, and we didn't know if we had to stay up for three more days to change the cams and this was very shaky stuff. Now the only confidence that I gave you was the confidence I had in that agreement. This was the reason why I was able to be grandiose about it all and say don't worry Maurice, we'll get it to you, and that date is all right. And we would say to Claes don't worry Claes, by the time you come back out to L.A. it will be running or the blower will be working, or the fabric will be sewn. We just knocked ourselves out until it happened. Every day I would drive out to Krofft and we would get a schedule. We would spec it; we would go over certain things. I would drive back home and get to work in the shop. This thing kept up for about three months. It was living hell but the kind of hell you would go through when you do set designing or when you're working with a little theatre or a professional theatre. That's the sort of spirit that went through the creation of the *Icebag.* To me it is the piece, Maurice, it really is the piece that did it

I think that all of us got involved in this project, you, Gemini, Claes, basically because we were all very convinced that something like this should be done and the time was right. It was right for the artist, it was right for you, and it was right for us. We weren't prepared maybe in the best of ways, but we certainly didn't baby ourselves in the situation and we certainly didn't have a lot of buffers to protect us. I think because you had a limited budget and you had limited time and you passed that on to us and the artist together we were all able to work together in this triangle association. We were proceeding on the course that Billy Kluver and E.A.T. thought about for years but never were really able to pull off. So the missing link in Art and Technology has to be timing, and it is

something very few people are willing to talk about because they just don't think about it. I think if you would bring to us today the *Icebag* knowing what we know today, we would not commit to three months, we just wouldn't. We are too knowledgeable now. We would say eight months and we probably wouldn't do a better bag. I believe that the shortness of the schedule, the pressures that were brought upon everyone, the messed up situation in Osaka, were all extremely beneficial

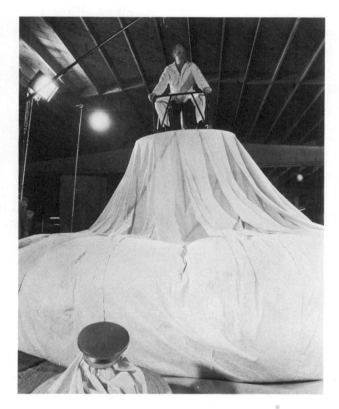

There are few artists other than Claes who could have done this, with such precision and logic. I am sure it took its toll. I saw it on Claes, who was very tired after this. This took a tremendous amount out of Claes the artist, but he had the foresight in the very beginning to know that he was going to have to operate within a very large arena of people and he set up certain kinds of responsibilities that he was willing to give to people who were operating in various capacities. This is very unusual stuff. Generally the artist is not capable of doing that

Art and technology rarely works, I think, and it has to do with the element of time, the surprise situation when timing becomes absolutely the most important thing. I think today if you would ask yourself this question, could I go out now and duplicate this or that project and improve it?—that is the key question —I think you would in most cases have to come up with the answer no. I don't think that Claes will ever do a collaboration like this again. He has learned too

much from it, and everyone around him has learned too much from it. That in no way takes away from the project, but I think in this whole enterprise—the surprise of the short budget, of the fanatic spirit that one gets into when all these obstacle courses are thrown at you, and the kind of tenacity that you exercise in situations like this as a creative person—that we are really talking about theatre. I think maybe this is *the* theatre—putting together all these families of people and their interaction. This really is the living theatre. It's not on Broadway any more, but this certainly is it. For me the technicians are the stage designers, the set builders, the choreographers, and our guys like Claes are the actors. We may be the producers or directors, or writers, or what have you, that are involved in this complex of work. But we are really performing in the greatest tradition of theatre, no time, no money, all impossible deeds, but somehow it gets across and some accomplishment comes from it.

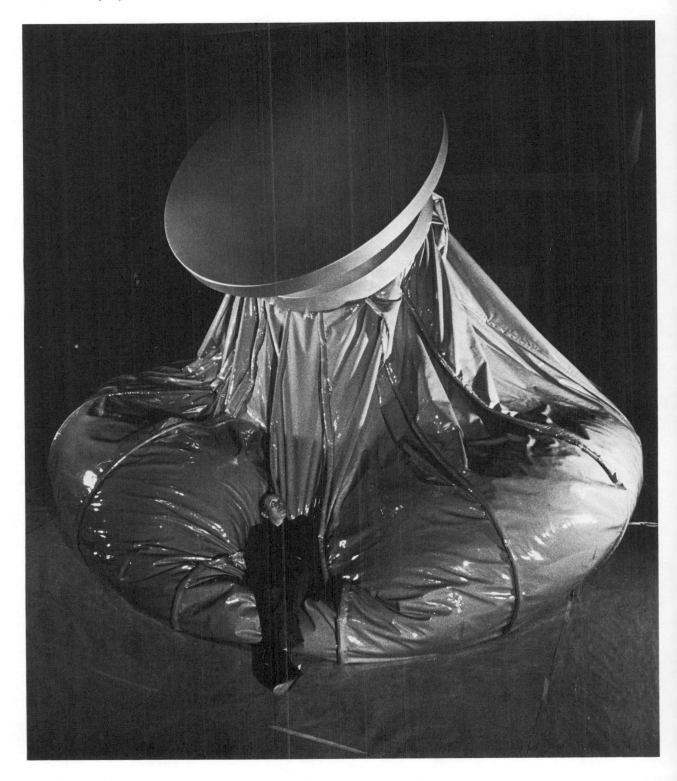

The *Icebag* was completed in early January and was
shown in a preview at Krofft [19], before it was shipped
to the U.S. Pavilion at Expo. Oldenburg, Tyler and a
crew of Japanese workmen installed it in one week's
time. It was placed at the entrance to the New Arts
exhibition.

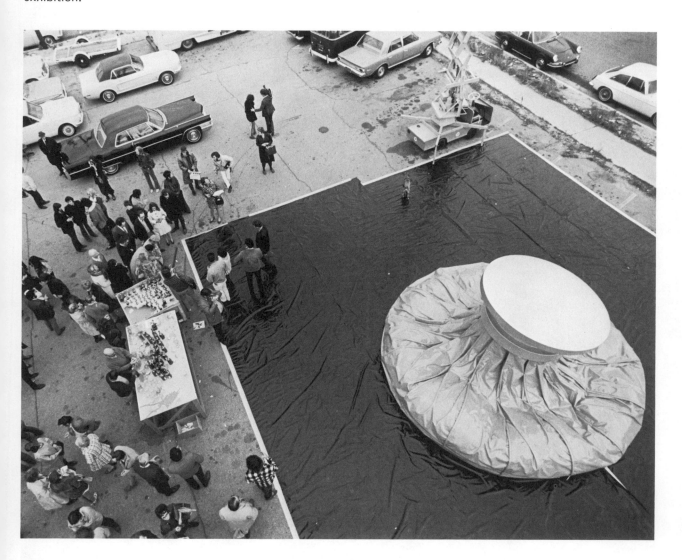

19

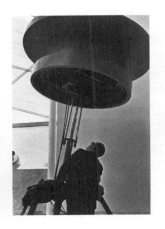
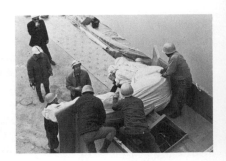
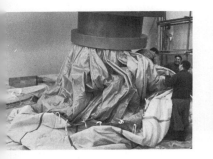
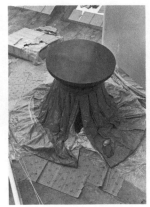
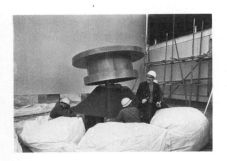
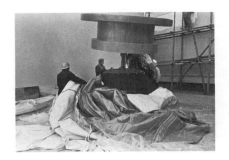
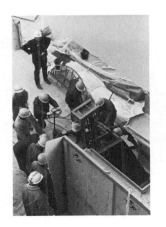
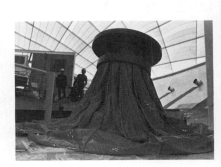

Oldenburg has speculated on the *Giant Icebag* and A & T at length, in taped interviews with Eric Saarinen, with Jane Livingston and with MT. The following excerpts come from these various conversations, made in March, July and September, 1970:

Getting involved with Art and Technology, I had to ask myself first of all what particular problem was it that I couldn't solve myself in my own studio and I needed help with; and I thought the most difficult thing was really to find some soft material which could be used in a quantity and also be durable enough to serve outdoors as a public sculpture. And this I hadn't solved, and I hoped perhaps that Art and Technology could provide me with the resources for, oh, some kind of material—rubber or something stronger and thicker than the kind of vinyl that I had been using. The other thing that I needed was, of course, machinery which could create a slight movement of the object itself. Up to this point I had relied on the suggestion of movement or on the spectator, say, who would own a piece and would move the piece around himself. But it was now interesting to me to see if I could discover a way to make the piece itself move in a very slight way and change its aspect. So these two things I really couldn't solve in my studio because I knew very little about mechanics and I had no workshop. And I had been using vinyl, but I hoped that through Art and Technology I could discover something stronger, thicker. As it turned out in the final result, what was used for the *Icebag* was vinyl again and not much different from the sort of vinyl that I had been using all along, so that there wasn't any advance on that front, but there was an advance on the front of mechanics—that is, a structure was built with a gear system and hydraulic system, which all cost quite a bit of money and took a lot of expert help, and this motor enabled the sculpture to move. So I had what I wanted, which was a sculpture that moved or an object that moved by itself. The *Icebag* as it operates in Osaka, is doing pretty much what I wanted it to do, but one finds that—or I found that there were always compromises. The whole problem with technology is that you can't achieve the directness that your fingers can make when you alter something the way you want it in the studio. I mean if you have clay or if you have cloth or if you have some simple material that's non-technical and doesn't involve a lot of other people's help, you can very easily alter it and make it look exactly the way you want it to. But this is not possible in working with technicians—it becomes a very indirect process, so that you have to give an order or command perhaps long distance and wait for several weeks before it's achieved, and then it's not achieved quite the way you want it—but it's pretty close to it. But it becomes so difficult just to make a slight little movement to make is exactly the way you want it,

and so it becomes finally a kind of—well, finally the technicians say we've reached the limit and you decide that perhaps they have reached the limit, and one has to settle for just a little bit less of what one wants. Sometimes one's lucky. But it's these little, tiny, final adjustments that I miss perhaps in the *Icebag*—there might have been a few things that I would have thought of right at the end which would have brought the piece into a much more personal solution or context, which I could not do simply because technology had determined a certain direction and it was too expensive and the time didn't allow for these final adjustments and changes. But that's all right because I consider the whole thing rather experimental, anyway. It certainly is the most complex piece I've ever done, and the first of what I hope to be more complex pieces

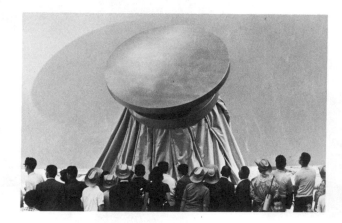

Technology is an available material, which is very different from certain conventional ideas of artistic activity in that it involves a lot of other people, and it involves using skills that the artist or the originator of the event or action doesn't necessarily possess. I don't know anything about mechanics, and yet I'm creating something, or I'm imagining something which involves mechanics and I'm asking someone else to do it for me. The question is, can anyone else do it for me, or could I allow other people to do things that I don't know anything about, and what kind of controls and what kind of respect can I create in them for my intention if I don't really know what they're doing. So there are very special problems involved in technology. There's also a kind of a rush towards completion on the one hand—you start something going and you invest a certain amount of money in a kind of machine, and you get a result, which is very limited—because in technology everything is highly limited. You get a limited result, and you don't like the result and it becomes difficult then to throw away the whole machine and start over again. So that technology is very deterministic—the activity in the studio is so much more fun because you can change things constantly. In technology you just—you have to be

very sure what you're doing before you give the orders to go ahead, so it's an activity which in every way denies the freedom and the pleasure of being an artist. And yet it's a challenging thing—I think of it as kind of a defensive activity on the part of the artist; if he can't handle this material which is so very much present in all his surroundings, then, you know, he'll sort of lose face—John Marin used to feel very put down by taxi cabs—he saw a taxi cab especially in the old days when taxi cabs were very clean and very beautifully colored, and he said to himself what is my painting worth next to a taxi cab?—a taxi cab is so much more powerful and beautiful and so much more expressive of the present time. That used to depress him. And I feel sometimes the same way about machinery—when I see it. In my happening in '63 in Los Angeles, I used automobiles, and one of the best pieces in the happening was a concrete mixer—a brand new concrete mixer that I had gotten from the construction company just by asking them if they'd send it over. It had never been used before, and I used it in the performance—I just moved it very slightly. It was this heavy, powerful object, and it was sort of completely at my disposal, and what I chose to do with it was just to move it inches this way and that way, and this way and that way, just to see how well such a huge mechanical object could perform for me without doing what it was made to do, without functioning. It's almost like lion taming, you know, dealing with technology this way. I suppose it would be very difficult to feel like a modern artist if you weren't in some way coping with the presence of things that you do not understand. There's so much surrounding you, so much specialization that you don't comprehend. And the artist is supposed to be the person who can unify or make a whole out of diverse things, to give direction and order and he has to contend with technology and specialization. And if he doesn't do that, he limits himself. So I think it's kind of a necessity forced on the artist by the times

I think perhaps my approach to technology is to remove the difficulty of technology, as to take something which is formidable in its complexity, and make it do some very foolish thing—and I sort of like the idea that all this time and effort was spent on the *Icebag.* I'm creating something which really doesn't do very much. It just does something very simple; and it doesn't do anything more really than a leaf does in the wind. I don't want to get into complex motions. I would never make the subject of the work the fantastic complexity that technology could achieve—like a Swiss watch, for example. I mean that's very interesting to watch, but that's not my aim. I think I would go in just the opposite direction. I would take all this complexity that technology can provide and direct it

towards a simple solution that equates it more with nature, or gets it, you know, out of the mechanical realm and back into nature. So I'm very concerned that the *Icebag,* after all its machinery action, looks like it was alive. It's the philosophy of the automaton and it was what Walt Disney dreamed about, which was the great irony—that he had spent millions to create technology that would give him the effect of life. His dream was to strap these recording apparatuses on an acting company and do all the plays of Shakespeare so that he could then reconstruct the plays with automatons—in other words to get back to nature, but to make nature yourself—in other words to give, I guess to give birth to nature yourself through the machine. But I wouldn't try to take on anything that complex—I mean the *Icebag* has a very simple life—it's a very simple organism, it's something like a starfish, a very low level of organism. And I would like to keep it that way. I wouldn't want it to walk around and behave like a robot. I would just like it to kind of crawl around—I'm very fond of snails and I have a zoo of snails in the back—and it's that kind of activity that I like

There are some things that I played around with before which probably relate to the *Icebag*—once I had a big fried egg about fourteen feet across, which was used in a performance at Stockholm in '66. There were people under the egg which animated the egg— the fried egg—it looked very much like an icebag. Bob Breer did some things with a self-moving object and a few years ago he put a cloth and some silver foil over some of his moving objects, and it produced a material that looked as if you had dropped a cloth on the floor and the material itself had come to life and began to move—but you couldn't see the motors underneath. So at that time I proposed combining the two agents—the motors that Bob developed with the fried egg that I had developed—so what we would have would be kind of a crawling, moving fried egg, a flexing fried egg. So things like that had been in my head for some years before I had the opportunity to play with that in *Art and Technology.* The *Icebag* is chosen as an object because it has a lot of rather flaccid material tied together under a hard shape, so that you have a contrast between the flaccidity of the material which is always changing and the hardness of the top or the cap which holds it, which binds it. That way you have limits to how much the material can behave, which it didn't have in these earlier experiments—the fried egg of course was all soft, but if you take a fried egg and put, say, maybe the yellow part, a mirror or a hard surface, you'd have—you'd be on your way to achieving an icebag, an icebag effect. So it's perhaps even suggested by handling a bag or handling any kind of material which you would bunch up and say hold in your fist in order to manage

it somewhat and then watch the movements that you would create in it by bumping or pushing it against other surfaces. And what the cap does, it sort of organizes the material in a way that gives it some kind of form. I mean I desired the movement of material, and the point of the object is just to organize this sort of thing in some way so that it can be presented.

The first configuration in Oldenburg's art to anticipate the *Giant Icebag* is a remarkable watercolor of 1963, *Frankfurters and Mustard Cup.* [20] A costume design of artist conceived in 1965 also suggests the monumental

20

sculpture. The *Icebag* became perhaps the most complex synthesis of associative forms Oldenburg has made to date. In addition to the "fourteen foot fried egg" Oldenburg referred to above, he has mentioned the following images as relating to the final shape of the *Icebag*:

the human head (hard like the fiberglass cap) and body (soft as the foam and vinyl)
the Museum's enormous vacuum cleaner (used to clean the concrete plaza)
Mount Fuji
an inkwell bottle
the planned centerpiece of Walt Disney World in Florida (a ride that "looks like a white icebag")
a sandbagged ashtray
the artist's cap [21]

21

marble

8/69.

Retains cold temperature extra long.

DIRECTIONS

— melting butter

sphincter shutter

8525. The Sponge, Upper Geyser Basin, Yellowstone National Park.

domes, particularly the cupola of the Capitol building in Washington, D.C.
moon craters
Hollywood premiere searchlights
tomatoes
breasts [22]
the "universal concept of the sun"
the atomic bomb
"The Sponge, Upper Geyser Basin, Yellowstone National Park" [23]

As seen from above, the *Icebag* was further suggested to Claes by
 the poster for Expo 70
 a doughnut
 a clock
 the moon's relationship to earth as photographed by astronauts
 a Chinese cookie

22

In October, 1970, as this report goes to press, Oldenburg spoke with MT about his changed feelings in regard to the problems posed by Art and Technology. Art, he said, was basically a "matter of childhood," while "technology concerns adulthood." His original reluctance to interact with corporations had to do, he now believes, with the fears that attend responsibility. Oldenburg now affirms the necessity to take such responsibility. He feels that only in this way can a primary dilemma of our time be faced: the imperative to "achieve harmony between the two natures—that of the machine and true organic nature." He drew up a chart for us to indicate the transformations an artist must undergo in order to deal successfully in the corporation-technology arena:

Artist in Studio	Artist in Collaborative Situation
1. intolerant	tolerant
2. impatient	patient
3. static	mobile
4. rigid	flexible
5. inward-looking	outward-looking
6. uncooperative	cooperative
7. stingy	giving
8. violent	restrained
9. impulsive	deliberate
10. vindictive-paranoid	forgiving
11. proud	self-effacing
12. destructive (especially self)	constructive
13. compulsive	non-compulsive
14. unpredictable	foresighted
15. drunk or high (looking for sublimity) (custodian of the sublime)	sober (indifferent to the sublime, like airplane pilots)
16. caprice	perseverance
17. feverish	calm
18. magic applied without reservations	magic circumspectly applied
19. alienation	participation
20. image of self	image of *more than self*
21. ease	difficulty
22. God (identification with nature)	more difficult to be God (apartness from nature)
23. control	leave be (do not interfere)
24. obsessive (primitive mind)	scientific

Maurice Tuchman

Jane Livingston met with Jules Olitski in New York in April, 1969, to talk about A & T. A new group of elaborate painted sculptural works by Olitski were at that time being shown at the Metropolitan Museum; their existence seemed to imply possibilities for the artist's interest in working with industry that his paintings or past sculpture probably would not have. JL, in her talk with the artist, stressed the availability of Kaiser Steel and American Cement, basing this on her feeling about the Met exhibition. Olitski was definitely intrigued with particular ideas in relation to his sculpture. The present aluminum works had been made in a factory in Connecticut, and he was arranging to have some works executed in England, but he was definitely open to investigating other materials and industries for a further sculptural series. Specifically, he mentioned his interest in finding a way of coloring metals so that they would be impervious to weathering (obviously this was difficult to achieve with ordinary paints); he was also thinking about making environmentally scaled sculptures that would have movable parts, so that they could be expanded or contracted laterally, or have vertically adjustable ceilings. He was open to considering various materials besides metal, such as cement or fiberglass.

In May, Olitski came to Los Angeles. He first toured Kaiser Steel's Fontana plant with JL. The Kaiser technicians he spoke with seemed quite interested in his proposals, especially as they were experimenting with certain types of chemical treatments which work upon metal surfaces to alter coloration, and seemed to feel this might be applied to Olitski's work. There were revealed, however, distinct limitations as to the range and intensity of the colors that could be achieved by these processes. Both the artist and JL were rather skeptical, as well, about Kaiser's ability to resolve the problem of creating flexible, or rearrangeable, sculptures, since the steel used would be extremely heavy, and would probably require sophisticated mechanical or hydraulic systems beyond the resources of Kaiser's Fontana plant to engineer.

The next day, Olitski visited American Cement's Riverside Technical Center with Hal Glicksman. The artist met with American Cement's Dr. Geoffrey Frohnsdorff, Manager of the Technical Center, and Kenneth Daugherty, and toured the facility. After these two corporation visits, Olitski returned to New York. From his view of American Cement and his discussions with Frohnsdorff, he felt that this company offered him more interesting possibilities than Kaiser, and once back in his studio, he proceeded to make a series of four models for sculptures which might be fabricated, at least partially, in cement. [1, 2, 3, 4] On May 20, American Cement's structural engineer Dr. Samuel Aroni spent several hours with the artist at the request of Frohnsdorff to discuss a project. Aroni, who had previously been closely involved with us and Jean Dubuffet when we were attempting to arrange

1

2

a match between American Cement and the French artist, met Olitski at the Metropolitan Museum to see the artist's sculpture exhibition there, and was impressed with the work. He then returned to New York in June, and visited Olitski at his studio, where they looked at the new models and considered the problem of how they might be structurally executed. This question, however, became secondary in importance to the question of *coloring* the works. In his previous paintings and sculptures, Olitski had mixed color by spray painting surfaces with various hues, mixing color in a given area by applying one color at a time, in layers of varying density. Aroni had been working for two years with colored synthetic aggregates made of cement sand, which could be *premixed* in combinations of different hues, and then applied, perhaps onto a resin matrix, with a spray gun. This process, allowing as it did for mixed colors to be applied simultaneously, rather than one at a time in separate layers, seemed to offer a new approach for Olitski. Aroni and Olitski talked about making the sculptural components not of cement but of molded fiberglass, applying a resin matrix, and then coloring the surfaces by Aroni's method. They agreed that they should first experiment with flat surfaces—create paintings, in other words—before fabricating molded plastic units for large sculptures. Aroni had brought with him samples of the synthetic aggregates in various colors; Olitski felt that the red, blue and green hues shown to him would be satisfactory exactly as they existed, but

that they should develop brown, yellow and black aggregates specially, and also use natural aggregates, in white and other colors.

Aroni returned to California feeling extremely enthusiastic about the artist's proposals, but somewhat concerned about American Cement's willingness to support the project fully. He later said that the problem lay not in the company's disapproving the artist or his work—on the contrary, the proposal was felt to be eminently appropriate to American Cement's technology and esthetically appealing—but in the corporation's current paralysis for reasons of an internal political shake-up. Olitski had suggested that Aroni telephone his friend Robert Rowan in Pasadena—Rowan is a serious art collector, and owns many of Olitski's works—to enlist his support of the project in presenting it to the company management. Aroni learned that Mr. Rowan's brother was a member of American Cement's board, which seemed a fortuitous connection. After discussing this with MT, Rowan cooperated in recommending through his brother that the Olitski project be undertaken by the company, and we emphasized our keen enthusiasm about the potential collaboration. Unfortunately, as a result of the political reorganization within the company, its commitment to A & T was ignored by the new administration. We then made an intensive effort to solicit the cooperation of Owens-Corning specifically for the Olitski project, but were unsuccessful.

3

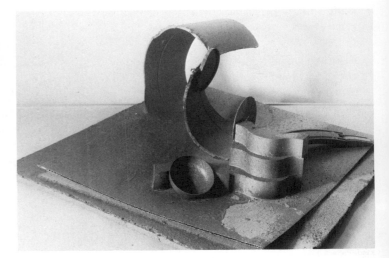

4

Eduardo Paolozzi was visited in London by MT in October, 1968. When A & T was described to Paolozzi on that occasion, he responded by expressing interest in working with computers. His work at that time was involved in computer-generated imagery, and thus it was natural that he should wish to develop these ideas. In Paolozzi's letter to us of October 30, he spoke about the areas he visualized pursuing:

It is my intention of bringing a portfolio of schemes in connection with the Los Angeles show. These schemes are an extension of work concerning images and words (ref: the Berkeley catalogue; Christopher Finch's book *Art and Objects*).

You may realize that I did a certain amount of computer research while at Berkeley, but the Art Department there was unable to extend any of these ideas—which certainly could be realized within the framework that we discussed in London during your visit.

At the moment, I have an assistant working on colour mosaics and endless permutations on the grid pattern. This is according to my interpretation of current computer literature and can be used in connection with sound experiments. Also the reverse, I understand, is possible; which is, sounds can be used to create patterns.

The feasibility of the theory of these programmes require an electronic design engineer for further comment, and this particular auxiliary is being investigated at this moment.

Next week, a visit is planned to the Computer Division of the Ferranti empire, the particular study here is numerical control machines and their particular computer-aided design programme

Following this letter, we sent Paolozzi literature on Information International. Paolozzi arranged to fly to Los Angeles for a week in January, 1969, to visit companies. By the time he arrived, IBM was tentatively available for an artist match (though they were still considering Vasarely's proposal), so we scheduled visits to their Los Angeles headquarters, to Information International and also to Wyle Laboratories. The tour to Information International was unproductive. For various technical reasons, Paolozzi felt that their capabilities in computer graphics would not be of use to him. The situation at IBM was somewhat more complicated. Paolozzi first toured their downtown Los Angeles offices and saw various advanced computers demonstrated; the next day, he met again with Dr. David Heggie, our IBM contact man, and we discussed the possibility of touring IBM's huge San Jose plant. This meeting was difficult for everyone involved. Somehow Paolozzi did not feel that Heggie or IBM either understood his intentions or were

really prepared to offer him the kind of freedom or the degree of access to their personnel and hardware that he required—though the corporation was equipped technically to deal with whatever demands the artist might make in the area of computer graphics. On the evening after this encounter, Paolozzi telephoned Jane Livingston from his hotel and explained to her that he saw no point in touring the San Jose facility or bothering further with IBM. Paolozzi then visited Wyle Laboratories. He was interviewed by the company's president, Frank Wyle [1]; Gail Scott wrote the following memo recounting this event and later discussion:

1

GS went with E. Paolozzi to Wyle Labs for interview with Frank Wyle. Wyle's first take was that Paolozzi should be exposed to many facilities for first week and try to absorb the diversity of technologies available. He suggested making a sculpture using 'birefringence' flow-pattern technology which has a very impressive visual effect [2]. Size is no limitation; it's merely a question of learning the principles of the technology and then working out the mechanics of the construction—which can be done anywhere. Birefringence consists basically of sheets of semi-transparent polarized screens through which a closed-loop liquid circulation system is channeled. (The liquid is water with an additive which causes the birefringence effect.) An internal, monochromatic light source is used which is modulated and changed according to certain flow principles of the liquid as it is pumped through the channels. Eric Miller, a physicist at the Huntsville facility, is the authority on the subject.

Paolozzi was interested in this possibility, but still would like to work with computer graphics. However,

2

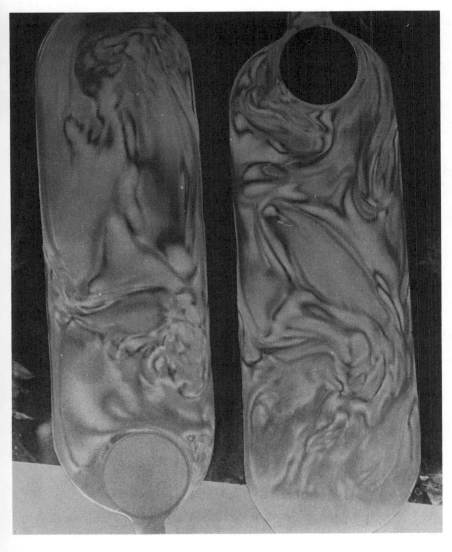

in a meeting with MT, Paolozzi, JL and BA on January 17, it was decided that because of the problems with Vasarely and IBM, it would be best for Paolozzi to concentrate on working something out at Wyle. Paolozzi is not interested particularly in another 'Howard Wise-type' visually interesting sculpture, but wants to penetrate to something more meaningful. He is willing to pursue the possibilities available at Wyle, provided he can get an informed corporate person to give him an extensive tour of their facilities when he returns in March to begin work. I suggested that Kenneth Eldred, whom Paolozzi and I met yesterday, and who is Director of Research, managing all research activities at the Labs, would be an ideal contact man. Wyle said that Eldred is 'the most creative person around here.'

Paolozzi seemed undecided when he left Los Angeles about the medium—birefringence, or binary infraction—with which he was encouraged to experiment by Frank Wyle. He was still reluctant to abandon his idea for working with computers, but apparently he became increasingly intrigued, as he later thought about it, with the notion of using a technique entirely new to him and unrelated to his past work. In any event, he wrote to us in February, saying that he would be sending an assistant, James Kirkwood, to Los Angeles before he himself could come from London, and he indicated his willingness to work at Wyle Laboratories. Hal Glicksman wrote this memo after touring Wyle with Paolozzi:

Met with Frank Wyle and Harry Greybill to view working space and see demonstration of effect that Paolozzi would utilize. Space was located on upper floor at northeast corner of the lab complex. Rather an elaborate route from the entrance. Space is a separate room about 15 x 20 feet, drafting table along one wall, separate desk and work table. Paolozzi plans to move in March 18, 10 A.M.

Viewed demonstration: A special liquid dye changes color under polarized light according to the speed at which it is flowing. Thus the rate of flow of liquids in a system of plastic pipe is graphically illustrated by rainbow hues in the liquid. Corners, bends, constrictions, and irregularities in the pipe all cause brilliantly colored turbulence to appear in the liquid. The fastest flowing parts are bright yellow, the slowest parts green. The entire system can be slowed down with a master valve that causes all the liquid to darken and shift color toward the green. The system when completely shut down is an almost opaque, dark green. Elaborate pipe systems can be simulated by cutting a pattern out of a flat sheet of plexiglass and sandwiching it between two solid sheets. The liquid flows in the cut out spaces.

Paolozzi and Kirkwood worked daily at Wyle for about three weeks, consulting with several technicians who

Otto Piene
Born Laasphe, Germany, 1928
Resident New York City

advised them about the capabilities of chromatic control which could be obtained with the polarized fluids. A table was set up with a sort of flat tank set on it, into which dyes were pumped under polarized plastic sheets. Paolozzi was able to determine by observing the flow patterns under various conditions in his apparatus what he might be able to achieve on a larger scale. He visualized making a wall of color patterns, and thought of incorporating some sort of mechanism whereby spectators could themselves manipulate the color patterns either by "playing" a console, or simply by walking in front of the structure. The more he worked with the device, however, the less confident he became that the medium was worth developing into an art work. He also felt that the environment at Wyle was constricting to him, and he sensed that he was being "railroaded," to use his word, into a narrow and unreasonably specific area, when he would have liked to freely explore the complex of buildings around him and conceivably make use of other resources available at Wyle.

On April 4, MT sent Frank Wyle the following letter, terminating the Paolozzi/Wyle collaboration:

I have been informed by Eduardo Paolozzi that he will not be able to continue his 'residence' at Wyle Laboratories. The artist believes that only work of insufficient value could result from the collaboration. Paolozzi feels that the only area at Wyle made available to him concerned binary infraction, and that this area, as interesting as it is technically, is not fecund ground for his personal aesthetic. He also indicated to me that his attempts to make something in this area were hampered by various restrictions placed on the scope and scale of his involvement; means of implementation were, in Paolozzi's opinion, too restrictive to allow for success.

I very much regret that this collaborative effort has failed. It is the first time a contracted artist and a Patron Sponsor Corporation have not been able to work out a satisfactory relationship. I tried to contact you when this situation developed last week in an attempt to ward off the problem. Perhaps we should discuss this matter, at your convenience, in order to prepare for future involvements with artists. Since we regard Wyle Laboratories as one of the most extraordinary of the thirty-one corporations joining with us in this program, we are especially eager to have a valuable situation develop.

HG took Paolozzi to both Cal Comp and to TRW Systems before the artist returned to London. Paolozzi and TRW agreed to work on a computer graphic project; the artist would send the company drawings and instructions by mail from London for them to program and compute. We have not been able to ascertain from Paolozzi whether work is indeed progressing at this time.

See Stockhausen section, page 322

Michael Cain wrote to us for Pulsa, a team of "research-ers in programmed environments," in April, 1969:

Pulsa proposes to realize for the L.A. Museum an environment sensitive to aspects of its own condition through an input system integrated into our existing outputs and controls capable of receiving and inter-preting many kinds of information from its surround-ings. In the past we have developed a variety of instrumentation for generating and outputting infor-mation as perceptible wave energies and are most recently involved in the design and programming of large scale outdoor matrices of strobe lights and loud speakers. It has long been our goal to feedback infor-mation from the environment of the matrix to the matrix as its program.

We feel fortunate in having an opportunity to do re-search on environmental sensors in L.A. where the special manmade ecology is provoking such attentive environmental studies, and are convinced that local industries will be eminently capable of helping us realize our project. We wish to consider acoustical, optical and infrared, radio, and radar scanning devices as means of designing sensors capable of determining the behavior and distribution of persons, animals and plants, local air and temperature conditions, ambient light and sound, and the outputs of the system itself. These sensors will require interface and software to adjoin them to the small tandem time-shared com-puter with which we intend to be controlling all of our future installations. We should like to work on this proposal with Information International, R.C.A., Litton Industries, T.R.W., and especially Gilphilin, for help in acquiring a radar system.

Our proposal for L.A. would entail using these infor-mation input devices in a large space, hopefully a square mile of open land, in association with a pro-grammable matrix consisting of 128 strobe lights and an equal number of loudspeakers in an array con-formed to the site. This system should be extant and available for presentation during the L.A. show after its initial fabrication and installation in the World's Fair at Osaka. A Digital Equipment Corporation PDP-8 computer and Grason-Stadler multiplexer with five input-output stations would accept information from the sensors and from a teletypewriter and gener-ate patterns and sequences. This information would be transmitted to a second computer, a General Auto-mation SPC-12 and there expanded into specific instructions to a signal synthesizer and to the output devices which would be digitally controlled. By the spring of 1970 our previous presentations in Central Park, the Guggenheim Museum, and Osaka will have given us facility to take full advantage of the very great flexibility of this system.

If other industries are willing to donate the time and money for collaboration on a second proposal, we should use the opportunity to experiment with sources of light and improve further our design for output devices.

The ideal device would include a source of light digi-tally controlled and widely variable in intensity, duration, and spectrum. Gas discharge tubes, fluores-cents, incandescents, electroluminescent panels, phos-phors and fluorescent pigments, and chemilumines cent materials have all been useful to us but none have been fully satisfactory. We should welcome assistance from Union Carbide and International Chemical and Nuclear among others.

Born Brooklyn, New York, 1943
Resident Solana Beach, California

Jeff Raskin is an artist and Assistant Professor of Art at UCSD where he also heads a new computer center for the Visual Arts Department. He was recommended to us by his teaching colleagues, David Antin and Harold Cohen, because of a concept for a building module he wanted to design and fabricate. We gave him literature on Container Corporation and Eldon Industries, a Los Angeles toy manufacturing company. On March 12 Raskin and Hal Glicksman toured the two companies, after which the artist wrote a formal proposal:

> The basic output is to be a construction module, or at *most* two modules whose dimensions are larger than 4 inches and less than 20 inches in all directions. The module will fold flat for storage and transportation, and will be easily set up, and taken down. Each unit, of cardboard or clear plastic, will interlock with adjacent units in a large variety of ways.

> The principal work of art proposed here is a sculpture or environment approximately 10 by 20 by 30 feet made exclusively of these modules. The object might be a house. While the module could be of cardboard, at best it would be of clear plastic, polyethelene or styrene. In the latter case, it is possible that the module will not fold, but be watertight so that each unit could be filled with colored or uncolored liquids, liquid crystals, powders or objects.

> The exact shape and design of the module will (and can only) be determined by working with the company finally chosen. Problems of manufacture will influence the nature of the module. In fact part of the fascination of this project is working within and around the technical nuances of the industry.

Later Raskin elaborated on the concept, explaining its derivation and rationale, and its potential as a building unit:

> I like to play with toys a lot and I've always been frustrated with building sets. They always have some direction in which they're heading. I remember when I was a kid in New York and we decided to build our own house, and I got this plastic block set. It was very suitable for building a model—like a scale model of the house. But it only allowed the bricks to be laid on top of one another in normal brick-like staggered fashion. If you suddenly wanted to go out from one wall at right angles to it, you couldn't do it at all. More recent brick sets are made so that if you find the right *piece*, you might be able to make projections from a square wall, or make something free standing or arching over. Each set of bricks or Lincoln logs always had some particular genre of construction in mind. I had settled on actual simple cubes of wood or metal or plastic. I made myself such a building set out of clear plastic cubes. They simply stack, but at least there was no restriction; they didn't have any sense of direction built into them aside from the rectangularness. I like the rectangularness (basic square rooms seem eminently practical). Building things at right angles doesn't seem to be much of a hang-up for me. I wanted the most general block that I could have; any two blocks would have to be able to attach together firmly so that they could be self-supporting over a small span; larger spans requiring additional structure. They would have to not be limited to flat walls, but any block would have to, on any face, be attachable to any other block. No other block set comes anywhere close to that. This would allow you to build an absolutely solid, completely interlocked cube. To make this perfectly general, I spent some time finding out if there's any way to make a hermaphrodite connector that could be both male and female so that every face of every block would snap together. If I had one of those sets, I'd enjoy building with it more than any other set I've ever seen. Furthermore, a two to five centimeter size block is fine for building models, but I'd also like to have a larger set of blocks twelve inches across or one quarter meter, and you could use these things for architecture. building wall partitions, for building *buildings.* If they are made out of plastic like Delrin, they would be strong enough to build stairs and a few structural members. If I violated my principles only slightly and glued some of them together you could make quite large structures. I rather like to be able to take whatever one makes apart and rearrange it as the need changes. I envisage (and would probably build for myself) a house, a garage. They would be relatively light also. Because they are hollow, if you needed weight, they could be filled with sand, fluids, plastic. Cubes can come apart into two symmetrical pieces, each being three sides of a corner. And so you can stack very compactly; you can take a building and put it into a hundredth of its space, or even less than that, and transport all the parts economically. It's a practical thing as well as a nice thing. If you then took certain blocks and modified them (although that's not very pure of me) by drilling holes in the sides, you could have all the plumbing running through the wall; you could see it all. (Although certain kinds of plumbing I guess you would want to have running through the walls.) You could have a fish tank built in the wall; with some blocks clear and some full of sand, you could have windows. You could move the windows around by shaking the sand out of one and now the window is there. I would have all the blocks clear, but if you do want an opaque wall, you would spray paint the inside or the outside. I like large things: I don't know why because I like miniature things too. You had some of my favorite miniature things here in the Cloisters exhibition—a little wooden model with a whole battle scene inside. Working on that scale has

SECTION 'AA'

always fascinated me, and I build an awful lot of ultra-miniature things, but I've never exhibited them. First of all because it would take hours of educating people to see what I'm seeing; nobody's adjusted to looking at things that way. There's another thing, though, about being able to walk around in stuff. That's nothing new; everyone has done that who's working with environments. The last mazes show I had at UCSD left so many avenues to be explored—literally and figuratively. I want to explore some of those with the clear blocks. If I were to build a thing that was contorted, perhaps not really a labyrinth so that you could be six inches from somebody on the other side of a set of blocks and still be a half hour's walk from them. I would like to do something on that scale. And the idea fascinates me of having identical rooms in different places, so that you can't tell if you're in Room A or Room B. You think you come back to the same place but it's really different. The room merely looks the same. I'd like to explore things like that.

In May, after Raskin had made a prototype unit [1], we arranged further meetings at Eldon with an engineer. Tony Smith was already working with Container Corporation of America, and since Raskin's first option was to fabricate the module in clear plastic, we proceeded with Eldon. On July 23 we met with Robert Silverstein, president of the company, to describe the piece in greater detail and to discuss the feasibility of executing the modules. Silverstein agreed to project a cost analysis and

1

intimated that on the basis of that estimate, Eldon would proceed to fabricate the units. Shortly after this meeting, however, Silverstein's office called to say that Eldon declined to take on the project because it was too expensive for them.

We then approached Dart Industries, which had previously considered a proposal by John Chamberlain. Raskin's proposal received careful and enthusiastic study by Dart designers. However it was again rejected by management as being too expensive. For several weeks after that, we pursued the fabrication problem elsewhere, at various local plastic manufacturing firms, but without success. In September, 1970, we made a last

attempt to carry out the project. Much earlier in the program, we had invited Mattel Toys, Inc. to join A & T but they refused, not wishing an artist in residence at the company for twelve weeks because of its tight security regulations. Nevertheless we approached Elliott Handler, Mattel's president, once again to explain that Raskin's project was completely planned and would not necessitate a lengthy collaborative period. Raskin described to

Jack Barcus of Mattel's design department the uniqueness of his module. Although the work was not marketable from the company's point of view (as a toy, it was too expensive), they expressed definite interest but did not take action on it. Late in October, 1970, Raskin re-designed the module for fabrication in cardboard or other similar material, with the end-view of effecting an economical production. [2]

2

Robert Rauschenberg
Born Port Arthur, Texas, 1925
Resident New York City

Bob Rauschenberg's collaboration with Teledyne began in September, 1968, after a tour of the company in Los Angeles, has continued over a two-year period, and is at present still in the final stages of completion. It has perhaps been longer in process than any other project in the A & T program, and has been characterized by brief moments of intense interaction between Bob and Teledyne personnel (principally Frank LaHaye, Vice-President [1 at right], and Lewis Ellmore, Director of Special Programs) and long intermittent periods of inactivity or company fabrication in the artist's absence. There was never an extended residence period by the artist. The reason for this slow evolution was not, however, due to lack of enthusiasm by anyone involved. From the start Teledyne was eager to accommodate Rauschenberg and his project proposals; for his part, Bob was always willing to make himself available when some aspect of the project required his attention.

In a series of meetings during Rauschenberg's initial visit in September, 1968, the artist was introduced to several key executives at Teledyne's head office in Century City—George Roberts, President, and Vice-Presidents Frank LaHaye and Berkeley Baker, all of whom were acquainted with Bob's work. At this time the company agreed to accept the artist in residence, and additional meetings were held with Lewis Ellmore, who was asked to assist in the collaboration. Ellmore later recounted this first interview with Bob in a letter to us dated November 12, 1970:

> We had an absolutely fascinating discussion over lunch, and both Bob and I became entranced with the possibilities available. We really had not the slightest idea as to what form the project should take, but Bob's thesis was that, after all, art is creative manipulation of materials and processes, and there appeared to be a great many new developments in technology to be exploited. All this sounded quite good; the difficulty seemed to lie in the fact that the typical artist had neither access to, nor full understanding of advanced technology and the artistic ability of the average technician or scientist is vanishingly small. Thus, the combination of Bob and me with the resources of Teledyne.

> At that first luncheon it became obvious that Bob was certainly not a typical artist, and I grew increasingly enthusiastic; more, I suspect, about the prospect of working with Bob than about the project in general, since it seemed to me that any contribution I could make would be insignificant compared to the artistic creativity injected by Bob. It also appeared that we could work together easily since we shared a . . . sincere belief that although life was pretty grim, it was possible to improve it. So, amidst a pledge of assistance and dedication of resources from Teledyne,

1

we parted, the first step to be the exchange of letters between Bob and me, each expressing an initial viewpoint.

In December, LaHaye and Ellmore met again with Bob in his New York studio, visited the Museum of Modern Art to see Rauschenberg's piece *Soundings* currently on exhibition there, and resumed their discussion on the project. In the same letter cited above Ellmore recapitulated this and subsequent meetings:

The meetings we had were refreshingly informal and a genuine pleasure. Bob's goal was to create a dynamic work, which not only would stimulate more than just the visual senses, but would in fact interact with the observer. He had pioneered in this field and was at that time exhibiting his *Soundings* at the New York Museum of Modern Art. He felt that that represented a direction to be further pursued, and we, over the next several months, exchanged many thoughts and ideas. Fundamentally, Bob wanted to escape from the limitations of two dimensions and to couple the work, in a way yet to be defined, to the observer. My role in all this was really as technical censor, if you will, serving only to comment on the technical feasibility of what Bob wanted to do

We considered many types of three-dimensional displays ranging from mixing air currents made visible by thermal differentials, to closed loop machining systems where the output of the machine was subsequently modified and fed back into the input. We considered fluids of various types flowing, mixing, and in general doing all sorts of things. We considered different geometries, materials, methods of manipulation and alteration, and, overall, just about everything one can conceive of. We thought about the types and forms of energy, which could be sensed and used to activate and regulate the dynamics of the work. Again, everything from deliberate and direct observer control to purely random processes. We included sound, light, motion, odor, etc., etc. At one time we looked into actually being able to sense the mental state of the observer, but while theoretically possible, it seemed to be a bit advanced in terms of actually implementing it.

We went on to explore ways of stimulating the observer, not only visually, but with both audible and non-audible sounds, pressure differentials and so on. Finally, we looked into means of selectively creating emotional responses in an observer and, in fact, of using these emotions to further modify the art.

We had, by this time, started to vaguely define the limits within which we would operate, and started to formulate ideas in terms of the materials and technologies needed. In recalling this phase, it was certainly one of the most stimulating of my experience. We literally were unfettered conceptually, limited only by Bob's imagination, which appears to be boundless.

Sometime during the course of this series of interchanges, which extended through the Spring of 1969—at exactly what point it is not altogether certain—it became clear to Rauschenberg what the piece should actually be. According to the artist's own account, he was lying on the beach when it occurred to him spontaneously to use mud and to reproduce the bubbling activity of the "paint pots" at Yellowstone National Park; sound stimuli would be channelled to directly generate the mud movement. He conveyed this notion to Ellmore and other engineers at Teledyne who began to investigate the feasibility of activating mud by sound waves. It was quickly determined that the level of sound required to cause by itself any movement or bubbling effect in an expanse of viscous material would deafen the human ear. Again, Ellmore summarized for us this stage of research:

The visual mechanism chosen by Bob was to be a large tank of viscous liquid through which a less viscous liquid or a gas would be released; the control of such release to be governed by the sensing and processing of selected elements of the environment. Simultaneously this was to be accompanied by a similarly processed acoustic display.

We found rather rapidly that the constraints of reality were upon us. For example, following a meeting with one of the Teledyne Companies engaged in the manufacture of viscous liquid, Bob, after due experimentation, discovered the combination of chemicals, which would yield the desired effect. Alas, the cost [would have been] monumental and it was some time before it was realized that simple drilling mud was actually superior. Similarly we decided on injecting air into the mud and planned on using a valve which would release air in direct proportion to the applied electrical signal. It required some experimentation before we found that controlling the duration of one of three constant pressure sources gave nearly equivalent results at a cost reduction of about 99%. There were many many such examples, stemming, I suspect, largely from the space age environment within which the various contributing companies were accustomed to operating. In short, there was no incentive to do other than pursue the most technically convenient path

In the fall of 1969 we considered the possibility of including Rauschenberg's piece, tentatively titled *Mud-Muse*, in the Expo show. After informing Teledyne of this, they agreed to build a small model to test the system. Work on a square eighteen inch prototype tank began immediately at Teledyne's Torrance division, Sprague Engineering, supervised by George Carr. The

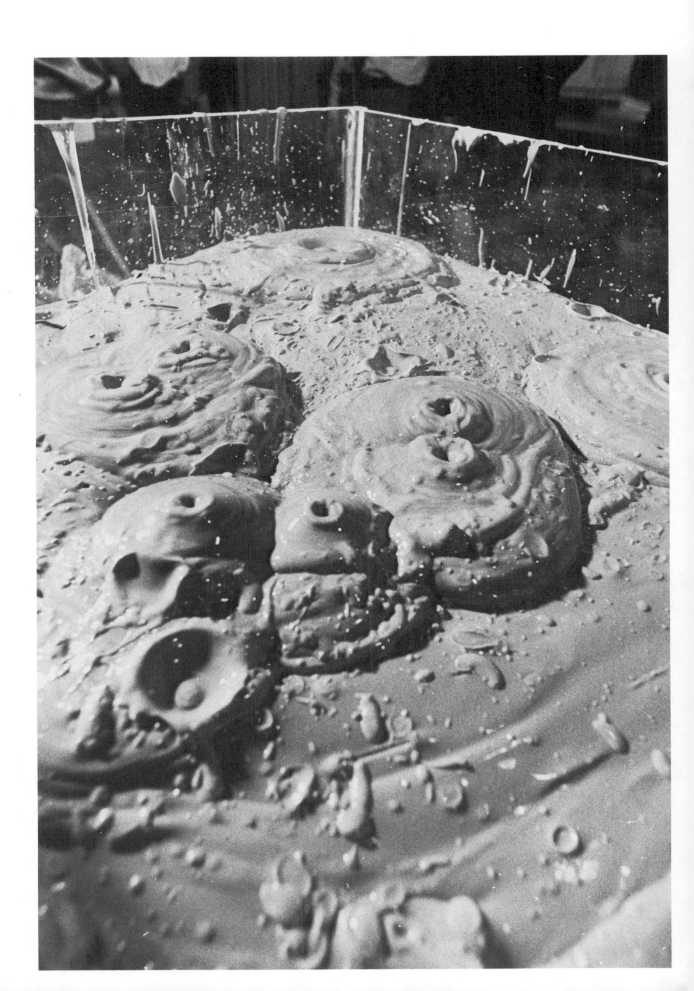

model was finished in January, 1970 and functioned satisfactorily. However, because of delays in obtaining the necessary fabrication materials for the full-scale version, the Expo deadline could not be met.

The pressure to finish *Mud-Muse* for the Expo show and the construction of the prototype served to bring into focus several problems of mechanical design which were then resolved. The piece would be a nine by twelve foot tank. Bob had originally conceived of it as measuring sixteen by twenty-one feet, but the scale was reduced in accordance with the maximum size capacity of an airplane, in anticipation of shipping the piece at the last possible moment to Japan. The tank would appear to be free-standing, being elevated three inches off the ground, and would have a two foot aluminum skirt to hide the electrical and pneumatic mechanisms. Above the metal base would be thirty inch high plexiglass sides; the tank would have no cover, so that the mud would be exposed to top view. (For structural reasons glass was later substituted for plexiglass.) The tank would contain a high viscosity, high density (100 pounds per cubic foot) derivative of driller's mud, light brown in color and extremely soft to the touch. This material was acquired from Teledyne Movible Offshore in LaFayette, Louisiana. At a later stage of its design Frank LaHaye wrote a description of the piece which states in part,

> In the bottom and hidden sides of the tank there are located approximately thirty-six compressed air inlets. Each inlet is connected to three manifolds by low pressure tubing. The manifolds are maintained at three different pressures (2-6-12 PSI). Each line of tubing contains an electronically operated 'on-off' valve.

> In operation, the effect is a continuous and random boiling eruption of different intensity at different locations. Selection of location and intensity will be done electronically using three or four microphones dispersed at random, either near the piece or at a random location. If located near the piece, the microphones would have to be hung from the ceiling or from a side wall.

> It is also planned, though the details have not been resolved, to have a number of special sound tracks playing from under the piece. Selection of one or more of the sound tracks would tie in with the electronic selector system controlling the pneumatic valves. Typical sounds might include the surf, an owl, the wind, musical notes, etc. [2]

By June, 1970, the design of the electronic and pneumatic systems had been resolved, and fabrication began in earnest at Teledyne's Aero-Cal division near San Diego where Jim Wilkinson, Chief Engineer, supervised the operation, and Carl Adams coordinated the actual construction.

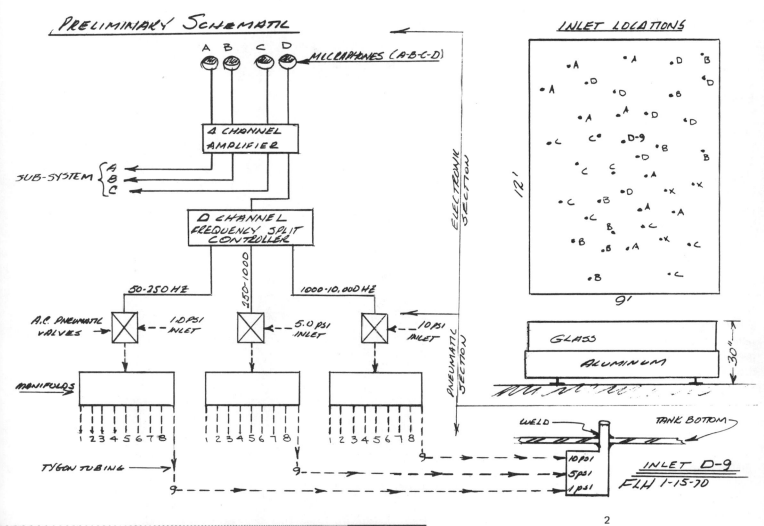

PRELIMINARY SCHEMATIC

A B C D MICROPHONES (A-B-C-D)

4 CHANNEL AMPLIFIER

SUB-SYSTEM { A B C

4 CHANNEL FREQUENCY SPLIT CONTROLLER

50-250 HZ 250-1000 1000-10,000 HZ

A.C. PNEUMATIC VALVES 1.0 PSI INLET 5.0 PSI INLET 10 PSI INLET

MANIFOLDS

1 2 3 4 5 6 7 8 1 2 3 4 5 6 7 8 1 2 3 4 5 6 7 8

TYGON TUBING

ELECTRONIC SECTION

PNEUMATIC SECTION

INLET LOCATIONS

12'

9'

GLASS

ALUMINUM

30"

WELD TANK BOTTOM

10 PSI
5 PSI
1 PSI

INLET D-9

FLH 1-15-70

2

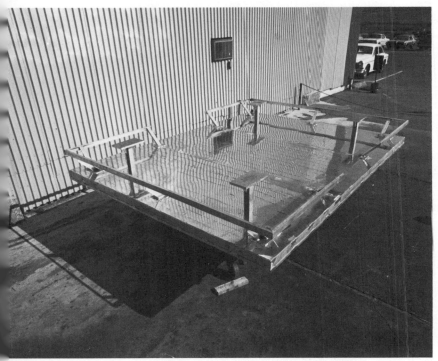

By October construction of the tank was sufficiently completed to allow preliminary testing of the mud movement through mechanical means; the sound system was still unfinished. Rauschenberg, MT and JL were present at Aero-Cal for this long-awaited event. Twenty 50-gallon drums of mud were poured by hand into the tank, and it heaved and bubbled impressively. Bob was delighted. The final stages of the project will take place in December, 1970 when the valves will be fully operable and the electronic system installed. By that time, Rauschenberg will have recorded the soundtrack he wants—a combination of jumbled, incoherent or semi-coherent man-made noises, and sounds from nature.* These will be incorporated into the system to interact with the random action of the mud controlled by sounds from microphones located in diverse parts of the exhibition area or Museum proper.

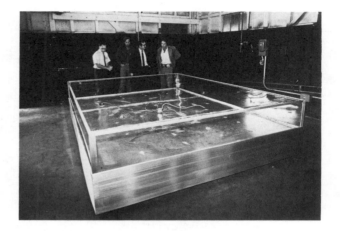

In an interview with MT and GS in October, 1970, Rauschenberg commented on *Mud-Muse,* and reflected upon his experience in the A & T program, on the general phenomenon of art and technology, and the differences between A & T and E.A.T., which he helped found.

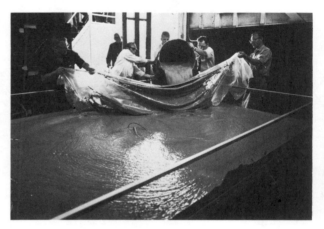

My piece is not the work of a magician. It only exists in sensation and it is exactly what I thought was missing from the phenomenon of art and technology, because usually whatever the artist does in relationship to technology tends most often to look like exploitation of technology, or what he does is so primitive and simple in depth [compared] to the profound qualities of technology. Like most technological art, this [program] is a beginning, and you can't expect one of the most sophisticated forms to be able to actually emerge overnight. But one of the big problems is the whole social problem, sociological problem—the wooing of industry to even care. Then again, most often the artist himself is so seduced by the simple marvels of science that are really just utilitarian for the scientists and for the industrial world, that the art concept doesn't match, it doesn't even compare to it because the artist usually incorporates the phenomenon. He is seeing a *fact* as a romantic phenomenon, as filled with beauty, and if he touches it and says that's it, then that's his work. Whereas what you really have is a bunch of very old hydraulic ideas, things that we didn't probably pay much attention to when we were going to school, as a thing of beauty. So either it should be just that and left, or you have to take it for granted and move from there and not have the art part of it being a kind of cosmetic for technology because it doesn't need roughing up. Technology has not been unsuccessful The temptation for industry is to take the artist

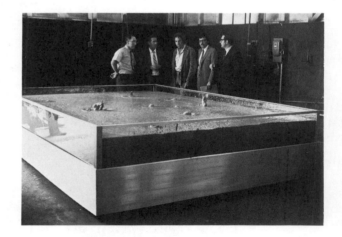

*Petrie Mason acted as Sound Collaborator with Rauschenberg.

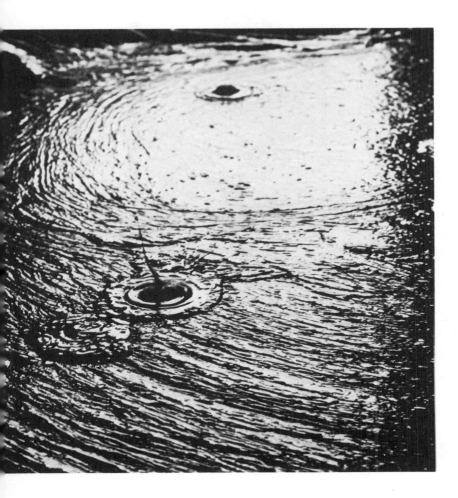

in superficially as the artist is appearing to them. If they can get just a little company color out of the collaboration, that is all they want *really* in most cases. They would do it rather than recognize this [broader] collaboration that Frank La Haye has talked about, where it is essential that humanities are considered in industry.

The thrill of making another dollar has carried us so far out of our lives and any real sense of what technology is about and what it does mean to us; what its influences are. We are so busy progressing that we have absolutely lost any realistic sense or even need for it. You can't trust that to a few Ford Foundation grants, for some people who go off and make a bunch of surveys and come back with some figures. It's got to be something really in practice. You were talking about the fact that industry needs a conscience, and it seems to me that the artist is the only person to hire because nearly every other phase of the professional world is already caught up in it, and the artist is the last, freelance professional person. The reason he is not involved, hasn't been involved, is because of the sense of dealing with the totality instead of a specialization. He is dealing with an intangible. With even the most successful artists, it would cost you more to keep him from doing what he wants to do next, if he wants to do it, than it would for you to support him. Now that's sure unique We are suffering a really serious hangover with technology. Taken abstractly, you can be anything but extremely proud of its accomplishments. I think we are still medieval about our uses of it. Applying technology is on the sunny side of witch-craft. It's all tricks, and so therefore we have an extremely serious waste. Technology isn't going to suffer, because technology doesn't have to have a heart or anything. Technology will probably work just as well in polluted air as not. In fact, there could be new developments where polluted air would be more advantageous to certain technological things; but not to people I think you immediately get involved with *Mud-Muse* on a really physical, basic, sensual level as opposed to its illustrating an interesting idea, either successfully or unsuccessfully, because the level of the piece, on the grounds of an idea, is pretty low . . . There is no lesson there It was to exhibit the fact that technology is not for learning lessons but is to be experienced. I've done technical pieces before and there is a much more self-conscious use of technology In *Soundings* I tried to start that out by just using the single image of the chair. And I took all the photographs myself and kept turning the chair, so there was no entertainment, supposedly. It's an entertaining piece, but there again I was working to *not* educate anyone. I wanted them to have the sense that *they* were half of the piece and so there was a

one-to-one response. If you walked in the room
silently, soundlessly, then nothing would happen, you
wouldn't see anything except your own reflection.
That's already a kind of idea. But *Mud-Muse* doesn't
have an idea like that because *Soundings* already had
a *lesson* and this is a very difficult area: it is hard not
to try to build in a lesson for me because I really care
so much about this whole area. We're really going to
be lost if we don't come to terms. The statistics on
how many years we have to live are frightening; they
are being printed every day, and we are learning. That
information is so much more available than it was,
even a year ago, but our rate of doing anything about
it is so much slower. This has absolutely to do with
our relationship to technology—our idea about the
world as being this great big apple or something
which is put here for us and if we get in trouble God
is going to take care of all that. God's not going to let
anything happen to his world because after all, he
made us. That's a lot of bull But there's not that
moral content in *Mud-Muse* Pure waste, sensual-
ism, utilizing a pretty sophisticated technology I
did earth paintings, [1953 or 1954] before the peak
of abstract expressionism. [3] Bill deKooning still
wasn't selling anything; he was showing in one of the
only five galleries in New York City that would show
modern Americans, and I went into these earth
things. There again, I didn't want to make a big thing
about that, but those paintings were about looking
and caring. If somebody had a painting they would
have to take care of it. It is just as simple as that. I
don't care what the motivation is, selfishly, unselfish-
ly, if they're taking care of it because they're thinking
more about the other person or they're taking care of
it only because they're thinking about themselves, the
result is the same, that they're taking care of it. And
those were pieces that would literally die if you
didn't water them. They were growing art pieces on
the wall, not on the ground, and I said this is art,
too

3

I don't see that A & T and E.A.T. are in competition,
so comparison doesn't say anything interesting except
on any level other than trying another way to arouse
people's sensibilities about the problem that is all too
obvious, only to people who know about it, who
unfortunately have to be in the minority I think
that what you are doing here is interesting in the
respect that E.A.T. has to play from guts. The mere
fact that E.A.T. has survived this long with so many
people still involved in it, means that it is a success. It
was an idea before its time, even though it was a little
late. It still didn't come from any vogue. You started
from the idea of art, and the fact that you were
proposing it, guaranteed a level of encounter that
E.A.T. isn't interested in because we had to do just
the opposite and say that we are not involved in

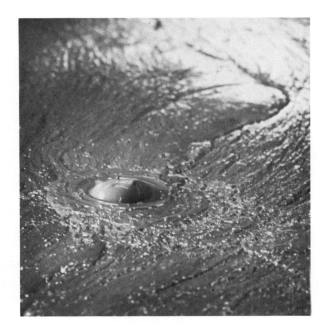

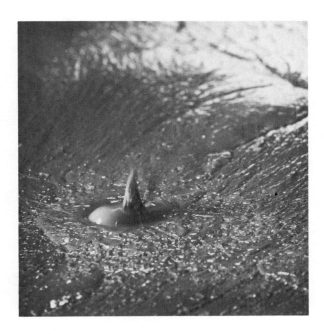

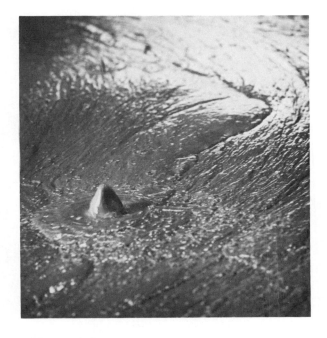

esthetics. We are not censors, we are not talent scouts. Anyone who needs help, technological help, ought to have it available for them, and we are catalysts who not only provide that help but excite other people, and an organization could get to them where an individual couldn't. We have really been criticized. Our biggest enemy are people who say, 'Now what is wrong with a Rembrandt?' You started from the other end, and because of your endorsement and the fact that you provided the possibility of a guarantee of a showing, it meant that if they committed themselves, then they would have to do it well, which we couldn't do. All of our things begin at one end and either die before they get to the other end or the work is finished. You started at the art end and drew all of these things to that, using the fact and your influence that the end result would be art. In E.A.T. we say, we can get something started but we can't promise you anything. You can only do what you did, by setting those limitations, saying that there is going to be an exhibition; the work will be shown and by such and such a time. But we couldn't do that sort of thing and just go on year after year changing I don't think your problems, though, have been any different from ours in spite of the different approach because we ran into the same thing—skepticism, patronizing. Then it is about the middle-management guy who is afraid even though the boss has told him that we are doing this. He can't believe the boss will admit it when he sees it . . . The research people are at the bottom of all industry. The research people immediately get interested. Those guys were able to watch air passing through mud and were involved. There was no esthetic judgment there about whether somebody ought to be doing this or not be doing this—with those people that you really rely on to do the work, and so does the company. The top guy is always just a little bit interested. If he is interested at all, he is excited by the prospect that there is going to be this collaboration which is unique, but the problem is the middle-man. When he gets home his wife is going to say, 'what did you do today dear,' and he will lose face unless he says, 'there's this funny-looking guy who came in today, God knows where from, and he talked strange, had some funny ideas, and asked me to do some strange things!' That does nothing for his status.

Mud-Muse starts from sound: An impluse is turned into electrical signal and then spreads out into three other breakdowns, depending on its dynamics. Then each one of those splits off in three ways. I don't want it to have a one-to-one relationship to the spectator. It *is* primitive but I hope in being primitive that it can be simple and the intent be legible. It is an existing fact that the world is interdependent. The idea of art very often tends to illustrate some solitary

independent concern recognized as isolation. It celebrates most often a kind of withdrawal or self-concern; and it's unrealistic. Even works that are about the other thing usually have a short life because they too get included in this other very precious work.

Gail R. Scott

Jesse Reichek
Born Brooklyn, New York, 1916
Resident Berkeley, California

By the summer of 1969, IBM had been contracted with A & T as a Patron Sponsor for more than a year, but we had not succeeded in placing an artist with the company. (We had proposed matches with Vasarely, Vjenceslav Richter, Eduardo Paolozzi and Jackson MacLow, and Robert Irwin had toured IBM's San Jose facility; discussion of these attempts can be found in the sections on these artists.) In July, Jane Livingston contacted artist Jesse Reichek in Berkeley to sound him out on his potential interest in working with IBM. Reichek is a painter and Professor of Design at Cal Berkeley; both the nature of his work and his published ideas on problems of urban design and education, and his esthetic philosophy in general suggested to us an approach that might well imply his desire and ability to work with computer technology. As early as 1951, Reichek wrote a short statement which appeared in *Arts and Architecture,* March, 1951, outlining an attitude which has continued to inform his work and thinking to the present time:

It is not what I see that is important to me. Vision is but one means of absorbing or projecting the construction of forces which is experience. The problem is in the way these forces are constructed; giving rise to the endless variety of experiences and acts of which we are capable.

Such experiences and acts as: space, color, light, motion, time, forms, moods, emotions, personal history, social comment, imaginary worlds, etc., etc., are indeed undeniable facts. But facts, regardless of the amount of detail they include, are limited truths. The process, ever-changing and limitless, by which these facts are constructed is the constant truth. A structured process is composed of especially formed, organized, and placed elements. These elements are placed according to the dictates of the conceived structural form; the conceived functions; potential functions; and possible functions of the structured form as a totality. The elements in addition to their position in the life, history, and assembly of the structural whole have a life, history, and assembly of their own. They are simultaneously a whole and elements of a whole. The structured process is not only conceived—the elements so assembled—as to allow for the continued existence of the whole, but the total structure acts IN the functions of the elements. The elements which make up the structured process besides having their own activities outside the whole, act independently and/or in relationship with each other UPON the whole. The total structure is established in a constant state of being re-established.

Reichek spent some time considering our proposal, and agreed to meet with us and members of IBM's Scientific Center at Century City, Los Angeles. Through our contact man, Dr. David Heggie, the artist was introduced immediately to the man he was to work closely with in

the ensuing months, Dr. Jack Citron, a physicist and mathemetician. [1] James Kearns, Manager of the Los Angeles Scientific Center, also met Reichek at the outset of his collaboration and has continued to be involved in the development of the project.

1

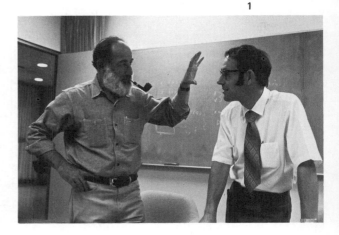

Citron, because of his background and special interest in the arts, particularly music, was receptive in principle to the notion of working with an artist, and he was enthusiastic about Reichek's ideas as they related to his work in the area of computers. On the basis of his and his colleagues' positive response to Reichek, IBM approved the project. A system was arranged by which, starting in September, 1969, Reichek would fly to Los Angeles at least once a month to meet with Citron and Kearns. The first few sessions were basically used in dialogue, to clarify the artist's intentions and determine what was feasible to do and how, given the possibilities and limitations of the computer. According to Reichek's initial description of his theoretical area of interest, the concept of *process* was critical. He was interested in the capability of the computer to transform visual images into series of configurations, based on a limited number of pictorial elements, or parameters. He wanted to determine whether the computer, once programmed with certain information which could somehow be translated into graphic form, could respond to that initially given information by some internal process, to create series of variations. The principle would be one of continuous, somehow self-perpetuating, input, transformation, output; that output would become input, transformation, output, etc. Citron seemed to indicate, during these early discussions, that many of the notions Reichek described were not possible. Reichek left with Citron a series of drawings to familiarize him with the kinds of figures and color systems he might want to work with.

Although most of the long sessions between Reichek and Citron were taped, and transcriptions made, it is difficult to cull from them excerpts which would communicate the technical gist of the problems they were confronting.

However, Reichek set down in a letter written in September, 1970, a sort of recapitulation and progress report of the project as he saw it; and in October, Citron wrote a technical description of the project at our request.

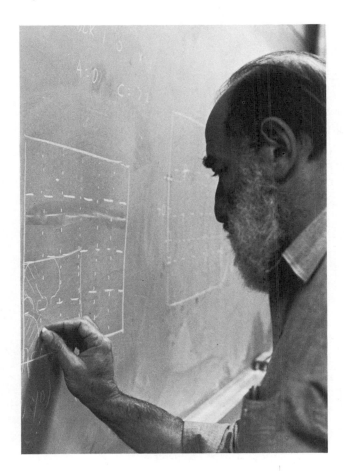

At the time of Reichek's letter, there had arisen some problems regarding IBM's willingness to continue supporting the collaboration after December of 1970; these considerations prompted him to formulate the statement. He wrote,

It seems to me that we now have sufficient working experience with this project to allow us to review where we are and indicate the directions it can take and the products it may produce. Since I view this project as a collaborative effort between the Museum, IBM and myself, I would like this memorandum to serve as a basis for discussion, modification and decision by all of us.

Background
When you called me in July, 1969 concerning my interest in working in a project with IBM as part of your Art and Technology program, I asked for two weeks to think about it. I spent those two weeks reviewing some of the non-technical literature on the use of computers, the development of my own work over the past 25 years and the direction it might take in the future. I also gave a great deal of thought to

the use of computers and related advanced technologies as it impinges on the situation and the problems of our present-day society and the manner in which they may determine our future personal and societal life-styles. I should add, that I have been concerned, as others have, with these issues for many years; both in my work as an artist and in my academic activities as a professor.

Briefly, these are the objectives I set for my participation in and the design of the project.

1. That while being aware and respecting the role of any tool in the process of generating any form, be it a work of art, a paper clip or a political system, this project should not be a display of technological gymnastics.

2. That the products which will be produced are to be determined by the logic made explicit from the study of my present and past work.

3. That the implicit meaning and the conceptual basis of my work must be embodied in the works coming out of the project.

4. That the manner in which the works produced are presented should be consonant with characteristics of the underlying conception inherent in my work and the nature of the tools used— the computer, etc.

5. That this project should not produce a unique work or several unique works: such a result would be a contradiction of the fundamental characteristics of the computer and do violence to the basic philosophical position which has guided the development of my work.

These statements need elaboration which we should do when we discuss this memo. More precise meaning can be derived from the description of the project and my proposals for what the project should produce.

In August, 1969 at our first meeting with Jack Citron, Jim Kearns and others from IBM, I sketched out some tentative notions for a project. There was an expression of interest and a desire to engage in it. Simply stated, the project called for the computer to be programmed using the rules of logic which have generated my paintings. The logic is such as to not only produce a painting, but is capable of utilizing the 'experiencing' of that painting in order to produce the next—ad infinitum. At a subsequent meeting with Jack, we thoroughly discussed and analyzed some 40 sketches of my work. (I've since added many

more as part of the project.) Jack kept these sketches for further study and at a later meeting we again discussed them. Jack developed a proposal which was approved and the work on programing began in January, 1970.

Since then, I have been meeting with Jack at IBM almost monthly. He has explained the non-technical aspects of the program he is designing and has kept me abreast of the problems involving equipment.

Present Status

The programming part of the project is well along. During our last meeting on September 3, Jack explained the coding system which would enable me to interact directly with the equipment to be used in making the three color separations. For the present time, the plan to have me interact with a display panel which would give me immediate visualizations, in outline form, of my instructions is being put aside. As I understand the situation, the necessary piece of equipment is not available now and Jack does not expect to have it for another six months. The idea at present is for me to work at a terminal which would feed directly into the color-separation machine. Although I shall attempt to do this, I feel that I will be greatly inhibited by the inability to see what I'm doing.

The color separation machine produces one color separation (approximately 4" x 5") in a half hour, i.e., an entire picture in an hour and a half. In addition, the use-time on the machine available to this project is restricted. This places important limitations on the speed with which I can see the results of my direct in-put (assuming that I find it possible to work effectively without a visualization device) and the number of works that can be produced.

It may be that these difficulties are insurmountable. However, with the exception of the production time required for the color-separation machine, it may be that increased access-time can be obtained and a visualization panel can be made available. We ought to discuss this and explore how this might be accomplished.

The many trips to Los Angeles, I imagine, were necessary in the early stages of the project. I would hope that it is possible to drastically reduce the number of these trips as the project progresses. I would think that at least one of the factors mentioned above, visualization, has a bearing on the alternative arrangement possible. We ought to discuss this.

Future Development

I see a two-fold development of the project, a main-line and a branch-line. The branch-line terminates at the Museum in May 1971 as part of the Art and Technology exhibition. The main-line terminates at the Museum in May or November 1972 as part of a retrospective exhibition of my work.

The Branch-Line

Taking into account equipment limitations and more crucially, the time required to produce separations and process them into color, I would guess that the most we could produce by May 1971 is 30 to 50 images. Jack may have a better estimate. My very tentative idea is that these images be made into transparencies and be back-projected on a fairly large sized screen. The projection to be continuous in a permutated sequence (1 2 3 4 etc., 4 3 1 2 etc., 4 3 2 1 etc. . . .) for the duration of the exhibit. We can fix the time of exposure for each image. Although I have not done the calculations I feel sure that, allowing for a reasonable time for the viewing of each image, the sequence would not be repeated at any time during the exhibition. At least one other alternative way of displaying the images on the screen could be to show all the images on the screen at the same time in a grid pattern. In which case the permutation would be the spatial order of their appearance. Written material as part of the exhibit and/or in the catalog would describe the project.

The Main-Line

In many ways this part of the project is more consistent with the characteristics of the computer and the conceptual underpinning of my work: it has four parts.

1. Retrospective Exhibition: which will show that this project is a logical continuation of the direction in which my work has developed over the years. It should show the historical evolution of the form and the structure of the image as well as the compatibility between the conceptual framework underlying my work and the basic characteristics and implications inherent in computer technology.

2. Multi-Editions: A display of a large number (100-200) of the images the computer has generated. These images to have been reproduced in runs of 5,000 each. This would be a manifestation of an affinity between a conception in art and an implication of a technology. The appropriate use of the computer as a tool is to produce a large number of varied works in large quantities of first-rate quality at low cost for mass communication. The computer's

capacity for diverse and duplicatable responses does not call for a unique work of art.

3. Book (s): Available at the Museum and elsewhere during the exhibit and later on. A book is another form of mass communication and the rationale is essentially that which was described above.

4. Film: To be shown at the Museum during the exhibit and elsewhere later on. Here too, the rationale described earlier applies since a film is composed of many and varied images and is another form of mass communication.

Finally, I want to say what I see as the most interesting and exciting aspect of this project as it relates to my own work and, perhaps, art in general. I've written about this more fully elsewhere. I see each of my paintings as a fragment and what one calls a 'body of work' as only a larger fragment. I believe this can be shown to be true of existent individuals and societies. What fascinates me about this project is that its development and the products it will produce is related to the evolutionary process in nature. Evolutionary 'design' in nature differs from the way man designs in that it is not 'design' according to external specifications. Biological 'design' is controlled by an internal basic mechanism contained within all species—the 'designed' object. Differences in species are accounted for by configurational changes of the basic mechanism; differences within species by rearrangement of the configuration. What I am trying to suggest is an analogy between the program for this project and a genetic code, the computer's capacity to store and arrange bits of information and DNA's similar capacity, the works we can produce and species variations, our process and the biological process.

Jack Citron's description of his project with Reichek is as follows:

Background
Over the past few years, a number of artists have been able to make use of computers in one way or another. In each case, they were given a predesigned system and told how to use it or what its inherent capabilities and limitations were. The artist was then free to experiment within the defined framework presented by the computer hardware and software.

In the present case, the approach is quite different. We have nominally entered what Joseph Schillinger called 'the fifth morphological zone in the evolution of art.' Reichek's work is in some ways ideal for this because his principal thematic component—what he refers to as 'process'—is methodology. And methodol-

ogy is the essence of science and technology. Our goals can then be described as follows.

The first step is to analyze the Reichek style—not in anticipation of mimicry—but to isolate a complete set of creative components which could serve in all three phases:

1. recording or notation (analogous to a musical score)

2. modification (variations on a theme is equivalent to changes in these basic components)

3. synthesis (conversion from these components to mathematical and logical relations to geometric relations to the final material form)

Next, a user-oriented system is to be designed in which the artist would manipulate the creative components like words in a language to get his ideas into a computer. The computer would then use this information to control an output device to produce the defined piece of art. It will also be possible to describe 'temporal' modifications of the input which in turn would cause the computer to produce an endless succession of pictures based on the 'original'. The precise methods of interaction with the user, the forms of intermediate and final computer output, and the process of converting the latter into a final product are also to be defined in detail and depend completely on the particular hardware that is available for our use.

Analysis
An examination of forty or so paintings revealed a number of logically related features. Since each work was carried out on graph paper, exact size relationships were readily apparent and Reichek's intuitive methods of handling strict mathematical symmetrics could be easily seen. Color, while restricted to red, blue, and black, was clearly used to accent the symmetry in each work by employing permutations as accompaniment to the symmetry operations on the spatial material. This spatial material in turn consisted of three distinct classes:

1. framed figures with two possible orientations inside areas with boundary sizes making some simple ratios with the background size

2. vertical and/or horizontal lines usually in paired colors and one unit wide

3. solid areas really marking the absence of the above two classes

Three types of works also appeared in which the featured elements were:

1. Just figure blocks with an interplay of the symmetrics relating block position, figure orientation, and color permutation

2. Just lined areas again with symmetry relations between areas to complete a theme

3. Both figures and lines where the latter play a definite role in 'connecting' the various figure blocks

System design

An initial estimate as to the number of possible Reichek paintings is both enlightening and astounding. If only a 40 by 40 grid is considered and we simply ask how many ways three colors can be arranged, one to a square, the answer is a number containing 764 digits! Notice the number one million contains 7 digits, a trillion is 13 digits long, and even an octillion is 'only' a 28 digit number.

At least two important conclusions can be drawn from this. The first and obvious one is that there is no danger of 'running out' of something to do in this style. The second and more subtle one provides information as to the kind of user control that is necessary. A common tendency among many of today's artists would be to allow random choice from this enormous backlog of possibilities. However, thermodynamic arguments concerning large ensembles show clearly that the results would be most disappointing and, even more important, would show no relation to Reichek's main theme: 'process'! Thus control must be exercised over the basic components isolated in the section on analysis by establishing mathematical/logical operations and operators which can then be used to specify unique works or practically infinite classes of works by allowing the artist's mind to dwell upon the 'method' to be used or developed without the distractions inherent in any extra-logical approach.

Because the computer we are currently using is located on the East Coast (Cambridge, Massachusetts) and our access to it is via voice-grade telephone lines through a typewriter-terminal, input to the system must be in some form of typed code. The implementation currently under development compresses the necessary information into six types of statements.

These serve the following functions:

1. establish background grid size and color

2. specify up to four types of spatial periodicity

3. define blocks uniquely or with reference to previously defined blocks

4. set up figure information for a block

5. set up line information for a block

6. describe symmetry operations when developing new blocks from old ones

Interaction with the developing composition must also be carried out through the terminal. We hope to be able to use a graphic terminal to make this easier, but may have to rely on a typed printout of the developing picture.

The output from this phase will be a computer produced tape which contains a new representation of the picture. This tape could then be used as input to another computer which in turn would control either a milling machine or a photo-composer to produce engraved printing plates or color separated film transparencies. This secondary output will then be used to produce the final results in the form of conventional visual products.

At the time of this writing, the outcome of the Reichek/IBM project is dependent upon the corporation's willingness to extend their commitment into 1971.

Jane Livingston

Vjenceslav Richter
Born Drenova, Yugoslavia, 1917
Resident Zagreb

Yugoslavian architect and sculptor Vjenceslav Richter has been developing for the past few years what he calls "system sculpture." In his first one-man exhibition at New York's Staempfli Gallery in November, 1968, he showed twenty-six works, each of which was constructed of thousands of uniformly shaped rectangular aluminum components. These measured one-fourth inch square on the face and two inches in depth. Each sculpture was composed according to a mathematically defined system, employing this basic unit or "mono-element," as he calls it, to build diverse three dimensional, often curvilinear forms. Ideally, Richter wishes to mobilize the sculptures by means of a computerized mechanism called by the artist a "relief-ometer" which would allow each mono-element to be moved back and forth according to a predetermined program, rendering a perpetually changing "membrane" of forms not unlike a rippling surface of water. The ultimate extension of this notion for Richter would be to enlarge the size of the basic unit into architectural dimension, eventually culminating in "system architecture," his dream for future urban planning.

By 1967 Richter had already devised a mechanical method for moving *sections* of a sculpture, but had been unable (for lack of financial support and technical expertise) to develop an instrument to program each component individually and thereby to achieve complete kinetic versatility.

We invited Richter to come to Los Angeles to discuss the problems first hand with several contracted companies—IBM, Wyle Laboratories, Litton Industries and Information International, each of which was apparently capable of executing the sculpture.

By the time Richter arrived on April 2, 1969 the possibilities had been narrowed down for various reasons to Litton Industries, where Richter was promptly taken. He met with Fred Fajardo, from Public Relations and Cy Schoen, a division coordinator who advised that Litton's Mellonics division, specializing in computer products, could handle the programming while a physicist at their Guidance and Control Division could assist with the mechanics. That afternoon and the following day Richter and a team of Litton's scientists and technicians entered into lengthy problem solving sessions. Dr. Richard Feynman was present at one of these meetings and, after discussing alternative solutions for the engineering of the system, it was Feynman who convinced Richter that a compromise was necessary.

Litton's experts agreed that programming the piece was a relatively straightforward procedure, but the central difficulty was devising an internal micro-mechanical system to actually move each unit while maintaining the four-sided external integrity of the form. Richter was insistent in his refusal to close off from view one side in order to house the motor. He did, however, agree to a compromise in the scale of the intended sculpture in order to facilitate certain otherwise insurmountable obstacles. After explaining all details and setting forth his demands for the performance and form of the piece, he returned to Yugoslavia while the Litton staff proceeded to project a cost estimate.

The ensuing financial projection was staggeringly high due to the fact that the "state-of-the-art" of this type of micro-electronics is not sufficiently advanced to be economically feasible for such esthetic implementation. Moreover, the resulting sculpture would have been a considerable compromise from Richter's original proposal. For these reasons, which we conveyed to Richter, we were unable to carry out the project.

James Rosenquist
Born Grand Forks, North Dakota, 1933
Resident New York City

James Seawright
Born Jackson, Mississippi, 1936
Resident New York City

We talked to James Rosenquist regarding A & T in April, 1969, and he expressed enthusiastic interest about it. In particular he wanted to tour Ampex, M.G.M. (a company not contracted) or an aerospace industry where research was being conducted in environmental control for space travel. The aerospace industries participating in the program were already working with other artists, but when Rosenquist came to Los Angeles two weeks later he toured Container Corporation, Ampex and RCA. However, none of these companies inspired the artist, and he returned to New York without presenting a proposal.

MT saw James Seawright in New York and arranged for the artist to visit General Electric's Nela Park facility in May, 1969. Seawright required a specific type of technical assistance—a particular kind of lamp and the hardware for a control system, in order to execute a new series of light sculptures. He toured G.E. with Hal Glicksman and was certain they could accommodate his needs. Meanwhile, we had been in contact with Dan Flavin who toured G.E. and went to work there in the Summer.

Richard Serra
Born San Francisco, 1939
Resident New York City

By June, 1969 we had taken six artists to Kaiser Steel Corporation (Len Lye, François Dallegret, Philip King, Jules Olitski, Robert Smithson, and Mark di Suvero) without effecting a match. James Monte, who had by this time moved to New York, urged us to invite Richard Serra to visit Kaiser's Fontana division. On June 10, HG and Serra toured the facility, and the artist was enthusiastic about what he saw. Shortly thereafter, he submitted the following proposal: [1]

1

PROPOSAL FOR LOS ANGELES COUNTY MUSEUM

IN CONJUNCTION WITH KAISER STEEL

The work will be related to both the physical properties of the site (Kaiser Steel) and the characteristics of the materials and processes concomittant to it. The work falls into three basic categories:

A. casting in location
B. overlaying processes
C. constructions.

A. Casting: The molten metal for casting is to be brought directly from the furnaces by turret car to the yard. Sand casting molds are to be used to control the pouring flow in location.

 1. Slabs are to be embedded and supported in place in the molds.

 2. Shapes are to be derived from direct pouring.

B. Overlaying Processes: Specific diverse processes are to be superimposed in final states. The juxtaposition is to point to the specific characteristics contained in each step and method of processing. Work will assume a holistic striated form. Stacking will be the control.

Example: poured form overlaid by in crops, hot rolled slab, galvanized sheet, cold rolled, discarded gangue, etc.

C. Constructions: Work is to be erected in place. Slabs, hot rolled (ploom), to be used. Principle of work is to rely on physical tension, balance, and gravity.
 Example: Stonehenge type construction.

We invited Serra to take up residence at Kaiser, and on July 21 he commenced work. After negotiations with Kaiser management and supervisory staff, it was agreed that the artist would work, at certain specified times, in the "skullcracker" yard. (Here various scrap materials are broken down so as to be reprocessed.) To do this Kaiser provided the artist with an H-shaped overhead magnetic crane, an experienced crane operator and several construction assistants. Bill Brinkman, foundry foreman, was assigned to oversee the collaboration; he became an invaluable assistant to the artist. For the next four weeks Serra worked closely with this crew of assistants, often during the night shift, when the crane was available. He usually positioned himself on the ground near the location on which the piece was to be built, signaling directions to the crane operator standing at the controls in an overhead tower.

In his work of the past two years, Serra's primary structural method has been that of propping, leaning and stacking various types of massive materials—lead sheets, rolled lead columns, steel, and giant logs. His basic approach to these methods is empirical, combined with an intuitive understanding of the physical properties of gravity, tension and balance. In all these works, among which *One Ton Prop (House of Cards)* and *Sign Board Prop,* both of 1969, are notable examples, the notion of *process* is inherent to the sculpture and as important as the final construction resulting from the accumulation of individual components. The artist best explains his approach at Kaiser in the following statement written after his period of collaboration at the plant:

Skullcracker Stacking Series (name of yard)
Work at Kaiser Steel (Fontana, California) was erected with an overhead magnetic crane. The structures were not conceived in advance. A hand language was learned. (Collaboration existed between the operator and myself.) Material primarily utilized: crop, the waste product of the hot roll mill. These large chunks of steel cut from the ends of slabs provided a variety of nonfixed relational possibilities.

The scale 15 to 30 feet in height and weighing 100-250 tons was related directly to the potential of the place. The problem: to avoid architectonic structure, i.e. to allow the work to be both dense, loose and balanced without relying on previous forms or given methods.

The series involved the possibilities of constructing with weight, i.e. gravitational balanced weight overhead as support. This series was further abstracted with the resultant lead structures made in New York in the fall.

Direct engagement with the materials (crop, plate, slab, billets, stools, etc.) that is, the elements in-

volved, enabled concrete identification with each step in the process. Paradoxically the solutions to the problems of construction (stacking) appear rational, although the process of finding these solutions was not. The apparent potential for disorder for movement endowed the structures with a quality outside of their physical or relational definition. Complete disorientation occurred daily. Work that both tended upward and collapsed downward toward the ground simultaneously was o.k. In all twenty structures were erected in eight weeks—the pieces were put together and taken apart.

Technology is a form of tool making (body extensions). Technology is not art—not invention. It is a simultaneous hope and hoax. It does not concern itself with the undefined, the inexplicable: it deals with the affirmation of its own making. Technology is what we do to the Black Panthers and the Vietnamese under the guise of advancement in a materialistic theology.

It was in the context of this past body of work and with the above stated attitude that Serra directed his efforts at Kaiser. He proceeded by trial and error, and, after establishing a rapport with his crew and experimenting with the equipment, he executed about twelve constructions in a period of two weeks of intense activity. The procedure would be to erect a piece, and, if he considered it successful, to have it recorded photographically when possible. The structure was then dismantled. These were process experiments which would later be evaluated by Serra.

The first piece Serra executed involved piling sixteen "stools"* in a cantilevered stack. Each stool weighs approximately six tons, and the piece as a whole weighed close to one hundred tons. This massive amount of material, compacted into dense rectangular forms and erected on a tilt, produces a powerful sense of precarious balance. [2]

2

*A stool is a rectangular block of cast iron used in the steel-making process to close off the bottom of the mold into which molton iron is poured.

From this method of stacking the elements according to a regular pattern, Serra progressed into more experimental stacking processes, following a loosely organized distributional procedure and using varied steel materials. He arranged "crops," or "fish tails"† in a loose pile, low to the ground; over this he laid large steel slabs or sheet plate at an angle from the ground forming an incline. [3, 4] As he worked along this line, he exerted increasing control over the stacking method, allowing more and more complexity in the structural format. He would pile together a loose arrangement of the fish tails against which a twenty foot steel slab was propped, one end on the ground; on the lower end the mass would be counter-balanced. This method of organization was continued until an acceptable structure was produced. Some of these pieces reached to a height of twenty-five

4

3

†In the steel making process, the blocks of steel are cropped and squared at either end before being sent to the rolling mills; the cutoff ends, irregular in shape are called crops or fishtails.

feet. Six works of this type were executed [5, 6], some
of which included counterbalanced plates of steel thrust
out laterally. [7] The works in this group are anti-archi-
tectonic; the massive steel components are disposed so
that their relational quality defies structural logic.
Instead, the works evince the process by which they
were built.

5

6

7

After one month Serra left for New York with the intention of returning in a few months to continue working. He was not able to travel west again until January, 1970, and then spent only a few days in Fontana. He searched around the Kaiser plant for a new type of steel material and eventually located a vast yard of "slag," which is an impure oxide residue from smelting and takes the form of giant boulders. These he had taken to the skullcracker yard and with them executed three works, again using methods of propping and leaning. [8] However, the work bogged down, apparently due to the lack of proper assistance.

It was agreed that Serra would return to Los Angeles early in the Spring of 1971, when he would execute a sculpture, or a series of works for the Museum exhibition, with the help of Kaiser's equipment, men and resources. In September, 1970, Serra indicated that in addition to erecting one of the works from the "skullcracker" series, he would also like to do a piece relating to his more recent thinking; the idea derived directly from what he had learned about steel at Kaiser. It is to be installed on a selected incline of the Museum park grounds. The place selected for the work will be measured; this variable will determine the shape and length of the work. Once the land is measured, a plate is set into the ground so that it is diagonally bisected, revealing the elevational fall (i.e. the height and length) between two pre-determined points. (At zero elevation the work negates itself; at a 45° slope the shape is a square.) Once the piece is installed, it is cut along its bisecting contour, flush to the ground, and allowed to fall. The resulting shape reveals on one edge the contour line of the ground. [9]

Gail R. Scott

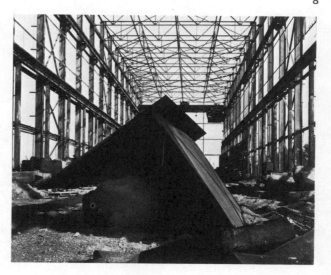

8

9

Jane Livingston met with Tony Smith in New York in April, 1969 and suggested to him the notion of doing a work for A & T. Smith talked about executing a "soft" suspended sculpture (he used the term *pneumatic* in describing his intention), using perhaps some sort of inflatable vinyl or plastic in biomorphic configurations. Smith later discussed this idea:

> I had wanted to do a project that was technical in nature in that I wanted to make a certain type of structure in which all of the compressive elements would be made of air or gas in compression, and therefore all the materials would be in tension—that is, whatever contained the air would be in tension, and then there would also be some lineal elements, also in tension.

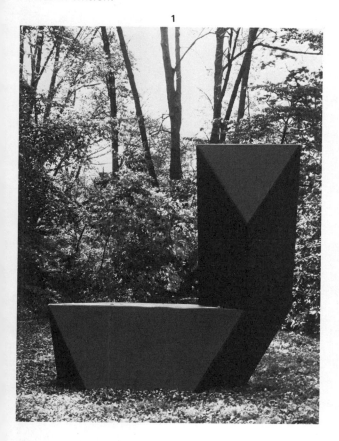

1

Since none of the corporations contracted to A & T were equipped with the kind of technology or materials appropriate for the kind of structure Smith described to her, JL encouraged him to consider working with Container Corporation of America. Tony seemed interested in this possibility and mentioned in particular his long-standing interest in doing an architectural-sculptural work using fourteen-sided modules. It occurred to him that this might well be executed in paperboard.

Smith went to Aruba for several weeks, and then to the University of Hawaii in June. In the meantime, Hal Glicksman investigated the possibility of soliciting a corporation that could execute an inflatable or pneumatic sculpture, but we finally abandoned the pursuit.

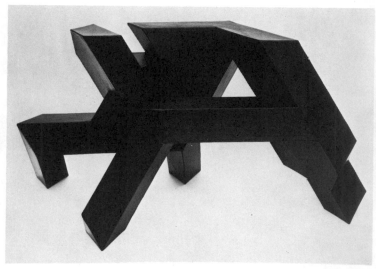

2

At the same time, we talked to Anthony Marcin, Public Relations Manager of Container Corporation in Chicago, about collaborating with Smith. Marcin discussed this with his colleagues and indicated that they were enthusiastic. (Several artists had previously expressed interest in CCA—specifically Oyvind Fahlstrom, Francois Dallegret and Les Levine—but their proposals never developed sufficiently.) Marcin was to be unusually cooperative throughout the collaboration and seems to have been directly responsible for many of the important decisions which enabled the project to come to fruition.

Smith stopped in Los Angeles en route to Hawaii; he discussed the work in some detail with us, still with an idea of using the fourteen-sided module. Then in a letter from Hawaii of June 23, 1969, he said:

> My reason for temporarily abandoning [the 14-sided solid] as the module for a piece is that it would become too much of an engineering feat. I would prefer to achieve esthetic and psychological effects. The ingenuity of the Corporation's engineering and technical resources would be called upon to help me achieve such results. As I once said, in speaking of *Amaryllis* [1], I wanted to make a cave. Since I have all the maquette components from which I intended to develop the piece for the [Hawaii] campus, and for which I now have no immediate use, I'll start to work with them today on your project

The maquette modules referred to were of two geometric configurations—the tetrahedron and the octahedron; this combination was to become the basis for the artist's final conception of the piece. In speaking further about the history of his interest in making a cave-like work, Smith said,

> I've always had a certain interest in caves, and one of the reasons that it was particularly important in this case was that I had started a series of pieces which ended with the making of a piece called *Gracehoper* which is in Bennington, Vermont. [2] This piece has

certain inner forms that struck me as not necessarily cave-like in themselves, but they suggested the idea of making a further piece in the series which would literally have more of the sense of a cave. Around that time I saw a photograph of an eroded part of the desert in Arizona or somewhere in the West and it gave me something of the sense of the way in which I wanted to develop the piece. [3] Now, it would have required so many components that I wanted to use the same parts that I had used in the previous piece, but the model was kept by the people who built *Gracehoper* and I realized that I didn't have the energy to start making the great number of components that would be necessary to start a new model, so

I always felt somewhat frustrated in that *Gracehoper* was probably done in 1962, and I would have made the following piece, which I had thought of as more cave-like, at that time had I had the components, but it's very boring to make those little parts and so I never did make that piece. So it's just something that had been in my mind for a long time and immediately before going to Los Angeles to discuss this project with Jane Livingston, I had been in Aruba and had visited some bat caves there. I think that when we spoke of the possibility of doing something for the Container Corporation, I recalled the previous intention of making a cave and then coupled that with the very recent experience I had in caves in

3

4

5

Aruba [4], so it seemed natural that these two thoughts should revive an interest in caves* You know, if I'd had to make all those small components myself, I wouldn't have done it—there are thousands of pieces in that form and unless the pieces were stamped out, as they were by the Container Corporation, I would certainly never have done it on my own.

Over the July 4 weekend, Pete Clarke, a structural engineer for CCA in Los Angeles, and JL went to Hawaii to see Tony Smith. Smith had several partial models, formed with tetrahedra and octahedra, which served to demonstrate the fundamental principle of the structure. Clarke indicated that these units could be easily die-cut in flat corrugated board and then assembled individually and built with no lock joints or tabs (Tony was adamant about avoiding the use of lock joints) by gluing the units together. Tony stressed that the feeling he wanted in the cave was of softness—he often made the analogy to the texture and color of a wasp's nest (and indeed presented Jane Livingston with a gift of one months later). [5] He

*At one time, Smith considered titling the piece Guadirikiri, the name of a specific bat cave in Aruba. The work was never, however, definitely titled.

felt strongly that the natural brown color of the board should remain untreated, and that the surfaces should retain the quality of slight rippling imparted by the subsurface corrugation. Smith later described, from a technical point of view, his original intentions for the Container Corporation project:

> In my work I use small cardboard maquettes, actual little tetrahedra and octahedra, and I paste them together with tape in order to arrive at the forms of the work When I had worked on a small scale in the past, [the original model] would be made into a model with smooth sides from which the steel fabricator works; that way individual components are actually absorbed in the final work. But it seemed that in making something with actual cardboard boxes, I was doing exactly what I do on the small scale and I felt it might be interesting to get the effect of a soft sculpture—that is, soft in the sense of using a material that isn't durable or which is relatively weightless.

> Space frames of the sort that I use have been used in architectural structures. It's just that they've been fabricated by using struts which are joined at the corners—at the meeting of the edges of the elements. My intention was to use the complete component and simply glue it—glue the surfaces in the way that I had been in the habit of doing with my [maquette] units. This actually is a different type of structure than a structure which is based on lineal elements or struts which are fastened at the joints. In other words, *there isn't any structure except the components from which the form has been made.*

During the Hawaiian visit, Tony talked of introducing light, in shafts, into the cave, and gradually came to emphasize the importance of special illumination in the work. He characterized the effect he visualized by drawing an analogy to nineteenth century stage lighting:

> Sometimes one sees an effect—in caves, actually, if there's a crevice between rocks and light comes in—of the light entering in the form of a sheet rather than as a beam. It's broad Sometimes [this effect] is used in the stage. There was a great stage designer at the end of the nineteenth century by the name of Adolphe Appia who did some sets for Wagner. He used some sets which were made up almost entirely of light—that is, there were no other elements used very much, and his lighting had somewhat the effect of sheets of light. [6, Set for *Mime's Cave,* in *Siegfried,* 1896] I've seen it on the German stage also—they'll block out a certain part of the stage by a kind of curtain of light [This technique] usually has been used in order to create space—create planes of space, receding planes of space.

Smith at one point had thought of introducing sound

into the work but said in later conversation that he was not concerned with sound or tones *per se,* but with the sensations of hearing produced by vibrations in the air. He was interested in the phenomenon encountered in bat caves, when a person's entrance can prompt mysterious sonic waves and fleeting air displacements as the bats are disturbed. Smith investigated the state of scientific knowledge regarding this phenomenon, and located an expert in La Jolla, California.

It was agreed in Honolulu that Pete Clarke would have some small, die-cut units made (four inches on a side) of thin, white paperboard, for Tony to use in constructing a mock-up in Los Angeles. We were at this point thinking definitely of the work for display at Expo, and on

6

July 17, sent Tony plans of the New Arts Section of the U.S. Pavilion.

Smith in the meantime sent us some rather obscure polaroid shots of details of modules fitted together, to show us in a general way what he was after. These snapshots proved to be very revealing of Smith's primary intention for the sense of the work.

In a letter dated August 11, from Tokyo, Smith said,

> This is about the polaroid photographs. What is shown is not intended as the piece. It is what a piece of it might be like. It is made up of about 120 modular units in the ratio of about three tetrahedra to two octahedra. I think the final sculpture should have more than four times that number of units—at least 500 in all. [The Expo sculpture finally comprised 2500 units.]

> . . . The girl who made the components also took the pictures, and, although she has no idea of what the piece is about, she insisted upon including several photographs which she thought were good. She thought she had failed completely in the close-ups taken the next day, but they are very close to what I really want

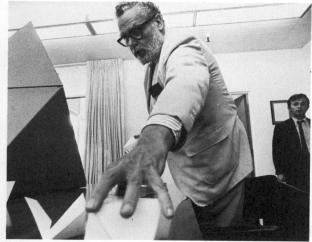

and thus Smith never actually worked with the full-sized units. Moreover, when the corrugated modules were made en masse, they had lock joints. This was in violation of the understanding reached between Smith and Pete Clarke in Honolulu, and displeased the artist considerably.

Tony remained in Los Angeles for about three weeks to make a small-scale maquette for the work. This was erected on a ping-pong table he set up in his suite at the Chateau Marmont. Several local kids were pressed into service folding modules and taping them together. Somehow there were never enough modules. Two rush deliveries were made during the course of Tony's stay here, as he used up cardboard units—they were rapidly swallowed up into the model and a temporary dead-end would be reached—but the five by seven foot model was finally completed and brought to the Museum.

Tony returned to New York in September to resume teaching at Hunter College; he had missed several classes on our account.

In September, 1969, Smith, JL and MT met for most of one day with the Expo designers at their New York headquarters. We were able at length to decide on a space for the work, after several alternative plans were considered and abandoned, and it became clear that a new model would have to be made. It also transpired that the ceiling height was considerably lower than we and the artist had thought—thirteen rather than sixteen feet.

A funny thing happened. While my assistant was making the [small modules], I decided that it might be better to use an altogether different modular unit—that of *New Piece* (shown at Philadelphia in 1966 and 1967). I thought that this might be an opportunity to try out, on a large scale, a system which has intrigued me for many years Then I showed the drawing for the [U.S.] pavilion and the photograph of the model to an architect in Honolulu who had worked for Wright just after I did. He remarked on how fortunate it was that the pavilion had been designed on my own triangular module. This made me realize that the other scheme [the 14-sided design] would have been impossible!

In August, 1969, the artist toured the Container Corporation corrugated plant in Los Angeles. CCA had made for him two full-size corrugated mock-ups of single units—one tetra- and one octahedron, two feet on a side, with no lock joints, which Smith felt were precisely right. Container Corporation agreed to produce about 500 full-scale units at their Los Angeles corrugated plant, for Tony to use in making a model, as well as making several hundred four-inch, carton-material modules. The former commitment was never fulfilled,

During our session at the Design Team Headquarters in New York, Tony was adamant in characterizing the work as sculpture, as opposed to architecture. It was clear at this point that he had resolved in his own mind the essential nature of the work though it still existed only conceptually. We were all extremely concerned about the problem of handling the enormous traffic flow through the U.S. Pavilion, but Tony seemed to feel he could design the work to accommodate the expected 10,000 visitors per hour. However, he did have to make important sacrifices. He was to say later,

My intention was to make a piece of sculpture which emphasized the negative space rather than the positive form. The other pieces I've done have been placed usually out of doors or even if they're indoors, they tend to be compact: I think that even though the negative space has been used in some of them, the main effect is one of massiveness. I have always been interested in the volumes made by the pieces, and I felt that in this case it would give me an opportunity to deal with these negative spaces as the main element of the sculpture itself. So I set out to do a piece where I was defining the negative spaces as much as possible. Of course, when I began, I didn't realize that

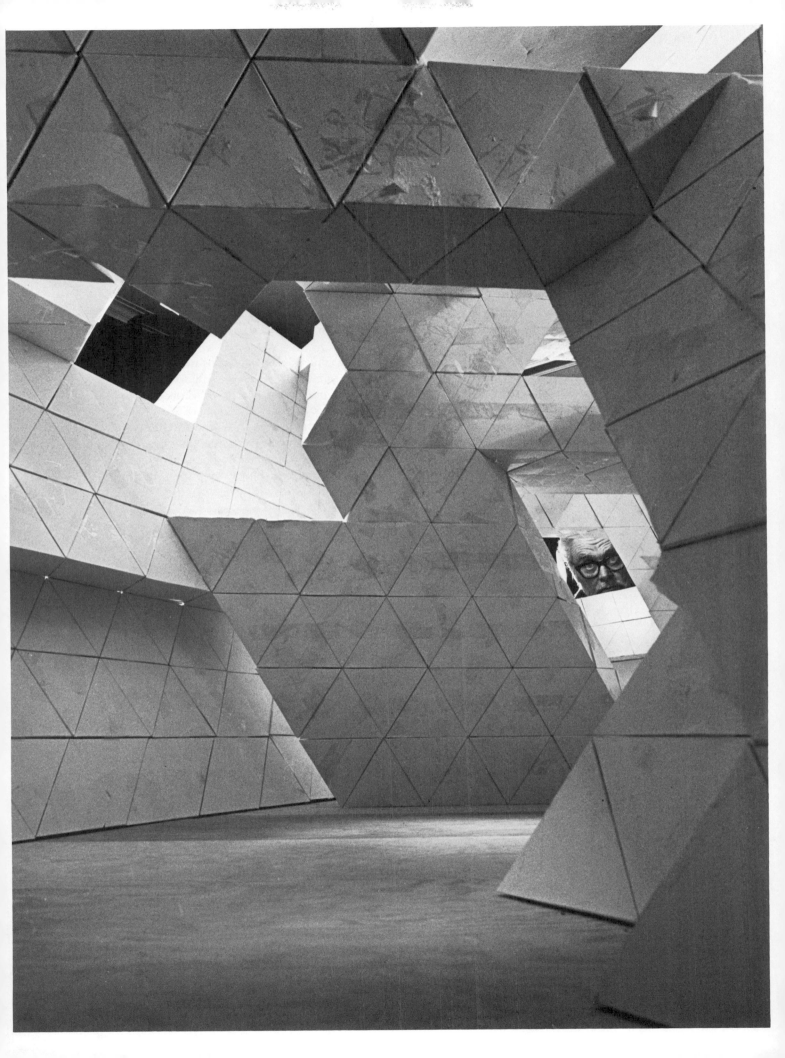

such crowds would be involved, and so in the end I wound up getting a space that's much more architectural than what I had hoped for. I had hoped to mold much more sculptural space than has actually resulted; but when I began to learn about some of the problems of just moving the people through the pavilion, I had to open the space so as to make what is almost a passageway now—which wasn't my intention in the first place. I had intended to do something much more labyrinthine, something which would have many choices of movement rather than a guided movement. So I think the piece probably loses a good deal because it had to be smoothed out to such an extent—I couldn't have any projections or indentations on the lower part of the space, because people could fall or be pushed into places, and then the actual ceiling height of the pavilion was lower than we had originally hoped, and again we lost some of the possibility of molding the space above peoples' heads simply because the ceiling wasn't tall enough to allow for it. So in that sense, I think that the space is closer to the space of buildings, perhaps than was my intention originally.

In November, 1969, Tony received the modules necessary to build his second, incredibly complex model for Expo. By the end of the month he began work on the model, accomplishing it in a matter of days. [7] At this point, through the offices of Marcin in Chicago, William Lloyd, Chicago-based manager of design for Container Corporation of America, was brought into the project. Lloyd visited Tony at his home for one day just before the model was crated for shipment to Expo, and on the basis of that meeting he was able to direct the immensely laborious construction of the work at Expo 70. Lloyd and Smith seem to have quickly established a sense of mutual trust, and Lloyd thus made a series of decisions later for which the final work owed its existence.

The shipment of components to Expo consisted of the model, several palletized flats of precut cardboard and three fifty gallon drums of glue. Part of the cardboard units were made in Los Angeles—amounting to 3000 tetrahedra and 1500 octahedra; the rest—another 100 cubic feet and some 3000 pounds of cardboard—were made at the last minute in Container Corporation of America's Cincinnati plant and shipped from there to Expo.

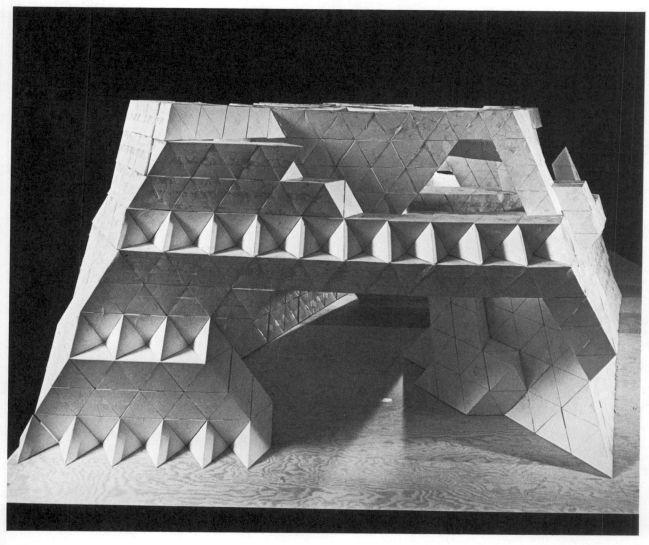

7

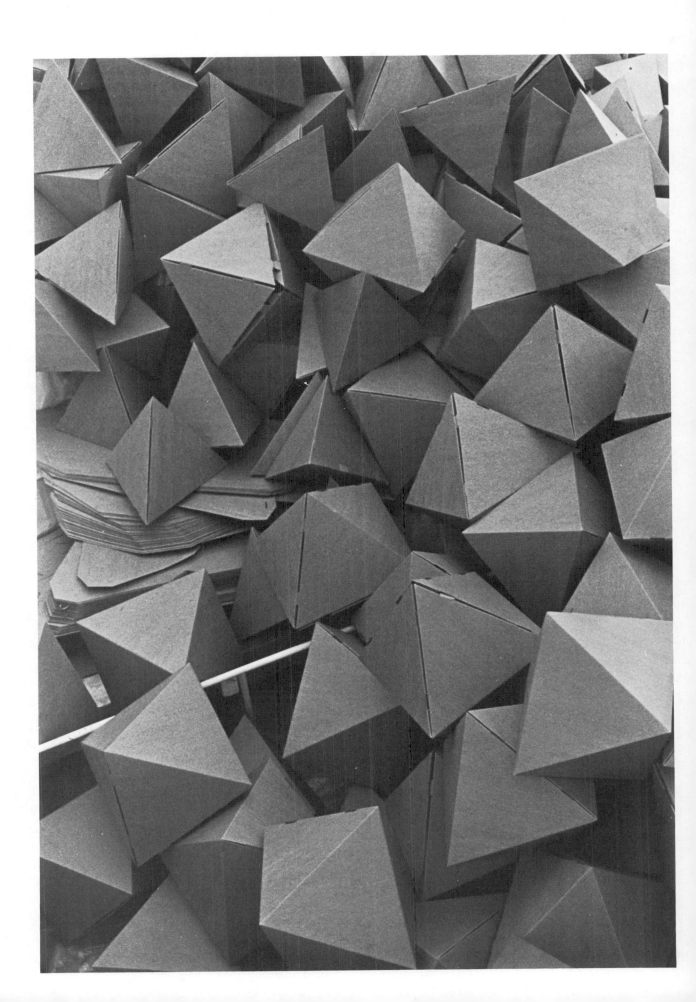

8

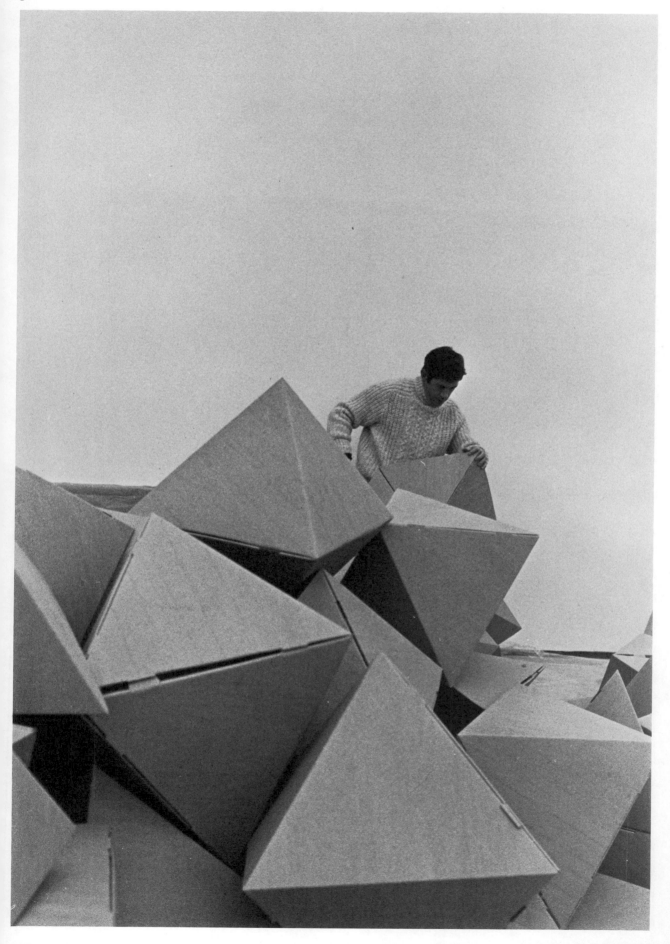

Bill Lloyd and his wife arrived in Osaka February 16 to begin the five-week process of constructing the work. [8] (We had originally allowed two to three weeks for this task.) Several days and scores of laborers were required simply to fold and secure each module, before the units could be taped together and mounted. The work was half completed by the first week in March, but it had become increasingly apparent that the effect was not at all satisfactory. The interior surfaces were uneven at best, and the overall structure was precarious. It was decided to tear it down and begin again, using an improvised system whereby the previously insoluble engineering difficulties were overcome. Smith feels that many of the problems resulted from the way in which the modules were made to fit together. He said,

> . . . When the [Container Corporation] engineer came from Los Angeles to Honolulu last summer, we established in about five minutes that the pieces were going to be glued, not put together with lock joints, and when he showed me the mock-ups in Los Angeles later, they were as we had decided to do them—they were glued. And even the shop drawings which they gave me were made in order to be assembled by gluing; but when Bill Lloyd went there to put the piece together, they were made with lock joints rather than glued. That's why they had to tape them I feel that [the lock joints] mar the piece, because you see the spaces where the lock joints occur, and in the end they had to put tape over those joints too. So I think the whole piece loses a good deal by being put together that way I think the reason that the structure actually sagged or collapsed, whatever happened to it in the course of making it, was because . . . the components weren't made as they were intended to be made.

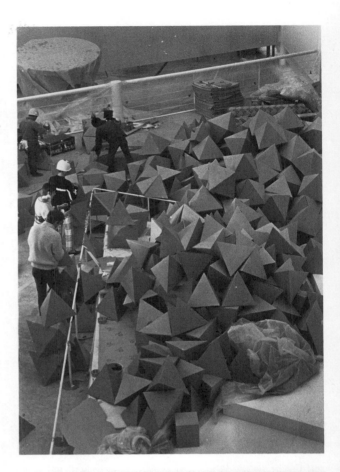

The lighting of the piece was achieved under the supervision of Lloyd and the USIA's lighting contractor, with a view to approximating Smith's stated effects as closely as possible. It was not totally successful. Smith stated, "I think I wasn't able to convey to the engineer [Bill Lloyd] the type of lighting I wanted. I wanted a rather sheetlike light, whereas from the photographs [of the Expo work], it seemed as though they used . . . two spots, just two rather conical shaped lights." (Actually, there were four spots used.) When the lighting had been completed, it began to appear that the cardboard surface was simply too vulnerable, in the sense that one was psychologically drawn to *touch* the walls as one walked through; obviously, under the circumstances, the work could not long withstand such handling. It was one of the Design Team members' suggestion to paint the entire interior of the cave with red or blue phosphorescent pigments and introduce ultra-violet light in place of incandescent light, with the notion that the spectators would then focus on the effects of illumination as such, rather than on the raw cardboard surfaces. A call was

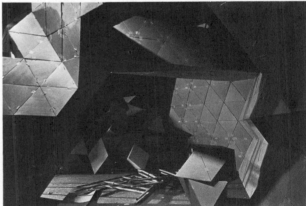

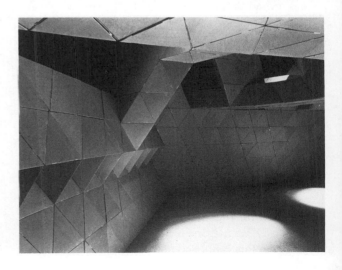

9

made from Bill Lloyd in Osaka to Smith in New Jersey
to consult with him on this possibility, and—rather to
everyone's surprise—Smith was agreeable. We felt that
this alternative might well be esthetically calamitous
suggesting as it could have the multi-media, electric-
circus ambience rampant at Expo 70. The work re-
mained unpainted, though in the course of the Fair its
interior was to become densely covered with multi-
colored international graffiti. [9] The artist was so
delighted with this fact that he requested that all of the
graffiti-embellished modules that could be retrieved be
returned to him after the closing of Expo.

Whether the completed Expo work truly represented the
intentions the artist originally had in mind is necessarily
questionable, since Smith did not supervise its construc-
tion or even see it in Japan. In rebuilding the structure,
Smith's design was altered somewhat to strengthen
certain spans which had previously sagged, and to create
broader passageways. Nevertheless, despite these changes
and despite the impossibility, for reasons of safety, of
darkening the interior as much as the artist might have
liked, the fundamental feeling of the piece remained
remarkably close to that conveyed in the early Polaroid
detail photos Smith had sent us, and to the look and feel
of both maquettes.

Bill Lloyd, when asked to comment later about the
construction of the work at Expo, said to JL,

> The structure Smith had conceived was extremely
> challenging. His model was architecturally sound; it
> fit the space perfectly. And it would have been strong-
> er than the Pavilion building had we used cement
> rather than glue to build it.

> Tony was right about the disadvantages of the lock
> joints. I have no explanation for the fact that the
> components were made that way

> The changes we made were necessary because of the
> problems of traffic. I would say the original model
> was revised about thirty per cent. The entryway was
> all but eliminated, there were structural changes at
> the exit, and the passageways were widened. It was
> difficult To make one little change, you had to
> alter as many as thirty pieces. Each piece acts as a
> keystone. To widen one passageway took three or
> four hours of mathematical figuring—it had to
> support an overhead beam, etc.

Despite the artist's reservations about the lighting of the
work, based on photographs he saw of it, Lloyd felt it
worked quite well. He said,

> I think the work did finally accomplish what Smith
> wanted it to. This was really due to the lighting.
> Originally, we had one bank of light—that wasn't
> good. We tore it out and re-lit it, with shafts. Tony's

plan for lighting would have been too dim. People
would have barged into walls. Sure, we made compro-
mises, but it worked.

The primary discrepancy which Smith felt existed
between his initial conception of the work and its
manifestation at Expo is expressed, aptly, in his words:
 I feel that it's a weakness in the piece that it appears
 so much like a building. I would rather have had . . .
 a greater diversity of spaces within, than the place
 actually has; and in that sense [more like] the way
 we think of a cave as hollowed out rather than
 something constructed as we would construct some-
 thing with stones or other masonry elements. I don't
 think of it as masonry, although I know that most
 people do associate it with masonry.

In planning for the Los Angeles exhibition of the Expo
works, we decided in April, 1970, to give over an entire
plaza level gallery of the Special Exhibitions area for
Smith's work. This comprises a larger area than allotted
for any other work. Jane Livingston met with Smith,
Lloyd and Marcin in New York in April, 1970, to discuss

the sculpture for the Museum exhibition. It was under-
stood by all of us that the work would be substantially
different from the Expo structure. Tony was pleased at
the prospect of having an extended space within which
to work, chiefly because he wanted to design the struc-
ture as a freestanding entity, with several points of
access. To demonstrate the kind of configuration the
overall sculpture would have, he formed his hand into a
crabbed, or grappling position, fingers down and bent,
wrist high. He commented that given a larger, freer,
space, he could accomplish a piece that would be much
closer to his original cave idea than what was done at
Expo. Smith and Bill Lloyd discussed the desirability of
using a lighter and firmer material than corrugated
cardboard, probably solid fibre board, and avoiding lock
joints. Thus it was agreed that both Tony and CCA
would virtually begin again in designing and fabricating
the piece for Los Angeles. We requested that Lloyd
supervise the work's construction. As we prepare the
catalog for press, Smith is working on his new model.

Jane Livingston

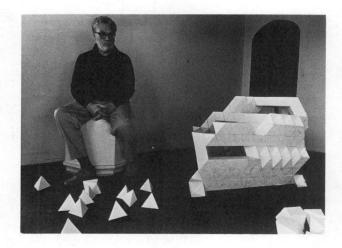

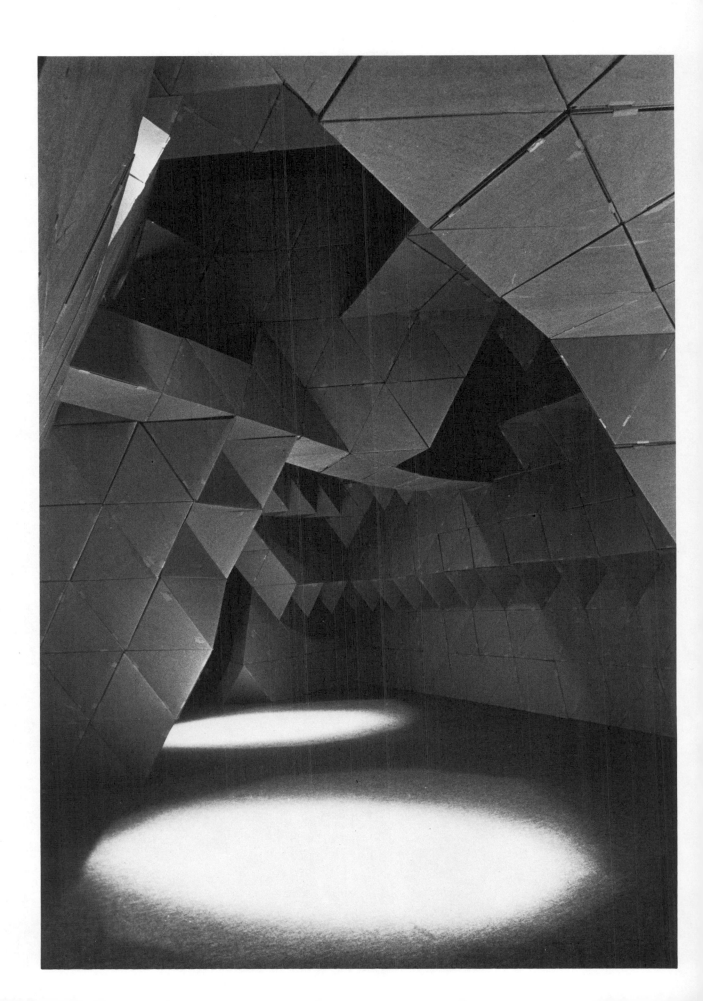

Robert Smithson

Born Passaic, New Jersey, 1938
Resident New York City

In April 1969 we invited Robert Smithson to tour Kaiser Steel and American Cement. In May, he came to Los Angeles and went first with Gail Scott to Kaiser. Unlike other artists who were primarily interested in Kaiser's steel mill products and fabrication capability, Smithson directed his attention to the raw materials and processes used in the making of steel. The tour consisted of climbing through giant mounds of limestone, iron ore, coking and power coal and wandering through a vast yard of slag—the impure by-product of the steel making process.

On May 22 Smithson and GS visited American Cement Company in Riverside where, again, the tour was unusual. Previous artists had spent their time in discussions with research engineers of the Advanced Technical Center, but Smithson wanted to see the limestone mining facilities. Consequently, he joined a tour for company personnel into the limestone mine, was driven around the grounds and saw enormous stockpiles of the raw materials that go into making cement and concrete.

Smithson's intention was to execute a work in one of the vast abandoned caverns inside the mine, distributing masses of various earth substances—blue calcite, pure white limestone, etc. The corresponding part of the piece for the exhibition would be fragments of the same material dispersed on a site on the Museum grounds. Another idea was to construct a concrete building at the Riverside location and then demolish it; the Museum piece would consist of the concrete fragments. Smithson presented his ideas to Dr. Kenneth Daugherty, who was to discuss them with his superiors. The next day Smithson presented us with several project drawings, including the "Dearchitectured Projects" for American Cement, and a distributional project for Kaiser Steel. [1, 2]

Ken Daugherty called us to say that American Cement had just experienced an upheaval in corporate management and was no longer likely to take any artist in residence, and Kaiser indicated its lack of interest in Smithson's proposals.

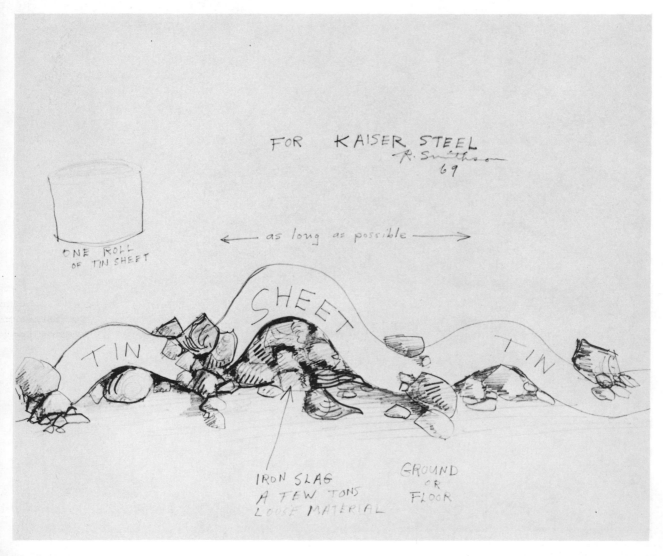

1

PortLand Cement Sites
A Dearchitectured Project

R. Smithson 1969
L. A.

1. The 3 sites will be photographed during dearchitecturization process and mapped.

2. Photos and Map (4'x4') will be shown inside Museum.

3. 3 to 4 tons of Dearchitectured material from each of the Portland Cement Sites will be placed on random sites on and in the region of the Museum.

4. The sites around the Museum will be mapped and photographed.

5. The maps of both sites will be shown together.

6. Aerial photo-maps may also be used to designate sites.

7. Material may also be tested and studied X rayed – carbon dated ect.

8. Ecological studies of "things" near the materials may be documented. This is an on-going process and could end in a book.

the Museum + Park will give limits to a widely displaced Nonsite.

No single focus but many focuses.

Mine Tunnel

Collapsed Cavern In Mine

Near top pit fence

=

L.A.C.M. Site

Demolished Concrete Building

=

in a pond

L.A.C.M. Site

Blue Limestone

record the dislocated crystal lattice in blue calcite as opposed to white calcite

in a thicket

=

L.C.C.M. Site

Landside Limestone Boulders

Karlheinz Stockhausen
Born Modrath, Germany, 1928
Resident Koln-Bayenthall, Germany

Otto Piene
Born Laasphe, Germany, 1928
Resident New York City

Early in 1969, we consulted with Lawrence Morton, the Museum's Curator of Music, on the possibility of inviting a musician-composer to work in A & T. At least one corporation, Ampex, was available and capable of providing sound equipment of various kinds. Lawrence Morton recommended that we contact the German composer Karlheinz Stockhausen, and offered to write to him for us. Morton outlined for Stockhausen the nature of the program, and inquired about his interest in and availability for participation. The composer was at that time living in Madison, Connecticut, and from there he replied on February 15,

> . . . one of my projects is to make open-air events together with Otto Piene, the German founder of the light-ballet in the ZERO group. We intended to work together for the World's Fair (Expo 70), and as there is—at least for the moment—too much inner-German politics involved, we are looking for the next chance. He is . . . at M.I.T. as a member of the visual research group of artists and has done several open air shows on large fields with helium-balloon sculptures that are blown up, carried, directed in their movements with the participation of the public under his guidance, and especially at night the whole quality of his events becomes extremely beautiful. The balloons (of strange shapes, also changing in shape) are filled with colored gas, and huge light projectors are criss-crossing through the air and playing with the balloons. Some are 1200 feet long: they make wonderful movements.

> We have met several times during the last months, and what we want to do is this: combine sound (on multi-channel tape) with the movements of his air-sculptures in a really meaningful polyphony. I would produce the sound material on tape in my studio, but in order to *perform* this material in reaction to the sculptures, I would need various electronic equipment, and Ampex could indeed provide it. Piene and I could perform together and as often as desired (2-3 times per week). We could do it in a place where the sound does not disturb others (small air field, large plaza or whatever is good for the public). I am *not* disturbed by airplanes.

> Please tell Mr. Tuchman, he would really have a wonderful thing, if he can get Piene

In March, we arranged to have both Stockhausen and Otto Piene come to Los Angeles to discuss setting up a series of performances, of the kind described by Stockhausen in his letter, to take place at the Museum during the time of the A & T exhibition. The two artists spent several hours looking at the Museum site and environs, and found a particular area of the park, to the North and East of the Museum buildings, suitable for their events. At this point, having ascertained that both Piene and Stockhausen were interested in doing the series of per-

formances and were willing to come to Los Angeles for three or four weeks at the time of the exhibition to prepare them, our problem became that of finding, on the one hand, the company or companies to supply and assemble the elaborate sound equipment Stockhausen required, and on the other to find some way of procuring Piene's giant balloons. We went to considerable lengths to resolve these problems. In Piene's behalf—he wanted several huge, colored ballons to hover, secured from the ground, at heights of up to 50 feet—we approached Goodyear and Allied Products; none of our investigations were fruitful. Stockhausen's requirements were written up by us so that we could attempt to find means of fulfilling them (Ampex had by this time indicated that they were not able to take on the project, since much of the equipment needed was not manufactured by them). The statement of the composer's needs is as follows:

> Sixteen outdoor speakers with individual amplifiers are required. To give an estimate of the power of one speaker in relationship to the space it has to fill with sound, in my experience a capacity of at least 400 watts per speaker is necessary.

> Twelve of the speakers will be mounted on high towers arranged to circumscribe an oval-shaped area of about 600 feet long by 400 feet wide, and four of the speakers will be suspended in the central area by moored, helium-filled balloons.

> For the reproduction of sound, two four-channel tape machines are needed with one-half inch or one inch tape. The two machines will be used only for playback, not for recording. Each of the four channels of each machine will be connected to an individual group of speakers. Both of these four-channel machines should be continuously variable in speed within a minimum range of two octaves (e.g. 3¾" to 15" per second). The speed control should be provided by two generators with continuously variable frequencies driving the motors, and special amplifiers. The two four-channel tape machines could be installed inside the Museum buildings, although the sound projection will take place in the outdoor environs of the Museum.

> In order to control volume, rhythm and pitch, a control console is required. For this console, eight sliding potentiometers are needed (like the MAIHAK-W66C type which is used in all German radio studios) for the eight independent sound channels that are pre-recorded on the two four-channel tapes.

> At the inputs of the eight potentiometers, eight push-buttons with an on-off function are needed so that each channel can be interrupted by depressing the

At the inputs of the eight potentiometers, eight push-buttons with an on-off function are needed so that each channel can be interrupted by depressing the corresponding button. Each pushbutton should be mounted on a coil spring, so that the sound is interrupted only while the button is held down (comparable to a Morse code device). When each pushbutton is manipulated, the on-off transition should not produce any click. The eight pushbuttons are played with two hands (eight fingers) by the performer, in order to produce rhythmic patterns, and the same eight figures are manipulating the eight potentiometers (distanced approximately like piano keys). The same console houses two generators (placed one to the right and one to the left of the eight potentiometers), controlling the speed of the two four-channel machines. Attached to each of the generators should be a knob with 180 degrees turning radius, with a semi-circular, marked chromatic scale of 25 steps for two octaves, each step being a minor second in pitch.

The control console will be installed in a control tower in the center of the area surrounded by speakers. The console should have eight inputs for the eight channels and sixteen outputs, two parallel outputs per channel.

A meeting was held at the Museum with several gentlemen from the J.B. Lansing Company, a company called Medico Electric (a subsidiary of Ampex) and the Langevin Corporation, in order to obtain technical advice on the quality and type of speakers and other equipment, including the console, and to perhaps solicit the companies' participation in the undertaking. The result of that meeting, essentially, was to demonstrate that the expense and complexity of this apparently simple project were unexpectedly great.

On the basis of this meeting, we wrote to Stockhausen for more precise information to use in projecting an estimate for the equipment. The reply, written by a friend of the composer's, Rolf Gehlhaar, indicates the magnitude of Stockhausen's intentions:

Stockhausen asked me to answer your letter:

Point 1. The complete loudspeaker system should effect a loudness comparable to that of a large orchestra, ca. 100-110 phon (the noise level of the traffic on the surrounding streets lies, as you know, fairly high, about 60-70 phon).

Point 2. 20-15,000 Hz.

Point 3. 40-10,000 Hz.

Point 4. The SPL must be great enough so that a sound that is to be heard moving between only *two* loudspeakers can actually be perceived as doing so; this means that at any point within one of the circles of speakers, two opposite speakers of that circle must add up to approx. 110 phon.

Point 5. From sine waves to white noise, covering the whole harmonic spectrum in between.

Point 6. The area of the park, i.e. 600 by 400 feet; this was agreed upon in Los Angeles and Piene would certainly not agree to the plaza area in front of the museum. If the above mentioned area (600' x 400') is the park, then no space outside of it will be required.

Point 7. Stockhausen has never worked on a project of this nature and magnitude before, especially what concerns the diffusion of sound over a large area outdoors; perhaps Altec-Lansing 9 foot speakers are suitable.

As the project evolved, we realized that there would necessarily be as many as six or seven different companies involved in seeing it through, and no one corporation was in a position to coordinate the process, or take special proprietary interest in it. Under these circumstances, we were unable to proceed.

Takis
Born Athens, Greece, 1925
Resident London

In February, 1969, after MT had visited him in New York, Takis wrote to advise us of an invention called "Sea Oscillation" which he had developed over the past year with the assistance of Professor Ain Sonin of MIT. Takis inquired if we had in A & T a corporation capable of excuting his proposed work. He sent the following description of the device, its origin and practical uses:

In its actual state [this invention] is an object of art, thought of by Takis 1957 in Venice. The object itself has been executed by Takis, Prof. Ain Sonin, and Prof. Sonin's assistant. From Takis' observations in Venice comes out that indeed the sea moves (oscillation) even in the calmest day. Takis observed that the cargo-boats, loaded with bricks and stones in the Venice channels were moving up and down without any visible waves on the water surface. Takis thought that this was an interesting perpetual energy which could be exploited to set in motion a disk and then, why not use that motion to generate electrical power? Takis proposed his idea to Prof. Sonin in March '68 in Cambridge. Prof. Sonin agreed and stated that the sea indeed oscillates perpetually. In fact there are records existing about the differences of oscillation from every sea on earth, which [vary] in the lengths of frequencies and in numbers per minute. Therefore we have a perpetual force which we could make evident by creating a device, sensitive enough to activate from these oscillations. The device, tested in a part of the Boston harbor (Oct. 6, 1968) successfully, rotated a disk perpetually. The device in the actual state has 6-13 turns per second. By adapting a sensitive dynamo it could generate electricity between one and six watts. The novelty of this device is that, floating in the sea it activates two bodies in a different rhythm. One body consists of the main float, where its own mechanism is attached together with a weight to keep it upright. The generator could be adapted to this mechanism. The other body consists of a smaller float, as light as possible, attached at the end of an arm. The length of this arm could be [varied], according to the length of the sea-oscillation, and by consequence this float would move independently and in a different rhythm from the main body. The axle of a gear is attached which winds up the gear. When the main body moves, it moves the gear on its axle. When the second body moves, the gear moves in the same direction by its own device. The gear winds up a spring which, on a certain point, releases and transmits its own power to a free cylinder which is free from the gear and turns with a speed which depends on the power of the spring. The mechanization of the gear and the cylinder is known in simple mechanics. The novelty of this invention is the fact that this cylinder is set in motion by two independently activating bodies through the oscillation or the waves of the sea. The practical application of this device could be for many uses:

For charging batteries, for transmitting directly radio-signals, for light-houses, for illumination of buoys. The main body could be attached on a boat or floating free into the sea; it could be fixed at the shore (in that case we would have only one body to activate the gears) and having, as a body, a mobile counter-weight. The device, executed in a bigger scale could generate much more electricity to illuminate villages around shores. The possibility of creating electricity with this device has been confirmed by the top engineer-designer of Sylvania Corporation, Mr. Donner, by Prof. Sonin and also in an interview between Prof. Schapiro and Takis by CBS-Television.

Takis and Prof. Sonin made a patent application.

We found no company for Takis, but we have been informed by the artist's representative, the Howard Wise Gallery, that in 1969 "the Treadwell Corporation in New York agreed to undertake the development and Turning to Account of the Device for commercial applications as well as for objets d'art."

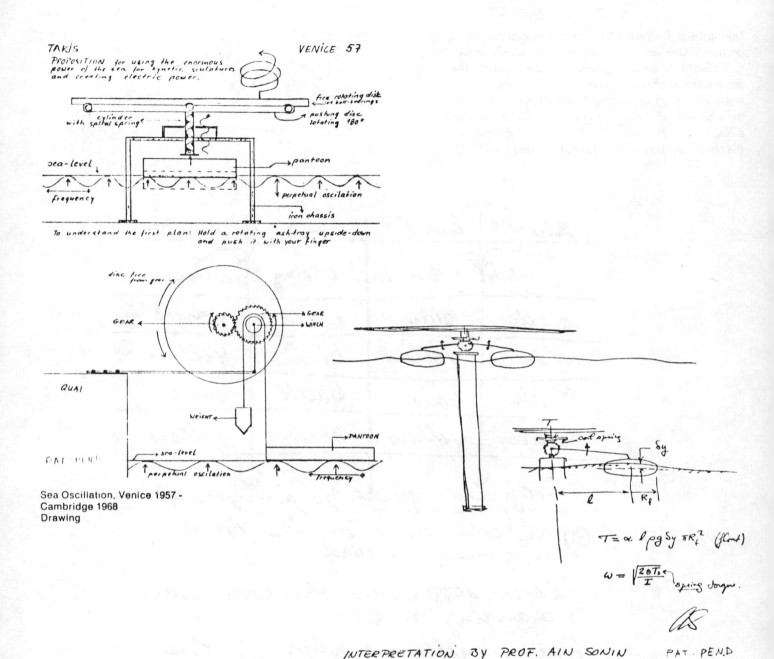

TAKIS

VENICE 57

PROPOSITION for using the enormous power of the sea for kynetic sculptures and creating electric power.

free rotating disk on ball-bearings

cylinder with spiral spring

pushing disc rotating 180°

sea-level

pantoon

frequency

perpetual oscilation

iron chassis

To understand the first plan: Hold a rotating ash-tray upside-down and push it with your finger

disc free from gear

GEAR

GEAR

WINCH

QUAI

WEIGHT

PAT PEND

sea-level

PANTOON

perpetual oscilation

frequency

Sea Oscillation, Venice 1957 –
Cambridge 1968
Drawing

$T = \alpha \cdot \ell \rho g \, \delta y \, \pi R_f^2$ (float)

$\omega = \sqrt{\dfrac{2 \sigma T_s}{I}}$ spring torque

INTERPRETATION BY PROF. AIN SONIN PAT. PEND

Sea Oscillation — Interpretation
by Professor Ain Sonin,
Cambridge 1968
Drawing

Oct. 68

Gerhard Trommer
Born Germany, 1941
Resident Wolpburg, Germany

During 1969, Gerhard Trommer sent us two project proposals. One concerned colored neon tubes that would be activated by the flow of people in the street. Of the second, the artist wrote, "This idea is a color-coded highway. It is art for driving. I think that it is possible to use a highway or a main road near Los Angeles for about a length of 2000 meters The speed of the car shows the people the behavior of this color coded road."

line 1	line 2	line 3	line 4
Driving direction		Driving direction	
black	blue	black	white ↕ 1m
white	yellow	blue	yellow ⊗)
black	blue	black	white
white	yellow	blue	yellow
⋮	⋮		

—This code shall go a length of 1000 meters—

⊗) the color-stripes on the road are 1 meter broad

—After 1000 meters the color-code is changing in ↓

blue	yellow	white	blue
white	black	yellow	black
blue	yellow	white	blue
white	black	yellow	black
⋮	⋮		

James Turrell
Born Los Angeles, 1943
Resident Venice, California

See Irwin section, page 127

Victor Vasarely
Born Pecs, Hungary, 1908
Resident Paris

Before going to Europe in the Fall of 1968, MT wrote to Victor Vasarely in Paris to inform him of the A & T project, mentioning specifically IBM, and to arrange an appointment to see the artist in his studio. By the time MT met with the artist in October, Vasarely had written up a proposal for an art work involving computer technology. The statement he formulated for us is as follows:

> From my youth, impregnated with the teachings of Bauhaus, I have felt a strong attraction for the linear and corpuscular structures. My past studies, namely *Tigres, Zebras, Martiens,* and *Echiquiers* bear witness.
>
> In 1953 begins my Kinetic period in black and white where the structures are freely developed. At this time, my thoughts are taken up with the idea of a binary plastic language which could be introduced into an electronic circuit.
>
> Towards 1960, my method of plastic units exists in its final form, a method I have developed in numerous works and writings. The application of this binary black and white, positive-negative system to the wider field of colour and monochromic games revealed a mine of riches hitherto unsuspected. The Folklore Planetaire (1962), Permutational (1965) series and also the more recent 1966 structures based on the perspectivist and axonometric hexagon are representative of this.
>
> I now have in my possession a matchless primer for combining plastic units and I become more and more involved in my studies in cybernetics. In fact, as of this period all my works are programmated; colours, tones and forms all being reduced to a simple code.
>
> My attention is drawn to the possibility of creating an electronic machine working in collaboration with persons specialized in this field. What a formidable and costly enterprise! My first contacts are encouraging but it is difficult to get assistance and the delays are long.
>
> But what exactly is this proposed device? It is a large lumino-cybernetic screen that can send out millions of different colour combinations. Practically speaking, in my mind I see a metallic box about 312.5cm x 312.5cm with a depth of 10 to 20cm varying according to necessity.
>
> This box is subdivided into a net-work of 625 compartments each measuring 12.5 x 12.5cm and each containing a circle 10cm in diametre. This structure of squares as well as the individual circles therein should be made of thin solid metallic strips about ½ a millimetre thick. This infra-structure contains the multi-coloured electric device which functions by electronics and a complementary rheostat.

I start with six basic colours, RED, BLUE, GREEN, MAUVE, YELLOW and GREY. Each colour is subdivided into 12 tones which makes 72 colour variations. Each individual compartment must be able to put out alternatively the 72 color variations. It is the perfect isolation of the compartments (and of course the circles in them) and the opaque screen that renders the tones clearly and makes them visible. Taking as a base any one of my programmations, we are now able to recreate the work *and a countless number of other compositions the machine proposes*. In this way, the limitations due to the artist's method of working in a studio would be overcome.

There are enormous possibilities. Firstly, by filming the pictures projected on the screen, we can compile a repertory of composition references which is inexhaustible. The artist chooses among the best of the compositions the machine has proposed and then recreates the work in the form of a painting, a tapestry, a serigraph, a fresco, a stage setting, a setting for a film or television.

Without a doubt the most important of the possibilities the machine offers is that involving architectonic experimentations. The requirements are immense for the integration of plastic beauty in future constructions be it a question of urban or rural habitat or public monuments. Based on the *Informatic* and the *Prospective,* the prefabrication of polychrome elements for architecture cannot be decided without bringing in cybernetics. This will interest many technical branches such as construction, chemical dyes, synthetics without mentioning traditional materials such as metals, glass, cement or ceramics.

Lastly, thanks to our machine, we will be able to conduct human experiences of the highest importance in the domain of Experimental Psychology. In offering this spectacle to the masses and in asking them to express their preferences, we will obtain statistic truth of esthetic values of an entire population. From this time on, art can freely enter the general circuit of production-consumption.

MT returned to Los Angeles at the end of October, and immediately contacted Dave Heggie, our contact man at IBM, about Vasarely's proposal. IBM's initial response to the Vasarely idea was to convey definite interest; we hoped they would send an engineer to Paris to talk directly with the artist, but they elected first to study the written statement in terms of a cost estimate for its realization before involving themselves more deeply. The figure they arrived at was about $2,000,000; this was regarded as prohibitively high, and they declined to pursue it further.

We then submitted the Vasarely proposal to RCA and Teledyne for study. RCA kept the matter pending for months without making a definite statement as to their possible willingness to execute such a work, and finally replied negatively, again on the basis of the expense represented. Teledyne analyzed the proposal carefully, and even suggested a way of executing the work which might be within reasonable technical means to pursue, but by the time this developed, that company was already in collaboration with Robert Rauschenberg.

By the Fall of 1969, a year after our original connection had been made with Vasarely, we wrote to inform him finally that we were unable to elicit a commitment to fabricate his proposed work under A & T.

Stephan Von Huene
Born Los Angeles, 1932
Resident Los Angeles

Peter Voulkos A&T
Born Bozeman, Montana, 1924
Resident Berkeley, California

After hearing about A & T, Los Angeles sculptor Stephan Von Huene approached us with a particular request for technical assistance. For some time he had wanted to execute a completely transparent musical sculpture, using a fluidic generating system running through glass components. The idea was to have music mysteriously emanating without visible mechanical movements. To design and construct such a piece he needed a corporation dealing in fluidic mechanics and having glass blowing facilities. We contacted Dr. Robert Meghreblian at JPL who informed us that although they were conducting experiments using fluidics, they had no facility for extensive production of glass components.

Peter Voulkos, at our invitation, toured the Vernon plant of Norris Industries. He was impressed by their steel forming capabilities, specifically the enormous hydraulic presses for steel extrusion and numerous machine shops for other metal forming processes. However, he declined to work at the Vernon plant because of its involvement with military contracts; casings for nuclear warheads are one of the principle products of this Norris facility. We called G. P. Eichelsbach, Vice-President of the firm and our main contact, suggesting that another division might be a more suitable location for collaboration, in particular the Thermador division in Walnut, which manufactures porcelain and ceramic coated steel products. After checking with the manager of that division Eichelsbach agreed to make available the Thermador plant. However, when we informed Voulkos of this development, he was disinclined to participate, due primarily to his teaching commitments.

Andy Warhol
Born Philadelphia, 1930
Resident New York City

By the end of 1968 several of the corporations contracted to A & T produced or used laser equipment and thus had the capability of making holograms. We had received several proposals from younger artists wanting to work with holography, but these struck us as being potentially uninteresting, too-literal approaches to a technique which, by its very novelty and exoticism, presented pitfalls. MT had for some time thought of this medium in connection with Andy Warhol. In February 1969, Warhol visited Los Angeles for several days and met with us to investigate corporations. We mentioned to him the notion of working with lasers to make 3-D images, and Warhol was distinctly intrigued. At that time, there was an exhibition of self-portrait holograms by Bruce Nauman at the Nicholas Wilder Gallery which Warhol saw with us; Warhol seemed quite taken with Nauman's images, and this served for us as a reference point in visualizing the kind of effect he might pursue.

We arranged for Warhol to visit RCA's Burbank division. This proved rather unfruitful in terms of concrete media that might be explored. Just before Warhol returned to New York, he and his entourage toured Ampex's Redwood City facility accompanied by Dr. Charles Spitzer. The examples of holography available there were not particularly striking, especially in terms of scale. The most interesting aspect of that visit was a demonstration video tape recently produced by Ampex which showed various special effects in video cutting, etc.

On Warhol's return to New York, we sent him some literature on holography and annual reports from Ampex and Hewlett-Packard which he read. Andy then had constructed, at his expense, a series of mock-ups with which some sort of 3-D image might be combined. We had only a remote conception of what these were about until some weeks later when in April, 1969, Jane Livingston went to New York and saw the three mock-ups at Warhol's studio. In one of them, small polyethelene particles were agitated in a circular motion by air blowers to simulate whirling snow flakes; this was encased between two glass faces embedded in an approximately six by eight foot rectangular wood frame. There was also a rain machine of similar size, but not enclosed by glass; it consisted of a simple pump system through which water circulated, falling in strands from apertures in a top section of pipe into a trough concealed beneath an artificial grass bed. The rain was side lighted to create an effect of sparkling beads. There was also a wind machine, simply a wooden box encasing an air blower. Each of these was intended to work in conjunction with a 3-D image; behind the rain, for example, would be a hologram or video screen; the snow machine would incorporate a holographic image in the center, through and around which the plastic flakes would circulate; the wind machine would vibrate and a 3-D holographic sphere would vibrate as well. At this point Warhol had

no set conviction about what the images might represent, and when pressed spoke vaguely about simple geometric shapes such as a sphere or cube.

By the time Warhol was really committed to the project, the only contracted corporation able or prepared to execute an elaborate holographic display—Hewlett-Packard—was already engaged in collaboration with Rockne Krebs. Even Hewlett-Packard could perhaps not have produced holograms in large enough scale for Andy's requirements. Thus we turned to investigate a medium recently seen on postcards—plastic 3-D printing—with a view to substituting this kind of image for holography in Warhol's project.

In June 1969, Hal Glicksman, at the request of MT, made a study of various 3-D printing techniques. According to Hal's report, dated June 17, 1969,

> The first commercial process for 3-D printing was developed by a Los Angeles inventor named Sam Leach who worked with Eastman Kodak and Hallmark cards. The first process was called PID—Printing in Dimension. Hallmark now holds the patents for the process and grants licenses under the name Visual Impact. In this process the image is printed on the back of lenticular plastic. The lenticular plastic is made by Rowland Products, Inc. Rowland also makes patterned plastic with the appearance of depth called Rowlux. They do not do any 3-D printing themselves. Large, back-lit 3-D pictures are made by several manufacturers under license from Visual Impact. They require a very thick lens and are very expensive. The image is usually a transparency on film, not printed. These are made by Three Dimensionals Inc., 3764 Beverly Blvd., L.A. 90004, Harvey Prever. (Mostly religious subjects sold door to door for $1.00 each.) This process is suited to unique items and large sizes. Prever claims to have worked three by six feet; also Victoria Productions, 'Veraview,' New York.

> The Cowles Communications process is called Visual Panagraphics. Their representative is Stan Harper, presently in Boulder, Colorado, but will be at 5670 Wilshire Boulevard, California, after July 10. Harper also knows a great deal about the other processes and people in 3-D. The Cowles process utilizes a similar camera, lenses, etc. to original Visual Impact process, but Cowles' process prints the picture directly on the magazine stock and then coats the image with plastic and embosses the lenticular screen on instead of a thick pasted on addition. It is also much cheaper in the million plus range of magazine printing. Stan Harper claims the next issue of *Venture* will be much higher quality because of new lenses and new 300 line screen. Harper will send samples and investigate the cost and feasibility of larger images. Cowles might be willing to sponsor us

There are several Japanese 3-D processes—all are variations of the Visual Impact (Hallmark) process. The Japanese cannot photograph in the U.S. because of U.S. Patents, but they can ship finished pictures to the U.S. . . .

In late June, 1969, we made contact with Allen F. Hurlburt, Director of Design for Cowles Communications in New York [1]; Hurlburt had worked with Warhol in the past and was in principle enthusiastic about joining with A & T to collaborate with Warhol. From the beginning of our contact with Hurlburt it was understood that the project would be considered for display at Expo. Warhol, for his part, was definitely interested in the 3-D printing process, though it is of course entirely different from holography and required a rethinking of his work. Cowles joined A & T as a Sponsor Corporation in July.

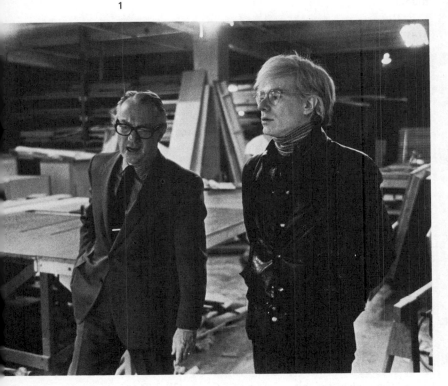

1

Allen Hurlburt wrote to Andy Warhol on July 3, 1969,
> I have talked to Maurice Tuchman and he tells me that you are interested in working with us on the Art and Technology project.
>
> You have had a brief look at our Xograph facilities and whenever you are ready to make use of this equipment, I would like to work closely with you so that we can produce the effects you want. Cowles is also prepared to assist you in the construction and fabrication you may need to complete the art.
>
> If it would he helpful for me to come to your studio and go over the material at any time, I would happy to do so.

On July 15, Hurlburt wrote to MT,
> Here's the signed contract for our involvement with you and Andy Warhol on Art and Technology.
>
> I have seen Andy's construction (the rain machine) and both he and Harold Glicksman have had a look at our facilities here. We are interested and anxious to use these facilities in any way we can.
>
> I am only concerned about one thing—the nature of Andy's project does involve outside construction which cannot be controlled by us. I would hope that we would only be required to spend a reasonable amount (a few thousand dollars) in this area. I don't wish to place any limitation on the potential of this work of art but I do hope there is a way of keeping this under control.
>
> I am very excited about the possibilities of this collaboration and we will make every effort to bring it to a successful conclusion.

By August, when the collaboration had been officially underway for about a month, Warhol and Hurlburt had still not decided upon what kind of image should be depicted. Andy asked us to suggest ideas for images to him. The notion of using a flower, or flowers, to be photographed and repeated serially, was presented to Andy and Hurlburt. Andy liked the idea and decided to follow it through. Cowles then photographed a number of colored, plastic flowers against beds of artificial grass and plastic foliage, in various formats measuring about four by six inches. In September, 1969, a meeting was held at the Cowles New York office with Hurlburt, Warhol, David Sutton (representing the USIA Expo Design Team) and us. The 3-D flower photos made by Cowles for Andy to compare were shown, and one of them—four daisies against green foliage—was selected more or less on the basis of communal preference, with Warhol's agreement. [2]

The following memo was sent September 19 from Allen Hurlburt to Messrs. Andy Warhol, MT, Jack Masey, Ivan Chermayeff, Don Dorming, Ron Glazer, David Sutton:

Subject: Art and Technology Meeting
Held Sept. 18, 1969 at Cowles Communications, Inc.

This meeting was held to review the progress on the A & T project, and to determine future plans in assisting Andy Warhol in the development of an art work for the Los Angeles County Museum of Art program, and the exhibition to take place at Expo 70 in Osaka, Japan.

Several photos taken in the 3-D process were exhibited and one showing a group of four daisies was selected. It was agreed that this image would be reproduced in quantity.

It was generally agreed that the images should be mounted on a curved panel behind the curtain of rain provided by the rain machine. There was some discussion about three options for the construction of final work of art. These were:

1. Construction of a mock-up in New York to be later duplicated in Osaka.

2. Determination of a plan by experimentation here but without a mock-up.

3. The development of a total construction in New York that would be transportable to Osaka and wherever else the art work might be exhibited.

There was general agreement that the third alternative was best if problems such as costs, construction and mobility could be solved. It was agreed that Mr. Masey and Mr. Sutton would pursue the feasibility of this approach and procure estimates of its cost.

In the meantime, Cowles Communications, Inc. has agreed to cover the cost and assume the risk of 3-D reproductions. We must receive and approve an estimated cost of construction.

The rain machine through which the panels of 3-D images would be viewed, it was then agreed, would be contracted to the New York firm Today's Displays to be designed and built; Today's Displays would also design the panels themselves and secure the Cowles images to them.

This letter was sent from Joe Grunwald of Today's Displays to MT, Sept. 26, 1969:

As explained to me by Mr. Warhol and Mr. Sutton, there are three possible interpretations of the basic idea, the most economical of which would be a straight wall approximately 12' high x approx. 18' long, covered with three-dimensional photos provided to us.

For this wall we have budgeted the amount of $2,000 to $3,000.

The next possibility would be a curved wall, approx. 12' high and approx. 25' long. Again this wall would be covered with three-dimensional photographs provided to us. The budget for this would be $3,000 to $4,000.

The de luxe possibility would be to cover both walls of the 21' triangle or a total of 42', again 12' high, with zigzags of approx. 11" depth. These zigzags to be covered with three-dimensional photos provided to us. The budget for this would be $7,000 to $8,000.

In addition to the above, is the 'rain machine' which would cover the 21' front of the area. Again there are various possibilities of realizing the basic idea. A minimum budget for this would be approx. $5,000.—

However, due to complexities of possible requirements in water pressure, use of one, two or three possible rows of jets and quantity of water involved, this item could go as high as $8,000–$10,000.

At various stages in the development of Warhol's project with Cowles, Andy prompted Hurlburt, Grunwald and us to develop alternative possibilities for the work. In each case—in the development of the photographic images, the rain machine and the constructed environment for these—Andy would view the alternatives and choose among them. Andy continually placed us in the position of weighing the merits and disadvantages of numerous possibilities. Sometimes he would discard altogether our proposal—as for example, in the case of the rain machine, which we visualized as an enclosed and

2

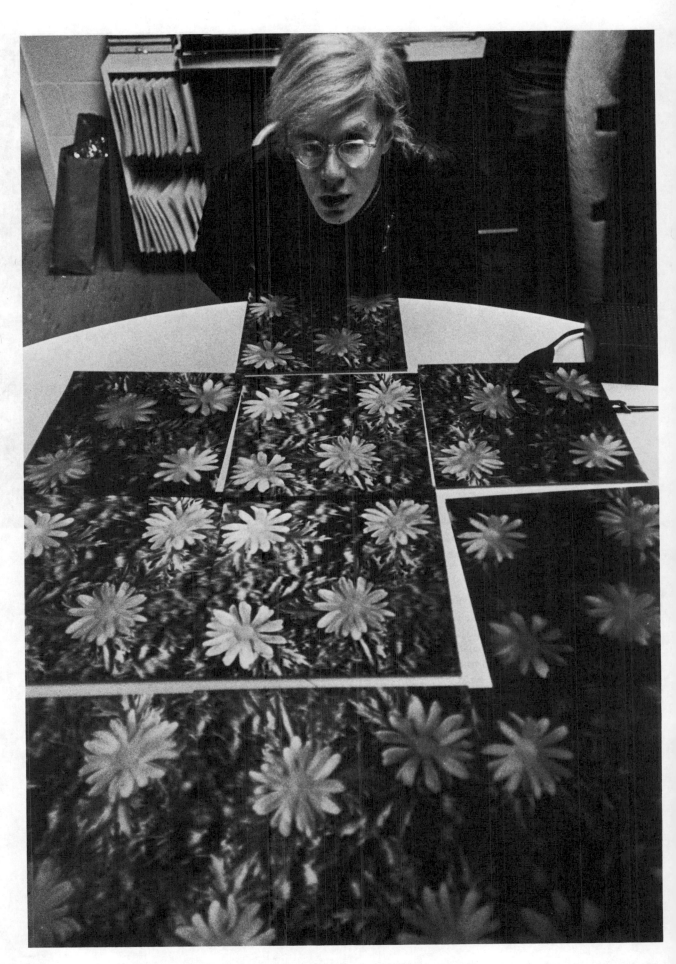

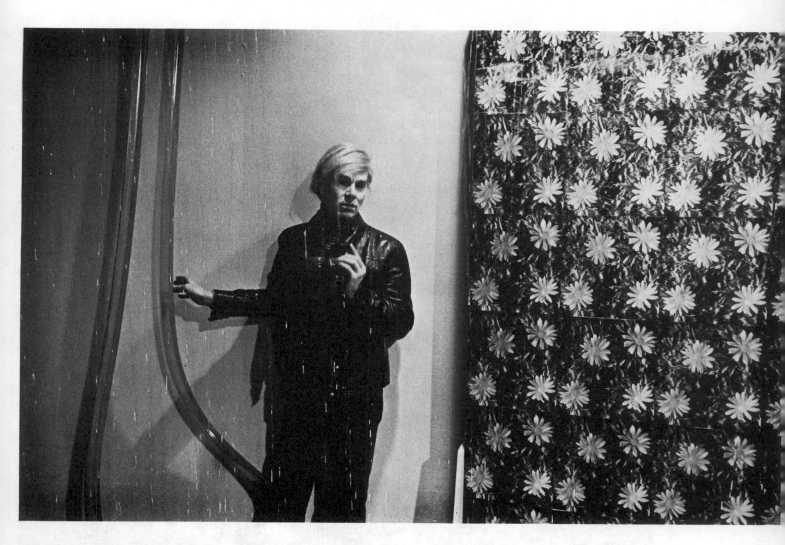

sophisticated mechanism, and which he decided should
be presented crudely.

In November 1969, MT met in New York at the St.
Moritz with Warhol and Joe Grunwald. It was decided
not to adopt any of the three proposals outlined in
Grunwald's September 26 letter regarding the shape and
size of the rear panel, but instead to build five separate
panels, each four by eight feet. The key question was
how to dispose the panels when the work was installed.
Warhol was encouraged to make a series of drawings
showing several possible arrangements of the panels, but
he resisted having to work that way. He finally said to
MT that he would prefer having the five units placed in a
random arrangement, or, failing that, in simply a flat
plane, abutting each other. It was agreed that MT would
use his own discretion at installation time in placing the
panels. The other important factor discussed in that
meeting involved the rain machine. Warhol favored the
idea of producing two parallel layers of water, and
having the water move in a swishing manner, side to side,
as opposed to creating a single screen of water pouring
from a row of evenly spaced nozzles. Grunwald planned
accordingly to execute the more elaborate, two-layered
system.

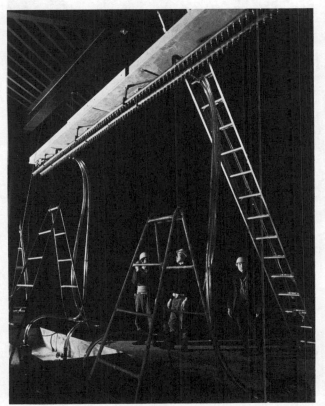

It occurred to Warhol at this time that he liked the idea of simply displaying the rain producing mechanism forthrightly, rather than encasing the pipes and trough in a wooden structure, as he had in his earlier small model.

One of the artist's reasons for this decision had to do with his attitude about the 3-D printed images as such. He had said to MT, "You know, this 3-D process isn't all that glamorous or new or exciting." He wanted, therefore, to present the images in conjunction with a naked, unembellished and inelegant structure so that they would *reveal themselves*—maybe perversely—in their rather vulgar and certainly imperfect quality. His original idea for the holograms, to be seen hazily through water, or snowflakes, or vibrating and out of focus, held over in his approach to the 3-D printed images: he had wanted, in his word, a "ghostly" effect. However, the reality of the situation by the time the daisy pictures and rain machine were visualized together, fell short of this vision of ghostliness. Warhol thus adapted his approach to a changed esthetic.

Based on these decisions Today's Displays began work on the project. We felt it would have been helpful for them to build a mock-up for Andy's approval before constructing the final mechanism, but there was no time to do this and meet the Expo deadline.

Perhaps the most important decisions determining the work's final appearance in the U.S. Pavilion at Expo were made not by Warhol but by MT, the Expo Design Team members, and some of the other artists in the show. The entire installation operation was characterized by a sense of crisis, and there were moments when the piece seemed simply destined to ignominious failure. In the end, somehow, it worked: many people and particularly the artists who were there installing their own pieces, felt the Warhol to be one of the most compelling works in the exhibition because of its strangely tough and eccentric quality. Robert Whitman commented that "of course Andy's forcing everyone into the act;" the work itself, when completed, made that conspicuously evident, and yet it was unmistakably Warhol. When it was rumored at one point just before the opening of Expo that the work might be taken out of the show, as was suggested by several of the Expo Designers and by a visiting critic who was conversant with Warhol's oeuvre, the American artists who by this time knew the piece intimately objected strenuously.

Virtually every stage in the assembling of the work was problematic. The question of how best to distribute the five image-faced panels presented major difficulties. A "random" placement was tried and failed totally. At one point, they were to be arranged horizontally, one atop the other, in a single, flat plane; only four could be accommodated in the space, but this was judged to be the unavoidable solution, since the purpose was to

de-emphasize a certain unevenness in the rows of images caused by faulty gluing. However, something seemed profoundly amiss, and was. The effect of three-dimensionality would have been completely lost, since the parallel, raised striations in the plastic segments, which create the visual illusion of depth, cease to function optically when turned 90 degrees. Other alternatives were tried, and finally the panels were placed vertically, side by side, in a flat plane. The entire unit of adjacent panels was raised off the ground, at MT's suggestion, to create the effect of a hovering field of flowers.

The lighting of the work was extremely difficult. In order to disguise the disturbing unevenness caused by the slight pulling-away from the panel surface of the edge of each segment, light could not fall directly on the panels. To illuminate the falling water ideally, the lights should have been mounted in two rows facing each other on either side of the sheets of rain, but this had to be avoided to prohibit an overflow of light from interfering disastrously with Lichtenstein's screens in the adjacent area. Finally the rain was illuminated from the top. The water thus could not be made to sparkle as intensely as might have been intended by the artist, based, at least, on his original rain model.

It was not realized until the time of installation at Expo that the illusion of depth in the photographic images was apparent only at a distance no greater than from eight to ten feet. This understandably detracted from the impact of the work. An even more significant problem, however, was the scale of the images. This was never resolved satisfactorily, and it was determined that in reconstructing the work for the Museum exhibition, each identical image would depict not four but one greatly enlarged flower. Moreover, in developing new images for the second work, Cowles recommended that the 3-D effect be technically improved to allow the illusion to be discerned from a much greater distance—from eight to about twenty feet away.

Jane Livingston

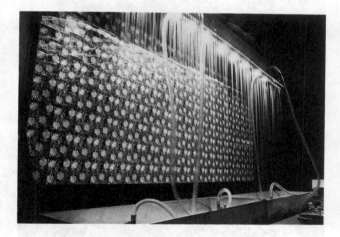

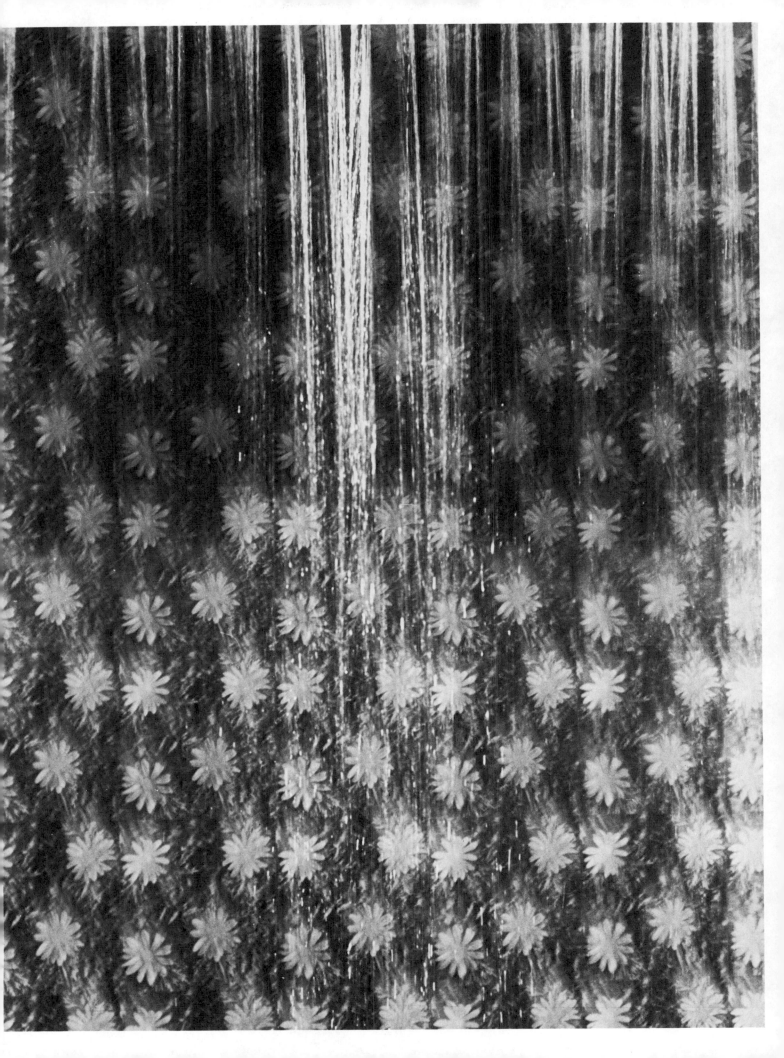

Robert Watts
Born Burlington, Iowa, 1923
Resident Bangor, Pennsylvania

Martial Westburg
Born Des Moines, Iowa, 1939
Resident New York City

In December, 1968, Robert Watts wrote,
I would like to propose an aural-visual environment
utilizing various sensing devices that would receive
signals from inside and outside the Museum space.
These signals can be arranged in such a way that
various environmental 'senses' can be achieved,
dependent upon source signals and additional man-
ipulation.

These signals would be collected at a master mixing
console where further modulation could occur
contingent upon the mass, number, and proximity of
persons moving within the environment.

The final display of signal—the 'sights' and 'sounds' of
the mixed environment would be various and chang-
ing and could be presented to the audience on con-
ventional sound and display equipment such as TV
monitor, oscilloscope, front and rear screen, and
print-out devices, etc. Indeed, it would be possible for
each person to carry home a print-out, a visual
reminder, as it were, of his experiences with the
environment.

In a letter of March, 1967 Martial Westburg proposed
the manufacture of three tori. One of these is repro-
duced with his suggestions for implementation:

Martial Westburg

MEMO #1

INFLATABLE TORUS

Material: Nylon reinforced Neoprene
Source: du Pont
Fabricators: Goodyear
Color: Natural

Contact: Phil Gaylord, Manager of New Products
 Goodyear Aviation Products Division
 Goodyear Tire and Rubber Corporation
 Akron, Ohio

In October, 1968, after Philco-Ford had signed a Sponsor contract (they later became a Patron Sponsor with a $7000 grant from the Ford Foundation), we visited their Aeronutronics Division at Newport Beach, Hugh Jessup and Dick Dickson of the Public Affairs Office described the defense research in radar, sensors and image processing carried on at the Newport facilities. We toured chemistry, electro-optics and biophysics laboratories and met two physicists, John Forkner and Michael Doyle, who were enthusiastic about the A & T program and eager to work with an artist on a collaborative venture.

They were helpful in suggesting areas and materials for potential use in an esthetic context: Doyle showed us several laser displays and liquid crystals, a heat sensitive, viscous material which reacts to temperature change by shifting from reddish pearlescent hues to deep blues and greens; Forkner told us of several optical coating machines available in his section.

During the next few months we considered a number of possible artists for Philco-Ford—John McCracken (who toured the facility), Robert Morris and Bruce Nauman. In February, we invited Robert Whitman to visit the Aeronutronics Division at Newport Beach.

This visit is summarized in the following memo written from Gail Scott to MT on February 11, 1969:

GS went with Robert Whitman to Philco-Ford. Met with Dick Dickson, Mike Doyle and Eli Reisman (another engineer).

Bob has had experience with E.A.T. and is looking for a collaborative situation in which he would have extensive technical assistance and the 'TA' with whom he works would do all the engineering, programming etc. He has no preconceived idea for a project but wants to work *with* someone who is mutually stimulating. In other words he's looking for the *right people* with whom he could work, rather than (as with Bob Morris) wanting certain facilities for a specific problem. Whitman was, of course, interested in their facilities and equipment, etc., but the contact people seem to be crucial for him.

Mike Doyle was (as usual) responsive and seemed interested in Whitman's description of *Pond* (at the Jewish Museum), Bob might want to use liquid crystals in some sort of environment which would also include mylar, mirrors, sound etc.

John Forkner, the other physicist with whom we had talked on our first visit, was not available that day to meet Whitman, but we had advised Bob of Forkner's expressed interest in the program. Largely on the basis of his interview with Mike Doyle, Whitman decided that he would like to pursue the possibility of a collaborative effort at Philco-Ford. Although he had no specific project in mind, we felt confident, given his past work and experience with E.A.T., and considering the scientists we had already met at the Newport division, that it would be a productive match. The company accepted him in residence without insisting on a project proposal in advance. In March he signed the contract and on April 21 arrived in Los Angeles; he promptly located a house for himself and his family in Balboa, and went to work.

In an interview recorded some months after his residence at Aeronutronics, Whitman recalled his first weeks there:

I went out to Philco-Ford and after talking to them briefly, they introduced me to all the guys with beards. John Forkner was one of them; he had the longest beard So we talked. I had been interested in optical types of situations before, and so we had some basic community of interest to get started with. [1, Whitman; 2, Forkner]

Before meeting Forkner, Whitman had not been especially interested in executing another project in optics, following his recently completed *Pond,* which incorporated pulsating mirrors. Whitman later remarked, "Both of us wanted to escalate out of something we had already done but we naturally drifted back into optics." As they talked, they became engrossed in certain optical problems which are described by Forkner in an article on his project with Whitman, written for the *Journal of Applied Optics:* *

The following fragmentary ideas he [Whitman] was playing with at that time indicated some of the directions in which he was searching: a method of focusing ultrasonic waves on a special wall so that an audible sound would seem to emanate from a localized area: a room environment programmed to react to the presence of people and to respond in a feedback manner; ways of using real optical images to lead the viewer to re-examine familiar objects such as his own face. The ideas had some interesting repercussions. Commenting on the feedback room environment, one of our scientists remarked somewhat caustically that it would make the viewer nothing but a robot. Being immersed in the idea, Bob hadn't seen the function of the room from this very human point of view, and was delighted to have a criticism of this depth. As a result, he re-directed his thinking about the whole problem. The real image ideas fell into my area of knowledge, as optical engineer, and I recall being puzzled by Bob's fascination with this seemingly trivial phenomenon.

*To be published in the Spring of 1971

1

2

Whitman later explained this fascination with such effects:

> I've always been interested in ghosts and spirits and weird things. I've been trying to do that for a long time—ethereal images. The whole thing about ethereal images and real images is that they are natural, and it's only just recently that the kind of technologies have been available that could do that. Before, I was

3

4

> doing films which had something to do with that. Then I got into the laser thing from doing movies, and I found by using a laser I could do it much better and easier than I could with movies. Then I found what I could do with optics—just another step along the line.

Forkner proceeded to experiment along the lines of Whitman's thinking. His article continues,

> One day, having found a large spherical mirror of fair quality, I set this up on my desk and reached my hand toward the center of curvature of the mirror. [3, 4] The very realistic, *three-dimensional* image of my hand that seemed to come out of the mirror was so startling that I immediately showed this incredible effect to my colleagues who were equally amazed. In retrospect, what is surprising is my surprise. Real images as a phenomena are so venerable that the most ancient physics texts (natural Philosophy) show experiments to demonstrate the effect—including the

famous 'rose in a vase' exhibit seen in many science museums. The difference, I think, results from my hand being a moving rather than a stationary object and the fact that it was *my* hand (the effect of touching the image of your forefinger without receiving a touch sensation comes as a complete surprise). This little experiment proved to be crucial from my point of view, because, for the first time, I began to understand what the artist was trying to do. This turned out to be the actual beginning of the collaboration, because Bob was also now able to formulate technical questions resulting from evolving artistic ideas. One weekend, shortly after that, his thinking had crystallized sufficiently so that he could state a definite problem. In an effort to restructure space in a visually exciting way Bob wanted an optical system that would image objects as though they were turned inside out—pseudoscopic imagery. He was especially intrigued by the possibility of seeing your face inside-out. Never having worked on this problem before, I wasn't sure that it could be done, but I remembered the pseudoscopic property of certain holographic images and realized there was at least some basis for the idea.

Despite his doubts, Forkner continued to investigate the phenomenon of pseudoscopic imagery. While driving home from work one day he was struck by a possible method of creating the effect he envisioned. Noticing the red reflectors on the back of a car, he reasoned that he might be able to produce a pseudoscopic image using a series of small corner-shaped reflectors (similar in principle to those on automobile taillights) with a beam splitting mirror to extract the desired image. In an attempt to make such a corner-reflector device, and incidentally to call attention to the scientific uses which might arise from the project, Forkner sent the following memo to his Philco-Ford supervisor:

If the concept proves feasible it might be constructed on a larger scale as a room with one wall covered with molded, plastic, corner-reflector, mirror tiles and a large Mylar film, beam splitting mirror stretched diagonally across the room. Someone standing at one door of the room would see a real image of a person standing at a door in the adjacent wall, and the image would appear to be only a few feet from him and turned inside out! It should be a really startling illusion, and would be especially interesting technically due to the relation to current work in holography.

To construct a small scale version of the device in order to check feasibility, and to investigate this illusion—which I suspect has never been observed before with real physical objects (holograms are only static, photographic images)—it is proposed to make a special, accurate mold from which a number of plastic corner reflector plates can be generated. I have done some initial design investigation including ray tracing and estimating resolution (diffraction effects, tolerances) and from this arrived at the tool design shown in the attached sketch. This tool can be made in the research model shop, preferably by one of the better model makers because of the accuracy required. The plastics lab could then use the tool to emboss plexiglass or similar acrylic sheet into the desired reflector plates.

The results of his first attempts to construct this device were unsatisfactory, and Forkner decided instead to try to locate a commercially made product. After considerable scouting and detective work, he found a reflecting device (manufactured by the Stimsonite Division of the Elastic Stop Nut Company) which, unlike most similar devices, had small enough corner cubes for his purposes, with the required accuracy of reflection. As Forkner's account explains,

Samples were quickly procured and after experimenting with methods of scanning to supress the cellular pattern of the array (using a rotating turntable), we actually were able to see live pseudoscopic images. Using even smaller corner cubes (about .060 inch), the resolution improved to the point where cups could be turned inside-out and a spherical ball appeared as a concave hollow space. We were shocked, however to find that very familiar objects such as a hand, would not invert—except occasionally in an ambiguous way. With the hand oriented so that your thumb was aligned in front of the gap between two fingers, the top part of the thumb often appeared to be *behind* the fingers and looked as though it were no longer connected to the lower part. This strange result had also been observed by Wheatstone [a Nineteenth Century scientist] we later found out, and is evidently intimately connected with the psychology of visual perception and pattern recognition by which the mind reconstructs the object, despite what the eye actually sees. Thus the hope of seeing depth-inverted faces seemed remote. This rather fundamental difficulty as well as the potential cost of constructing a wall size pseudoscopic mirror, led us to temporarily set aside this idea in order to concentrate on the possibilities of real images, which we had played with earlier.

In experimenting with the real image effect, Forkner set up a somewhat primitive arrangement consisting of a flat short focus mirror and a long focus spherical mirror to observe the real image of one's face in side view. The experiment proved startling; to see the reflection of one's own face, viewed from the side and appearing to float in space as a solid image, is a most disconcerting phenomenon. Extending the principle of this effect, Whitman reasoned that to present familiar inanimate

objects in this extraordinary optical context would be equally disorienting and compelling. He and Forkner also discovered that heat radiated by an electric heater could be focused to coincide with the precise location of the optical image, so that the "ghost" image of the heater, hovering in space, would actually be hot to the touch.

During the first three weeks of June, while Forkner proceeded with his experiments, Whitman designed the room in which the optical effects would be experienced. The environment was to consist of a spiral-shaped, enclosed space twenty-five by thirty feet in dimension. [5] As Forkner says in his article,

> Within this space he would encounter ten real-image displays as follows: The electric-range heater we experimented with earlier, as well as the ice cube display; an image of a microphone, the counterpart of which would be electrically connected through sound-modifying circuitry to a transitor radio, which in turn would be optically imaged at another part of the room (thus exploiting the sound-focusing properties of curved mirrors); a rag; a continuously flowing column of water, viewed from below; a face mask; and, finally, a pair of locations utilizing the mutual imaging of two viewers' faces through the medium of the pseudoscopic, corner-reflector array mechanism— ten display situations in all. To further complicate matters, Bob wanted most of the displays to have a zoom feature in which the real images would appear initially to be remote from the viewer and then rather quickly to rush forward and appear to pass through him. In this, Bob hoped to use the idea of the vari-focal mirror employed in an earlier work, *Pond,* in

5

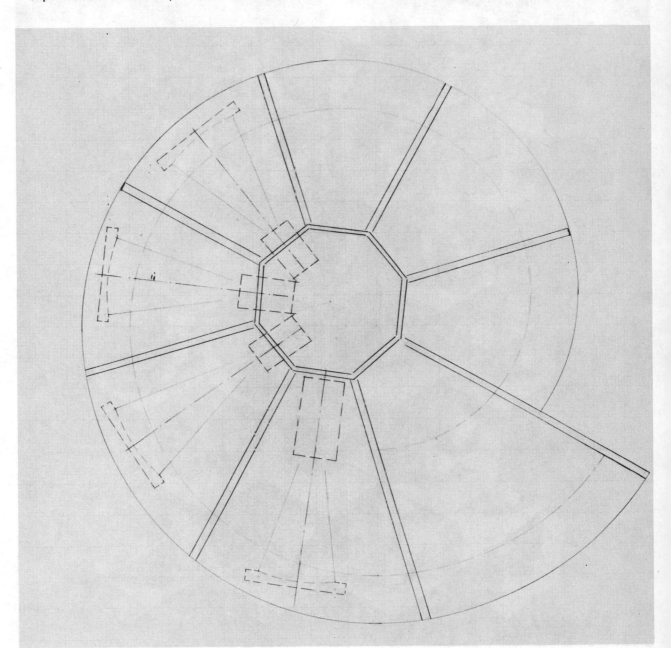

which he collaborated with Eric Rawson of Bell Telephone Laboratories. He wanted these real-image displays to appear in the space above a special wall consisting of an array of six inch corner cube reflectors extending from the floor of the room to about six feet above this level. The viewer would see himself in these corner reflectors illuminated under chance circumstances by one of a number of parallel columns of light emanating from large, Fresnel lenses in the ceiling of the room. He would see literally thousands of images of his face (the size of the reflectors and the viewing distance being such as to so limit his view), inverted and extending horizontally over the entire extent of his field of vision. [6]

By the end of June the design for an optical environment was completed and drawn up in blueprint. It was immensely ambitious, and would be costly to construct and install. However, we felt that the project was formidably impressive, and were most anxious to see it realized.

To the end of encouraging Philco-Ford to carry out its construction, on June 25 MT, GS and Dr. Richard Feynman went to Newport to meet with John Lawson, President of the Philco-Ford Aeronutronics Division. Forkner and Whitman attended the meeting to present and explain the designs they had drawn. MT stressed the technical and esthetic breakthroughs already achieved by

6

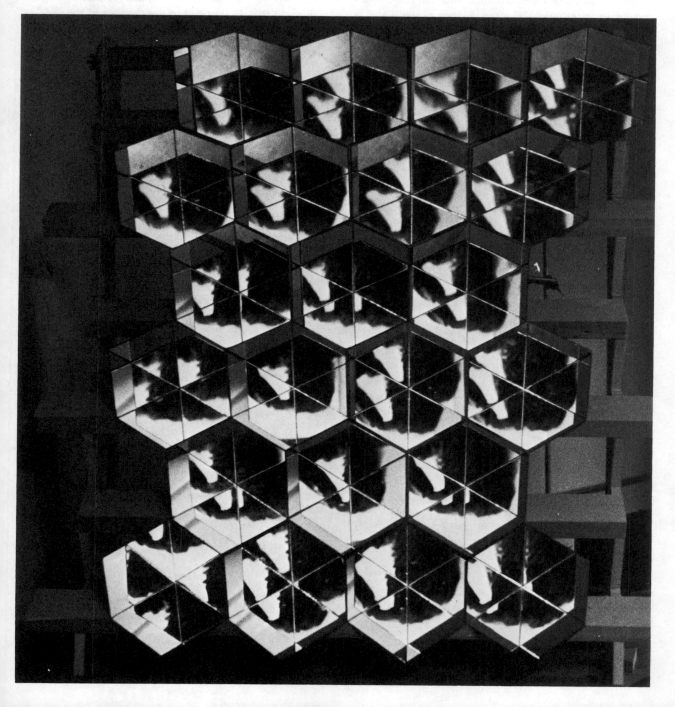

the project; Dr. Feynman commented favorably on certain of its technical aspects, and expressed interest in the visual phenomenon. Despite our efforts, Lawson declined to commit additional Philco-Ford funds to build the room. His decision was final, and did not allow for negotiation. Needless to say, we were intensely disappointed. Four days later Whitman returned to New York, but before he left we agreed to seek technical and financial support elsewhere, primarily from funds provided by our Benefactor corporations.

We were seriously considering the work for the Expo show. After several discussions with USIA designers the plans were extensively revised. The spiral shaped room

which accommodated only one entrance-exit opening was not practical for the Fair situation with its massive crowds. Forkner and Whitman agreed on an alternative design for a more open, semi-circular layout with six (later reduced to five) large mirrors and faced with 1,000 corner reflectors running along the lower wall surface. [7, 8]

Over the summer Forkner continued to study the concept of the large *spherical* mirrors, attempting to find a method of achieving the desired optical effect without resorting to expensive polished glass processing. He worked with reflective Mylar, stretched over a circular frame and drawn into a concave shape with a partial

7

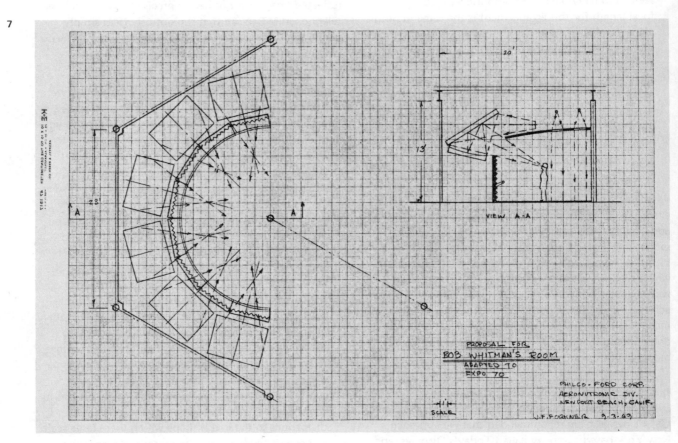

8

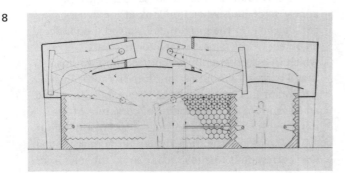

vacuum; this method at first produced excessive distortions in the reflected image, "due partially to non-uniform tensioning of the Mylar during mounting and also due to more fundamental non-linear stress distributions inherent in the geometry." Abandoning the use of spherical mirrors, Forkner experimented instead with a pair of *cylindrical* mirrors to generate the same focusing effect as a sphere. Forkner explains,

> I reasoned that since two cylindrical lenses can be crossed to approximate a spherically symmetrical lens, an analogous arrangement of mirrors should be possible. The usual problem, of course, is that mirrors tend to get in the way of each other. I tried several configurations to get around this, and the best seemed to be two circular cylindrical mirrors. The focal length for this arrangement is the same in both planes, and aberrations are minimized. In fact, when I subsequently ray-traced the system, the results indicated that the size of the image of a point source was limited only by the 'spherical aberration' of the upper mirror in the horizontal plane, while the 'cross-talk' aberration in the vertical plane was quite small, even for large apertures. I was surprised that this system could theoretically perform this well—it would be more than adequate for our purpose.

After much trial and error experimentation, Forkner evolved a means for constructing the cylindrical frames and a method for applying the reflective Mylar. The two sections of mirror frames (each measuring about five by seven feet) would consist of curved plywood ribs over which a plywood sheet would be glued. The surface would be sanded with a specially made fitted tool to achieve a perfectly smooth surface. Over this, one-eighth inch metallized acrylic sheets would be fastened with double faced masking tape. Forkner made a working model for this plan. [9]

In October, after searching for a means to construct the cylinder and corner-reflector mirrors, a member of the USIA's design team recommended that we approach a New York based company called Today's Displays, an installation and display company in New York. The firm's president Joseph Grunwald visited the Philco-Ford plant to see Forkner's model and agreed to undertake the project, following the above-described procedure. Today's Displays was contracted to build the corner mirrors and the large curved mirrors, while Forkner continued to develop and construct the varifocal mirrors, control units, and vacuum pumps. This equipment was to be placed out of sight above a false ceiling in the installation. The vari-focal mirrors served as an intermediary directing device between each object and the large cylindrical mirrors. Without them the real objects could not have been hidden from view. Philco-Ford now limited its support to allowing Forkner the time and materials needed to complete this part of the project.

Because of limited available funds, it was decided to abandon temporarily the one mirror which would produce the pseudoscopic device; we hoped to find some means to include it in the exhibition at the Museum. At this point, it seems likely that we will be able to do so.

As reports came in from Today's Displays, Forkner expressed concern that the mirrors would not be satisfactory and stressed the need for precision in building the structure support. He had already made several trips East to consult with Whitman on various developments in the project, and in November he went to New York to inspect the work in progress at Today's Displays. As he had feared, the support structures were inadequate—the reflected image was not nearly precise enough. Forkner telephoned MT to say that the optical effect simply would not work and that Today's Displays should cease working on the units.

This was again a disheartening setback, and we felt we had reached an impasse. But with characteristic persistence and ingenuity, Forkner proceeded to develop yet another construction method. He wrote,

> When I settled down from the shock of this new failure, I realized that my own assessment of the required accuracy of the mirrors was too optimistic I reasoned that at a point when you examine a real image, you are actually looking at two spots on the mirror (whether spherical or cylindrical), and these spots have a diameter and a separation determined by eye separation and pupil diameter and the ratio of observer to image and observer to mirror distances. The diameter of the instantaneous spot actually used on the mirror is small enough (less than 1") so that accuracy of curvature is fairly easy to hold in this case. The really difficult problem comes from the need to hold accuracy over the much larger eye separation distance (about 10" at the mirror, typically). Errors in this instance cause distortions in the apparent depth dimension of the image. The distortions in the image shape which these large scale errors also cause are even more serious since they appear so obvious when you look at the images. To get a feeling for the magnitude involved, I considered an object whose largest dimension is about 10" and which is imaged at unity magnification. I assumed that a bulge of about one-fourth over a three inch portion of this image might be acceptable. Assuming an eleven foot effective radius of curvature of the mirror, this corresponds to an angular error of about 1.8 milliradions. The three inches in the image dimension corresponds to a ten inch span on the mirror and over this span the assumed angular error is equivalent to a deviation from a true circular curve of about .002 inches. The way I interpreted this result was that if you use a three-leg spherometer with a span of ten inches to measure surface errors, the maximum

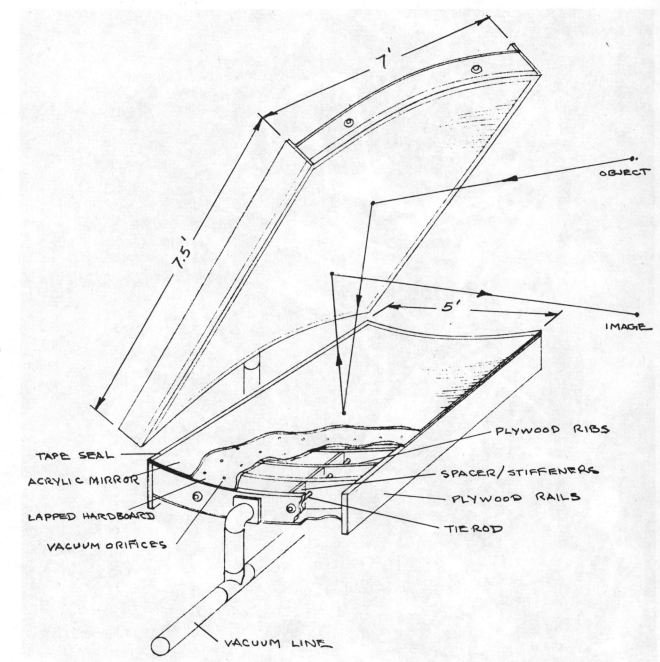

OBJECT

7'

7.5'

5'

IMAGE

9

TAPE SEAL

ACRYLIC MIRROR

LAPPED HARDBOARD

VACUUM ORIFICES

PLYWOOD RIBS

SPACER / STIFFENERS

PLYWOOD RAILS

TIE ROD

VACUUM LINE

CYLINDER MIRRORS

J.F. FORKNER

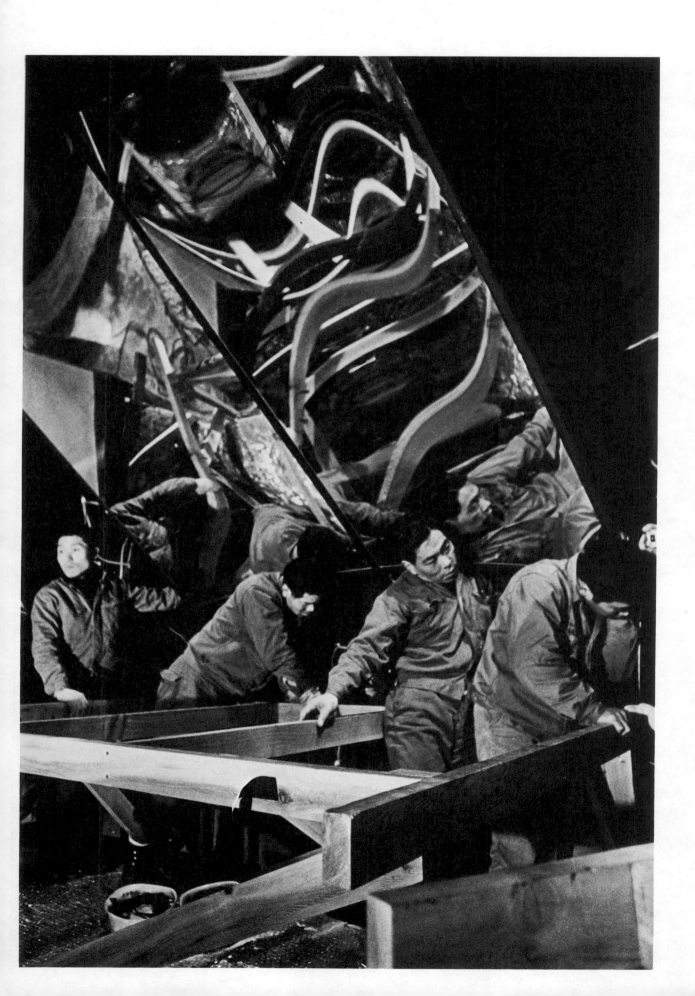

allowable deviation as shown by the dial indicator
should be no more than double the calculated devi-
ation of .004 inches. Notice that this is a smoothness
requirement and does not imply that the radius of
curvature of the mirrors need be held to tolerances of
this magnitude—which would have made the project
nearly impossible. With this new insight into the
tolerances needed for an acceptable image, I began to
understand the difficulty we were having in construc-
tion.

In order for Forkner to achieve the degree of precision
described above, he decided to substitute masonite for
the plywood surface. (The softer material could be
ground much more smoothly than wood.) This was done
on the four foot model and the results were encouraging.
He invited us to view a test set-up. Because of USIA
deadlines, we had been waiting anxiously for some
breakthrough, and as a result of the successful test
situation, we were now optimistic that the project could
progress. Building the model had demonstrated that the
construction theory would work; however, only one
month remained in which to build five double sets of
huge mirrors before all materials had to be shipped to
Japan.

To accomplish this immense task Forkner enlisted the
help of his church group, the Laguna Beach Unitarian
Fellowship. They borrowed building space in an empty
Laguna Beach grocery store and began work under his

direction, with the technical help of George Quinn, a
man of great professional versatility who supervised the
operation. The Fellowship members were assisted by
various friends, and whoever else wandered into the
store out of curiosity and was willing to help. The
history of what transpired in that Laguna Beach store
between January 2 and February 9 constitutes an
important part of the Whitman-Forkner saga. It was a
Herculean undertaking, as is indicated in John Forkner's
detailed account which follows this discussion on p. 353.

After witnessing this extraordinary cooperative en-
deavor, we agreed to recompense George Quinn for his
supervisory assistance, to defray the cost of certain
carpentry work that had to be subcontracted, and to pay
a rental fee for the building space.

The mirror frames, the internal mechanism (vacuum
pumps, varifocal mirrors, and special lights), and the
corner mirrors from Today's Displays were shipped to
Osaka in early February. Philco-Ford authorized a leave
of absence for Forkner to supervise installation at Expo.
The installation of the environment was a tedious
process. It would have been impossible to accomplish
without Forkner's thorough knowledge of every stage in
the operation. Whitman was involved in E.A.T.'s construc-
tion of the Pepsi Cola Pavilion at Expo and depended
completely on Forkner to execute his A & T piece.

The Expo spectator, upon entering Whitman's darkened

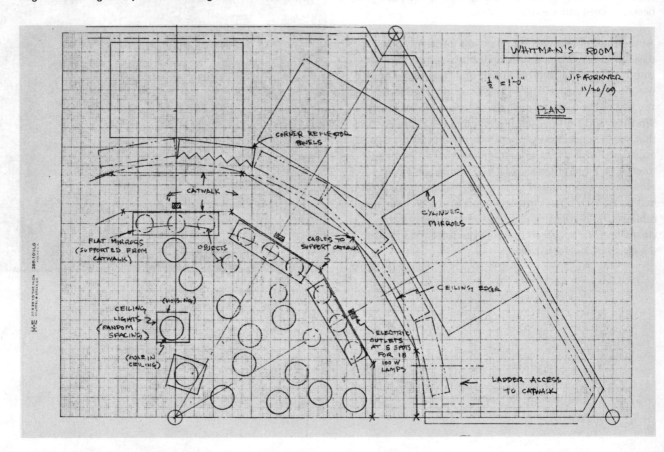

environment and standing under one of twenty-four ceiling light fixtures (each a 100-watt, incandescent lamp located at the focus of a ten-inch diameter plastic Fresnel lens), saw one thousand images of his own face reflected in the corner mirrors. Looking up, he saw, as he moved across the area, five successive pairs of images, projected by each of the hidden cylinder mirror systems. In other words, the "ghost" image of each object would suddenly appear in space as one of the miniature spotlights in the ceiling switched on; the image (unlike an ordinary mirror reflection) was seemingly detached from any reflecting surface, and as the mirrors began to pulsate, would advance toward the viewer, then disappear as the light shut off.

The items selected by Whitman were all familiar, common objects—an assortment of organic and man made things: a clock, an artificial fern, a pear, a cabbage, an electric drill, a brick [10], a knife, a wad of crumpled paper, and a tank of live goldfish. The experience resulting from this unique combination of optical phenomena is one of mysterious visual disorientation. This sensation is mainly owing to the incongruity between the type of images used—the intimacy of one's own reflection or the utter familiarness of the objects—and the feeling of unreality occurring in the observed situation. To see one thousand images of one's own face, discrete and isolated from the surrounding persons, is in itself startling; but coupled with the evanescent appearance and disappearance of strangely hovering objects, the experience becomes even more extraordinary.

At the time of this writing, plans are underway to develop the environment for exhibition at the Museum through structural and technical modifications. The pseudoscopic device will probably be included as one of the five or six types of image projections. In addition Whitman and Forkner are re-designing the room itself so that the lower section (the corner-reflector mirrors) and upper area (the object projecting mirrors) will combine to effect a more unified visual experience. One way to accomplish an increased coherence will be the transformation of each object into a second form; for example, a cabbage could appear and seem to move toward the viewer; as it disappeared it would gradually change into the shape of an electric drill.

Gail R. Scott

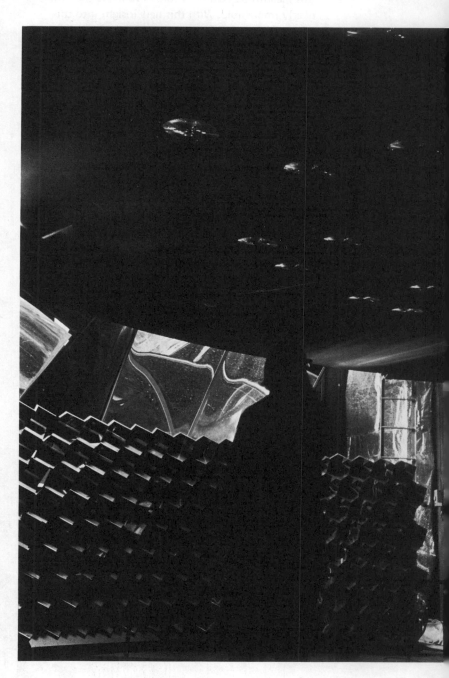

10

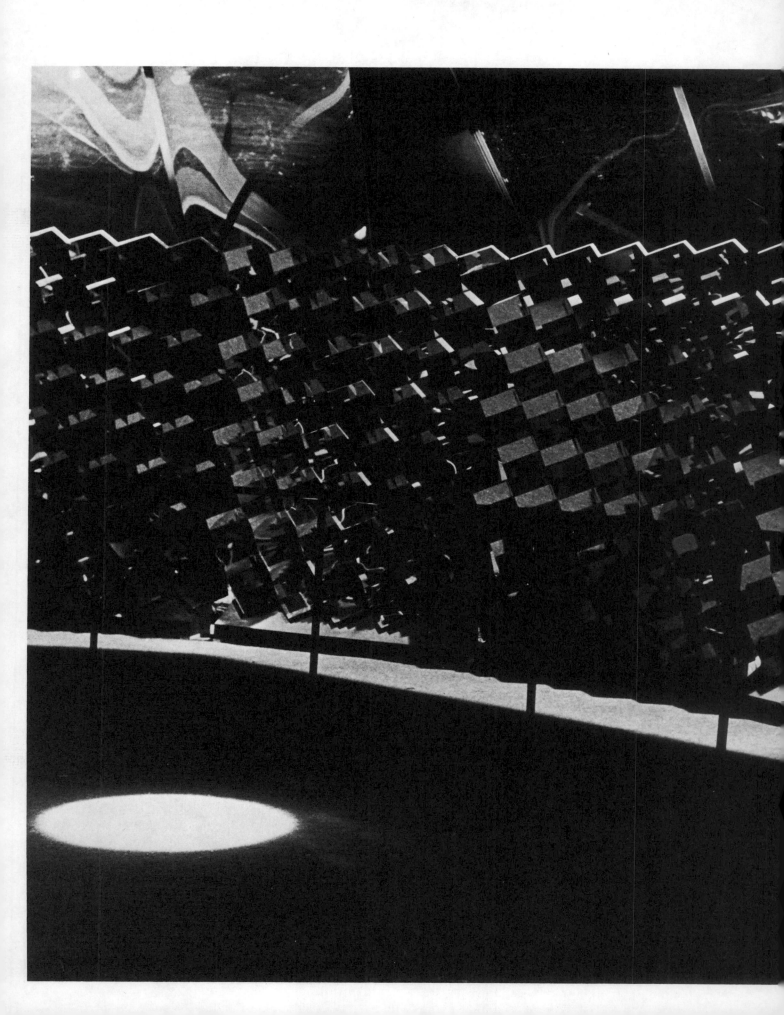

353

The construction of Robert Whitman's mirrors A&T
in Laguna Beach, California.

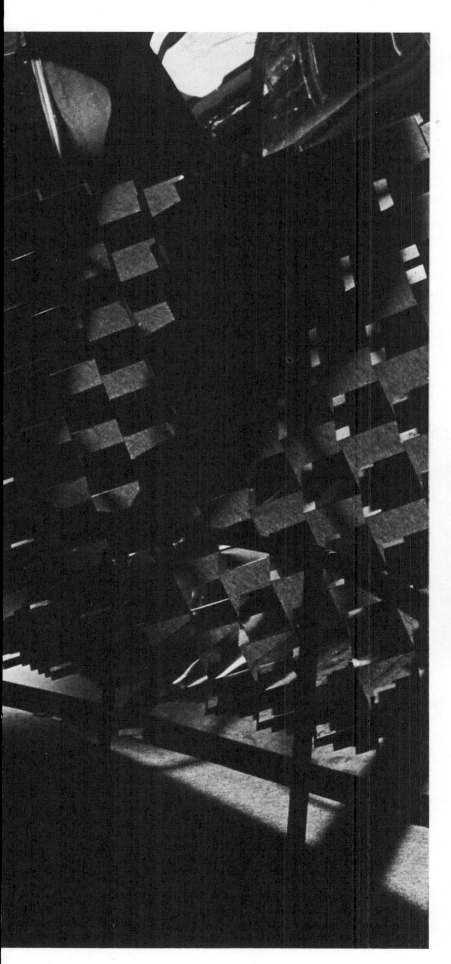

December 23, 1969

Mr. Tuchman, in desperation, gambled and accepted my proposal to consign fabrication of the cylindrical mirrors to the Laguna Beach Unitarian Church Fellowship. I approached Allan Christiansen, who, in addition to being a close friend and an engineer, was also the Chairman of the Fellowship. I discussed the possibility of the Fellowship building the mirrors as a group money-making endeavor. If Allan had been less than enthusiastic, the whole project might have failed at this point. But he, like I, had tremendous if somewhat irrational faith, that the membership could, under my constant guidance, construct five sets of mirrors even though a professional outfit had failed.

Allan and I then decided we must find one full-time supervisor to handle the multitudinous problems of volunteer work schedules and the vast ordering of materials. George Quinn, a member of our Fellowship, who most recently had been supervisor for Laguna's new community playhouse, and had formerly worked with volunteers in constructing a summer camp, was unexpectedly available and quickly accepted our offer. [1] We could hardly believe our good luck.

1

January 4, 1970

Byron Ritchy, the owner of Microtechnical Industries in Laguna and a very good friend of one of our members, put at our disposal rent-free, a huge vacant, barn shaped structure known forevermore as The Barn. It was about 7000 sq. ft., and once had been a supermarket. The idea of the project so far had hit everybody—Allan, George and Byron Ritchy—as great right off the bat. Byron, who is an engineer, really enjoyed the whole scene. As a measure of faith he let us take out the front windows, front wall, inside wall, and immovable structures of his barn and put holes in concrete floors. Later Byron, on a business trip to Japan, waited four hours in line to see the exhibit. He was quite moved. It had been worth it.

Every night for the rest of the week Allan, George and I met and discussed budget and organization. Allan

sketched the whole thing out nail by nail and screw by screw. He estimated a cost of $7,000. In actuality we spent $8,000, and the Fellowship profited by $2,000. During the day George had been buying materials and organizing the barn. He subcontracted to a quality furniture builder the most precise job—that of cutting hundreds of plywood ribs to an accurate circular arc. There were to be two sets of wooden parts. One for the five by seven foot mirror, and one for the seven by seven foot mirror.

We then planned to make five sets of mirrors, but actually made six. Fortunately by a slight compromise I was able to make the radius of curvature of the two frames identical—eleven feet. Therefore the builder was able to make a single fixture to do the fussy operation of accurately cutting this radius. He held to within .010 inches of the design curve by using marine glue plywood, because of its low warpage and uniform density. By doing this we had transformed the whole job into that of assembling rather spectacular kinds of kits. This made the work of a sort that we hoped could be handled by our group.

We spoke of building a motorized sanding machine to assure the accurate cylindrical shape of the masonite surface. We dropped this idea, hoping that my model—a two-man sandpaper lapping tool—could do the job. If I had known everything that would eventually have to be done, I could never have started. From the beginning I was in a constant state of panic. We had set January 31 as our goal.

January 11
We had our first organizational meeting in the barn. Riva Morton, the Program Chairman of the church, who had wandered into the barn the Friday before, mostly out of curiosity, contacted sixty members for the meeting. That Friday we knighted her official Personnel Director, and she continued for the duration of the project as George's and my executive secretary.* At that meeting George outlined the work involved, and I described the art-technology history of the mirrors.

Eddie Sturm, a retired bookprinter, intellectual, and amateur photographer was there avidly taking pictures. His usual dour expression was gone. George had appointed him official photographer of the project. He daily took dozens of pictures, developed them, and then mounted our reflections on the wall for us to see. We could order prints for $1.00 apiece.

January 12
Production began. Fifteen people came in two's and three's. No one quite knew what was required. George very quickly had some nailing, some measuring, and some stacking materials. There was work for everyone. No one was turned away. Our supervisor welded dancers, teachers, rock and roll musicians into an efficient task force of carpenters, gluers, and sanders. He sent Winnie Palmer, a famous writer of children's books, under the pen name of Winifer Wise to buy very special glue for sandpaper. After fruitless searching for hours, she came back with ordinary paper cement. It worked fine.

In the afternoon came Felicia O'Connell, who teaches French at the University of California, Irvine. George assigned Felicia the task of making signs. Within an hour workers were warned of dire results if they did not put tools away and keep off certain areas. The signs never stopped. They eventually became an important factor in the spirit at the barn.

In a small side room there was coffee, cake, and fruit juice. George outfitted this "office" with a Salvation Army rug, my patio chairs, and an antique drafting table. It was quieter than the main room and we often met here for special conferences.

At seven o'clock that evening George's estranged wife Ruth interviewed me for a story in the local paper. She did a thoroughly professional job. Throughout, our press coverage was excellent. We averaged two articles per week. A local reporter of our most right wing paper handed Riva his best Leica. He instructed her how to use it and sent her off to cover a barn happening. He had first met her when she walked into his office fifteen minutes before.

Our doors opened at 10 a.m., and closed after midnight. George kept the barn going seven days a week and stayed on if a single person wanted to work. Dependable work crews assembled in just a few days. There was the

*She also assisted me in writing this account.

early afternoon crew of Felicia O'Connell, French teacher; Winnie Palmer, writer; Nota Chari, physical therapist, and Greek exile; Jan Babcock, local artist, and Barbara Jones, art historian and print maker. Both Jan and Barbara also worked later shifts side by side with their husbands. Jan's husband, Norm, was the local narcotics police officer, a role which estranged him from most of the local youth in Laguna. At the barn he enjoyed a different role. He taught members of the church's youth group woodworking skills and then patiently worked side by side with them. Riva's seventeen-year old son, Eric, said, "It's great to be with Norm and not feel paranoid." In the late afternoon students and housewives came. After dinner salesmen, teachers, and engineers worked. Allan worked night after night, along with Ayda Brunnell, an electrolysist and our very competent treasurer. We amassed that week about thirty steady workers; some came for artistic reasons, others to practice their technical skills, and others for the sense of companionship that the barn afforded. We often drank

attached at two separate points on the rib. Misalignment of rib with respect to this line was corrected by gently tapping the rib up or down against the clamping force of the steel tie rods.

Allan was our stern, unbending master. He had the final say on whether the alignment was within the proper tolerances. Pressed by the lack of time I was angered by his demand for precision. Later George told me, "I would get so mad at Allan I could kill him, but that's O.K. I guess . . . conflict's O.K. when there are sparks . . . and there were." In the final analysis we all benefited immeasurably by Allan's tenacity. In fact, the project never would have worked without him.

After Allan approved the ribs, temporary nails were driven through the side rails in the ends of the ribs. After this the ribs were permanently attached with flathead wood screws driven in by a variable speed electric drill. I never quite got used to the ease and vigor with which untrained women handled the drill.

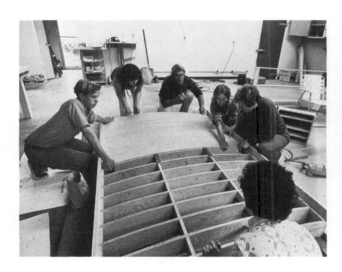
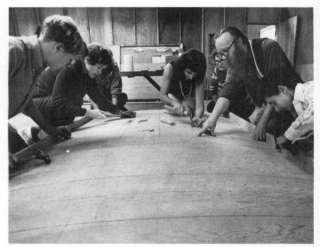

beer and listened to music while working long into the night until total exhaustion overcame everyone. The first major task was building work tables and some assembled fixtures. Once the assembled fixtures were available we used them to stack the curved ribs horizontally.

January 13
The first shipment of ribs arrived. We nailed spacer blocks on each side to maintain a uniform gap between the rib and ultimately to provide an intermediate support for the rib. Two half inch diameter steel tie rods equal in length to the long dimensions of the frame were then threaded through the ribs. Nuts on the ends of the rods were then tightened to clamp the rib assembly together. Plywood side rails about fourteen inches deep were then attached to the ends of the ribs with flat-head wood screws. A very tedious part of this operation was precisely aligning all of the ribs with respect to each other, so as to define a single smooth cylindrical surface. We did this alignment by using carpenter's chalk lines

The frame was now rigid enough (all joints were glued in addition to the fasteners) so that we could transfer it to another assembly location for attachment of the front and back coverings. The back, quarter inch thick plywood, was installed, first using nails and then glue. For this joyful, noisy operation George usually gathered everyone available in the barn—men, women and children. They pounded some two hundred nails in wild rhythm. While the glue was setting we prepared the nine-sixteenth inch thick masonite sheet for the critical front surface that was eventually to support the mirror material itself. The masonite was also to be nailed and glued to the ribs, but due to the somewhat brittle nature of this material (which was an advantage in the final sanding operation) we had to pre-drill and countersink holes for each nail—three hundred fifty holes per frame. We also had to drill another two hundred small holes to provide passage for the vacuum that would hold the plastic in place. Since the available size of masonite sheet was too small to cover the entire frame, we had to butt two

sheets together at the center—two ribs having been set close together to support the joint. Both George and Allan, though polite, were somewhat critical of my choice of masonite as a sanding material. I therefore was very anxious to see the sanding results of the first five by seven frame.

I was victorious! At the end of the week Jane Livingston, Associate Curator, Gail Scott, Assistant Curator, and James Kenion from the Museum came to check their financial investment and see our first finished five by seven mirror. George put up scaffolding so they could view the mirror from above. They were flabbergasted at our speed and technical competence.

Everything was going well with two more weeks to go. Our supervisor was working out beyond my wildest imagination. My constant state of panic was beginning to ease, even though one night Riva and I half-seriously discussed where I could hide (Bali, the Sahara) if the project failed. A feeling of euphoria was replacing my tension. Unfortunately it was only temporary relief.

The sanding on the small frames was going slower than the six hours I had anticipated. Felicia's and George's signs ("Sanding Improves Rhythm," "Sanding Builds Busts," and "Sanding Brings Good Karma") were inspiring. They brightened up the barn, but didn't improve our sanding record. The first of the large mirror frames had just reached the sanding stage. A couple of days were needed to smooth it to a reasonable accuracy.

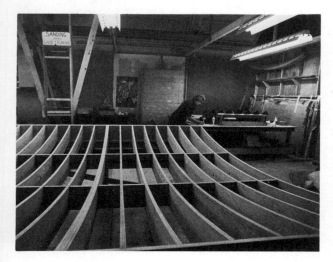

George pressed Riva to get more personnel and to set up work schedules around the clock. She gave a party for the high school in an effort to get some volunteers and failed. George related, "Walter (Riva's rather large husband) and I pushed that thing back and forth for an hour. I wore him out and he wore me out, and I knew we were in trouble."

The barn was getting quiet and sad. Twelve more days to go. A crisis conference was called. We decided to spend

money and time and effort to build a sanding machine. I chose the most dramatic model I could design. [2] I was so tired I remember thinking that at some point, they wouldn't need me, and I could take a rest.

The first night's work on the sanding machine was frustrating. George forcibly sent me home at one o'clock so I could start fresh the next day. I still had to go to my regular job at Philco-Ford, and I had all the other objects to design for the final installation in Japan. The next day I drove to L.A. to get the gears; that night I was so exhausted I couldn't figure out what I had bought. George sent over a young man, Richard Berryhill, a machinist, to help me. He had read about us in the newspaper, and had stopped to see if we needed help. He came back carrying a case of tools. His timing was incredible, and the beautiful part was I didn't have to explain anything. He knew exactly what went with what, and he had the right tools. Five of us, inspired by Richard, worked until five in the morning. He sensed our appreciation and he realized how much we needed him. After all, how many times in your life can you be such a hero! We didn't quit until that huge mechanical monstrosity worked. The source of power was a one horse-power electric motor, whose speed was slowed down to about two rpm through a home-made speed reducer incorporating a "V" belt pulley from a defunct washer-dryer and a collection of chain spocket wheels. This mechanism drove a three foot crank arm to which a fifteen foot long wooden connecting rod was attached, with a pivot bearing. The connecting rod communicated to the top of an enormous vertical wooden arm eighteen feet long, hinged two-thirds of the way up to supports on the building roof trusses. This arm doubled the stroke length so that we could cover the seven foot mirror frame. I felt like Rube Goldberg, my childhood hero. The sanding machine was a project within a project. It produced a tremendous uplift. The sanding millstone was off our necks.

At this point Bert Altemis, who had just finished the orals for his doctorate in psychology, came armed with sleeping bag. He made sure the sanding machine was manned sixteen hours a day seven days a week. A Japanese flag and an American flag decorated the machine along with a Felicia-made sign which read,
Sandman's Lullaby
Cherished Sandman
Bring us our dream
Make these the smoothest

Mirrors
Wirror

We've ever seen!
Pilots of this Keen Machine
Who helped us with promises to keep
And sanded miles and miles before we all can sleep!

January 24

Riva, who was completely enamored of the machine, threw a huge party at the barn in the machine's honor. Her son's rock band blasted over the noise of the sanding. Fifty people came and had a great time.

We had lost one week. Our original goal was only seven days away. Realizing it was impossible to meet this deadline, I asked for an extension to a shipment date of February 9. It was granted.

Time was still critical, and energies were running out. Yet George felt we should take out time to build a small model of the Japanese installation of the mirrors to keep up people's enthusiasm. George was sure people wanted to see a facsimile of the final project. Actually the project had proceeded on two levels: the intellectual, technical design and problem-solving level; and the emotionally exciting group construction effort. George's thing was the group effort. It was only halfway through the project that he realized we were trying to hold .002 inch to .004 inch. He was frustrated with something he couldn't physically see with his eye. But he knew his public. The model worked. A *Los Angeles Times* reporter, Lael Morgan, wrote a brilliant feature article which accurately caught our spirit. She and her photographer were impressed by the model. Two days later Jim Cooper, a well-known TV reporter, and his crew, moved in. They spent five hours preparing a six minute program. Our model was an important part of the show. We

were receiving so many visitors now that George appointed five hostesses whom I briefed to answer all questions and keep our guests out of the workers' way. Instead of losing workers, we picked up new ones.

We had one and a half weeks left, and most of us were very tired. Sanding around the clock we were able to finish the frames with enough leeway to do some testing of the final results. Using our homemade spherometer we found that with about five hours of sanding we could achieve a smoothness of .002 inch over the ten inch span of our measuring device, measured along the curved direction of the frame. Along the straight direction of the cylinder the errors were somewhat larger—as high as .006 inch in places, probably due to the difficulty we had in holding alignment between ribs in the initial assembly operation. The final test was to install the plexiglass mirror sheets together with the vacuum system to hold this material in place. The first tests were already encouraging, showing much smoother images than in my prototype model. We became very aware of the tolerances we were trying to meet when we noticed that some visually prominent local bumps in the mirror could be traced to nearly microscopic specks of dirt trapped between the mirror sheet and the frame. Cleaning finally had to be finished by using our bare hands to feel out and remove these specks. Another more serious source of distortion turned out to be due to local non-uniformities in the paint that the mirror manufacturer used to protect the rear surface of reflective aluminum film. Small runs in

2

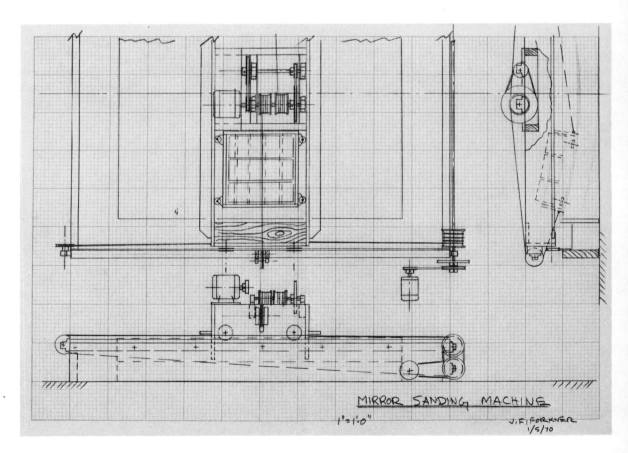

MIRROR SANDING MACHINE

1" = 1'-0"

J.F. FORKNER
1/5/70

this paint layer, which were probably only a few thousandths of an inch high, had to be removed by hand sanding with a very fine grade of emery paper so as not to sand through the reflecting coating. The last stages of testing were done with complete sets of upper and lower mirrors so that the quality of the real images could be examined. (It was very difficult to assess the individual mirrors because of the peculiar nature of cylindrical images.) We did a crude kind of Foucault test on the set of mirrors in which one's nose was the source and the iris of his eye the knife edge! This strange test proved sensitive enough to show all the effects of dirt, paint and excessive vacuum. We decided that two of the mirrors had some unacceptable rib-to-rib distortions, and returned these to the sanding operation. Since we had assembled one extra set of mirror frames, we left the worst pair for sanding during the shipping operation—to make use of the sanding machine before disassembly.

February 7
George had promised Riva he would have most of the frames packed, the mirrors crated, and the floor cleared in time for her final Saturday night party. George's optimism, at times, is not to be believed. Not only was he not ready, but he drafted Riva and her party crew to do the packing. By 8:00 P.M. everyone was so tired, the idea of a party was painful. But I had invited the whole town to free wine, food, and live music. I made a point at 7:30 P.M. of asking Riva to locate a special Chinese ink pen in order to have people sign a guest sheet. She nodded incredulously, too tired to complain, and our hundred guests signed with a plain pen. Good feelings ran high. Eddie Sturm took pictures of all the party-goers. There were free rides all night on the sanding machine. The barn rocked out for the last time until three in the morning.

February 8
The next day we felt a great letdown. We packed the crates morosely and in silence. On each crate was stencilled "To our Japanese brothers, with love." George was the most thorough packer I had ever seen. Thanks to him everything arrived in Japan in one piece. Even the mirrors, in a box that looked like it had been dropped to the ground from thirty feet, arrived undamaged.

February 9
It rained furiously. We put the crates on the truck and collapsed.

Why had the project succeeded? To begin with, Laguna is an ideal sized town with a population of 11,000. Visitors dropped in because they were just walking by and were curious. Publicity also helped and word spread quickly. Some began to feel this was not just a Unitarian project, but a Laguna project and non-Unitarians like Richard Berryhill came.

In the middle of the project I realized that only a few understood the scientific details and could care less. Only Allan and I cared. Occasionally when we had technical snags to unwind like the rib alignment problem, I felt everyone was saying "I wish they'd hurry up and get over their hang-up so we can go back to doing our thing." Most, however, sensed the intrinsic value in the project, primarily the value of process. The barn had a good feeling of warmth and community, and the sub-tasks were simply organized for success. Another value—one that I've never before vocalized but, of course, knew—was the sensual aspect of physical work. Everyone enjoyed the hammering, gluing, sanding, and even the menial task of sweeping and cleaning the bathrooms.

John Forkner, August, 1970

William T. Wiley
Born Bedford, Indiana, 1937
Resident Woodacre, California

William T. Wiley met with us in Los Angeles to discuss
the possibility of his participation in A & T. We de-
scribed Norris Industries and two divisions of Dart In-
dustries: Riker Labs and Syroco, and gave him corpora-
tion literature to study. In a telephone conversation a
few weeks later, Wiley indicated that he was not suffici-
ently interested in any of these companies to pursue the
matter, and at the time we had no other company to
offer him.

American Cement Corporation

American Standard

Ampex Corporation

Bank of America

Container Corporation of America

Cowles Communications, Inc.

Cummins Engine Company, Inc.

Dart Industries

Eldon Industries, Inc.

The Garrett Corporation, Life Sciences Dept.

Gemini G.E.L.

General Electric

Hall Inc. Surgical Systems

Heath and Company

Hewlett-Packard Company

Hudson Institute

Information International

International Business Machines Corporation

International Chemical & Nuclear Corporation

Jet Propulsion Laboratory

Kaiser Steel Corporation

Kleiner-Bell Foundation

Lear Siegler, Inc.

Litton Industries, Inc.

Lockheed Aircraft Corporation

Mifran-Bowman Corporation

Norris Industries

North American Rockwell Corporation

Pan American World Airways

Philco-Ford Corporation

The RAND Corporation

RCA

Teledyne, Inc.

Times Mirror Foundation

TRW Systems Group of TRW, Inc.

Twentieth Century-Fox Film Corporation

Universal City Studios, Inc.

Universal Television Company

WED Enterprises, Inc.

Wyle Laboratories

American Cement Corporation was formed in 1958 by consolidation of three cement companies in California, Michigan and Pennsylvania. Acquisition of Pascoe Steel Corporation led eventually in 1968 to a management shakeup from which Pascoe's president emerged as American Cement president. Another acquisition, Ted Smith Aircraft, brought heavy losses. American Cement now owns a new ski resort, Snowmass-at-Aspen, and a company that makes swimming pools and mini-bikes. American Cement is one of a handful of top cement producers which have established research centers: American's Technical Center near Riverside, California began by examining cement's structural characteristics, but in the last year has turned to researching possible new applications with other structural materials.

Patron Sponsor

See: Jean Dubuffet, Sam Francis, Philip King, Jules Olitski, Robert Smithson

American Standard manufactures and internationally distributes building products including plumbing fixtures and fittings, residential and industrial air conditioning units and heating and ventilation equipment. The company's major subsidiary, Mosler Safe Company, specializes in industrial security systems, data storage and retrieval equipment and office furniture and accessories.

Sponsor

See: Sam Francis

Ampex Corporation was founded in 1944 to develop new radar technology. Since then it has found itself in races with other high-technology companies: with Japanese companies in audio and video tape recorders and with American companies in consumer products like cassettes and 8-track tapes. Ampex makes 16-track recorders for the entertainment industry, memory cores for computers, video tape systems for UHF television stations. In Los Angeles, the Sheriff's office uses an Ampex system to view fingerprints over television. The Vietnam war has slowed Ampex's probe into even more sophisticated research in information storage and retrieval.

Patron Sponsor

Artist in residence: Frederick Eversley

See also: Michael Asher, John Chamberlain, François Dallegret, Sam Francis, Hans Haacke, Philp King, Les Levine, Robert Morris, Jules Olitski, James Rosenquist, Andy Warhol

Bank of America is the world's largest non-government bank.

Benefactor

Container Corporation of America is the nation's largest manufacturer of paperboard products. Its parent company, Marcor, Inc., was formed in 1968 to combine Container Corporation and Montgomery Ward. Container Corporation makes shipping containers, folding cartons, fibre cans, paper bags and a pulp used for packaging and shipping many commodities including food products, automobile and petroleum products.

Patron Sponsor

Artist in residence: Tony Smith
See also: Oyvind Fahlstrom, Les Levine, Jeff Raskin, James Rosenquist

Cowles Communication, Inc., is one of the largest consumer-magazine publishers, with *Look* magazine. Cowles is also involved in newspaper and book publishing, radio and TV broadcasting. It pioneered three-dimensional printing with its Xography process.

Sponsor

Artist in residence: Andy Warhol

Cummins Engine Company Inc., has branched out from its Columbus, Indiana headquarters to a network of plants and sales offices, all producing or selling diesel engines, in Ohio, Australia, Nassau and Tokyo. Engines for boats, trucks, busses, and industries like logging and farming still make up all but about ten percent of Cummins' sales. The company also makes automotive air conditioners, air and oil filters, and rebuilds its own engines.

Patron Sponsor

Artist in residence: Jean Dupuy

Dart Industries, formerly Rexall Drug & Chemical Company, gradually expanded into consumer products such as Tupperware tableware, West Bend Cookware, Thatcher glass bottles, and Babcock-Phillips cushions and pillows. These products now make up most of Dart's profits, the rest coming from Rexall products. Dart sold to 3-M Corporation most of Riker Laboratories, a higher-risk operation, along with Riker's British proprietary drug outlets, but saved Seamless Company, a Riker producer of hospital supplies.

Patron Sponsor

See: John Chamberlain, Jeff Raskin

Eldon Industries, Inc., specializes in electromechanical toys and sells about a tenth as many toys as Mattel, located in the same city, Hawthorne, California. Eldon is the largest manufacturer of electrical hand soldering tools, and also makes underwater sports equipment.

Sponsor

See: Jeff Raskin

The Garrett Corporation's specialty has been designing high-performance jet engines for military aircraft, but in the last few years Garrett (a subsidiary of The Signal Companies) began receiving contracts to produce jet engines for American, German and French business aircraft as well. For future rapid transit systems, Garrett has experimented with a Linear Induction Motor which would power 250 mph trains. Its Life Sciences Department developed environmental control systems (temperature, pressure, air purity) for all NASA space vehicles. Its simulation of weightlessness helps research into long-life space missions. Though Garrett applied its environmental control to commercial aircraft, government contracts still make up half of the company's sales.

Patron Sponsor

Artists in residence: Robert Irwin, James Turrell

See also: Iain Baxter, Len Lye

Gemini G.E.L. is a publishing house that commissions major contemporary artists to produce limited fine art editions. It was originally formed in 1965 as a hand lithography workshop and became additionally a workshop for research operations and the creation of dimensional objects, along with a gallery space. The staff of Gemini collaborates with some twenty manufacturing facilities around the world. Gemini has published over three hundred multiples, both two- and three-dimensional, by Jasper Johns, Ellsworth Kelly, Roy Lichtenstein, Robert Rauschenberg, Frank Stella, Kenneth Price, Josef Albers, Claes Oldenburg and many others.

Sponsor

Artist in residence: Claes Oldenburg

General Electric, besides making lamps and consumer appliances, is involved in manufacturing industrial equipment and in aerospace and defense technology, areas which make up three-fourths of its worldwide sales. It makes jet aircraft engines, equipment for nuclear reactors, and computers. (The competitive large-computer market led GE and Honeywell to propose a merger of their computer divisions.) Besides its other aerospace and defense contracts, which included Apollo equipment, GE has its own think tank, called TEMPO, which runs seminars on nuclear weapons and studies economic development for underdeveloped countries. At Nela Park, Ohio, G.E. Lamp Division operates a Lighting Institute with seminars in demonstration rooms for architects and engineers; the facility also researches new lighting technology and produces components such as glass and metals.

Patron Sponsor

See: Ron Cooper, Dan Flavin, James Seawright

Hall Inc., Surgical Systems, grew out of a product which oral surgeon Dr. Robert Hall invented in 1963, an air-driven, high-speed hand drill used for surgery. Hall adapted the turbine driven instrument for neurosurgery, orthopedic surgery and microsurgery. It is sold world-wide.

Sponsor

Artist in residence: Wesley Duke Lee

Heath and Company, owned by the New York Electrical contracting firm Fischbach & Moore, Inc., is one of the top ten electric sign makers in the U.S. The Los Angeles-based company produces metal and plastic signs for hotels, markets, drug stores, and car lots.

Sponsor

Artist in residence: Oyvind Fahlstrom

See also: John Baldessari

Hewlett-Packard Company's principal products are electronic measuring instruments which classify solid, liquid and gaseous chemical compounds, measure electrical variables, and record medical and biophysical data. Besides making other devices used in ultrasonic detection and in data processing (desk-top calculators, time-sharing systems), Hewlett-Packard is also heavily involved in defense equipment: radar, guided missile control, nuclear research.

Sponsor

Artist in residence: Rockne Krebs

The Hudson Institute was founded by Herman Kahn after he left the Rand Corporation. It receives most of its funding from the Office of the Secretary of Defense for studies on political and economic problems of foreign underdeveloped countries, for studies on strategic U.S. defense systems, and for a substantial number of classified studies on military technology and counter-insurgency warfare. Like many non-profit think tanks, the Hudson Institute has begun to concentrate more on domestic economic development problems such as urban transportation and planning, and poverty. Studies of economic and political models projected a few decades ahead resulted in a book by Kahn and another Hudson researcher, Anthony J. Wiener, called *The Year 2000: A Framework for Speculation.*

Sponsor

Artist in residence: James Byars

Information International, is one of many companies specializing in computer peripheral equipment and is the principal producer of equipment which can read graphs, maps, print, microscope images, and telescope images and translate them into computer language. The company also makes computer microfilm systems (which translate computer language into visual images), thereby joining much larger, established competitors like Kodak, 3-M and Stromberg DatagraphiX. It is one of a handful of computer companies experimenting in animating those visual images for scientific research and engineering.

Sponsor

Artist in residence: Jackson MacLow

See also: Wesley Duke Lee, Eduardo Paolozzi

International Business Machines Corporation is still the monolith of the computer industry; IBM usually sets computer selling and maintenance trends by example, although many smaller companies are finding specialized programming markets where IBM can't go. Its subsidiary World Trade Corporation, which computes hotel rooms in Japan, rainfall in Mexico and stock prices in Germany, symbolizes how rapidly the world is being computerized. IBM computers are used at the Houston Manned Spacecraft Center and aboard the Apollo spacecraft. IBM's research explores new kinds of information storage, but IBM also still makes small business machines like typewriters.

Patron Sponsor

Artist in residence: Jesse Reichek

See also: Jackson MacLow, Eduardo Paolozzi, Victor Vasarely

International Chemical and Nuclear Corporation, located in Pasadena, sells pharmaceuticals, radio-active isotopes, health and beauty aids. Its nucleic acid research institute explores memory, learning and aging processes.

Sponsor

See: John Chamberlain, Mark di Suvero

Jet Propulsion Laboratory, operated by the California Institute of Technology, is the center of advanced research and planning of U.S. space programs, and its level of activity consequently depends on NASA funding. JPL was project manager for the Mariner flybys past Mars, and is managing the Grand Tour past Jupiter, Saturn, Uranus and Neptune in the late 1970's, as well as whatever space programs NASA can fund in addition. JPL's primary job besides this has been deep space radio telescope probes and spacecraft tracking, but it continues a good deal of research in physical sciences (theory of relativity), electronics and telecommunications. It is doing studies on applying space program organization to social problems.

Sponsor

Artist in residence: Newton Harrison

See also: Michael Asher, James Byars

Kaiser Steel Corporation, largest steel producer on the West Coast and tenth-largest in the country, operates its own coal and ore mines (including some in Australia and British Columbia) for use in its twelve mills in Fontana, California. Kaiser's mill and fabricated products have run into competition with Japanese imports, which now makes up a fourth of the steel available on the West Coast. Kaiser has entered the modular and pre-fabricated housing field. Along with Kaiser Aluminum and Chemical, Kaiser Steel jointly owns United International Shipping Corporation.

Patron Sponsor

Artist in residence: Richard Serra

See also: François Dallegret, Mark di Suvero, Philip
King, Len Lye, Jules Olitski, Robert Smithson

Kleiner-Bell Foundation is endowed by Kleiner, Bell & Company, a well known West Coast brokerage firm.

Benefactor

Lear Siegler, Inc., primarily manufactures support equipment and systems for several industries: axles and auto diagnostic centers for the auto industry, guidance systems for aircraft and weapons, air conditioning and heating units for mobile homes, and maintenance centers for aircraft. In Europe and the U.S., it is one of the largest auto seat manufacturers. It also makes Bogen hi-fis and Olympic televisions, and operates twenty-eight technical schools in the U.S. Its main technological development goes into aerospace (including some Apollo guidance equipment), but some research has led to a six-way bucket seat adjuster for 1970's cars.

Patron Sponsor

Artist in residence: Robert Morris

Litton Industries, Inc., is a large conglomerate with a solid foothold in military contracts. Litton builds submarines, amphibious assault ships, and advanced guidance and fire control systems, selling the latter to Germany, Japan, Italy and Canada as well as to the U.S. Litton also makes Royal typewriters and Profexray X-ray tables, is the country's largest builder of paper and pulp mills, sells technical books (American Book Company) and manufactures laser crystals. Its Stouffer Foods sent food with Apollo, while another subsidiary, Western Geophysical, explores the world for petroleum. Research in microcircuitry (one step beyond integrated circuits) is tailored to the military market.

Patron Sponsor

See: John McCracken, Boyd Mefferd, Robert Morris, Vjenceslav Richter

Lockheed Aircraft Corporation, the nation's number one Department of Defense contractor, has long been a leader in military aircraft. In that position it has been particularly vulnerable to critical attitudes in Congress and the Pentagon. It produces the C-5A, world's largest aircraft, for the Air Force, and is developing advanced anti-submarine aircraft for the Navy. In the commercial market, it makes the L-1011, competitor for McDonnell-Douglas' DC-10. At its Rye Canyon, California, research facility it wind-tests prototype aircraft, tests antennae systems, researches new materials, and does solar research for NASA.

Patron Sponsor

Artist in residence: R. B. Kitaj

See also: Robert Irwin

Mifran-Bowman Corporation, deals in materials' handling, specializing primarily in forklifts and pallet trucks. The company is one of the largest local firms to sell, lease and service this type of equipment.

Contributing Sponsor

mifran-boman

Norris Industries has been a major ordnance manufactur-
er since World War II, and has since applied its expertise
in forming metal cartridge and bomb cases to the manu-
facture of compressed gas containers, fire extinguishers,
electrical outlet boxes and automobile wheels. Its
Thermador Division manufactures large home appliances
such as electric ranges and ovens, heaters and dishwash-
ers. Several other divisions supply brass fixtures for
homes and industry. Although Norris has begun to diver-
sify even more, for example with the purchase of Waste
King Corporation, the company's sales continue to be
primarily military.

Sponsor

See: Philip King, John McCracken, Peter Voulkos

North American Rockwell Corporation is a principal
Apollo program contractor.

Benefactor

NORRIS

Pan American World Airways, "the world's most experienced airline," was the first company to put 747s in the air.

Benefactor

Philco-Ford Corporation is the high-technology arm of Ford Motor Company, although it still makes appliances, televisions and stereos for the U.S., Japan, Europe and Latin America. Philco-Ford helped Apollo, produced Mariner communications systems, and developed anti-tank missiles and air defense systems for the Army and Air Force and radar for the Coast Guard. Its Aeronutronics Division in Newport Beach, California, which has developed laser target designators for air-dropped weapons, along with other major systems, is grouped along with Education Operations and a few other divisions under the heading Aerospace and Defense Systems Operation.

Patron Sponsor

Artist in residence: Robert Whitman

See also: John McCracken, Robert Morris

The RAND Corporation (from Research and Development) began in 1946 as a special project of Douglas Aircraft Company for the Air Force; Rand was to examine the many international variables which would control U.S. foreign policy. The think tank still receives most of its funding from the Air Force, Department of Defense and AID for studying such foreign policy factors as fertility rates in Pakistan and the influence of the Church on Latin American culture and politics. Rand monitors the Indochina war, has published volumes on Middle East politics and economy, and studies insurgency. It makes models (scenarios) of possible military interactions. Its first step into domestic problems has been studying where the interdisciplinary approach can untangle city budgets, combat VD, relieve fire departments and predict the impact of urban renewal. A large part of Rand's work remains classified.

Sponsor

Artists in residence: Larry Bell, John Chamberlain

RCA depends on the consumer market (televisions, records, stereo tapes, hi-fi and stereo equipment) for most of its sales. National Broadcasting Corporation, Random House and RCA Global Communications, which leases its satellite and cable transmissions, contribute about half as much. RCA also owns Hertz Rentals and makes electronic systems, including radar, guidance systems, communications systems and small computers for aerospace and defense markets. While RCA expands consumer sales around the world, its research is geared toward compactness: integrated circuits and color cartridge video tape machines for consumers. RCA applies computers to classroom instruction and runs its own technical schools.

Patron Sponsor

See: Walter de Maria, Sam Francis, Glenn McKay, James Rosenquist, Victor Vasarely, Andy Warhol

Teledyne in its ten-year history has formed expertise that ranges from electronics to materials technology, aviation, and industrial equipment. Teledyne makes super alloys for jet engines, gear rolling machines for the auto industry, special metals for nuclear generators, and avionics systems for military and commercial aircraft.

Its activities in propulsion include building piston engines for general aviation, jet engines for airplanes, multi-fuel engines for industry, and air-cooled engines for recreation. Teledyne provided Doppler radar for the Apollo Lunar Module landing, and also makes equipment for geological exploration, the Water Pik for oral hygiene, electronically controlled pilot-less supersonic aircraft, and television and stereo.

Patron Sponsor

Artist in residence: Robert Rauschenberg

See also: Victor Vasarely

The Times Mirror Foundation is endowed by the Times Mirror Company, which publishes the *Los Angeles Times* and other newspapers, magazines, and books.

Benefactor

Los Angeles Times

TRW Systems is a high-technology company specializing in electronics and the systems (interdisciplinary) approach to solving problems. TRW mapped Apollo's route to the moon.

Sponsor

See: Eduardo Paolozzi

Twentieth Century-Fox Film Corporation is one of the largest Hollywood film studios.

Contributing Sponsor

Universal City Studios, Inc., owned by MCA, Inc., is one of the most efficient movie and TV studios in the industry, and surrounds itself with its own city of apartment buildings, shopping center and hotel. Television series and motion pictures make up two-thirds of MCA's business; Universal also sells records and tapes under UNI, Decca, Brunswick and Kapp labels, and operates a flourishing tour business through its movie-TV studios. A technology subsidiary, MCA Technology, Inc., makes high-speed tape duplicators for the music industry. Universal's Optics Department has been refining a sixty year old rear-screen projection technique which puts actors in foreign settings without moving them from Universal City.

Patron Sponsor

Artist in residence: Roy Lichtenstein

Universal Television Company, founded in 1948, is principally engaged in electronic service with eleven "Home and Carry-in" service centers located in Northern and Southern California. The firm is presently considered the largest independent service company in America. Masco Sales, a subsidiary company, operates in television repair and accessory sales department in thirty-five West Coast locations. Dealers Installation Service, another division, maintains a private warehouse in the City of Commerce, specializing in customer installation of major appliances, televisions and stereos.

Patron Sponsor

Artist in residence: Boyd Mefferd

UNIVERSAL CITY STUDIOS, INC.

UNIVERSAL TELEVISION

WED Enterprises, Inc., is the Walt Disney Productions subsidiary which designs and fabricates new Disney projects, such as Florida's Walt Disney World, an entertainment complex which will dwarf Disneyland in size. Disneyland is the parent company's best performer. Its Florida offspring, along with RCA, will integrate a computer system into its operations handling credit, reservations, budgets and communications. Software companies have tried to computerize Disney's animations but haven't yet proved it feasible. Disney Productions also operates Mineral King, a ski resort in the California Sierras.

Patron Sponsor

Artist in residence: Claes Oldenburg

Wyle Laboratories' principal business used to be testing rockets and weapons systems in simulated environmental conditions; with many recent acquisitions it has branched into electronics and industrial manufacturing. Less than ten percent of its sales are now in testing and research. Wyle companies make tools in Cincinnati, St. Louis and Toledo, distribute electronic components in Los Angeles and run one of the biggest trucking companies in the Southeastern U.S. Wyle still does aerospace testing, but also is designing a laboratory test facility for high-speed rapid transit.

Patron Sponsor

See: Philip King, Eduardo Paolozzi

WYLE LABORATORIES

The following corporations were invited to join A & T but declined:

Aerojet-General Corporation
Aerol Company, Inc.
Alcoa
Allied Chemical Corporation
American Bulk Carriers, Inc.
American Construction & Pipe Company
American Cyanamid Company
American Smelting & Refining Company
American Standard, Inc.
Ameritone Paint Corporation
Anchor Hocking Corporation
Apex Smelting Company
Argo Plastic Company
Armstrong Cork Company
Atlantic-Richfield Company
Avery Products
Avis Rent-a-Car System
Beckman Instruments, Inc.
Bendix Corporation
Beneficial Standard Life Insurance Corporation
Bethlehem Steel Corporation
C.W. Bundren Truck Company
California Computer Products, Inc.
California Federal Savings and Loan Association
California Savings and Loan
Carnation Company
A. M. Castle Company
Century Plastics, Inc.
Chase Brass & Copper Company, Inc.
Coca-Cola Bottling Company of Los Angeles
Columbia Broadcasting System
Columbia Pictures Corporation
Computer Creations
Crocker Citizens National Bank
Crown Zellerbach Corporation
Crucible Steel Corporation
Dillingham Corporation
Dow Chemical Company
Ducommun Metals & Supply Company
Dumont
E. I. Du Pont de Nemours & Company, Inc.
Eastman Kodak Company
Economatics, Inc.
E G & G, Inc.
Electro-Optical Systems, Inc.
Max Factor & Company
Federal Steel Corporation
Fellows & Stuart
Feuer Corporation
Fibreboard Corporation
Firestone Tire & Rubber Company
First Western Bank and Trust Company
Flex-Coat Corporation
Flinkote Company
Flying Tiger Line, Inc.

Foremost-McKesson, Inc.
Formica Corporation
Fry Plastics International
Fuller Paint Company
General Dynamics Corporation
General Tire & Rubber Company
Georgia-Pacific Corporation
Getty Oil Company
Gibraltar Savings
Gilfillan, Inc.
Gladding McBean
Glass Containers Corporation
Glendale Federal Savings and Loan Association
B. F. Goodrich Company
Goodyear Tire & Rubber Company
Gulf General Atomic, Inc.
Hancock Oil Company
Harvey Aluminum Company
Hertz Corporation
Hess-Goldsmith, Inc.
Hoffman Electronics Corporation
Hollywood Turf Club
Home Savings and Loan Association
Honeywell, Inc.
Hughes Aircraft Company
Hunt Foods and Industries, Inc.
Industrial Asphalt, Inc.
International Paper Company
International Pipe & Ceramics Corporation
International Rectifier Corporation
International Silver Company
International Telephone and Telegraph Corporation
Interpace Corporation
Jones & Laughlin Steel Corporation
Jorgensen Steel Company
Joshua Hendy Corporation
Kilsby Tubesupply
Korad Corporation
Lannan Foundation
Lippincott Environmental Arts, Inc.
McCrory Corporation
McDonnell Douglas Corporation
M.S.L. Industries
Marshall Industries
Mattell, Inc.
Metro-Goldwyn-Mayer Studios
Metropolitan Water
Mobil Oil Corporation
Monsanto Corporation
Mosaic Tile Company
National Broadcasting Company
NASA
National Cash Register Company
National General Corporation
Northrop Corporation
Occidental Petroleum Corporation
Old Colony Paint & Chemical Company

Optical Coating Laboratories
Owens Corning
PPG Industries
Pacific Fiberglass Corporation
Pacific Metals Division A. M. Castle & Company
Pacific Telephone and Telegraph Company
Packard-Bell Electronics
Paramount Pictures Corporation
Pacific Lighting Corporation
Pendleton Tool Industries, Inc.
Pepsi-Cola Company
Phillips Petroleum Company
Poly-Optics Systems, Inc.
Pomona Tile Company
Portland Cement Association
Potlatch Forests, Inc.
Producers' Council, Inc.
Property Research Corporation
Purex Corporation, Ltd.
Raytheon Company
Reichhold Chemicals, Inc.
Republic Corporation
Republic Steel Corporation
Reynolds Metals Company
Rohm and Haas Company
Royal Industries
Ryan Aeronautical Company
Joseph T. Ryerson and Son, Inc.
Scientific Data Systems
Shell Oil Company
Signal Oil Company
Silmar Division of Vistron Corporation
Skidmore, Owings and Merrill
Southern California Edison Company
Standard Pressed Steel Company
Standard Oil Company of California
State Mutual Savings and Loan
Statham Instruments, Inc.
Swedlow, Inc.
System Development Corporation
Technicolor Corporation
3-M Company (Minnesota Mining and Manufacturing Company)
Transamerica Corporation
Union Bank
Union Carbide Corporation
Union Oil Company
United Artists Corporation
United States Gypsum Company
United States Plywood-Champion Papers, Inc.
United States Steel Corporation
Uniroyal, Inc.
The Upjohn Company
Warner Brothers-Seven Arts, Inc.
Webb Textiles
Wells Fargo Bank
Westinghouse Electric Corporation
Whittaker Corporation
Xerox Corporation

Samuel Aroni, pp. 87, 90

Aruba Tourist Bureau, p. 308 (top)

Rudolph Burckhardt, p. 306 (left)

Leo Castelli Gallery, p. 286

Cinnamon Productions, pp. 196 (left), 198

Ed Cornachio, pp. 55, 61, 64, 66, 79, 81, 109, 110, 111, 112,
 113, 119, 145, 150, 155 (bottom), 157 (top), 163, 171, 224,
 245, 246, 252, 253 (bottom), 255, 266, 277, 320, 321, 343,
 345, 357.

Cowles Communications, pp. 331, 333, 334

Barbara Crutchfield, p. 71

William Crutchfield, pp. 204, 289, 291, 341 (right top and
 bottom), 344

Cummins Engine Company, pp. 99

Design News, p. 257

Hal Glicksman, p. 60

Institute for Theater Wissenshaft, Cologne University, p. 309

Sidney Janis Gallery, pp. 104-105

Kaiser Steel Corporation, pp. 300, 301, 302, 304

James Kenion, p. 317

Tami Komai, pp. 121, 122, 124, 125, 172, 173, 174, 231, 232,
 233, 234-5, 263, 313, 314, 315, 319, 335, 336, 337, 348,
 350, 351, 352-3

Knoedler Gallery, p. 306 (top)

Malcolm Lubliner, pp. 102, 106, 120, 128, 129, 133, 135, 137,
 142, 150, 155 (top), 156 (right), 157, 158, 159, 186, 190,
 194, 196 (right), 201, 203, 206, 228, 229, 240, 243
 (bottom), 244, 247, 248, 249, 253 (top), 254, 256, 258, 259,
 260, 261, 262, 279, 281, 282, 299, 303, 309 (bottom), 310,
 318, 341 (left top and bottom), 353, 354, 355, 356

Marlborough, pp. 149, 152, 154, 159 (left), 160, 161

Eric Miller, pp. 153, 155 (middle, left and right), 156 (left)

Museum of Modern Art, New York, p. 57

Hans Namuth, pp. 311, 312

Eric Pollitzer, pp. 270, 271

Nathan Rabin, p. 267

Vincent Robbins, pp. 123, 175

Jay Rowen, p. 89

Y. Ernest Satow, p. 264

Teledyne, Inc., pp. 283, 284, 285, 287

Frank Thomas, p. 195

Maurice Tuchman, p. 238

Catalog Design: Louis Danziger

Paste-up: Robert Richards

Exhibition Graphics: Vincent Robbins

Printing: Continental Graphics

Typesetting: Garon Graphic